Aerial Photography
and Image Interpretation
for Resource Management

Aerial Photography
and Image Interpretation
for Resource Management

David P. Paine
Forest Management Department School of Forestry
Oregon State University
Corvallis, Oregon

John Wiley & Sons

New York Chichester Brisbane Toronto

To:

Janet

Carolyn

Mary

Library of Congress Cataloging in Publication Data:

Paine, David P.
 Aerial photography and image interpretation for resource management.

 Includes bibliographical references and indexes.
 1. Photography-Aerial. 2. Photographic interpretation.
 3. Aerial photography in forestry.

I. Title.
TR810.P25 778.3′5′-02433 81-4287
ISBN 0-471-01857-0 AACR2

Printed in the United States of America

10 9 8 7

Preface

The predecessor to this book, *An Introduction to Aerial Photography for Natural Resource Management,* published by O.S.U. Bookstores, Inc., has been extensively used by forestry students in two- and four-year colleges in the United States and Canada. This book has been expanded to include the use of aerial photography in many other natural resource disciplines. It is an elementary textbook with emphasis on aerial photo interpretation but includes some photogrammetry and an introduction to nonphotographic remote sensing — a subject of much broader scope.

Even though the subject matter is quantitative, the mathematics involved has been kept as simple as possible. All that is required is a basic understanding of elementary high school algebra and perhaps a little geometry. An understanding of elementary statistics and sampling methods is necessary for the understanding of Part Four but that is the subject of Chapter Nineteen.

As with most textbooks, the reproduction of photographs are halftones, not actual photographs resulting in a significant loss of detail. When the text discusses a specific object or characteristic illustrated by one of these halftones you should realize that the original photograph was of higher quality. You should also be aware that the scale of the halftones only approximates the original scale although an attempt was made to reproduce them at the same scale in most instances. This variation in scale may slightly alter some of the laboratory exercises when measurements are made on the halftones. Where the scale of the reproduction was purposely changed, the amount of change is indicated in the figure legend.

Each chapter begins with a specific set of objectives and concludes with sample questions and problems based on the objectives. The answers to these questions can be found either in the chapter or in Appendix F. The answers in Appendix F are only for those problems that have no specific answer in the text and are primarily answers to mathematical problems. Many of the chapters also have a laboratory exercise. The answers to some of these exercises are found in Appendix G.

The book is organized into an introduction and five parts. Part One, "Geometry and Photo Measurements," deals with the geometric and measurement aspects of the use of vertical aerial photography that are essential for both the interpretative and photogrammetric aspects of the use of aerial photography.

Part Two, "Mapping from Vertical Aerial Photos," delves deeper into the photogrammetric aspects of aerial photography. Photogrammetry, as contrasted to photo interpretation, is concerned with making reliable measurements on aerial photographs and the production of maps, both planimetric and topographic.

Part Three, "Photo Interpretation," starts with a chapter on films and filters and a chapter on the principles and techniques of photo interpretation. These chapters are followed by five chapters emphasizing photo interpretation in many

areas of interest to resource managers.

Part four, "Forest Inventory," includes three chapters. Chapter Nineteen covers elementary statistics and sampling methods and the next two chapters thoroughly cover aerial photo mensurational techniques for forest inventory. Included is an example timber cruise using photo measurements with a limited amount of field verification using a double sampling technique. The same technique can be modified and adapted for the inventory of other natural resources.

Part Five, "An Introduction to Nonphotographic Remote Sensing," briefly discusses radiant energy flow and two of the more common remote sensors (other than the camera) of interest to the natural resource manager — scanner and radar systems. Chapter Twenty-five briefly discusses the Landsat series of earth-orbiting satellites that carry two types of remote sensors to obtain information about the resources of the earth and introduces the space Shuttle.

This book is too long to be thoroughly studied in a single three-credit course on a term basis. However, it could be covered in a five-credit course or in a three-credit course taught on a semester basis. Many instructors, however, will elect not to cover the entire book. Selected chapters can be omitted depending on the specific discipline of interest. Students of all disciplines should cover Part One and those chapters of Part Three of significance to their particular discipline. Part Two is too shallow to compete with established textbooks in photogrammetry for surveyors, cartographers, and engineers, but the subject material is desirable background material for all natural resource disciplines that rely on maps.

Part Four was written specifically for foresters but the techniques can be applied to other disciplines as well. Finally, Part Five could be included or excluded from any course in photo interpretation. However, the sensors discussed are becoming increasingly more important to the resource manager as technology advances. This is particularly true of imagery obtained by the Landsat series of orbiting satellites. I hope that the study of Part Five will interest you for further study in this area.

I and others have developed a series of 17 slide-tapes based on this book that can be used in self-taught courses or as supplementary material for standard format courses on aerial photo interpretation. For more information contact:Director, Forestry Media Center, Oregon State University, Corvallis, Oregon 97331.

David P. Paine

Acknowledgements

I express my sincere appreciation to all of those who have contributed to this book. specifically, I wish to acknowledge the following individuals who reviewed the entire manuscript: Professors Joseph J. Ulliman, University of Idaho; Marshall D. Ashley, University of Maine at Orono; Garland N. Mason, Stephen F. Austin State University; and L. G. Arvanitis, University of Florida. I also appreciate the cursory review by Professor Roger M. Hoffer, Purdue University. Portions of the manuscript were also reviewed by Professors Roger. G. Peterson, Bo Shelby, and John R. "Dick" Dilworth, all at Oregon State University.

Special recognition goes to "Dick" Dilworth, my department head at the initiation of this writing, first instructor in aerial photo interpretation, and first major professor at the graduate level. I also acknowledge the current School of Forestry administrators for their support and encouragement.

I am also grateful for the help of Dr. Charles E. Poulton of NASA-Ames, Moffit Field, California, who helped in the writing of Chapter 16, Land Use Planning. I also thank Mr. Bruce D. Ludwig, Mrs. Charlene Crocker (graduate teaching assistants in photo interpretation), and Sue Mason, instructor in journalism for their very valuable proofreading. In addition I thank the many individuals, government agencies, instrument manufacturers, and other commercial firms who provided information and illustrations for this book.

Finally, special recognition goes to my wife, Janet, and children, Carolyn and Mary, who endured five years of neglect during the preparation of this book.

David Paine

Contents

One
Introduction

Would you, as a resource manager, be interested in an annual saving of up to 35 percent of the planning, mapping, and interpreting costs involved in the management of forest and range lands? This is the savings estimated by the staff of the Department of Natural Resources, State of Washington, through the use of aerial photography (Edwards, 1975).

With potential savings of this magnitude it becomes increasingly important that all natural resource agencies, whether federal, state, or private, make maximum use of aerial photography and related imagery.

The study of aerial photography whether it be photo interpretation or photogrammetry is a subset of a much broader discipline called remote sensing. Remote sensing is the identification and study of objects at a remote distance using reflected and/or emitted electromagnetic energy. It includes the use of a number of different sensor systems, including the well-known camera, to identify and measure objects, each using a different portion of the electromagnetic spectrum. Some of the nonphotographic sensor systems (scanners and radar units) are valuable to the natural resource manager and are included in Chapters Twenty-three to Twenty-five.

This book emphasizes photo interpretation but includes enough remote sensing and photogrammetry to provide an adequate background to enable one to become a competent photo interpreter. In addition, a good interpreter must have a solid background in one or more of the natural resource disciplines.

Photogrammetry is the art or science of obtaining reliable quantitative information (measurements) from aerial photographs (American Society of Photogrammetry, 1966). Photo interpretation is the determination of the nature of objects and the judgement of their significance. Photo interpretation involves a considerable amount of photogrammetry. The size of an object is often one of the important considerations in its identification. The result of photo interpretation is frequently a map and making a map from aerial photos is an important aspect of photogrammetry.

Objectives

After a thorough understanding of this chapter you will be able to:

1. Write precise definitions for remote sensing, photogrammetry, photo interpretation, electromagnetic spectrum, micrometer, atmospheric window, $f/$stop, film exposure, and depth of field.
2. Draw a diagram and write a paragraph to explain reflectance, transmittance, absorptance, and refractance.
3. List the ranges of wavelengths associated with (a) the human eye and (b) photographic film.
4. Diagram a typical but complete energy-flow profile from the sun to a sensor located in an aircraft.
5. Draw a diagram of a simple camera showing the lens, shutter, aperture, focal length, and the relative position of the film and the image on it.
6. List and explain the meaning of the information printed on most photographs including the fiducial marks.
7. Convert among the various units of measure presented in Tables 1.1 through 1.3.

ENERGY FLOW AND THE ELECTROMAGNETIC SPECTRUM

All imaging remote sensors, including the well-known camera, require energy to produce an image. The most common source of energy used to produce an aerial photo is the sun. The sun's energy travels in the form of wavelengths at the speed of light or 186,000 miles (299,000 km) per second and is known as the electromagnetic spectrum. The pathway traveled by the electromagnetic spectrum is the energy-flow profile.

The Electromagnetic Spectrum

Wavelengths that make up this spectrum (Figure 1.1) can be measured from peak to peak or trough to trough (Figure 1.2). The preferred unit of measure is the micrometer (μm), which is one thousandth of a millimeter. The spectrum ranges at one end of the scale from cosmic rays (about 10^{-10} μm) through gamma rays, X rays, visible light, and infrared to radar, television, and standard radio waves (about 10^{10} μm or 10 km). Different remote sensors are capable of measuring and or recording different wavelengths. Photographic film is the medium on which this energy is recorded within the camera and is generally limited to the 0.4 to 0.9-μm region.

Properties of Electromagnetic Energy

Electromagnetic energy can be detected only when it interacts with matter. We

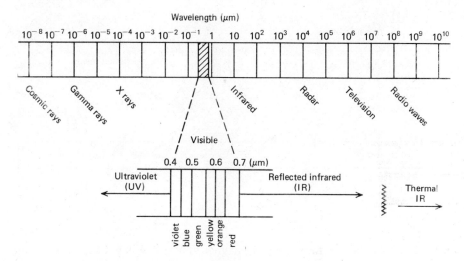

Figure 1.1. The electromagnetic spectrum.

Figure 1.2. Measuring wavelengths (λ). The preferred unit of measure is the micrometer (μm or one thousandth of a millimeter). Wavelengths can also be measured by their frequency — the number of waves per second passing a fixed point.

see a ray of light only when it interacts with dust or moisture in the air or when it strikes an object. Electromagnetic energy, which we will call rays, is propagated in a straight line within a single medium. However, if a ray travels from one medium to another that has a different density, it is altered. It may be reflected or absorbed by the second medium or refracted and transmitted through it. In many cases all four types of interactions take place (Figure 1.3).

Reflectance

 Reflectance is the ratio of the energy reflected from an object to the energy incident upon the object. The manner in which energy is reflected from an object has a great influence on the detection and appearance of an object on photographic film as well as display and storage mediums for nonphotographic sensors. The manner

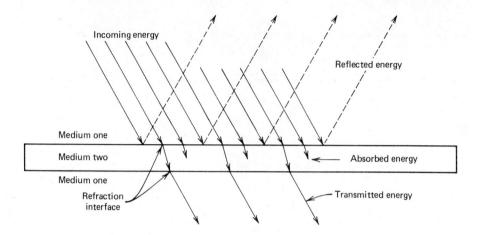

Figure 1.3. The interaction of electromagnetic energy. When it strikes a second
medium, it may be reflected, absorbed, or refracted and transmitted
through it.

in which electromagnetic energy is reflected is a function of surface roughness.
Specular reflectance takes place when the incident energy strikes a flat mirrorlike
surface where the incoming and outgoing angles are equal (Figure 1.4—left).
Diffuse reflectors are rough relative to the wavelengths and reflect in all directions
(Figure 1.4—right). If the reflecting surface irregularities are less than one-quarter
of the wavelength we get specular reflectance from a smooth surface, otherwise we
get diffuse reflectance from a rough surface. Actually, the same surface can produce
both diffuse and specular reflection depending on the wavelengths involved. Most
features on the earth's surface are neither perfectly specular or diffuse but some-
where in between.

Absorptance

Absorptance occurs when the rays do not bounce off the surface and do not pass
through it. Instead the rays are converted to some other form of energy such as heat.

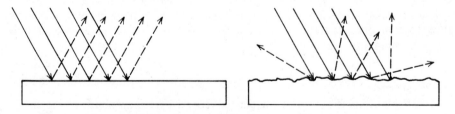

Figure 1.4. Specular reflectance from a smooth surface (left) and diffuse reflec-
tance from a rough surface (right).

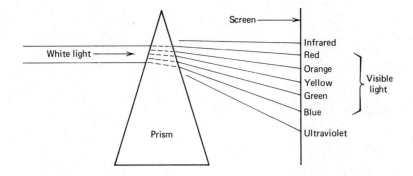

Figure 1.5. Separating white light into its components using a glass prism.

Within the visible spectrum, differences in absorptance qualities of an object result in the phenomenon that we call color. A red glass filter, for example, absorbs the blue and green wavelengths of white light and allows the red wavelengths to pass through. These absorptance and reflectance properties are important in remote sensing and are the basis for selecting filters to control the wavelengths of energy that reach the film in a camera. Absorbed wavelengths that are converted to heat may later be emitted to be detected by a thermal (heat) detector.

Transmittance and Refractance

Transmittance is the propagation of energy through a medium. Transmitted wavelengths, however, are refracted when entering and leaving a medium of different density such as a glass window. Refractance is the bending of rays at the interface of a different medium. Refractance is caused by the change in velocity of electromagnetic energy as it passes from one medium to another. Short wavelengths are refracted more than longer ones. This can be demonstrated by passing a beam of white light through a glass prism with a white screen placed behind the prism. The refracted components of white light (the colors of the rainbow) can be observed on the screen (Figure 1.5).

Atmospheric Windows

Fortunately many of the deadly wavelengths (cosmic, gamma, and X rays) are filtered out by the atmosphere and never strike the earth's surface. Atmospheric windows occur in portions of the electromagnetic spectrum where the wavelengths are transmitted through the atmosphere (Figure 1.6). The technology of remote sensing involves the entire electromagnetic spectrum with different sensors designed to operate in different regions of the spectrum.

The spectral range of human vision (visible light window) and two of the three image-forming sensors (cameras and scanners) in relation to the atmospheric windows are also shown in Figure 1.6. Radar operates in the centimeter-to-meter range where there is practically no atmospheric filtering.

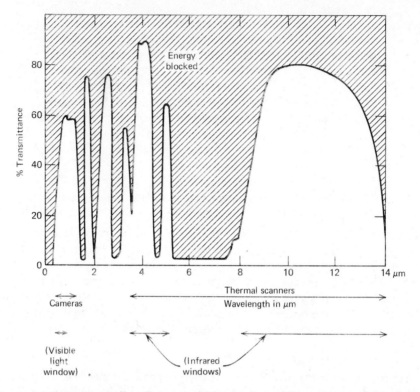

Figure 1.6. Atmospheric windows within the 0- to 14-μm range of the electromagnetic spectrum.

The human eye can detect wavelengths between about 0.4 and 0.7 μm. Fortunately this corresponds to an atmospheric window. Without the window, there would be no light. The sensitivity of photographic film range is greater than that of the human eye and goes from about 0.4 to 0.9 μm.[1] Normal color and panchromatic film is sensitized to the 0.4- to 0.7-μm range, whereas the range of infrared film (both color and black and white) is between 0.4 and 0.9 μm. The region between 0.7 and 0.9 μm is called the photographic infrared region. Thus, with the right film and filter combination, the camera can "see" more than the human eye. An interesting example is shown in Figure 1.7. Using aerial film with extended sensitivity to include ultraviolet (UV) rays between 0.3 and 0.4 μm and a special camera lens, Lavigne and Oristland (1974) were able to photograph white harp seal pups against their snowy background. The black adult seals are clearly visible on both panchromatic and UV photography while the white pups are visible only on the UV photography. Because of this white-on-white combination the pups are not visible to the human eye unless one is quite close. Animal fur, whether black or white,

[1]*Special film can be made to extend the range from 0.3 to 1.2 μm.*

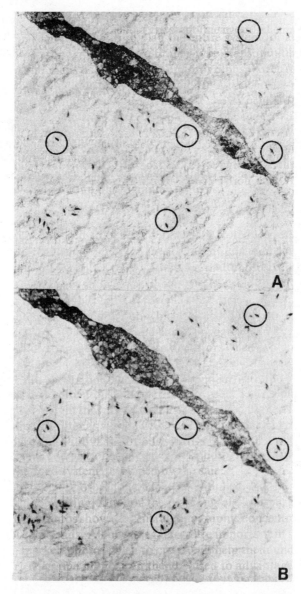

Figure 1.7. Using ultraviolet sensitized film (B) makes it possible to photograph white harp seal pups against a white, snowy background. Only black adults can be seen on standard panchromatic film (A). (Courtesy David M. Lavigne, University of Guelph, Ontario, Canada.)

absorb UV wavelengths while snow and ice reflect UV wavelengths back to the film in the camera. Thus the images of both the dark adults and white pups become visible on UV as compared to panchromatic photography, which shows only the dark adults.

Energy Flow from Source to Sensor

Contrary to common belief, infrared *photography* does not detect heat. It detects *reflected* infrared energy, which is not heat. *Emitted thermal* infrared energy (heat) is detected by a thermal scanner that operates on an entirely different process (Chapters Twenty-two and Twenty-three). Even though the results of thermal scanning frequently end up on photographic film, the film acts only as a display medium. In the photographic process (Chapter Twelve) film acts as both a detector and display medium.

The energy-flow profile (Figure 1.8) begins at the source, is transmitted through space and the atmosphere, is reflected by objects on the earth, and is finally detected by a sensor. Not all energy reaches the sensor because of scattering and absorption. Scattering is really reflectance within the atmosphere caused by small particles of dust and moisture.

Blue sky is nothing more than scattered blue wavelengths of sunlight. A red sunrise or sunset is the result of additional scattering. During the morning and

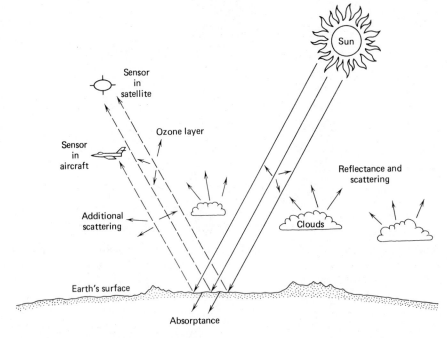

Figure 1.8. The energy-flow profile.

evening the solar path through the atmosphere is greatest and the blue and green portions of sunlight are scattered to the point that red is the only portion of the spectrum that reaches the earth. Small particles within the atmosphere cause more scattering of the blue and green wavelengths than the longer red ones. The ozone layer of the earth's atmosphere is primarily responsible for filtering out the deadly short wavelengths by absorptance.

Not all energy that reaches the sensor is reflected from terrestrial objects. Some of the rays that are scattered by the atmosphere reenter the energy profile and reach the sensor. Thus filters are used to filter out the shorter wavelengths when photographing from higher altitudes. Because the total amount of scattered energy increases with an increase in flying altitude, different filters are used for different flying altitudes. Scattered energy is analogous to static in radio reception and is called background noise or noise for short.

Energy Flow Within the Camera

In this chapter we limit our discussion to the energy flow within the cameras. A discussion of other sensors and the imagery they produce can be found in Chapters Twenty-two through Twenty-five.

The most common source of energy for the camera system is the sun, although other sources such as electric lights, flashbulbs, flares, or fire can be used. The following discussion is limited to the sun as the energy source.

Energy that finally reaches the camera has already navigated several obstacles. It has been reflected, refracted, transmitted, scattered, and has avoided absorption. The last obstacles before reaching the film are one or more lenses and usually a filter. In addition, many aircraft, especially high-altitude aircraft, are equipped with windows over the camera to protect it and the photographer from wind pressure and other atmospheric conditions. Camera windows and lenses absorb very little of the visible and photographic infrared portions of the spectrum and are usually of little concern. However, filters do absorb significant portions of the photographic range of the spectrum. Filters are used to control the quantity and quality of energy that finally reaches the film. The photographer selects the filter or filters to use depending on the altitude, lighting, haze conditions, the type of film used, and the photographic result wanted. Finally, a portion of the electromagnetic energy reaches the film and starts a chemical reaction which, after film development, produces an image (see Chapter Twelve).

THE PHOTOGRAPHIC PROCESS

Even though images produced by sensors other than the camera are frequently displayed on photographic film, the camera is the only sensor in which the film is an essential part of the detection system. Photographic film in a camera acts as a detector as well as a display and storage medium, whereas scanner and radar sensors use photographic film only as a display and storage medium. And the storage

function of film for these sensors is secondary because this information is better stored on computer tape in the form of digital data.

Components of a Simple Camera

The camera (Figure 1.9) can be described as a lightproof chamber or box in which an image of an external object is projected on light-sensitive film through an opening usually equipped with a lens, shutter, and a variable aperture. A camera lens is defined as a piece or a combination of pieces of glass or other transparent material shaped to form an image by means of refraction. Aerial camera lenses can be classified according to focal length or angle of coverage (see Chapter Two). The shutter is a mechanism that controls the length of time the film is exposed to light. The aperture is that part of the lens that helps control the amount of light passing through the lens. The design and function of a camera is similar to the human eye. Each has a lens at one end and a light-sensitive area at the other. The lens gathers light rays reflected from objects and focuses them onto a light-sensitive area. Images on the film negative are reversed from top to bottom and from right to left. A second reversal is made when positives are produced thus restoring the proper image orientation.

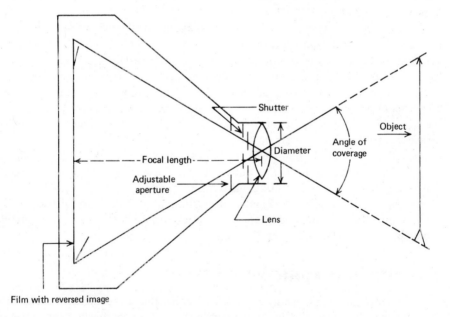

Figure 1.9. Features of a simple camera showing a reversed image on the film negative. (Adapted from U.S. Department of Agriculture, Forest Service, 1975.)

Exposing the Film

Film exposure is defined as the quantity of energy (visible light and/or photographic infrared) that is allowed to reach the film and is largely controlled by the relative aperture and shutter speed of the camera as well as the energy source. The proper exposure is necessary to produce a good image.

The relative aperture, or lens opening is called the f/stop and is defined as the focal length divided by the effective lens diameter (controlled by the aperture). Some of the more common f/stops, *from larger to smaller* lens openings are $f/2$, $f/2.8, f/4, f/5.6, f/8, f/11, f/16, f/22$, and $f/32$. If the time the shutter remains open is doubled, the lens opening must be decreased by one f/stop to maintain the same exposure. For example, let's assume that a photo is taken with a shutter speed of 1/100th of a second and a relative aperture of $f/11$. If the shutter speed is changed to 1/50th of a second, the relative aperture must be decreased one f/stop to $f/16$ in order to maintain the same exposure of the film. The whole idea is to maintain the same total quantity of light energy that reaches the film. Thus, if we want the same exposure and if we increase the size of the opening through which light passes, then we must decrease the length of time that light is allowed to pass through the lens to the film and vice versa.

Depth of Field

As we decrease the size of the lens opening we increase what is called the depth of field, which is the range of distances from the camera in which images are in sharp focus. Depth of field is seldom a consideration with aerial photography because it is only critical for objects relatively close (under 50 ft) to the camera.

Types of Aerial Cameras

An aerial camera is specifically designed for use in aircraft. Some of the more commonly used cameras are the aerial frame camera, panoramic camera, and continuous-strip camera. Most aerial cameras can be classified as frame cameras in which an entire frame or photograph is exposed through a lens that is fixed relative to the focal plane of the camera. Aerial frame cameras are used for reconnaissance, mapping, and interpretation purposes (Figure 1.10).

Unlike the frame camera, the panoramic camera takes a partial or complete (horizon to horizon) panorama of the terrain. In some panoramic cameras, the film is stationary and the lens scans the film by rotating across the longitudinal axis of the aircraft to produce highly detailed photography (Figure 1.11).

A continuous-strip camera exposes film by rolling the film continuously past a narrow slit opening at a speed proportional to the ground speed of the aircraft (Figure 1.12). This camera system was developed to eliminate blurred photography caused by movement of the camera at the instant of exposure. It allows for sharp images at large scales obtained by high-speed aircraft flying at low elevations and is

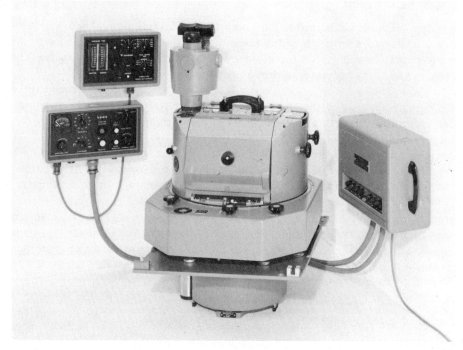

Figure 1.10. A typical aerial frame camera (Wild RC to 10 Aviophot camera
system), primarily used for reconnaissance, mapping, and interpre-
tation. (Courtesy of Wild Heerbrugg Instruments, Inc.)

particularly useful to the military or for research where very large-scale photo-
graphy is required.

PRINTED INFORMATION ON AERIAL PHOTOGRAPHS

During the processing of aerial film in the laboratory, certain important informa-
tion is printed on each photo. Figure 1.13 shows the first two photogrphs in a single
strip taken over forest and agricultural land. In the United States the printed
information is usually on the north edge for flight lines flown north and south, and
on the west edge if the flight lines are oriented east and west. In other countries or
within different geographical areas of the United States this practice may vary. In
British Columbia, Canada, for example, the printed information can be found on
the east, west, north, or south edge of the photo regardless of the direction of the
flight line. The interpreter needs to know what system was used for the photography
he or she has. On the first photo of each strip we frequently find the following
information (Figure 1.13): date (June 6, 1962), flying height above mean sea level
(13,100 ft), focal length of the lens (12 in.), time of the day (13:35 or 1:35 P.M.),

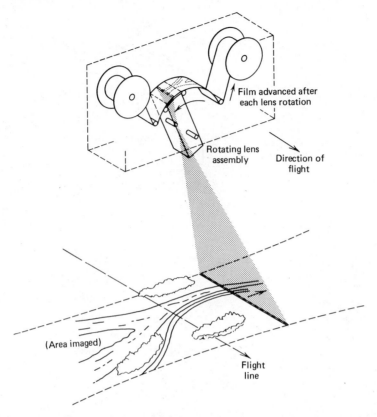

Figure 1.11. Operating principle of a panoramic camera. (From T. M. Lillesand and R. W. Kiefer, 1979, *Remote Sensing and Image Interpretation*, copyright 1979, John Wiley and Sons, Inc., reprinted by permission.)

project symbol (MF), flight strip number (3), and exposure number in that strip (1). On subsequent photos in the same strip, only the date, project symbol, flight strip number, and exposure number are printed. Sometimes you will find more or less information, but Figure 1.13 is representative with two exceptions. Many projects use the film roll number instead of the flight strip number and print the approximate photo scale instead of the flying height above mean sea level. Printing the scale on photos of mountainous terrain can be very misleading to the untrained interpreter because the photo scale changes significantly between and within photos. We discuss this in detail in Chapters Four and Five.

Many cameras are designed to provide similar or additional information in a different way. These cameras photograph different dials for each exposure and provide this information on one edge of the photo. Unfortunately, this information is frequently cut off and discarded when the photos are trimmed. These dials can include a circular level bubble to indicate tilt, a clock showing the exact time of exposure including a second hand, an altimeter reading, and an exposure counter.

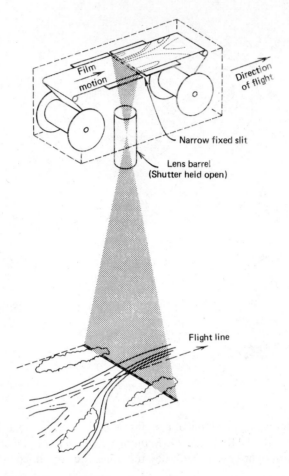

Figure 1.12. Operating principle of a continuous strip camera. (From T. M. Lillesand and R. W. Kiefer, 1979, *Remote Sensing and Image Interpretation,* copyright 1979, John Wiley and Sons, Inc., reprinted by permission.)

Fiducial marks are imaged at the corners or midway between the corners of each photo. Examples of side fiducial marks in the form of half arrows can be found in Figure 1.13. Their purpose is to enable the photogrammetrist or photo interpreter to locate the geometeric center of the photo.

UNITS OF MEASURE

For many years the metric system has been used to measure or calibrate cameras, film, and photographic equipment. The 35 mm and 70 mm film sizes are common

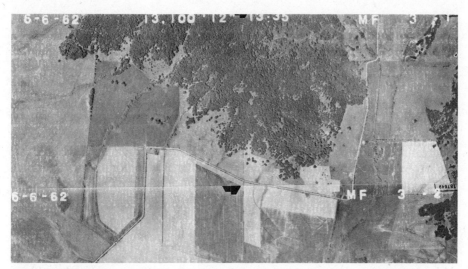

Figure 1.13. Information printed at the top of the first two photographs of a flight line.

examples. The United States is shifting from the English to the metric system of measurement. For these reasons, both systems are used in this book. The English system will be emphasized with frequent reference to the metric equivalent where feasible. Problems and examples in either system of measurement will give the student exposure to the conversions required. This is a compromise between going metric all the way and ignoring the shift from the English to the metric system that has already begun in this country.

Table 1.1 gives some of the English equivalents with which you may not be familiar. These units and those presented in Tables 1.2 and 1.3 will be used throughout.

TABLE 1.1 Selected English Equivalents

Length or Distance		
66 feet	=	1 chain
792 inches	=	1 chain
80 chains	=	1 mile
5,280 feet	=	1 mile
63,360 inches	=	1 mile

Area		
640 acres	=	1 square mile
43,560 square feet	=	1 acre
10 square chains	=	1 acre

Table 1.2 gives the relationship among various measures in the metric system. In the metric system the basic unit of length or distance measurement is the meter. Converting from one unit to another in the metric system is much simpler than in the English system because all conversions are in multiples of 10.

Table 1.3 gives conversion factors in the form of multipliers for converting between the two systems in either direction. For example to convert 2 in. to millimeters we would multiply by 25.4 to get 50.8 mm. Now, if we convert 50.8 mm back to inches we multiply by 0.03937 to get 2.0 in.

TABLE 1.2 Selected Metric Equivalents for Length or Distance

Unit	Symbol	Equivalent (meters)
Kilometer	km	1000 or 10^3
Meter	m	1 or 10^0
Centimeter	cm	0.01 or 10^{-2}
Millimeter	mm	0.001 or 10^{-3}
Micrometer	μm	0.000001 or 10^{-6}
Nanometer	nm	— 10^{-9}
Angstrom	$\overset{\circ}{A}$	— 10^{-10}

TABLE 1.3 Selected Multipliers for Converting Between the English and Metric Systems

Conversion Between	Multipliers for Changing from	
	English to Metric	Metric to English
Length or Distance		
Inches and millimeters	25.4	0.0394
Inches and centimeters	2.54	0.394
Feet and meters	0.3048	3.2808
Yards and meters	0.9144	1.0936
Chains and meters	20.1168	0.0497
Miles and kilometers	1.6093	0.6214
Area		
Square inches and square millimeters	645.1626	0.00155
Square feet and square meters	0.0929	10.764
Square yards and square meters	0.8361	1.196
Square chains and square meters	404.6856	0.00247
Square miles and square kilometers	2.5900	0.3861
Acres and hectares	0.4047	2.471
Square feet/acre and square meters/hectare	0.2296	4.356
Volume		
Cubic feet and cubic meters	0.02832	35.315
Cubic yards and cubic meters	0.76455	1.308
Cubic feet/acre and cubic meters/hectare	0.06997	14.291

Questions and Problems

1. Write precise definitions for remote sensing, photogrammetry, photo interpretation, electromagnetic spectrum, micrometer, $f/$ stop, film exposure, and depth of field.

2. Draw a single diagram to illustrate reflectance, transmittance, absorptance, and refractance. What happens to the energy that is absorbed?

3. Draw a generalized diagram of a typical energy flow profile from the sun to a sensor located in an aircraft.

4. Match the wave length to the appropriate sensor or film:

_____The human eye **(a)** 0.4 to 0.9 μm

_____Infrared film **(b)** 0.4 to 0.7 μm

_____Photographic infrared **(c)** 0.7 to 0.9 μm

5. The following is typical of the type or information printed on aerial photographs. Explain what it means:

 7-1-79 12,8000 12″ 13:35 MF 5-7

6. What are fiducial marks; where are they located; and what is their purpose?

7. Suppose that it has been determined from an aerial photograph that buildings occupy 9600 ft^2 per acre on the average for a particular residential area. Convert this figure to square meters per hectare.

Part One

Geometry, and Photo Measurements

Two

Geometry of a Vertical Aerial Photograph

A complete coverage of the geometry of a vertical aerial photograph would include scale, height measurement, displacement and distortion, stereoscopy, and perhaps mapping. Because some of these topics are subjects for future chapters, the discussion in Chapter Two is limited to types of aerial photographs, displacement and distortion, and the effects of focal length on the geometry of a vertical aerial photograph.

Objectives

After a thorough understanding of this chapter you will be able to:

1. Identify different types of aerial photographs as to whether they are vertical, high or low oblique, or horizontal and sketch the shapes of the ground area covered by each type.
2. Give precise definitions for camera focal length and angle of coverage and classify narrow, normal, wide, and super-wide-angle lenses according to focal length and angle of coverage.
3. Identify on an aerial photograph or sketch the fiducial marks, coordinate axes, and the three different photo centers on a "slightly tilted" vertical aerial photograph.
4. State the difference between photo distortion and photo displacement.
5. List the type of distortion or displacement that radiates from the three photo centers and know how to remove or avoid them.
6. List four other types of distortion or displacement.
7. Define ratioed and rectified prints and explain how each is obtained.
8. Compute the unknown variable given the equation for image dis-

placement due to relief and any four of the five variables involved.
9. State five inferences that can be made from the image displacement equation for topography and solve problems based on these inferences.

CLASSIFICATION OF PHOTOGRAPHS

There are various systems for the classification of aerial photographs. One system (Figure 2.1) separates photographs into terrestrial and aerial photos. Terrestrial photos are taken on the ground, while aerial photos are exposed from either a moving or stationary platform in the air. Aerial photographs may be further classified as vertical or oblique. Vertical photos can be true, in which case the axis of the camera at the moment of exposure is truly vertical, or they can be slightly tilted, where the axis of the camera is no more than 3° from the vertical. The majority of aerial photos fall into the latter classification of slightly tilted vertical photographs. Whenever the term vertical photograph is used in this book we assume it to be truly vertical, while in actuality it might be tilted less than 3°. The second type of aerial photo is an oblique in which the axis of the photograph is purposely tilted between 3 and 90° from the vertical. If the horizon is not visible, the photo is a low oblique. If the horizon is visible, the photo is a high oblique. Terrestrial photos are usually obliques or horizontals where the axis of the camera is tilted about 90° from the vertical.

The format of most aerial photographs is square but some may be rectangular depending on the camera. However, that portion of the ground covered by an aerial

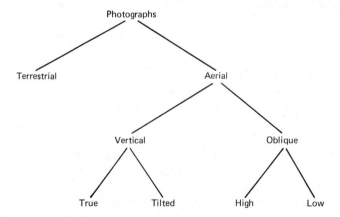

Figure 2.1. A classification of aerial photographs. (From D. P. Paine, 1979, *An Introduction to Aerial Photography for Natural Resource Management,* O.S.U. Bookstores, Inc., copyright 1973, reproduced with permission.)

photo is square or rectangular only if the photo is perfectly vertical and the ground is level. Figure 2.2 illustrates the ground coverage for several angles of photography.

Aerial photographs may also be classified by format or size and shape of the original negative within the camera. By far the most common format is 9 by 9 in. ✗
(approximately 23 by 23 cm). Other formats for aerial cameras are 2.2 by 2.2 in. (56 mm), 4½ by 4½ in. (114 mm), 4½ by 9 in. (114 by 229 mm), 7 by 9 in. (178 by 229 mm), 9 by 18 in. (229 by 457 mm), 70 mm, and 35 mm.

Advantages of Vertical as Compared to Oblique Aerial Photographs

1. The scale of a vertical photo, compared to an oblique photo, is *approximately* constant throughout; this makes it much easier to make measurements on the photo and the measurements are more accurate.
2. It is easier and more accurate to measure direction on a vertical than on an oblique photo. *Approximate* direction determination can be performed on a vertical photo in much the same manner as a map.
3. *Within limitations* a vertical aerial photo can be used as a map substitute by adding a grid system and marginal data.
4. A vertical photo is sometimes easier to interpret than an oblique. This is primarily due to a more constant scale and objects (buildings, hills, etc.) will not mask other objects as much as they would on obliques. Stereoscopic study is also more effective.

Advantages of Oblique as Compared to Vertical Aerial Photographs

1. An oblique photo includes many times the area covered by a vertical photo taken from the same altitude with the same focal length lens.
2. If cloud layer frequently covers an area, making vertical photography impossible, there may be enough clearance for oblique coverage.

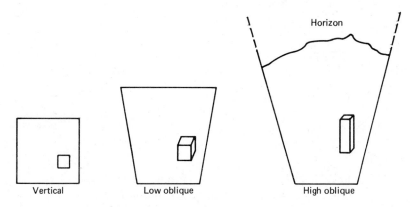

Figure 2.2. Relative size and shape of ground area photographed from three different angles.

3. The view is more natural because the profile view is similar to that of an observer located on a hill or high tower. This makes man-made objects such as bridges, buildings, and towers more recognizable because the silhouettes of these objects are visible.

4. Some objects are not visible on vertical photos if they are concealed from above (e.g., caves or objects under the edge of a forest cover).

FOCAL LENGTH AND ANGLE OF COVERAGE

One of the most important features of an aerial camera, besides the quality of the lens, is the focal length, which we define as the distance from the focal plane to approximately the center of the lens (rear nodal point) when focused at infinity. The parallel rays of light entering the lens from infinity are focused at a point on the focal plane (Figure 2.3). The angle of coverage is the angle of the cone of light rays that pass from the ground through the lens and expose the film. From Figure 2.4 we can see that the angle of coverage increases as the focal length of the lens decreases. The narrower the angle the smaller is angle of coverage. Of the focal lengths given, the 12-in., 8¼-in., and the 6-in. focal lengths are most commonly used. Because wide angle lenses excessively exaggerate the displacement of tall objects they are better suited for photographing flat than mountainous terrain.

Lenses for aerial cameras are very precisely ground and may cost several thousand dollars. Some lenses are so precise that the lens distortion of images on a photograph can be less than 10μm (about 39 millonths of an inch). For practical purposes these lenses are distortion free and are advertised as such.

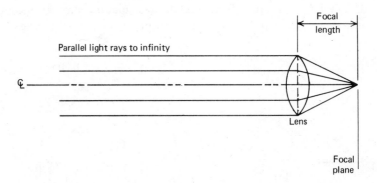

Figure 2.3. Focal length of a simple lens. (From D. P. Paine, 1979, *An Introduction to Aerial Photography for Natural Resource Management*, O.S.U. Bookstores, Inc., copyright 1973, reproduced with permission.

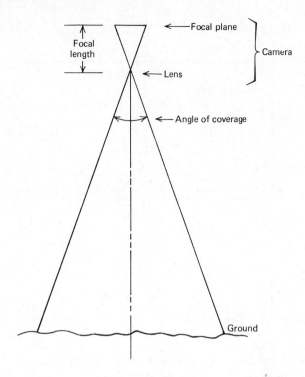

Classification	Focal Length	Angle of Coverage
Narrow angle	12 in. = 304.8 mm	Less than 60°
Normal angle	8¼ in. = 209.5 mm	60° to 75°
Wide angle	6 in. = 152.4 mm	75° to 100°
Super-wide angle	3½ in. = 88.9 mm	More than 100°

Figure 2.4. Relationship between focal length and the angle of coverage. As the focal length increases the angle of coverage decreases. (From D. P. Paine, 1979, *An Introduction to Aerial Photography for Natural Resource Management,* O.S.U. Bookstores, Inc., copyright, 1973, reproduced with permission.)

THE COORDINATE AXES

Before discussing the coordinate axes of a single vertical photograph we must define fiducial marks. Fiducial marks are optically projected fine crosses, dots, half arrows (Figure 2.5), or other geometric figures located either in the corners or on the sides of the photo. There are usually four on each photo, but sometimes there are

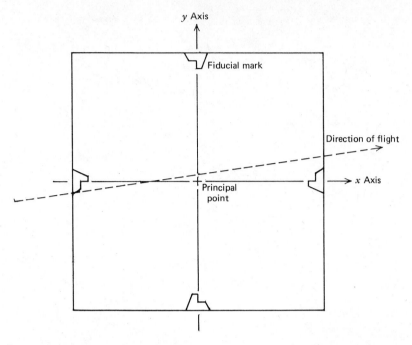

Figure 2.5. Fiducial marks, principal point and coordinate axes of a single aerial
photograph. (From D. P. Paine, 1979, *An Introduction to Aerial
Photography for Natural Resource Management,* O.S.U. Book-
stores, Inc., copyright, 1973, reproduced with permission.)

eight (sides and corners) depending on the type of aerial camera used. These fiducial
marks are reference marks that define the coordinate axes and the geometric center
of a single aerial photograph.

The x axis is the line on the photograph between opposite side fiducial marks
which most nearly parallels the direction of flight. The y axis is the line on the
photograph between opposite side fiducial marks perpendicular to the x axis and is
most nearly perpendicular to the line of flight (Figure 2.5). The x and y axes are
defined differently on a stereoscopic pair of aerial photos (see Chapter Three).

THE THREE PHOTO CENTERS

Except on a perfectly vertical aerial photo there are three different photo centers:
principal point, nadir, and isocenter. These different centers are of concern to the
photogrammetrist because different types of distortion and displacement radiate
from each of these points. On a perfectly vertical aerial photograph all three centers
coincide at the principal point.

Principal Point

The principal point is the point where a perpendicular projected through the
center of the lens intersects the photo image (Figures 2.5, 2.6). It is the geometric

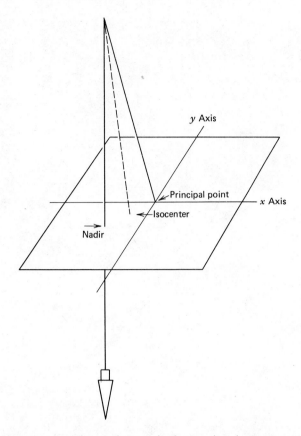

Figure 2.6. Relative locations of the principal point, isocenter, and nadir of a
 "slightly tilted" vertical aerial photograph. The amount at tilt is
 greatly exaggerated for illustrative purposes. (From D. P. Paine,
 1979, *An Introduction to Aerial Photography for Natural Resource
 Management,* O.S.U. Bookstores, Inc., copyright, 1973, reproduced
 with permission).

center of the photo and is assumed to coincide with the intersection of the x and y
axes. We can locate the principal point on a single photo by the intersection of lines
drawn between opposite side or corner fiducial marks. Lens distortion is radial from
the principal point.

Nadir

The nadir is the point vertically beneath the camera center at the time of
exposure where a plumb line extended from the camera lens to the ground intersects
the photo image (Figure 2.6). Topographic displacement is radial from the nadir.

It usually requires a sophisticated stereoscopic plotting instrument (Chapter Ten)
and expensive ground control (Chapter Eight) to locate the nadir on an aerial
photo. However, in certain situations the nadir is easily located. The nadir is at the
intersection of lines extended from the top to bottom of tall and perfectly vertical

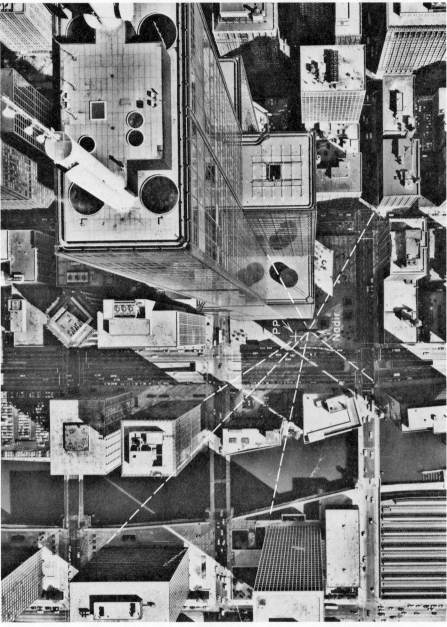

Figure 2.7. Locating the nadir using extensions of the sides of tall vertical build-
ings. The nadir and principal points do not coincide, indicating both
x and *y* tilt. The tall structure is the Sears building in Chicago and is
the tallest building in the world. (Courtesy Chicago Aerial Survey,
copyright, 1976, American Society of Photogrammetry, reproduced
with permission.)

objects as shown in Figure 2.7. The sides of tall buildings are used on this large-scale photo to find the nadir. Notice that the nadir is at a slightly different location than the principal point indicating both x and y tilt. The tallest building shown is the Sears building in Chicago and is the tallest building in the world.

Isocenter

The isocenter is the point on the photo that falls on a line and halfway between the principal point and the nadir (Figure 2.6). On a true vertical aerial photograph the principal point, isocenter, and the nadir all coincide at the geometric center of the photograph as defined by the intersection of lines drawn between opposite fiducial marks. The isocenter is the point from which tilt displacement radiates.

DISTORTION AND DISPLACEMENT

We define distortion as any shift in the position of an image on a photograph that alters the perspective characteristics of the image. Displacement is any shift in the position of an image on a photograph that does not alter the perspective characteristics of the photograph.

A vertical aerial photograph is not a map. A photo is the product of a perspective or central projection, and a map is the product of an orthographic projection (Figure 2.8). Unlike a map on stable base material, an aerial photo is subject to distortion and displacement as follows.

Types of Distortion	Types of Displacement
1. Film and print shrinkage.	1. Curvature at the earth.
2. Atmospheric refraction of light rays.	2. Tilt.
	3. Topographic or relief (including object height).
3. Image motion.	
4. Lens distortion.	

The effects of film shrinkage, atmospheric refraction, and the curvature of the earth are usually negligible in most cases—except for precise mapping projects—and are omitted from our discussion. Image motion distortion is discussed in Chapter Five so that leaves only lens distortion, tilt, and topographic displacement for our consideration here. Lens distortion is usually the smallest of these three.

Lens Distortion

This distortion radiates from the principal point and causes an image to appear either closer to or farther from the principal point than it actually is. This distortion is more serious near the edges of the photograph. By calibration of the lens, we can obtain a distortion curve that shows us how the distortion varies with the radial distance from the principal point. With this information we can make corrections for lens distortion if we know the position of the image on the photo with respect to

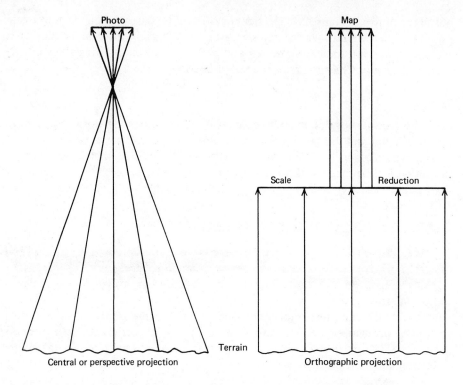

Figure 2.8. Illustration of a central projection (photo) on the left and an ortho-
 graphic projection (map) on the right. (From D. P. Paine, 1979, *An
 Introduction to Aerial Photography for Natural Resource Man-
 agement* O.S.U. Bookstores, Inc., copyright, 1973, reproduced with
 permission.

the principal point. This refinement is necessary only for very precise mapping
projects because high-quality aerial camera lenses are almost without distortion.

Tilt Displacement

Displacement due to tilt is caused by the aircraft or other airborne platform not
being perfectly horizontal at the moment of exposure (Figure 2.9). Rotation of the
camera *about* the y axis (nose up or down) is y tilt and rotation *about* the x axis
(wing up or down) is x tilt. Both radiate from the isocenter and cause images to
appear to be displaced radially *toward the isocenter* on the *upper side* of the photo
positive (not the negative) and radially *outward* or away from the *isocenter* on the
lower side. In Figure 2.10 point a represents the image of a ground object on a tilted
photograph. Point a' is the image of the same ground object on an equivalent
vertical photograph. Because of the tilt of the photograph, point a is displaced
radially inward, or towards the isocenter, by the amount ba'.

Figure 2.9. X and y tilt caused by the attitude of the aircraft (actually the camera) at the instant of exposure.

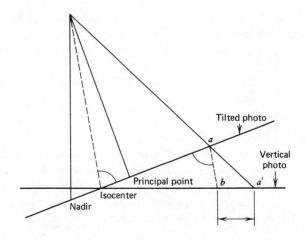

Figure 2.10. Displacement caused by tilt. (Point (*a*) on the tilted photo has been displaced a distance *a'* to *b* *toward* the isocenter on the upper half of the photo *positive*. (From D. P. Paine, 1979, *An Introduction to Aerial Photography for Natural Resource Management,* O.S.U. Bookstores, Inc., copyright, 1973, reproduced with permission.)

Because objects on the up and down side of a tilted photograph are displaced in opposite directions, large errors in average-scale calculations can be avoided by measuring the distance between two points that are the same distance from the photo center and diametrically opposite from the center.

Rectified and Ratioed Prints

The best solution to the problem of tilt would be to take tilt-free aerial photographs. However, a completely satisfactory technique for taking tilt-free photographs has not been developed for moving and vibrating aircraft. Gyroscopes, level bubbles, and other devices have been used with limited success.

Tilt-free prints can be produced from a tilted negative if the amount and direction of tilt is known. This is called *rectification* and is accomplished by recreating the relative tilt between the tilted negative and the printing paper. Rectified prints are expensive because the amount and direction of tilt is determined using expensive vertical and horizontal ground-control measurements.

Prints can be slightly enlarged or reduced to account for slight changes in flying height between exposure stations and for different average ground elevations. This results in *ratioed* prints that have an approximate common average scale among a series of prints and is a much cheaper process than rectification.

Topographic Displacement

Topographic, or relief displacement is usually the most serious of the displacement types discussed, especially in mountainous terrain. Topographic displacement radiates from the nadir and can be removed with stereo-plotting instruments or simple radial-line triangulation techniques (Chapter Nine). Topographic displacement can also be calculated and corrections for specific points can be made. Topographic displacement is not necessarily bad. Because of it we can view stereoscopic pairs of photos in the third dimension, measure heights, and make topographic maps from aerial photos.

Formula for Topographic Displacement.

We can derive an equation for computing the amount of topographic displacement from Figure 2.11 by using geometric relationships of similar triangles. Because the relief displacement, d, is equal to r minus r', we want to consider the following relationships: f is to r as $H-h$ is to R, and f is to r' as H is to R. Because the displacement, d, is equal to $r-r'$, we need to independently solve for r and r':

$$\frac{f}{r} = \frac{H-h}{R} \quad \text{therefore,} \quad r = \frac{f \cdot R}{H - h}$$

$$\frac{f}{r'} = \frac{H}{R} \quad \text{therefore,} \quad r' = \frac{f \cdot R}{H}$$

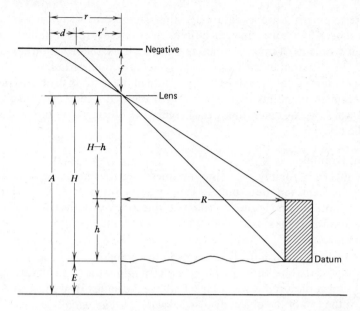

Figure 2.11. Geometry of topographic (relief) displacement. (Adapted from D. P. Paine, 1979, *An Introduction to Aerial Photography for Natural Resource Management*, O.S.U. Bookstores, Inc., copyright 1973, reproduced with permission.)

To obtain an equation for d, we subtract the equation for r' from the one for r and get: $\dfrac{(f \cdot R \cdot h)}{[(H\text{-}h)\ H]}$. Substituting r into the equation for $\dfrac{f \cdot R}{H\text{-}h}$, we find that the equation for calculating relief displacement becomes: $d = \dfrac{r \cdot h}{H} = \dfrac{r \cdot h^1}{A\text{-}E}$.

Where:

d = photo displacement, in inches or millimeters at the same scale as the datum

r = radial distance on the photo from the nadir to the displaced point, in inches or millimeters

h = height of the object (or vertical distance between two elevations), in feet or meters (h can be either + or -)

$H = A - E$ = flying height above the datum (nadir or base of the object)

A = altitude of aircraft above sea level

E = elevation of the datum

[1] *This is the first of several equations to be found in this book. A complete listing of all equations is found in Appendixes A and B for quick reference.*

The selection of the proper datum elevation is important because it is an arbitrary elevation chosen by the user and can be defined differently to facilitate the solution of different problems. It can be defined as mean sea level, the elevation at the base of an object, the elevation of the nadir, or anywhere the user wishes.

In this chapter the datum will be the elevation of the nadir in problems involving the displacement of points from (or toward) the nadir such as in mapping. In problems where we are determining the height of an object, the datum will be at the base of the object.

Numerical Examples

We could solve for any one of the variables given the remaining variables in the relief displacement equation, but we usually solve for d or h. On well-defined, large-scale photographs (Figure 2.7) it is possible to solve for the height of an object if d can be accurately measured. Let's take a look at some examples, first solving for d and then for h.

Suppose the radial distance from the nadir to a point on an aerial photo is 3.00 in. Further suppose that we know the point is 1000 ft *above* the nadir elevation and the flying altitude of the aircraft was 10,000 ft above the nadir. How much and in what direction is the top of the object displaced *relative to the nadir*?

Solving our equation for d, we find the photo displacement is 0.3 in. *away from* the nadir as indicated by a positive d.

$$d = \frac{r \cdot h}{H} = \frac{3.00 \text{ in. } (1000 \text{ ft})}{10,000 \text{ ft}} = 0.3 \text{ in.}$$

This means that the *correct or map position* of the point is 0.3 in. *closer to* the nadir than actually shown on the photo (photo displacement is away from the nadir). In Figure 2.12 the dot *furthest from* the nadir represents the displaced point on the photo and the dot *closest to* the nadir represents the true or map position of the point. If the point was at an elevation *lower* than the nadir (the datum in this illustration[2]), d would be negative as a result of a negative h and the true (map) position would be *further from* the nadir than the photo position. To some 0.3 in. may seem insignificant but to engineers and photogrammetrists it is too much and must be corrected. This would be an error of 300 ft on the ground if the photo scale was 1:12,000. It should be pointed out that we have assumed that the nadir and the principal points are the same in this type of problem. This is because the true nadir would be difficult to find without an expensive stereoplotting instrument and the nadir and principal point are usually not far apart when tilt is less than three degrees.

Let's try another example, this time solving for h. This can only be accomplished when the top and bottom of the object are visible on the photo, the top is directly over the bottom, and d is large enough to be measured. It would be nearly

[2] *Because the datum elevation is at the nadir, the calculated displacement is at the same scale as the nadir.*

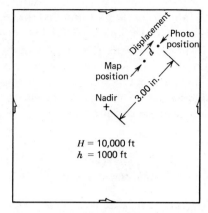

Figure 2.12. Radial displacement of a point caused by topography.

impossible to measure the height of an individual tree in a dense stand of timber because d would be small and the bases of most trees would not be visible. However, height measurement of tall buildings, storage tanks, or towers can be measured with accuracy on large-scale photos.

Suppose we have measured the displacement, d (Figure 2.13), of a building on a photograph to be 11.8 mm and the distance r from the top of the building to the nadir to be 82.8 mm. The flying height *above sea level*, as printed at the top of the

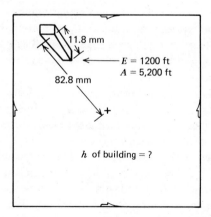

Figure 2.13. Calculation of height based on measurements from a single photograph.

photo is 5200 ft. From a topographic map we find that the base of the building is at an elevation of 1200 ft.[3] How tall is the building? Solving our equation for *h*, we get:

$$h = \frac{d \cdot H}{r} = \frac{d(A\text{-}E)}{r} = \frac{11.8 \text{ mm}(5200 \text{ ft} - 1200 \text{ ft})}{82.8 \text{ mm}} = 570 \text{ ft}$$

Notice how the units of measure canceled to get our final answer in feet. All you need to remember about units is that you must use the same units for *d* and *r* and the final answer is in the same units as used for *H* or *A-E*.

Inferences

A close look at the relief displacement equation reveals several important relationships about the nature of displacement due to relief.

1. Topographic displacement varies directly with the height of the object. A 1000-ft mountain would be displaced twice as far as a 500-ft mountain.
2. Topographic displacement varies directly with the radial distance from the nadir to the object. A particular elevation 4 in. from the nadir will have twice the displacement as the same elevation 2 in. from the nadir.
3. There is no topographic displacement at the nadir. If *r* is zero, so is *d*.
4. Assuming the datum elevation to be at the nadir, points *above* the nadir are displaced radially *away* from the nadir and points below the nadir are displaced radially *toward* the nadir.
5. Finally, topographic displacement varies inversely with the flying height above the base of the object. Therefore, there is very little topographic displacement on photographs taken from high altitudes such as orbiting space stations.

Combined Effects of Tilt and Topographic Displacements

Because most vertical aerial photos are slightly tilted, the isocenter and nadir points are not in exactly the same place on the photo. Thus, the combined effect of topographic and tilt displacement from two different centers may result in lateral as well as radial displacement of images.

In Figure 2.14, M is the map or true position of an object at a *lower* elevation than the nadir. Because it is at a lower elevation it would be imaged on the photo at R, or toward the nadir, provided there is no tilt. However, we have tilt in this illustration. Because our object is on the *down* side of the photo positive, the object is displaced *away* from the isocenter. Thus, the combined effects place the photo image at R + T (relief plus tilt). We get different results at other positions on the photo. Sometimes combined effects are accumulative and sometimes compensating. Along the axis of tilt, the only effect is from topographic displacement. There is no lateral shift at right angles to the axis of tilt on a line through the three photo centers. The point is

[3]When using the topographic displacement equation to solve for *h*, the flying altitude is always measured above the base of the object.

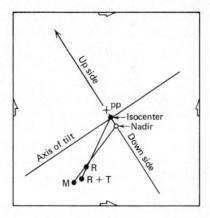

Figure 2.14. Illustration of lateral displacement caused by the combined effects of topography (relief, R and tilt, T).

that the combined effects of topographic and tilt displacements are variable and complicated. Tilt in excess of three degrees has an adverse effect on the process of radial-line triangulation (Chapter Nine).

Questions and Problems

1. Draw a 1-in. square on a piece of paper. This square represents the area photographed by a perfectly vertical aerial photo. At approximately the same scale draw the relative area covered if the photo had been a low oblique and a high oblique.

2. Fill in the blanks or select the correct word or words in the brackets:

 (a) The focal length of a camera lens is the distance between the _____ and _____ when focused at infinity.

 (b) The _____ axis of a single aerial photo passes through the [corner, side] fiducial marks that most nearly parallel the line of flight.

 (c) On a slightly tilted aerial photograph the [nadir, principal point, isocenter] is further from the intersection of the *x* and *y* axes.

 (d) As the focal length of a lens increases the angle of coverage [increases, decreases].

 (e) Topographic displacement varies [directly, indirectly] with the height of the object and [directly, indirectly] with the _____ distance from the [principal point, nadir, isocenter].

 (f) Displacement [alters, does not alter] the perspective characteristic of an aerial photograph.

(g) A [ratioed, rectified] print has had its scale altered to bring it in line with the average scale of other photos taken in the same photo mission.

3. The distance from the nadir to the base of a building is 3.42 in. and to the top of the same building is 3.60 in. The flying height above sea level was 11,400 ft and the ground elevation of the base of the building is 1400 ft. Calculate the height of the building.

4. The radial displacement of the top of a tower with respect to its base on a single aerial photo is 4.1 mm and the top of the tower is 73.8 mm from the nadir. If it is known that the tower is 500 ft tall and the base of the tower is 1000 ft above sea level, what was the flying height of the aircraft above sea level at the instant of exposure?

5. With an engineer's scale and the proper equation determine the height of the Sears building (tallest one) as shown in Figure 2.7. The flying height of the aircraft above the base of the building at the instant of exposure was 1800 ft.

Three

Principles of Stereoscopic Vision

Up to this point you have probably considered topographic displacement in aerial photographs as nothing but an obstacle and wish that it didn't exist. However, without it we would not be able to view a stereoscopic model in the third dimension. This 3-D interpretation of aerial photographs allows the interpreter to see much more than can be seen in a single two-dimensional photograph. This chapter will deal with the theory of stereoscopy and related topics and lay the groundwork for Chapter Seven, which discusses measurements in the third dimension.

Objectives

After a thorough understanding of this chapter you will be able to:

1. Define stereoscopy, stereopair, stereogram, stereoscope, and absolute parallax of a point.
2. List four types of stereoscopes and state the primary advantage of each.
3. Explain how the *x* and *y* axes are defined on a *stereoscopic pair* of aerial photographs as compared to a single photo.
4. Determine the absolute parallax of a single point on a stereopair.
5. Explain why two eyes are needed to see depth on a stereopair.
6. Define vertical exaggeration and state two ways of increasing or decreasing the exaggeration.
7. Calculate the vertical exaggeration of a specific stereoscopic pair of aerial photos given the proper equation and the necessary data.
8. Properly orient a stereoscopic pair of aerial photographs for stereoscopic viewing with a lens and a mirror stereoscope so that height measurements can be made.

DEFINITIONS

Before continuing further let's define some terms that we will soon encounter.

Stereoscopy

The art or science of stereoscopy deals with the use of binocular vision to achieve three-dimensional (3-D) effects. Stereoscopic vision enables us to view an object simultaneously from two different perspectives, like two aerial photographs taken from different camera positions, to obtain the mental impression of a three-dimensional model. Everyone with two normal eyes unconsciously uses the same principle to perceive distance or depth. Each eye, because it is separated, receives a slightly different view of the same object. These two different views are combined by the brain into a single 3-D model.

Stereoscopic Pair of Photographs

A stereoscopic pair of aerial photographs consists of two adjacent, overlapping photos in the same flight line. The stereoscopic view is seen only in the overlapped portion of the photos. Therefore, a minimum of 50 percent endlap is necessary for complete stereoscopic viewing of the area photographed.

Stereogram

If we take a stereoscopic pair of aerial photos, cut out of each photo the part that shows the same area of interest on the ground, then correctly orient and mount them side by side, we have a stereogram like the one in Figure 3.1. This is an unusual stereogram because there is very little evidence of topography when viewed without a stereoscope. This is due to the lack of definite drainage patterns and the arrangement of agricultural fields. Stereoscopic examination however reveals several drumlin mounds.

Stereoscope

To achieve our stereoscopic image, we use a stereocope, which is a binocular optical instrument that helps us view two properly oriented photographs to obtain the mental impression of a three-dimensional model. Most stereoscopes also magnify the images. The four types of stereoscopes with which we will be concerned are (1) the lens stereoscope, (2) the mirror stereoscope, (3) the scanning stereoscope, and (4) the zoom stereoscope.

Lens Stereoscope (Pocket)

The lens stereoscope (Figure 3.2) is the simplest and least expensive piece of equipment that we can use to view our overlapping stereopair of photographs to produce a three-dimensional image. This stereoscope consists of two magnifying lenses mounted with a separation equal to the average interpupillary distance of the

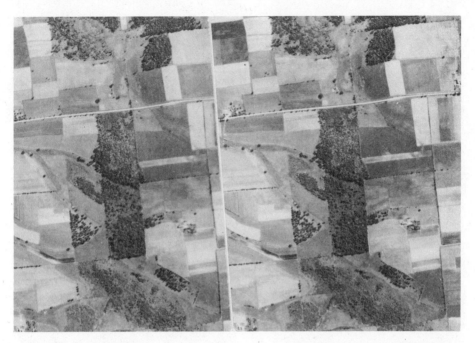

Figure 3.1. Stereogram of what appears to be flat agricultural ground. When viewed stereoscopically several drumlin mounds are evident. Photo scale = 1:20,400. (Courtesy of Illinois Photographic Service.)

human eye. A provision is usually made for changing this separation to suit the individual user. These two lenses are mounted in a frame so that they are supported at a fixed distance above the photographs on which the stereoscope is placed. When using a lens stereoscope the two photos being viewed are so close together that it may become necessary to "peel" the photo on top by gently lifting and bending it so that you can see the detail on the photo underneath. This can be done without permanently creasing the photo. The primary advantage of this stereoscope is its simplicity and small size. When the legs are folded it can easily be carried in a pocket for use in the field and is frequently called a pocket stereoscope. Most lens stereoscopes have two-power magnification, but some are four power.

Mirror Stereoscope

Mirror stereoscopes (Figure 3.3) consists of a pair of small eyepiece mirrors and a pair of larger wing mirrors, each of which is oriented at an angle of 45° with respect to the plane of the photographs. A pair of magnifying lenses can be placed above the two small mirrors to produce a magnification of a limited portion of the stereoscopic image. The greatest single advantage of the mirror stereoscope is that the photographs may be completely separated for viewing, and the entire overlap area

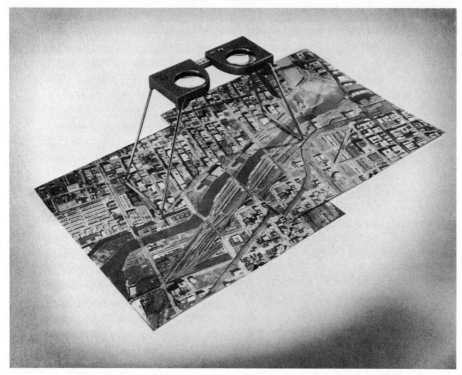

Figure 3.2. Lens stereoscope—also known as a "pocket stereoscope" because it folds up small enough to be easily carried in a pocket and is widely used in the field. (Courtesy Oregon State University Forestry Media Center.)

may be seen stereoscopically without having to "peel" the photographs to see the stereo model where the photos still overlap. Without the use of these magnifying lenses, the 3-D model is smaller than with the lens stereoscope. Large mirror stereoscopes are not very portable and their use in the field is limited.

Scanning Mirror Stereoscope

Figure 3.4 shows an Old Delft, which is a scanning mirror stereoscope. Each magnifying eyepiece can be individually focused, and the eyepieces themselves may be spread apart or pulled together to suit the individual viewer. Because of a highly corrected series of lenses and prisms, the stereoscopic image formed is very sharp. The greatest advantage of this stereoscope is that there are two knobs that allow the viewer to scan the stereoscopic image in both the x and y directions without moving the instrument or the photographs but it is not designed for use in the field. Magnifying lenses are a standard feature of this instrument.

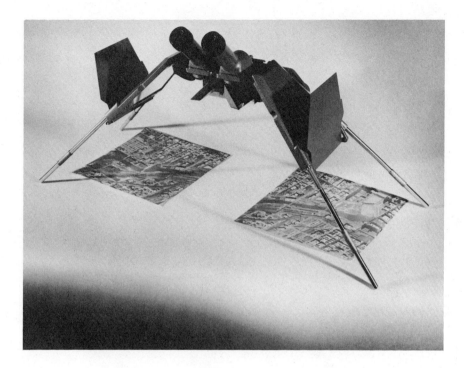

Figure 3.3. Mirror stereoscope. The stereoscope shown here has binocular attachments for magnification. (Courtesy Oregon State University Forestry Media Center.)

Zoom Stereoscope

The zoom stereoscope (Figure 3.5) provides a continuously variable in-focus magnification from 2.5 to 20 power with a single set of eyepieces. Another set of eyepieces can increase the magnification to as high as 40 power. One model is available with 360° image-rotation capability. This feature is particularly valuable for viewing randomly oriented uncut film (film still on a long roll). The high magnification afforded by these stereoscopes is useful only for interpreting very-high-quality photography taken with high-resolution film. Their primary advantage is the continuously variable in-focus magnification feature.

Now that we have defined stereoscopy, stereopair, and stereogram, and have discussed different types of stereoscopes, let's investigate the basic geometry of a stereopair of aerial photographs.

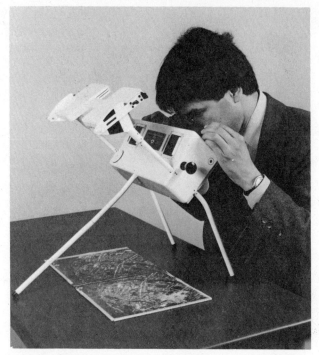

Figure 3.4. Old Delft scanning sterescope. The viewer can scan the entire stereos-
copic model simply by twisting of knobs. (Courtesy of Old Delft
Corporation of America.)

GEOMETRY

The geometry of overlapping vertical aerial photographs differs from the geome-
try of a single photograph in that the x and y axes are not defined by the fiducial
marks. For two successive photos in the same flight line, we define the x axis as the
line that passes through the principal and conjugate principal points[1] and the y axis
as the line that passes through the principal point perpendicular to the x axis[2]
(Figure 3.6). We call this the flight-line system of coordinates for stereoscopic pairs
of photographs as compared to the fiducial mark system used with single photo-
graphs. Only if both photos are free of tilt, drift, and crab will the x and y axes pass
through the side fiducial marks.

[1] *Conjugate principal points (CPPs) are the principal points of adjacent photos in the same flight line
transferred to the photo being considered.*
[2] *Technically the* x *axis passes through the* nadir *and* conjugate nadir *if the photo is not perfectly vertical.*

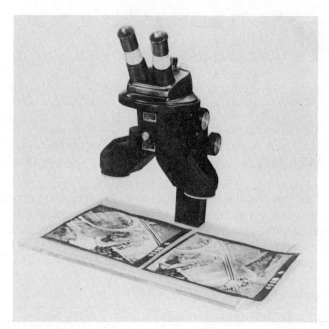

Figure 3.5. Zoom stereoscope. This stereoscope provides a continuously variable in-focus magnification from 2.5 to 20 power, which can be increased to 40 power with another set of eyepieces. (Courtesy of Bausch & Lomb, Inc.)

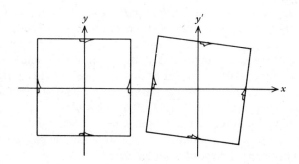

Figure 3.6. Coordinate axes of a stereoscopic pair of photographs. The *x* and *y* axes do not pass through the fiducial marks on the crabbed (rotated) photo on the right. (From D. P. Paine, 1979, *An Introduction to Aerial Photography for Natural Resource Management,* O.S.U. Bookstores, Inc., copyright 1973, reproduced with permission.)

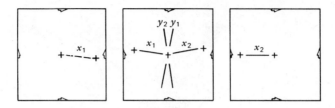

Figure 3.7. Two different sets of coordinate axes on the same (center) photo-graph. the x_1 and y_1 axes are used with the two photos on the left and the x_2 and y_2 axes are used with the two photos on the right.

Consider a stereo-triplicate (three successive photographs in a flight line). The center photo will have two different sets of x and y coordinates if the aircraft does not fly in a perfectly straight line without tilt, drift, or crab. In Figure 3.7 we would use x_1 and y_1 coordinates when using the two photos on the left and the x_2 and y_2 coordinates when using the two photos on the right.

Absolute Parallax

The impression of depth in stereoscopy is made possible because the images of points lying at different elevations have been topographically displaced by different amounts and directions on successive photographs. This difference in displacement is called the difference in absolute parallax (dP). The absolute parallax of a point on a pair of overlapping vertical photographs is equal to the x coordinate of the point measured on the left-hand photograph minus the x coordinate of the point measured on the right-hand photograph. A complete definition of *absolute parallax* (or x parallax) of a point is as follows. *Absolute parallax is the algebraic difference, measured parallel to the line of flight (x axis) from the corresponding y axes to the two images of the point on a stereoscopic pair of aerial photographs.* This definition assumes perfectly vertical photographs taken at the same altitude. In Figure 3.8 ground point A is imaged as points a and a' on the left- and right-hand photos, respectively. The x coordinate of point A on the left photo is x_a and the x coordinate of point A on the right photo is $x_{a'}$. Notice that x_a is positive (to the right) and $x_{a'}$ is negative (to the left). Therefore, by our definition, the absolute parallax of point A is x_a minus negative $x_{a'}$ or $x_a + x_{a'} = 1.47 + 0.66$, or 2.13 in.

Understanding the absolute parallax of a point is essential to understanding how we can make vertical measurements on a stereoscopic pair of vertical aerial photographs. This is the subject of Chapter Seven.

Flight-Line Location

One additional item we need to consider is how to locate the flight line (the x axis) on a stereoscopic pair of photographs. We know that the flight line passes through

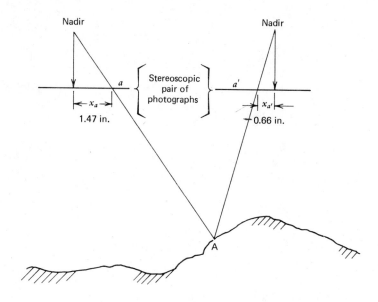

Figure 3.8. Absolute parallax of a stereopair of photographs. The absolute parallax of point *a* is 1.47 in. + 0.66 in. or 2.13 in.

the principal point on each perfectly vertical photo. Because photos in a strip should have an endlap of over 50 percent, the principal points of adjacent photos should be imaged on each photo. In Figure 3.9 points PP_1 and PP_2 are the principal points of two successive exposures. The point PP'_1 on the right photo is the image of the same ground points as PP_1 on the left photo. Thus, by viewing the two photos stereoscopically, the principal point of the first photo can be transferred to the second photo and vice versa. This transferred principal point, PP', is called the *conjugate principal point* or CPP. By drawing a line between the principal and conjugate principal points on a photo, we have defined the flight line on that photo. For slightly tilted vertical photographs it would be more precise to use nadirs and conjugate nadirs but to locate them usually takes expensive photogrammetric equipment that most practicing photo interpreters do not have. Now that we have a basic understanding of the geometry of overlapping vertical aerial photographs, let's take a look at the theory of stereoscopy.

THEORY OF STEREOSCOPY

The phenomenon of stereoscopic vision involves both mechanical and physiological principles. Our vision is so natural that we seldom stop to analyze it. Although a *single* human eye has a wide range of view both horizontally and vertically, it is very

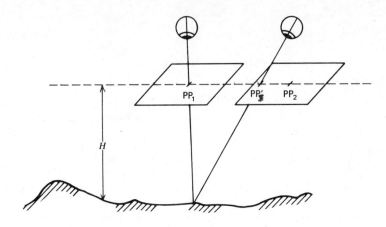

Figure 3.9. Locating the conjugate principal point (PP′ or CPP). (From D. P.
Paine, 1979, *An Introduction to Aerial Photography for Natural
Resource Management,* O.S.U. Bookstores, Inc., copyright 1973,
reproduced with permission.)

limited in its ability to convey a sense of depth. Except by inference or association
with other objects, a *single* eye cannot accurately determine whether one object is
nearer or farther than another object. Fortunately, we have two eyes and are
thereby able to perceive depth. A simple exercise will show you the need of having
two eyes to see depth.

Hold a sharpened pencil about 12 in. in front of your eyes with the point nearest
and the eraser farthest from you. By looking at the point with both eyes, you can see
that it has depth and tapers to a point. Now close one eye and look directly at the
point with your open eye. The end of the pencil appears flat as though it had not yet
been sharpened. You cannot perceive the depth of the pencil point with just one eye.
Similarly, two eyes are needed to stereoscopically view a pair of overlapping
photographs.

Accommodation and Convergence

The relationship of accommodation (change of focus of the eye for distance) and
convergence is very important in stereoscopic vision. When our eyes focus on a
nearby object, they also converge so that the lines of sight from our two eyes
intersect at the object, but if we focus our eyes on an object at infinity, our lines of
sight are parallel. One of the problems in stereoscopically viewing photographs is
that we must maintain parallel lines of sight while focusing our eyes at a close range.
This temporary disruption of the relationship between accommodation and con-
vergence takes practice.

Persons with normal vision and eyes of equal strength can develop a facility for
stereoscopic vision without the use of a stereoscope. The trick is to keep the lines of

Figure 3.10. The "sausage" exercise. This exercise helps develop the ability to see stereoscopically without the aid of a stereoscope. (Courtesy of the U.S. Department of the Army.)

sight from each eye parallel and still bring the photo images into sharp focus. The "sausage exercise" (Figure 3.10) is helpful in developing this ability. Focus your eyes on a distant object and slowly bring your forefingers into the line of vision. The farther apart your fingers and the larger the sausage when it forms the more nearly parallel are your lines of sight—try it.

Depth Perception

Now let's see why we can perceive depth when viewing a stereoscopic pair of photographs. Figure 3.11 is a schematic diagram of the Washington Monument, which has been imaged on two successive exposures. If we orient these photos and view them so that the left eye sees only the image on the left photo, and the right eye sees only the image on the right photo, we have a perception of depth. As you can see at the bottom of the illustration, the top of the monument appears to be at T and the bottom at B.

Floating Dot.

This same phenomenon provides us with the floating-dot principle. This principle can be applied in the transfer of principal points from one photo to the next. The dots (Figure 3.12) are on transparent material that has been laid on top of the correctly oriented photos. The left dot has been placed on the left photo and the right dot is placed on the right photo. Thus, the left eye sees the left dot and the right eye sees the right dot. The two dots fuse together in your brain, at the apparent position A. You will sense that the image of the dot lies in space above the ground,

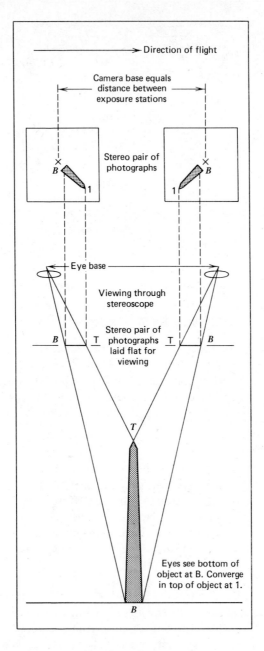

Figure 3.11. Mechanics of stereoscopic viewing. (Courtesy of the Depts. of the Army, Navy, and the Air Force.)

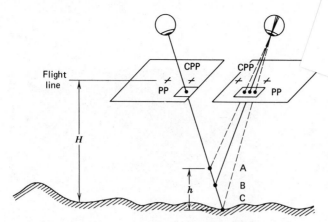

Figure 3.12. The floating-dot principle. (From D. P.Paine, 1979, *An Introduction to Aerial Photography for Natural Resource Management*, O.S.U. Bookstores, Inc., copyright 1973, reproduced with permission.)

hence the same floating dot. Now, if we slowly move the dot on the right photo slightly to the right, with the left dot fixed and with both dots still fused, the dot will appear to sink to position B and then to position C. At position C, the left and right dots define the exact position of a pair of conjugate points on the ground even though they might not be identified by discrete images. By moving the right dot still farther to the right, some photo interpreters can drive the apparent fused dot into the ground. As we will see in Chapter Four, floating dots are used to measure heights on stereoscopic pairs of aerial photographs.

Vertical Exaggeration

One of the first things you may notice when viewing a stereoscopic pair of vertical aerial photographs is a sense of vertical exaggeration. Figure 3.13 is a stereotriplicate allowing you to see two different stereoscopic models of the same area. The left model has a vertical exaggeration of 2 whereas the right model has a vertical exaggeration of 4. This means that the heights of objects appear to be two and four times greater when viewed stereoscopically than they really are. That is, the vertical scale is two and four times larger than the horizontal scale. This phenomenon is created by different air bases for the two models.

Vertical exaggeration increases with the ratio of the distance between exposure stations (the air base) over the flying height above the ground. There are other factors involved in vertical exaggeration but the primary one is the lack of equivalence between this ratio and the corresponding viewing ratio. Vertical exaggeration can be *approximately* calculated by multiplying the airbase to flying height ratio

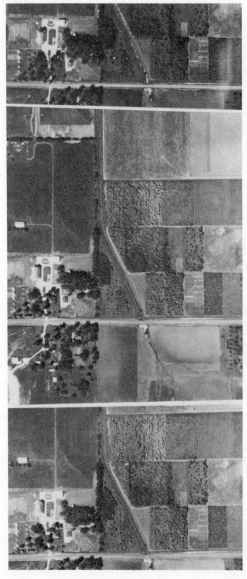

Figure 3.13. Vertical exaggeration. The left model of this stereo-triplicate has a vertical exaggeration of two and the right model has a vertical exaggeration of four. (Courtesy of Illinois Photographic Service.)

times the inverse of the eyebase to apparent viewing distance ratio (Miller, 1960; LaParde, 1972; Wolf, 1974).

$$VE = \left(\frac{AB}{H}\right)\left(\frac{AVD}{EB}\right),$$

Where:

VE = vertical exaggeration
AB = airbase (ground distance between exposure stations)
 H = flying height above the average ground elevation
EB = eyebase or distance between your eyes
AVD = apparent stereoscopic viewing distance

All but the AVD can be easily determined. Stereoscopically view a pair of aerial photos and try to estimate apparent viewing distance; it is not the distance from the stereoscope lenses to the photos. The 3-D model appears to be somewhere under the table top. We will use an average estimate of 17 in. based on estimates of several different people using a variety of stereoscopes (Wolf, 1974). Using this value and assuming the average adult eye base to be 2.6 in., we get a ratio of 0.15. Based on these assumptions we can develop an approximate, but workable, vertical exaggeration equation as follows:

$$VE = \left(\frac{AB}{H}\right)\left(\frac{AVD}{EB}\right)$$

$$= \frac{(1 - \%E)\,(Fmt\ inches)\,(PSR)}{H\ ft}\ \frac{1\ ft}{12\ in.}\ \frac{1}{0.15}$$

$$= \frac{(1 - \%E)\,(Fmt)\,(PSR)}{1.8\ H}$$

$$\text{or}\quad \frac{(1 - \%E)\,(Fmt)}{1.8\,f}$$

where

%E = percent endlap (Overlap of a stereoscopic pair expressed as a decimal. For example 60% = 0.6
1 − %E = net gain per photo (expressed as a decimal)
 Fmt = photo format in the direction of the flight in inches or cm
 1.8 = a constant = 0.15(12) with units of in./ft or 15 cm/m
PSR = photo scale reciprocal[3]
 H = flying height above the average ground elevation in feet or meters

[3]*See Chapter Four.*

Suppose we wish to know the vertical exaggeration of a 9 by 9 in. format photo with 55 percent endlap taken with a 12-in. lens at 20,000 ft. We calculate:

$$VE = \frac{(0.45) \ (9 \ in.) \ (20,000)}{1.8 \ in./ft \ (20,000 \ ft)} = 2.25$$

which means that objects in the stereo model appear to be 2.25 times taller than they really are compared to the horizontal scale.

We can change the vertical exaggeration either by changing the percent endlap, the flying height, or both, while maintaining the same scale.

For example, let's keep everything the same but decrease the net gain from 45 to 25 percent by increasing the percent endlap to 75 percent. This reduces the vertical exaggeration from 2.25 to 1.25. Now, let's look at an example where we change the flying height.

Suppose we use the same data as in the first example, but now we use a 3 1/4 in. lens. This would require a flying height of 5417 ft in order to maintain the same scale. This results in a vertical exaggeration of 8.31 as compared to 2.25 for a plane flying at 20,000 ft. Note that changing the focal length does not alter the vertical exaggeration. Focal length does not appear in the equation. A change in focal length without a change in flying height results in a change of scale and a compensating change in the airbase. In the above example it was the change in flying height that changed the vertical exaggeration. All three of these examples have been at the same scale, but the mental images formed in the stereoscopic model are quite different.

It would be difficult to eliminate vertical exaggeration with conventional cameras, however, it can be accomplished by increasing the endlap and by flying at higher altitudes. In most cases vertical exaggeration is actually a help to the interpreter as long as he or she is aware of it. Geologists consider vertical exaggeration an important aid to interpretation of low dip angles and low relief. If it is desirable to have both a large and a small exaggeration, photographs can be taken with a short focal length lens with an endlap of 80 percent. Two consecutive photographs with 80 percent endlap would have a small vertical exaggeration and alternate photographs, with 60 percent endlap (Figure 3.14) would have more exaggeration.

Practical Application

One practical use of the calculated vertical exaggeration factor is to convert the apparent slope percent, obtained by stereoscopic examination, to the actual slope percent.

To obtain the apparent slope percent Miller (1960) used a *slope estimator*, which consists of a butt hinge tightened at the joints by hammering (Figure 3.15). In use, the *slope estimator* is placed on one of the photographs of the stereoscopic model just to the rear of the stereoscope. Then orient and adjust it until the plane of its slope is parallel to the selected slope in the model. You look through the stereoscope at the terrain model and then alternately to the slope estimator, adjust the estima-

Figure 3.14. Obtaining both 60 and 80 percent endlap on the same photo mission. Every other photo is used for 60 percent endlap.

tor's slope until it has the same apparent slope as the model, and measure the distance *b* (Figure 3.15). This procedure should be repeated several times and an average value obtained.

Because side *c* remains constant a table can be prepared from which apparent slope can be read. The table is made using the formula (Miller, 1960):

$$\text{Apparent percent slope} = \left(\sqrt{\frac{4c^2}{b^2} - 1} \right) 100$$

The true percent slope is the apparent slope divided by the vertical exaggeration factor.

Based on 22 trained interpreters, each measuring 23 different slopes Miller (1960) found that this method was faster and easier than the parallax method (Chapter Seven) of slope determination.

PSEUDOSCOPIC STEREO MODEL

Another illusion we might encounter is accidentaly reversing the two photos so that the right eye views the left photo and the left eye views the right photo. The result is a pseudoscopic view, or reversal of relief, a phenomenon illustrated in Figure 3.16. View the stereogram with a stereoscope. The river appears to be on top of the ridge, while ridges and other high points appear as valleys and depressions. To many, a nonstereoscopic view also produces a pseudoscopic effect. Sometimes a pseudoscopic effect is purposely obtained to identify stream bottoms and drainage patterns better.

Sometimes you may see a pseudoscopic image if the shadows fall away from you in the model. If this happens, just reorient your photo pair so that the shadows fall toward you—in fact, the general rule for good interpretation is to always do this.

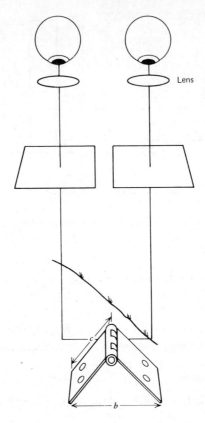

Figure 3.15. Use of the "slope estimator." This is a butt hinge with the joints tightened by hammering. (Copyright 1960, by the American Society of Photogrammetry. Reproduced with permission.)

PROPER ORIENTATION OF A STEREO MODEL

The next item we need to discuss is the proper orientation of a pair of vertical aerial photographs for the best stereoscopic examination of the three-dimensional model. This proper orientation is absolutely necessary for accurate measurements in the third dimension.

The first thing we want to do is make sure that the two photographs are consecutively numbered and in the same flight line. Next locate and mark the principle point on both photos. To do this draw intersecting lines between opposite

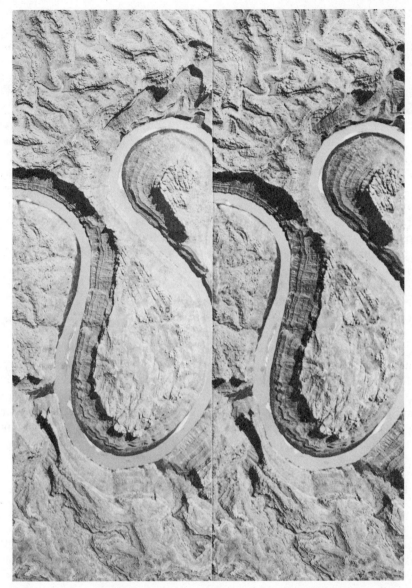

Figure 3.16. Pseudoscopic stereoscopic model. The right and left photos have been purposely reversed to create a reversal of relief. Photo scale is 1:41,900. (Courtesy of Illinois Photographic Service.)

side (or corner) fiducial marks. Once located, the principal points should be pricked with a needle or sharp pin. Also locate and prick the conjugate principal point on both photos. Sometimes this can be done by carefully inspecting the detail in the two photos and picking out identical points on the ground, but it is best done by viewing the two photographs stereoscopically to transfer the principal points as discussed earlier. Now we have marked four points along the flight line, two on each photo.

The next step is to orient the photos so that all four points are on a single straight line, and separated by a comfortable viewing distance (Figure 3.17). You will need a straightedge, such as a plastic drawing triangle with two guide marks about 2 1/4 in. apart as shown. First, decide which photo should be on the bottom, then overlap the second photo on the first photo and observe the direction in which shadows fall. They should be toward you. If they are not, pick up both photos together and turn them 180 degrees, thus reversing the direction of the flight line. When using a lens stereoscope, separate the two photographs in the direction of the flight line until conjugate images are separated by about the same distance as the centers of the lenses of the stereoscope (between 2 and 2 1/2 in.). With all four points still in a straight line fasten the photos to a desk or table. Place the stereoscope over the pair of photos so that the line joining the lens or eyepiece centers is parallel with the direction of flight. These photos are now ready for stereoscopic viewing.

When using a mirror stereoscope, separate the two photographs in the direction of the flight line until conjugate images are about the same distance apart as are the centers of the large wing mirrors still maintaining a straight line between principal and conjugate principal points. Then place the stereoscope over the pair of photos and adjust the photo separation to permit you to see a stereoscopic image as comfortably as possible while looking through the stereoscope. Do not alter the photo alignment. If it appears wrong it's the stereoscope that is out of alignment. Rotate it clockwise or counterclockwise until the 3-D model is sharp.

A TEST FOR STEREOSCOPIC PERCEPTION

There are several different tests that an instructor can use to determine if students are perceiving the stereoscopic model or not. There is one test that determines the degree of perception on a quantitative basis. It was developed by Moessner (1954) and consists of stereograms of floating circles (Figure 3.18). Both stereograms are the same except for their base separation. In rare instances beginners sometimes require an even smaller separation than in stereogram II.

A portion of these circles appear to float in space when viewed stereoscopically because some matched pairs of circles (one circle in each half of the stereogram) are a different distance apart than the pairs that do not float. In Figure 3.19 dot b floats above dot a because B and B' are closer together than A and A'. The test is arranged in blocks with each block becoming progressively more difficult due to smaller separation differences. The separation differences in block A range from 0.045 to

Guide oriented on first photo

Sliding second photo into position

Final orientation complete

Figure 3.17. Orienting photos for proper stereoscopic viewing. Notice the guide marks on the triangle. (Courtesy of the U.S. Forest Service, P.N.W. Forest and Ranger Experiment Station.)

Stereogram I

(Lens separation - 2.25 inches)

Stereogram II

(Lens separation - 1.9 inches)

Figure 3.18.　Floating circle stereo test. The upper and lower stereograms produce the same results. Only their separation is different. (Courtesy U.S. Forest Service, Central States Forest Experiment Station, Technical Paper 144.)

60

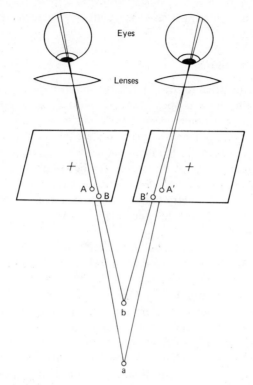

Figure 3.19. Stereoscopic vision using a stereoscope. Circles A and A' are closer together than circles B and B'. Therefore, when viewed stereoscopically b (fused image of A and A') appears to float above a (fused image of B and B').

0.020 in. and block D from 0.002 to 0.0005 in., which is about the limit of human depth perception. The average test score based on 171 of Moessner's untrained students was 87.7 percent. After training, the scores were significantly higher.

How to Take the Test

The test consists of the stereogram (Figure 3.18) and requires a lens stereoscope. When the stereoscope is properly oriented over either of the two stereograms, the pairs of block designations, A, B, C, or D, will fuse in your brain so that you will clearly see only one letter—one A, one B, etc. Then for each *horizontal* row one or two circles will appear to float above the stereogram. These floating circles are recorded on an answer sheet.

How to Grade the Test

Omissions and incorrect identifications are counted as −4. For example, a test with one omission would score 96 percent, but if in addition another circle was

incorrectly marked as floating, the score would be 92 percent. The correct answers are found in appendix G.

Questions and Problems

1. Fully define the following terms: stereoscopy, stereopair of photos, stereogram, stereoscope, absolute parallax of a point, vertical exaggeration, and accommodation and convergence.
2. List four types of stereoscopes and state the primary advantage of each.
3. A stereoscope is an instrument that helps the viewer see a stereoscopic pair of photos in the third dimension for better interpretation. How does it accomplish this function? What else does it do to aid the interpreter?
4. How does the geometry of the x and y axes of a stereoscopic pair of aerial photos differ from the geometry of these axes on a single aerial photograph?
5. Using the diagram provided of a stereo triplicate (Figure 3.20) measure (to the nearest 0.01 in.) the absolute parallax of points y and z. (Hint: you will have to draw some additional lines with a sharp pencil.) In Chapter Seven we learn how to use the *difference* in absolute parallax between these two points to calculate the difference in elevation between them.
6. On a stereoscopic pair of aerial photographs, locate, and pinprick the principal and conjugate principal points. Then properly orient the photos for stereoscopic viewing for a lens and a mirror stereoscope.
7. Given a stereoscopic pair of vertical aerial photographs with:

 PSR 12,000
 Endlap 60%
 H 8250 ft
 Format 9 × 9 in.

 Calculate the approximate vertical exaggeration. Would the topography in this stereoscopic model appear more exaggerated or less exaggerated than in a stereoscopic model with a vertical exaggeration of 4.23?
8. List two ways of increasing vertical exaggeration while maintaining a constant scale during the planning stage of photo mission planning.

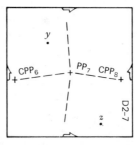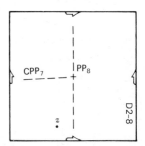

Figure 3.20. Stereo triplicate for Problem 5.

Four

Scale of a Vertical Aerial Photograph

One of the first things a photogrammetrist or photointerpreter must know about an aerial photograph is its scale. Without a knowledge of scale it is impossible to relate the distances between two points or the size of an object on the photograph to an actual distance or size on the ground. Any quantitative measurement made on an aerial photograph involves the use of scale to convert the photo measurement to the actual measurement. The photointerpreter uses actual size to help identify objects. For example, an apartment building and a house could look about the same on an aerial photograph but if their actual sizes are known the interpreter can make a more positive identification.

In this chapter we concern ourselves only with the scale of vertical *aerial photography. A detailed discussion of the scale of* oblique *photography is left to other textbooks.*

Objectives

After a thorough understanding of this chapter and completion of the laboratory exercise you will be able to:

1. Define photographic scale and list the three most common methods of expressing it.
2. Convert between these three methods.
3. Define average scale and point scale.
4. List the two primary causes of variation in photo scale within a single photograph.
5. List two general equations that can be used to calculate photo scale.
6. Compute the *average* scale of a single photo or photo project given the

focal length and the flying height above the average elevation of the ground.

7. Compute the *average* photo scale between two points given the photo distance and the corresponding ground or map distance (and map scale) between the same two points.

8. Compute the photo scale at a *point* given the focal length and the flying height above the point.

9. Compute the flying height above mean sea level given a point photo scale, the focal length of the camera lens, and the ground elevation above mean sea level at the point of known scale.

10. Compute the scale at a *point* given the focal length, the scale at another point, and the elevations of both points.

THE THEORY OF SCALE

Both photographic and map scale are defined as a ratio of distances between corresponding points on the photo (or map) and on the ground. Scale can be expressed as a representative fraction (RF), photo scale reciprocal (PSR), or as an equivalence. Most maps use equivalent scale whereas photo scale is usually expressed in terms of RF or PSR. Even though most textbooks use RF, we will emphasize the use of PSR because it is easier to work with in the formulas presented throughout the book.

Representative Fraction

Representative fraction is the ratio of a distance on the photo to the same distance on the ground and can be expressed as a simple fraction (1/15,840) with one in the numerator or for convenience it may be printed as 1:15,840. This means that one unit on the photo is equivalent to 15,840 of the same units on the ground. Because the units on the photo and on the ground are the same, they cancel and the ratio is unitless.

Photo Scale Reciprocal

Photo scale reciprocal is the inverse of RF and is also unitless. Thus an RF of 1:15,840 is a PSR of 15,840, meaning that the ground distance is 15,840 times the photo distance. PSR is the ratio of the ground distance divided by the photo distance with both distances expressed in the same units. An importnt feature of PSR is that *a smaller numerical value of PSR represents a larger scale* (PSR of 10,000>PSR 20,000) because PSR is the reciprocal of RF. Think of it this way:

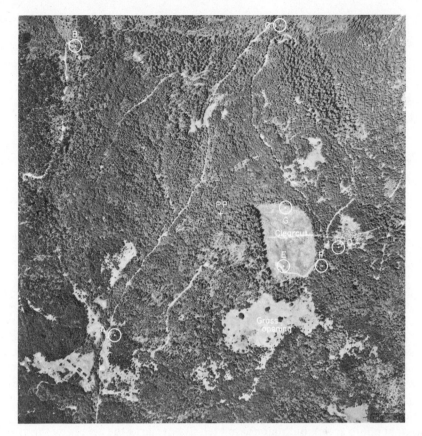

Figure 4.1. There is no way of determining the area of this clear-cut without knowing the photo scale. This annotated photo is to be used with the laboratory exercises at the end of Chapters Four and Five.

PSR is a number we must multiply the photo size of an object to get the actual size. Therefore, if the PSR is small, it is closer to the actual object size than if the PSR is large.

Equivalent Scale

The third method of expressing scale is an equivalence. A PSR of 15,840 for example is the same as an equivalent scale of 4 in. equals 1 mile.

To convert from an equivalence to an RF or PSR, we have to change the units of measurement so that they are the same. For example, we change 4 in. equals 1 mile

to a representative fraction by setting it up as a ratio and multiplying by unity so that all the units cancel and we get an RF of 1:15,840 or a PSR of 15,840.

$$\text{Equivalence: 4 in.} = 1 \text{ mile, or } \frac{4 \text{ in.}}{1 \text{ mile}}$$

$$\text{Multiply by unity: } \left(\frac{4 \text{ in.}}{1 \text{ mile}}\right) \left(\frac{1 \text{ mile}}{5280 \text{ ft}}\right) \left(\frac{1 \text{ ft}}{12 \text{ in.}}\right) = \frac{1}{15,840} = RF$$

$$\text{or: } \left(\frac{1 \text{ mile}}{4 \text{ in.}}\right) \left(\frac{5280 \text{ ft}}{1 \text{ mile}}\right) \left(\frac{12 \text{ in.}}{1 \text{ ft}}\right) = 15,840 = PSR$$

Similarly, we can convert RF and PSR back to an equivalent scale by the same process of multiplying by unity so that all units cancel:

$$RF = 1:15,840 = \left(\frac{1}{15,840}\right) \left(\frac{5280 \text{ ft}}{1 \text{ mile}}\right) \left(\frac{12 \text{ in.}}{1 \text{ ft}}\right) = \frac{4 \text{ in.}}{1 \text{ mile}} = \text{equivalence}$$

$$PSR = 15,840 = \left(\frac{15,840}{1}\right) \left(\frac{1 \text{ mile}}{5280 \text{ ft}}\right) \left(\frac{1 \text{ ft}}{12 \text{ in.}}\right) = \frac{1 \text{ mile}}{4 \text{ in.}} = \text{equivalence}$$

Photo scale is important because it relates size or distance on the photo to actual size or distance on the ground. For example, consider the clearcut on an aerial photograph shown in Figure 4.1. Let's assume that we want to replant it with tree seedlings spaced 12 ft apart, with 12 ft between rows. How many seedlings should we order? To determine this, we need to know the size of the area on the ground. The area on the original photo had dimensions of about 1.0 by 1.5 in. (original photo scale), but that doesn't tell us how large the area is on the ground. We need some way to relate measurements on the photo to actual sizes on the ground. If we know the scale of the photo, then we can translate distances and areas on the photo into corresponding distances and areas on the ground.

TYPES OF SCALE (2 types of Photo Scales).

There are two general types of photo scales — average scale and point scale. Average scale can refer to the entire project, a single photo, or to a portion of a photo. The average project scale is the nominal scale specified in the contract. It is the desired average scale and is the goal of the aerial photo mission. Due to several factors, the project scale is rarely exactly the same as the actual scale of the individual aerial photo. Primary factors contributing to this difference are tilt, changes in flying height between exposure stations, and differences in elevation of the terrain.

Average Scale

The average photo scale may be between two points, the average for a part of a photo, an entire photo, an average of several photos, or the entire project. Except in flat terrain, this average photo scale only approximates the actual scale at all points on the photo.

Point Scale

The second and most exact type of scale is the point scale. It is the photo scale at a point on the ground at a given elevation. Every point on the photo at a different elevation has a different point scale. In a vertical photograph, the range in these point scales depends on the focal length of the camera lens and the amount of variation in elevation of the terrain shown on a given photo.

VARIATION IN SCALE

It is evident from the preceding discussion of types of scales that the photo scale is not constant over the entire photo project or even within a single photo. The two primary causes of these differences in scale over a *single* photo are tilt and differences in flying height above the ground caused by differences in ground elevation—or topography. An additional source of scale variation *among* photos within the same project is slight changes in flying height of the aircraft between exposure stations.

In addition to defining RF as photo distance divided by ground distance, we can define it as focal length divided by the flying height above the terrain. Focal length remains constant on an aerial photo mission, but flying height above the terrain varies as the ground elevation changes. As a result, *higher* ground elevations have a *larger* scale than lower elevations. This means that an object would appear larger on an aerial photo if it is at an elevation of 2000 ft. than if the same object were at an elevation of 1000 ft. In Figure 4.2, for example, you see two lines on the ground, each 1000 ft long, but at different ground elevations. The line at the higher elevation is obviously imaged much longer on the photo than the line at the lower elevation. Therefore, since the ground distances are the same, the two lines on the photo must be at different scales. The same effect is obtained if the aircraft does not maintain a constant altitude between exposure stations due to atmospheric conditions, navigational errors, or by design.

Because the distance between the aircraft and the ground is different for nearly every point on the ground, the scale changes from place to place on the photo. Ridgetops are pictured at a larger scale than valley bottoms. Moreover, the average scale of one photo is likely to be different from that of other photos. As a result, a photo project that is supposed to have a scale of 1:12,000 may have individual average photo scales ranging from 1:11,000 to 1:13,000 or more, and the average

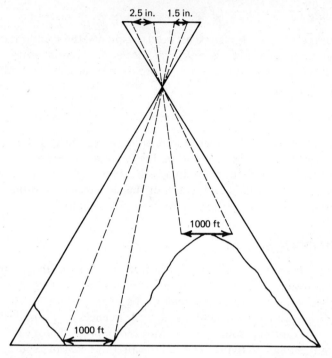

Figure 4.2. Effect of topography on photo scale. Photo scale *increases* (PSR *decreases*) with an increase in elevation. (From D. P. Paine, 1979, *An Introduction to Aerial Photography for Natural Resource Management*, O.S.U. Bookstores, Inc., copyright 1973, reproduced with permission.)

scale of all the photos in the project might turn out to be 1:12,182 or some other scale rather than the 1:12,000 that was the planned project scale.

In addition to the ground elevations and attitude of the plane, the focal length of the camera affects the photo scale. By using a camera with a *longer* focal length, the scale of the photos is *increased*. Figure 4.3 illustrates that by doubling the focal length from 6 to 12 in. the RF is doubled (scale increased) from 1:20,000 to 1:10,000. Notice that line on the ground, which is 5000 ft long.

When using a focal length of 6 in., this line might be 3 in. long on the photo, but when we use a focal length of 12 in., the length of this line on the photo doubles to 6 in.

Tilt also causes scale variation within a single photograph (Figure 4.4). The scale of a tilted photo changes in a regular manner throughout the photo. If the scale

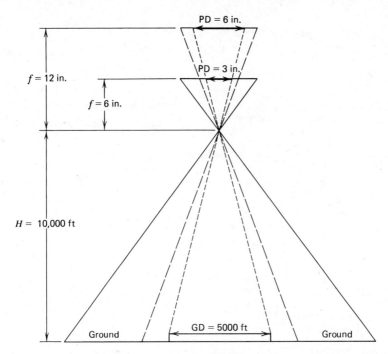

Figure 4.3. Effect of camera lens focal length on photo scale. Increasing the focal length from 6 in. to 12 in. doubles the scale, for example, from an RF of 1:20,000 to an RF of 1:10,000. (From D. P. Paine, 1979, *An Introduction to Aerial Photography for Natural Resource Management,* O.S.U. Bookstores, Inc., copyright 1973, reproduced with permission.)

near the center of the photo is approximately correct, then the scale is *smaller* on the side of the photo positive that is tilted *upward*, and *larger* on the side that is tilted *downward*. The scale changes across the photograph in the direction of the tilt. You can see in Figure 4.4 that the length of the 3000-ft ground line on the photo varies depending on whether it is on the upper or lower half of the photo.

BASIC SCALE EQUATIONS

From the geometry of the central projection of an aerial photograph (Figure 4.5) we can see that by using similar triangles photo scale can be computed in one of two ways: first by using focal length (*f*) and flying height above the ground (*H* or

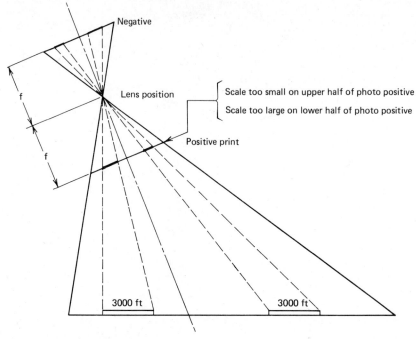

Figure 4.4. Effect of tip on the scale of an aerial photograph. The scale is smaller on the up side and larger on the down side of the positive print. (From D. P. Paine, 1979, *An Introduction to Aerial Photography for Natural Resource Management,* O.S.U. Bookstores, Inc., copyright 1973, reproduced with permission.)

A-E), or second, by using the photo distance (PD) and the ground distance (GD) between the same two points:

$$RF = \frac{f}{H} = \frac{f}{A - E} = \frac{PD}{GD}$$

and

$$PSR = \frac{H}{f} = \frac{A - E}{f} = \frac{GD}{PD}$$

Where

GD	=	ground distance
PD	=	photo distance
H	=	*A − E* = flying height of the aircraft above the ground in feet or meters
A	=	altitude of aircraft above sea level
E	=	ground elevation above sea level
f	=	focal length of the camera lens in the *same* units of measure as for *H* (usually ft or m)

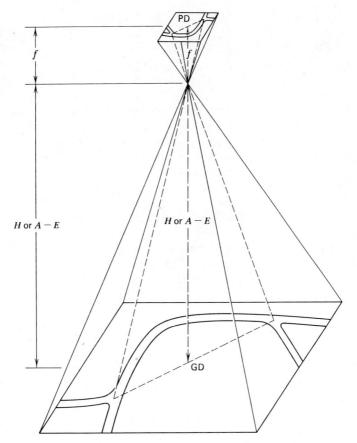

Figure 4.5. The two basic scale equations can be derived using similar triangles shown in dashed lines. (Courtesy U.S. Forest Service, P.N.W. Forest and Range Experiment Station.)

It is important to remember that for RF and PSR to be expressed as unitless ratios, we must convert f to feet or meters if H is in feet or meters.

Average Scale Calculations

The method using PD and GD has three variations:

1. We can measure ground distance directly on the ground.
2. We can measure the distance on a map and compute the ground distance by knowing the scale of the map.
3. We might know the size of some feature on the ground directly, in which case only the photo measurement would be necessary. For example, we might know the size of a farmer's field, city block, or the distance between roads.

Figure 4.6. Sometimes photo scale can be calculated if a ground distance is
known, such as the old cutting boundary as shown here.

Many times, the delineation of sections in the Public Land Survey System, which
are squares one mile on a side, are well defined on the photo by clearcuts, fields, or
the network of roads. In Figure 4.6 the distance between old clearcut boundaries is
40 chains, or one-half mile. Now let's see how we can compute photo scale using
these various methods. Let's begin with some examples of how to compute average
photo scale.

Example 1

Suppose the average *project* PSR is 14,000 (Figure 4.7). This is the nominal
scale that was the goal of the photo mission and will usually vary from photo to
photo. Further let us suppose that the attempted flying height above mean sea
level is 8000 ft and the focal length of the camera lens is 6 in. From a
topographic map of the same area we estimate the average ground elevation
covered by the photo to be 800 ft. Therefore, the average *photo PSR is:*

$$\text{PSR}_{800} = \frac{A - E}{f} = \frac{8000 \text{ ft} - 800 \text{ ft}}{0.5 \text{ ft}} \quad \text{or} \quad \text{PSR}_{800} = \frac{H}{f} = \frac{7200 \text{ ft}}{0.5 \text{ ft}} = 14,400$$

Example 2

Now let's determine the average scale between two road junctions (points A
and B) on this same photo (Figure 4.7). The distance on the original photo, as

Figure 4.7. Aerial photo for Examples 1, 2 and 3.

measured with an engineers scale is 1.14 in. and the distance as measured on the ground is 1395 ft. Furthermore, let us assume that the elevation of point A was 526 feet and point B 584 feet. We find the average PSR to be:

$$PSR_{555} = \frac{GD}{PD} = \left(\frac{1395 \text{ ft}}{1.14 \text{ in.}} \right) \left(\frac{12 \text{ in.}}{1 \text{ ft}} \right) = 14,680$$

Notice the use of subscripts, here and elsewhere, for PSR. The 555 in this case indicates that the PSR is valid for all points on the photo at an elevation of 555 feet above *MSL* (mean sea level) which is the average of 526 and 584 ft.

Also notice that we rounded PSR to the nearest 10. This is the usual procedure because measurement errors on the photo, map, or ground usually create errors in PSR determination of at least this much and probably more. Because foresters and other natural resource managers frequently measure ground distances in chains (66 feet per chain), let's work the same problem using chains. Our ground distance would be 21.14 ch and our PSR calculation would be:

$$PSR_{555} = \frac{GD}{PD} = \left(\frac{21.14 \text{ ch}}{1.14 \text{ in.}} \right) \left(\frac{66 \text{ ft}}{1 \text{ ch}} \right) \left(\frac{12 \text{ in.}}{1 \text{ ft}} \right) = 14,690$$

This is *not* the scale for either point A or B. It is the scale for the *average elevation between the two points* (555 ft.) This is not the same scale as we obtained for Example 1. The average scale for Example 1 was for the entire photo with an estimated average elevation of 800 ft. We also assumed that *H* was 800 ft in Example 1; it might have been slightly different.

Throughout this book we stress the use of units. If your units do not cancel in RF or PSR calculations you know that you have set the problem up wrong. In our first three examples all the units canceled leaving our final answer (PSR) unitless as it should be.

Example 3

Instead of measuring the distance between these same two road junctions on the ground, suppose that we have a map of the same area on which the road junctions can be located. Our map has an equivalent scale of 1 in. = 400 ft and we measure the map distance from point A and B to be 3.48 in. What is the average scale between these two points? What was the flying height above sea level?

First convert map equivalent scale to map scale reciprocal (MSR):

$$\frac{400 \text{ ft}}{1 \text{ in.}} \frac{12 \text{ in.}}{1 \text{ ft}} = 4800 \text{ MSR}$$

It should be noted that $\text{MSR} = \dfrac{\text{GD}}{\text{MD}}$ and that GD = (MD) (MSR), therefore:

$$\text{GD} = (3.48 \text{ in.}) (4800) \frac{1 \text{ ft}}{12 \text{ in.}} = 1392 \text{ ft}$$

Our PSR_{555} is then:

$$\frac{\text{GD}}{\text{PD}} = \frac{1392 \text{ ft}}{1.14 \text{ in.}} \frac{12 \text{ in.}}{1 \text{ ft}} = 14{,}650$$

This is a slightly different scale than we had in Example 2, but this difference can be attributed to slight errors of measurement or in locating points A and B on the map. For those who would like to work this example in one equation we have:

$$\text{PSR}_{555} = \frac{(\text{MD}) \ (\text{MSR})}{\text{PD}} = \frac{(3.48 \text{ in.}) \ (4800)}{(1.14 \text{ in.})} = 14{,}650$$

Now we can calculate the flying height above sea level (A) because we know the scale at an elevation of 555 ft and we know that the focal length is 6 in. If we solve one of our scale formulas, $\text{PSR} = \dfrac{A - E}{f}$, for A we get:

$$A = f(\text{PSR}) + E = 0.5 \text{ ft}(14{,}650) + 555 \text{ ft} = 7880 \text{ ft}$$

Notice that this is slightly different than the planned flying height of 8000 ft.

Point Scale Calculations

Actually our answers in Examples 1, 2, and 3 were point scales since they represent the scale on the photograph where the elevation is 555 ft, but it is more convenient to think of them as average scales. Now that we know the flying height above sea level for this particular photo we can calculate the photo scale at any point on the photo as long as we know the elevation of that point and the focal length. For example, let's calculate the point scale at another point on the same photo.

Example 4

From our contour map we find the elevation of the new point to be 475 ft. Thus our PSR at this point becomes:

$$PSR_{475} = \frac{A\text{-}E}{f} = \frac{7880 \text{ ft} - 475 \text{ ft}}{0.5 \text{ ft}} = 14{,}810$$

For comparison, let's find the point scale at another point on the photo that has an elevation of 1250 ft.

$$PSR_{1250} = \frac{7880 \text{ ft} - 1250 \text{ ft}}{0.5 \text{ ft}} = 13{,}260$$

From this example we can see how much a change in ground elevation affects the photo scale. The difference in PSR between the last two calculations is 1550 and the difference in elevation exactly half that amount, or 775 feet. This suggests that we could derive a single equation that would allow us to calculate the PSR at any elevation on the photo if we know the focal length, the PSR and elevation at any one point, and the elevation of the point of unknown PSR. Here it is:

From

$$PSR_A = \frac{A - E_A}{f},$$

we get

$$A = f(PSR_A) + E_A,$$

and

$$PSR_B = \frac{A - E_B}{f}.$$

Therefore:

$$PSR_B = \frac{f(PSR_A) + E_A - E_B}{f}$$

$$PSR_B = PSR_A + \frac{E_A - E_B}{f}$$

Now let's use this equation to see if we get the same answer as before for the point with an elevation of 475 ft, using the known PSR and elevation from Examples 3 and 4.

Example 5

$$PSR_{475} = PSR_{555} + \frac{E_{555} - E_{475}}{f} = 14,650 + \frac{555 \text{ ft} - 475 \text{ ft}}{0.5 \text{ ft}} = 14,810$$

or

$$PSR_{475} = PSR_{1250} + \frac{E_{1250} - E_{475}}{f} = 13,260 + \frac{1250 \text{ ft} - 475 \text{ ft}}{0.5 \text{ ft}} = 14,810$$

which is exactly what we obtained in Example 4. Don't get confused if the PSR we want to calculate is at a *higher* elevation than the known PSR.

Example 6

As our last example let's calculate the PSR at 1250 ft, knowing the PSR at 475 ft.

$$PSR_{1250} = PSR_{475} + \frac{E_{475} - E_{1250}}{f} = 14,810 + \frac{475 \text{ ft} - 1250 \text{ ft}}{0.5 \text{ ft}} = 13,260$$

which is the same as we obtained before for PSR_{1250}.

Assumptions

In all of our computations of scale we have assumed that we were dealing with a truly vertical photograph. This assumption is not entirely correct, but because there is no simple way to determine the amount of tilt in the photo, we have no way of calculating the rate of change in photo scale due to any tilt that might be present.

A further assumption is that any error caused by topographic displacement when measuring the photo distance of the baseline[1] is negligible. This error can be minimized by establishing the baseline as close to the nadir as possible to reduce r in the relief equation and/or by keeping both ends of the baseline at about the same elevation.

Figure 4.8 illustrates the effect of topographic displacement on the photo measurement of a baseline for six different situations. The solid lines represent the true baseline length as would be shown on a map without displacement. The dashed lines show the baseline lengths as measured on a photo with the same scale at the nadir as the map (12,000 PSR in this example).

Situation A shows the photo-measured baseline to be too long, but we can mathematically correct the PSR of the baseline and there is no error involved. That is, GD divided by PD gives us the correct point PSR *for a 1600-ft elevation.* Situation B results in a shorter baseline measurement, but once again GD divided by PD gives us the correct point *PSR for a 400-ft elevation.*

[1] *The baseline is between two selected points positively identified both on the ground and on the photo.*

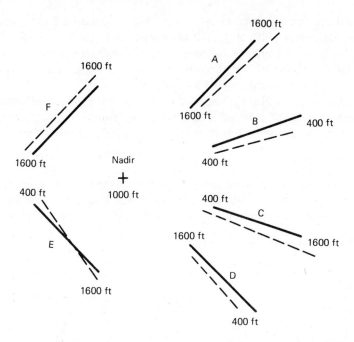

Figure 4.8. The effect of topography on photo baseline lengths. The solid lines represent true (map lengths) and the dashed lines represent photo lengths (see text).

For example, with a PSR of 12,000 at the nadir and a 6-in. focal length lens we calculate the true baseline PSR for a situation A to be $12,000 + (\frac{1000 \text{ ft} - 1600 \text{ ft}}{0.5 \text{ ft}})$ or 10,800. Similarly, the true PSR for situation B is $12,000 + (\frac{1000 \text{ ft} - 400 \text{ ft}}{0.5 \text{ ft}})$ or 13,200. In this example, the map distance for all situations is 1 in. and using a 12,000 MSR we calculate the GD to be 1000 ft. Thus, using the $\frac{GD}{PD}$ equation for PSR we get $(\frac{1000 \text{ ft}}{1.11 \text{ in.}})(\frac{12 \text{ in.}}{\text{ft}}) \approx 10,800$ for situation A and for situation B we get PSR $(\frac{1000 \text{ ft}}{0.91 \text{ in.}})(\frac{12 \text{ in.}}{\text{ft}}) \approx 13,200$, which is the correct PSR for both situations. This will always be the case when both ends of the baseline are the same elevation.

However, *situation C and D can not be mathematically corrected.* Because the average elevation of both baselines is the same as the nadir, the true average baseline PSRs are exactly the same as the point PSR at the nadir. Yet the photo measured baseline length is much too long for situation C and much too short for situation D. Using GD divided by PD gives us PSRs of approximately 9160 and 16,900 respectively, which are a long way from the correct PSR of 12,000.

Using the photo measured distance of 1.04 in. in situation E produces a small error. We calculate a PSR of 11,540 as compared to the true PSR of 12,000. Situation F where both ends of the baseline are at the same elevation once again results in little or no error. The photo baseline measurement of 1.11 in. results in a PSR that is very close to the true PSR of 10,800.

Thus there are an infinite number of situations that produce different magnitudes of error. Because some of these errors are large, it is necessary to select baselines in the field so that their ends are at about the same elevation.

Laboratory Exercise

For this laboratory exercise you will need to use the annotated aerial photo in Figure 4.1 and the map of the same area in Figure 4.9. Your instructor can alter the exercise by changing the assumptions and/or the data for each problem.

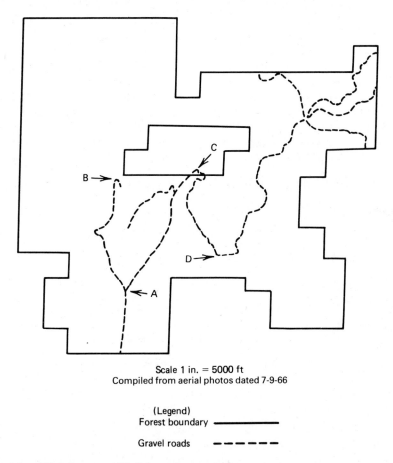

Scale 1 in. = 5000 ft
Compiled from aerial photos dated 7-9-66

(Legend)
Forest boundary ————————

Gravel roads — — — — — —

Figure 4.9. Map for use with laboratory exercise.

Assumptions

Average project elevation	= 900 ft
Focal length of camera lens used	= 3 in.
Planned flying height above MSL (A)	= 6900 ft

1. Calculate the planned average project scale.
2. Based on the information given so far, calculate the average scale of the photo in Figure 4.1 if the average ground elevation is 1050 ft.
3. Using the map in Figure 4.9 with an equivalent scale of 1 in. equals 5000 ft, and the aerial photo in Figure 4.1, calculate the average scale between points A and B and between C and D. Average your two scales. Give two reasons, other than errors of measurement, why the average scale between points A and B is different than that between points C and D.
4. Calculate the average scale between points E and F if the ground measured distance between the same two points is 11.70 chains.
5. If the elevation at point E is 1380 ft, point F is 1450 ft, and point G is 800 ft, what is the point scale at G? Do not use the attempted flying height (A) that was given earlier — the actual flying height was slightly different. Use the scale you calculated in the previous question to calculate the actual flying height first.

Questions and Problems

1. Photo scale is the ratio of what two distances?
2. List three methods of expressing scale and give an example of each method.
3. Convert a PSR of 63,360 to an equivalent scale in units of inches per mile and in units of centimeters per kilometer.
4. Convert an equivalent scale of 1 in. equals 80 chains to an RF.
5. Match the following situations with the proper classification of scale types:

 ____Scale of average con-
 tour of a single photo
 ____Scale at the intersection (a) Point scale
 of two roads (b) Average photo scale
 ____Average scale between (c) Average project scale
 two points
 ____Scale specified for the
 project
6. What are the two major reasons for scale changes within a single photo?
7. Calculate the average RF and equivalent scale in terms of inches per mile if the plane flew at 11,290 ft above MSL using an 8¼ in. lens camera and an average ground elevation of the area photographed of 400 ft.

8. What would be the average PSR of one of the photos in the previous problem if the average elevation of the area photographed is 750 ft? 229 m?

9. What would be the average PSR between two points that are 53.6 mm apart on the photo and 32.64 chains apart on the ground?

10. Suppose in the previous problem that the two points are at elevations of 150 and 550 ft. What would be the PSR of another point on the same photo at an elevation of 950 ft if a 6-in. lens is used?

11. Calculate the average RF between two points if the photo distance is 170.7 mm and the map distance is 1.68 in. and if the map equivalent scale is 1 in. equals 4 miles.

12. Assuming everything remains constant except the variable listed, state what happens to the photo distance (increases or decreases):
 (a) Ground distance increases _____ .
 (b) Numerical value of PSR increases _____ .
 (c) Focal length increases _____ .
 (d) The flying height above sea level decreases _____ .
 (e) The average ground elevation increases_____ .

13. At what elevation above sea level must a plane fly to photograph at a PSR of 10,000 if the average ground elevation is 4125 ft and the camera lens focal length is 209.55 mm?

Five

Horizontal Measurements— Distance, Bearings, and Areas

Because scale is an essential part of distance and area measurement, and because topographic displacement has a significant influence on both scale and bearings measured on aerial photographs, a thorough understanding of these topics must be mastered before we continue.

Objectives

After a thorough understanding of this chapter and completion of the laboratory exercise you will be able to:

1. Determine ground distances between two points on an aerial photo of known scale, using either an engineers scale or the multiple scale templet.
2. Define bearing and azimuth and be able to convert from one to the other.
3. Establish a photo baseline, for the purpose of determining a bearing, using (a) land ownership lines on the photo, (b) a compass line established in the field, and (c) an existing map of the same area.
4. State the rules for minimizing the effects of tilt and topographic displacement on bearings.
5. Determine the bearing of a line on an aerial photograph where the bearing requires a correction for topographic displacement.
6. List four methods of area determination for irregularly shaped areas on an aerial photograph or map and describe how each works.

7. Measure and compute the acreage on the ground of an area imaged on an aerial photo or a map knowing the scale of that area on the photograph or map.

GROUND DISTANCE

As we learned in Chapter Four, PSR is the ratio of ground distance to photo distance. Therefore, if we know the photo scale and measure the photo distance we can calculate the corresponding distance on the ground by solving a scale equation to get:

$$GD = PD \ (PSR)$$

For example, if the distance between two points on a 10,000-PSR photo is 2.46 in., the ground distance is:

$$GD = (2.46 \text{ in.}) \ (10,000) \ \frac{1 \text{ ft}}{12 \text{ in.}} = 2050 \text{ ft}$$

A faster, but less precise method of determining ground distance is to use the multiple scale templet shown in Figure 5.1. The vertical numbers on the left are various photo scales expressed as representative fractions, from 1:8000 to 1:40,000. The horizontal numbers along the top and the bottom of the templet represent the horizontal ground distance between two points, in chains.(There are 66 ft in one chain.)

Using this method, let's determine the ground distance between two clear-cut boundaries on the aerial photo shown in Figure 5.2. First we need to know the average scale between the two boundaries. From the information printed at the top of the photo we determined that the flying height above mean sea level was 15,000 ft, and the focal length of the camera was 8¼ in. (0.6875 ft). Let's assume that the average elevation of these two points is approximately 600 ft. This gives us a PSR of:

$$PSR = \frac{A - E}{f} = \frac{15,000 \text{ ft} - 600 \text{ ft}}{0.6875 \text{ ft}} = 20,950 \approx 21,000$$

Now lay the multiple photo scale templet on the photo so that the distance to be measured lies along the 1:21,000 RF scale, which is interpolated between the 1:20,000 and 1:22,000 scale lines. Next line up the zero end of the distance scale over the west boundary (top of photo in Figure 5.2 is north) and read a ground distance of 80 chains to the east boundary. Do you remember from Chapter Four where we stated that many land ownership boundaries are frequently laid out on the Public Land Survey System? This is probably the case here because 80 chains is exactly one mile.

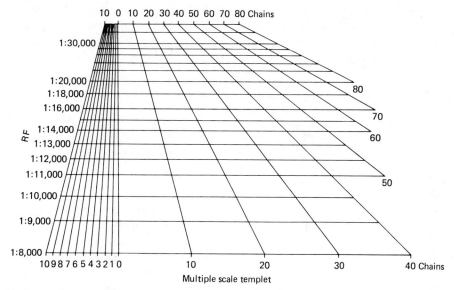

Figure 5.1. Multiple scale templet.

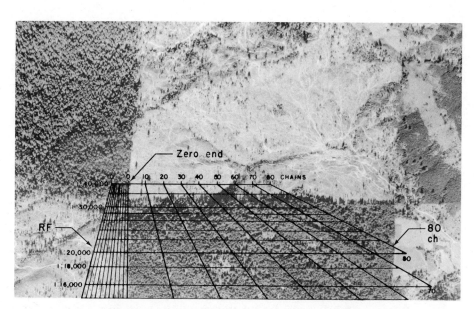

Figure 5.2. Using the multiple templet scale to determine ground distance if the scale is known. If the ground distance is already known, the multiple templet scale can be used to determine photo scale.

If we happened to know in advance that the two points are 80 chains apart and the photo scale is unknown, it can be determined by placing the multiple scale templet on the photo so that the distance between the points is 80 chains and interpolating an approximate RF of 1:21,000.

HORIZONTAL ANGLES

Due north, east, south, and west are called the cardinal directions. If we want to describe some other direction we must do so in terms of angles starting from north or south. Two common methods of indicating direction are bearings and azimuths.

Bearings

A bearing is an angle of 90° or less measured from either north or south towards either east or west. In Figure 5.3 (left) you see examples of bearings in each of the four quadrants. The angle to the first line is 53° clockwise from north, so the bearing of the line is north 53° east because it is in the northeast quadrant. Similarly, the bearings of the remaining three lines are south 45° east, south 89° west, and north 22° west. Bearings should never be greater than 90° and always measured from north or south—not from east or west. In this book we use bearings to measure direction.

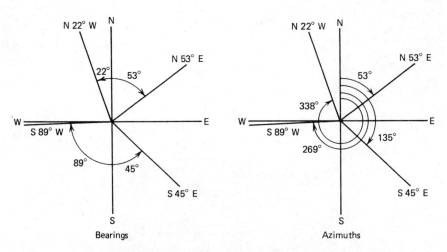

Figure 5.3. Bearing and azimuths. Bearings are measured in quadrants and do not exceed 90°. Azimuths are measured from north in a clockwise direction up to 360°. (From D. P. Paine, 1979, *An Introduction to Aerial Photography for Natural Resource Management,* O.S.U. Bookstores, Inc., copyright 1973, reproduced with permission.)

Azimuths

Azimuths are angles from 0 to 360° measured in a clockwise direction from north. In Figure 5.3 (right), you see the same four angles—or directions—as previously discussed, but this time in azimuth form. Thus the four azimuths become 53, 135, 269, and 338° respectively.

Back Angles

A back angle is a 180° shift in direction or the exact reverse of the original direction. A back bearing has the same numerical value as the forward bearing, but with the cardinal direction reversed. For example, the back bearing of N 22° W is S 22° E and the back bearing of N 53° E is S 53° W.

To obtain a back azimuth *add* 180° if the foreward azimuth was less than 180° and *substract* 180° if the foreward azimuth is between 180° and 360°.

MEASURING ANGLES

Frequently we want to find our way to a field plot, suspected section corner location, or other point of interest, which has been located on an aerial photo. If it cannot be found by following the photo detail the best way is to establish a distance-bearing line from a reference point (which can be located both on the photo and on the ground) to the point we wish to find. The bearing and distance of the distance-bearing line can be measured on the photo. To get the direction we need to establish a baseline on the photo of which the azimuth or bearing is known or can be determined. The direction of the distance-bearing line is found by measuring the angle between it and the known baseline.

Because most aerial photos are taken in cardinal directions, one might assume that the edges of the photo define the cardinal directions. We can't get too far off if we are running a line only two or three chains long. However, because photo crab of 5 to 10° is not uncommon, we wouldn't want to run a *long* line on these assumptions. Therefore, we must establish a baseline. This can be accomplished at least three different ways: (1) using land ownership lines on the photo, (2) using a compass line established in the field, or (3) using an existing map of the same area.

Using Land Ownership Lines

If rectangular ownership lines show on the photo we can use one of them as an assumed baseline if we have reason to believe that it is in a cardinal direction. City blocks, farmers' fields, roads, and clearcut boundaries frequently follow cardinal directions. However, some of these lines may not follow cardinal directions and it would be wise to verify any assumptions with a map of the area.

Suppose in Figure 5.4 we wish to find the center of plot 7 so that we can measure the volume of timber on this plot which is only one of many plots in our

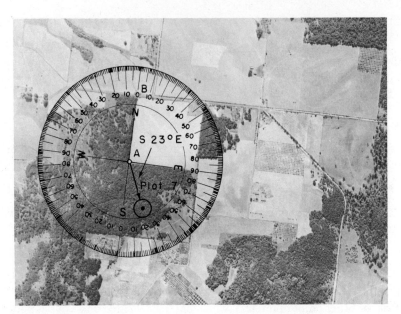

Figure 5.4. Using land ownership lines to measure direction.

inventory. It would be impossible to locate the exact plot center on the ground just by looking at the photo so we must establish a baseline. There appear to be several clearcut boundary lines in cardinal directions that are close, but not exactly parallel, to any of the photo edges. A look at a map confirms that the boundary from A to B is in a north-south direction and we can use it as our baseline.

First, draw a line on the photo from point A to the center of plot 7. Next, place the center of a protractor over point A and orient the north-south line of the protractor with the boundary from A to B. The bearing from point A to the plot center can be read directly as S 23° E.

The final step in the field would be to measure the photo distance from point A to the center of the plot, convert to ground distance, and then measure this distance on the ground from point A in the proper direction to find the center of the plot.

Using a Compass Line

In Figure 5.5. there are no ownership lines or roads going in any known direction and we have no map of the area. Therefore, a baseline must be established in the field. To help find the center of plot 2, the two road junctions at A and B are located on the ground and on the photo. On the photo, lines are drawn between A and B and from A to the center of plot 2. The line is drawn from point A only because it is closer to the plot than point B. Next we take a compass bearing from A to B and read S 53° E. Then we place the center of our protractor over point A and align it so that we read S 53° E as a bearing from A to B. The bearing from point A to the center of plot 2 is then N 52° E.

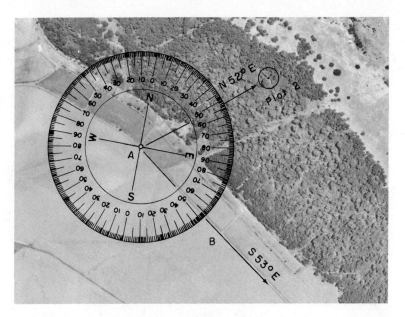

Figure 5.5. Using a compass line measured in the field to measure direction.

Using an Existing Map

The third way to establish a baseline of known direction and distance is to draw a line between two identical points on both the map and photo. This was done in Figure 5.6 with the two ends of the baseline labeled A and C. Point B (on the map only) shows the location where a section line crosses the baseline. We assume that this section line runs in a true north-south direction. This time we place the center of the protractor at Point B on the *map* so that it is properly aligned with the north-south section line. We read a bearing from B to C of S 58° W. The back bearing from C to B (or C to A) would be N 58° E. Because point C is closer to the destination, plot 42, we place the center of the protractor on the photo at point C and align it to read N 58° E (the back bearing) from C to A. The bearing from C to the plot center is read as S 13° W.

This time we can also calculate our photo scale from the map. The original map scale was 2 in. = 1 mile and the map distance between A and C was 0.58 in. The original photo distance from C to plot 60 was 1.35 in. The calculated ground distance from C to the plot is:

$$\text{MSR} = \frac{1 \text{ mile}}{2 \text{ in.}} \frac{5280 \text{ ft}}{1 \text{ mile}} \frac{12 \text{ in.}}{1 \text{ ft}} = 31,680$$

$$\text{PSR} = \frac{(\text{MD})(\text{MSR})}{(\text{PD})} = \frac{(0.58 \text{ in.})(31,680)}{1.35 \text{ in.}} = 13,611$$

$$\text{GD} = \text{PD(PSR)} = 1.35 \text{ in. } (13,611) \left(\frac{1 \text{ ft}}{12 \text{ in.}} \right) \left(\frac{1 \text{ ch}}{66 \text{ ft}} \right) = 23.2 \text{ ch}$$

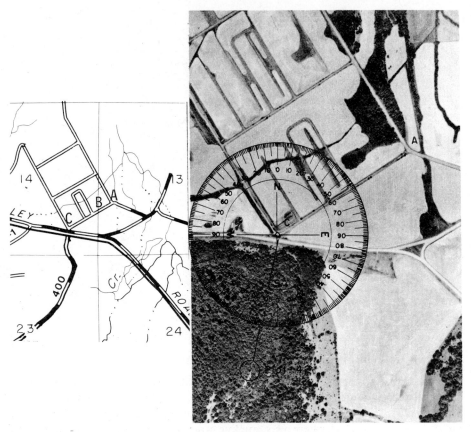

Figure 5.6. Using a map and a photo to measure direction.

The photo for Figure 5.6 was chosen for this example because there are no ownership lines or roads that appear to run in cardinal directions despite the existence of numerous roads and agricultural fields on relatively level terrain.

 ### Effects of Tilt and Topographic Displacement on Bearings

We should remember that tilt has an effect on bearings measured on an aerial photograph in much the same way as it causes changes in scale. Because rectification greatly adds to the cost of photography it is usually not done except for precise mapping projects. About all the interpreter in the field can do about tilt is to realize that it can influence a bearing. Because tilt displacement radiates from the isocenter, which should be close to the principal point, bearings passing through or close to the photo center are little affected by tilt.

A more serious problem concerning bearings in rough terrain is the effect of topographic displacement. As we learned in Chapter Two, topographic displace-

ment is directly proportional to differences in elevation and the distance from the nadir, and inversely proportional to the flying height. Using the displacement formula and a protractor we can make a correction for topographic displacement on an aerial photograph. The procedure is best explained by the use of an example.

In Figure 5.7 the *photo* baseline is from A to B. Point A (elevation 440 ft) is located 3.81 in. southwest of the nadir and point B (elevation 1450 ft) is 2.60 in. south of the nadir (elevation 1000 ft). Let's further assume that the plane flew at 6000 ft above MSL, that a 6-in. lens was used, and that the bearing from A to B *taken in the field* was N 78° E. Using the topographic displacement formula we calculate the displacement of points A and B on the photo as follows:

$$d_A = \frac{r(h)}{A - E} = \frac{(3.81 \text{ in.}) \ (-560 \text{ ft})}{6000 \text{ ft} - 1000 \text{ ft}} = -0.43 \text{ in.}$$

$$d_B = \frac{r(h)}{A - E} = \frac{(2.60 \text{ in.}) \ (+450 \text{ ft})}{6000 \text{ ft} - 1000 \text{ ft}} = +0.23 \text{ in.}$$

Assuming the datum elevation to be at the nadir the true or map location of the baseline in Figure 5.7 is from A' to B'. Note that point A, being lower in elevation than the nadir, is displaced toward the nadir, which means that the correct position of A is further from the nadir at A'. Point B, at a higher elevation than the nadir, is displaced away from the nadir, which means that the correct position of B is toward the nadir at B'.

Using a protractor we find that the error of our bearing line *on the photo* is 9° in a clockwise direction, therefore, the corrected photo bearing is 9° counter-

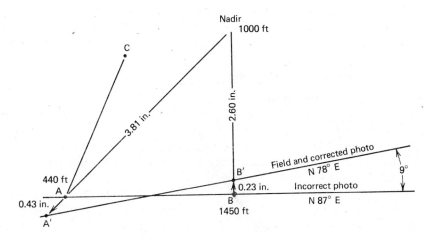

Figure 5.7. Graphic solution to the problem of correcting for topographic displacement when measuring direction directly on photographs (see text).

clockwise. This is an extreme case, but it illustrates the magnitude of errors in bearings caused by topography.

Whether or not corrections of this type are made on aerial photographs depends on the degree of accuracy required. In actual practice corrections are not made in the field for routine interpretation or inventory work, but a thorough understanding of the problems involved allows the establishment of some general rules to follow for establishing photo-bearing lines.

Based on our knowledge of the geometry of a vertical aerial photo, it should be clear that errors in bearings caused by topographic displacement are nonexistent under the following conditions.

1. The bearing line passes through the nadir (topographic displacement is radial from this point).
2. The nadir and both ends of the bearing line are at the same elevation.
3. Both ends of the bearing line are at the same elevation and are the same distance from the nadir (bearing line and nadir not at the same elevation).

In the last situation the radial displacement is exactly the same for both ends of the bearing line making the corrected and uncorrected bearings parallel.

Because the nadir, isocenter, and principal points are usually quite close together, the following general rules should be followed to minimize the effect of tilt and topographic displacement when establishing bearing lines on aerial photos.

1. Establish the line close to the principal point, thus minimizing the distance r in the topographic displacement equation.
2. Establish both ends of the line at about the same elevation as the principal point.
3. If rule 2 can not be followed, establish both ends of the line at about the same elevation and at the same distance from the principal point.
4. Establish the line so that it passes through or close to the principal point.

Declination and Local Attraction

In our discussion of bearings we have assumed that we were working with true and not magnetic bearings. However, a compass needle points to magnetic and not true north. To correct for this a declination angle is usually set off on the compass. If you want to travel in a true north direction usually you don't go where the magnetized needle on the compass points. Instead you follow a different sighting, made with the compass, with the declination accounted for.

The magnitude of this declination angle changes with different geographic locations. In the United States it ranges from approximately 25° east declination in the Pacific Northwest to about 25° west declination in the Northeast. The agonic line, where the declination is zero, passes over the east coast of Florida in an approximately straight line through about the center of Lakes Michigan and Superior. Thus, in the western two-thirds of the United States the compass needle points east of true north so that the declination angle must be set off in a

counterclockwise direction and vice versa for the eastern one-third of the country.

Local attraction can alter the direction that a compass points. This is usually caused by local mineral deposits within the earth. Other causes of local attraction that you should be aware of are fence lines, power lines, and even metal objects in your pocket. These latter problems can be avoided with a little care. Local attraction caused by local mineral deposits is a different matter and is discussed more thoroughly in most surveying books.

AREA MEASUREMENTS

Area measurements made directly on an aerial photograph are subject to error caused by distortion and displacement, particularly tilt and changes in scale caused by changes in ground elevation. Even though rectification can remove the effects of tilt and mathematical manipulations can correct for topographic differences, it is best to measure areas from a planimetric map made from the photographs if precise area measurements are required.

Figure 5.8 illustrates the seriousness of topographic displacement when making area measurements directly on aerial photos. The solid lines around area A and B represent the true map position and shape of 2000 ft square areas at an MSR of 12,000. The dashed lines show the photo position and shape of the same two areas on a photo with a PSR of 12,000 at the nadir and elevation as shown.

Because area A is 600 ft higher than the nadir, the true scale of the area is calculated to be 10,800 assuming a 6-in. focal length lens. The area, as calculated

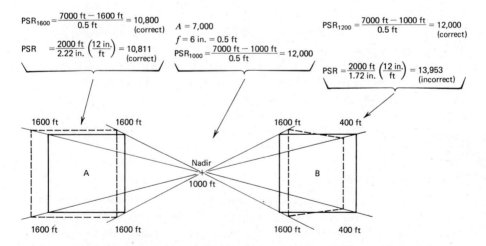

$$PSR_{1600} = \frac{7000 \text{ ft} - 1600 \text{ ft}}{0.5 \text{ ft}} = 10,800 \text{ (correct)}$$

$$PSR = \frac{2000 \text{ ft}}{2.22 \text{ in.}} \left(\frac{12 \text{ in.}}{\text{ft}}\right) = 10,811 \text{ (correct)}$$

$$A = 7,000$$
$$f = 6 \text{ in.} = 0.5 \text{ ft}$$
$$PSR_{1000} = \frac{7000 \text{ ft} - 1000 \text{ ft}}{0.5 \text{ ft}} = 12,000$$

$$PSR_{1200} = \frac{7000 \text{ ft} - 1000 \text{ ft}}{0.5 \text{ ft}} = 12,000 \text{ (correct)}$$

$$PSR = \frac{2000 \text{ ft}}{1.72 \text{ in.}} \left(\frac{12 \text{ in.}}{\text{ft}}\right) = 13,953 \text{ (incorrect)}$$

Figure 5.8. The effect of topography on area measurement taken directly from photographs (see text). The scale of this diagram is different than the original as discussed in the text. At the original diagram scale, the average lengths of the dashed lines were 2.22 in. and 1.72 in. for A and B respectively.

from both the map and photo (using the corrected scale), is 91.3 acres and there is no error in this situation where all corners of the area are at the same elevation.

However, there is a substantial error associated with area B. Notice that the average elevation is 1000 ft, which is the same as the nadir and no mathematical correction can be made for the average scale difference. The photo measured area, however, is approximately 67.9 acres or in error by over 25 per cent.

It is pointed out that this error can be minimized by keeping the area as close to the nadir as possible. That is, when the same area is imaged on two or more photos, select the photo where the area is closest to the nadir.

This error can also be reduced at the flight-planning stage by photographing at a higher altitude. The same scale can be obtained by a change in focal length. For example, we could cut the error in half by doubling the flying height above the ground and maintaining the same photo scale by doubling the focal length of the camera lens.

Ignoring the problem of topographic displacement on photos, the actual technique of measuring irregularly shaped areas is the same on a map as on a photo. Most techniques involve the determination of the areas on the photo or map and the conversion to ground areas using the appropriate scale. Calculating the area of well-known geometric shapes such as squares, rectangles, circles, or triangles is a simple task, but to do so for the irregularly shaped areas, representing different land-use practices (Figure 5.9) requires a different approach. In addition to the formula method there are at least four other ways of accomplishing this: planimeter, weight apportionment, dot grid, and transect.

Planimeter

The polar planimeter is an instrument specially designed for measuring areas. To measure the area enclosed by a boundary, a tracing point of the planimeter is traversed around the perimeter. Area readings on the instrument's dial are given directly in square inches or square centimeters, which must be converted to ground areas. This method is especially adapted for measuring a few small irregularly shaped areas. To measure all the irregular shapes that might be found on a map, however, requires running the pointer around every type island, a process that is somewhat laborious.

Weight Apportionment

The weight apportionment method involves the use of a sensitive laboratory balance. A *copy* of the land-use map or photo is carefully cut into individual type islands, which are then sorted into the various type classes, and the total weight of each class is precisely determined on the balance. The grand total of all types is then weighed to insure that the sum of the parts equals the whole. The total acreage in the survey unit, which must be known from some other source, is then distributed among the various types in proportion to the type weights. This method is not suited

Scale: PSR = 12,670

Figure 5.9. Area determination of ir-
regular shapes. See text.
(From D. P. Paine, 1979,
*An Introduction to Aerial
Photography for Natural
Resource Management,*
O.S.U. Bookstores, Inc,,
copyright 1973, repro-
duced with permission.)

to the measurement of a few small areas, but is efficient for determining the area of
the various land use or cover types for large ownerships, especially when many type
islands are involved.

Dot Count

Perhaps the most widely used method of estimating areas on aerial photo is by
the use of dot grids. Dot counting involves a minimum of special equipment and is
well suited to the estimation of area totals from a type map or for specific type
islands.

The method consists of superimposing a transparent dot grid (Figure 5.10)
over a map or photo. Each dot is counted according to the type class in which it falls.
The total number of dots in each type class and the grand total in the survey areas
are then tallied. If we know the total area in the survey unit, then we can determine
the individual type acreages by apportionment. If the total area is not known, or we
are interested in only a few type islands, we can calculate the number of acres per dot
or per square inch or square centimeter and convert to acres or hectares on the
ground. We will explain the calculations a little later.

Figure 5.10. Examples of dot grids. Scale has been reduced.

Transects

The last method of determining areas that we wish to consider is known as the line-transect method. In this method we draw or superimpose a series of lines on the map or photo. These lines are usually spaced at even intervals but may be randomly spaced. We then measure the length of each line passing through each type class in question, then compute the total length of all lines. Next we apportion the total area in the survey unit into type classes in proportion to the total length of the lines in each class.

Calculations

So far all we have—with any of the methods described—is either a percentage of an area in each land use or cover type or the number of dots or square inches of the desired area at the photo or map scale. Now we must convert this information to

acres or hectares on the ground. There are two methods of doing this that we will call the apportionment and the acres per unit area methods. The easiest way to explain them is with examples.

Apportionment Method

In order to use this method we must already know the acreage of the total area in question. For example, suppose we know that the total area of land represented in Figure 5.9 is 640 acres or 1 square mile (259 hectares) and we wish to know the number of acres or hectares in each of the five types A through E. With a planimeter we find the number of square inches and acres or hectares per type as shown below:

Type	Sq. In.	Proportion	Acres	Hectares
A	7.70	0.3080	197.12	79.77
B	3.79	0.1516	97.02	39.26
C	8.52	0.3408	218.11	88.27
D	3.71	0.1484	94.98	38.44
E	1.28	0.0512	32.77	13.26
Totals	25.00	1.00	640.00	259.00

$$\text{Type A} = \frac{7.70 \text{ sq. in.}}{25.00 \text{ sq. in.}} (640 \text{ acres}) = 197.12 \text{ acres}$$

or

$$= \frac{7.70 \text{ sq. in.}}{25.00 \text{ sq. in.}} (259 \text{ hectares}) = 79.77 \text{ hectares}$$

In this example we apportioned by square inches because we used a planimeter calibrated in square inches. However, we could have apportioned by the number of square centimeters, dots, weight, or length of transect lines.

Acres Per Unit Area Method

Now, suppose we don't know the total area but we do know the scale. Suppose all we want is area D and we know the PSR in this vicinity to be 12,670. The ground area can be calculated by either:

$$\#\text{Acres} = \frac{(\text{PSR})^2}{6,272,640 \text{ sq in./acre}}\left(\frac{DC}{DI}\right)$$

or

$$\#\text{Acres} = \frac{\left(\dfrac{\text{PSR}}{12 \text{ in./ft}}\right)^2}{43,560 \text{ sq ft/acre}}\left(\frac{DC}{DI}\right)$$

or

$$\#\text{Hectares} = \frac{(\text{PSR})^2}{100,000,000 \text{ sq cm/hectare}}\left(\frac{\text{DC}}{\text{DI}}\right)$$

Where

PSR = photo scale reciprocal or we could use MSR in the same way

43,560 = number square feet in an acre

100,000,000 = number of square centimeters in a hectare

6,272,640 = number square inches in an acre

DC = dot count

DI = number of dots per square inch or per square centimeter on our dot grid

$\dfrac{\text{DC}}{\text{DI}}$ = number square inches or square centimeters on the photo or map

Suppose in our example we used a dot grid intensity of 100 dots per square inch and we counted 371 dots for area D. In the metric system we would count 383 dots using a 16-dot per square centimeter grid. The number of acres or hectares would be:

$$\#\text{Acres} = \frac{(12,670)^2}{6,272,640 \text{ sq in./acre}} \frac{371 \text{ counted dots}}{100 \text{ dots/sq in.}} = 95 \text{ acres}$$

or

$$\#\text{Acres} = \frac{(\frac{12,670}{12 \text{ in./ft}})^2}{43,560 \text{ sq ft/acre}} \frac{371 \text{ counted dots}}{100 \text{ dots/sq in.}} = 95 \text{ acres}$$

or

$$\#\text{Hectares} = \frac{(12,670)^2}{100,000,000 \text{ sq cm/hectare}} \frac{383 \text{ counted dots}}{16 \text{ dots/sq cm}} = 38.43 \text{ hectares}$$
$$= 95 \text{ acres}$$

Laboratory Exercise

For this laboratory exercise you are to once again use the annotated photo in Figure 4.1 (Chapter 4) and the scale data you obtained for the laboratory exercise at the end of Chapter Four.

1. What is the horizontal ground distance in chains from point F to point G? You should use the average scale between F and G, which you can calculate from the data given and your answers to questions 4 and 5 of the previous laboratory exercise. You should realize that using the average scale only partially corrects for errors caused by topographic displacement.
2. If the elevation of point H is 500 ft, determine the road distance from H to D if the elevation of D is 1000 ft. Ignore topographic displacement.

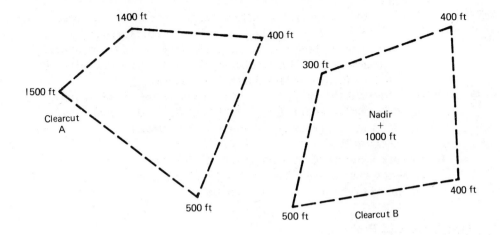

Figure 5.11. Diagram for laboratory problem 6.

3. If the field measured bearing from point E to point G is (N 5° W), what would be the bearing from F to E and from E to G if we ignore problems of tilt and topographic displacement?

4. Determine the amount and direction of the error for the E to G bearing line on the photo caused by topography. Use the elevation of these points as given in the previous laboratory exercise. The elevation of the principal point is 600 ft.

5. If the average elevation of the clearcut (where E, F, and G are located) is 1100 ft, calculate the acreage of the clearcut using the dot-count method. (Ignore topographic displacement.) How many seedlings should be ordered to replant the clearcut if the trees are to be planted on a 12 by 12 ft spacing.

6. For this problem refer to Figure 5.11, which represents two clearcuts on a 1:10,000-scale aerial photo (at the nadir) with the nadir and corner elevations as shown. The size and shapes of these clearcuts would be different on a map at the same scale because it would be void of topographic displacement.

 (a) Using a dot grid or planimeter measure the area of each clearcut and calculate the number of acres represented on the ground assuming a 10,000 PSR. Do not adjust for topographic displacement.

 (b) Recalculate the clearcut acreages but adjust the PSR to the average elevation of the clearcut corners assuming that a 3-in. camera lens was used.

 (c) Trace the nadir and clearcut boundaries onto a separate piece of paper. Use the topographic displacement equation assuming that a

3-in. focal length lens camera was used and plot the true location of the boundaries using solid lines. (They are not necessarily square or rectangular.) Measure the corrected areas and convert to ground acreages using the 10,000 PSR. These are the true areas. Still assume that a 3-in. focal length camera lens was used.

(d) Why did the method used in (b) come closer to the true area for clearcut B than for clearcut A? List at least two reasons.

(e) Why was the percent error obtained in (a) greater for clearcut A than clearcut B?

7. Rework 6(b) and 6(c) assuming that a 12-in. focal length camera lens camera was used. How did the change in focal length affect the error as compared to the error obtained in 6(a)?

Questions And Problems

1. Select the best word or words within the brackets:
 (a) Azimuths are measured in a (clockwise, counterclockwise) direction from (north or south, east or west, north, east, south, west).
 (b) Bearings are measured from either (north or south, east or west, north, south, east, west) in a (clockwise, counterclockwise, either a clockwise or counterclockwise) direction.
 (c) A bearing of N 80° W is the same as (a bearing, an azimuth) of (80°, S 100° W, 280°, W 10° N).
 (d) An azimuth of 95° is the same as the bearing of (N 95° E, S 85° W, S 85° E).

2. List the three different methods of establishing a baseline on an aerial photo.

3. Given: Point A is 2.9 in. south 22° west of the nadir
 Field measured bearing from A to B = N 88° E
 Point B is 2.9 in. from the nadir
 Elevation of nadir = 1000 ft
 Elevation of point A = 1200 ft
 Elevation of point B = 600 ft
 Which way should the bearing line on the photograph be rotated, or is it correct as it is? Why?

4. Given: Field measured bearing from point A to point B = N 82° W
 Elevation of points A and B = 820 ft.
 Elevation of the nadir = 600 ft
 Photo distance from both A and B to nadir = 2.15 in.
 Which way (clockwise or counterclockwise) should the bearing line on the photo be rotated to correct for topographic displacement, or is the bearing line correct as it is? Why?

5. What are the four guidelines for establishing bearing lines on aerial photos designed to keep errors at a minimum?

6. A trail in wilderness area is measured on an aerial photo to be 26.71 cm long. If the average PSR is 11,500, how long would it take a family to walk the trail if they averaged about 2 km per hour?

7. Suppose a Polaroid aerial photo is taken at 5:30 A.M., which clearly shows the boundary of a forest fire. If the fire boss estimates it will take 4½ hours to get a fire-fighting crew to the area and build a fire line, what would be the minimum distance from the 5:30 A.M. position *on the photo* that the fire line should be built if the fire is traveling an estimated 10 chains per hour and the PSR of the photo was 10,000?

8. Given: Dot grid used = 16 dots per square cm
 Dot count of campground = 137
 Average PSR = 12,000

 How many hectares does this campground cover? How many acres does it cover?

9. List three other methods in addition to dot counts that are used to either measure or estimate the number of square inches or square centimeters of irregularly shaped areas outlined on an aerial photo or map.

10. Given: Total number of acres in a timber sale = 40.0
 Total dot count on 40 acres = 684
 Dot count of the mixed hardwood area within
 the cruise area = 418

 How many acres are there in the mixed hardwood type?

Six

Acquisition of Aerial Photography

Aerial photography presently exists for most of the United States and for many foreign countries. Obtaining copies of this photography is much cheaper than contracting new photography because once the negatives are available, making contact prints is relatively inexpensive.

Frequently, however, there is no suitable existing photography. The existing photography may be out of date, at the wrong scale for your use, of poor quality, or not of the desired film type. Under these circumstances new photography must be contracted. Most of us will never actually plan a photo mission but it is highly desirable that we know something about the process in order to work with an aerial photo contractor to get exactly what we want at a reasonable cost. All orders for new photography should be accompanied by a signed contract to protect both the purchaser and the contractor (see Appendix D).

Objectives

After a thorough understanding of this chapter and completion of the laboratory exercise you will be able to:

1. Locate and obtain existing aerial photography.
2. List 10 of the many variables that should be considered when planning a photo mission for new photography.
3. Calculate the number of photos required to cover an area at a specified scale, given the number of photos needed to cover the same area at a different scale.
4. Define endlap and sidelap, and state the usual minimum requirements for each.
5. Differentiate between drift and crab and give the primary causes of each.

6. Solve for the unknown variable given the remaining variables in either of the two image-motion equations.
7. Solve for the third variable given the other two in the camera cycling time (or distance) equation.
8. Fully define "hot spots" on an aerial photograph, explain what causes them and describe how they can be avoided.
9. List and define three different types of aerial photo mosaics.
10. Plan a photo mission complete with cost estimate given the objectives of the mission and other necessary information.

ACQUISITION OF EXISTING PHOTOGRAPHY

The federal government is the source of much existing photography that can usually be obtained at the cost of reproduction and handling.

The National Cartographic Information Center

The place to start looking for available federal government photography is the National Cartographic Information Center (NCIC), located at:

U.S. Geological Survey (USGS)
507 National Center
Reston, Va. 22092
Phone: (703) 860-6045, FTS[1] 928-6045

The NCIC handles all photography for the following federal agencies: USGS, the Bureau of Land Managment (BLM), the Bureau of Reclamation (BR), the National Aeronautics and Space Administration (NASA), the U.S. Air Force, the U.S. Navy, and the U.S. Army. The NCIC also has four general centers as indicated in Figure 6.1. The addresses for these centers are as follows:

Eastern Mapping Center	**Rocky Mountain Mapping Center**
National Cartographic Information Center	National Cartographic Information Center
U.S. Geological Survey	U.S. Geological Survey
536 National Center	Box 25046, Stop 504
Reston, Va. 22092	Denver Federal Center
(703) 860-6336, FTS[1] 928-6336	Denver, Colo. 80225
	(303) 234-2326, FTS[1] 234-2326

[1]*Federal Telecommunications System.*

Mid-Continent Mapping Center	**Western Mapping Center**
National Cartographic Information Center	National Cartographic Information Center
U.S. Geological Survey	U.S. Geological Survey
1400 Independence Road	345 Middlefield Road
Rolla, Mo. 65401	Menlo Park, Ca. 94025
(314) 364-3680 ext. 107, FTS[1] 276-9107	(415) 423-8111 ext. 2427, FTS[1] 467-2427

Figure 6.1. Map showing the area serviced by the four regional centers of the National Cartographic Information Center. See text for addresses. (Courtesy U.S. Geological Survey.)

The Aerial Photography Field Office

The Aerial Photography Field Office (APFO) is now a consolidated depository for all photography obtained by (1) the Agricultural Stabilization and Conservation Service (ASCS), (2) the U.S. Forest Service (USFS), and (3) the Soil Conservation Service (SCS).

This photography covers about 90 percent of the United States, primarily agricultural and national forest areas, at scales ranging between 1:15,840 and 1:80,000. About 95 percent of the photography was taken with black-and-white panchromatic film. Natural color and color infrared film has been used over selected national forest areas.

For assistance in ordering you should contact your local county ASCS office, SCS field office or the USFS. These local offices have photo index sheets from which you can select the photo or photos desired.

If you wish photography of a distant county you can purchase an index of that county with the assistance of your local county office. If you do not wish to purchase an index prior to ordering, send APFO a legal definition of the area of interest. This should include the state, county, and township, section and range numbers (see Chapter Eight), or provide coordinate locations. If this information is not available, outline the area of interest (as accurately as you can) on a map and send it to the APFO.

 U.S. Department of Agriculture
 ASCS
 2222 West, 2300 South
 P.O. Box 30010
 Salt Lake City, Utah 84125
 Phone (801) 524-5856 (Commercial)
 588-5856 (FTS)

For photography obtained in 1941 or earlier you should write to:

 National Archives and Records Service
 Cartographic Branch
 General Service Administration
 Washington, D.C. 20408

This older photography was originally secured on a nitrate-base film, which was destroyed after being copied on 70 mm film and sent to the National Archives for custody.

The National Aerial photo Library (of Canada)

For information on Canadian photography you should write to:

National Air Photo Library
Room 180, Surveys and Mapping Building
Department of Energy, Mines and Resources
615 Booth Street
Ottawa 4, Canada

Other Sources of Photography

In addition to the above federal government sources of aerial photography, there are many private contractors and state agencies that fly their own photography. These addresses can be obtained from your local telephone directory. For photographic coverage outside the United States and Canada, see volumn 25(1): 117-120, 1959 of the technical journal, *Photogrammetric Engineering* for *World Air Photo Coverage*.

PLANNING THE PHOTO MISSION FOR NEW PHOTOGRAPHY

There are many variables to consider when planning the photo mission, including some of the following important ones.

1. Scale, flying height, and focal length.
2. Required percent endlap and sidelap.
3. Orientation, location, and number of flight lines required.
4. Total number of photographs needed.
5. Allowable drift, crab, tilt, and image motion.
6. Camera characteristics: format, lens quality, shutter speed, aperture, intervalometer setting, and cycling time.
7. Film and filter characteristics.
8. Acceptable season of year, time of day, and allowable present cloud cover.
9. Hot spots.
10. Aircraft capabilities: maximum and minimum speed, range, maximum altitude, load capacity, stability, and operating cost.

Scale, Flying Height, and Focal Length

The average project scale is the first variable to be considered because it largely determines how much detail we can interpret on the final image and how many photographs it will take. The scale must be large or small enough to meet the objectives of the mission. For example, we would want a relatively small scale to identify large geological features on the earth or separate forest from nonforest lands. On the other hand if we are primarily interested in specific rock and soil types or specific types of vegetation we would want a larger scale.

Another consideration is economics. It is frequently nice to have large-scale photography but it is more expensive because it takes more photos and more flying time to cover the same amount of area. The relative number of photographs required to cover a given area is proportional to the square of the ratios of the PSRs involved. For example, if it takes 100 photographs to cover a given area at a PSR of 30,000, how many photographs would it take to cover the same area at a PSR of 10,000? It would take 900 photographs because:

$$\left(\frac{30,000}{10,000} \right)^{2} = 9 \text{ times as many, or } 900 \text{ photos}$$

Let's take a look at another example. If it takes 100 photographs to cover a given area at a PSR of 30,000, how many photographs would it take to cover the same area at a PSR of 50,000? It would take:

$$\left(\frac{30,000}{50,000} \right)^{2} 100 = 36 \text{ photographs}$$

Once the scale has been decided the flying height and focal length of the camera lens must be matched to obtain the desired scale. Any number of flying heights and focal length combinations can produce the desired scale but with different image characteristics. From our topographic displacement formula we learned that as the flying height increases, topographic displacement decreases. The same relationship can be observed in the parallax height equation (Chapter Seven). Sometimes we want to reduce the overall topographic displacement if we want to use the photography as map substitutes or make well-matched mosaics. On the other hand there are times when we might want to increase the topographic displacement in order to better interpret small differences in elevation in a stereoscopic model or increase the difference in parallax so that we can more accurately measure in the third dimension (Chapter Seven).

Another variable to be considered is the altitudinal capabilities and speed of the aircraft. It is more expensive to fly at higher elevations for short flights. Flying height and speed of the aircraft are two of the factors that control image motion on a photograph. Once the average project scale and flying height have been determined the focal length is fixed. If the exact focal length required is not available, we select the closest focal length available and adjust the flying height.

Orientation, Location, and Number of Photographs Required

When planning a photo mission the planned approximate location of the center of each photograph is usually plotted on a map and the number of locations is counted to determine the number of photographs required. The *actual* photo center locations may be slightly different for the final product, in which case a second flight map with the correct locations is prepared for the customer.

Flight Lines and Overlap

A flight line or flight strip is a succession of overlapping aerial photographs taken along a single flight line. We usually indicate the desired lines of flight and the position of the exposure stations on the flight map prior to taking the photographs. Flight lines are normally oriented in a north-south or east-west direction and are usually parallel to each other. To photograph the desired area on the ground, the aircraft flies along the entire length of one strip, then makes a 180° turn and flies back along the entire length of the next adjoining strip. This procedure is repeated until the desired ground area has been completely photographed (see Figure 6.2).

Another factor to consider is the amount of endlap and sidelap desired. Both terms refer to the amount by which one photograph covers the same area on the ground. In the same flight strip it is called endlap, and the overlap between photographs in adjacent parallel strips is called sidelap (Figure 6.3). Standard specifications for most missions where complete stereoscopic coverage is required are 60±5 percent for endlap and 30±15 percent for sidelap. For a given average project scale the amount of sidelap influences the number of flight lines needed to cover the desired area on the ground, and the endlap determines the number of photos to be taken on each flight line. At least 50 percent endlap is necessary for complete stereoscopic coverage of the area photographed and for the proper alignment of photos for measurement in the third dimension. Sidelap is required for control points used in mapping and provides a safety factor to insure that there are no skipped areas between flight lines. This seemingly large safety factor is necessary to compensate for changes in topography (therefore scale), tilt, drift, and crab as well as navigational errors. The usual maximum allowable tilt is 3°.

Drift and Crab

Drift and crab (Figure 6.4) are the two primary causes of unsatisfactory photographic ground coverage. Drift is the lateral shift or displacement of the

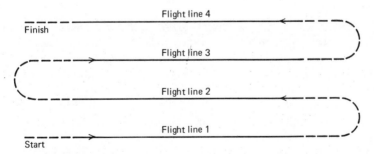

Figure 6.2. Typical flight line pattern. Exposures are made only along the solid lines. (From D. P. Paine, 1979, *An Introduction to Aerial Photography for Natural Resource Management,* O.S.U. Bookstores, Inc., copyright 1973, reproduced with permission.)

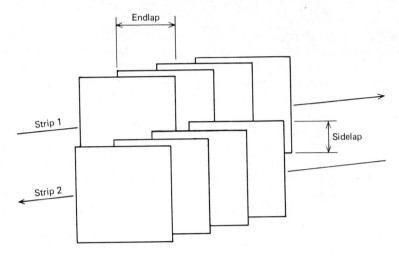

Figure 6.3. Photographic overlap. This illustration shows excessive *crab* only to better illustrate the overlap. (From D. P. Paine, 1979, *An Introduction to Aerial Photography for Natural Resource Management,* O.S.U. Bookstores, Inc., copyright, 1973, reproduced with permission.)

aircraft from the planned flight line due to the action of wind, navigational errors, or other causes. The result can be a gap in photographic coverage between adjoining strips of photography. Crab is the condition caused by failure to orient the camera with respect to the planned flight line. In vertical photography it is indicated by the edges of the photographs not being parallel to the airbase (flight path between photo centers). For these reasons the actual location of the flight lines and photo centers may be slightly different than the planned location.

Controlling Endlap

For a fixed focal length the amount of endlap is controlled by the speed of the aircraft and the time interval between film exposures. When a constant time interval between exposures is desired it can be done automatically with what is called an intervalometer. Sometimes when photographing areas of rapidly changing topography the time interval between exposures is not uniform for a constant endlap. In these cases the camera operator trips the shutter manually using a ground glass viewfinder to determine when the desired endlap has been attained.

Calculating the Intervalometer Setting

Basically, the intervalometer setting formula is the ground distance between exposure stations in feet divided by the speed of the aircraft in feet per second. From this beginning let's derive an intervalometer setting equation by using an example. Suppose we have the following information:

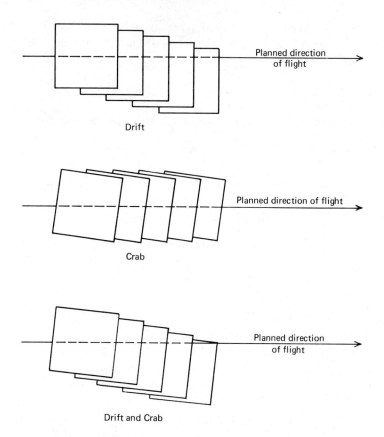

Figure 6.4. Drift and crab. Drift is a result of the plane not following the planned flight line. Crab is the result of the camera not being oriented parallel to the flight line. (From D. P. Paine, 1979, *An Introduction to Aerial Photography for Natural Resource Management,* O.S.U. Bookstores, Inc., copyright 1973, reproduced with permission.)

Photo format = 9 in. by 9 in.
Desired endlap = 65 percent
Aircraft speed = 200 miles per hour
PSR = 12,000
MSR = 63,360

Because photo missions are first laid out on a flight map we need the MSR in our derivation even though it will not appear in the final equation. Starting with the formula—Intervalometer setting (I) = GD between exposure stations in feet divided by the aircraft speed in feet per second—we must first calculate the GD in feet.

Because we want a 65 percent endlap, that means each new photo covers 35 percent new area. This we will call net gain. The net gain in ground distance or the distance between exposure stations is:

$$GD = (PD)\ (PSR) = (0.35)\ (9\ \text{in.})\ (12,000)\ \frac{(1\ \text{ft})}{12\ \text{in.}} = 3150\ \text{ft}$$

Next, we convert the aircraft speed from miles per hour to feet per second:

$$\frac{(200\ \text{miles}/\text{h})\ (5280\ \text{ft}/\text{mile})}{3600\ \text{s}/\text{h}} = 293.3\ \text{ft}/\text{s}$$

Our intervalometer setting becomes:

$$I = \frac{\text{Net gain per photo}}{\text{Aircraft speed}} = \frac{3150\ \text{ft}}{293.3\ \text{ft}/\text{s}} = 10.74\ \text{s}$$

These three formulas can be combined and algebraically simplified to:

$$I = \frac{(1 - \%E)\ (Fmt)\ (PSR)}{17.6V}$$

Where

I = Intervalometer setting in seconds
$\%E$ = Percent endlap in decimal form
Fmt = Photo size in inches (format) in the direction of flight
17.6 = Constant with the units of inch hour per mile second
V = Velocity of the aircraft in miles per hour

Using this equation on our problem we get:

$$I = \frac{(1 - .65)\ (9\ \text{in.})\ (12,000)}{(17.6\ \frac{\text{in. h}}{\text{mile s}})\ (200\ \frac{\text{miles}}{\text{h}})}$$

$$= \frac{(0.35)\ (9)\ (12,000)}{(17.6)\ (200)} = 10.74\ \text{s}$$

For intervalometers that can only be set to the nearest second we must decide between 10 and 11 s. Our value is closer to 11 s but we must remember that doing this would reduce the endlap slightly below the desired 65 percent. To be safe we would round down and have a little extra endlap. However, depending on the contract specifications we might round up and slightly reduce the percent endlap.

Number of Exposures Required
Once the scale, overlap, size and shape of the area to be photographed, and format size have been established, the number of flight lines and the total number of exposures can be determined. Format, scale, and the amount of overlap control the spacing between flight lines, the photo spacing within flight lines, and therefore the

total number of exposures required. A complete example of the calculations is found later in this chapter.

Cameras, Films, and Image Motion

The major types of cameras available to the aerial photographer were discussed in Chapter One. Different film types will be discussed in Chapter Twelve. These are important considerations in planning the photo mission but in this section we consider only film speed and shutter speed as it relates to image motion.

Film speed refers to the sensitivity of the film to light. A slow film requires more light than a fast film and the length of time the shutter is open (shutter speed) is one of the factors that controls the amount of light reaching the film. Shutter speed is also one of the factors that influences image motion. Each discrete point on the photograph will be imaged as a line because the plane and hence the camera is in motion during the time the shutter is open. We can calculate the amount of this movement by either of two equations:

$$M = \frac{(17.6)\ (v)\ (t)\ (f)}{H} \quad \text{or} \quad M = \frac{17.6\ (v)\ (t)}{\text{PSR}}$$

Where

M = image movement on the photograph in inches

17.6 = a constant, with units: inch hours per mile second

v = ground speed of the plane in miles per hour

t = shutter speed in seconds

f = focal length of the camera lens in feet

H = flying height of the plane above the ground in feet

PSR = photo scale reciprocal

As an example, let's consider a plane flying 5000 ft above the ground at 400 miles per hour, taking photos with a 12-in. focal length camera lens and a shutter speed of 1/50th of a second.

$$M = \frac{(17.6\ \frac{\text{in. h}}{\text{mile s}})\ (400\ \frac{\text{miles}}{\text{h}})\ (0.02\ \text{s})\ (1\ \text{ft})}{5000\ \text{ft}} = 0.028\ \text{in.}$$

This much image motion would result in a definite blur because the acceptable limit for image motion for good interpretation is about 0.002 in. (0.05 mm). For precise mapping projects the acceptable image motion is about half as much. One method of reducing image motion or blur is to use a faster shutter speed that would require either a larger aperture or a faster film. Another solution would be to use a slower-flying aircraft. This image-motion problem sometimes makes it difficult to obtain satisfactory large-scale photography especially when using fast aircraft and older color films that have relatively slow film speeds.

Let's consider a second example. As we stated earlier, an acceptable limit for image motion on a photograph for interpretation is 0.002 in. Assume we are using an aircraft with a photographing speed of 200 miles per hour. Our aerial camera has a shutter speed of 1/250th of a second and a focal length of 6 in. What is the minimum flying height above the ground, in feet, that will assure us of acceptable image movement on the photograph? Rearranging the image motion equation we get:

$$H = \frac{(17.6)\ (v)\ (t)\ (f)}{M}$$

$$= \frac{(17.6\ \frac{\text{in. h}}{\text{mile s}})\ (200\ \frac{\text{miles}}{\text{h}})\ (0.004\ \text{s})\ (.5\ \text{ft})}{0.002\ \text{in.}} = 3520\ \text{ft}$$

Cycling Time

Another characteristic of the camera that must be considered is cycling time. Cycling time refers to the amount of time required for the camera to advance the film and prepare for the next exposure. On many aerial cameras cycling time is 2 to 5 s. The reason we consider this factor is to insure that the camera will be ready to take the next photo when the plane is in the correct position over the ground area to be photographed. Let's consider the following example: Suppose our plane speed is again 200 mph, and the camera cycling time is 4 s. Let us further assume that in order to get the desired scale and endlap the exposure stations are 1000 ft apart. Does the camera cycle fast enough? It does not because:

$$(\frac{200\ \text{miles}}{\text{h}})\ (\frac{5280\ \text{ft}}{\text{mile}})\ (\frac{1\ \text{h}}{3600\ \text{s}})\ (4\ \text{s}) = 1173\ \text{ft}$$

which is 173 ft past the next station. This also reduces to a simple equation, which we will call the cycling distance equation.

$$D = (1.467)\ (v)\ (c)$$

Where

D = distance traveled between exposure stations

1.467 = a constant, with the units: foot hours per mile second

v = ground speed of the plane in miles per hour

c = camera cycling time in seconds

Using the same example as before, what would be the maximum allowable aircraft speed? Rearranging our equation we get:

$$v = \frac{D}{1.467c} = \frac{1000\ \text{ft}}{(1.467\ \frac{\text{ft h}}{\text{mile s}})\ (4\ \text{s})} = 170\ \text{miles/h}$$

Season and Time of Day Considerations

The time of the day and the season of the year must also be considered when planning for aerial photography. The time of day will influence the color or tone balance, especially when color film is used. Of more important is the sun angle, which in turn influences shadow length. For some missions we may want long shadows while for others short or no shadow at all might be desirable.

The season of the year will also have an influence on both color balance and shadow length. Another seasonal consideration would be the condition of the vegetation especially for deciduous tree and brush species that turn color in the fall and completely lose their leaves in the winter. Photographing coniferous regeneration in the early spring before the deciduous brush leafs out is much better than photographing in the summer. For certain photo missions a light snow background might better show what we are looking for—big game counts on winter feeding grounds, for example.

It nearly goes without saying that every contract for photography should have a statement concerning the maximum allowable percent cloud cover. In most locations there is more cloud cover during certain seasons of the year. A complete and continuous cloud cover is sometimes desirable if it is high enough so that the plane can photograph below it. This greatly reduces the contrast between shadowed and nonshadowed areas. Partial cloud cover is never desirable. Even if the plane flies below the clouds, much detail is lost in the shadows created by the clouds.

Hot Spots

Hot spots, or how to avoid them, should also be considered when planning a photo mission. A *hot spot* is the reflection of the sun within the cone angle of the camera lens. It appears as a bleached out or overexposed portion of the photograph and is particularly bothersome over water or forested land (Figure 6.5). Hot spots

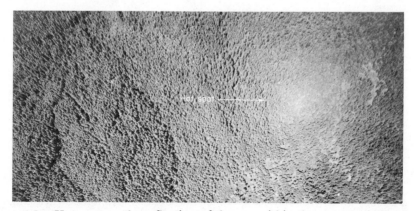

Figure 6.5. Hot spot — the reflection of the sun within the cone angle (angle of coverage) of the camera lens. See text and Figure 6.6.

are recorded on an aerial photo when the sun passes an altitude equal to one-half the angle of coverage from the zenith position. Thus it can be seen that hot spots can sometimes be avoided by using a longer focal length camera (Figure 6.6). The sun's altitude changes not only with the time of day but also with the season of the year and the latitude. During certain times of the year at certain latitudes, the critical angle is never reached at any time during the day but the possibility of hot spots should always be considered when planning the photo mission. There are a set of nomograms in the *Manual of Color Aerial Photography* (American Society of Photogrammetry, 1978), which can be used to easily determine when aerial photography can be taken to avoid hot spots.

Aircraft Capabilities

Finally, in planning the photo mission we should consider the characteristics of the aircraft to be used. Factors that influence the choice of an aircraft are the load

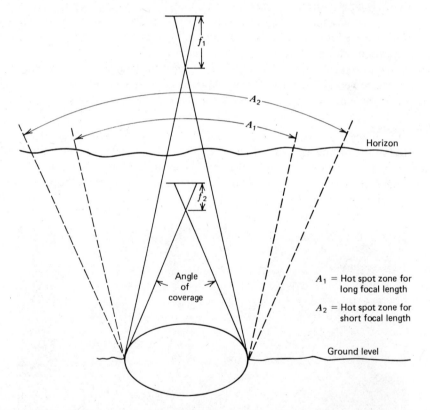

Figure 6.6. Geometry of a hot spot. When the sun is within the critical angle, A_1 for a long focal length lens or A_2 for a short focal length lens, a hot spot appears on the photo.

capacity, passenger capacity, maximum and minimum speed, ceiling or maximum altitude with a full load, aircraft stability, pilot's visibility, working space, range, and operating cost. All of these factors are considered in planning any photo mission.

MOSAICS

A mosaic is a photographic reproduction of a whole series of aerial photographs assembled in such a manner that the detail of one photograph matches the detail of all adjacent photographs. Mosaics are usually reproduced at a much smaller scale than the original photography. There are three principal types: index, controlled, and uncontrolled.

Index Mosaics

An index mosaic is usually prepared for the purpose of providing an index to individual photographs. The overlap of the individual photographs is purposely not trimmed so that the indexing numbers (flight line or roll number and photo numbers) are clearly visible. From such a mosaic one can quickly determine which photographs cover a particular piece of ground—thus, the primary use is for indexing. Index mosaics are usually produced at additional cost for most photo missions but are the least expensive type of mosaic because they are uncontrolled and not permanently mounted on a backing. Figure 6.7 is a partial index mosaic of a section of forested land.

Controlled Mosaics

Sometimes it is convenient to view several photographs covering a large area in a single view. To do this, two or more photographs are trimmed so that the overlap duplication is eliminated and permanently mounted on a hard backing so that the photo detail is matched as well as possible.

In a controlled mosaic several points are located on the ground and precisely located on the photographs. Distances and bearings among the ground control points (Chapter Eight) are measured and drawn to scale on the mosaic backing. The photos are then glued to this backing so that the control points on the photographs are directly over the corresponding ground control points on the backing. Ratioed and rectified prints are usually used. Mosaics constructed with limited ground control are semicontrolled mosaics. Additional control points can be established using the photos alone by a process called radial line triangulation (Chapter Nine).

Uncontrolled Mosaics

Because controlled mosaics are expensive, most mosaics are uncontrolled. The uncontrolled mosaic lacks the field and photo control points and nonrectified prints are used. Uncontrolled mosaics are put together by matching the detail from one

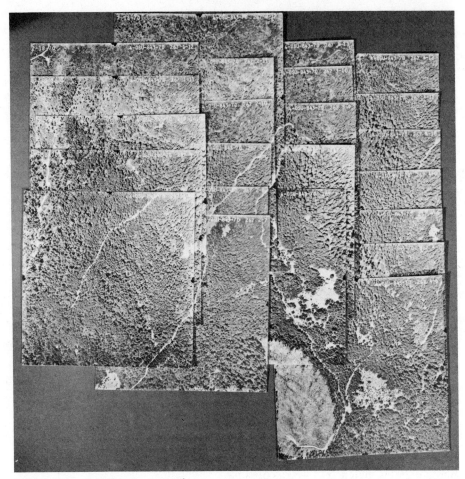

Figure 6.7. Small index mosaic.

photo to the next as well as possible. Because of tilt and topographic displacement, measurements on these mosaics are not reliable. The errors involved from one photo to the next are usually additive and not compensating.

Constructing an Uncontrolled Mosaic

A hardboard such as masonite makes an excellent mounting board. When using masonite, gum arabic (see Appendix C) should be the adhesive used. However, common rubber cement can be used on an artist's mounting board or even on heavy drawing paper. The masonite-gum arabic mosaics will last for many years whereas those constructed with rubber cement will tend to curl and separate after several months.

The order in which prints are assembled is an important factor in the distribution of errors. Because errors are accumulative, you should start with the print covering the central portion of the mosaic and then work in a circular pattern toward the edges until the mosaic is complete.

The first print to be mounted should be placed face up on a smooth surface. The approximate effective area (Chapter Ten) should be outlined following natural tonal boundaries on the photo where possible. The emulsion layer is cut lightly through along the selected line with a sharp knife or razor blade. Do not cut clear through the photo. The part of the print to be retained is placed with the emulsion side down and held flat on the board with one hand while the discard edge is grasped by the other hand and torn *away* with a lifting motion to produce a feathered edge. The feathered edges can then be smoothed with fine sandpaper to reduce ridges.

The first print is then mounted on the central part of the mounting board. Gum arabic or rubber cement is spread on both the mounting board and on the back of the photo. One edge of the correctly oriented print is placed on the mounting board and then with a rolling motion the rest of the print is placed down. This reduces the possibility of creating blisters of trapped air. Remaining trapped air can be worked out with a squeegee working from the center of the print outward. The squeegee should be worked gently to keep the print from stretching. Excess gum arabic should be removed with the squeegee and damp sponge before it dries.

Each succeeding print is cut, feathered, matched for detail, and mounted with the feathered edge overlapping previously mounted prints. Some mosaics are made without feathered edges but the overlap produces a very noticeable ridge. Still another technique is to simultaneously cut clear through two or more thicknesses of properly oriented photos for what is called a butt-joint assembly. To complete the mosaic the outside edges should be trimmed to square it up and a frame made around the edge with a high quality pressure tape. A title, north arrow, and title block with an approximate average scale should be added.

CONTRACTS FOR NEW AERIAL PHOTOGRAPHY

All orders for new photography should be covered by a written contract to avoid misunderstandings and guard the interests of both purchaser and contractor. There are many factors to be considered in any contract for aerial photography. A sample contract is supplied in Appendix D.

PHOTO MISSION PLANNING—AN EXAMPLE

The following problem and solution concerning the planning of a photo mission, complete with a cost estimate, acts as a chapter summary. You may never plan a mission, but a knowledge of how to do so should be of great help if you need to enter into a contract for new photography. The following is a real example with cost estimates supplied by a private commercial firm. All costs are current as of late 1979. The method that follows is just one of several methods used today.

Problem

Prepare a flight map showing prospective flight lines and photo centers that will provide complete stereoscopic coverage of a 480,000-acre county as shown in Figure 6.8.

1. Calculate the total number of exposures required.
2. Calculate the mean flying height above sea level.
3. Calculate the intervalometer setting.
4. Check for excessive image motion.
5. Prepare a complete cost estimate (total and per acre) for one set of black-and-white *and* one set of color prints using aeronegative film (both black-and-white and color prints can be made from the same negative) and one set of black and white index mosaics.

Specification

1.	Project scale	PSR = 20,000
2.	Flight map scale	1 in. = 6 miles
3.	Photo format	9 in. by 9 in.
4.	Camera focal length	8 1/4 in.
5.	Shutter speed	1/250 s
6.	Endlap	60 ± 5%
7.	Sidelap	30 ± 5%
8.	Flight line direction	N and S
9.	Average ground elevation	500 ft
10.	Aircraft speeds	
	(a) While photographing	125 mph
	(b) Average for mission	100 mph
11.	Distance from airport to area to be photographed	40 miles
12.	Mosaic scale	1:100,000

Cost Information

1.	Plane and two-person crew	$300.00 per hour
2.	Film and processing to a negative	
	(a) Black and white	$3.00 each
	(b) Aeronegative (color or B/W)	$6.50 each
3.	Mosaics (photographing and printing)	
	(a) Black and white	$0.02 per square inch
	(b) Color	$0.05 per square inch

4. Cost per print (varies with number of prints ordered):

Number of Prints	Black and White	Color (from Aeroneg.)
1	$7.25	$18.25
2 - 50	$1.50	$ 3.25
51 - 200	—	$ 3.00
51 - 500	$1.25	—
201 - 500	—	$ 2.50
500 - 1000	$1.00	$ 2.30
1000+	$0.85	$ 2.15

Solution (Determining the Number of Exposures Required)

Step 1

Convert map equivalent scale to MSR:

$$\text{MSR} = \frac{GD}{MD} = \left(\frac{6 \text{ miles}}{1 \text{ in}}\right) \left(\frac{5280 \text{ ft}}{\text{mile}}\right) \left(\frac{12 \text{ in.}}{\text{ft}}\right) = 380,160$$

Step 2

On the map provided (Figure 6.8) draw the first flight line in a north-south direction so that 30 percent of the photo coverage is outside the west boundary. This is a safety factor allowance, which means that the center of the flight line will be inside the west boundary a distance equivalent to 20 percent of the photo coverage. From the formula:

$$\text{PSR} = \frac{(MD)\,(MSR)}{PD}$$

we get:

$$\text{MD} = \frac{(PSR)\,(PD)}{MSR} = \frac{(20,000)\,(0.20)\,(9 \text{ in.})}{380,160} = 0.095 \text{ in.}$$

Step 3

Calculate the map distance between flight lines so that each new flight line covers 70 percent new area (30 percent sidelap). This is called net side gain. We get:

$$\text{MD} = \frac{(20,000)\,((0.70)\,(9 \text{ in.}))}{380,160} = 0.331 \text{ in. (net gain per flight strip)}$$

0.095 in

Then we draw the first and last flight lines on the map (both ~~0.33 in.~~ inside the boundary) and measure the distance between them. In this example we get 6.39 in. The number of flight lines is then 6.39 in. divided by 0.33 in. minus 1 plus the two outside flight lines or 20.3 flight lines. Because we cannot take a fractional number of flight lines we must choose between 20 and 21. The choice depends on how rigid

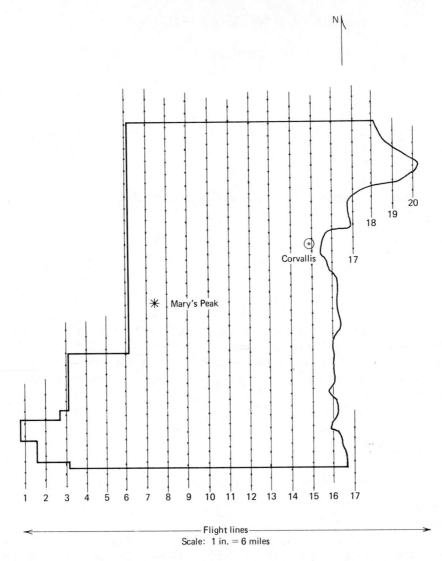

Figure 6.8. County map showing proposed flight lines and exposure stations. The
scale at this map has been reduced. (Adapted from D. P. Paine, 1979,
*An Introduction to Aerial Photography for Natural Resource Man-
agement,* O.S.U. Bookstores, Inc., copyright 1973, reproduced with
permission.)

the contract specifications are. For our example we assume that we need 20 flight lines (Figure 6.8).

Notice that we must make a few exposures outside the boundary on flight lines 3, 6, and 17. This is done to ensure complete coverage of the area. The northern part of flight line 7, for example, would not cover all the way to the western boundary because this portion of the boundary is much closer to flight line 6 than 7. The general rule in such cases is: when in doubt take a few extra exposures. The extra expense of reflying part of a mission is far greater than taking a few extra exposures the first time.

Step 4

Calculate the map distance between exposure stations within the flight line. We get:

$$MD = \frac{(20,000) \ (0.40) \ (9 \ in.)}{380,160} = 0.189 \ in. \simeq 0.19 \ in. \ (net \ gain \ per \ photo)$$

Step 5.

Calculate intervalometer setting.

$$I = \frac{(1 - \%E) \ (Fmt) \ (PSR)}{17.6V} = \frac{(1 - 0.6) \ (9 \ in.) \ (20,000)}{(17.6 \ \frac{in. \ h}{mile \ s}) \ (125 \ \frac{miles}{h})} = 32.7 \ s$$

Rounding to 33 s would result in a different percent endlap, which should be recalculated to see if it is within the *minimum* required (55 percent).

$$V = \frac{(125 \ miles/h) \ (5280 \ ft/mile)}{3600 \ s/h} = 183.3 \ ft/s$$

$$Net \ gain \ per \ photo = (33 \ s) \ (183.3 \ ft/s) = 6048.9 \ ft$$

$$GD \ per \ photo = (9 \ in.) \ (20,000) \ (ft/12 \ in.) = 15,000 \ ft$$

$$\%E = 1 - (\frac{6048.9 \ ft}{15,000 \ ft}) = 1 - 0.403 = 59.6\% \ (well \ within \ the \ minimum)$$

Step 6.

Calculate adjusted map distance between exposure stations. We get:

$$MD = \frac{(0.403) \ (9 \ in.) \ (20,000)}{380,160} = 0.191 \simeq 0.19 \ in.$$

Step 7

Starting at a random point on each flight line, plot the proposed exposure stations at 0.19 in. intervals along the entire flight line and add two exposures at both ends. One of these extra photos is to ensure complete stereoscopic coverage within the boundary and the other is a safety factor.

Step 8

Determine the total number of exposures required. We can do this by measuring the distance between the first and last exposure stations, dividing by the map distance between exposure stations and adding 1. Thus, for flight lines 6 through 16 we need (6.08 in. ÷ 0.19 in.) + 1 = 33 photos. Repeating the process for all flight lines and adding gives us the total number of exposures required, which is 458. We should get about the same answer by actual count. In some cases you may wish to plot only the first and last exposure stations on each flight line so that you can measure the map distance between them for calculation purposes. Then after the mission, the actual photo centers can be plotted on the map. For filing and indexing purposes this map can serve as a substitute for an index mosaic.

Calculate Flying Height Above Sea Level

With an 8 1/4-in. focal length lens and a PSR of 20,000 we get:

$$A = f(\text{PSR}) + E = 0.6875 \text{ ft } (20,000) + 500 \text{ ft} = 14,250 \text{ ft}$$

above sea level (the datum in this problem).

Image-Motion Check

An image-motion check should always be made before the flight is made because if it is excessive the mission can usually be redesigned to reduce image motion to within acceptable limits. This can be done by reducing the aircraft speed or increasing the shutter speed. If this cannot be done we must change the scale. At first you might conclude that we could reduce image motion by reducing the focal length or increasing the flying height. Changing either of these alone will change the scale. Altering both in order to maintain the same scale will not change the image motion. If we doubled the flying height we would also have to double the focal length to maintain the same scale, leaving image motion the same. In our example image motion is not excessive because it is less than 0.002 in.

$$M = \frac{(17.6)\ (v)\ (t)\ (f)}{H} = \frac{(17.6)\ (v)\ (t)}{\text{PSR}}$$

$$= \frac{(17.6\ \frac{\text{in. h}}{\text{mile s}})\ (\frac{125 \text{ miles}}{\text{h}})\ (0.004 \text{ s})}{20,000} = 0.0004 \text{ in.}$$

Cost Estimate.

From our flight map we measure the total length of all flight lines including turns and get 106 in. On the ground this converts to:

$$GD = (MD)\ (MSR) = (106 \text{ in.})\ (380,160)\ (\frac{\text{ft}}{12 \text{ in.}})\ (\frac{\text{mile}}{5280 \text{ ft}}) = 636 \text{ miles}$$

To this we must add 80 miles to get to and return from the target for a total of 716

miles at 100 mph (average for the mission) or 7.16 h of flying time. The flying cost at $300.00 per hour for the plane and two-person crew is $2148.

The cost of one set of positive prints is[2]: 458 ($1.00) + 458 ($2.50) = $1603.00. The cost of the black-and-white index mosaic at two cents per square inch would be calculated as follows:

1. Square inch net gain per photo = (0.7(9 in.)) (0.4(9 in.)) = 22.68 sq in.
2. 22.68 sq in. per photo × 458 photos = 10,387 sq in. at a PSR of 20,000
3. Number of square inches in the mosaic = (sq in.) $\left(\dfrac{\text{Photo scale}}{\text{Mosaic scale}} \right)^2$

 $= (10,387) \left(\dfrac{20,000}{100,000} \right)^2 = 415.5$ sq in. + border = 576 sq in. = 24 in. by 24 in.
4. Mosaic reproduction = $0.02/sq in. (576 sq in.) = $11.52
5. Mosaic assembly cost = $30.00
6. Cost of photos for mosaic: 458 ($1.00)[2] = $458.00
7. Total cost of mosaic = $11.52 + $30.00 + $458.00 = $499.52 ≈ $500.00

Because we want complete sets of both black and white and color photography we can use Kodak aeronegative film and get by with one negative instead of two (see Chapter Twelve). The total cost is summarized below:

Cost of flying	$ 2148
Cost of negative (458 × $6.50)	2997
Cost of black-and-white prints	458
Cost of color prints	1145
Black-and-white mosaic	500
Total cost	$ 7248

$$\text{Cost per acre} = \frac{\$7248}{480,000 \text{ acres}} = \$0.01506 = 1.51 \text{ cents per acre}$$

The total cost may seem high, but per acre it is really inexpensive for the information you get. For black-and-white prints only (using $3.00 negatives) without a mosaic would cost $3980, or only 0.83 cents per acre. Color alone (using $6.50 negatives) without the mosaic would cost $6270, or 1.31 cents per acre. A general rule of thumb is that it costs a little less than double for color as compared to black-and-white photography depending on the scale and size of the area photographed. The advantage of using aeronegative film is that we can get both black-and-white and color prints for just a little over the cost of the color alone. It is frequently convenient to use the black-and-white prints in the field and color positive transparencies in the office.

[2] *Use the $1.00 per photo cost because a total of 916 black-and-white photos are required. Photos for index mosaic are frequently stapled and not reusable.*

Laboratory Exercise

Assume that you are the vice-president and part owner of Quality Aerial Surveys, Inc. One of your many jobs is to design photo missions for existing customers and prepare competitive bids for potential customers for flying, developing, and printing aerial photography. You have just received a letter from a potential customer asking how much you would charge to fly, develop, and print *two* sets of color prints—one set for field use and the other set to be kept in the office as a permanent record and for office interpretation. The area to be photographed is shown in Figure 6.9. The customer did not specify an index mosaic or index map showing the location of photo centers but you should consider the possibility. The following specifications were supplied by the prospective customer:

Area to be photographed (Figure 6.9)	6800 acres
Average elevation of the area	800 ft
Distance from airport	40 miles
Desired project PSR	15,840
Endlap	60% ± 5%
Sidelap	25% ± 10%
Flight line direction	Cardinal directions
Photo format	9 in. by 9 in.
Allowable image motion	0.002 in.

You have two aircraft and three cameras available for the mission with specifications as follows:

	Aircraft 1	Aircraft 2
Aircraft speeds		
(a). While photographing	150 mph	110 mph
(b). Average for mission	140 mph	100 mph
Cost per hour (plane, camera, crew)	$350.00	$300.00
Maximum flying altitude (A)	18,000 ft	11,000 ft

	Camera A	Camera B	Camera C
Focal length	6 in.	8 1/4 in.	12 in.
Shutter speeds (s)	1/50, 1/100, 1/250	1/50, 1/100, 1/250	1/50, 1/100, 1/250
Cycling time	5 s	5 s	3 s

Your laboratory exercise is to prepare a typed business letter telling the prospective client how much it will cost and what the client will get. Because this is a competitive bid, you may suggest *reasonable* alternatives that may cost a little extra or result in a savings for a slightly different product. However, do not suggest a

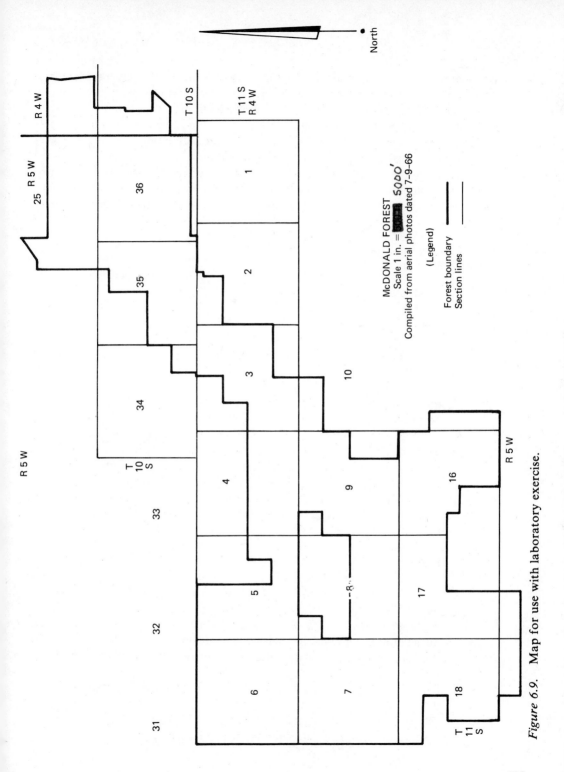

Figure 6.9. Map for use with laboratory exercise.

McDONALD FOREST
Scale 1 in. = 5000'
Compiled from aerial photos dated 7-9-66

(Legend)

Forest boundary
Section lines

North

125

different scale or type of photography because the customer definitely wants color photography. Remember the customer is not interested in how you arrive at your costs and therefore does not want to see your calculations.

The second part of the assignment is to prepare a memorandum to your pilot and camera operator telling them everything they need to know in order to complete the mission. You should attach a copy of your flight map to the memorandum.

You must also turn in your calculations, but this is just for the benefit of your instructor. You do not need to prepare a contract for new photography but should read the specimen contract in Appendix C before writing your letter to the customer.

Questions and Problems

1. If it takes 800 photographs at a PSR of 15,840 to completely cover a given square area, how many photographs would be required to cover the same area at a PSR of 63,360?

2. Draw one or more diagrams of three or more photos each to illustrate:
 (a) Endlap (also give the usual percent)
 (b) Sidelap (also give the usual percent)
 (c) Drift
 (d) Crab
 (e) Drift and crab combined

3. What is a photo mosaic? List three different kinds of photo mosaics.

4. Suppose you want to fly a photo mission with a 24-in. focal length lens over an area with an average elevation of 4000 ft. If your plane has a maximum flying altitude of 30,000 ft above sea level (the datum), could you obtain photography with a 15,840 PSR? Why or why not?

5. What would be the intervalometer setting if we must have a *minimum* of 55 percent endlap for 12,000 PSR photos with a 9 in. by 9 in. format if the plane is flying at 250 mph?

6. What would be the minimum ground speed of an aircraft on a photo mission if the PSR is to be 20,000, the shutter speed is 0.02 s and the minimum acceptable image motion is 0.002 in.?

7. What would be the minimum flying height above the ground if the plane flew at 200 mph, the shutter speed was set at 1/100th of a second, a 209.55-mm focal length lens was used, and the minimum acceptable image motion for a mapping project is 0.001 in.?

8. Are the two extra photos at both ends of the flight line strictly for safety? Why or why not?

9. Suppose, in planning a photo mission, we find that the design will result in an excessive amount of image motion. Would it be possible to correct this problem by reducing the focal length of the camera and making other necessary adjustments to maintain the same scale? Why or why not?

10. What are *hot spots*? What causes them? How can they be avoided?

11. Given: MSR of 63,360, a PSR of 12,000 and 22.86 by 22.86 cm format:

 (a) How many inches from the outside boundary of the map should the first flight line go if you want a safety factor of 30 percent, (you want 30 percent of the first flight line to fall outside the boundary)?

 (b) What is the map distance between flight lines if we have a 25 percent sidelap?

 (c) What is the map distance between photo centers within a flight line if we have 65 percent endlap?

Seven

Vertical
Measurements

In Chapter Three we defined and learned how to measure the absolute parallax of a point on a stereoscopic pair of vertical aerial photographs. In this chapter the emphasis is on measuring the difference *in absolute parallax, dP, between two points for the purpose of measuring the difference in elevation between two points and the height of objects. We also cover the measurement of object heights on a single photograph.*

Objectives

After a thorough understanding of this chapter and completion of the laboratory exercise you will be able to:

1. Draw a diagram illustrating the effects of ground slope, tree lean, tree crown shape, and the presence of snow or brush on height measurements using the sun angle-shadow method of determining tree heights.
2. Calculate the height of an object using the proportional shadow-length method and state the conditions under which this method gives accurate results.
3. Identify each of the terms in all three of the parallax height equations given for stereoscopic pairs of photographs and state the conditions under which each of the equations is valid.
4. State the "rule of thumb" for determining when to use the level terrain, parallax-height equation instead of the mountainous-terrain equation.
5. Make the required measurements for P, Pb, and dP on a stereoscopic pair of aerial photographs and calculate the height of an object using any of the parallax-height equations.

6. Calculate the percent error caused by using the short-cut height equation.
7. Show on a sketch the absolute parallax of a point and difference in absolute parallax between two points on a stereoscopic pair of overlapping photographs.
8. State three direct and one indirect inference that can be derived from the parallax height equations.
9. Explain with the use of a diagram how all the terms in the height equation are measured.
10. Draw a diagram of the parallax bar and parallax wedge, and describe how each is used to measure dP.
11. Given adequate information, either on aerial photographs or diagrams, measure the difference in parallax using an engineer's scale, a parallax bar, and a parallax wedge (only those with good stereoscopic vision can properly make use of the parallax bar or wedge).
12. Given a sterescopic pair of photos, the focal length of the camera lens, and the height of an object on the photos, determine the flying height of the aircraft and the photo scale at the base of the object assuming a level terrain situation.

MEASURING HEIGHTS ON SINGLE AERIAL PHOTOS

There are two basic methods of measuring heights on *single* aerial photographs — the topographic displacement method and the shadow method. The shadow method has two variations.

The Topographic-Displacement Method

In Chapter Two we introduced the formula, $h = \dfrac{d(H)}{r}$, which in isolated cases can be used to measure the height of an object on a single large-scale aerial photo. This method requires that (1) the object being measured must be vertical from bottom to top, like a tower or building, which rules out measuring differences in elevation between two points on the ground that are not directly over one another; (2) the distance from the nadir must be great enough to create enough topographic displacement to be measured; (3) the photo scale must be large enough so that the displacement on the photograph can be measured; and (4) both the top and bottom of the object being measured must be visible on the same photo.

Because these criteria are seldom met, the method is used only on rare occasions when interpreting aerial photos for natural resources. If you have a situation when this method can be used, you should refer to Chapter Two for the technique.

The Shadow Methods

Sun-Angle Shadow Method

If you can measure the length of a shadow and know the angle of the sun that creates the shadow, the height of the object can be calculated with simple trigonometry. However, this method assumes that the ground on which the shadow falls is level and that the object being measured is perfectly vertical. Snow or brush on the ground will also shorten the shadow. Finally, the object must have a sharp-pointed distinct top so that the top of the object creates a definite shadow point on the ground. Figure 7.1 illustrates these sources of error.

Another difficulty with this method is that the calculation of the sun angle at the instant of exposure is a long process and the angle changes with the position on the earth, time of day, season of year, and even changes from year to year. However, the method is sometimes used. This is one of the reasons for printing the date and time of day on the top of some photographs.

Because of these complications and because the parallax method of height measurement on stereoscopic pairs is usually better we will not discuss this method further or illustrate the calculating procedure. However, there is another shadow method that is simple and worth a brief discussion. We will call it the proportional shadow-length method.

Proportional Shadow-Length Method

In this method you must know the height of at least one object on the photo that has a measurable shadow. Suppose the known height of an object is 160 ft and it casts a shadow on the photo of 0.16 in. What would be the height of an object with a shadow length of 0.11 in? By simple proportion it would be 0.11/0.16 of 160 ft, or 110 ft tall. This method assumes vertical objects but the ground does not have to be level as long as these conditions are the same for both the known and unknown objects. Snow or brush on the ground will also create errors when using this method of height measurement.

MEASURING HEIGHTS BY PARALLAX DIFFERENCES

This is the most useful method of measuring heights on aerial photographs. It requires a stereoscopic pair of high-quality aerial photographs and good depth perception on the part of the interpreter.

The Parallax-Height Equations

There are many forms of the parallax height equation. They all assume perfectly vertical photography, but if tilt is 3° or less the resulting error in height

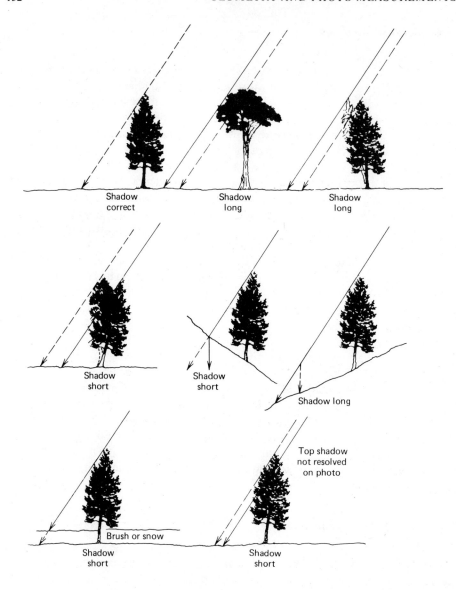

Figure 7.1. Causes of incorrect shadow length and therefore, incorrect heights when using the sun-angle shadow method. Correct shadow lengths indicated by dashed lines.

measurement is small. Three different parallax-height equations modifications are given: (1) the mountainous-terrain equation, (2) equation, and (3) the short-cut equation.

The mountainous-terrain height equation is valid for both n level terrain but is more complicated than the other equations. equation is valid only when the base of the object being measure elevation as the average elevation of the two principal points of the stereopair or photos. The short-cut equation with a slight modification can approximate either the level terrain or the mountainous-terrain equations but is never completely valid. It is the simplest of the height equations and can be used with previously prepared tables.

The Mountainous-Terrain Equation

Two different forms of this equation are as follows:

$$h = \frac{(H)dP}{P_b + dP} = \frac{(H)dP}{P + \left[\dfrac{P(\pm\ \triangle E)}{H}\right] + dP}$$

Where

h = height of the object being measured

H = flying height above the *base* of the object

dP = difference in absolute parallax between the top and bottom of the object

P = the average absolute parallax of the two ends of the baseline (measured as the average distance between the principal and conjugate principal points of the stereopair of photos)

P_b = the absolute parallax at the base of the object (measured as the distance between the principal points of the two photos minus the distance between the images of the base of the object on the two photos when they are properly aligned for the measurement of dP)

$\pm\triangle E$ = difference in elevation between the base of the object and the average of the two principal points, plus if higher and minus if lower (Figure 7.2)

For these two equations to be equal, P_b *must equal* $P + \left[\dfrac{P(\pm\triangle E)}{H}\right]$. The term P is the average absolute parallax of the baseline and $\dfrac{P(\pm\triangle E)}{H}$ is the difference in absolute parallax between the baseline and the base of the object being measured. Therefore, when added together the result is the absolute parallax at the base of the object, or, by definition, P_b.

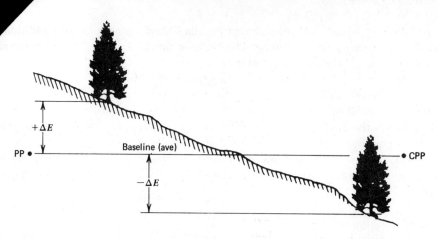

Figure 7.2. Illustration of $\pm\triangle E$. See text. (From D. P. Paine, 1979, *An Introduction to Aerial Photography for Natural Resource Managment*, O.S.U. Bookstores, Inc., copyright 1973, reproduced with permission.)

The reason for presenting two mountainous-terrain height equations is that in certain situations one equation may be more applicable than the other. An accurate measurement of P_b is difficult if the base of the object is not clearly visible on both photos as is the case in densely vegetated areas. On the other hand, $\pm\triangle E$ is frequently unknown and not easily determined. In the situation where both $\pm\triangle E$ and P_b are difficult to obtain it is still better to make the best estimate possible of either value rather than to use the level terrain equation when the mountainous equation should be used.

The Level-Terrain Equation

This equation is valid only when $\pm\triangle E$ is zero. When $\pm\triangle E$ is zero, the mountainous-height equation reduces to the level terrain equation or:

$$h = \frac{(H)dP}{P + dP}$$

Examples of the use of this, and the other height equations are given later.

Because *small* differences in elevation between the base of the object being measured and the average elevation of the baseline ($\pm\triangle E$) result in small errors in h, the following rule of thumb is generally recognized. *The level-terrain height equation can be used when the difference in elevation between the base of the object being measured and the average elevation of two principal points is less than 5 percent of the flying height above the base of the object.* Under this condition the error in the calculated height is usually less than the error created by the inability of the average photo interpreter to precisely measure dP. It is *never* incorrect, however, to use the mountainous-terrain-height equation. Later we will show examples to illus-

trate the magnitude of errors in height caused by using the level terrain equation when the mountainous-terrain equation should have been used.

The Short-Cut Height Equation. This equation can also be written two ways depending on whether it approximates the mountainous or the level-terrain equation as follows:

$$h = \frac{(H)dP}{P_b} = \frac{(H)dP}{P}$$

Neither of these equations is completely accurate because they ignore *dP* in the denominator, but the error is small if *dP* is a small proportion of *P* or P_b.

The advantage of the short-cut equation is that tables of differential parallax factors (DPF) have been developed for different baselines (*P* or P_b) and different camera lens focal lengths to simplify the calculation of object heights (Tables 7.1 and 7.2).

To use the DPF tables we convert the short-cut equation to a simpler form. Starting with the short-cut, mountainous-terrain equation,

$$h = \frac{(H)dP}{P_b}$$

and substituting *f*(PSR) for *H* we get:

$$h = \frac{f(PSR)dP}{P_b}$$

Next, we substitute DPF for $\frac{f}{P_b}$, because it remains constant for a given stereoscopic pair of aerial photos. We get:

$$h = (DPF)\ (PSR)\ (dP)$$

Starting with the level-terrain height equation gives us the same answer if we substitute DPF for $\frac{f}{P}$. When using the DPF tables we can approximate either the mountainous terrain or the level-terrain equation depending on whether we use *P* or P_b.

Let's compare the appropriate short-cut equation with the level-terrain equation and see how much error is involved. Suppose we measure a *dP* of 1.14 mm on photos with a PSR of 12,640 at the base of an object, that an 8¼-in. camera lens was used and that *P* is 63.50 mm. Using table 7.2 we find the DPF to be 0.0108. Solving our equation we get:

$$
\begin{aligned}
h &= (DPF)\ (PSR)\ (dP) \\
&= (0.0108)\ (12,460)\ (1.14) \\
&= 153.4\ \text{ft}\ (46.8\ \text{m})
\end{aligned}
$$

TABLE 7.1 Differential Parallax Factors for Height Measurement in Feet When dP is Measured in Inches. For Heights in Meters, Multiply by 0.3048.

P or P_b in		Focal Length of Photography		
in.	mm	6 in. (152 mm)	8¼ in. (209 mm)	12 in. (305 mm)
2.0	50.80	0.250	0.344	0.500
2.1	53.34	0.238	0.327	0.476
2.2	55.88	0.227	0.312	0.454
2.3	58.42	0.217	0.299	0.435
2.4	60.96	0.208	0.286	0.416
2.5	63.56	0.200	0.275	0.400
2.6	66.04	0.192	0.264	0.384
2.7	68.58	0.185	0.255	0.370
2.8	71.12	0.179	0.245	0.358
2.9	73.66	0.172	0.237	0.345
3.0	76.20	0.167	0.229	0.333
3.1	78.74	0.161	0.222	0.322
3.2	81.28	0.156	0.215	0.312
3.3	83.82	0.151	0.208	0.303
3.4	86.36	0.147	0.202	0.294
3.5	88.90	0.143	0.196	0.286
3.6	91.41	0.139	0.191	0.278
3.7	93.98	0.135	0.186	0.270
3.8	96.52	0.132	0.181	0.263
3.9	99.06	0.128	0.176	0.256
4.0	101.60	0.125	0.172	0.250
4.1	104.14	0.122	0.168	0.244
4.2	106.68	0.119	0.164	0.238
4.3	109.22	0.116	0.160	0.233
4.4	111.76	0.114	0.156	0.227

Using the mountainous equation we get:

$$h = \frac{0.6875 \text{ ft } (12,460) \ (1.14 \text{ mm})}{63.50 \text{ mm } + \ 1.14 \text{ mm}} = \ 151.1 \text{ ft } (46.0 \text{ m})$$

Thus using the short-cut equation resulted in an error of 2.3 ft (0.70 m) or only 1.5 percent for this particular example. Notice that in this solution we substituted f(PSR) for H.

Units of Measure

When using any of the parallax height equations, both P and dP must have the same units of measurement, usually inches or millimeters. All vertical distances (H,

TABLE 7.2 Differential Parallax Factors for Height Measurement in Feet When dP **is Measured in Millimeters. For Heights in Meters, Multiply by 0.3048.**

P or P_b in		Focal Length of Photography		
in.	mm	6 in. (152 mm)	8¼ in. (209 mm)	12 in. (305 mm)
2.0	50.80	0.0098	0.0135	0.0197
2.1	53.34	0.0094	0.0129	0.0187
2.2	55.88	0.0089	0.0123	0.0179
2.3	58.42	0.0085	0.0118	0.0171
2.4	60.96	0.0082	0.0113	0.0164
2.5	63.50	0.0079	0.0108	0.0157
2.6	66.04	0.0076	0.0104	0.0151
2.7	68.58	0.0073	0.0100	0.0146
2.8	71.12	0.0070	0.0097	0.0141
2.9	73.66	0.0068	0.0093	0.0136
3.0	76.20	0.0066	0.0090	0.0131
3.1	78.74	0.0063	0.0087	0.0127
3.2	81.28	0.0061	0.0085	0.0123
3.3	83.82	0.0059	0.0082	0.0119
3.4	86.36	0.0058	0.0080	0.0116
3.5	88.90	0.0056	0.0077	0.0113
3.6	91.41	0.0055	0.0075	0.0109
3.7	93.98	0.0053	0.0073	0.0106
3.8	96.52	0.0052	0.0071	0.0104
3.9	99.06	0.0050	0.0069	0.0101
4.0	101.60	0.0049	0.0068	0.0098
4.1	104.14	0.0048	0.0066	0.0096
4.2	106.68	0.0047	0.0065	0.0094
4.3	109.22	0.0046	0.0063	0.0092
4.4	111.76	0.0045	0.0061	0.0089

$\pm\triangle E$, and h) must also be in the same units, usually feet or meters. Thus, the units for dP in the numerator cancel the units for $P+dP$ in the denominator, leaving the answer (h) in the same units as (H). Actually, we can mix units by measuring P and dP in millimeters and H in feet and get feet as we did in the last example.

Inferences Derived From the Parallax-Height Equation

Even though the inferences to follow apply to all of the parallax-height equations, we will use the level-terrain equation to illustrate. In this equation, $P+dP$ is really the absolute parallax at the top of the object. If we call this P_t, the equation becomes:

$$h = \frac{(H)dP}{P_t} = \frac{f(\text{PSR})dP}{P_t}$$

Solving for dP we get:

$$dP = \frac{h(P_t)}{H} = \frac{h(P_t)}{f(\text{PSR})}$$

from which the following direct and indirect inferences can be made:

1. dP is directly proportional to the height of the object.
2. dP is directly proportional to P_t and therefore to P, which is inversely proportional to the percent endlap.
3. dP is inversely proportional to the flying height and therefore to f and PSR.
4. dP is independent of the distance of the object from the nadir. This is an indirect inference and was not the case with topographic displacement measured on single photographs.

Derivation of the Parallax-Height Equation

For our example we will use the level-terrain equation from which all other height equations can be obtained. The geometry of the level-terrain equation is illustrated in Figure 7.3. All the symbols have been previously defined, but let's elaborate on dP, the difference in absolute parallax. It is defined as the difference in absolute parallax between the top and bottom of an object. This also applies to the difference in absolute parallax between any two points in our stereoscopic model. All points of equal ground elevation have the same absolute parallax in a vertical stereoscopic pair of photographs. Similarly, points at different elevations have different absolute parallaxes. Therefore, the accurate measure of dP is the key to successful height measurement on aerial photographs.

Considering the geometry of similar triangles ABC and ADE in Figure 7.3 we can state that:

$$\frac{h}{(H-h)} = \frac{dP}{P}$$

and with a little algebraic manipulation we have the parallax-height equation for level terrain.

$$P(h) = dP(H-h)$$

$$P(h) = dP(H) - dP(h)$$

$$P(h) + dP(h) = dP(H)$$

$$h(P+dP) = dP(H)$$

$$h = \frac{(H)\,dP}{P+dP}$$

Figure 7.3. Geometry for the derivation of the level terrain parallax height equation. (Courtesy of U.S. F.S. Pacific Northwest Forest and Range Experiment Station.)

The determination of H was discussed in Chapter Four on scale, where H equals $f(\text{PSR})$.

The variable, P, in our equation is really the average absolute parallax of our two principal points. The absolute parallax of the PP on the left photo of any stereoscopic pair is the distance between the PP and CPP on the right photo and the absolute parallax of the PP on the right photo is the distance between the PP and CPP on the left photo. On the ground these distances are the same. On the photos they are the same only if the aircraft maintained the same flying height (A) over both exposure stations, there is no y tilt in the photos, and the principal points of both photos are at the same elevation. Because these conditions are seldom met, we use an average distance measured on the photos when using the level terrain equation.

When using the mountainous terrain equation we use P_b (previously defined) or add the correction factor to P as we discussed earlier.

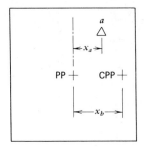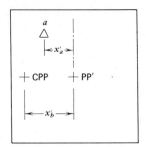

Figure 7.4. Absolute parallax of point *a* and of the baseline, x_b or x_b'. (From D. P.
Paine, 1979, *An Introduction to Aerial Photography for Natural
Resource Management,* O.S.U. Bookstores, Inc., copyright 1973,
reproduced with permission.)

 This leaves only the variable dP for discussion. We have previously defined it
but now let's take a closer look at the theory of dP. The instruments used to measure
it will be discussed later.

 In Figure 7.4, a diagram of two overlapping photos, the x axis is positive (to the
right) of the principal point on the left photo and negative (to the left) on the right
photo. The absolute parallax of object a^1 is $x_a - (-x_a')$, or $x_a + x_a'$. The average
absolute parallax of the baseline is $x_b + x_b'$ divided by 2. If point a is at the same
elevation as the baseline, then $x_a + x'_a - (x_b + x'_b)/2 = dP = 0$. To have a difference
in absolute parallax we need different elevations, such as the top and bottom of a tree.
Then the difference in absolute parallax of the tree is the absolute parallax of the top
minus the absolute parallax of the bottom.

 Let's consider a single tree illustrated on diagrams of two adjacent overlapping
vertical photos (Figure 7.5.). On the left photo (top illustration) the x coordinate of
the top of the tree is x_t and the x coordinate of the bottom of the tree is $+ x_b$. On the
right photo the x coordinate of the top of the tree is $-x_t'$ and the x coordinate of the
bottom is $-x_b'$. Considering both photos, with the PPs and CPPs perfectly aligned
the absolute parallax of the top of the tree is $x_t - (-x_t')$, or $x_t + x_t'$, and the absolute
parallax of the bottom of the tree is $x_b + x_b'$. Then the difference in absolute parallax,
the term dP in our equation, is $(x_t + x_t') - (x_b + x_b')$.

 However, instead of measuring x_t, x_t', x_b, and x_b', we can determine dP by
measuring only c and d (Figure 7.5) and taking their difference. We can also
rearrange our equation for dP so that dP equals $x_t - x_b + x_t' - x_b'$, or $dP_1 + dP_2$, which
is exactly the same as $d-c$. This is also the same as $dP_1 + dP_2$ shown in Figure 7.3 used
to derive the parallax-height equation. The way we actually measure dP on the
photographs is to subtract c from d.

[1] *The elevations of object a, the PP, and the CPP are all the same.*

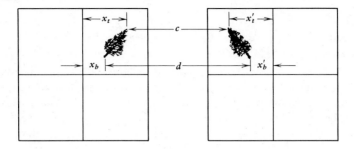

Absolute parallax of top = $x_t - (-x_t') = x_t + x_t'$
Absolute parallax of bottom = $x_b - (-x_b') = x_b + x_b'$
Difference in absolute parallax, $dP = (x_t + x_t') - (x_b + x_b')$

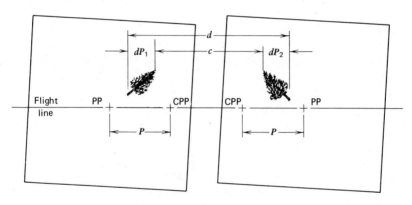

$$dP = x_t - x_b + x_t' - x_b' = d\text{-}c = dP_1 + dP_2$$

Figure 7.5. The difference in absolute parallax (dP) between the top and bottom of a tree. (From D. P. Paine, 1979, *An Introduction to Aerial Photography for Natural Resource Management,* O.S.U. Bookstores, Inc., copyright 1973, reproduced with permission.)

Numerical Examples

Before discussing various techniques and special instruments for measuring dP on the photographs let's look at some example problems. The first example will illustrate the effect of using the level-terrain equation in a situation where the mountainous-terrain equation should have been used.

Example 1

Assume that we have three trees, all the same height—one tree is at the same elevation as the photo baseline and the other two are 1000 ft above and below the baseline elevation (Figure 7.6 top). Because these trees are the same height, the photo-measured dPs would have to be different because they would be viewed at different angles by the camera (Figure 7.6, bottom). This substantiates the inference made earlier, that "dP is inversely proportional to the flying height" (H) above the base of the object. Let us also assume that:

Elevation of the baseline	2000 ft
Average PSR of the baseline	12,000
Average photo length of the baseline (P)	3.00 in.
Focal length of camera lens used (f)	6 in.
Difference in absolute parallax (dP)	
Case 1 dP 0.100 in.	
Case 2 dP 0.145 in.	
Case 3 dP 0.073 in.	

How tall are these trees? First, we must calculate the flying height above the base of the tree.

$$H = f(\text{PSR}) = 0.5 \text{ ft. } (12,000) = 6000 \text{ ft}$$

Case 1

(P and baseline are at the same elevation.)

$$h = \frac{(H)\ (dP)}{P + dP} = \frac{(6000 \text{ ft})\ (0.100 \text{ in.})}{3.00 \text{ in. } + \ 0.100 \text{ in.}} = 194 \text{ ft}$$

Notice that in case 1 we used the level-terrain equation because the base of the object and the photo baseline were at the same elevation. However in both case 2 and 3 we must use the mountainous terrain equation because:

$$\frac{+\triangle E}{H}\ (100) = \frac{+1000 \text{ ft}}{6000 \text{ ft } - \ 1000 \text{ ft}}\ (100) = 20\% \text{ for case 2}$$

and

$$\frac{-1000 \text{ ft}}{6000 \text{ ft } + \ 1000 \text{ ft}}\ (100) = 14.3\% \text{ for case 3}$$

which is greater than the 5 percent that we allow before shifting to the mountainous-terrain equation.

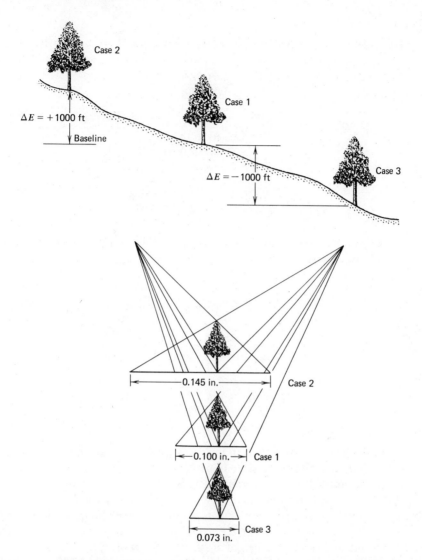

Figure 7.6. Illustration to go with Example 1. See text. (From D. P. Paine, 1979, *An Introduction to Aerial Photography for Natural Resource Management,* O.S.U. Bookstores, Inc., copyright 1973, reproduced with permission.)

Case 2
 (The base of the object is 1000 ft *above* the baseline P for an H of 5000 ft.)

$$h = \frac{(H)\,(dP)}{P + \left[\dfrac{P(\pm\triangle E)}{H}\right] + dP}$$

$$= \frac{(5000\ \text{ft})\,(0.145\ \text{in.})}{3.00\ \text{in.} + \left[\dfrac{(3.00\ \text{in.})\ 1000\ \text{ft}}{5000\ \text{ft}}\right] + 0.145\ \text{in.}}$$

$$= \frac{(5000\ \text{ft})\,(0.145\ \text{in.})}{3.00\ \text{in.} + 0.60\ \text{in.} + 0.145\ \text{in.}} = \frac{725\ \text{ft}}{3.745} = 194\ \text{ft}$$

Using the level-terrain equation in case 2 would have given us an erroneous height of 231 ft, an error of +37 ft or 19 percent.

Case 3
 (The base of the object is 1000 ft *below* the baseline P for an H of 7000 ft.)

$$h = \frac{(7000\ \text{ft})\,(0.073\ \text{in.})}{3.00\ \text{in.} + \left[\dfrac{-1000\ \text{ft}\ (3.00\ \text{in.})}{7000\ \text{ft}}\right] + 0.073\ \text{in.}}$$

$$= \frac{7000\ \text{ft}\ (0.073\ \text{in.})}{3.00\ \text{in.} - 0.429\ \text{in.} + 0.073\ \text{in.}} = \frac{511\ \text{ft}}{2.644} \approx 194\ \text{ft}$$

Using the level terrain equation in case 3 would have given us an erroneous height of 166 ft, an error of -28 ft or 14 percent.

 These examples illustrate extreme cases where $\pm\triangle E$ is large to emphasize the effect of using the level-terrain equation when $\pm\triangle E$ greatly exceeds 5 percent of H. How much error is involved when $\pm\triangle E$ is about 5 percent? Suppose $\triangle E$ is +300 ft (+5.3 percent of H) in case 2. The dP would be 0.111 in. Using the level-terrain equation results in a calculated height of 203 ft, an error of +9 ft or 4.6 percent. The percent error would be even less if E was a -300 ft (4.8 percent of H) in case 3. Errors of this magnitude are not serious because errors in the measurement of dP frequently create errors greater than this. Therefore, our 5 percent rule of thumb appears reasonable for the average photo interpreter.

Example 2

 Suppose we have the Washington Monument on a stereoscopic pair of aerial photographs. We do not know the scale or the flying height, but we do know that the monument is 555 ft tall and that an 8¼-in. lens camera was used. How could we calculate the flying height and the photo scale?

First, we properly align the photos and find by careful measurement that P is 3.36 in. and dP is 0.340 in. Then we solve the level-terrain equation for H and get:

$$H = \frac{h(P + dP)}{dP} = \frac{555 \text{ ft } (3.36 \text{ in.} + 0.340 \text{ in.})}{0.340 \text{ in.}} = 6040 \text{ ft}$$

and the PSR at the base of the monument is:

$$\text{PSR} = \frac{H}{f} = \frac{6040 \text{ ft}}{0.6875 \text{ ft}} = 8785$$

This is not the most accurate way to determine H or PSR; it is an approximate method that can be used when other methods are not feasible.

Techniques and Instruments for Measuring dP

As stated earlier, the key to accurate height measurements on stereoscopic pairs of photographs is the accurate measurement of dP. The most accurate instruments are expensive stereoplotting instruments designed for making topographic and planimetric maps that require highly skilled operators. These instruments also correct for tilt, an additional source of error when measuring heights on nonrectified photographs.

The average photointerpreter must settle for something a little simpler. The simplest instrument is an engineer's scale but its use is limited to situations where the top and botom of the object are visible on both photos, and measurements can only be approximate to the nearest 0.01 of an inch, which is not as precise as frequently required. Parallax bars and parallax wedges (or ladders) can theoretically be used to measure dP to the nearest 0.001 in. or 0.01 mm and have a much wider application.

The Engineer's Scale

As explained in Figure 7.5, dP can be measured by subtracting the distance between the tops of two images of a single object from the distance between the bottoms of the object on a properly oriented stereoscopic pair of photographs. If the images of objects were always as well defined and exaggerated as the buildings in Figure 7.7, we would have fair success with the engineer's scale. However, this is seldom the case when interpreting photos for natural resources and because we should measure more precisely than to the nearest 0.01 in., we should learn to use either the parallax bar or the parallax wedge.

Parallax Bar

The parallax bar consists of two transparent cursors, each with a small etched dot, separated by a bar. One of these cursors is rigidly fastened to the bar. The other is moved along the bar, toward or away from the first cursor, by means of a micrometer screw that records the distance between the two dots to the nearest thousandth of an inch or hundredth of a millimeter. Parallax bars have been designed for use with both lens and mirror stereoscopes (Figures 7.8, and 7.9).

Figure 7.7. Tall buildings on large-scale, low-elevation photography illustrate large absolute parallaxes. Differences in absolute parallax can be measured with an engineer's scale on stereograms of similar photography.

Figure 7.8. Lens stereoscope with parallax bar attached. (Courtesy Alan Gordon Enterprises, Inc., North Hollywood, California.)

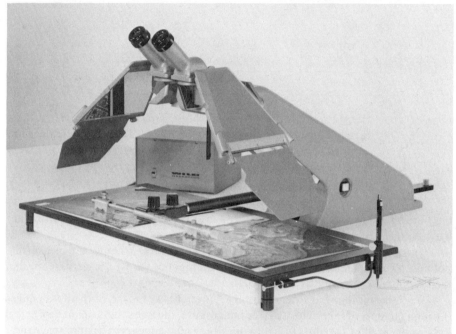

Figure 7.9. Parallax bar for use with a mirror stereoscope. (Courtesy Alan Gordon Enterprises, Inc., top.) Mirror stereoscope with parallax bar and cantilever stand — bottom. (Courtesy Wild Heerbrugg Instruments, Inc.)

To operate a parallax bar we first properly align a stereoscopic pair of photographs with respect to the flight line. The photos are separated by a distance compatible with the particular stereoscope and parallax bar you are going to use. Both photos should be securely fastened to the table top to prevent slippage during measurement. Then place the fixed dot (usually the left one) of the parallax bar beside one of the image tops, a tree for example, and adjust the micrometer so that the movable dot is beside the image top on the other photo (do not use the stereoscope). You can then read the micrometer setting, which we can think of as the distance between the two image tops (Figure 7.10). Next we do the same thing for

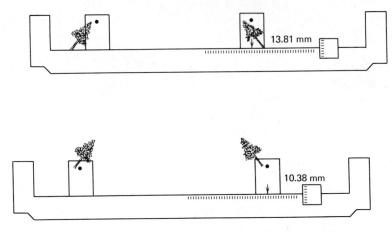

Figure 7.10. Measuring the difference in absolute parallax (*dP*) of a tree using a
parallax bar. In this illustration the *dP* is 3.43 mm. The scale is not
reversed here. (Adapted from D. P. Paine, 1979, *An Introduction to
Aerial Photography for Natural Resource Management,* O.S.U.
Bookstores, Inc., copyright 1973, reproduced with permission.)

the bottom of the tree and read this distance on the micrometer. The difference
between these two readings gives us *dP.*

This explanation of the use of the parallax bar shows what we are measuring,
not how *dP* measurements are made. In actual practice we use the stereoscope and
the floating dot principle as was discussed in Chapter Six.

With the parallax bar oriented as in Figure 7.10, we look at both photo images
through the stereoscope. The two tree images fuse, the tree stands up in the vertical
dimension, and the two dots fuse into one dot, which appears to float in space right
at the tip of the tree. If we turn the micrometer knob back and forth we will see the
dot rise and fall in space. You will notice that it does not follow a strictly vertical
line, but slants a little, because one dot is fixed and the other moves. With this type
of instrument we can determine the parallax differences we are after by merely
"floating" the dot at the top and the bottom of the object and taking the difference
between the two readings obtained. The procedure for elevation difference is the
same as for height, except that the dot is floated at the ground level in two different
locations.

You may notice a couple of odd characteristics of your parallax bar. First you
are not reading the actual distance between images — it is an arbitrary reading.
However, when you take the difference beween the two measurements, you get a
true *dP.* Second, many parallax bars have the scales reversed so that the reading you
get when the dot floats at the image top is greater than when it floats at the bottom,
which is opposite the true situation. Manufacturers have done this because it might
seem more logical to have a greater reading at the image top than at the bottom
(Figure 7.10).

Parallax Wedge

The third method of measuring *dP* is with a parallax wedge. It is a simple, inexpensive device for measuring parallax difference. It can be thought of as a whole series of parallax bars, each set at a reading differing from the adjacent ones by a constant amount. The result is two rows of slightly converging circles, dots or lines, separated by about 2 to 2½ in., as you see in Figure 7.11. The distance between the two lines can be read from a scale alongside one line. When properly oriented on a pair of photos under the sterescope, the two lines fuse together for a portion of their length. Because the lines are different distances apart at each end, the fused portion floats in space as a sloping line or series of dots. To read the parallax difference for an object like a tree, the wedge is moved about on the photos until the sloping line appears to intersect the ground at the base of the object. A reading is then taken alongside the line at that point (Figure 7.12, right) then the wedge is moved until the sloping line appears to cut across the tip of the tree (Figure 7.12, left). The scale along the line is again read at this point. The difference between the two readings is the parallax difference, or 0.134 in. in this example.

The wedge is neither more or less accurate than the bar. The choice is mostly one of personal preference. The wedge is inexpensive and has no mechanical parts

Figure 7.11. Training parallax wedge (left) and standard parallax wedge (right). The scale has been reduced in this illustration. (Courtesy U.S. Forest Service).

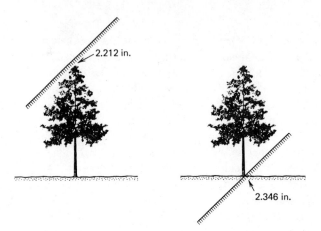

Figure 7.12. Parallax wedge orientation (side view as it would appear from above) for reading parallax differences between the top and bottom of a tree. The *dP* would be 0.134 in. (From D. P. Paine, 1979, *An Introduction to Aerial Photography for Natural Resource Management,* O.S.U. Bookstores, Inc., copyright 1973, reproduced with permission.)

to get out of adjustment. The bar is considerably more expensive but has certain advantages. Many people find it quicker to learn and easier to use in practice. With the bar, you can make any number of repeated measurements without the bias of knowing what the previous readings were. When using the wedge you can see the numbers on the scale when selecting top or bottom readings which might influence your selection, if you remember what you got the time before. To do so with the bar you have to take your eyes off the floating dot to read the vernier.

Measuring *dP* with Different Instruments

Now let's work some examples using each of these methods—the engineer's scale, the parallax bar, and the parallax wedge. To make it easy let's begin with the large-scale stereogram of model trees in Figure 7.13. We will assume that the letter G is on the ground at the same elevation as the base of the tree. The parallax of the baseline *P* is 7.11 mm, or 0.280 in. The baseline is at the same elevation as the base of the tree and the flying height above the base of the tree is 630 ft. From this information we wish to measure the height of tree G using each instrument.

Using the engineer's scale we get a tree-base separation of 2.35 in. and a treetop separation of 2.21 in., which gives us a difference in parallax, *dP*, of 0.14 in.

From our level-terrain height equation we calculate the height of the tree to be:

$$h = \frac{630 \text{ ft } (0.14 \text{ in.})}{0.28 \text{ in.} + 0.14 \text{ in.}} = 210 \text{ ft}$$

Now let's measure the same tree, using the parallax wedge, still without the sterescope. Using the parallax wedge without a stereoscope involves placing corres-

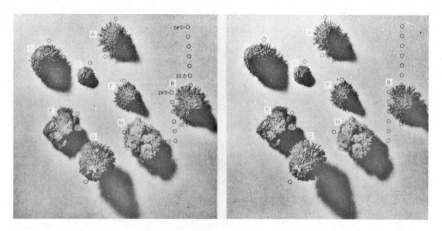

Figure 7.13. Stereogram of model trees for laboratory exercises. (Courtesy U.S. Forest Service, Pacific Northwest Forest and Range Experiment Station.)

ponding points on the wedge over images of the same point on each side of the stereogram. Doing this, we get a tree base separation of 2.34 in. and a treetop separation of 2.21 in., for a dP of 0.13. This time our tree height turns out to be 200 ft.

Now, once again, let's measure the same tree, but using the stereoscope, first with the parallax wedge and then with the parallax bar. Each of these methods should result in more precise answers. First, using the parallax wedge with the stereoscope, we get a tree-base separation of 2.346 in. and a treetop separation of 2.212 in. for a difference in parallax, dP, of 0.134 in. From our parallax equation we compute the height of the tree to be 204 ft. Now let's see what we get with the parallax bar.

Using the stereoscope, we turn the micrometer screw until the dot appears to float on the ground, then at the top of the tree. The results are that the tree base separation is 59.61 mm and the treetop separation is 56.18 mm for a dP of 3.43 mm. Because dP was measured in millimeters we must either convert to inches or we can leave dP in millimeters and simply use the previously given baseline length in millimeters of 7.11. Notice how the units cancel so that our final answer is in feet. Using this instrument the tree height is:

$$h = \frac{630 \text{ ft } (3.43 \text{ mm})}{7.11 \text{ mm} + 3.43 \text{ mm}} = 205 \text{ ft}$$

The last two methods are the most precise. The use of the engineer's scale and parallax wedge without the stereoscope gives us only approximate answers for the height of the tree. In fact in most situations a stereoscope with parallax wedge or bar is the only way heights can be satisfactorily measured on stereoscopic pairs. We used the letter G in Figure 7.13 for our ground measurement when not using the

stereoscope. In actual practice we don't have any such letters although in rare instances we might use a stump, rock, or other discrete image on large-scale photographs. At most common scales of photography, the use of the parallax bar or wedge with a stereoscope is the only practical way to make height measurements except for approximate differences in elevation where these differences are large and where discrete conjugate images on both photos are clearly evident.

False Parallax

Another phenomenon that can influence the accuracy of height measurement and the appearance of the stereoscopic model is *false parallax*. This is caused by the slight movement of objects from one position to another while the plane is flying from one exposure station of a stereoscopic pair of photos to the next. An example is wind-sway of trees. The different position of tree tops on two successive photos will create an error in dP and therefore in the measured height. Foam, ice, or other debris floating down a river will sometimes cause the stereoscopic model to show the river as a curved surface because the debris in the center of the river moves a greater distance (between exposures) than the debris along the edges. Objects may move under their own power to create a false parallax as evidenced by the flying cows in Figure 7.16.

The following laboratory exercise will give you actual practice in making verical measurements on aerial photographs.

Laboratory Exercise

1. If tree F (Figure 7.13) is known to be 97 ft tall, calculate the height of tree A using the proportional shadow-length method.
2. Using the stereogram (Figure 7.13) make the necessary measurements and calculate the height of trees C and D. You may use an engineer's scale, parallax bar, parallax wedge, or all three instruments, but state which instrument or instruments you used. Assume H to be 630 ft, P to be 0.280 in. or 7.11 mm and that the level-terrain equation is appropriate.
3. Do exactly the same as question 2 except assume that $\triangle E$ is -50 ft (about 8 percent of H). Use the same measurements of dP.
4. Once again use the same measurements of dP but assume that $\triangle E$ is now a + 50 ft.
5. Obtain a stereoscopic pair of photos from your instructor of your area, determine the height of several objects and check these heights with field measurements.
6. Using the stereogram in Figure 7.14 determine (1) the road grade, and (2) the straight-line slope from points A to B. Use the level-terrain height equation. Additional information:

Figure 7.14 Stereogram for use with laboratory exercise 6. (From D.P. Paine, 1979, *An Introduction to Aerial Photography for Natural Resource Management,* O.S.U. Bookdstores, Inc., copyright 1973, reproduced with permission.

$$
\begin{aligned}
\text{PSR at B} &= 12{,}050 \\
\text{Elevation at point B} &= 950 \text{ ft} \\
\text{Average photo baseline length } (P) &= 3.10 \text{ in.} \\
\text{Average elevation of baseline} &= 900 \text{ ft} \\
\text{Camera lens focal length} &= 12 \text{ in.} \\
\text{Percent slope and percent grade} &= 100\left(\frac{\text{vertical distance}}{\text{horizontal distance}}\right)
\end{aligned}
$$

Hint: To get the correct ground horizontal distance you will have to first determine the average scale between points A and B. To do this you must first calculate the vertical distance between A and B.

Questions and Problems

1. The *absolute parallaxes* of points y and z are 3.28 in. and 3.12 in., respectively, and the average distance between the PP and CPP of the stereopair is 3.33 in. Which point, y or z, is the highest elevation? Why? What is the relative elevation of points y and z with respect to each other and to the average baseline elevation?

2. Given: A stereoscopic pair of photos and:

>Average PSR of baseline = 10,000
>Average baseline length (P) = 3.00 in.
>Difference in absolute parallax
>between points A and B = 0.50 in.
>Average elevation of the principal points = 2000 ft
>Elevation of point A which is lower than B = 1000 ft
>Focal length of camera lens = 6 in.

 Calculate the elevation of point B using the most appropriate parallax equation.

3. In the solution to question 2 you should have calculated -0.50 in. for the second term in the denominator of the mountainous-terrain height equation. This is the same value as dP but with opposite sign. What should this immediately tell you about the elevation of point B without further calculation? Why?

4. Given: A stereoscopic pair of photos and:

>Known height of a building = 300 ft
>Focal length of camera used = 6 in.
>Average distance between PP and CPP = 2.87 in.
>Difference in absolute parallax between
>the top and bottom of the building = 2.92 mm
>Elevation at the base of the building = 250 ft
>Average elevation of the two PPs = 250 ft

 Calculate the flying height of the aircraft above sea level (A) and the PSR at a point on the same photo with an elevation of 100 ft.

5. Given: A stereoscopic pair of photos and:

>PSR = 15,840
>Focal length of camera lens = 8¼ in.
>Average distance between PPs and CPPs = 84 mm
>Parallax difference between the top and
>bottom of an object = 0.92 mm

 Determine the height of the object using Table 7.2 and the short-cut height equation if $\pm\triangle E$ is negligible.

6. On a stereoscopic pair of photos the dP of both trees A and B is measured to be 0.55 mm. On the ground, however, tree A is found to be 100 ft tall and tree B is only 90 ft. tall. Assuming the dP measurements to be correct, which tree is growing at the higher elevation? Why?

7. The distance on the *ground* between the principal and conjugate principal point for two perfectly vertical photographs of a stereoscopic pair are the same. Assume both photographs were taken at exactly the same flying height above sea level. The baseline (P) on the first photo is 3.05 in. and on the second photo it is 3.09 in. Which photo has the PP with the highest elevation? Why? Assume perfectly vertical photographs.

Figure 7.15. Stereogram for use with Problems 8 and 9.

8. What is the difference in absolute parallax between points *y* and *z* on the diagram in Figure 7.15? Which point is at the higher elevation? Why?

9. What is the difference in elevation between points *y* and *z* (Figure 7.15) if *H* is 10,000 ft? (Use an engineer's scale and the level terrain equation.)

10. Figure 7.16 shows some cows in a pasture. Because some of them moved between exposures, creating a false parallax difference, they appear to float above the ground. In which direction did they move (right or left)? Explain your answer. How would they appear in the stereogram if they had moved the opposite direction? Assume the plane flew from right to left.

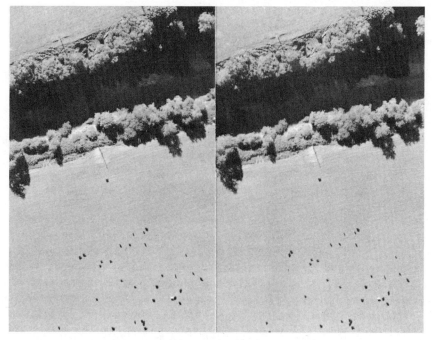

Figure 7.16. Birds or flying cows? See Problem 10 for answer.

References for Part One

American Society of Photogrammetry. 1960. *Manual of Photographic Interpretation,* Falls Church, Va.

American Society of Photogrammetry. 1966. *Manual of Photogrammetry,* Third Edition. Falls Church, Va.

Barrett, J. P. and J. S. Philbrook. 1970. "Dot Grid Area Estimates —Precision by Repeated Trials," *Journal of Forestry,* Vol. 68. pp. 149-151.

Edwards, John R. n.d. Uses of Aerial Photography in the Department of Natural Resources, State of Washington. Department of Natural Resources, Olympia, Washington.

Johnson, E. W. 1954. "Shadow-Height Computations Made Easier." *Journal of Forestry,* Vol. 52. pp. 438-442.

Johnson, E. W. 1957. "The Limit of Parallax Perception." *Photogrammetric Engineering,* Vol. 23. pp. 933-934.

Landis, G. H. and H. A. Meyer. 1954. "The Accuracy of Scale Determinations of Aerial Photographs." *Journal of Forestry, Vol. 52. pp. 863-864.*

LaParde, G. L. 1972. "Stereoscopy — A More General Theory." *Photogrammetric Engineering,* Vol. 38, No. 12, pp. 1177-1187.

Miller, C. E. 1960. "Vertical Exaggeration in the Stereo Space-Image and its Use." *Photogrammetric Engineering,* Vol. 26, No. 5. pp. 815-818.

Moessner, K. E. 1954. *A Simple Test for Stereoscopic Perception.* U.S. Forest Service, Central States Forest Experiment Station. Technical Paper 144.

Moessner, K. E. 1961. "Comparative Usefulness of Three Parallax Measuring Instruments in the Measurement and Interpretation of Forest Stands." *Photogrammetric Engineering,* Vol. 27, No. 5. pp. 705-709.

Moffitt, H. 1959. *Photogrammetry.* International Textbook Company, Scranton, Pa.

Paine, D. P. 1979. *An Introduction to Aerial Photography for Natural Resource Management.* Oregon State University Bookstores, Inc., Corvallis, Ore.

Spurr, S. H. 1960. *Photogrammetry and Photo Interpretation,* Second Edition. The Ronald Press Company, New York.

Ulliman, J. J. 1978. *Aerial Photo Interpretation of Renewable Natural Resources.* Course notes, University of Idaho, Moscow, Idaho.

U.S. Department of the Army, the Navy, and the Air Force. 1967. *Image Interpretation Handbook,* T.M. 30-245. Government Printing Office, Washington, D. C.

Wolf, P. R. 1974. *Elements of Photogrammetry.* McGraw-Hill, Inc., New York.

Part Two

Mapping from Vertical Aerial Photographs

Eight

Map Projections, Grid Networks and Control

This chapter includes a few basic considerations of concern to everyone involved in the production and/or use of maps made from aerial photographs. This chapter presents an overview of map making problems and their solutions. For a more detailed coverage of these topics, you should consult the list of references at the end of Part Two.

Objectives

After a thorough understanding of this chapter you will be able to:

1. Draw a diagram of the earth to show (a) the relative position of the equator, poles, meridians, and parallels, (b) the position of a point on the earth's surface in terms of latitude and longitude, and (c) the angular measurement system of longitude and latitude.
2. Illustrate with diagrams and short paragraphs the functional features of the following map projections and state the primary advantage of each: orthographic, Lambert conformal, polyconic, and Mercator.
3. State the difference between plane and geodetic surveying.
4. Describe in writing the system of plane coordinates including the U.S. military grid coordinates.
5. Locate specified areas of given sizes (down to 40 acres) on a map that uses the U.S. Public Land Survey Grid known as the General Land Office (GLO) plots, and, given specified areas, write the legal descriptions.
6. Given the legal description of an area, (a) state the size of the area in acres, and (b) calculate the distance and direction of a given point from the initial point.

7. Completely describe what is meant by horizontal and vertical control and how it is used in the preparation of maps made from aerial photographs.
8. List four steps involved in making a map from aerial photographs.

GEOMETRY OF THE EARTH

One of the first problems encountered in map making is displacement that results from representing an approximately spherical earth on a flat surface. The flattening of even a small portion of the earth is obviously going to produce problems of scale variation and the measurement of direction on a map. The map projection used will determine the type and magnitude of this displacement. However, before discussing map projections let us first review some terminology concerned with the geometry of the earth.

There are two basic kinds of surveying, geodetic and plane. In geodetic surveying, the curvature of the earth is accounted for, and in plane surveying small portions of the earth are treated as flat planes. Plane surveying should be limited to areas of not over 10 miles on a side. For our discussion of geodesy we assume that the earth is a perfect sphere, although in reality it is slightly flattened at the poles.

Great Circles

The intersection of the surface of the earth with a plane that *passes through the center* of the earth is called a great circle. It is the largest circle that can be drawn on the earth. A line connecting any two points on the surface of the earth represents part of a great circle.

The importance of this fact is that an arc of any great circle is the shortest distance between two points. This knowledge is used by navigators of planes and ships traveling long distances. For example, the great circle route between Tokyo and New Orleans passes over Alaska and is a shorter route than from Tokyo to San Francisco to New Orleans. Of interest to map users is the fact that some map projections (explained later) show great circles as straight lines while others show them as arcs. Great circle routes are easily located on some projections and almost impossible to locate on others.

Meridians and Parallels

Ringing the earth in cardinal directions are meridian lines which run north and south, and parallels that go east and west (Figure 8.1). Parallels always remain the same distance apart, but meridians are furthest apart at the equator and converge to a point at the poles.

Both meridians and parallels are measured in degrees of arc from the center of the earth (Figure 8.2). Distances between meridians are measured as arcs of longitude east and west from the prime meridian which passes through the Royal Observatory at Greenwich, near London, England. Distances between parallels are

Figure 8.1. Meridians of longitude are measured east and west from Greenwich, England, and parallels of latitude are measured north and south from the equator. (From G. T. Trewartha, A. H. Robinson, and E. H. Hammond, *Elements of Geography.* Copyright 1967, McGraw-Hill Book Co. Used with permission of McGraw-Hill Book Co.)

Figure 8.2. Illustration showing how arcs of parallel (longitude) and arcs of meridian (latitude) are measured.

measured in arcs of latitude north and south from the equator. For example, a specific point in central Kansas can be defined as 38° 10′ 15″ north latitude and 98° 26′ 37″ west longitude.

MAP PROJECTIONS

A map projection is defined as an orderly system of projecting portions of the earth's surface to a plane or flat surface—a map. If there was a perfect method of doing this, we would have only one projection system in common use. Because there is no perfect projection, several different projections have been developed—all with certain advantages and disadvantages. A few basic projections are discussed as examples.

Classification of Map Projections

There are two broad classifications of map projections, equivalent and conformal. In equivalent projections the *area* of a portion of the earth's surface is the *same* on a round globe as on a flat map of the same scale but the shape is not the same. In conformal projections a portion of the earth's surface has the same *shape* on the map as on the globe but the relative *area* is not the same. Some projections are neither truly equivalent nor conformal, but a compromise. Conformal projections are frequently preferred because of their true shape.

Orthographic

The orthographic projection (Figure 8.3) is the simplest of all projections because it does not account for the curvature of the earth. It is produced by projecting detail on the earth to a plane tangent to the earth at the center of the projection. The scale gets smaller creating increased displacement as the distance from the center of the projection increases. Therefore, this projection should be limited to mapping small areas of just a few square miles.

Lambert Conformal

The Lambert conformal projection (Figure 8.4) is made from a single cone placed over a globe representing the earth in such a way that its apex is directly over one of the poles. The lower portion of the cone intersects the globe along two standard parallels so that two-thirds of the north-south range lies between them with one-sixth each lying north and south of the standard parallels. After the parallels and meridians are projected onto the cone by drawing rays from the center of the globe, the cone is cut and flattened to produce the base map. This projection produces meridians that are straight lines radiating from the poles and parallels that are arcs of concentric circles.

The Lambert conformal projection is more accurate in an east-west than in a north-south direction and in the United States it has been adapted as the basis for the coordinate system used by many states where the long axis is east and west.

Figure 8.3. Orthographic projection. (Adapted from Stephen H. Spurr, 1960, *Photogrammetry and Photointerpretation,* Second Edition, The Ronald Press Company. Copyright 1960 by the Ronald Press Company. Reprinted by permission of John Wiley & Sons, Inc., the present copyright holder.)

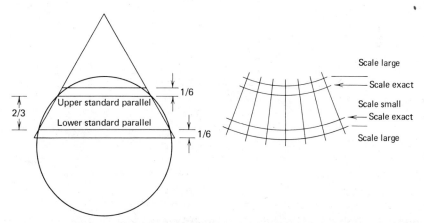

Figure 8.4. Lambert conformal projection. (Adapted from Stephen H. Spurr, 1960, *Photogrammetry and Photointerpretation,* Second Edition, The Ronald Press Company. Copyright 1960 by the Ronald Press Company. Reprinted by permission of John Wiley & Sons, Inc., the present copyright holder.)

Using the 33rd and 45th parallels as the standard parallels, the maximum scale error is only 0.5 percent for nine-tenths of the United States.

Polyconic

This projection (Figure 8.5) gets its name because it uses several cones, one for each parallel of latitude. The parallels of latitude are arcs of nonconcentric circles and the meridians, except the central meridian, are curves. The projection is correct for each parallel of latitude and therefore fairly accurate in a north-south direction. However, only along the central meridian is the scale the same as along all parallels. Distortion of scale and area is relatively small within 560 miles on either side of the central meridian where scale error is 1 percent or less.

A major disadvantage of this projection is that all but the central meridian is curved, which makes it impossible to match adjacent map sheets when trimmed to the meridian lines. Therefore, the Lambert conformal and other projections with straight meridians are more popular.

Mercator

In a Mercator projection, points on the earth's surface are projected onto a cylinder. In a standard Mercator projection the cylinder has a north-south axis and the cylinder is tangent to the earth's surface at the equator. A transverse Mercator projection (Figure 8.6) has an east-west axis and the cylinder is tangent to the earth's surface at a given meridian line.

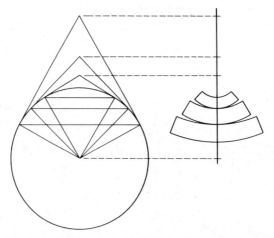

Figure 8.5. Polyconic projection. (Adapted from Stephen H. Spurr, 1960, Photo-togrammetry and Photointerpretation, Second Edition, The Ronald Press Company. Copyright 1960 by the Ronald Press Company. Reprinted by permission of John Wiley & sons, Inc., the present copyright holder.)

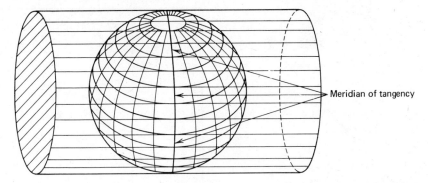

Figure 8.6. Transverse mercator projection. (Adapted from Stephen H. Spurr, 1960, *Photogrammetry and Photointerpretation,* Second Edition, The Ronald Press Company. Copyright 1960 by the Ronald Press Company. Reprinted by permission of John Wiley & Sons, Inc., the present copyright holder.)

In both projections the cylinder is flattened to form a map. Because the standard Mercator projection conforms to the curvature of the earth in an east-west direction, it is more accurate in that direction, and vice versa for the transverse Mercator. For the standard Mercator projection the meridians are straight vertical lines, which means that they have been spread apart everywhere except at the equator. They must be spread further and further as the distance from the equator increases. At about 60° north and south latitudes, the meridians are spread by a factor of 2, and at 80° latitude they are spread by a factor of 6, resulting in scales that are increased two and six times respectively. At the poles the amount of spread approaches infinity, which explains why the poles are never shown on a standard Mercator projection.

The important feature of a standard Mercator projection is that a straight line drawn in any direction, anywhere on the map, is a line of constant compass bearing. This is the only projection for which this unique feature holds and is therefore used by ships and planes for navigational purposes. Note, however, that this line is not a great circle or the shortest distance between two points. Travel along great circle routes, except at the equator or along a meridian line is not a constant direction (Figure 8.7). For other uses the projection has little value because of excessive scale distortions.

The transverse Mercator projection, being more accurate in the north-south direction, has been adopted by some states with long north-south axes as the basis for their rectangular grid coordinate system.

MAP COORDINATE SYSTEMS

A coordinate system is defined as any system whereby points on the earth's surface are located with reference to a previously determined set of intersecting

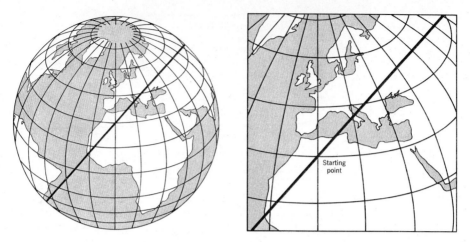

Figure 8.7. A great circle is not a constant direction. Notice how the great circle (dark line) intersects the meridians (north south lines) at different angles. A. Robinson, R. Sale, and J. Morrison, 1978. (*From Elements of Cartography,* Fourth Edition. Copyright 1953, 1960, 1969, 1978, by John Wiley and Sons, Inc. Reprinted by permission of John Wiley and Sons, Inc.)

lines. We have already discussed the system of parallels and meridians known as the geographic coordinate system. The U.S. Geological Survey's topographic map series is a good example of this system. The 15½ min quadrangle sheets, for example, are a constant 17½ in. in the north-south direction because one degree of latitude represents a constant distance, but the width of these sheets varies from about 15 in. in Texas to 12 in. in North Dakota because of the convergence of meridians.

Other examples of coordinate systems include state plane coordinates, the military grids, and the township grid system of the U.S. Public Lands Survey.

State Plane Coordinate Systems

The measurement of distances between two points using latitudes and longitudes creates problems. For example, one degree of longitude at the equator is approximately 69 miles, but at the 60th parallel of latitude it is only one-half this distance and at the poles it is zero. Because of this and other problems, state plane coordinate systems have been developed. Plane coordinate systems treat small portions of the earth's surface as flat planes—not as curved surfaces.

The State Plane Coordinate System consists of 111 separate projections within the continental United States (Figure 8.8). The reason for so many projections is that it reduces projection error to less than 1 part in 10,000. The north-south zones utilize the transverse Mercator projections and the east-west zones utilize the

Figure 8.8. State plane coordinate systems. A total of 111 separate projections are required for the 48 states. (From the *Manual of Remote Sensing,* copyright 1975, by the American Society of Photogrammetry, reproduced with permission.)

Lambert conformal projections. To eliminate negative coordinates the origin of all zones is placed southwest of the particular zone.

The advantage of the State Plane Coordinate System is the small projection distortion. The disadvantage is the large number of zones with no transformation formulas to convert between zones. With the use of modern satellite imagery covering hundreds of square miles per frame, the use of 111 separate zones is cumbersome.

Plane coordinates consist of an x and y grid system of straight lines. East-west distances are called departures and north-south distances are latitudes. The units of measure are in feet and not degrees of arcs. The term latitude is unfortunate because this is different from the geodetic system using latitude and longitude.

Straight line distances between points on the plane coordinate system can be calculated using the Pythagorean theorem. This distance, called a scale difference, is a grid distance and may be different from the ground-measured distance because of curvature of the earth. Where long distances are involved, a table of scale factors is used to convert from grid distances to ground distances and vice versa.

Military Coordinates

Because the military found that geographic coordinates are both difficult to calculate and cumbersome to use, they developed their own systems. The first system was developed from the polyconic projection where the central meridian is a straight line. The unit of measure is in thousands of yards. The second system, developed after World War II, is based on the Transverse Mercator projection and the unit of measure is in thousands of meters.

The first system divides the United States into seven grid zones with a new central meridian every 8° of latitude. Each zone is 9° wide to provide overlap. The north-south center of each zone, designated the central parallel, is 40° 30′ N. latitude.

The second system, known as the UTM (Universal Transverse Mercator) grid, is more widely used although both systems are marked on all military maps. This eliminates the conversion between yards and meters. When using the UTM grid a new central meridian is used every 6° of longitude (Figure 8.9).

Both systems utilize an x and y grid with the x axis running east-west and the y axis running north-south. They both avoid negative numbers by assigning large positive values of yards or meters to the center of each zone. All military maps are read to the right and up. Because they are in thousands of units more precision is obtained by using decimals such as 899.42 right and 621.17 up. This would be an x coordinate of 899,420 yd (or meters) and the y coordinate of 621,170 yd (or meters).

General Land Office Plots

Because much of the land in the United States has been surveyed using General Land Office (GLO) plots, as authorized by Congress in 1785 under the U.S. Public Lands Survey, it is important that we briefly review this system.

Most of the United States west of the Mississippi River and north of the Ohio River, plus Alabama, Mississippi, and portions of Florida have been subdivided by the system. The original intent was to establish perfect townships exactly six miles on a side or 36 square miles, subdivided into square sections of 640 acres each.

At first no allowance was made for the curvature of the earth and problems soon arose. Most of these problems have now been resolved but many townships and sections are not perfect due to errors created by the earth's curvature and errors made surveying by the field parties.

The method of subdivision starts with a series of 32 carefully selected initial points for which latitude and longitude is precisely determined. Some states, California, for example, have more than one initial point, but more frequently two or more states use the same point, such as Oregon and Washington.

Figure 8.9. UMT zones in the United States. A total of 10 separate projections are required for the 48 states. (From the *Manual of Remote Sensing,* copyright 1975 by the American Society of Photogrammetry, reproduced with permission.)

From these initial points north-south "guide meridians" and east-west "standard parallels" were established at 24-mile intervals (Figure 8.10). As one goes north for 24 miles the distance between the "guide meridians" is 24 miles less the convergence due to the curvature of the earth. The next guide meridian starts out again—a full 24 miles apart.

Next, the six-mile-square townships are laid out using north-south *range lines* and east-west *township lines*. Townships are numbered consecutively north and south, and east and west from the initial point.

Townships are further subdivided into sections (square miles) and quarter sections. Thus the smallest subdivision markers found on the ground from the original surveys are section corners and quarter corners located halfway between the section corners. The subdivision of a township starts in the southeast corner, thus all irregularities are theoretically in the northern and western tiers of the sections within each township. However, because of errors made in the field, sections other than in the northern and western tiers may be irregular. Sections are consecutively numbered from 1 to 36 starting in the northeast section of each township as shown in Figure 8.11. Also shown is a further breakdown of a section

Figure 8.10. Standard U.S. Public Land Survey System subdivision of townships. (From J. R. Dilworth, 1980, *Log Scaling and Timber Cruising,* copyright 1973, reproduced with permission.)

Normal subdivision of township and sections

Figure 8.11 Subdivisions of a township into sections (square miles) and smaller units. (From J. R. Dilworth, *Log Scaling and Timber Cruising*, 1980, copyright 1973, reproduced with permission.)

into 40-acre tracts. Further subdivisions are usually called lots and in practice may be any size or shape depending on the ownership boundaries.

Before continuing, let us take a look at some examples of this system. Consider the 40-acre tract of land in Figure 8.11 that has been darkened. What is the legal description of this area? It is the S. E. ¼ of the S. W. ¼ of section 34 of township 11 south, range 5 west of the Willamette Meridian (W.M.).

Approximately how many miles is the northeast corner of this 40 acres from the initial point of the Willamette Meridian? It turns out to be 65¾ miles south and 26½ miles west. Using the Pythagorean theorem, the straight line distance would be: $\sqrt{(65.75)^2 + (26.5)^2} = 70.9$ miles. If you have difficulty in arriving at these answers, remember that the northeast corner of the township is 60 miles south and 24 miles west of the intial point. We could also calculate the approximate bearing from our point to the initial point. The tangent of the angle at our point is 26.5 divided by 65.75, or 0.403, or almost 22°. The approximate bearing is therefore N 22° E. In this problem we have ignored the curvature of the earth and have assumed normal townships.

GROUND CONTROL

In addition to problems created by the curvature of the earth, aerial photos have problems of distortion and displacement. Of primary concern in mapping are the displacements caused by tilt and topography. For these reasons and in order to establish the desired map scale, control points (vertical and/or horizontal) must first be established when making maps from aerial photographs. Ground control is established by survey crews on the ground who provide triangulation networks.

Ground control consists of carefully located positions of known longitude and latitude, or known grid coordinates (horizontal control), and elevation above mean sea level (vertical control). Horizontal control is used to establish and maintain the desired map scale and to properly orient the map for direction. Vertical control is required for orientation of the stereoscopic model when stereoplotting instruments are used and for the correct location of contour lines.

These accurately established points are then plotted on the map base at the desired scale. All ground control points must also be accurately located on the aerial photos. Because ground control points are expensive, additional horizontal control points can be established on the map base using aerial photos by a method called radial-line triangulation (Chapter Nine).

A minimum of two control points is necessary to establish scale, but three are preferred. With three control points on a single photo it is possible to remove x and y tilt using stereo plotters and vertical control points. The correct planimetric location of the points can be calculated and nonstereoscopic instruments used if the elevations are known.

STEPS IN MAKING MAPS FROM AERIAL PHOTOGRAPHS

To briefly summarize, let's list the steps involved in making a map from aerial photographs.

1. Choose a map scale and establish a coordinate system on the map base at the desired scale. For large projects the coordinate system may be one of the map projections. For smaller projects it may be one of the plane coordinate systems.
2. Establish control points (horizontal and/or vertical) based on a ground survey (positively identified on the photographs) and locate their relative positions on the map base.
3. If necessary, establish additional photo control points using the theory of radial-line triangulation (Chapter Nine).
4. Transfer the detail from the photographs to the map using any of a number of instruments designed for that purpose. (Chapter Ten).

Questions and Problems

1. Draw and label a diagram of the earth showing the location of the north pole, equator, meridians, parallels, longitude, and latitude.

2. What unit of measure is used to measure longitude and latitude? Draw a diagram showing how these measurements are made.

3. Draw a simple diagram and write a short paragraph illustrating the functional features of each of the following map projections: orthographic, Lambert conformal, polyconic, and Mercator.

4. What is the difference between geodetic and plane surveying?

5. What is the difference between plane coordinates and map projections?

6. If there are 640 acres in a standard section (one square mile), how many acres are there in each of the following parcels of land:
 (a) The north ½ of section 8?
 (b) The south ½ of the southwest ¼ of section 8?
 (c) The west ½ of section 2, added to the adjoining northwest ¼ of the northeast ¼ of section 2?
 (d) Township 12 south, range 6 west?

7. Assuming completely normal townships and sections, how many miles south and east of the initial point is the center of section 12, T. 10 S, R. 31 E? what is the straight-line distance between these two points (in miles) and how could you calculate the bearing from the initial point to the center of section 12?

8. What is ground control and how is it used in the production of maps from aerial photographs?

9. What are the four steps involved in making a map from aerial photographs?

Nine

Radial-Line Triangulation

In previous chapters, mention has been made of a process called radial-line triangulation. In Chapter Ten the radial-line plotter is listed as a stereoscopic instrument that can be used to transfer detail from aerial photographs to a map. Because the radial-line plotter is the least expensive type of instrument available for the removal of topographic displacement, and because radial-line triangulation can be used to establish additional horizontal control points, this chapter is devoted entirely to radial-line triangulation.

Objectives

After a thorough understanding of this chapter and completion of the laboratory exercise, you will be able to:

1. Fully define what radial-line triangulation is and what it accomplishes.
2. List two applications of radial-line triangulation.
3. State three relationships that can be inferred from the topographic-displacement equation.
4. Calculate the value of the unknown variable in the topographic-displacement equation given the remaining variables.
5. In writing and with diagrams, fully explain the theory of radial-line triangulation in terms of resection and intersection.
6. Given a base map of a known scale and the necessary control points, perpetuate control points from one stereoscopic pair of aerial photos to the next.
7. Transfer a small amount of detail from a stereoscopic pair of aerial photos to a map of a specified scale using hand templets.
8. List five different ways of performing radial-line triangulation.

9. In writing and with diagrams, illustrate the operating features of the radial-line plotter.
10. List four errors associated with the performance of radial-line triangulation techniques and state how each can be minimized.

RADIAL-LINE TRIANGULATION DEFINED

Radial-line triangulation (RLT) is a graphical or mechanical method of photogrammetric triangulation in which vertical aerial photos are properly oriented with respect to ground control in such a way that additional control points can be created in true planimetric positions. That is, the effect of topographic displacement is eliminated. This definition is not completely accurate because in recent years RLT has been numerically accomplished using high-speed computers, which is not a graphic or mechanical method. However, the computerized numerical method is beyond the scope of this book. In this book we are concerned only with the optical-mechanical methods that are easy to understand and perform.

Because RLT does not remove or account for photographic tilt, the theory assumes vertical photography so that the isocenter and nadir coincide with the principal point. For photos with tilt of 3° or less taken over areas with moderate topography, the errors caused by tilt are relatively small. However, errors introduced by using tilted photos become more serious as topographic variation increases. Of course, tilted photography can always be rectified, but this creates additional expense. Because most photography is tilted less than 3°, rectification is usually not performed.

APPLICATIONS OF RADIAL-LINE TRIANGULATION

The *primary* application of RLT is the establishment or extension of horizontal control points. These additional control points can be used in the construction of controlled mosaics and in conjunction with the transfer of detail from photos to maps by other instruments that do not correct for topographic relief. In addition, the radial-line plotter can be used to transfer planimetric detail directly from the photo to the map by continuously solving the triangulation problem by optical-mechanical means. This instrument is discussed in more detail later.

TOPOGRAPHIC DISPLACEMENT RELATIONSHIPS

Because RLT removes the effects of topographic displacement, let's briefly review the topographic displacement equation that was presented in Chapter Two. The equation is:

$$d = \frac{r(h)}{H}$$

For discussion here we alter the equation slightly to:

$$d = \frac{r(\pm \triangle E)}{H}$$

Where

d = radial displacement on the photo of a point away from (d = +) or toward (d = −) the nadir in inches or millimeters

r = radial distance on the photo from the nadir (principal point) to the displaced point in inches or millimeters

H = flying height above the nadir in feet or meters

$\pm \triangle E$ = difference in elevation between the nadir and the displaced point in feet or meters (positive if point is higher than nadir and negative if lower)

This is really the same equation as given before except that $\pm \triangle E$ has replaced h and the datum is the elevation of the nadir. For a better understanding of topographic displacement and RLT it is important that we review some of the topographic relationships that have an influence on RLT.

First, topographic displacement is directly proportional to the distance from the nadir (principal point) to the displaced point. Thus, the further the point is from the principal point the more the photo image is displaced from its true planimetric position.

Second, the amount of displacement is directly proportional to the elevation difference ($\pm \triangle E$) between the nadir (principal) point and the displaced point. If two points are the same distance from the nadir then the point with the greatest difference in elevation from the nadir will be displaced further on the photo. A corollary to this is that objects at higher elevations than the nadir are displaced radially away from the nadir and objects at lower elevations are displaced toward the nadir.

Third, topographic displacement is inversely proportional to the flying height of the aircraft above the datum. Thus satellite imagery taken at about 570 miles above the earth has very little topographic displacement.

These relationships are important to the photogrammetrist for several reasons. They act as guidelines for the use of photos as map substitutes and also allow us to predict some of the results that will occur when we plan a photo mission. If we are flying a mission, with mapping as the primary objective, then we might want to fly as high as possible (to reduce displacement) and still be able to see adequate ground detail for our mapping objective. In actual practice, however, most mapping photography utilizes 6- and 8¼-in. focal length camera lenses at low flying altitudes.

THEORY OF RADIAL-LINE TRIANGULATION

The basic principle behind RLT is that on a truly vertical aerial photograph, angles about the principal point (nadir) will remain constant and true, regardless of

changes in scale and the amount of relief. As a result, any line drawn radially from the principal point to a given object will pass through the true location of the object. Put another way we could say the displacement of photo images occurs radially from the center of the photo.

Resection and Intersection

Radial-line triangulation is accomplished by two distinct operations: (1) resection and (2) intersection. Both operations are usually performed simultaneously.

✱ Resection is used to locate true planimetric map positions of principal points. Resection requires a minimum of two horizontal ground-control points within the overlapped portion of a stereoscopic pair of photos, but three or more ground points are desirable.

✱ Intersection is the establishment of the true planimetric position of additional points that have discrete images within overlapped area of the stereopair of aerial photos using intersecting lines and the already established principal points.

In Figure 9.1 we have a diagram of a stereo triplicate (photos 3-1, 3-2, and 3-3) on which we have accurately located the principal and conjugate principal points, ground-control points (GC_1 and GC_2), and photo control points (PC_1 and PC_2). Ground-control points are carefully located on the ground as well as the photo, whereas the photo-control points are located on the photos only. The photo-control points (PC_1 and PC_2) must be situated so that they appear on three consecutive photos, which means that the endlap must exceed 50 percent. Photo-control points, as well as ground-control points, must be positively identified, discrete images visible on all photos and should be a reasonable distance from the photo baseline (PP to CPP). These photo control points are called *pass points* because they pass horizontal control from one photo to the next.

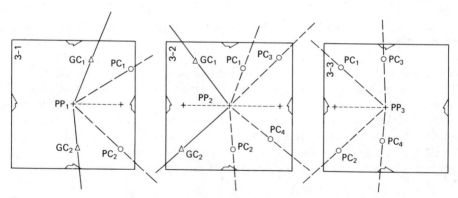

Figure 9.1. Stereo triplicate with transparent overlays for two point resection. The overlays must be larger than the photos if the map is to be at a scale larger than the photos because the radiating lines must be extended in length.

If more than one flight line is to be tied together, pass points must fall within the side lap area as well. Thus the same point can be located on as many as six photos. The best location for pass points is opposite the principal and conjugate principal points in the side lap area.

All points (principal, conjugate, and pass) are accurately pinpricked on transparent overlays (one overlay per photo) and labeled. Then straight radiating lines are drawn from the principal points of each overlay through all control points (ground control as well as photo control or pass points) found on the particular overlay as well as lines between the principal and conjugate principal points.

The transparent overlays are then removed from the photos and placed over a map at the desired scale (Figure 9.2) in such a way that (1) the ground-control radial lines from photo 3-1 and 3-2 pass through, and therefore intersect, at GC_1 and GC_2, and (2) the photo baselines on the overlays are in perfect alignment.

The true planimetric location of the principal points PP_1 and PP_2, is then pinpricked through the overlays, at the intersection of radial lines to the map. In a similar manner the overlay from photo 3-1 is placed on the map using PC_1 and PC_2, just as we used GC_1 and GC_2 before, to locate the true planimetric position of PP_3. Theoretically we could continue to pass on control points indefinitely but, no matter how careful we are, mechanical errors accumulate and it is desirable to have additional ground-control points every few photos.

Our discussion so far has assumed an existing map with an established scale. If we were making a new map, the control points would be placed a calculated distance

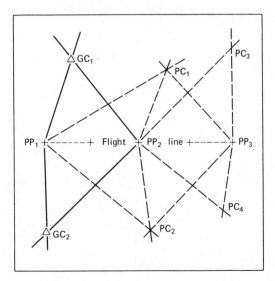

Figure 9.2. Triangulation network of photo control (pass points) from Figure 9.1 on a map base at an enlarged scale. The flight lines (PPs and CPPs) must be perfectly aligned.

apart depending on the desired scale. Suppose for example we wanted the map to be at a scale of 2000 ft to the inch (MSR = 24,000) and the ground distance between the two ground-control points was 3420 ft. The two ground control points on the map would then be:

$$MD = \frac{GD}{MSR} = \frac{3420 \text{ ft}}{24,000} \left(\frac{12 \text{ in.}}{\text{ft}}\right) = 1.71 \text{ in. apart}$$

It should be observed that we can increase or decrease the map scale by sliding the overlays further apart or closer together while keeping the baselines perfectly aligned. Enlarging the scale requires larger transparent overlays so that the radial lines can be extended well past the points.

Three-Point Resection

The resection procedure just described is called two-point resection because we used two ground control points. We can also use three-point resection that differs from two-point resection in the following ways: (1) three or more ground-control points are required, (2) the control points may be located anywhere on the photograph, but for accuracy they should be well spaced, (3) conjugate principal points need not be located, and (4) only one photo is required to locate one principal point. The method is illustrated in Figure 9.3.

The advantages of three-point resection are that the conjugate principal points need not be located on the photograph and only one photo is required. The disadvantages are that more ground control is required and, if control is to be passed from one photo to the next, the images of at least three control points must appear on adjacent photos. Therefore, the two-point system is usually better suited for graphical or mechanical radial-line triangulation.

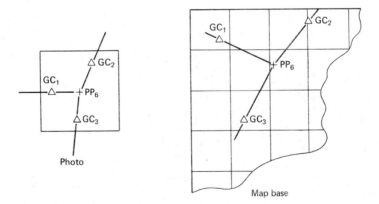

Figure 9.3. Illustration of three-point resection to establish PP_6 on a map (with ground control) using a single photograph.

Intersection can accomplish much more than pass on or create new photo control points. It can be used to transfer detail from photos to a map. Using overlays (hand templets) for the transfer of detail as just described is a slow tedious job. However, before describing alternate methods of performing RLT, a step-by-step example of radial-line triangulation using hand templets to transfer a section of road from a photo to a map is given.

EXAMPLE OF RADIAL-LINE TRIANGULATION

Figure 9.4 illustrates how a section of road is transferred from a stereoscopic pair of photos to a map with the effects of topographic relief eliminated. Two-point resection is used and the final map is at a larger scale than the photos. Even though we have used only two ground-control points and five road intersection points, it becomes necessary to label each radiating line on the overlays because, when superimposed, a particular line on one overlay may cross several lines on the other. We are only interested in those intersections created by lines going to the same point. In this example we are transferring that section of the road from v to z on an *existing* map. The specific steps are:

1. Carefully select two ground-control points, GC_1 and GC_2, that can be *accurately* located on *both* photos *and* the *map*. When this is done, field measurements between control points are not necessary, but the *existing* map must be accurate. Pinprick the selected control points on both photos and on the map.
2. Select points *v* through *z* on both photos and pinprick. These points were selected at bends in the road using discrete objects visible on both photos. Targets placed on the road prior to photographing are an ideal way of ensuring that the points are pinpricked in exactly the same place on both photos.
3. Place a piece of clear acetate or other transparent material over each photo and copy all the above points (properly labeled) on the overlays.
4. Remove overlays. All future work will be on the overlays and on the map.
5. Connect the photo centers and conjugate centers with dashed lines.
6. Draw straight lines from the respective photo centers (do not use conjugate centers) to and beyond points *v* through *z* as well as both control points.
7. Accurately locate the ground-control points on the base map and place both overlays on the map so that (a) the dashed line connecting the photo centers and their conjugates are perfectly lined up, and (b) the overlays are adjusted to the map scale by altering the distance between photo centers so that the radiating lines from both centers cross directly over the ground control points as marked on the map.
8. Temporarily fasten the overlays to the map and pinprick the map where line *v* on one overlay crosses line *v* on the other overlay, line w crosses w, and so on. These pinpricks on the map represent the true location of points

v through z with topographic displacement removed and at the map scale.

9. Remove templets and draw in the road using points v through z as guides.

The only difference between this procedure and making a new map is that a new map must be scaled by measuring the ground distance between the control points as previously described.

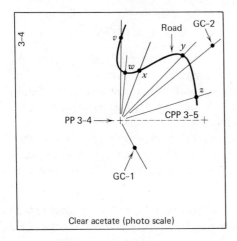

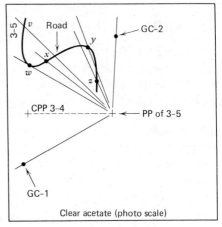

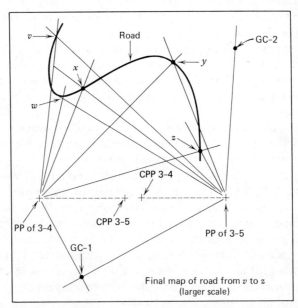

Figure 9.4. Producing a map by radial line triangulation using hand templets. (From D. P. Paine, 1979, *An Introduction to Aerial Photography for Natural Resource Management,* O.S.U. Bookstores, Inc., copyright 1973, reproduced with permission.)

METHODS OF ACCOMPLISHING RADIAL-LINE TRIANGULATION

There are several methods of achieving a radial-line triangulation network that include (1) hand templets, (2) slotted templets, (3) radial-arm templets, (4) use of the radial-line plotter, and (5) computerized numerical methods. The hand-templet method using overlays has already been explained and the numerical methods are beyond the scope of this book, which leaves three methods yet to discuss. The theory behind all these methods is the same.

Slotted Templets

The slotted-templet method is a simple mechanical solution of the templet assembly problem just described. Instead of drawing radial lines on acetate sheets, long, narrow radial slots are cut in the templet material in which we insert close-fitting round studs, that are free to slide along the longitudinal axis of the slot. Slotted templets do not have to be made of transparent material, but they should be reasonably thin, and above all, rigid. This rigidity is necessary to force the studs along the axis of the slots while fitting the assembled system over the base map.

The photo work for slotted templets is the same as for hand templets. However, the production of the templets is different. The photos are placed face up on a piece of templet material. Then the location of all necessary points on the photos is pinpricked onto the templets, circled with a pencil, and the number of the photo is written on the templet next to the principal point. The templets are then punched with a slotted templet cutter (Figures 9.5 and 9.6). A circular punch, the size of the metal studs to be used, is cut at the principal point. Then this center is placed over a stud on the slotted templet cutter. The stud is free to move in a groove in line with

Figure 9.5. Slotted templet and slotted templet cutter. (Courtesy Carl Zeiss, Oberkochen.)

Figure 9.6. A more precise slotted templet cutter using an optical-mechanical
system to transfer points on the photo to precise slots on the templet.
(Courtesy Carl Zeiss, Oberkochen.)

the slotted cutting head, which allows the templet to be rotated on the stud and slid
back and forth until a centering pin on the cutting head is directly over the
pinpricked point on the templet. Then long narrow slots, one for each point, are cut
in the templet.

These slots correspond to the lines radiating from the principal point on hand
templets. All templets are assembled with the slots intersecting at the same common
point. Because the studs are free to move only in the radial direction from the
principal points they will adjust themselves into theoretically correct planimetric
map positions. When the templets are all assembled, the project sometimes covers a
large table (Figure 9.7) or even an entire room.

Radial-Arm Templets

The radial-arm method is very similar to the slotted templet method. Instead of
cutting slots in a templet, the radial-arm method uses precut slots in thin metal arms
of various lengths, bolted together at the principal point. The system of radial arms
bolted together to represent a single photo is called a *spider* (Figure 9.8). A set of
spiders assembled over a base map is shown in Figure 9.9.

Radial-Line Plotters

The radial-line plotter (Figure 9.10) is a simple, relatively inexpensive plotter
designed to transfer detail from stereoscopic pairs of paper prints (photos) to maps.
The details transferred can be photo-control points to be used with even simpler
instruments for the transfer detail (Chapter Ten) or the actual detail can be trans-
ferred by constantly solving the radial-intersection problem mechanically. Radial-

Figure 9.7. An assembly of slotted templets.

line plotters remove topographic displacement and affect scale changes between the photos and the map—they do not eliminate tilt displacement. The theory behind the operation of this instrument is the same as for the methods already described.

The primary components of the radial-line plotter consist of an adjustable mirror stereoscope mounted over the two photo stages with a movable, radiating transparent arm attached to the center of each stage. The two radiating arms are linked together by a series of metal rods forming parallelograms. A tracing pencil is attached to the parallelogram.

To operate, each photo of a stereoscopic pair is positioned on one of the stages and fastened with a single pin through the principal point (Figure 9.11). The two photos are then rotated about the pins until the line between the principal and conjugate principal points of both photos is in perfect alignment for stereoscopic vision. The photos are then fastened to the stages with tape. The two transparent radial arms with fine red or yellow lines etched on them are also pinned to the stages through the principal points of each photo.

The other end of the radial arms is attached to a slotted metal bar underneath the stages. The two slotted bars are attached to a single parallel bar with a stud that is free to slide within the slots. The parallel bar is also attached to a plate, which carries the tracing pencil and the fine scale adjustment. Major scale adjustments are made by changing the effective length of the parallel bar by adjusting the position of the studs in the slots. Minor adjustments are made by means of a micrometer screw.

Figure 9.8. A set of radial arms bolted together forming a *spider*. (Courtesy of
Abrams Aerial Survey Corporation, Lansing, Michigan.)

The limits of scale adjustment on most radial line plotters is not great—ranging
between about 0.33 (a reduction) and 1.1 (an enlargement).

The plotter is scaled and oriented over the base map by repeated trials using a
minimum of two control points. To trace detail the operator views the two photos
stereoscopically. When this is done the two fine lines on the radiating arms appear
to intersect in the three-dimensional model. The point of intersection is the true
planimetric position of that point and is recorded on the map by lowering the pencil.
To trace detail, of a road for example, the intersecting lines are placed at one end of
the road, the pencil is lowered and the road is drawn by moving the pencil in such a
way that the radial lines always intersect on the road while viewing the photos
stereoscopically.

ERRORS ASSOCIATED WITH
RADIAL-LINE TRIANGULATION

All methods of performing radial-line triangulation are subject to the following
sources of error:

1. Differential shrinkage of the photos and/or the map base.

Figure 9.9. A radial assembly composed of several *spiders* forming a network of additional control points. (Courtesy of Abrams Aerial Survey Corporation, Lansing, Michigan.)

2. Errors in the location of principal points and the transfer of conjugate principal points.
3. Using tilted photos.
4. Graphical or mechanical errors including the final tracing of detail.

Differential shrinkage creates only small errors, but this can be eliminated completely by using a stable base material such as polyester for both photos and map base. Tilt errors can be kept to a minimum by obtaining as close to tilt-free photos as possible, or by rectification of photos. All other errors can be kept to a minimum only by exercising extreme care in all steps of the operation and by using a sharp-pointed, hard drawing pencil.

Laboratory Exercise

The help of your instructor is required to set up specific laboratory exercises in radial-line triangulation. Generally, all that is needed is a set of aerial photos and a map of the same area with identifying control points or field-measured control points and a statement as to the desired map scale if a new map is to be constructed.

Figure 9.10. Radial-line plotter with a stereoscopic pair of photos properly posi-
 tioned for the mapping process. (Courtesy Philip B. Kail Associates,
 Inc.)

Laboratory exercises could be limited to locating a series of principal points on
an existing map by resection or the establishment of additional control points on
adjacent photographs by intersection. A small amount of detail could also be
transferred by hand templets or a radial-line plotter if available.

The following exercise not only gives the student practice in radial-line triangu-
lation but also allows him or her to actually see that the distortion is radial from the
principal point and that it varies directly with an increase in elevational differences
and the distance from the principal point.

Equipment Needed
The only equipment needed for this exercise are (1) a stereoscope, (2) a
stereoscopic pair of aerial photos with moderate-to-steep topography with several
discrete points that can be positively identified on both photos, (3) three pieces of
transparent material the size of the overlapped portion of the photos, (4) straight-
edge, (5) pinpricker, (6) sharp hard pencil, and (7) masking tape.

Preparation
Have your instructor pinprick three to five well-defined points within the
overlapped portion of one of the photos (not too close to the photo baseline) of the
stereoscopic pair to insure (1) variation in radial distances from the principal point,

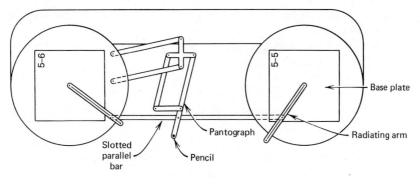

Figure 9.11. Schematic diagram of a radial-line plotter without the mirror stereo-scope. (From D. P. Paine, 1979, *An Introduction to Aerial Photography for Natural Resource Management,* O.S.U. Bookstores, Inc., copyright 1973, reproduced with permission.)

(2) a range of elevational differences between the selected points and the principal point, and (3) some of the selected points should be above and some below the elevation of the principal point.

Steps

The following steps assume that only three points have been selected, but any number of points will work.

1. Circle and number the points selected by your instructor.
2. Pinprick the PP and CPP on both photos and label.
3. Pinprick the points selected by your instructor on the second photo, circle, and number them the same as on the first photo. This transfer process must be as precise as possible and you should use the stereoscope to do so.
4. Place one of your transparent overlays over each photo and secure with tape. At this point it is a good idea to also mark at least two of the fiducial marks on the transparent overlay so that the sheet can be relocated if necessary.
5. With a pinprick, accurately transfer all points on both photos to the transparent overlays. All future work will be done on the overlays.
6. Draw a fine dashed line between the PP and CPP on both overlays and properly label each line.
7. Draw fine solid lines from the PP (not the CPP) of each photo radially through (and ½ in. past) each of the selected points and label them 1, 2, 3, . . . *n.*
8. On the third transparency pinprick two points exactly the same distance apart as the distance between PP and CPP on the *first* photo. Connect the two points with a dashed line, mark the points with a circle or open cross,

and label. This transparency represents a map with the same scale (at the baseline) as the *first* photo.

9. Remove the two transparencies from the photos and place them over the third transparent sheet so that:

 (a) The PP of the first transparency and the CPP of the second transparency are directly over the PP of the map.

 (b) All lines connecting the PPs and CPPs are perfectly aligned, letting the other end of the baseline fall where it will.

10. Being very careful not to change the alignment (step 9) fasten all three acetate sheets together with tape. Pinprick all three sheets where line 1 crosses line 1, where 2 crosses 2, and where 3 crosses 3, etc.

11. Separate the sheets and label the pinpricked intersections on map sheet as 1M, 2M, and 3M, etc. The M stands for map position.

12. Place the map sheet over the *first* photo with the PPs and the CPPs superimposed. Now pinprick the photo positions of points 1, 2, and 3 on the map sheet. Label these points 1P, 2P, and 3P. The P stands for photo position. With an engineer's scale, accurately measure the distance between the map and photo positions for all three points and record below.

Topographic displacement for point 1 = _____ inches
Topographic displacement for point 2 = _____ inches
Topographic displacement for point 3 = _____ inches

Please observe the following:

1. We have forced your map sheet to exactly the same scale as the base line of first photo so that the distances you measured represent displacement due to topography. We can alter the distance between the PPs on the map to achieve any desired map scale. For instructional purposes this was not done because this would eliminate a comparison with the photo positions.

2. Your displacement should be radial from the PP on the *first* photo.

3. The amount of displacement is proportional to the distance from the PP to the points and with their respective differences in elevation.

This last observation can be verified if your instructor knows the flying height above the baseline and has a topographic map of the area so that he or she can get elevations of the PP of the first photo and of the selected points. Then you can find the differences in elevation between each of the selected points and the principal point ($\pm \triangle E$); measure the radial distance from the selected points to the principal point of the first photo and calculate the displacement using the topographic formula:

$$d = \frac{r(\pm \triangle E)}{H}$$

The calculated and measured distances might be slightly different because of (1) mechanical errors in your procedure and (2) tilt in the photographs.

Questions and Problems

1. What is radial-line triangulation?
2. What is radial-line triangulation used for?
3. State whether each of the following variables increases, decreases, or has no effect on the magnitude of topographic displacement on aerial photos. Also state whether the change is toward or away from the principal point.
 (a) A decrease in the distance between the principal point and a given point that is 500 ft higher than the principal point.
 (b) An increase in the distance between the principal point located in the middle of a lake and another point on the same lake.
 (c) An increase in the distance from the principal point where both the original distance and the increased distances are at the same elevation as the principal point.
 (d) An increase in the flying height of the aircraft above the datum.
4. What is the theory of radial-line triangulation?
5. What is the difference between resection and intersection and how does each work?
6. List four mechanical or optical-mechanical methods of performing radial-line triangulation.
7. Draw a schematic diagram of a radial-line plotter and label all essential features.
8. What are four different sources of error that can influence the accuracy of points or the transfer of detail from photos to a map when using radial-line triangulation? How can each of these errors be kept to a minimum?

Ten

The Transfer
of Detail

The transfer of photographic detail to maps can be accomplished by a wide variety of instruments. These instruments range from simple and inexpensive instruments incapable of transferring detail in its true planimetric position to complicated and expensive double projecting stereoplotters. These plotters are capable of producing planimetric and topographic maps with a high degree of accuracy as well as the accurate transfer of detail. In this chapter only an overview of the types of instruments available for the transfer of detail and the establishment of control points will be presented. For a more detailed discussion of these topics refer to the list of references at the end of Part Two.

Objectives

After a thorough understanding of this chapter you will be able to:

1. Define the effective area of a photo and delineate the effective areas of a set of aerial photographs containing portions of three or more flight lines.
2. Draw a schematic diagram to classify the various instruments used to transfer detail from aerial photos to a map — or to produce a new map —as to their basic design and function.
3. Draw a diagram of and write a paragraph to explain the camera lucida principle.
4. List the three components of the multiplex stereoplotting system.
5. With a diagram and a few paragraphs, explain how the multiplex system produces a three-dimensional model using different colored filters (anaglyph system) and how this model is accurately transferred to a map.
6. List two additional methods (other than the anaglyph system) of producing a three-dimensional model using the multiplex system.
7. List and define the three types of orientation required in properly setting up a three-dimensional model for double projecting instruments.

8. List and define the six motions available for orienting diapositives in their correct position when making a planimetric or topographic map.
9. Using the *C*-factor equation, calculate either the minimum flying height or the *C*-factor rating of a camera and stereoplotting system required to produce a contour map of a given accuracy.

EFFECTIVE AREAS

Because of endlap and sidelap on conventional aerial photography it is unnecessary to map the detail from every square inch of every photo. Frequently every other photo within a flight line is mapped, but this still produces considerable duplication of effort. Therefore, the common practice is to establish *effective area* boundaries and map within these boundaries.

The effective area is defined as the central area on a photograph that includes one-half of the overlapping area of all adjacent photos. Mapping only within these boundaries ensures that the entire area is mapped, but with no duplication of interpretation effort. Effective areas can be placed on every photo, or because of more than 50 percent endlap, only on every other photo. In the latter case photos without effective areas are used for stereoscopic vision and not mapped.

If only alternate photos are used, the effective areas are twice as large as when all photos are used. The advantage of mapping on every photograph is that the mapping is closer to the center of the photo where topographic and tilt displacement is less. The disadvantages are that it takes more time to put effective areas on twice as many photos and the total boundary perimeter is greater, which creates more matching problems (of type boundaries for example) among photos.

Regardless of whether every, or every other photograph is used, the mechanics of establishing effective areas is the same. The cross-hatched lines in Figure 10.1 show the theoretical effective area boundary of a single photo in the situation where all photos are delineated. The specific steps in the boundaries of effective areas are:

Step 1

Delineate boundaries between the photographs within the same flight line (figure 10.2)

(a) Overlap the first and second photos of the flight strip and match the images.

(b) Determine the centers of the overlap area along both edges of the matched photos. These points do not have to be located with mathematical precision. Moving a point slightly to permit using a point location that can be transferred to the adjacent photo without the aid

Figure 10.1. Effective area (cross-hatched portion) of an aerial photograph. (Adapted from U.S. Forest Service, Pacific Northwest Forest and Range Experiment Station.)

of a stereoscope is an acceptable practice.

(c) Draw a straight line between these two points as shown at *a*.

(d) Transfer this line to the overlapping photo, as shown at *b*, by the use of a stereoscope or preferably by transferring three or four points usually at the high and low points of the terrain along the original line connecting these points with straight lines. In rough country, the transferred line will not be straight.

(e) Repeat these steps for the overlap between the second and third photos, the third and fourth, etc., as shown at *c*. Each photo except the first and last, will have two approximately parallel lines marking the limits of the effective area.

Figure 10.2. Step one of establishing effective areas. (Adapted from U.S. Forest Service, Pacific Northwest Forest and Range Experiment Station.)

Step 2

Delineate boundaries between lines of flight (Figure 10.3).

(a) Overlap matching photos of adjacent flight strips so that image detail coincides.

(b) Determine the centers of the sidelap.

(c) Draw a straight line (on the top photo) connecting these two center points, as shown at *d*.

(d) Transfer this line to matching photo of adjacent flight strip. (Same procedure as in Step 1 (d).

(e) Transfer the corners formed at *e* on photos 1-1 and 2-1 to photos 1-2 and 2-2.

(f) Overlap photos 1-2 and 2-2 and draw a straight line from point *e* splitting

Figure 10.3. Step two of establishing effective areas. (Adapted from U.S. Forest Service, Pacific Northwest Forest and Range Experiment Station.)

evenly the sidelap of these two photos, as was done in Step 1 (b). Transfer this line to the adjacent photo (2-2).

(g) Repeat the above steps on subsequent photos along the adjacent flight lines.

Step 3.

Cross-reference photos for ease of handling in the field and office (Figure 10.4).

Figure 10.5 illustrates how the effective areas of five photos in two flight lines might look. Once the effective areas have been delineated and the photos mapped within these areas, the transfer of detail from the photos to a map can begin using any of a number of instruments designed for this purpose. The simplest of these instruments effect a change in scale only. The more complicated instruments are capable of removing tilt, topographic displacement, and lens distortion as well as effect changes in scale.

CLASSIFICATION OF PHOTO-MAPPING INSTRUMENTS

There are many different ways of classifying the various photo-mapping instruments. Figure 10.6 diagrams one of these methods. You should study this diagram to help clarify the different types of instruments as to how they function in the preparation of maps with varying degrees of accuracy.

Single-Print Transfer Instruments

Single-print transfer instruments are the simplest type. All they do is transfer detail and change scale. They do not remove tilt or topographic displacement and are not capable of producing topographic maps. When using these instruments, errors caused by displacement and distortion are averaged out between control points by shifting the photo image from time to time during the transfer process.

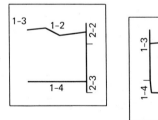

Figure 10.4. Step three of establishing effective areas. (Adapted from U.S. Forest Service, Pacific Northwest Forest and Range Experiment Station.)

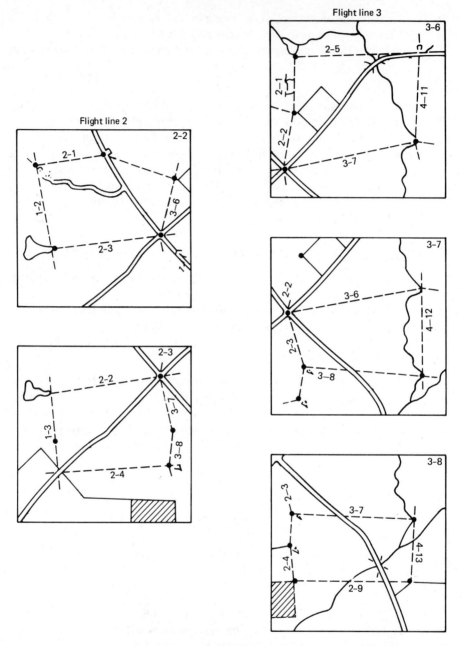

Figure 10.5. Appearance of effective areas on five photos when using every photo.
(Adapted from U.S. Forest Service, Pacific Northwest Forest and
Range Experiment Station.)

Figure 10.6. Classification of instruments that are designed for the transfer of detail from photos to maps or to make new maps.

There are two types of single-print transfer instruments: (1) reflecting projectors and (2) instruments using single prints and the camera lucida principle.

Reflecting Projectors
 Reflecting projectors optically reflect photographic detail onto the map surface. They may reflect the image down to the map for tracing of detail (Figure 10.7) or to the back surface of a frosted glass surface (Figure 10.8). When reflected to the back side of a glass surface, the map must be at least semitransparent in order to trace detail. Both types of reflecting instruments require a dark room for best operation.

Single-Print Camera Lucida
 The camera lucida principle is based on a *semitransparent* mirror used in such a way that the eye receives two superimposed images, one from the photograph and one from the map. The operator simultaneously views the map through the *semitransparent* mirror and the photograph by *reflection from* the first-surface mirror and *through* the semitransparent mirror (Figure 10.9). Thus, the two images are superimposed, allowing the operator to trace detail from the photograph to the map

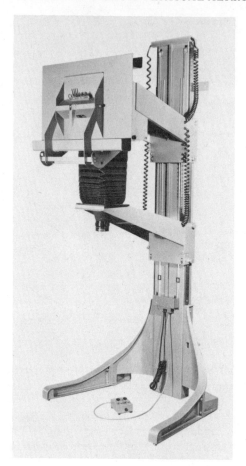

Figure 10.7. Map-O-Graph. The photo
image is projected down
onto a table (not shown).
The entire unit moves up
or down to change scale
and the bellows moves
up or down to focus the
image by altering the
focal length. (Courtesy
Art-O-Graph, Inc.)

Figure 10.8. Kail reflecting projector. The photo is placed emulsion side down over the glass plate at A. The image is reflected over and up to the frosted glass at B. (Courtesy Philip B. Kail Associates, Inc.)

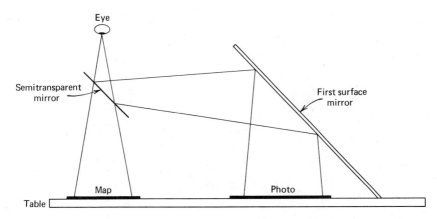

Figure 10.9. Operating components of a vertical sketchmaster using the camera lucida principle. (Adapted from Paul R. Wolf, 1974, *Elements of Photogrammetry*. Copyright 1974, by McGraw-Hill Book Company. Used with permission of McGraw-Hill Book Company.)

or from the map to the photograph if their positions are reversed. The camera lucida principle can also be used with stereoscopic transfer instruments.

There are several types of single-print instruments using this principle that are inexpensive, lightweight, and portable, which makes them ideal for foresters, geologists, range managers, and other natural resource managers who do not always require precise transfer instruments. The vertical and Aero-sketchmaster (a horizontal instrument) (Figures 10.10 and 10.11) are good examples. These instruments can accommodate moderate changes in scale by adjusting the viewing distance to the map and/or the distance to the photo holder, in the case of the Aero-sketchmaster. The Aero-sketchmaster can change the scale ratio from 1:0.4 to 1:2.8. The range is less for the vertical sketchmaster.

The more recently developed Zoom Transfer Scope (Figure 10.12) also makes use of the camera lucida principle. It provides binocular viewing of both the photograph and the base map. There are now two types, the standard model (nonstereo) and the newer stereo Zoom Transfer Scope. These instruments can use either paper prints or transparencies and provide variable enlargement, image rotation, and differential magnification ratios in the x and y direction, for the use of the stretch capability. These features make it a very versatile instrument, which facilitates the adjustment of photo images to control points on the map.

Stereoscopic Transfer Instruments

The two advantages of stereoscopic transfer instruments are that (1) displacement due to tilt and topography can be removed and (2) prior delineation of detail

Figure 10.10. Vertical Sketchmaster. (Courtesy of Keuffel & Esser Company.)

Figure 10.11. Zeiss Luz Aero-Sketchmaster. (Courtesy Carl Zeiss, Inc.)

with a stereoscope is not always required. Some stereoscopic transfer instruments remove only one type of distortion and some remove both (tilt and topographic), while still other more sophisticated instruments can remove lens distortion as well.

Stereoscopic transfer instruments can be classified into two broad categories: (1) those using paper prints and (2) those using diapositives. Diapositives are positive transparencies that are frequently reproduced on glass plates for dimen-

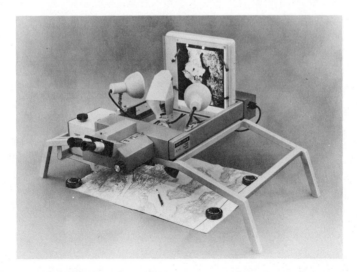

Figure 10.12. Zoom Transfer Scope with wide base. (Courtesy of Bausch & Lomb.)

sional stability when double-projection systems are used. Those using paper prints are optical-mechanical type instruments. Instruments using diapositives can be either direct optical double-projection instruments or instruments that simulate direct optical projection by means of space rods.

Paper Print Stereoplotting Instruments

These instruments are generally less precise than those that use diapositives. Some assume truly vertical photographs and cannot remove tilt. Most remove topographic displacement and some require a parallax bar.

The Stereo Contour Plotter (Figure 10.13), formerly called a stereocompara-graph, consists of a mirror stereoscope and parallax bar mounted together as a unit. It is frequently mounted on a standard drafting arm so that it can be moved in the x and y directions to scan the entire stereoscopic model. With a pencil attachment the instrument can be moved about, tracing details from the stereoscopic model to a map by keeping the floating dot (of the parallax bar) on the ground in the stereoscopic model. Contour lines may also be traced once the parallax bar readings are calculated and set on the parallax bar. With this type of instrument the resulting map contains the tilt and topographic displacement of one of the photos (usually the left one).

The Stereopret (Figure 10.14) consists of an oblique viewing stereoscope, a parallax bar, a movable photo carriage, an instrument base plate, a plotting surface, and a pantograph that provides a scale change of 1:0.2 to 1:2.5. The Stereopret is an instrument of intermediate precision between a mirror stereoscope with a parallax

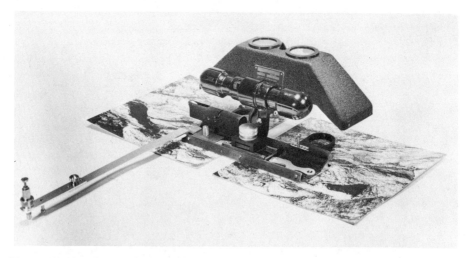

Figure 10.13. Stereo Contour Plotter. (Courtesy Alan Gordon Enterprises, Inc., North Hollywood, California.)

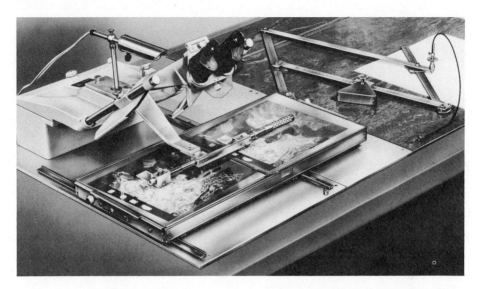

Figure 10.14. Stereopert. This instrument is of intermediate precision between a mirror stereoscope with a parallax bar and a third-order stereo plotter. (Courtesy Carl Zeiss, Inc.)

bar and a third-order stereoplotter.

The KEK plotter (Figure 10.15) is an example of a parallax-bar type instrument that is capable of removing tilt and topographic displacements. The KEK consists of a mirror stereoscope, parallax bar, and a pair of adjustable photo carriers. Each photo carrier can be independently rotated and tilted to eliminate tilt displacement. Topographic displacement is eliminated by raising and lowering the height of the photo carriers at the time of detail transfer by keeping the floating dots on the ground. Contour maps can also be produced using a tracing pencil attachment. Slight scale changes between the photographs and map can be made by means of a pantograph attachment.

The radial-line plotter is another instrument that falls in the category of paper print stereoplotters. This instrument removes topographic displacement only and can make small changes in scale. This instrument was discussed in more detail in Chapter Nine.

The Stereo Zoom Transfer Scope has about the same capabilities as the Zoom Transfer Scope described earlier, except that it utilizes stereoscopic pairs of photos to superimpose a 3-D image on the map. It comes equipped with a mode switch to select any of the following viewing combinations: (1) mode A stereo (left photo-left eye, right photo and map-right eye), (2) mode B camera (right photo and map into camera port), and (3) mode C mono (both eyes see right photo and map superimposed).

Figure 10.15. KEK Stereo Plotter. This is a parallax bar type instrument that is
 capable of removing tilt along with topographic displacement.
 (Courtesy Philip B. Kail Associates, Inc.)

Stereoplotters That Use Diapositives
 These plotting instruments, frequently called double-projection stereoplotters,
are the most common type of instrument used for the accurate production of maps
from aerial photography. They are capable of removing tilt and topographic
displacement and some with the aid of a minicomputer, even remove lens distortion.
 There are three broad categories of stereoplotters that use diapositives: (1)
direct optical projection instruments, (2) optical-mechanical instruments, and (3)
automated instruments.

Direct Optical Projection Instruments
 There are many different makes of these instruments but they all use the same
basic principle. The multiplex system illustrates the theory of double-projection
stereoplotters (Figure 10.16).
 There are three distinct systems involved: (1) the projection system, (2) the
viewing system, and (3) the tracing and measuring system.
 The projection system consists of two high-intensity light projectors that
project images from a stereoscopic pair of diapositives located between the condenser
and objective lenses (Figure 10.17). A diapositive is a positive transparency, a

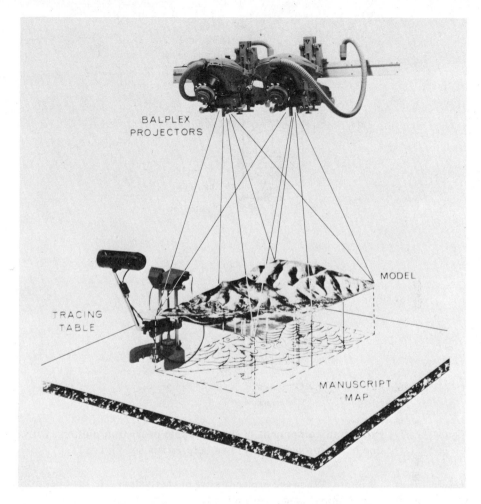

Figure 10.16. The multiplex system of double projection stereoplotters. (Courtesy of Bausch and Lomb.)

35-mm slide for example. Diapositives used in optical projection systems are larger than 35 mm and are frequently made of glass for dimensional stability. An anaglyphic filter is positioned between the light source and the lens system of both projectors. These filters are of complementary colors, usually red and blue. Thus two different images of the same terrain are projected to the tracing table, each in a different color.

The viewing system enables the operator to see the model three dimensionally. In the case of the anaglyphic multiplex system, stereoscopic viewing is accomplished by viewing the model through red and blue glasses (filters), a different color over each eye. Thus the left eye sees only one photo and the right eye simultaneously

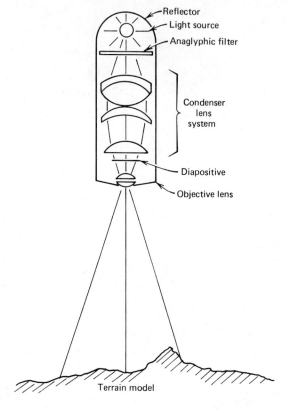

Figure 10.17. Projection component of direct double projection plotters. Only one of two projectors is shown here. (Also, see Figure 11.3.)

sees only the other photo. When the projectors are properly oriented, the operator sees a true three-dimensional model within the overlap area (Figure 10.16).

The viewing system just described is called the anaglyph system. More recently developed systems include the polarized-platen system and the stereo-image alternator system.

The polarized-platen system essentially uses the same theory as the anaglyph system. Instead of colored filters, filters of opposite polarity are placed in front of the projectors and the operator wears glasses with correspondingly polarized filters over each eye.

The stereo-image alternator system uses synchronized shutters in front of each projector lens and another pair of shutters in front of the platen (Figure 10.18). These shutters are synchronized so that alternate images of the left and right photographs are flashed on the viewing screen to present a stereo view of the terrain model in the mind of the operator.

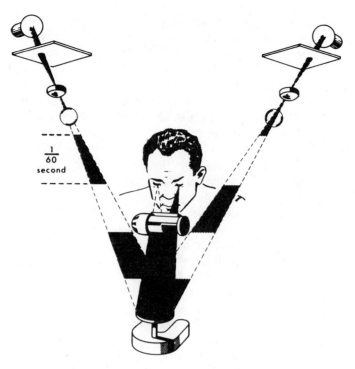

Figure 10.18. Stereo-alternator system. (Copyright 1961, by American Society of Photogrammetry, reproduced with permission.)

Both of the newer systems have two distinct advantages over the anaglyph system. They both cause a minimum of light loss and allow the use of color diapositives. Another advantage of all three of these methods of creating a stereoscopic model is that the normal accommodation-convergence relationship is not altered as it is when using a stereoscope. The lines of sight between your two eyes do not have to be parallel while focused at a short distance.

The main component of the measuring and tracing system is the tracing table or platen, the white round disc in Figures 10.16 and 10.18. In the center of the platen is a small hole through which shines a tiny speck of light that acts as a reference point. With the projectors properly oriented, this point appears to float in space within the model. The platen can be raised and lowered by turning a screw, which through a system of gears is attached to a dial from which vertical elevation can be read. Using the proper set of gears allows for vertical measurements to be made directly in feet or meters at the ground scale.

A tracing pencil is located directly below the floating point. When drawing contours, the floating point is adjusted to the desired elevation, the pencil is lowered and contours are traced onto the base map by moving the entire tracing table over

the map while keeping the floating dot on the ground within the stereoscopic model. In order to move the tracing table over the map without friction and without wear, some tracing tables are equipped with an air-bearing attachment, which provides a cushion of filtered air 20 microns (20μm) thick. Planimetric detail, such as roads, streams, and vegetation boundaries, may also be traced. Because these features are not necessarily on the same vertical plane, the operator must constantly raise and lower the platen to keep the floating dot on the ground while tracing.

There are three types of orientation required in order to produce a true three-dimensional model from which to work: (1) interior orientation, (2) relative orientation, and (3) absolute orientation. Interior orientation involves the preparation of the diapositives and properly positioning them within the projectors.

Relative orientation consists of adjusting the two projectors in such a manner that they are in exactly the same relative position to one another as was the film at the instant of exposure. To do this each projector is independently moved in six different directions or motions. They can be moved in the x, y, and z directions. The z direction is up and down and the x and y directions were defined in an earlier chapter. They can also be tilted about both the x and y axes. The sixth motion is called swing, which is a rotational movement about the z axis.

To accomplish relative orientation, the operator must use the floating dot on the platen and proceed through a series of adjustments in a repetitive manner until exact relative orientation is accomplished. The actual method of doing this is beyond the scope of this book. A complete set of operating instructions is included with the purchase of each instrument as well as in many books on photogrammetry.

The last step in the overall orientation process, absolute orientation, is to bring the model to the desired scale and level it with respect to a reference datum. Scaling the model within narrow limits is accomplished by moving the projectors closer together to reduce the scale or by pulling them apart to increase the scale without changing the relative orientation. The model scale is set within limits by the scale of the photography and the characteristics of the particular stereoplotter used. Plotters equipped with a pantograph can further alter the model scale to the desired map scale. Otherwise, the model scale and map scale are the same. A miniumum of two horizontal control points is necessary to scale the model, but it is a good idea to have a third control point as a check.

The final step in absolute orientation is leveling the model, which requires a minimum of three vertical-control points distributed over the model to form a large triangle. Actually four or five control points are desirable. The actual leveling consists of moving the entire projector assembly by tilting the bar on which the projectors are mounted in the x and y directions until the model is level as indicated by the floating point on the platen when set for the correct vertical elevations. This leveling process can upset both the scaling and the relative orientation, requiring the operator to repeat all these processes in an iterative manner until the model is oriented as accurately as possible.

Optical-Mechanical Instruments

Optical-mechanical projection stereoplotters simulate direct optical projection plotters by means of two metal space rods (Figure 10.19). Instead of using different-colored filters and glasses the operator looks through binocular viewers which, through a system of mirrors, allow the left eye to see the left diapositive and the right eye to see the right diapositive. When properly oriented this produces a true stereoscopic model in the mind of the operator. This system uses half marks, which fuse into a single mark that appears to rest on the surface of the model.

The whole system is very similar to that of the direct optical projection plotters. The telescoping space rods are attached to the tracing stand, which has a tracing pencil for recording detail on the map in the same way as for the direct double-projection systems.

Automated Stereoplotters

In recent years research has taken place to design automatic stereoplotters that can eliminate the human operator. Potential advantages of these instruments include increased speed, reduced costs in the long run, and increased precision. At present the original capital outlay for these instruments is very high and not economically justifiable except for oganizations with very extensive mapping needs.

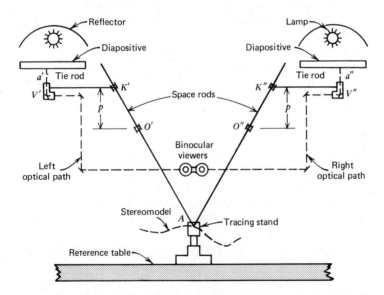

Figure 10.19. Basic principle of mechanical projection systems. (From Paul R. Wolf, 1974, *Elements of Photogrammetry,* copyright 1974, by McGraw-Hill Book Company. Used with permission of McGraw-Hill Book Company.)

ACCURACY OF STEREOSCOPIC PLOTTERS

The relative accuracy of stereoscopic plotters that produce contour maps is commonly expressed in terms of a C factor. The C factor is defined as the flying height of the aircraft above the ground divided by the contour interval that can be reliably plotted. Reliably plotted means that 90 percent of all elevation points selected at random on the map must be accurate to one-half the contour interval and 100 percent of all points accurate to within one contour interval. Therefore the C factor is determined not only by the plotting instrument but also by the entire camera system, quality of photography, the number of ground-control points, and ability of the stereoplotter operator as well. Nevertheless stereoplotting instruments are usually rated according to an approximate C factor — usually somewhere between 500 and 1800. In equation form the C factor is:

$$C \text{ factor} = \frac{H}{\text{CI}} = \frac{f(\text{PSR})}{\text{CI}}$$

where CI is the contour interval.

In actual practice the C factor equation is usually solved for the maximum H allowed for a given contour interval desired using a specific stereoplotter. For example, suppose you want to make a 20-ft contour interval map with a stereoplotter rated at $C = 800$ ft, what is the maximum flying height? It would be 800 times 20 feet, or 16,000 ft.

The C-factor relationships can also be used to determine instrument requirements. Suppose photography has already been flown at 8000 ft above the ground and we want a 5-ft contour interval map. This would require a stereoplotter with a C-factor rating of at least 1600.

Questions and Problems

1. Draw a diagram that classifies the operational features of types of instruments discussed in this chapter as to their operation and use.
2. Draw a diagram and explain in a short paragraph the theory of the camera lucida principle and how it is used to transfer detail.
3. What is the basic theory of the multiplex system that produces a three-dimensional model?
4. What are the two components of the multiplex stereoplotting system other than the viewing system? List and describe the three types of viewing systems discussed.
5. List the three types of orientation required to properly set up a stereoscopic model using a double-projecting instrument. Specifically what does each type of orientation accomplish?
6. What are the six motions available to the operator for orienting the diapositives in their correct relative positions for producing a three-dimensional model?

7. What would be the maximum allowable flying height above the ground if we wanted to make a topographic map with 2-ft contour intervals using a stereoplotting instrument with a *C*-factor rating of 1200?

8. Suppose we have high-quality aerial photography from which we wish to make a 10-ft contour interval map. What would be the minimum acceptable *C*-factor rating of a stereoplotter if the average PSR of the photography was 13,750 and was taken with an 8¼-in. focal length lens camera?

Eleven

Orthophotography

During the past two decades orthophotography has become an increasingly popular and useful tool for land managers. As quality and availability improves, this trend will continue. It combines the planimetric precision of maps with the wealth of detail found on aerial photographs.

Objectives

After a thorough understanding of this chapter you will be able to:

1. Define fully what orthophotography is and how it differs from conventional aerial photography.
2. With words and diagrams explain fully how orthophotographs are made using the anaglyph principle.
3. List two categories of optical projection orthophotoscopes and state the primary advantage of each type of instrument.
4. Explain fully the difference between a standard orthophoto and a stereomate which, when used together, can be used stereoscopically.
5. State the primary advantage of an orthophoto as compared to (a) conventional photography and (b) line maps.
6. State the primary disadvantage of standard orthophotography as compared to conventional photography for detail photointerpretation.

ORTHOPHOTOGRAPHY—WHAT IS IT?

An orthophoto is a photo reproduction that has been corrected for tilt, topographic displacement, and sometimes camera lens distortion (Figure 11.1). Orthophotos are produced from stereoscopic pairs or triplicates of aerial photographs by a process called differential rectification so that the resulting photographic images are in a correct orthographic position.

An orthophoto differs from a standard rectified photograph in that only tilt has been removed from a rectified photo, whereas topographic displacement is also

Figure 11.1. An orthophoto with contour lines superimposed. This looks like an
ordinary photo, but all topographic displacement has been removed.
(Courtesy Wild Heerbrugg Instruments, Inc.)

removed in an orthophoto. Ordinary rectification is accomplished by copying the
nonrectified print or negative with a camera that is tilted relative to the original
negative in such a way that the new photo is free of tilt.

Differential rectification as used to produce orthophotos also requires the
rephotographing of the original imagery. However, instead of rephotographing the
entire image all at once, it is done in very small segments (in thousands for a 9 by 9
in. photo) or by a series of narrow strips. These segments or strips are all brought to
a common scale by keeping the scanning slit continually in contact with a three-
dimensional *terrain model*. The resulting orthophoto is planimetrically correct,
which allows one to make accurate measurements of distance, area, and direction
directly on the orthophoto.

A theoretically perfect orthophoto could be achieved only if each infinitely
small point in the stereoscopic model is exposed separately. Orthophotoscopes
using scanning slits of about 5 mm in size can therefore only approximate a perfect
orthophoto. However, for all practical purposes, this approximation is entirely
satisfactory. The size of the slit and the scanning speed can be altered to achieve the
results desired. Smaller slits and slower scanning rates should be used for rugged
topography than for flatter terrain.

Orthophotos are geometrically equivalent to standard line and symbol maps, but instead of lines and symbols they show actual photographic images. Therefore there is much more detail on an orthophoto. All detail that is recorded by the camera system is potential detail for the final orthophoto. Because an orthophoto is planimetrically correct it is considered to be a map—or more correctly an orthophoto map.

HOW ORTHOPHOTOS ARE MADE

The production of an orthophoto entails the conversion of conventional photography by utilizing a double-projection orthophotoscope. The first orthophotoscopes were modified conventional stereoplotting instruments. Even though the idea of orthophotos originated in the early 1900s, they did not appear in the United States until the 1950s and did not become fully operational until the late 1960s. Today, highly specialized equipment such as U.S. Geological Survey's Model T-64, Gigas-Zeiss Orthoprojector GZ-1, Wild Avioplan OR (Figure 11.2). Kelch K-320 Orthoscan, and other similar models are used.

Photographic Requirements

In some cases existing photography can be used to produce an orthophoto but a special mission is frequently necessary to produce photography to fulfill all the many constraints imposed by the equipment and the desired final product. These constraints include the selection of proper geographical positions for exposure stations, the proper sun angle and film, as well as the usual constraints of focal length, flying height, endlap, and sidelap. Although not always necessary, the

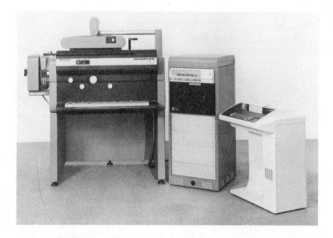

Figure 11.2. Wild Avioplan OR1 orthophotoscope. (Courtesy Wild Heerbrugg Instruments, Inc.)

correct location of exposure stations allows for quad- or township-centered ortho-
photos. Selecting the proper sun angle minimizes shadowed areas (caused by
topography) and the proper selection of film emulsion, film speed, and exposure
time assures proper densities in the subsequent orthonegatives. Because the final
orthophoto is several generations removed from the original photo negative, this is
more important for orthophotography than for conventional photography.

The Anaglyph Principle

Even though each year brings development of more complicated and sophisti-
cated orthophotoscopes, the basic principle remains the same. Most orthophotos
are produced through the use of diapositives and direct optical projection systems
that use the anaglyph principle (Chapter Ten).

Figures 11.3 and 11.4 illustrate the basic theory of double-projection ortho-
photography using the anaglyph principle. An anaglyph consists of the two super-
imposed images of the overlapped portion of a stereoscopic pair of photos. These
superimposed images are produced by double-projection optical systems within

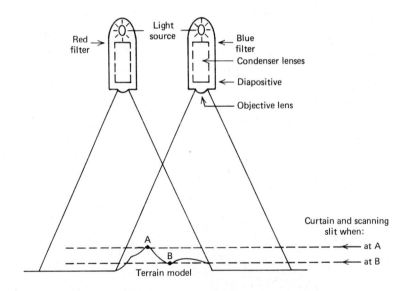

Figure 11.3. Operating principle of an orthophotoscope. The movable two-piece
curtain (see Figure 11.4), shown at positions A and B, is moved up
and down by the operator to keep the scanning slit always on the
ground within the model during the scanning process. (From D. P.
Paine, 1979, *An Introduction to Aerial Photography for Natural
Resource Management,* O.S.U. Bookstores, Inc., copyright 1973,
reproduced with permission.)

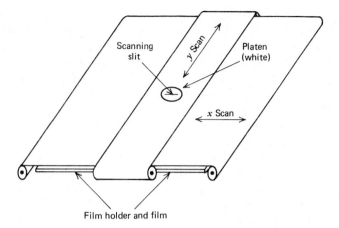

Figure 11.4. Movable two-piece curtain of the model T-64 orthophotoscope with scanning slit and platen through which the film is exposed to produce orthophoto negative. (Adapted from Paul R. Wolf, 1974, *Elements of Photogrammetry.* Copyright 1974, by McGraw-Hill Book Company. Used with permission of McGraw-Hill Book Company.)

most orthophotoscopes by placing red and blue filters between the light source and the diapositives—a different-colored filter for each projector. The three-dimensional model, as viewed through colored glasses (also red and blue), is projected by the orthophotoscope onto a film carrier that can be raised and lowered by the operator. The table carries a photographic film (the film plane) that is sensitive only to blue light. When exposed and developed, this film becomes the orthophoto negative.

Some orthophotoscopes like the U.S. Geological Survey's model T-64 use a stereo triplicate and three projectors. Red filters are used in the outside projectors and a blue filter is used in the middle projector. This produces two stereoscopic models but only one model can be correctly viewed by the operator at a time. To view the other model the red and blue filters, worn as glasses, must be reversed from one eye to the other. In operation the outside projector not being used is turned off.

The Scanning Mechanism

Situated directly above the unexposed film is a dark-colored, two-piece, movable curtain (Figure 11.4), with a small slit through which the film is exposed. Surrounding the slit is a small, circular white disc called a platen. In operation the operator sees only the portion of the stereo model that is projected onto the platen. The curtain is constructed in such a way that the scanning slit can be moved in both the *x* and *y* direction to scan the entire model. During exposure the film remains stationary with respect to the *x* and *y* directions but is raised and lowered along with

the curtain by the operator, who keeps the scanning slit on the ground of the stereo model. The slit acts as a floating dot as discussed in previous chapters. When each y scan is complete the slit is moved its length in the x direction and a new scan line is made. This process is repeated until the entire model is covered.

The y scan is achieved by an electric motor that steadily moves the slit across the film as the operator keeps the scanning slit always on the ground in the model. A constant scan speed is necessary to ensure uniform exposure of the film. The film, being sensitive only to blue light, is exposed by the rays from only one of the projectors. By switching filters, either of the diapositives of the stereo pair can be used to produce the orthophoto negative.

The orthophoto negative is at the same scale as the stereoscopic model. However, enlargements or reductions can be made from the orthophoto negative by conventional photographic means. The orthophoto scale will depend on the projected use and desired quality. Orthophotography has its widest acceptance for mapping at scales 1:12,000 and smaller.

ANNOTATION

Orthophotos are produced to complement or replace conventional line maps. They can be produced rapidly, economically (as compared to an accurate map), and generally meet map accuracy standards if adequate ground control is used. Grid lines, and frequently, township, range, and section lines can be printed on the final orthophoto along with the names of towns, rivers, ridgetops, and other features of interest along with a legend, scale, and other features found on conventional line maps. Contour lines can also be added to produce topographic orthophoto maps.

IMAGE QUALITY

The quality of orthophotography is generally lower than that of standard photography. There is the problem of keeping the film clean and free from dust and scratches during all reproduction phases. There are also problems of tone matching between scanning strips, visible scanlines, image blurring, duplication of imagery, gaps, and scanline discontinuities.

The most troublesome problems are created when scanning steep terrain. When producing orthophotos of terrain with slopes of over 40° with some optical orthophotoscopes, image blurring will occur due to rapid up and down movement of the film plane. When using electronic scanning systems, blurring is eliminated because the terrain is continously and differentially rectified by patch scanning and the film plane is stationary at the instant of exposure.

Resolution of the final imagery is less than the original photography, primarily because the final image is frequently four to five generations removed from the original. Most of the resolution is lost during the process of diapositive production.

However, this loss of resolution does not detract from the production of high-quality, accurate orthophotos.

Economically, orthophotography is considerably more expensive to produce than conventional photography but is less expensive than the production of accurate and detailed maps.

CLASSIFICATION OF INSTRUMENTS

There are two different types of instruments used to produce orthophotos. The most widely used type produces images by direct optical projection, and the other type produces images electronically. Instruments of the first type are modified versions of standard optical projection stereoplotters and require an operator. Electronic instruments are automatic, but their cost is so high that their use is limited.

The optical projection instruments can be further classified into two categories—on line and off line. On-line instruments are the least expensive. They expose the orthonegative at the time of actual scanning and no record of profile elevations is recorded. Off-line instruments produce orthophotos in two separate operations and a record of profile elevations is made. First, profiles are scanned and recorded either in graphic or digital form on computer tapes. In a separate operation the profile data is read into an instrument that automatically exposes the orthonegative as determined by the profile information.

A disadvantage of the on-line system is that operator errors regarding the film-plane orientation cannot be corrected without beginning the entire scanning process again. Because off-line systems require two separate steps, errors can be erased and corrected on the computer tape before the orthonegative is exposed.

STEREOSCOPIC ORTHOPHOTOGRAPHY

What would happen if we were to stereoscopically view two orthophotos, one made from each member of a stereoscopic pair of aerial photographs? The resulting image would be flat because all topographic relief has been removed. However, a relatively recent development makes it possible to use a standard orthophoto and a stereomate with a stereoscope to produce a three-dimensional model (Figure 11.5). The stereomate is a differentially rectified photograph on which image shifts have been introduced that are proportional to elevation differences in the terrain. This might be visualized as taking all topographic displacement out of one photo (resulting in the orthophoto) and adding it to the other photo of the stereo pair (the stereomate).

The stereo orthophoto model in Figure 11.5 is exceptionally sharp. This is the result of another advance in technology. Higher-order differential rectification is due to the elimination of double images and gaps at the interface of adjacent scan strips that are present in the old technique.

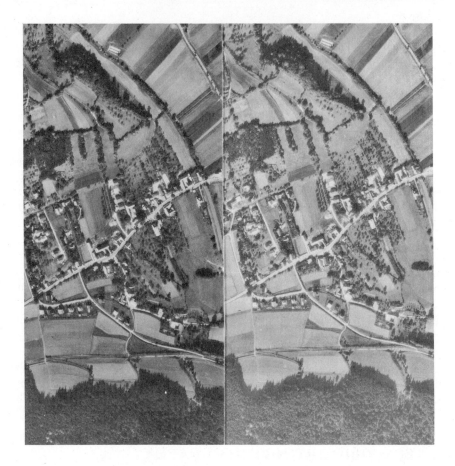

Figure 11.5. Stereogram composed of a standard orthophoto (right) and a ste-
reomate (left). The PSR is 10,000 and the scanning slit used was 5
mm by 0.1 mm. Scanning time for the entire 9 by 9 inch orthophoto
was 16 minutes and for each of two stereomates was 7 minutes for the
Avioplan OR1 orthophotoscope. (Courtesy Wild Heerbrugg In-
struments, Inc.)

Double images and gaps can be eliminated by the use of a computer built into
an orthophoto system such as the Avioplan OR1 (Figure 11.2), which processes the
data from neighboring scans. The computer instantaneously determines the control
commands for the optical system and drives the picture carriage on the center line
of the image profile. The result is a sharper image without double images and gaps.

Stereo orthophotography combines the advantages of stereoscopic viewing for
interpretation with geometric accuracy for mapping purposes. However, it must be
remembered that, because of the loss of resolution associated with orthophotog-

raphy, the resulting three-dimensional model has less detail than a standard stereo-scopic pair of aerial photographs and is therefore inferior to standard stereoscopic aerial photography for interpretation purposes.

APPLICATIONS IN NATURAL RESOURCE MANAGEMENT

Even though the usefulness of orthophotography for natural resource manage-ment has been enhanced by the development of stereo orthophotography, the greatest demand is for its use as base maps. With an orthophoto, the forester, range manager, engineer, or geologist can correlate images on the photo with those observed in the field much more easily than with a conventional line map. Knowing the scale of the orthophoto, the land manager can make direct measurements on the orthophoto with accuracy. Field observations can also be plotted accurately on orthophotography without first making a base map.

Annotation of orthophotography for land managers can include contour lines, section and township lines, and man-made features not otherwise visible on the photo. In addition overlays can be produced that contain vital information neces-sary for making land-use planning decisions. These may include soil classification, vegetative classification, insect and disease information, geologic data, existing or potential recreational developments, forest or range-fire prevention information, grazing allotments, the location of timber sales and logging roads, and silvicultural treatments. The collection of this type of information on separate overlays for a single base map with unlimited detail provides the overview necessary for the planning process and allows for the comparison of different interpretations afforded by the different specialists involved.

The stereo orthophoto has additional potential, particularly for land managers working in areas with steep topography, for geologic interpretation, road location, and timber-sale layout. Distances and areas can be accurately calculated on the standard orthophoto, thus eliminating errors involved in the transferral of data to a separate base map.

ADVANTAGES AND DISADVANTAGES
OF ORTHOPHOTOGRAPHY

The primary advantage of the orthophoto map as compared to standard line planimetric or topographic maps lies in the abundance of detail found on the orthophoto, which is not present on the conventional map. Instead of conveying detail by lines and symbols, the orthophoto shows the natural and cultural detail by photographic images. The orthophoto potentially shows all the photographic detail that appears on the original aerial photograph. When compared to conventional photography, the orthophoto shows the exact location of all features allowing for the precise measurement of areas, distances, and bearings. However, the *conven-tional* orthophoto is of less use for detailed photointerpretation because of the loss of resolution and the absence of displacement necessary for stereoscopic viewing.

Questions

1. What is orthophotography and how does it differ from standard photography?

2. What kind of data base (planimetric map, standard orthophotography, stereophotography) would be best to accomplish the following?
 (a) Identification of timber in stands for the purpose of making a type map.
 (b) Calculation of the area of a recent forest fire in mountainous terrain.
 (c) Measurement of tree heights for the purpose of determining timber volumes.
 (d) Establishment of property lines on the ground using only the data base selected.

3. With words and diagrams explain fully the theory of orthophotography using the anaglyphic principle.

4. What is the primary advantage of (a) on line orthophotoscopes, (b) off-line orthophotoscopes?

5. In what way is standard orthophotography: (a) superior to conventional aerial photography, (b) inferior to conventional aerial photography and (c) superior to a planimetric map?

References for Part Two

American Society of Photogrammetry. 1960. *Manual of Photographic Interpretation*, Falls Church, Va.

American Society of Photogrammetry. 1966. *Manual of Photogrammetry*, Third Edition, Falls Church, Va.

American Society of Photogrammetry. 1968. *Manual of Color Aerial Photography*, Falls Church, Va.

American Society of Photogrammetry. 1975. *Manual of Remote Sensing*, Falls Church, Va.

Blachut, T. J. and M. C. von Wijk. 1970. "3-D Information from Orthophotos," *Photogrammetric Engineering*, Vol. 36, No. 4. pp. 365-374.

Bureau of Land Management. 1973. *Manual of Instructions for the Survey of the Public Lands of the United States*, U.S. Dept. of the Interior. U.S. Government Printing Office, Washington, D.C.

Collins, S. H. 1968. "Stereoscopic Orthophoto Maps." *The Canadian Surveyor*, Vol. 22, No. 1.

Collins, S. H. 1972. "The Stereophoto Pair." *Photogrammetric Engineering*, Vol. 38, No. 12. pp. 1195-1202.

Deetz, C. H. and O. S. Adams. 1938. *Elements of Map Projection,* Fourth Edition, U.S. Dept. of Commerce, Coast and Geodetic Survey, Special Publication 68.

Kelly, R. E., P. R. H. McConnell, and S. J. Mildenberger. 1977. "The Gestalt Photomapping System." *Photogrammetric Engineering and Remote Sensing*, Vol. 43, No. 11. pp. 1407-1417.

Moffitt, F. H. 1959. *Photogrammetry*. International Textbook Company, Scranton, Pa.

Paine, D. P. 1979. *An Introduction to Aerial Photography for Natural Resource Management*, Oregon State University Bookstores, Inc., Corvallis, Ore.

Robinson, A. H., R. D. Sale, and J. Morrison. 1978. *Elements of Cartography*, Fourth Edition, John Wiley and Sons, New York.

Spurr, S. H. 1960. *Photogrammetry and Photointerpretation*, Second Edition, The Ronald Press Company, New York.

Simpson, J. A. 1968. *Manual of Instructions for Use of Oregon Plane Coordinates,* Oregon Technical Institute, Klamath Falls, Ore.

Strahler, A. N. 1951. *Physical Geography.* John Wiley and Sons, New York.

Trewartha, G. T., A. H. Robinson, and *E. H. Hammond.* 1967. *Elements of Geography,* Fifth Edition, McGraw-Hill Book Company, New York.

Wilson, R. L. 1969. *Elementary Surveying and Mapping.* Oregon State University Bookstores, Inc., Corvallis, Ore.

Wolf, P. R. 1974. *Elements of Photogrammetry.* McGraw-Hill Book Company, New York.

Part Three

Photo Interpretation

Twelve

Films, Filters and the Photographic Process

In Chapter One, a generalized energy flow profile from the source to a sensor located in an aircraft or satellite was presented. The energy source for aerial photography is usually the sun from which light rays are reflected by features of earth's surface back to the camera to form a latent image on the film. In this chapter we briefly discuss the theory of color and then trace the energy flow through the camera lens and filters, to the film, and finally to the final product, which is usually a positive paper print or positive transparency.

Objectives

After a thorough understanding of this chapter you will be able to:

1. Draw two diagrams to fully illustrate (1) the optical mixing of the three primary additive colors and (2) the optical subtraction of the three primary subtractive colors from white light.
2. Explain why a reflecting surface appears to have a particular color.
3. Explain what a photographic filter is and give one practical use for each of the following types of filters used in aerial photograpy: (1) antivignetting, (2) polarizing, (3) haze cutting, (4) color correcting, and (5) narrow band pass.
4. Given the Aerial Exposure Index rating of a film and a filter factor, calculate the appropriate adjusted index rating to be used in determining exposure.
5. List four advantages and disadvantages of panchromatic and standard color films as compared to infrared films (both color and black and white) and state the sometimes overriding disadvantage of infrared photography.

6. List one primary advantage and two disadvantages of color photography as compared to black-and-white photography.

7. Given a list of factors that influence resolution, state whether each factor is directly or inversely proportional to resolution.

8. State how resolution is measured and calculate the resolution given the minimum width of a line that is barely discernible on a given photograph.

9. Outline the steps involved in the production of a final image using (1) negative film and (2) color reversal film, starting at the time light energy first strikes the film.

10. State the relationships between silver halide size, film graininess, film speed, and resolution.

11. Give one advantage and two disadvantages of color reversal films as compared to color negative films.

THE THEORY OF COLOR

Light is that portion of the electromagnetic spectrum that is visible to the eye and for most people ranges between approximately 0.4 and 0.7 micrometers (μm). White light is composed of the three primary additive colors that are red, green, and blue. Other colors are mixtures in varying proportions. An additive primary color is one that cannot be created by adding other colors.

There are also three primary subtractive colors: cyan, magenta, and yellow, which are combinations of two of the primary additive colors. Similarly, optically subtracting two primary subtractive colors creates one of the primary additive colors. These relationships are illustrated in Plate I, top. Notice that optically adding the three additive primaries produces white light and that when all filters composed of the subtractive primary colors are placed in front of white light, the result is black, which is no light at all. This can be demonstrated in the classroom using three projectors and the proper filters. Notice that we are dealing with the mixing of light—mixing red, green, and blue paint pigments certainly would not produce white paint.

The Munsell System

Even though color is difficult to describe, it can be quantitatively measured in terms of brightness, hue (color), and saturation as illustrated in Figure 12.1. Hue is quantified in terms of wavelengths. The Munsell color chart is based on this system.

The Phenomenon of Color

The phenomenon of color is the result of a sequence of events. First, there must be a source that is modified either by reflectance from, or transmitted through, some medium. You do not see a beam of light in a dark room until it is reflected from

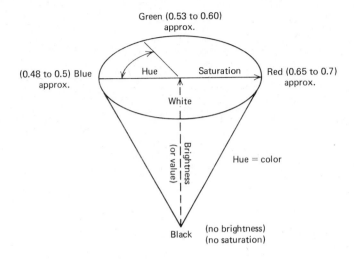

Figure 12.1. The quantification of color by brightness, hue, and saturation. (Copyright 1967, *Photogrammetric Engineering,* Vol. 33, No. 9, published by the American Society of Photogrammetry, reproduced with permission.)

something like a wall or particles of dust and moisture in the air. Next, this modified light must reach the optical and physiological components of the eye. Finally, a signal must be sent to the brain to create a mental image in color.

Why Are Objects a Particular Color?

Let's consider the reflection of white light, which is really a mixture of blue, green, and red light (Figure 12.2). If the reflecting surface absorbs green and blue, but reflects red light, it appears red. Similarly, an object that absorbs red and green appears blue, and absorbing red and blue results in green.

What would be the color of surface that reflects all the white light it receives? It would appear white—a mixture of red, green, and blue. Similarly, a surface that does a poor job of reflecting white light would appear dark or black because the white light is absorbed as heat energy. This is why it is preferable to wear white or light-colored clothing when the weather is hot and dark-colored clothing when it is cold.

Filters work a little differently. A red-colored filter, when held up to a white light source, appears red because it *absorbs* blue and green but *transmits* red light. A filter that transmits red and green and absorbs blue will appear yellow. It is frequently called a minus-blue filter. Table 12.1 shows the colors of light absorbed to produce colors as seen by the human eye.

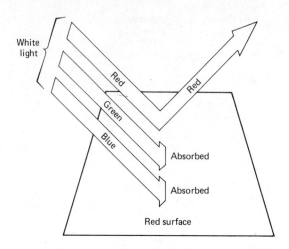

Figure 12.2. A red surface appears red because green and blue light is absorbed while red light is reflected. (Adapted from Eastman Kodak Company, 1978, copyright Eastman Kodak Company, 1975, reproduced with permission.)

TABLE 12.1 Perceived Colors from Reflected White Light from Surfaces with Different Light Absorption Characteristics

Perceived Colors	*Colors Absorbed*
Red	Blue and green
Green	Red and blue
Blue	Red and green
Magenta (red plus blue)	Green
Cyan (blue plus green)	Red
Yellow (red plus green)	Blue
White (red plus green plus blue)	None
Gray	Equal percentage of red, green, and blue
Black	Red, green, and blue

Adapted from Eastman Kodak Company, 1978a.

FILTERS FOR AERIAL PHOTOGRAPHY

A filter is a piece of material (frequently glass) placed between the film and the reflected light rays coming from the scene, which absorbs unwanted light rays, thus not allowing them to reach the film. Filters for aerial cameras are classified by their use (American Society of Photogrammetry, 1968). The following classifications are

used here: (1) antivignetting, (2) polarization, (3) haze compensation, (4) color correction, and (5) narrow band-pass filters.

Antivignetting Filters

Antivignetting filters compensate for unequal light transmission associated with very-wide-angle lenses for 9 in. by 9 in. format and larger cameras. At present it is impossible to design these lenses so that they transmit as much light to the corners and edges of the film as to the center. Thus, these filters have a slightly darkened central area that gradually diminishes from the center to the outside edge. This filter should be matched to the characteristics of a particular lens and should be checked for light-transmission characteristics for all $f/$ stop settings.

Polarizing Filters

Polarizing filters are used to penetrate haze and to reduce reflections from surfaces such as water. Smith (1968) stated that research and use of polarizing filters for vertical aerial photography has been neglected. In some of his experiments he polarized water surfaces to the extent that *shallow* ocean bottoms appeared as if all the water has been removed. Polarization is effective only when the angle of reflection is approximately 35° and therefore polarization must be well planned in relation to the sun angle. There is no effect when the sun is directly above the aircraft.

Polarization does not refer to a light property that we can see, such as brightness or hue. It is concerned with the direction in which a light ray vibrates. Usually, light rays vibrate in all possible directions. A ray is said to be polarized when the vibrations in all directions but one are absorbed. Thus, polarizing filters transmit only the rays of light that are traveling in a specified plane as illustrated in Figure 12.3. Visualize the filter as a grate with parallel slits. As the grate is rotated, the slits that are parallel to the plane of polarization allow only those rays to be transmitted. Different amounts of polarization can be achieved by different amounts of rotation.

In operation the main filter is placed over the lens of the camera and geared to a second, smaller polarized filter through which the photographer looks. Thus the

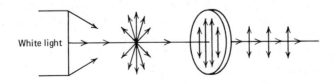

Figure 12.3. How a polarizing filter works. (From *Manual of Color Aerial Photography,* 1968, copyright 1968, by American Society of Photogrammetry, reproduced with permission.)

photographer turns the small filter, which also turns the large filter to determine the desired amount of polarization.

Haze-Cutting Filters

Atmospheric haze is caused by weather conditions (dust and moisture particles) or by humans through their creation of smoke and other air pollutants. Haze is the scattering of blue light by these particles in the atmosphere. Haze-cutting filters remove various amounts of blue light and range from almost clear to dark yellow. For aerial photography, the greater the flying height, the darker is the recommended filter. In general, infrared photography uses the darker filters and, hence, has better haze penetration.

Color-Correction Filters

Color-correction (CC) filters are most commonly used in the color-printing process and sometimes in picture taking with unusual light sources such as fluorescent lights. They are available in cyan, magenta, yellow, blue, green, and red in various densities ranging from 0.025 to 0.50. For example, a CC20Y (yellow) filter would absorb about 20 percent of the blue radiation.

More recently CC filters have been used in the picture-taking process in conjunction with color infrared film to achieve a shift in color balance to increase the interpretability in some situations. For example, Worsford (1972) and Tarnocai and Thie (1974) found that the filter combination of W12 + CC20M (W = Wratten, 12% (yellow), and M= magenta) provides the best photographs in terms of image sharpness while retaining infrared data and a combination of W12 + CC20B provides the best information in terms of infrared content. Research concerned with the use of these filters in the picture-taking process has just begun and their use will probably increase in the future.

Narrow Band-Pass Filters

Narrow band-pass filters, sometimes called spectrazonal filters, are used for color separation purposes when using multiband color enhancement (Chapter Thirteen). When working with the full photographic spectrum including infrared, four filters are used: W47 (blue), W58 (green), W25A (red), and W89B (infrared). These filters are used with black-and-white infrared film to produce color separation negatives.

Spectral Characteristics of Filters

Because different filters absorb different amounts of light energy in different wavelengths, they are best described by two-dimensional curves of the percent transmission over wavelength. Figure 12.4 illustrates the characteristics of 3 out of the approximately 100 filters available. Notice that the percent transmittance axis is a logarithmic scale. The Wratten 15 filter is yellow and transmits red and green light

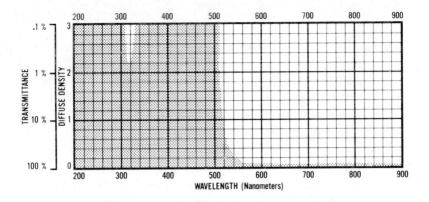

Wratten 15 (yellow)

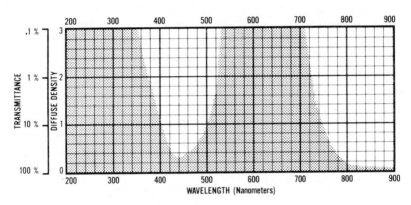

Wratten 47 (blue)

Infrared filters

Figure 12.4. Spectral characteristics of three of the many filters available. (From Eastman Kodak Company, 1978, copyright 1970, reproduced with permission.)

beyond about 0.52 μm while absorbing blue light. Infrared filters transmit only infrared radiation beyond about 0.7 μm, and are used for *true* infrared photography. You cannot see through these filters. The Wratten 47 filter is an example of a spectrazonal filter that allows only blue light to pass. A whole series of CC magenta filters ranging from 0.025 to 0.50 densities are shown in Figure 12.5. Notice that these filters do not completely absorb any wavelength.

Filter Factors

Because filters absorb light, either the shutter speed, f/stop, or both must be changed for proper exposure. Each film-filter combination has a known filter factor to be used in calculating an adjusted exposure when using filters. Because each film type has different spectral characteristics, the same filter used with different films may have a different filter factor. Filter factors keyed to film speeds are simple to use. For example, suppose the aerial exposure index (speed) of a particular film is 400 and you wish to use a filter with a filter factor of 4. You simply divide the aerial exposure index by the filter factor to get the effective rating—in this case you would get 100.

Figure 12.5. Spectral characteristics of the magenta color correction filters. (From Eastman Kodak Company, 1978, copyright 1970, reproduced with permission.)

PHOTOGRAPHIC FILM TYPES

Even though there are several different types and makes of aerial photographic film they can be easily classified as to black and white and color. Within the black-and-white category, most films are either panchromatic or infrared (Figure 12.6). Panchromatic film is sensitive to approximately the same wavelengths as the human eye (0.4 to 0.7 μm), thus producing a natural-looking image. Black-and-white infrared film has a sensitivity range between 0.4 and 0.9 μm. True infrared photography utilizes a black filter, such as the Wratten 89B, to absorb all the visible spectrum (below 0.7 μm). Modified infrared photography is produced from infrared film in conjunction with either a yellow or red filter, which allows some of the visible spectrum to react with the film in addition to the photographic infrared region of the spectrum. Sometimes modified infrared photography combines the advantages of both types of film.

Color film can also be classified into two broad categories, normal color and color infrared (Plate I bottom and Plate II). Normal color film is sensitive to the 0.4 to 0.7 μm range of the spectrum just like panchromatic film. Color infrared, like black-and-white infrared, has had its sensitivity extended to 0.9 μm. Figure 12.7 illustrates the range of sensitivity of the various films discussed. A yellow filter is always used with color infrared film and sometimes CC filters are used in addition. Color infrared film is frequently called false color film because the colors in the final product do not match the natural colors of the objects photographed. The most obvious color difference is that all live, healthy, and green foliage appears red while dead foliage appears green or some color in between. The predecessor to this film was called camouflage detection film and was used to detect areas camouflaged with nonliving foliage or green paint. Green paint, even though green, does not reflect the photographic infrared region of the spectrum, causing the image to show up as blue on the film (Plate II, bottom). Other color differences are shown in Table 12.2.

Following is a list of advantages of panchromatic and normal color film as compared to infrared film (both black and white and color) followed by advantages of infrared film as compared to panchromatic film.

Advantages of Panchromatic and Normal Color Films

1. Standard color is more natural to the human eye than color infrared. Panchromatic is more natural to the human eye than black-and-white infrared, because we are more accustomed to viewing panchromatic than infrared photography.
2. More detail can be seen *within* areas covered by shadow.
3. Usually there is better resolution with panchromatic than with infrared film.
4. Better *penetration* of water.

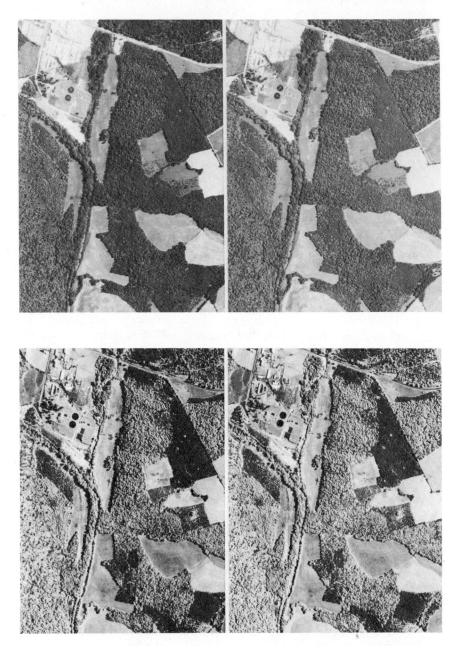

Figure 12.6. Comparison of panchromatic photography (top stereogram) and black-and-white infrared photography (bottom stereogram). The difference between conifers (dark forests) and hardwoods (lighter forest) is much more pronounced on infrared than on panchromatic photography. (Courtesy of Illinois Photographic Service.)

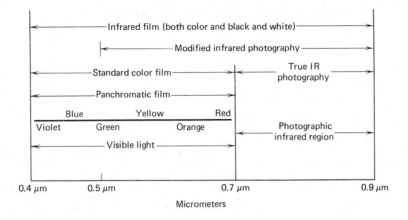

Figure 12.7. Range of sensitivity of various film types within the photographic range of the spectrum. (Adapted from D. P. Paine, 1979, *An Introduction to Aerial Photography for Natural Resource Management.* O.S.U. Bookstores, Inc., copyright 1973, reproduced with permission.)

TABLE 12.2 Appearance of an Object on Normal Color and Color Infrared Photography

Object	Normal Color	Color Infrared
Most hardwood foliage	Green	Magenta
Most coniferous foliage	Green	Magenta to dark-blue magenta
Young conifers	Green	Magenta to pink
Old conifers	Green	Dark-blue magenta
Plant foliage (brush)	Light green	Pink
Sick foliage	Yellow	Mauve
Hardwood foliage (autumn)	Yellow	White
Larch foliage (autumn)	Yellow	Mauve to white
Hardwood foliage (autumn)	Red	Bright yellow
Dead, dry foliage	Straw-yellow to red-brown	Yellow to yellow-green
Defoliated branches	Gray to brown-black	Green, blue-green, blue
Defoliated branches with exfoliated bark	Whitish	Silvery, silvery-green
Wet branches, exfoliated bark	Dark gray	Green, blue-green, blue
Shadows	Blue (with some detail)	Black (without detail)
Clear water	Blue-green	Light blue
Silty water	Light green	Dark blue to black

Adapted from Murtha (1972).

Advantages of Black-and-White and Color Infrared Films

1. Better penetration of haze.
2. *Emphasizes* water and moist areas.
3. Good differentiation between hardwoods and conifers (Figure 12.6 and Plate V, left).
4. Sick, dying, or stressed vegetation is more easily detected—especially on color infrared film (Plate III).

The above advantages can be restated as disadvantages of the other type of film. Because there are as many advantages listed for infrared as for panchromatic film it might appear that it is an equally good film for overall interpretation of natural resources. This is not usually the case. The overriding disadvantage of infrared film (particularly black and white) is that details within shadowed areas are not visible. This becomes a very serious problem in areas with tall dense forests and/or steep topography. This effect can be reduced, however, by obtaining what is called shadowless photography (see Plate IV and Chapter Thirteen).

THE PHOTOGRAPHIC PROCESS

Photographic film is used not only because it produces images that are easily recognizable but also because it is capable of storing a very large quantity of data for long periods of time.

Black-and-White Film

Photographic film consists of a film base for support and a light-sensitive emulsion. There are other layers or coatings such as anticurl and antihalation backings and even an antistress or antiscratch layer over the emulsion layer, but the emulsion layer is where images are formed and stored. The antihalation backing prevents light from reflecting back through the emulsion to cause haloes around bright parts of the photo.

The film base should have low shrink characteristics in order to keep dimensional distortions to a minimum, especially if the photography is to be used to produce maps. Although it is not possible to completely eliminate shrinkage and swelling, the use of modern polyester-based films has greatly minimized the problem.

Silver Halides

The heart of any photographic film emulsion consists of silver halide crystals suspended in gelatin. These light-sensitive silver halides are in the form of silver chloride, silver bromide, silver iodide, or any mixture of the three. The silver halide crystals vary in size and any emulsion has a mixture of many different sizes. The *average* size of the silver halide crystals is an important feature of any photographic film because it has significant influence on (1) the amount of light required to form an image and (2) on the film's graininess, which influences resolution. The emulsion

layer also contains other chemicals for stability and improvement in its sensitivity to light.

The Latent Image

The latent image is a pattern of an image produced by exposure to light that can subsequently be made visible by development. Before development there is no visible change, not even with a powerful microscope. Early films used only the shorter wavelengths of visible light to produce latent images but modern films are sensitive to the longer wavelengths as well.

Exposure

The proper exposure of a film depends on its speed, the amount of energy reflected from a scene back through the lens and the filter, the filter used, the relative size of the camera aperture (f/stop), and the shutter speed. This can be looked at as the total amount of energy reaching the film. The amount of energy reaching the film also depends on the intensity and quality of the light source, which is usually reflected sunlight in the case of aerial photography.

Film speed or its sensitivity to light is dependent on the number and size of silver halide crystals and other chemicals in the emulsion and is also affected by the way in which the film is processed. Film speed can be calibrated using any one of a number of different exposure indexes. Unfortunately there is no simple way of converting from one system to another. Film for terrestrial cameras usually utilizes the ASA or DIN exposure rating systems, while aerial photography uses the AEI or AFS system.

The difference between aerial and terrestrial exposure indexes is attributable to haze and other characteristis of the atmosphere. There are at least nine different atmospheric components of sunlight that influence the brightness and, therefore, the brightness range of a photographic scene. For example, a 20:1 reflectance ratio (at ground level) between light and dark terrain objects may be reduced to 10:1 on clear days and to as low as 3:1 under heavy atmospheric conditions when flying above 15,000 ft. The goal of the photographer is to produce imagery as it would appear without atmospheric haze.

To help the aerial photographer determine the correct exposure, Kodak has developed an aerial exposure computer (American Society of Photogrammetry, 1968) in the form of a circular slide rule, which gives the proper combination of shutter speeds and f/stops based on the solar altitude angle, aircraft altitude, and corresponding Aerial Exposure Index (AEI) for various film-filter combinations.

Grain

One factor that affects film speed is the size of the silver halide crystals. An emulsion with large crystals needs less light (faster film) to form an acceptable image than an emulsion with small crystals. Actually, a large crystal does not need any more light to create a latent image than a small crystal, but a large crystal will yield

more metallic silver when developed, thus requiring fewer crystals of silver (and less total energy) to produce dark tones on the negative.

To cut down on image motion it might seem desirable for aerial film manufacturers to always produce fast films with large crystals. However, this approach has a disadvantage; the bigger the crystals, the poorer the image. Coarse-crystal emulsions produce grainy or speckled photographs that are lacking in fine detail. Actually, because individual crystals are never visible, graininess is the result of an uneven distribution and overlapping of many crystals. The balance between speed and grain is also influenced by other chemicals in the gelatinous emulsion and by the developing process. Some compromise between speed and grain is necessary depending on the objectives of the photographic mission.

Resolution

Resolution is defined and measured in several different ways. The simplest and most commonly used definition for aerial photography expresses resolution as to the number of line-pairs per millimeter that can just barely be distinguished. The standard U.S. Air Force resolution target (Departments of the Army, Navy, and Air Force, 1967) is shown in Figure 12.8. This target consists of a series of parallel black bars on a white background with a 100:1 contrast. The length of each line is five times its width and the spaces between black lines are equal to the width of the black lines. Successive patterns within the target are progressively smaller.

Figure 12.8. Standard U.S. Air Force resolution target. (*From Image Interpretation Handbook,* Volume 1, 1967, Department of the Army, Navy and the Air Force.)

When using the target, the width of the line is the combined width of the black line and the space. For example, suppose the width of the smallest black line barely distinguishable on a photograph is 0.02 mm, the combined width is 0.04 mm, and the resolution is 25 line-pairs per millimeter for a 100:1 contrast ratio.

There are many things that affect resolution. First, there must be a difference in reflected energy between an object and its background reaching the film. If this is not the case, the best imaging systems available cannot create a discernible image. This is the reason for stating the contrast ratio along with the number of line-pairs per millimeter. Resolution is also affected by the quality of the lens and the spectral sensitivity of the film. A fine-grained film has better resolution capabilities than a coarse-grained film.

In general, resolution is directly proportional to:

1. The contrast ratio between the object and its background.
2. The ratio between the object's length and its width.
3. The number of objects in the pattern.

Resolution is inversely proportional to:

1. The graininess of the film.
2. The amount of image motion during exposure.
3. The amount of atmospheric haze present.

Resolution can be considered from a different aspect. We might want to know the size of the smallest object that we can see on the ground. The answer to this question depends on photo scale as well as all the aspects of resolution already discussed. Suppose we have two photographs with the 25 line-pairs per millimeter resolution, but at different scales. We would be able to discern smaller objects on the ground with the larger-scale photograph.

Negatives

The negative is formed when millions of exposed silver halide crystals are converted to silver metal in the developing process. The developer greatly magnifies the slight chemical changes that took place in the creation of the latent image to create a visible photographic image on the negative. The areas on the film receiving the most light are darkened by silver and areas receiving no light at all remain transparent on the developed negative because they contain no silver. When the film is *fixed* in the development process, residual silver halides not used to produce the metallic image, are removed. Intermediate areas receiving various amounts of light, and therefore intermediate amounts of silver, create varying shades of gray (tone differences) to produce images.

Very briefly, the developing process consists of:

1. Immersion of the film in a chemical developing solution.
2. Immersion in another chemical solution to stop the developing process.

3. Fixing to remove unaffected silver salts.
4. Washing to remove all processing materials.
5. Drying.

Positives

Most black-and-white films employ a negative-to-positive sequence. A black-and-white negative image is a reversal of the original scene. That is, bright images of the original scene are dark on the negative and vice versa. The geometry of the negative is also reversed from right to left and top to bottom.

A second reversal of both brightness and geometry is the result of the negative to positive process which results in a positive image with true relative brightness and geometry. Paper print processing is nearly identical to the processing of a negative. Most aerial photography utilizes a *contact printing procedure* although enlargement printing techniques are also employed. The negative is placed in emulsion to emulsion contact with the print paper. Light is then passed through the negative exposing the emulsion layer of the print paper to produce a latent image, which becomes a positive print when developed. Positive images can also be produced on plastic- or even glass-based emulsions producing diapositives—a 35 mm slide, for example.

Color Film

Aerial color films are available as either reversal color films or as negative color films. Negative color films produce color negatives in a similar manner as described for black-and-white photography except that three separate color emulsion layers are involved. Color negatives are also reversed as to scene brightness and geometry, and the negative colors are complements of the original scene. Prints made from the negatives are correct as to geometry, brightness, and color of the original scene. Color reversal films produce color positive transparencies *directly* without first producing a negative.

One disadvantage of a transparency is that it must be viewed over a light table, which makes field use somewhat difficult, although portable light tables for field use have been developed. Another disadvantage of color reversal film is that the final product is the original film used in the camera. Thus if it is damaged or destroyed it cannot be replaced. The primary advantage of transparencies is that they are very fine grained and reveal a maximum of detail. Because of this feature, transparencies are preferred by photo interpreters using light tables and magnifying stereoscopes.

Even though color reversal films are designed to produce color transparencies, some can be processed to color negatives from which both black-and-white and color positive prints can be made. One such film is Kodak Aerocolor Negative film, 2445. This film is the basis for the Kodak Aero-Neg Color system from which color transparencies, prints and glass diapositive plates as well as black-and-white paper prints and diapositive glass plates can be produced.

The actual processing of color film will not be covered in this book but a general discussion of the various emulsion layers of two typical aerial color films follows. A thorough understanding of how those emulsion layers produce images in the final product greatly aids in their interpretation, especially the interpretation of color infrared photography in which the perceived colors are different than the original scene.

Normal Color Negative Film

Figure 12.9 is a schematic diagram showing how the various colors of the original scene are reproduced on a typical normal color photograph. At A we have the spectral reflectance of the original scene for the three primary additive colors and reflected or photographic infrared. At B we have the film after exposure, but before development. The blue-sensitive layer has been activated by blue light, the green-sensitive layer has been activated by green light, and the red-sensitive layer has been activated by red light. Because normal color film is not sensitive to reflected infrared, none of the light-sensitive layers has been activated by infrared radiation. Notice the yellow filter between the blue and green sensitive emulsion layers. This is to prevent blue light from reaching the green and red sensitive emulsion layers which are also *slightly* sensitive to blue light.

At C we have the photograph after development. We can think of color film as having three separate layers of silver halide crystals. In black-and-white film development, the silver halides that are not activated are washed out. However, in color film processing, dyes are introduced into each sensitivity layer in *inverse* proportion to the intensity of light recorded in each layer. For example, an intense exposure of the blue layer to blue light results in little or no yellow dye being introduced into the yellow dye layer, but with large amounts of magenta and cyan dyes being introduced into the other two layers as shown. When viewing the developed image with a white light source we see the colors of the original scene through the subtractive process as illustrated at D. For example, when the original blue object is viewed in white light, the magenta dye subtracts the green component, and the cyan dye subtracts the red component leaving the blue component. Original green and red colors are perceived in a similar fashion and all other colors are various mixtures of green, red, and blue.

Color Infrared Film

Color infrared film is of the color reversal type. It also has three separate emulsion layers containing silver halide crystals into which colored dyes are introduced. However, from this point on there are distinct differences as illustrated in Figure 12.10. Once again at A we have the spectral reflectance of the original scene for the three additive primary colors and reflected infrared energy. At B we have the film after exposure, but before development. At this point you should notice some

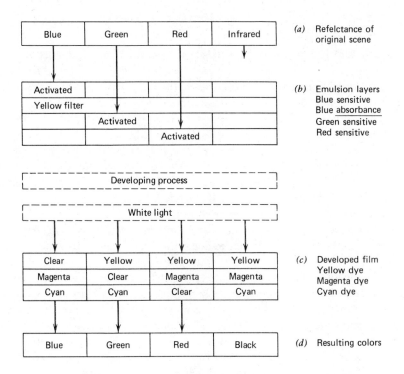

Figure 12.9. Color formation on normal color film. This film consists of three separate emulsion layers and a built in yellow filter under the blue sensitive layer. (Adapted with permission from *Kodak Aerial Films and Photographic Plates,* 1972, Eastman Kodak Company and the *Manual of Remote Sensing,* published by the American Society of Photogrammetry, copyright 1975.)

PLATE I Color additive (top left) and subtractive (top right) processes. See text for more detail. (Courtesy Eastman Kodak Company, copyright Eastman Kodak Company, 1972, reproduced with permission.) At bottom left is a scene recorded on Kodak Ektachrome *Infrared* Film 2443 and at lower right is the same scene recorded on Kodak Aerochrome MS Film 2448. (Courtesy Eastman Kodak Company, copyright Eastman Kodak Company, 1979, reproduced with permission.)

PLATE II Normal color film (bottom) and color infrared film (top) of the same scene. See text for details (Chapter Twelve, p. 235-247). (Courtesy of Illinois Photographic Service.)

PLATE III Color infrared film showing the difference between healthy vegetation (red to pink) and dead, dying, or stressed vegetation (tan, green, or dark green). Upper left — Mountain pine beetle kill (tan) and fall-colored yellow needles of larch trees (white). PSR = 3,000. Upper right — Tussock moth kill (green), PSR = 5,000. Lower left —Winter shadowless photography of diseased trees (green), the white is snow. (All courtesy of U.S. Forest Service, Pacific Northwest Forest and Range Experiment Station.) Lower right — normal color (top) and CIR (bottom) of late blight in potatoes. Diseased plants are dark green on the CIR photo. (Courtesy Maine Agriculture Experiment Station, University of Maine.)

PLATE IV Shadowed (top) and shadowless (bottom) normal color photography
Both photos were taken in January 1974. The upper photo was taken in full sunlight
out with a low (winter) sun angle — the lower photo was taken under a complete cloud
cover. See Chapter Thirteen for a discussion of shadowless photography. (Courtesy
U.S. Forest Service, Pacific Northwest Forest and Range Experiment Station.)

PLATE V Left: Color infrared photo showing a contrast between hardwoods (bright red to pink) and conifers (dark red to purple) and a variety of textures caused by different sizes of timber. See the section on texture, Chapter Thirteen, p. 256.

Right: Example of Anderson et. al., 1976, "Land Use and Cover Classification System." See Chapter Sixteen. (Right photo, courtesy U.S. Environmental Protection Agency, Environmental Monitoring and Support Laboratory, Las Vegas, Nevada.)

PLATE VI Examples of Poulton's Comprehensive Ecological Legend System on 1:250,000 enlarged CIR Landsat imagery (top) and 1:130,000 high-flight CIR photography (bottom). Macrorelief symbols are not shown. South San Francisco Bay—Crystal Springs Reservoir Area. See Chapter Sixteen for a discussion on legend systems and Chapter Twenty-five for LANDSAT information. (Courtesy Dr. Charles E. Poulton, Earth Satellite Corporation, and NASA.)

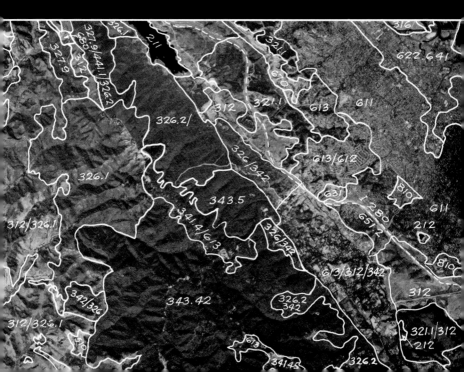

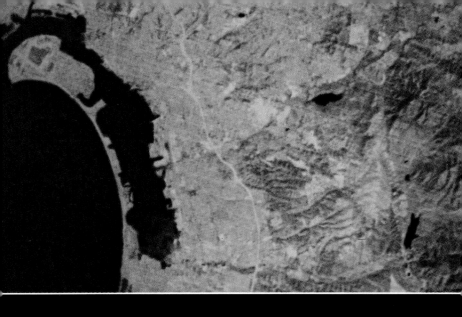

PLATE VII Enlarged 1:250,000 LANDSAT image of the San Diego Bay area (top) and LANDSAT/Radar color composite of the same area (bottom). See Chapter Twenty-four for more information. (Courtesy of Goodyear Aerospace Corporation and Aero Service Division of Western Geophysical Corporation of America.)

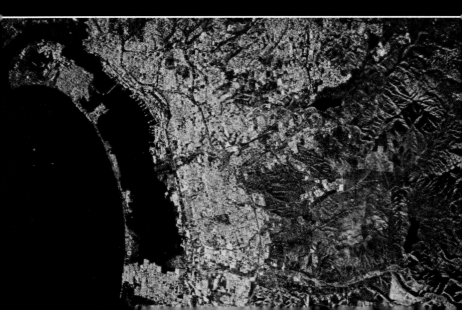

PLATE VIII Top left: Color radar image — 1:100,000 scale. (Courtesy of Goodyear Aerospace Corporation and Aero Services Division of Western Geophysical Corporation of America.) Top right: Color-coded computer interpretation of lava beds and forest cover type in central Oregon. See Table 22.2 for legend. (From R. D. Lawrence and J. H. Herzog, 1975, copyright 1975, by the American Society of Photogrammetry, reproduced with permission.) Bottom: color infrared photograph of forest land in southwest Oregon showing a contrast between clear-cutting policies of two different ownerships, 1:30,000 scale. See Chapter Sixteen and Table 16.2 for more information.

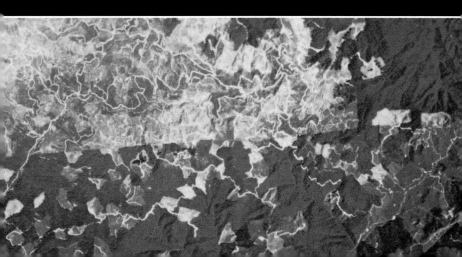

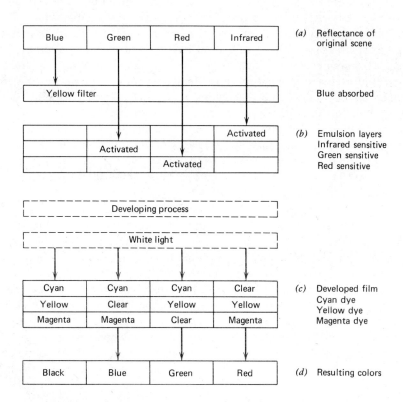

Figure 12.10. Color formation on color infrared film. This film also consists of three separate emulsion layers, but the yellow filter is in front of the film and not a part of it. (Adapted with permission from *Applied Infrared Photography*, 1977, Eastman Kodak Company and the *Manual of Remote Sensing*, published by the American Society of Photogrammetry, copyright 1975.)

differences in the emulsion layers. The layers of this film are sensitive to reflected infrared, green and red energy instead of blue, green and red. Another difference is that the blue absorbing filter is not in the film but on the camera, which prevents blue light from reaching *any* of the three layers.

Other differences are shown at C. For example, green light has activated the green-sensitive layer that is now the *yellow* dye layer in contrast to normal color film in which the green-sensitive layer was the *magenta* dye layer. Thus the yellow dye layer is clear after processing, leaving cyan and magenta, which produces blue when viewed. In a similar manner red images in the original scene appear green and reflected infrared energy produces a red image on color infrared film. Notice the green *painted* tanks on the normal color stereogram in Plate II, bottom. The same tanks are a definite blue on the color infrared stereogram of the same area (Plate II, top). On the same pair of photos the red roofs of houses on the normal color photo show up as green to a greenish-yellow on the color infrared photo. But why does the green grass and tree foliage appear red and not blue on the color infrared photo as did the tanks? This is because healthy green foliage is highly infrared reflective and the infrared sensitive layer creates red on this type of film.

Because most healthy plant foliage is basically green it is frequently difficult to separate conifer from deciduous trees and brush on normal color film. The task becomes a little easier on color infrared film as indicated in Table 12.2 and illustrated in Plate V, left. It has been reported that conifer needles reflect as much photographic infrared as do hardwood leaves (Olson, 1962) but conifers photograph darker on infrared films. This is partially accounted for by the greater area of shadow in the conifer crown caused by individual needles and branches (Murtha, 1972). The broad, flat hardwood foliage provides a continuous reflecting surface with fewer changes. It has also been shown that young coniferous foliage reflects more photographic infrared than old foliage (Plate V, left). Thus, young conifer reproduction frequently has about the same infrared reflectance as brush, making their separation more difficult.

One of the most important forestry and agricultural uses of color infrared photography is in the detection of foliage under stress caused by insects or disease (Plate III), and drought, or other factors. Sometimes incipient disease development can be detected with color infrared film before it becomes visible on any other film or to the human eye. This is true for potato blight (Plate III, bottom) (Manzer and Cooper, 1967), rust and virus diseases of small grains, and some diseases of citrus fruit trees, but not for coniferous trees. However, insect and diseased conifers are usually easier to pick out on color infrared than any other film after damage is visible to the eye.

Advantages and Disadvantages of Color Films
Compared to Black-and-White Films

The primary advantage of color as compared to black-and-white photography for interpretation purposes is that the average observer can discriminate somewhere

between 20 thousand and 5 million different colors (depending on the literature source) as compared to only 200 shades of gray. Thus, even if the colors on photographic film are not true, the greater number of discernible levels of separation is extremely valuable to the interpreter.

The main disadvantages of color film as compared to black-and-white film are: (1) the greater expense of production, as well as storage to keep colors from fading and (2) the resulting images on photographic *prints* are generally not as sharp. Images on color positive *transparencies* can be very sharp, however.

CHOICE OF FILM

The proper choice of film to use in a given situation is not always easy. Should you use normal color, color infrared, black-and-white panchromatic, or black-and-white infrared? Color films are generally more expensive, but the added number of colors discernible to the eye as compared to shades of gray for black and white photography generally makes color film better for identification and interpretation purposes even though they may not be quite as sharp as black and white film. For plant species identification and cover type mapping, color is usually best; for insect and disease damage identification, color infrared is usually best, while black and white (panchromatic) is usually best for photogrammetric mapping purposes.

However, if the choice is some type of color film, there are other problems. Color reversal film is sharper and contains more detail than color negative film, but the film actually used in the camera becomes the final diapositive used for interpretation. If it is damaged or destroyed it cannot be replaced. It is possible to make paper prints or duplicate diapositives from the original film but this is expensive and the copies are not as good as the original. There is always a loss in resolution and detail each time the photographic process is used. Then, if you decide that color negative film is the best choice, you are limited to regular color because all color infrared film is of the reversal type.

The final choice is one of economics to accomplish the particular job required. In general, if using a more expensive film type that will give you more information vital to your project, its use will be cheaper in the long run if it reduces the amount of field checking required, or if the data obtained are more accurate.

A good example of improved accuracy for timber type identification obtained through the use of color infrared photography as compared to panchromatic photography is illustrated in Table 12.3. A 12 percent gain in overall accuracy, expressed as a percentage of area correctly identified, was obtained through the use of color infrared film. Notice specifically the eucalyptus type. Eucalyptus was correctly identified 95 percent of the time on color infrared film and zero percent of the time on panchromatic film.

TABLE 12.3 A Comparison of Timber-Typing Accuracy Between Panchromatic and Color Infrared Film (CIR) Based on 1:30,000 Scale NASA Photography—Flicker Ridge Study.

Cover Type	Total Area (Acres)	Mixed Hdwds.	Mont. Pine	Eucalyp-tus	Knob. pine	Chap-arral	Red-wood	Grass-land
		Pan-CIR	Pan-CIR	Pan-CIR	Pan-CIR	Pan-CIR	Pan-CIR	Pan-CIR
Mixed hardwoods	653	85-88	0-0	0-0	1-2	7-5	5-5	2-0
Monterrey pine	15.5	58-32	10-45	0-16	19-0	0-0	0-0	13-7
Eucalyptus	87	0-0	0-0	0-95	98-0	0-2	2-3	0-0
Knobcone pine	33	3-1	0-0	0-0	79-94	18-5	0-0	0-0
Chaparral	185	13-11	0-0	0-0	3-5	77-79	0-0	7-4
Redwood	199.5	32-6	0-0	0-0	0-0	0-0	68-94	0-0
Grassland	287	3-2	0-0	0-0	0-0	1-2	0-0	96-96

Correct identifications are in the dark boxes. Adapted from Lauer (1968).

Questions and Problems

1. Draw two diagrams that illustrate the results of optically (1) mixing the three primary additive colors and (2) subtracting the three primary subtractive colors from white light.
2. What is a photographic filter?
3. List one use for each of the following types of filters: (1) antivignetting, (2) polarizing, (3) haze cutting, (4) color correcting, and (5) narrow band pass.
4. What is the color of a reflecting surface that absorbs the following colors assuming a white light source:
 (a) Red?
 (b) Green?
 (c) Blue?
 (d) Red and green?
 (e) Red and blue?
 (f) Green and blue?
 (g) Red, green, and blue?
 (h) None?
5. Suppose you are using a film with an AEI of 200 and wish to use a filter with a filter factor of 2. What would be the adjusted AEI to use in determining exposure?
6. For each of the characteristics listed, state whether they are characteristics of infrared (black and white or color) or panchromatic film. Note that

characteristics of panchromatic film are the same as for normal color film.

(a) Best penetration of haze.

(b) Moist areas more easily discernible.

(c) More detail visible in shadows.

(d) Looks more natural to the human eye.

(e) Best separation of conifers from hardwoods.

(f) Best separation of healthy from unhealthy foliage.

(g) Best penetration of water.

7. List one primary advantage and two disadvantages of color photography as compared to black-and-white photography.

8. State whether film resolution is directly or indirectly proportional to each of the following factors: (a) ratio of object's length to width, (b) film grain, (c) amount of image motion, (d) the number of objects in the pattern, (e) amount of atmospheric haze present, (f) contrast ratio between the object and its background.

9. What would be the resolution of a photograph on which the smallest width discernible of a *single black* line on a standard resolution target was 0.05 mm?

10. Trace the steps involved in the production of a final image on (1) a positive paper print using color negative film, and (2) a diapositive using color reversal film.

11. Give one advantage and two disadvantages of color reversal film.

Thirteen

Principles and Techniques of Aerial Photo Interpretation

Even though the title of this chapter concerns aerial photo interpretation, all chapters in Part Three are concerned with photo interpretation. Before studying this chapter you should have a thorough understanding of those parts of Chapter One that discuss the electromagnetic spectrum, the energy flow profile, and the photographic process, all of Part One, and Chapter Twelve. It is permissible, however, to skip Part Two, Photogrammetry.

Objectives

After a thorough understanding of this chapter and completion of the laboratory exercise you will be able to:

1. List the seven basic principles of photo interpretation and give one example of how each principle is used to help identify objects on aerial photographs.
2. Give an example of how each of the nine photo interpretation techniques or aids can be used to help identify and quantify objects on aerial photographs.
3. Using words and schematic diagrams, explain how additive color enhancement works.
4. List four advantages and one disadvantage of the use of additive color enhancement techniques.
5. Describe how shadowless photography is obtained and list two benefits of this type of photography to the photo interpreter.

BASIC PRINCIPLES OF PHOTO INTERPRETATION

Whereas photogrammetry deals with measurements and the production of maps from aerial photographs, photo interpretation is defined by the American Society of Photogrammetry (1966) as "The act of examining photographic images for the purpose of identifying objects and judging their significance." The skilled photo interpreter is able to recognize features on aerial photographs and to make inferences about the environment by consciously or unconsciously synthesizing a few or perhaps all of the principles of photo interpretation. This skill is developed through long hours of practice with photos, coupled with ground visitations to check the accuracy of the interpretations. In addition, the expert interpreter must have a good background in the earth sciences—particularly geology, geomorphology, hydrology, soils, and the biological sciences including plant ecology. Thus, the photo interpreter is first a geologist, an engineer, a forester or other type of resource manager, who has learned the skills of photo interpretation as an aid in his discipline. Photo interpretation, therefore, is merely a means to an end and not an end in itself. The seven basic principles of photo interpretation are discussed as follows.

Absolute and Relative Size

By relative size we mean the size of an unknown object in relation to the size of a known object (Figure 13.1). The photo on the left is a residential-industrial area with the houses *relatively* smaller than the apartment buildings below A. Even larger buildings in the vicinity of B indicate warehouses or possibly a small complex

Figure 13.1. Relative and absolute size help to identify objects. See text for more detail.

of industrial buildings. The photo on the right is an agricultural area of a much smaller scale than the photo at the left as indicated by the small farm buildings at C. The orchard at D has very large tree crowns, being nearly as wide as the two-lane highway at E. They are probaby large apple or walnut trees. However, at F the trees are much smaller indicating an orchard of dwarf fruit trees or perhaps filberts. They are planted too close together to be interpreted as just young trees that will grow to the size as those at D. Thus, we should be able to separate cars from buses and trucks, mature trees from young trees, and single dwelling houses from apartment buildings based on relative size. Absolute size is also important; therefore a thorough understanding of photo scale is essential in any size analysis. At the larger scales more detail can be seen, which might otherwise go undetected. On the other hand, smaller-scale photography will place large features of the surface within their regional environment and make comparisons with objects of known size easier.

Shape

Many objects can be recognized by their two-dimensional shape on a single aerial photograph (Figure 13.2), or from three-dimensional views of stereoscopic models. Railroads may appear as narrow bands with smooth gradual curves and level grades as compared with wider superhighways that have sharper curves and steeper grades. Secondary roads may be relatively narrow and with very sharp curves and even steeper grades. The interpreter must learn to identify objects on the photograph by their shape as viewed from above as compared with the shapes he or she is accustomed to viewing on a horizontal plane while on the ground. Tilt and topographic displacement may lead to the wrong interpretation—particularly near the edges of a photograph.

In Figure 13.2 there are several familiar *shapes* and some not so familiar. See if you can identify them before reading further. In the upper left corner is either a baseball or softball diamond. If we know the *absolute* dimensions of the base paths, we would know which kind of diamond it is.

In the upper right corner is the familiar shape of the runways of an airport except that there are no buildings or airplanes. Therefore, it must be a temporary airstrip used by planes when spraying agricultural or forest land with fertilizer or pesticides.

At center left is a drive-in movie. On the original photo the movie screen can be seen at A and the projection booth can be seen at B.

At center right is a sewage plant at C and a highway bridge at D going over railroad tracks at E. The main highway has long gradual curves as compared to secondary roads with sharper curves. The railroad is straight here, but if it curved, it would be more gradual than the highway.

The stereogram at the bottom shows tailings from a placer mine. You can see dredges at F and G. Clear (dark) water can be distinguished from the muddy water near the dredges by *tone* differences. This photo was taken in 1937, before environmental problems were considered.

Figure 13.2. Shape is an important factor in the identification of many objects.
See text for more detail.

Shadow

Shadows, when correctly interpreted, can be extremely useful (Figure 13.3). They give valuable clues as to profile shapes and relative sizes of objects such as bridge structures, towers, or trees. On the other hand, shadows often obscure important detail that one may wish to see. The best stereo view is obtained when shadows fall toward the interpreter; otherwise, pseudostereo may be the result.

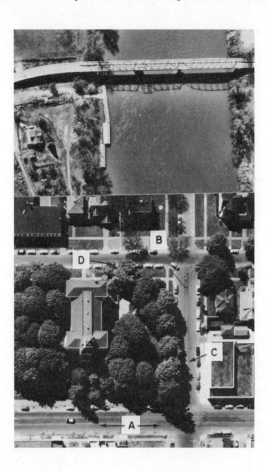

Figure 13.3. In some situations where good shadows exist, they can be very helpful to the photointerpreter by enabling one to get an idea of the profile of an object such as the structure of the bridge in the upper photograph and the trees in the lower photograph.

Interpreters should be aware that the radial displacement of objects with height may result in a situation where the objects themselves may obscure their own shadows. Thus, shadows should be analyzed in relation to the principal point or nadir.

Without the shadow of the bridge in the upper photo in Figure 13.3 it would still be obvious that it is a bridge, but without the shadow it would be impossible to guess the type of superstructure of this bridge. We can also conclude from the tree shadows that they are hardwoods without their leaves, indicating winter photography.

In the bottom photo we have conifer (Douglas-fir) shadows at A as indicated by their conical profiles. At B are rounded shadows of hardwoods, again without their leaves. This could be either a spring or fall photo since many hardwoods still have their leaves. It is probably a fall photo as indicated by the different tone of trees at C and D as they change to autumn colors.

Tone or Color

On black-and-white photographs, tone varies from black to white with various shades of gray in between. On color photography, hue (color), saturation, and brightness all contribute to the interpreter' s ability to differentiate objects. It is believed that an interpreter can distinguish at least 100 times more variations of color on color photography than shades of gray on black-and-white photography. Tone is also described in terms of pattern such as uniform, mottled, banded and scabbed and in terms of boundary sharpness such as sharp, distinct, gradual, and fuzzy (Figure 13.4).

One of the major factors affecting tone is soil moisture content and vegetation (Figure 13.5). Variation due to soil moisture alone is illustrated at 1 ab and 2 ab while the variation in 3 abcd and 4 abcd is due to both vegetation and soil moisture. Tonal variation caused by vegetation and soil moisture are correlated because of the effect of moisture on the vegetation.

It is emphasized that both tone and hue are relative and vary within, as well as between, photographs of similar objects. This results from differences in exposure settings at the time of photography and differences in developing and printing. Tone also varies with the season of the year and the position of the sun in relation to the camera position. Some water bodies may show up as white where the sun's reflection is high, but other water bodies may be black on the same photo where there is no reflection at all.

Texture

Texture is the result of tonal changes that define a characteristic arrangement of tones. Texture ranges from smooth or fine to coarse. For example, in Plate V

Original Scale: 1:31,680
Reduction: 2.4x

Figure 13.4. Photographic tone is measured in shades of gray with white at A, light gray at B, dull gray at C, and dark gray or black at D. Tone may also have distinctive patterns, such as uniform at E, mottled at F, banded at G, and scabbed at H. Boundary sharpness is distinct at I and gradual or fuzzy at J. Notice the banded tones at 2b due to plowing. A typical V-shaped gully in till is shown at 3a and 4a. (From N. Keser, 1976, aerial photos from Surveys and Mapping Branch, Government of British Columbia.)

Original Scale: 1:15,840
Reduction: 2.3x

Figure 13.5. Variation in tone due to differences in soil moisture. The area was
irrigated at different times with the oldest at A and the most recent
irrigation at C. A straight man-made canal is visible near the bottom
of the stereogram illustrating a sharp tone boundary. (From N.
Keser, 1976, aerial photos from Surveys and Mapping Branch,
Government of British Columbia.)

(left) the texture ranges from very fine to very coarse as we go from A to E. The *very fine* texture at A is a stand of dense red alder all about the same height and with the tree crowns all grown together. At B we have a dense young stand of Douglas-fir poles that exhibit a *fine* texture. The stand of small Douglas-fir sawtimber at C is of *medium* texture. At D is a *coarse*-textured stand of mature sawtimber and at E is a very coarse stand of old-growth Douglas-fir. As stands of timber become older, there is more variation in height and density which adds to the texture. The light pink at F is grass (without height) and the darker pink at G is brush intermingled with hardwoods and some conifer. The black at H is the result of a recently burned clear-cut.

Pattern

Pattern is the spatial arrangement of objects. Patterns can be man-made or natural. In general, man-made patterns can be distinguished from natural ones. Humans usually create well-defined geometric patterns made up of smooth curves and straight lines such as cities, highways, power lines, clearcuts, farmers' fields and orchards (Figure 13.6). Natural patterns are not nearly as uniform. Both man-made and natural patterns are evident in Figures 13.7 and 13.8.

Location, Association, and Convergence of Evidence

Some authors list location, association, and convergence of evidence as separate principles, but they are all very closely related and are combined for our discussion. Sometimes individual features of objects on the ground cannot be identified by themselves, but when studied in association with each other, their identification becomes apparent.

Association, or convergence of evidence, is a skill developed by the interpreter, which involves a reasoning process that uses all the principles of interpretation to relate an object to its surroundings. In forestry, biological association is particularly important in making type maps. One would expect to find cottonwood located along moist drainage bottoms and not on dry ridge tops and a smooth area in the middle of a wilderness area is more apt to be a lake than a farmer's plowed field.

What is located at area 6 on the stereogram of Figure 13.7? Using your stereoscope and the convergence-of-evidence principle, you should be able to identify the object. Try it before reading further.

The object has a very light tone indicating a nonvegetated area. Could it be a rock or gravel pit? Probably not—rock would be hauled out on the lower side and

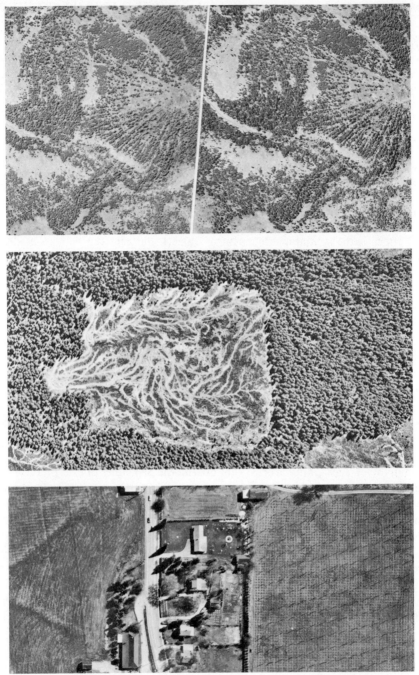

Figure 13.6. Typical forestry and agricultural patterns. The top stereogram indicates that a thinning has been accomplished by cable logging. (Courtesy of Illinois Photographic Service.) The center photo shows a clear-cut that was logged by tractors. The bottom photo shows poles and a series of wires for hops on the right and a recently harvested field of hay on the left.

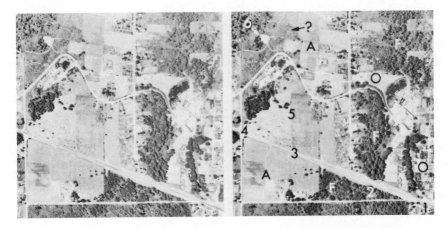

Figure 13.7. Stereogram for photo interpretation. Agricultural land is at A, fore-sted land is at F, and brush at the question mark. There is an improved road between 3 and 4 with a cut between 2 and 3. What is at 6? It can be identified using the principles of location, association, and the convergence of evidence. See text for answer. (Courtesy U.S. Forest Service, Pacific Northwest Forest and Range Experiment Station.)

there is no road here. Is it a garbage dump? This is a possibility but it is more likely to be a sawdust pile from an old lumber mill located close by. Notice the log pond by the mill. There is another mill on the stereogram with its sawdust storage or disposal area at O.

There are several man-made patterns in Figure 13.8. Use your stereoscope and see if you can identify objects labeled A through J before you read the answers that follow:

Location

A Primary sewage treatment plant (aeration bubbles)
B Clarifier (thickener)
C Sewage spill basin
D Railroad cars for wood chips
E Parking area
F Log piles
G Transformer (power lines are visible on the original)
H Saw mill
 I Wood chip pile
J Logs chained together for shore protection

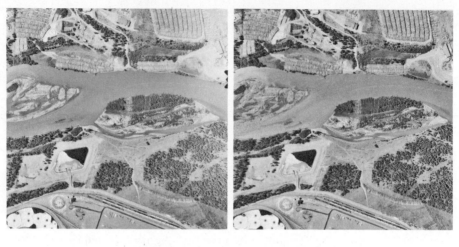

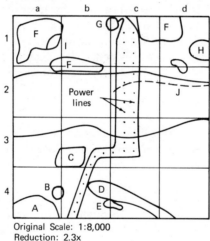

Original Scale: 1:8,000
Reduction: 2.3x

Figure 13.8. There are several natural and man-made patterns on this stereogram. Use your stereoscope and try to identify objects labeled A through J before you read what they are in the text.

ADDITIONAL HINTS FOR PHOTO INTERPRETATION OF PANCHROMATIC FILM

Cultivated Land

1. Range of tones from black to white; lighter tones predominate.
2. Recently plowed or harrowed fields are darker (more moisture) than unplowed but normally cultivated land.

3. Field lines, fences, roads, etc., are almost regular, often checkerboard pattern.
4. Drill marks (machine planting) are sometimes visible on large-scale photography; furrows show as dark line pattern.

Orchards

1. Regular spacing and alignment of trees.
2. Near other human occupance; usually away from natural woodlands.
3. Spacing may indicate orchard type. Filbert trees, for example, are usually closer spaced than apple trees.
4. Former orchards, long removed, are often still visible as a stippled pattern in cultivated fields.

Grasslands

1. Tone is characteristically mottled, unkempt.
2. Small dark spots are brush, trees, stumps.
3. Few fence lines; lacks cultivated land regularity.
4. Darker patches often evident when damp or wet.

Brushland

1. Mottled; wide range of tones.
2. Open spaces that lose the regular texture of woods.
3. If logged over, shows traces of logging operations including skid roads, trails, possibly burns.

Woodland

1. Variable texture; smooth to billowy hardwoods and smooth to very coarse textured conifers.
2. Highly varied tones and textures indicate a variety of timber types.
3. Tree shadows may indicate timber type.
4. Conifers usually are darker than hardwoods; small even-aged stands of conifers are fine textured while mature and/or all-aged stands of conifers are coarser textured.
5. Soil moisture conditions as related to aspect, slope, topography may help with species identification if one is familiar with the ecology of the area.

Clearing Lines and Fence Lines

1. These represent changes in tone and texture between cultivated and grassland, or brush and forest land.
2. Stone fences and zigzag rails are clear on large-scale photos.
3. Fences are seed catchers with vegetation often growing along them; includes trees.

 4. Paths for cattle and lanes often are along fences or on clearing lines.
 5. Many highways and streams are fenced.

Fire Lines

 1. Multiple lines in managed forested regions.
 2. Easily mistaken for roads or trails; look for steep grades and lack of bridges or fords where they cross streams.

Transmission Lines

 1. Cleared lanes through woods; usually wider than trails.
 2. Shadows sometimes are towers.
 3. Straight trajectory without regard to established patterns in open and cultivated country.

Rivers, Streams

 1. Uniform tone, meanders, and continuous topographic features.
 2. Shoals, rapids, dams, bridges are often visible.
 3. Flood plains and high bank lines; vegetation along water course.
 4. Vegetation is denser along water course, especially in cultivated areas.

Fords

 1. Found where river bank breaks down, thus access to streams.
 2. Roads, trails, tracks, etc., often coverage.
 3. Sometimes vehicle tracks are seen on stream bed.
 4. Often lighter color showing less water depth.

Rapids

 1. White appearance of water between darker spots.
 2. Banks narrower, high bank lines, and rock ledges.
 3. Portage trail sometimes evident.

Abandoned Meanders

 1. Often occupied with marsh, brush, forest.
 2. Light-colored concentric markings indicate lateral stream movement.
 3. Show concentric banding on one side and steep undercut on the other.

Lakes, Ponds Dam Backwaters

 1. A general uniform tone; tone is dependent on depth and the amount of sediment. Deeper and sediment-free water is darker.
 2. Shorelines have usually abrupt tone and texture change.

3. Tone gradually lightening indicates shallower water near shore with shoals, sandbars, etc.
4. Water bodies that are dead white indicate intense reflection of sun rays often due to their position in respect to camera.
5. Dam backwaters are similar except there is an abrupt change in width where the dam is located.

Canals, Ditches

1. Both are uniform and regular, except ditches are narrower.
2. Other artificial signs include dirt piles, rocks alongside, sometimes trails or roads. There may be locks and weirs on canals.
3. Clear appearance of water indicates a canal is well kept or in use.
4. The ground around ditches is often darker or swampy.
5. Irrigation ditches sometimes follow ridge tops or side slopes; drainage ditches always follow depressions.

Swamps

1. Appear wet with dark irregular tone.
2. Usually densely vegetated; generally, vegetation has uniform tone and texture.
3. Standing water may reflect white.
4. May be drainage ditches; numerous fills and ridges, some with roads.
5. Flooded areas are distinguished from swamps by the absence of well-established drainage in temporarily flooded areas.

Marshes

1. Darker tone than grasslands; although covered with willows and long grass.
2. Water generally shows between vegetation.
3. Absence of human occupation; drainage ditches.
4. Often ringlike vegetation found from brush in less wet areas to swamp grass and water in saturated areas.

Railways

1. Thin lines—straight with long gradual curves; cuts and fills.
2. Widening or narrowing of right-of-way with bridges and trestles.
3. Tracks rarely visible, although crossties sometimes are.
4. Stations, side tracks, sidings, trains, evident.
5. Crushed rock roadbed is a white or light gray; little-used railroads may have some vegetation on roadbed producing a darker tone.
6. Width of bridges may indicate single or doubletrack.
7. Tunnel mouths are small black shadows.

 Roads

 1. White to black; concrete is white but darkens with age and use and becomes spotted and streaked with oil down the center of lanes; macadam and dirt roads are much darker; gravel is light, sometimes with a lighter streak down center where stone is heaped with use.

 2. First-class roads are better engineered with cuts and fills evident, while second-class roads avoid obstacles and have many bends and turns in hilly country.

 3. Width of right-of-way often indicate class as do the types of curves.

 4. Roads cutting directly cross country, regardless of previous patterns, are generally hard surface first class roads.

Trails

 1. Usually follow winding courses, avoiding obstacles; however, aspect of shortcuts sometimes shown where thin straight lines go through woods, fields, pastures.

 2. Great numbers seen around outskirts of towns, in parks, and in rugged areas.

 3. Footpaths are light, almost hairlike lines, but dark, however, when snow covers the ground.

 4. Skid trails and roads with many branch lines cut through the timber with intervening timber cut; skid trails at more or less regular intervals.

Bridges

 1. Vehicle bridges are usually wider than the approach roadway; opposite is true for railway bridges.

 2. A long bridge is usually trestle or truss type; a short bridge is usually a girder or arch type; more often seen by shadows.

Cemeteries

 1. Characteristic arrangement with drives, walks, vegetation; tombstones visible as small white images.

 2. Roads and footpaths have sharp and numerous curves.

 3. Located often along outskirts of town or rurally near church or on high ground away from drainage and water.

 Buildings (general)

 1. Shadows show relative height, shape and type, hip roof lines, chimneys, porches, etc.

 2. Use often indicated by studying surroundings.

Urban Buildings

1. Circular or semicircular shapes include some churches, fuel storage tanks, sewage disposal basins, railway roundhouses, residential driveways, traffic circles, stadiums, etc.
2. Usual linear structures include row houses, warehouses, some industrial establishments, filtration plants, apartment projects.
3. Factory type often distinguished by number, type, and position of various buildings in a group.
4. Thin upright forms such as flagpoles and radio and transmission towers discernible only by shadow.

Rural Dwellings

1. Often closer to road than other parts of farmstead; further from other buildings than other buildings are from each other.
2. Smaller than barn; larger than outbuildings.
3. Usually in tree clump, presence of planned landscaping or driveway; varied architectural design.
4. Often grass lawn as opposed to well-beaten ground around other buildings.

Rural Barns

1. Largest farmstead structure, simple design.
2. Absence of trees; farm driveway to door.
3. Use of other buildings often shown by well-worn footpaths, grain bins, potato cellars.

Rural Schools

1. Geometric design; different from farmstead by lack of buildings.
2. Small schools usually have evidence of playground or area of hard use and may occupy elevated sites.
3. Larger schools often have a tall chimney; very often a semicircular driveway; athletic fields.
4. Small town school often near outer edge of town.

Churches

1. Resemble schools in central location on plot and few, if any, outbuildings.
2. Surroundings darker because of more and better grass.
3. Steeple or some sort of roof often projects.
4. Cemeteries often nearby.

Railway Stations

1. Near tracks; few outbuildings but sidings and platforms.
2. Train sheds in larger stations.
3. Road to parking lot near stations.

Oil Wells

1. Derrick may be seen by shadow; derrick floor square.
2. Splotches of drilling mud and square mud pits.

Gravel Pits

1. Long giant furrows, sharply defined.
2. Deep gashes into ground, sudden break between light gray to white of workings, darker tone of vegetation in adjacent areas.
3. Large sorting, washing, loading buildings often visible.

Soils

1. Very difficult to determine; however, dry soils are lighter gray than damp soils.
2. Sandy soils are light gray while clayey soils are darker to very dark gray.

Sand Areas, Beaches

1. Pure white—applies to sand trails, beaches, bars, spits, dunes.
2. Abandoned beach lines and old dunes often of characteristic shape alternating with swampy areas.
3. Beaches are white if sand; darker and mottled if stone.
4. Beaches are darker near water with dampness; surf lines often visible.

Sea Cliffs or Bluffs

1. Absence of beach indicates rock formations dipping into sea or wave cutting at cliff bottom.
2. Water body changes suddenly to very dark adjacent to shore line; often narrow white surf line.

Rock Outcrops

1. Light colored, no vegetation, in midst of more densely cultivated areas.
2. Very often found along hillsides in poorly wooded region or grassy slopes.

TECHNIQUES AND AIDS FOR PHOTO INTERPRETATION

There are several techniques and aids available to the photointerpreter. Some of the more important ones include (1) stereoscopic examination, (2) sample stereograms, (3) magnification, (4) interpretation keys, (5) photo measurement, (6) conversion tables, (7) statistical analysis, (8) templets, (9) multiband color enhancement, density slicing and (10) a whole series of newly developed techniques requiring the use of computers and sophisticated equipment such as digital image analysis and microdensitometry. These techniques are beyond the scope of this book.

Stereoscopic Examination

Even though stereoscopic examination of aerial photography has been used for photointerpretation for decades, it continues to be an extremely useful and simple technique. Three-dimensional viewing is essential for certain interpretation tasks, the analysis of land forms and drainage patterns, for example. More detail can be observed stereoscopically than by monocular viewing. Stereoscopic viewing also allows the measurement of height, which is often very helpful. A 260-ft tree photographed on the California coast would certainly indicate redwood and not some other species in the same area.

Stereograms

Stereograms are used in many disciplines. Stereograms of all kinds have been developed of known features to give the photo interpreter something to compare unknown features with. Identification of different forest cover types is a common use of stereograms. For maximum value, stereograms should be on the same type of film and at approximatley the same scale as the photos being interpreted.

Magnification

All pocket stereoscopes and mirror stereoscopes with binocular magnification attachments provide valuable magnification of the imagery. Most pocket stereoscopes are 2-power but some are 4-power. Binocular attachments for mirror stereoscopes usually range from about 3 to 10 or even 30 power. Even though there is no theoretical limit to the amount of optical enlargement possible, there are some definite practical limits.

For much photography the grain of the film becomes quite noticeable and bothersome at 4 to 6 magnification. Color positive transparencies, however, can be viewed over a light table at much higher magnifications without the film grain problem.

Another practical limitation to the amount of magnification that is helpful is that you can not see something that is not there. That is, there is no advantage in

magnifying beyond the limits of resolution of a given film. This is not only true of optical magnification by stereoscopes but also of enlargements.

Interpretation Keys

Photo interpretation keys offer valuable aid to the photo interpreter, especially the beginning interpreter. There are two types: selective and dichotomous. Selective keys are comparative where the interpreter simply matches the features of the key with the features of what he or she is looking at. These keys can be in the form of written descriptions, tables, stereograms, or a combination.

Dichotomous keys, sometimes called elimination keys, require the interpreter to make step-by-step decisions from the general to the specific. Good dichotomous keys are difficult to make and are frequently difficult to use. One wrong decision along the way usually leads to an incorrect identification. However, wrong decisions usually occur near the end of the process when a decision must be made between two similar characteristics. Examples of photointerpretation keys are (1) military—such as types of aircraft, warships, or defense installations; (2) land use (Chapter Sixteen)—such as urban, suburban, industrial, agriculture (Table 18.2); and (3) cover type keys—such as forest cover types (Chapter Seventeen) or range condition classes.

Photo Measurements

Measurement both in the vertical and horizontal plane is not only helpful but sometimes necessary in photointerpretation work. Besides photo measurements already discussed, the forester makes detailed measurements of tree crown diameters, tree and stand heights, and percent crown closure to estimate the volume of timber in a given area (Chapters Twenty and Twenty-one).

Conversion Tables

Frequently a photo interpreter wants to determine something that cannot be measured directly on an aerial photograph. For example, in timber type mapping (Chapter Seventeen), the average diameter of the tree stems must be known, but it cannot be measured directly. However, conversion tables have been developed to convert measurable variables such as tree height, crown diameter, and percent crown closure to close approximation of stem diameter (Table 17.1). Similar tables are available for basal areas and timber volumes for a wide variety of tree species.

Statistical Analysis

The tables mentioned in the previous section were developed using a technique called regression analysis. Double sampling with regression (Chapters Nineteen, Twenty, and Twenty-one) is another technique that can be used by the photo interpreter. Suppose a forester wished to know how many live tree seedlings remain

on an area that was planted a few years ago, but he or she cannot see all the trees on the photographs because of brush problems. The forester can count the trees that are visible on selected plots on the aerial photos and make similar counts on a subsample of ground plots. The forester uses this information in a double sampling with regression technique to adjust the photo counts for the unseen trees to estimate the number of trees on all the plots and on the total acreage. The same technique can be used by the range manager, recreation specialist, or wildlife census taker.

Templets

There are a variety of templets available to the photo interpreter in the form of transparent overlays that are placed over one or both photos of a stereoscopic pair. Most templets are designed to help take measurements such as parallax for height measurement, length scales and wedges for distance measurement, dot grids for area measurement, density scales for percent crown closure, protractors to measure angles and direction, and slope scales. Most templets are designed to fit a particular photo scale but some can be used for several scales.

Multiband Color Enhancement

A relatively new and promising technique is called multiband color enhancement. There are two variations available: (1) subtractive color enhancement and (2) additive color enhancement. Only the additive technique is described here (Figures 13.9 and 13.10).

This technique involves the use of two or more black-and-white positive transparencies of the same scene photographed in different regions (bands) of the photographic portion of the electromagnetic spectrum (0.4 to 0.9 μm). True or false

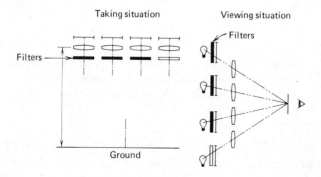

Figure 13.9. The taking and viewing situations for the color additive process. (Copyright 1967, *Photogrammetric Engineering,* Vol. 133, No. 9, published by the American Society of Photogrammetry, reproduced with permission.)

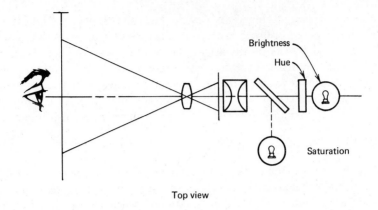

Top view

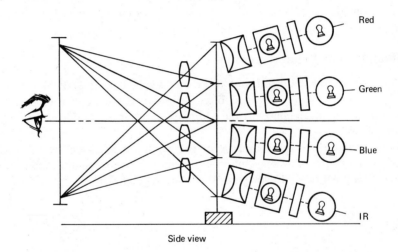

Side view

Figure 13.10. Schematic diagram of a multispectral additive color viewer. (Copyright 1967, *Photogrammetric Engineering,* Vol. 33, No. 9, published by the American Society of Photogrammetry, reproduced with permission.)

color images are produced by projecting multiple images of the same scene through band-pass filters to produce a *perfectly registered single image* (see Figures 13.9 and 13.10). Hundreds of different false color images can be produced with only a three-to four-band system using various color filters. This technique often detects and emphasizes subtle spectral differences between objects where no perceptible color difference was evident before enhancement. Infrared photography utilizes wave lengths up to 0.9 μm whereas the human eye can perceive only up to about 0.7

μm. Therefore, one band that should always be considered with other bands is the photographic infrared region from 0.7 to 0.9μm.

The advantages of this system include the following factors.

1. The higher resolution of black-and-white emulsions can produce better resolution (with perfect registration of all images) of the projected color composite image than is obtainable from conventional color film.
2. Small tonal differences between objects are enhanced for better interpretation.
3. The same image as obtained by standard color or color infrared film can be created as well as hundreds of additional false-color images to enhance objects of specific interest.

The primary disadvantage of multiband color enhancement is the extra cost, effort, and equipment necessary to do the job.

Density slicing

Density slicing is a specialized technique that converts the range of continuous gray tones of an image into a series of density intervals, or *slices*, each corresponding to a specified range. This requires a sophisticated piece of equipment such as the *electronic image analyzer*. These systems consist of a high-resolution TV camera that views the image. The image can be photographic, thermal, or even a radargram. The TV camera converts the image brightness levels to a video signal that is fed into a processing unit.

Each discrete brightness level, which corresponds to one of the gray tones of the original image, is assigned a unique color. These colors are then displayed on a color TV monitor in a color coded image that produces many more distinct colors than the original shades of gray. Most image analyzers will also compute the area of any image that falls into any one of the color ranges. Some image analyzers can even portray a false 3-D perspective view, which can be rotated to enhance features of the earth such as lineaments.

SHADOWLESS PHOTOGRAPHY

Shadowless photography is a photographing technique that for some types of photography can be of great benefit to the photo interpreter. Shadowless photography is taken when the sky is completely covered with a layer of uniform density clouds to minimize or eliminate shadows on the ground. Obviously, the film exposure must be adjusted and slower flying aircraft may be required, but the results are sometimes startling (Plate IV). The photo at the top was taken on January 4, in full sunlight. The shadows caused by steep topography, tall trees, and the low winter sun angle makes the photo almost useless. The image at the bottom is another January photo taken under a completely overcast sky. Plate III (lower left) is an example of shadowless color infrared photography revealing a wide variety of

colors caused by diseased trees. The same photograph taken in full sunlight would not reveal nearly as many different colors. Shadowless photography not only improves interpretability in some situations, but it also extends the photographing season.

Laboratory Exercise

Interpret each of the 50 points identified on stereograms A through T (Figures 13.11 and 13.12) by selecting one of the four possible answers (a through d) as given below. Use *all* the seven basic principles of photo interpretation discussed in this chapter. On these stereograms, bare soil and rock appear light, grass somewhat darker, and brush or forest still darker. Water and shadows are darkest of all. Grass has a very fine texture, stands of trees range from fine to coarse, depending on species, size, and density. Ledge rock is indicated by straight lines and vertical cliffs, tallus slopes are light with a rough texture. Trees can also be identified by relative tone, height, and shadow profile. These stereograms are at a 20,000 PSR. The correct answers to this laboratory exercise are found in Appendix F.

	a	b	c	d
1.	plantation	piles of rock	orchard	vineyard
2.	bridge	dam	siphon	ford
3.	drain ditch	fence line	irrigation canal	highway
4.	borrow pit	farm pond	basement hole	sludge pit
5.	farm building	mine building	lumber pile	haystack
6.	dry ditch	railroad grade	pack trail	road
7.	small town	construction camp	mine building	ranch building
8.	aspen	cottonwood	pine	spruce
9.	irrigated field	plowed field	swamp	tall grass
10.	farm buildings	lumber piles	baled hay piles	corral
11.	bare ground	grass-sagebrush	rock slope	sand slope
12.	irrigation ditch	fence line	hedgerow	windbreak
13.	clay bank	lava rock ledge	sandstone ledge	boulder rocks
14.	hardwoods	conifers	juniper	white pine
15.	hard rock cliff	tilted rock	clay bank	retaining wall
16.	sand bar	dry bed	dam	rapids
17.	fence line	irrigation ditch	road	tillage pattern
18.	fence line	soil change	tillage pattern	irrigation ditch
19.	hayfield	grass-sagebrush	sand dunes	chaparral
20.	irrigation canal	stream	drainage canal	highway ditch

Figure 13.11. Stereogram for laboratory exercise. (From K. E. Moessner, 1960, courtesy U.S. Forest Service, Intermountain Forest and Range Experiment Station.)

Figure 13.12. Stereogram for laboratory exercise. (From K. E. Moessner, 1960, courtesy of U.S. Forest Service, Intermountain Forest and Range Experiment Station.)

21.__marsh pattern	__beaver ponds	__muskeg swamp	__salt flats
22.__clay piles	__rock piles	__dry grass	__brush piles
23.__standard-gage RR	__narrow-gage RR	__old road grade	__water ditch
24.__gravel pit	__sawmill	__mine buildings	__cabins
25.__abandoned mine	__old rock slide	__old sawmill	__gravel pit
26.__standard-gage RR	__improved road	__paved highway	__haul road
27.__water ditch	__drain ditch	__fence line	__road
28.__pine trees	__cottonwood	__oak trees	__spruce trees
29.__pinyon pine	__pine saplings	__juniper	__sagebrush
30.__rock pile	__tree stump	__water hole	__exploration pit
31.__cutting line	__fireline road	__sale boundary	__mining road
32.__aspen poles	__cottonwood poles	__oakbrush	__pine poles
33.__hayfield	__sagebrush	__old lakebed	__mountain meadow
34.__aspen poles	__pine saplings	__tall grass	__hardwood brush
35.__ledge rock	__rock dike	__line fence	__tilted sandstone
36.__main haul road	__unimproved road	__old RR grade	__paved road
37.__clearcut	__selective cut	__dead spruce	__fire-kill trees
38.__gravel pit	__sand and rock	__fire pattern	__beaver meadows
39.__cutting line	__type line	__section line	__fireline
40.__spruce	__lodgepole	__aspen	__oak
41.__mud flat	__irrigated area	__beaver pond	__ice
42.__main haul road	__skidroad	__spurr road	__mine road
43.__main haul road	__skidroad	__fire trails	__spurr roads
44.__landing	__yard	__skidding setup	__road junction
45.__clay bank	__toe slope	__cirque wall	__talus slope
46.__toe slope	__talus slope	__gravel slope	__snowslide
47.__cirque wall	__cirque floor	__sand	__talus slope
48.__blue spruce	__lodgepole pine	__spruce, fir	__pinyon juniper
49.__timberline fir	__sagebrush	__chaparral	__pinyon juniper
50.__bare rock	__sand	__short grass	__snow

Questions and Problems

1. For each of the following principles of photo interpretation, give one or more examples of how each principle is used in aerial photo interpretation: (a) absolute and relative size, (b) shape, (c) shadow, (d) tone or color, (e) texture, (f) pattern, and (g) location, association, and convergence of evidence. Try to think of examples that are not in the book.

2. Give one or more examples of the practical use of each of the following techniques or aids to photo interpretation: (a) stereoscopic examination, (b) stereograms, (c) magnification, (d) interpretation keys, (e) photo measurements, (f) templets, (g) conversion tables, (h) statistical analysis, and (i) multiband color enhancement. Try to think of examples not in the book.

3. Draw a schematic diagram showing the viewing situation as used in additive color enhancement and explain how the system works.

4. List four advantages and one disadvantage of the use of additive color enhancement techniques.

5. How is shadowless photography obtained and what are two advantages of this technique.

Fourteen

Landforms and Drainage Patterns

It is essential that all photo interpreters interested in any phase of natural resource management become skilled in the proper interpretation of landforms and drainage patterns. A landscape, which is a collection of landforms, responds to the environment. The environment is dominated by climate that changes over long periods of time. Therefore, landscapes reveal important clues to the natural resource manager as to present and past climate, parent soil material, the availability of moisture, and the type of soil that might be present.

Stereoscopic analysis of aerial photos by a well-trained land manager is perhaps the best and most economic method of determining landform and making inferences about the surface and near subsurface of the earth's crust. Because of the extremely large coverage made possible by satellite imagery, new geologic formations have been recently discovered that were previously overlooked because of their large size. These small-scale images are ideal for regional planning and macrointerpretation purposes, but conventional medium to large-scale photography is still best for a detailed analysis of specific areas. Regardless of the scale of photography used it is always advisable to obtain ground verification.

Objectives

After a thorough understanding of this chapter you will be able to:

1. Define the term "landform" in a way that it is independent of geographic location.
2. List seven pattern elements that the photo interpreter uses to identify and categorize landforms.
3. Identify—either on schematic diagrams or aerial photographs—the seven drainage patterns shown and state the probable cause or significance of each pattern.

4. Calculate the drainage density, stream frequency, and relative infiltration of a given drainage from either a schematic diagram or an aerial photograph.
5. Draw schematic diagrams of cross sections of three different gully types and state what each gully type indicates as to soil texture, cohesiveness and the general slopes involved.

LANDFORM

The term "landform" can have a variety of meanings depending on the specific discipline involved. The geologist may describe landform in terms of surface characteristics that yield evidence as to the geologic structure of features of the earth's crust and may use such terms as faults, joints, domes, and basins. The geologist is interested in landform for academic reasons as well as for specific purposes—mining, engineering, and petroleum exploration, for example.

The soils scientist is more interested in studying landform for the purpose of identifying parent soil material, soil texture, potential fertility, soil moisture, soil drainage, and erodability.

The civil engineer would be more interested in studying landform to gain information about soil or rock-bearing strength, drainage patterns, the location of road-building materials and potential erosion hazards.

Landscape architects and outdoor recreation specialists think more in terms of the visual impact and use terms like valleys, mountains, cliffs, or floodplains.

The hydrologist studies landform to analyze water movement. The city and regional planner studies landform for land-use planning and zoning purposes.

The forester, being a combination ecologist, geologist, soils scientist, and engineer, must study landform to obtain clues to the physical and chemical characteristics of the soil as well as the visual significance of a particular surface feature or combination of features, and the logging engineer is particularly concerned with potential landslides and how to manage or avoid them in conjunction with logging road construction and other tree-harvesting operations.

An ideal landform classification should allow specific distinctions in landform regardless of their geographic distribution. With this in mind, Way (1973) defined the term "landform" as "terrain features formed by natural processes, which have definable composition and range of physical and visual characteristics that occur wherever the landform is found."

RECOGNITION OF LANDFORM

There are seven basic pattern elements that the photo interpreter can use to identify and categorize landforms and landscapes.

1. Topography.
2. Drainage patterns.

3. Drainage texture.
4. Gully types.
5. Photo tone and photo texture.
6. Vegetational patterns.
7. Land-use patterns.

Topography

The most obvious characteristic of any landform is its three-dimensional shape—easily analyzed in a stereoscopic model. Thus, the interpreter can quickly determine if the topography is relatively flat or steep, whether the hills are rounded or sharp, etc. Just this much information gives the geologist or soils scientist a good clue as to the soil characteristics if he or she knows a little about the specific geographic area being examined.

An important point to remember when analyzing topography is the effect of vertical exaggeration as discussed in Chapter Six. Because slope is so important when analyzing landform, it is very important that the interpreter make allowance for vertical exaggeration. As an aid to the interpreter, Table 14.1 shows the conversion of true slopes from slopes estimated on aerial photos for two different exaggeration factors. In critical situations the true slope can be measured (Chapter Seven).

TABLE 14.1 True Slopes based on Estimated Slopes for Two Vertical Exaggeration Factors

Estimated Slope (Degrees)		True Slope
Exaggeration Factor 2.5	Exaggeration Factor 3.5	Degrees
5	7	2
10	14	4
15	20	6
20	26	8
24	32	10
34	43	15
42	52	20
49	58	25
55	64	30
60	68	35
64	71	40
68	74	45
72	76	50
77	81	60
81	84	70
86	87	80
90	90	90

Drainage Patterns

Drainage patterns, which are closely related to topography and rainfall, are the most important characteristics for the classification of landforms. Dr. R.A. van Zuidam (1972), of the International Institute for Aerial Survey and Earth Sciences, Enschede, The Netherlands, says the following about drainage patterns.

> *Stream erosion produces many types of valleys, most of which exhibit topographic features revealing the lithology, the conditions of erosion and the geomorphological history of the area during erosion. The drainage system which develops on a regional surface is controlled by the slope of the surface, the types and attitudes of the underlying rocks, and the climatic conditions.*
>
> *Drainage patterns, which are easily visible on aerial photographs reflect, to varying degrees, the lithology and structure of a region. Except for climatic controls, drainage in an area of stratified rock depends mainly on the type, distribution, and attitude of the surface rocks, the arrangement of zones or lines of weakness such as bedding planes, joints and faults, and the shape and trend of local folds.*

Dr. van Zuidam defines a drainage pattern as "an aggregate of drainageways in an area, regardless of whether or not they are occupied by permanent streams" and a stream pattern as "the design formed by a single drainageway."

An analysis of topography and drainage patterns gives the trained geologist-photo interpreter much information about the underlying geologic structure, parent soil material, and erodability of a particular area in question. In this chapter we consider seven specific drainage patterns. In addition, there are many other combinations or modifications of these basic seven patterns.

1.	Dendritic.	**5.**	Radial.
2.	Parallel.	**6.**	Deranged.
3.	Trellis.	**7.**	Internal.
4.	Rectangular.		

Dendritic

The dendritic pattern (Figure 14.1) is the most common and is characterized by a treelike branching system where the branches (tributaries) join the stem (mainstream) at *acute* angles. This drainage system indicates homogenous rock and soil materials with little or no structural control. Soft sedimentary rocks, volcanic tuff and dissected deposits of thick glacial till typify the dendritic pattern.

Parallel

Parallel drainage systems (Figure 14.2) generally develop on gentle to moderate, uniform slopes whose main collector streams may indicate a fault or fracture.

Original Scale: 1:31,680
Reduction:2.4x

Figure 14.1. Dendritic drainage patterns: stereogram (top) drawing from stereo-
gram (bottom right), and a classical drawing (bottom left). (From N.
Keser, 1976, aerial photos from Surveys and Mapping Branch,
Government of British Columbia.)

The tributaries characteristically join the mainstream at about the same angle.
There are many transitions possible between this pattern and the dendritic and
trellis types.

Trellis

Trellis drainage patterns (Figure 14.3) are modified dendritic forms where
secondary streams occur at *right angles* to the mainstream with the tertiary streams

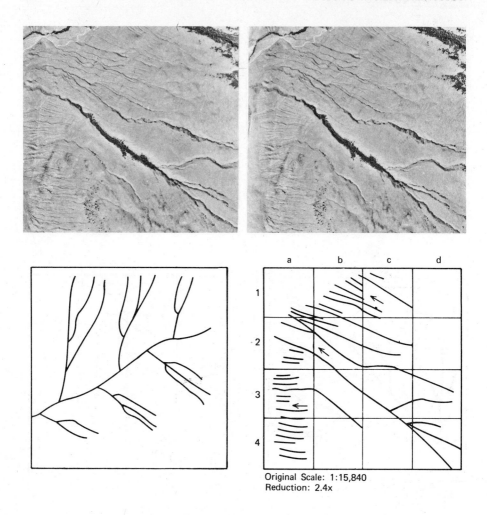

Original Scale: 1:15,840
Reduction: 2.4x

Figure 14.2. Parallel drainage patterns: stereogram (top), drawing from stereo-
gram (bottom right), and a classical drawing (bottom left). (From N.
Keser, 1976, aerial photos from Surveys and Mapping Branch,
Government of British Columbia.)

at *right angles* to the secondary streams. This type of pattern is typical of tributaries
eroded in belts of tightly folded sedimentary rock.

Rectangular

Rectangular drainage patterns (Figure 14.4) are also modifications of the
dendritic form, but the secondary streams joining the mainstream are more at *right*

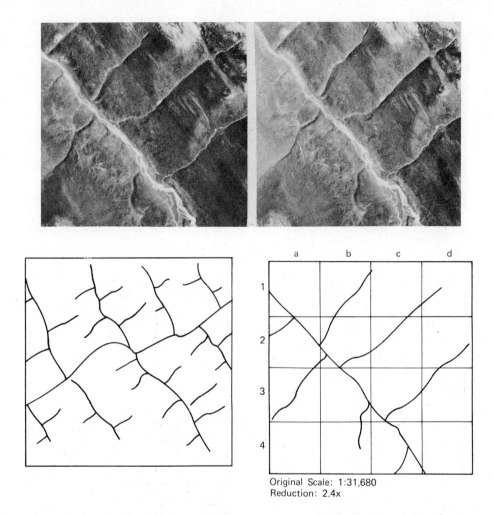

Original Scale: 1:31,680
Reduction: 2.4x

Figure 14.3. Trellis drainage patterns: stereogram (top), drawing from stereo-gram (bottom right), and a classical drawing (bottom left). (From N. Keser, 1976, aerial photos from Surveys and Mapping Branch, Government of British Columbia.)

angles. This pattern lacks the orderly repetitive quality of the trellis pattern and the right angles are *slightly* acute. Rectangular patterns frequently reflect the regional pattern of intersecting joint systems or a set of joints with cross belts of bedrock at a high angle. These patterns are often formed in slate, schist, or in resistive sandstone in arid climates, or in sandstone in humid climates where little soil profile has developed.

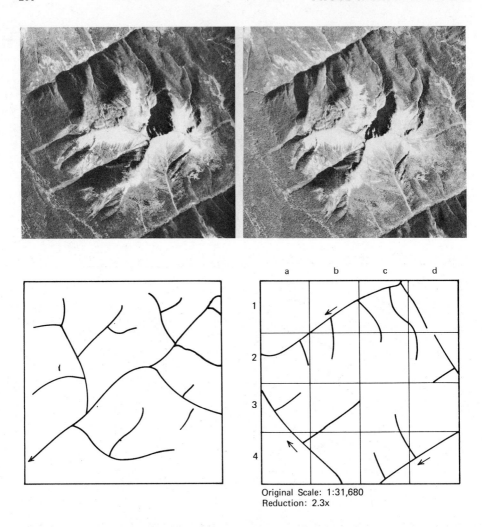

Original Scale: 1:31,680
Reduction: 2.3x

Figure 14.4. Rectangular drainage patterns: stereogram (top) drawing from ste-
reogram (bottom right), and a classical drawing (bottom left). (From
N. Keser, 1976, aerial photos from Surveys and Mapping Branch,
Government of British Columbia.)

Radial
 The radial drainage pattern (Figure 14.5) is characteristic of volcanoes and
other domelike landforms. It is characterized by a circular network of stream
channels flowing away from a central high point.

Deranged
 The deranged pattern (Figure 14.6) is nonintegrated and is characterized by

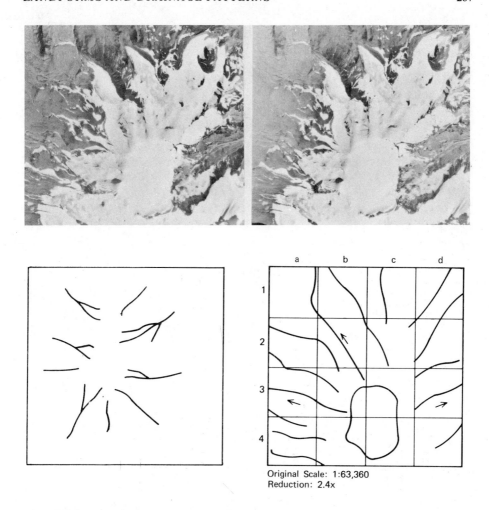

Original Scale: 1:63,360
Reduction: 2.4x

Figure 14.5. Radial drainage pattern: stereogram (top), drawing from stereogram (bottom right), and a classical drawing (bottom left). (From N. Keser, 1967, aerial photos from Surveys and Mapping Branch, Government of British Columbia.)

swamps, bogs, small ponds or lakes, and meandering streams. This usually indicates a young landform with low topographic profile, high water table, and poor drainage.

Internal
 This is really not a drainage system that has a definite pattern; in fact, it is best described as having no pattern at all. It is the result of highly permeable material with underground drainage channels and is sometimes characterized by sinkholes.

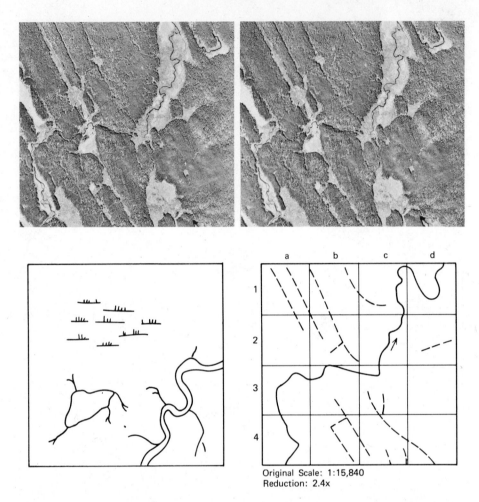

Original Scale: 1:15,840
Reduction: 2.4x

Figure 14.6. Deranged drainage pattern: stereogram (top), drawing from stereo-
gram (bottom right), and a classical drawing (bottom left). (From N.
Keser, 1976, aerial photos from Surveys and Mapping Branch,
Government of British Columbia.)

Drainage Texture

Drainage texture, as contrasted to photo texture, refers to the number and
spacing of drainages (with or without permanent streams). Drainage texture can be
classified as to fine, medium, or coarse as illustrated in Figure 14.7 for the dendritic
pattern. Drainage pattern and texture are important to the photo interpreter
because they reveal valuable clues as to the geologic structure of the landform and

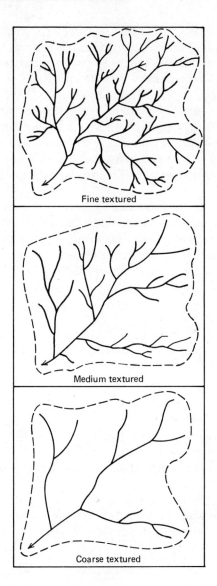

Figure 14.7. Examples of fine-, medium-, and coarse-textured dendritic patterns. The original PSR was 20,000, reduced in this illustration to 30,000.

the permeability of the soil mantle that we will call internal drainage.

Way (1973) defined fine-textured drainage patterns as those with average spacing between the mainstream and the first order tributaries as averaging 400 ft or less. Fine-textured patterns usually indicate high levels of surface runoff, impervious bedrock, and soils of low permeability.

Medium-textured drainage patterns have average first-order tributary spacings of from about 400 to 3200 ft. Coarse-textured patterns have spacings greater than 3200 ft. Medium-textured patterns are associated with medium levels of runoff and soils with mixtures of fine and coarse textures. Coarse-textured patterns typify more resistant bedrock that weathers to form coarse, permeable soils and relatively little runoff.

Drainage texture can be quantified by drainage density, steam frequency, and infiltration. These quantifications should be considered as only relative measures because they change between regions due to different climates and, if the values are determined from aerial photos, the results change with changes in photo scale. The tendency is to calculate a greater drainage density on larger scale photography because the smaller drainages are more easily identified.

Drainage Density

Drainage density is an expression of rainfall, infiltration capacity, the underlying geologic structures and can be quantified by the following formula:

$$D_d = \frac{\Sigma L}{A}$$

Where

D_d = drainage density in lineal feet per acre
A = area of a given basin in acres
ΣL = the sum of the lengths of all streams in a given basin in feet

When using the above formula and data taken from aerial photographs, one must account for the photo scale. From what we have previously learned in the chapters on scale and area, we can easily derive the following:

$$D_d = \frac{[PD(PSR)]/12}{[(PSR/12)^2/43,560](DC/DI)} = \frac{PD(522,720)}{PSR}\left(\frac{DI}{DC}\right)$$

Where

PD = sum of the drainage lengths as measured in inches on the photo
PSR = photo scale reciprocal
DC = dot count
DI = dot intensity of dot grid used (dots per square inch)

For this formula to be valid it must give the same answer regardless of the photo scale, for example. Let's use the coarse-textured pattern in Figure 14.7 for our example and assume the following values:

$$PSR = 20,000$$
$$PD = 10.5 \text{ in.}$$
$$DC = 584$$
$$DI = 100$$
$$D_d = [\frac{10.5(522,720)}{20,000}] [\frac{100}{584}] = 47.0 \text{ ft/acre}$$

Now let us assume the same drainage and a PSR of 10,000. Using this scale photo, the measured PD would be 2 times 10.5, or 21 in., and the dot count would be $(2)^2$ times 584, or 2,336 dots. We get:

$$D_d = [\frac{21(522,720)}{10,000}] [\frac{100}{2336}] = 47.0 \text{ ft/acre}$$

In a similar manner we calculate drainage densities of 98 and 153 ft/acre for the medium and fine drainage patterns of Figure 14.7. Thus, the drainage densities for coarse-, medium-, and fine-drainage textures as defined by Way (1968, 1973) are approximately 50, 100, and 150 ft/acre.

Ray and Fisher of the U.S. Geological Survey (1960) reported on preliminary data—too meager to allow a complete geologic analysis—from which several interesting observations were apparent. They observed that coarse-grained intrusive rock types show low drainage densities and that fine-grained clastic sedimentary rocks show relatively high drainage densities, despite the different geographic locations of the samples. For example, on 1:20,000 scale photography they found that shale formations had drainage densities of about 60 (medium texture) and sandstone and granite formations had drainage densities of 10 and 12 ft of drainage per acre respectively (coarse texture).

Ray and Fischer also found that the scale of photos used had an influence on calculated drainage densities. This was easily explained since the ability to see small drainage rills obviously decreases as the photo scale becomes smaller. They further found this relationship to be linear and suggested a simple conversion factor to permit equating drainage densities determined from different scales of photography.

Stream Frequency

Stream frequency is the number of drainage ways within a drainage basin per unit area of land and can be expressed by:

$$F = \frac{N}{A} = \frac{N(6,272,640)}{(PSR)^2} (\frac{DI}{DC})$$

Where

F = drainageway frequency per acre

N = total number of drainageways in the drainage basin

A = drainage basin area in acres

and the other symbology is as previously defined.

For example, if we assume that N is 8 in the same example as used for calculating drainage density (Figure 14.7 coarse texture), we get:

$$F = \frac{8(6,272,640)}{(20,000)^2} (\frac{100}{584}) = 0.021$$

Relative Infiltration

Relative infiltration (RI) is the product of drainage density and drainage frequency. Using the data from the last two examples we get:

$$RI = (D_d)(F) = (47.0) \ (0.021) = 0.99$$

For the medium and fine textured patterns of Figure 14.7 we get relative infiltrations of 7.62 and 36.69, respectively. Remember that these are relative values to be compared with each other as to water infiltration into the soil mantle.

Despite the fact that drainage density varies with geologic type, climatic and vegetational conditions, it still provides information as to fluvial erosion and the accessibility of an area. Of more importance is the fact that poor land management can lead to additional erosion and increased drainage densities. These changes over time can be detected on aerial photography that provide permanent records.

Gully Types

The type of gully formed in a given area can tell the soils scientist much about soil cohesiveness and texture. Gullies are formed by runoff that collects and erodes through the surface soils. These gullies adapt well-known cross-sectional shapes depending on the composition and cohesiveness of the soil. In Figure 14.8 we have three typical gully cross sections that are characteristic of different soil textures and cohesiveness.

The cross-section in Figure 14.8 (top) is typical in areas of gradual uniform slopes where the soil consists of clays and silty clays with relatively high cohesiveness. This gully type is usually found in lakebeds, marine terraces, or other areas of high clay content (Figure 14.9).

Figure 14.8 (middle) is typical of moderately cohesive soil, consisting of sand, clay, and silt (Figure 14.10). This gully type is usually found on moderate slopes of coastal plains and bedrock areas.

Figure 14.8 (bottom) is typical of the noncohesive, semigranular soils (sands and gravels) usually found in terraces and outwash plains where slopes are usually steep to very steep (Figure 14.11).

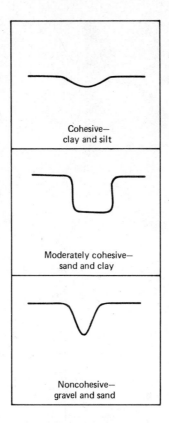

Figure 14.8. Characteristic gully profiles found in cohesive, moderately cohesive, and non-cohesive soil types.

Tone and Texture

Photographic tone refers to the various shades of gray from black to white (Figure 13.4) and photographic texture refers to the coarseness or fineness of a group of objects. Tone indicates surface characteristics and is influenced by soil type, soil moisture, and vegetation types (Figure 13.5). In general, the darker tones indicate relative high soil moisture content and associated high organic matter, which are often indicators of poor drainage and little leaching. The ligher tones are associated with dry areas with little organic matter and well-leached soils. Medium or gray tones usually indicate soils with good soil profiles and adequate organic content. Very light tones (white) usually indicate barren areas such as exposed sand, gravel, or salt deposits, and, of course, snow and ice.

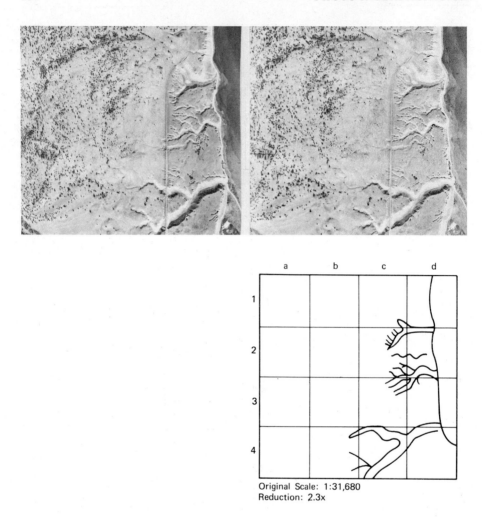

Original Scale: 1:31,680
Reduction: 2.3x

Figure 14.9. Gullies formed in silty soil material. (From N. Keser, 1976, aerial
photos photos from Surveys and Mapping Branch, Government of
British Columbia.)

In glaciated areas we frequently find light and dark tones randomly mixed.
This is known as mottling (Figure 13.4). Sometimes in old lakebeds, floodplains, or
outwashes, light and dark tones are alternately banded. This is a result of inter-
bedded sedimentary formations and is described as a banded appearance (Figure
14.12).

Since there is so much tonal variation between different photographs taken
and developed under different conditions and between different seasons of the year,

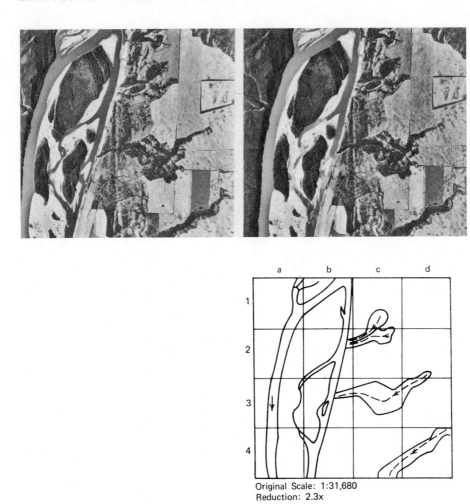

Original Scale: 1:31,680
Reduction: 2.3x

Figure 14.10. Gullies formed in moderately cohesive soil material. (From N. Keser, 1976, aerial photos from Surveys and Mapping Branch, Government of British Columbia.)

photographic tone should be considered as relative, and therefore should be compared within stereoscopic pairs, or at least within individual photographic missions.

Vegetational Patterns

Vegetation frequently prohibits the photo interpreter from viewing the ground, but its mere presence or absence provides a useful clue as to the soil conditions

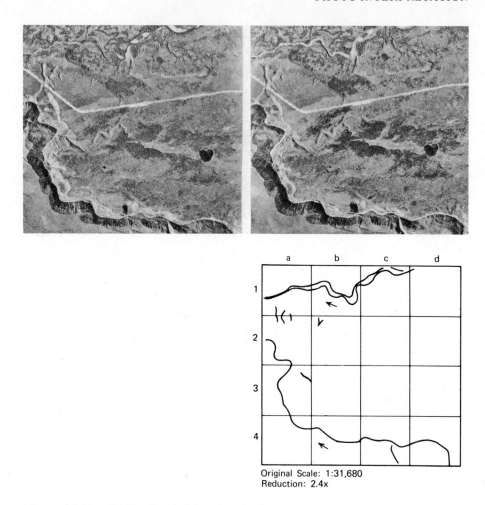

Original Scale: 1:31,680
Reduction: 2.4x

Figure 14.11. Gullies formed in noncohesive sand and gravel. (From N. Keser, 1976, aerial photos from Surveys and Mapping Branch, Government of British Columbia.)

below—as to texture, permeability, and moisture availability. Because of different vegetative cover associated with different geographic regions, local experience is absolutely necessary for an accurate assessment of just what different vegetational patterns indicate.

Land-Use Patterns

Land-use patterns are man-made alterations of the landscape, and are valuable clues as to soil conditions. Man-made patterns are conspicuous because they

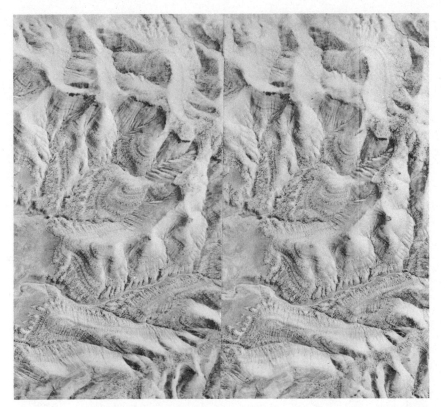

Figure 14.12. Distinct banding indicates interbedded sedimentary photos from Surveys and Mapping Branch, Goverformations. Frequently there is vegetation in the dark bands, but not in the light bands as a result of soil moisture differences.

usually consist of straight lines or other regular configurations. The location of transportation routes, cities, farms, and industrial complexes gives valuable clues as to the land surface and subsurface conditions. Winding roads indicate steep or hilly topography. Railroads must be located where grades are minimal and can be separated from roads since their curves must be gradual. Farm locations avoid poorly drained areas as well as rocky or other locations of poor or shallow soils. Cities and industrial areas are often located in certain areas because of transportation routes. Unfortunately, these areas are frequently of high-quality farm lands, but fortunately some of the better residential areas are developing in the foothills surrounding the cities and occupy the less valuable agricultural land.

Questions and Problems

1. Write a definition for the term "landform" in such a way that it is independent of specific geographic location.

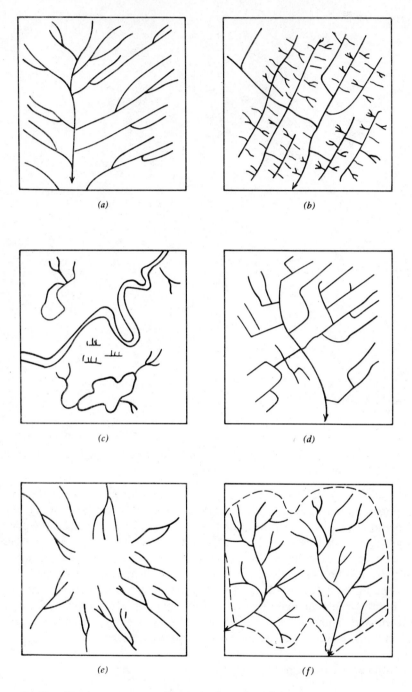

Figure 14.13. Drainage patterns for questions 3 and 4.

2. List seven pattern elements used by the photo interpreter to identify and categorize landforms.

3. Identify and name each of the drainage patterns in Figure 14.13.

4. Calculate the drainage density, stream frequency, and relative infiltration for the drainage pattern shown in Figure 14.13 that has the dashed line around it and classify the drainage density as to fine, medium, or coarse. Assume a 30,000 MSR and consider only the area within the dashed lines.

5. Draw a schematic diagram of the cross-section of three gully types and state what each gully type indicates as to soil texture, cohesiveness, and the general slopes.

6. Carefully examine Figure 14.15. What does the vegetation tell you about the annual rainfall of this area? What does the cross sectional gully shape of the tributaries to the main stream tell you about soil cohesiveness? What does the light tone of the creek in the flood plane and the tributary gully shapes tell you about the erodability of the soil?

7. Carefully examine Figure 14.14. What does the vegetation tell you you about the annual rainfall of this area? What does the cross-sectional gully shape tell you about the soil cohesiveness in the cleared agricultural areas? What does the presence of farm ponds constructed on sidehills tell you about soil permeability in this area? Why is the tone of one pond very light (at A) and the other very dark?

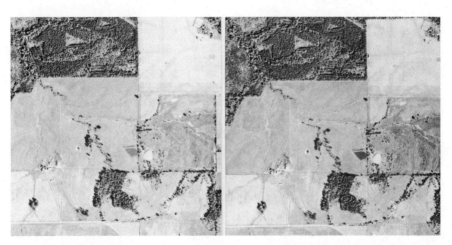

Figure 14.14. Stereogram for question seven. (Courtesy of Illinois Photographic Service.

Figure 14.15. Sterogram for question six. (Courtesy of Illinois Photographic
Service.

Fifteen

Geology, Soils and Engineering Applications

This chapter is an extension of Chapter Fourteen, but with more emphasis on application. In Chapter Fourteen we defined landform *as a terrain feature formed by natural processes. A* landscape *is a collection of landforms. Most of this chapter discusses many different landscapes keyed to tables that can be used by the trained geomorphologist-photo interpreter to make inferences about soil texture, soil drainage, land use, and engineering characteristics.*

Tables 15.1 through 15.6 have been adapted from Way (1973) in the form of photo interpretation keys. These keys by themselves are inadequate for the average photo interpreter who does not completely understand the fundamental, but complicated, geological processes that have taken place for centuries to create the specific landform to be discussed. To become skilled in the photo interpretation of landforms you must possess a thorough understanding of lithologic and structural influences, the effects of past and present climates, and the influence of man. A complete discussion of these processes is beyond the scope of this book.

Objectives

The primary objective of this chapter is to make the student aware of the usefulness of aerial photography in the study of geology, soils mapping, the location of engineering construction materials (sand, gravel, and other fill material), and the loction of suitable building sites or for the location of roads. A more complete discussion of engineering applications can be found in other texts. Similarly, for more detailed information on the use of aerial photographs in geomorphology, geology, and soils, texts devoted specifically to these subject areas should be consulted.

Because of the above limitations, only a few specific objectives based on this chapter are listed. After a thorough understanding of this chapter you will be able to:

1. Draw a properly labeled diagram of, or identify on a stereoscopic pair of aerial photos, the following features of glaciated landscapes: (1) alpine features, (2) glacial drift including kames, eskers, drumlins, and outwash plains.
2. Describe the formation of eolian and fluvial landscapes and how they can be identified on aerial photographs.
3. Given a written description, or stereoscopic pairs of aerial photographs, and Tables 15.1 through 15.6, identify specific landscapes and make specific inferences about them.
4. Define the term *mass wasting* and list the two factors that cause mass wasting.
5. Identify the *cuesta* landform on a stereoscopic pair of aerial photos and state the importance of identifying this form when selecting possible road locations.
6. State the difference between mature and old stages of geologic erosion.
7. List six of the nine factors that should be considered when evaluating the potential erosion hazard of a particular soil.
8. List the three steps, in sequence, for the production of a soils map using aerial photography and field checking.

SEDIMENTARY LANDSCAPES

Most sedimentary rocks were formed by the deposition of sediments by water, wind, or ice and are usually composed of other types of rock. When the transporting agent slows, sediments are deposited with the larger particles settling first followed by smaller particles. This results in sedimentary layers that are stratified by particle size.

Even though these layers were laid down in roughly horizontal planes, many were later uplifted to form mountainous terrain. Other types of sedimentary rock, coal for example, are the result of chemical reactions and an organic source. Approximately 75 percent of the exposed land surface of the earth is composed of sedimentary rock (Way, 1973).

Sedimentary rock types include conglomerates (unconsolidated sand and gravel), sandstone, siltstone, limestone, and coal. Limestone and coal are examples of organic sources. Figure 15.1 shows the distribution of *exposed* sedimentary rock in the United States. Table 15.1 can help the experienced geomorphologist-photo interpreter identify sedimentary formations and make certain inferences about associated soils, land use, and engineering characteristics.

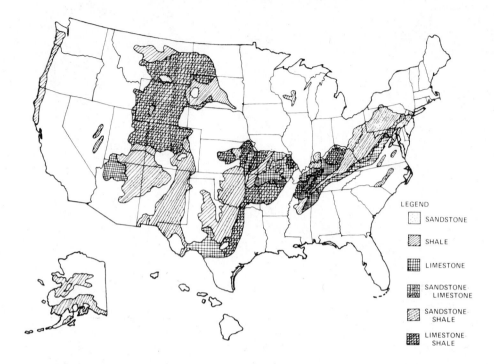

LEGEND

- [] SANDSTONE
- [] SHALE
- [] LIMESTONE
- [] SANDSTONE-LIMESTONE
- [] SANDSTONE-SHALE
- [] LIMESTONE-SHALE

Figure 15.1. Distribution of well-consolidated sedimentary rock parent materials in the United States. (From Douglas S. Way, *Terrain Analysis,* 1973, copyright 1973, reprinted with permission of Dowden, Hutchinson & Ross, Inc., Stroudsburg, Pennsylvania.)

IGNEOUS LANDSCAPES

Igneous rocks are formed by the solidification of molten rock either within or on the surface of the earth. They are classified as intrusive if they were formed beneath the surface of the earth and extrusive if they were formed on the earth's surface.

Rock types are classified as granitic or basaltic and are generally hard, durable, and associated with poor subsurface drainage. Igneous rock landscapes make up about 18 percent of the earth's exposed land surface (Way, 1973). The distribution of igneous landscapes within the United States is shown in Figure 15.2, and Table 15.2 can be used by the experienced geomorphologist-photo interpreter for identification of these landforms and for making inferences about them.

TABLE 15.1 Sedimentary Rock Characteristics

| | From Aerial Photos and Geologic Maps | | | | | Inferences | | |
Landform Climate	Topography	Drainage & Texture	Photo Tone	Gully Type	Soil Texture	Soil Drainage	Land Use	Engineering Characteristics
Shale Humid	Rounded hills	Dendritic Med.-fine	Light (mottled)	⟨curved⟩	Fine Silt-clay	Poor	Agriculture Forestry	Excellent base Poor septic systems
Arid	Rough-steep	Dendritic Fine	Light (banded)	⟨flat-bottom⟩	Med. Silty	Very poor	Barren	Excavation difficult. Poor agregate
Sandstone Humid	Massive and steep	Dendritic Coarse	Light	⟨V-shape⟩	Sandy	Excellent	Forestry	Excellent base Shallow to bedrock
Arid	Flat table	Dendritic Med.-coarse	Light (banded)	None	Fine	Poor	Barren	Poor septic systems

Limestone								
Humid	Flat or rough sink holes	Internal	Mottled	⎰	Silt-clay	Poor to good	Agriculture	Shallow soil Poor septic systems
Arid	Flat table	Dendritic	Light	None	Fine	Poor	Barren	Poor septic systems
Interbedded								
Flat (humid)	Terraced	Dendritic Med.-coarse	Medium (banded)	Variable	Variable	Variable	Some agric. Some forest	Good base Variable to bedrock
Tilted (humid)	Parallel ridges	Trellis Med.	Medium (banded)	⎰	Fine	Fair	Agriculture Forestry	Good base Excavation difficult

Adapted by permission from Way (1973).

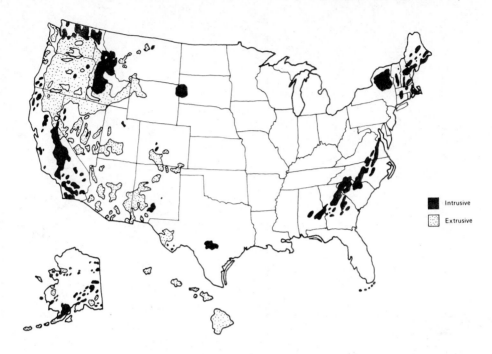

Legend:
- ■ Intrusive
- ⣿ Extrusive

Figure 15.2. Distribution of igneous landforms in the United States. (From Douglas S. Way, *Terrain Analysis*, 1973, copyright 1973, reprinted with permission of Dowden, Hutchinson & Ross, Inc., Stroudsburg, Pennsylvania.)

METAMORPHIC LANDSCAPES

Metamorphic rocks are formed beneath the surface of the earth by heat and pressure working on sedimentary or igneous rock. The more important rock types include slate, phylite, schist, gneiss, quartzite, and marble. Photo interpretation of metamorphic landscapes is made difficult because of intermingling with sedimentary and igneous types and the relatively small size of single deposits. Figure 15.3 shows areas that include metamorphic landscapes within the United States, and Table 15.3 can be used by the photo interpreter to make inferences about them.

GLACIATED LANDSCAPES

Glacial landforms are created by the carving action of glaciers and the deposition of this material at lower elevations. For our discussion we will separate glacial landscapes into (1) *alpine* (where the carving took place), and (2) *glacial drift* (the deposition of the material).

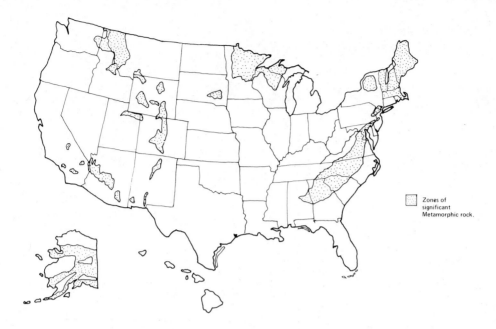

Figure 15.3. Distribution of major metamorphic rock formations in the United States. (From Douglas S. Way, *Terrain Analysis,* 1973, copyright 1973, reprinted with permission of Dowden, Hutchinson & Ross, Inc., Stroudsburg, Pennsylvania.)

Even though glaciers occupy only about 10 percent of the earth's surface at present, about 30 percent has been glaciated at one time or another (Way, 1973). Figure 15.4 shows the location of glaciated landscapes within the United States.

Alpine Landscapes

Alpine landscapes (Figures 15.5 and 15.6) are characterized by U-shaped valleys with steep side walls, truncated spur ridges, and hanging valleys. Small lakes called *tarns* are generally formed behind recessional moraines in the bowl-shaped cirques formed by glacial plucking and frost action. Many of these moraines may be dissected by normal geologic erosion leaving areas with lake sediments of glacial outwash material scattered about the landscape. These materials often appear as benchlike areas on canyon side slopes.

Glacial Drift Landscapes

Landforms composed of glacial deposits were created by the melting of glaciers and the retreat of the ice front. The material left behind created distinct landforms that are easily identified on aerial photographs (Figure 15.7).

TABLE 15.2 Igneous Rock Characteristics

| Landform Climate | From Aerial Photos and Geologic Maps | | | | Inferences | | | |
	Topography	Drainage & Texture	Photo Tone	Gully Type	Soil Texture	Soil Drainage	Land Use	Engineering Characteristics
Granite								
Humid and intrusive	Bold and domelike	Dendritic Medium	Light (uniform)	Variable	Silty sand	Poor	Agriculture Forestry	Excavation difficult Poor aggregate Good base
Arid and intrusive	A-shaped hills	Dendritic Fine or internal	Light (banded)	None	Fine	Poor	Barren (rangeland)	
Basalt								
Extrusive flows	Flat to hilly	Parallel or internal	Dark (spotted)	None	Clay to rock	Good	Agriculture to barren	Blasting not difficult. Landslides common. Soil is unstable when disturbed

308

Volcanic extrusive							
Cinder cone	Radial C to F	Dark	Variable	Silty clay	Poor (surface) Good (sub-surface)	Barren	
Fragmented tuff	Sharp-ridged hills (variable height	Dendritic Fine	Light		Noncoh. sand to dust	Excellent Forestry or Grass	Blasting not required. Unstable soil. Septic systems easily contaminated
Imbedded flows	Terraced hills	Parallel dendritic	Light and dark (banded)	Variable	Variable	Variable Agriculture to barren	Unstable soil

Adapted by permission from Way (1973).

TABLE 15.3 Metamorphic Rock Characteristics

| Landform Climate | From Aerial Photos and Geologic Maps | | | | Inferences | | | |
	Topography	Drainage & Texture	Photo Tone	Gully Type	Soil Texture	Soil Drainage	Land Use	Engineering Characteristics
Slate								
Humid and arid	Many small sharp ridges of same height	Rectangular Fine	Light	⟨U-shaped⟩	Coh. Fine		Unproductive natural veg. thin soil	Excavation difficult Rock slides
Schist								
Humid	Steep rounded hills	Rectangular Med.-fine	Light (uniform)	⟨stepped⟩	Mod. coh. sand-clay	Good to poor	Cultivated Forested	Seepage problems Poor septic systems
Arid	Rugged	Rectangular Fine	Light (banded)	⟨V-shaped⟩	Mod. coh. sand-clay	Good	Thin soil (grass and scrub)	Little excavation needed
Gneiss								
Humid and Arid	Parallel, steep, sharp ridges	Ang. dend. Med.-Fine	Light (uniform)	⟨V-shaped⟩	Mod. coh. sand-silt	Fair	Natural (forested, grass or scrub)	Much blasting Fair aggregate

Adapted by permission of Way (1973).

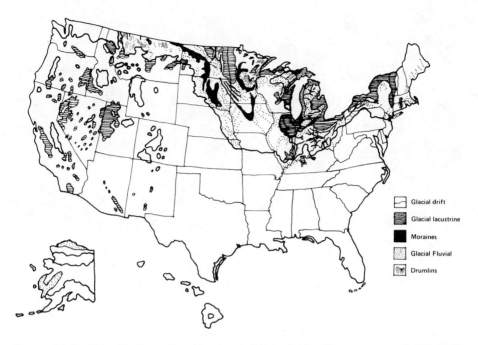

Figure 15.4. Distribution of major groups of glacial landforms across the United States. (From Douglas S. Way, 1973, *Terrain Analysis,* copyright 1973, reprinted with permission of Dowden, Hutchinson & Ross, Inc., Stroudsburg, Pennsylvania.)

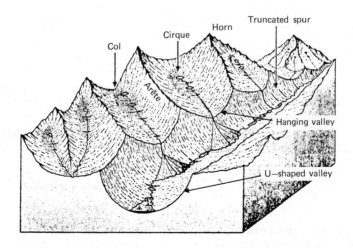

Figure 15.5. Features of an alpine landscape. (From Arthur L. Bloom, *The Surface of the Earth,* copyright 1969. Reprinted by permission of Prentice-Hall, Inc., Englewood Cliffs, New Jersey.)

311

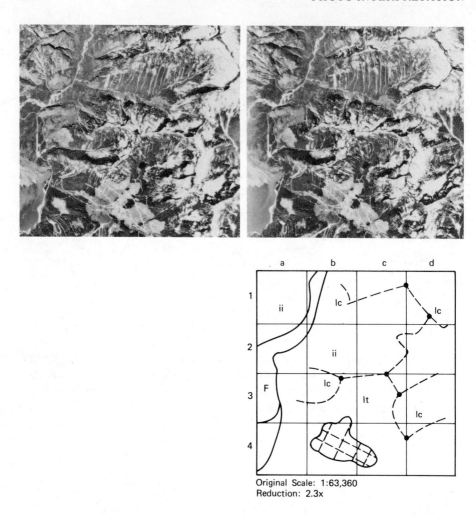

Original Scale: 1:63,360
Reduction: 2.3x

Figure 15.6. Massive glaciated alpine landscape illustrating several horns (•),
cirque glaciers (1c) a tarn (o), a logged area at 4bc, and fluvial
material at F. (From N. Keser, 1976, aerial photos from Surveys and
Mapping Branch, Government of British Columbia.)

Moraines

The term moraine designates a landscape constructed of drift—a heterogene-
ous accumulation of rock material deposited by ice. If the drift consists of ridgelike
mounds found where the glacier terminated, it is called an end or terminal moraine
(Figure 15.8) and has distinctive linear elements. Without distinctive linear elements
it is called a ground moraine. A moraine may have gentle relief or consist of a

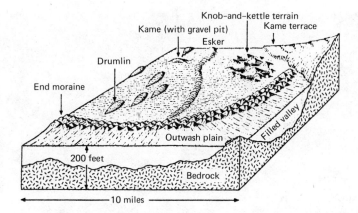

Figure 15.7. Features of a glacial drift landscape. (From Arthur L. Bloom, *The Surface of the Earth,* copyright 1969. Reprinted by permission of Prentice-Hall, Inc., Englewood Cliffs, New Jersey.)

hummocky maze of drift mounds separated by basins called kettle holes (Figure 15.9), which are a result of chunks of ice that melted leaving a hole. If the accumulation of weathered debris was deposited along the glacier margin it is called a lateral moraine (Figure 15.8).

Kames

A kame is a flat-topped or conical mound usually composed of water-laid sand and gravel and is an excellent source of construction material (Figure 15.10).

Eskers

An esker is a snakelike ridge of water-laid drift that may be up to 100 ft high and many miles long (Figure 15.11). Eskers are also excellent sources of sand and gravel and are often completely excavated by sand and gravel companies in populated areas.

Drumlins

Drumlins are gently rounded, oval to cigar-shaped ridges of unconsolidated debris deposited by glacial ice (Figure 15.12). They are typically one-half mile to a mile long and between 50 and 200 ft high with a long teardroplike tail indicating the direction of ice movement. They usually occur as drumlin swarms oriented in the same direction and are easily identified on an aerial photo.

The soils can be either coarse or fine grained, but with good drainge. Drumlins are frequently farmed (see Figure 3.1) on the top or sides if they are not too steep, with the cultivated fields parallel to the long axis. If the sides are too steep for farming, they are usually timbered. Drumlins are frequently a good source of material for road construction.

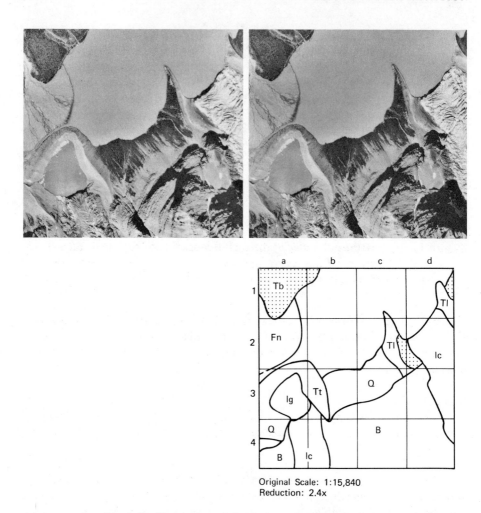

Original Scale: 1:15,840
Reduction: 2.4x

Figure 15.8. Glacial drift landscape featuring a terminal moraine at Tt, lateral
moraines at Tl, and basal till at Tb. Other features include bedrock
(B), cirque glacier (1c), ice marginal lake (1g), fandelta (Fn), and
mass movement (Q). (From N. Keser, 1976, aerial photos from
Surveys and Mapping Branch, Government of British Columbia.)

Outwash Plains
 Outwash plains were created beyond the last blocks of melting ice by sediment-
laden outwash streams to build up valley floors with many feet of alluvium. In some
areas these deposits have also been downcut by geologic erosion leaving remnant
deposits as benchlike terraces along the valley bottoms and canyon wall toe slopes.

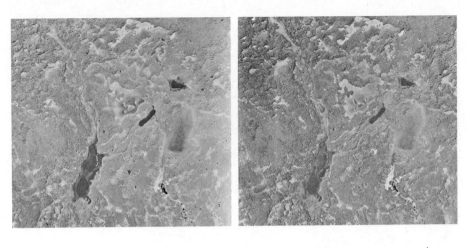

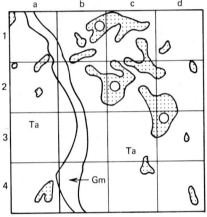

Original Scale: 1:31,680
Reduction: 2.3x

Figure 15.9. Typical kettle-hole topography with deposits of organic material (O) and a meltwater channel (Gm). (From N. Keser, 1976, aerial photos from Surveys and Mapping Branch, Government of British Columbia.)

Glacial deposited material is normally deep and bouldery. Morainal soils of intrusive granitic origin are usually coarse textured, well drained, and of relatively low fertility. Morainal soils of extrusive volcanic rock origin (basalts, andesites, tuffs), although usually gravelly and bouldery, are normally loam to clay textured and not as well drained as the coarser-textured morainal soils of granitic origin. Moisture-holding capacities and relative fertility are usually greater for soils of volcanic origin than those of morainal soils of granitic origin.

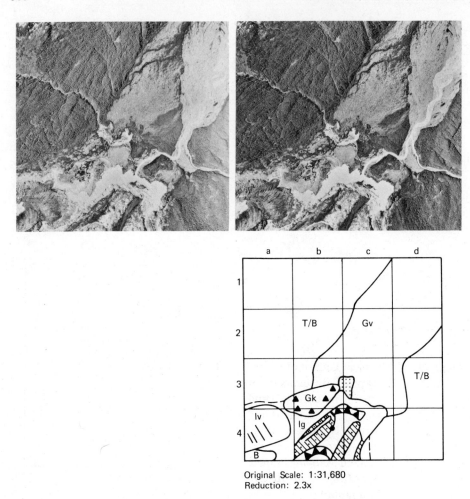

Original Scale: 1:31,680
Reduction: 2.3x

Figure 15.10. Glacial drift landscape showing kames (▲) and a conical kame (●).
Also shown is till underlain by bedrock (T/B), valley glacier (Iv),
and an ice marginal lake (Ig), and a valley train (Gv). (From N.
Keser, 1976, aerial photos from Surveys and Mapping Branch,
Government of British Columbia.)

In general, soil characteristics are reflected in the relative vegetative productivity, which can be observed by stereoscopic study of aerial photos. In areas of high annual precipitation, it becomes more difficult to discern this relative productive difference.

Table 15.4 helps the experienced geomorphologist-photo interpreter identify glaciated landscapes and make inferences about them.

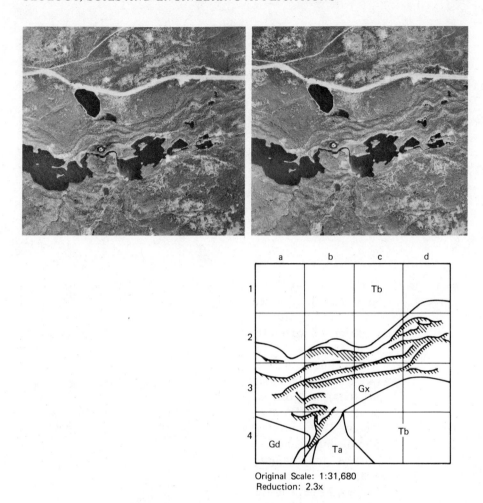

Original Scale: 1:31,680
Reduction: 2.3x

Figure 15.11. Glacial drift landscape showing kame complex (Gx) and a limited amount of drumlinization (Tb). (From N. Keser, 1976, aerial photos from Surveys and Mapping Branch, Government of British Columbia.)

EOLIAN AND FLUVIAL LANDSCAPES

To complete our abbreviated discussion of landscapes we must include eolian or windlain deposits and fluvial or waterlain deposits.

Eolian Landscapes

Eolian landscapes consist of sand dunes and loess, or silt deposits. Sand dunes

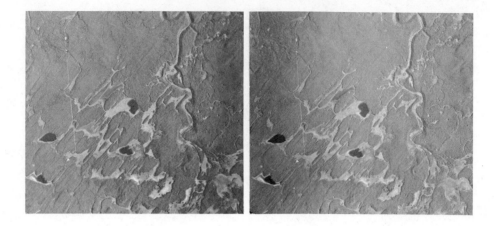

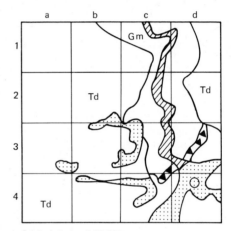

Figure 15.12. Glacial drift landscape showing a drumlinized till plane (Td) with the direction of ice movement from 4a to 1d. Also visible is an esker (▲), a meltwater channel (Gm), and organic deposits (O). (From N. Keser, 1976, original photo supplied by The Surveys and Mapping Branch, Department of Energy, Mines and Resources, Ottawa, Canada.)

Original Scale: 1:63,360
Reduction: 2.3x

occur close to the source, and loess, being made up of much smaller particles, is often carried great distances by wind and covers large areas as evidenced by Figure 15.13. About 30 percent of the United States is covered by eolian sediments (Way, 1973).

Loess deposits sometimes cover hundreds of square miles and usually decrease

in thickness with the distance from the source. The mineral content depends on the source of the parent material. Loess soils are light colored and well drained vertically (internally), but poorly drained horizontally. Loess soils are highly erosive and characterized by box-shaped gullies indicating a high silt content.

Sand dunes are easily identified by the photo interpreter because of their characteristic shapes, of which there are many, and their bright tone. Their bright tone is due to their light color and lack of dense vegetation. Gullies are usually nonexistent due to rapid internal drainage. Table 15.5 can be used by the experienced photo interpreter to identify and make inferences about eolian landscapes.

Fluvial Landscapes

Fluvial landscapes are a result of water erosion where large quantities of soil material have been transported from higher to lower elevations and deposited. These deposits are frequently stratified by particle size because different water velocities allow differential settling of different size material.

Fluvial landscapes can be classified into three categories: (1) river associated forms, which include flood plains, and deltas, (2) alluvial forms, which include alluvial fans, valley fills, and continental alluvium, and (3) freshwater forms, which include plyas and organic deposits. Figure 15.14 shows the location of major fluvial landscapes within the United States and Table 15.6 can be used by the experienced geomorphologist-photo interpreter to help identify these landforms and make inferences about them.

MASS WASTING

Mass wasting is defined as the downslope movement of rock material (including soil) under the influence of gravity, but without a transporting agent such as wind, flowing water, or glacial ice. Even though flowing water is excluded from our definition, nonflowing water is a major contributing factor in mass wasting through its action as a lubricant. Mass wasting can proceed at rapid rates (avalanche) or they can proceed very slowly (creep).

Mass wasting is usually the result of a combination of two factors: the presence of structurally weak bedrock, which has deep seated zones of weakness, and the moisture status of the different strata.

Examples of weak bedrock situations are (1) interbedded sedimentary rocks such as graywacke and slate, and/or schists such as the phyllite and graphite schists, (2) serpentine rock mantles characterized by highly fractured, slick, shiny surfaces, (3) potential shear zones at the contact point of veneered or plastered morainal till with the underlying bedrock material along steep canyon walls, and (4) the weak, easily weathered, incompetent layers of volcanic tuffs and tuff breccia interbedded with hard flow basalt and andesite.

TABLE 15.4 Glacial Drift Characteristics

Landform Climate	From Aerial Photos and Geologic Maps				Inferences			
	Topography	Drainage & Texture	Photo Tone	Gully Type	Soil Texture	Soil Drainage	Land Use	Engineering Characteristics
Till plains Old	Broad, level, dissected	Dendritic Variable	Light (mottled)	Variable	Variable	Poor	Agriculture Forestry	Poor subgrade High water table
Young	Broad, gently rolling	Deranged Variable	Light (mottled)	Variable	Variable	Poor	Agriculture Forestry	Poor subgrade High water table
Ground moraine	Between till plain and moraine	Deranged-dendritic Medium	Light-medium (mottled)	Variable	Variable	Poor	Forestry Range (swamps)	Boulders. Coarse textured—good fill
End moraine	Broad belts of hills under 500 ft	Deranged-dendritic Medium	Light-medium (mottled)	⌐⌐	Noncoh. sand	Poor to well	Forestry Range (swamps)	Variable

							Agriculture	Construction
Drumlin	Parallel-oval swarms in one direction	Internal	Light	Variable	Coarse or fine	Good	Forestry	Construction difficult. Excellent fill
Esker	Long, narrow winding ridges ½ to 2 miles long	Internal	Light	(symbol)	Noncoh. sand	Very well	Forestry or none	Excavation easy. Excellent sand & gravel
Kame	Conical to irregularly shaped mounds under 50 ft high	Internal	Light	(symbol)	Noncoh. sand	Very well	Forestry (humid climates)	Excellent sand and gravel

Adapted by permission from Way (1973).

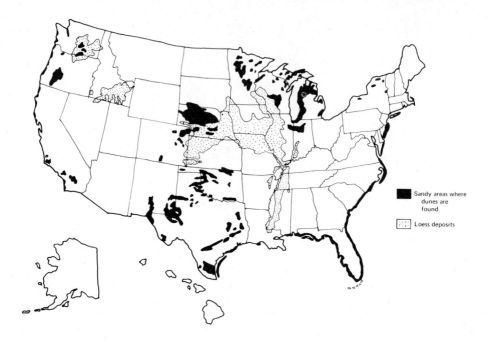

Figure 15.13. Distribution of eolian landforms within the United States. (From Douglas S. Way, 1973, *Terrain Analysis,* copyright 1973, reprinted with permission of Dowden, Hutchinson & Ross, Inc., Strouds-burg, Pennsylvania.)

In areas of high annual precipitation, the soil mantle, particularly the subsurface strata, is saturated throughout most of the year. The internal cohesional and frictional forces of the soil mantle material when wet are considerably reduced and the potential for movement is greatly increased. Soils derived from the easily weathered, incompetent rocks, such as shales, phyllite schists, slates, tuffs, and tuff breccias are usually clay textured and highly plastic when wet. The potential for mass movement of these soils is high. Disturbance caused by human activity on the landscape or by natural earth movement can easily trigger mass movement of these potentially unstable areas.

In areas of mass movement the soil material usually, but not always, is clay textured and plastic when wet. The material loses all stability and structural strength and flows as a mudflow when saturated with moisture.

THE CUESTA LANDFORM

An important landform that is easily detected by the photo interpreter is the *cuesta* — characterized by the difference in slope between the two opposite sides of

TABLE 15.5 Characteristics of Eolian Deposits

Landform Climate	From Aerial Photos and Geologic Maps				Inferences			
	Topography	Drainage and Texture	Photo Tone	Gully Type	Soil Texture	Soil Drainage	Land Use	Engineering Characteristics
Loess	Smooth, rounded, un-dulating hills	Dendritic (pinnate) Fine	Medium	⊓⊔	Mod. coh. silt	Good	Agriculture	Frost, compac-tion, and ero-sion problems
Sand Dunes	Variable shapes	Internal	Very light	⋁	Noncoh. sand	Exces-sive	Barren	Excavation easy

Adapted by permission from Way (1973).

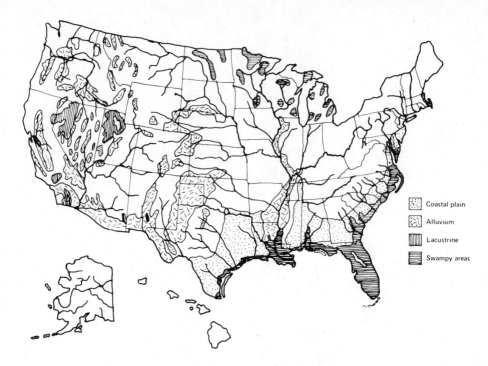

Figure 15.14. Distribution of fluvial forms throughout the United States. (From Douglas S. Way, 1973, *Terrain Analysis,* copyright 1973, reprinted with permission of Dowden, Hutchinson & Ross, Inc., Strouds-burg, Pennsylvania.)

a ridge. Ridges are frequently a result of one or more layers of dipping resistant rock (Figure 15.15). The cuesta land form is of particular significance to forest and civil engineers, land-use planners, or others who may have reason to disturb the land surface with road construction, or other developments that might contribute to mass wasting.

The gentle dip slope of a cuesta is less than 20 to 25° with a much greater antidip slope. An adverse dip slope is where the strata dip in the same direction as the surface slope. The gentle slope of the cuesta landform is the adverse slope.

Because approximately 80 percent of the earth's surface is layered, the cuesta form is relatively common in certain geographic regions. The importance of this form is that when alternate layers of resistant and nonresistant material exist there is a tendency for slippage between strata during periods of high rainfall. Where

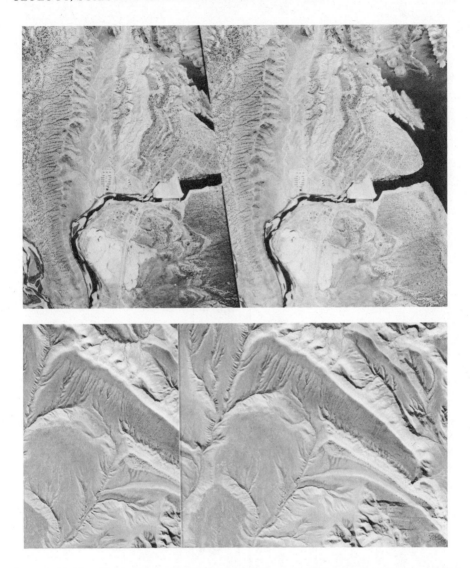

Figure 15.15. Typical cuesta landforms composed of tilted sedimentary material — note the banding in the upper stereogram. The dip slopes are less than 25° with much greater antidip slopes. The cuesta in the upper photo is west of the Alcova Dam in Natrona County, Wyoming. (Courtesy of Illinois Photographic Service.) The cuestas in the lower stereogram are in Hot Springs County, Wyoming.

TABLE 15.6 Characteristics of Fluvial Deposits

Landform Climate	From Aerial Photos and Geologic Maps					Inferences		Engineering Characteristics
	Topography	Drainage and Texture	Photo Tone	Gully Type	Soil Texture	Soil Drainage	Land Use	
Flood plains	Flat	Meanders	Variable	Few	Variable	Poor (variable)	Agriculture	Gravel—poor Minor slumping
Deltas	Level with stream channels	Dendritic (fine)	Medium	∨	Silt to gravel	Very poor	Variable (marshy)	Poor for construction
Alluvial fans	Convex fan-shaped	Radial	Light (gray)	None	Coarse	Good	Barren to natural cover	Poor support Excavation easy

Valley fills	Gradual slopes	Parallel to dendritic	Light (uniform)	Variable	Coarse (variable)	Variable	Agriculture or natural	Fair support Excavation easy
Continental alluvium	Flat	Dendritic to internal	Light (gray)		Silty-loam	Poor	Agriculture or natural	Poor for septic tanks. Fair support
Plyas (arid lakebeds)	Flat basin	None (evaporative)	Light	None	Silty-clay	None	Barren	High water table (flooding) Poor for sewage
Organic deposits	Flat (depressions)	Dendritic (variable)	Very dark	None	Organic (silt-clay)	None	Agriculture if drained	Not suited for construction

Adapted by permission from Way (1973).

possible, adverse dip slopes should be avoided when constructing roads or zoning for building sites of any kind. These areas may remain relatively stable for many years until human excavation triggers an active slippage. Even without human help, slippage occurs—sometimes in the form of large landslides and sometimes in the form of creep. Creep can sometimes be detected on aerial photos by the presence of leaning trees, telephone poles, or other objects. The photo interpreter should always be aware of asymmetric ridge slopes (cuestas) when any type of construction is anticipated.

GEOLOGIC EROSION

Landscapes characterized by sharp ridges and long, steep side slopes indicate a mature stage of geologic erosion. The landscape is at the height of its normal geological wearing away processes during this stage. Soils are shallow and slopes are critically steep. Any management planning activity on these kinds of landscapes should be given adequate study and consideration before project action is taken.

Landscapes characterized by broad, flat ridges, gentle slopes, and wide, flat valleys with meandering streams indicate an old-age stage of geologic erosion. The soil mantles are usually deep, finer textured, have high moisture-holding capacities, are less stony or rocky, and are frequently not as well drained as the soils characteristic of the mature stage of geologic erosion.

The foregoing sections point out only a few examples of the gross kinds of landscape interpretations that can be made by stereoscopic study of aerial photos and a knowledge of the earth sciences. Small to medium scale aerial photography of about 1:70,000 provides a wide coverage of the landscape. When used stereoscopically, the photos allow the interpreter to see how the landscape fits together and the mode of origin of many of the landscape segments or landforms. Use of large-scale photography does not allow stereoscopic study of a large section of the landscape and landform interpretations can be overlooked.

SURFACE EROSION

During the process of surface erosion, soil particles are detached and transported by the forces of wind, glacial ice, or raindrop impact and overland waterflow. The ease in which these particles can be detached and transported depends on the structural stability of the surface soil and the effective total energy acting on the particles by raindrop impact and overland waterflow.

Several variables should be considered when evaluating the potential surface erosion hazard of a particular soil (A.D. Zander, R.M. Pomeroy, and J.R. Fisher, 1966): (1) storm frequency, intensity, and duration for the area, (2) structural stability of the surface inch of soil when wet, (3) infiltration rates of the surface soil, (4) depth of soil profile, (5) percolation and permeability rates or the movement of water through the soil as affected by clay-textured horizons, iron-cemented hard-

pans, or hardpans formed by other means such as compacted glacial till, etc. (7) steepness and length of slope, (8) amount of surface stone and rock outcropping, and (9) amount and density of litter, duff, and plant cover present for surface soil protection. Aerial photographs can be used directly to assess variables 7 through 9. Photos can also be used in conjunction with on-the-ground inspection to evaluate the remaining variables.

Many areas highly susceptible to surface erosion show little or no evidence of accelerated erosion because of the extremely effective soil surface protection afforded by a thick layer of litter and duff. When the protective plant cover has been removed, by natural causes or through human activities, soil loss and site deterioration by accelerated erosion can often be devastating.

SOIL MAPPING ON AERIAL PHOTOS

The proper use of aerial photographs by a trained soil specialist can greatly reduce the cost of soil mapping. Many soil scientists find this difficult if they have not had training and experience with aerial photographs. To these people soil mapping on aerial photographs requires too much subjective judgment. However, these same specialists must exercise a certain amount of subjective judgment when soil mapping on the ground. They must decide on soil texture, color, and the types and numbers of soil horizons. Delineation of soil boundaries on maps or photos (Figure 15.16) must show sharp boundaries between different soil types, which is not always the case on the ground, thus introducing error regardless of how the soil map is made. In addition, it is impossible to field check every square foot on the ground, necessitating the use of some type of sampling system with the resulting sampling error. Therefore, two different soil mappers will not end up with exactly the same map even though all work is done in the field without the use of aerial photos.

On the other hand, soil mapping entirely on aerial photos is not completely satisfactory either. Even highly trained specialists in both soils and photo interpretation require some ground truth.

The ideal method is to use aerial photography to extend soils information collected in the field (including expensive soil pits and laboratory analyses) for similar-looking areas on aerial photographs. This reduces but does not entirely replace the amount of relatively expensive field work required.

Soil mapping from aerial photos should begin with a geologic map if possible. This lets the interpreter know what to expect in the way of landform, parent material, etc. A knowledge of the regional distribution of landforms and their properties is also helpful. For example, glacial till in the Midwest contains greater proportion of silt and clay particles than glacial till found in the New England states, which contains more sand.

Next the interpreter should identify specific landforms by their topography, drainage pattern, drainage texture, and photographic tone (Tables 15.1 through

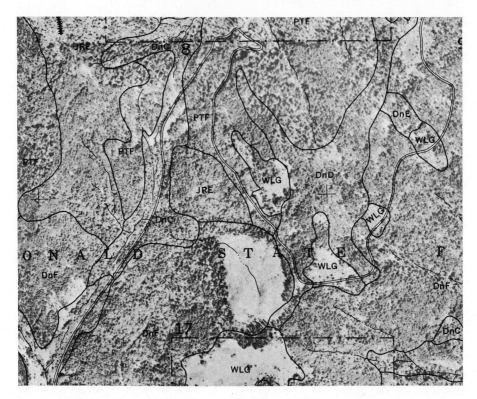

Figure 15.16. Soils type map on an aerial photo. This is the same area as shown in
 Figure 4.1. (From U.S. Department of Agriculture, Soil Conserva-
 tion Service.)

15.6). Just this much interpretation greatly reduces the possible number of soil types
to be found; for example, wind-deposited loess soils are much different from those
made up of glacial till. Finally, if the photographic scale is large enough, much can
be inferred about soil texture and cohesiveness through a careful study of gully cross
sections. As discussed earlier, much can be inferred about soil organic matter
content by examining the existing natural vegetation and photographic tone. The
darker tones are an indication of high organic matter and/or high soil moisture.

 Finally, the soil mapper who has used aerial photographs must field check a
portion of the photo-derived soils map. Hopefully this confirms what he or she has
done, and corrects errors. It also provides valuable training and experience for the
next soil map or for the completion of the current mapping project.

 When using aerial photos in conjunction with geologic maps and field checks,
relationships between photo characteristics and specific landforms as to kinds of
geology and soil materials become increasingly apparent to the photo interpreter.

Continually relating soil and geologic characteristics to landforms and land surface configuration, as seen stereoscopically on the photos, will develop confidence in the photo user for making more reliable interpretations and predictions for management use.

The best method is to conduct a preliminary ground reconnaissance near the beginning of the project and periodically throughout the project. This should produce soil maps of acceptable accuracy in the least amount of time at a minimum cost.

OBTAINING GEOLOGIC, HYDROLOGIC, AND TOPOGRAPHIC MAPS

For information on how to obtain geologic, hydrologic, topographic, and other types of maps, you can write to:

Branch of Distribution
U.S. Geologic Survey
1200 South Eads Street
Arlington, Va. 22202

and ask for "A Guide to Obtaining Information from the USGS, 1978," Geological Survey Circular 777.

THE LAND MANAGER'S RESPONSIBILITY

A land manager must be aware of the effect of management activities on the sustained yield of high-quality water because of the increasing need for water and the emphasis on improved water management. Furthermore, the manager must consider the effect of management activities on timber, forage, wildlife, and recreation as well as the water resource. Because soil is one of our most important nonrenewable resources, and is intimately related to the sustenance of the other resources, it is imperative that the land manager give full consideration to the soil resources in his or her planning.

The foregoing discussion has emphasized the need for land managers to develop their skills in stereoscopy and photo interpretation and to acquire a basic knowledge of the earth sciences for use in land-management planning.

To become a truly competent photo interpreter for land-use management one must have an understanding of geology, hydrology, and soils beyond the scope of this book. However, for those who lack this background, Tables 15.1 through 15.6 have been adapted from *Terrain Analysis* by Douglas Way (1973). These tables should be of great help in identifying important terrain features, soil characteristics, engineering problems, the location of engineering materials, and current land use or land-use potential. It is recommended that these tables be used in conjunction with published geologic and soils maps in addition to the aerial photographs.

The maps are valuable for generalized locations of soils and landforms and they alert the photo interpreter as to what to look for. With this information the photo interpreter can make specific identification of features of interest and establish precise locations of these features.

Questions and Problems

1. How are sedimentary, igneous, and metamorphic rock formations created?
2. Either draw a diagram of or write a paragraph to describe (1) alpine glaciated landscapes and (2) glacial drift landscapes. Be sure to include kames, eskers, drumlins, and outwash plains in your answer to the second part of the question.
3. Where would you expect to find sand, gravel, or other fill deposits within a glaciated landscape?
4. How are eolian and fluvial landscapes created and how are they identified on aerial photographs?
5. Given the following descriptions, use Tables 15.1 through 15.6 to identify the landform or parent material:
 (a) Medium-toned smooth rounded hills with a dendritic drainage pattern and boxlike gullies.
 (b) Medium to light mottled-toned rounded hills with a dendritic drainage pattern and shallow rounded gullies in a humid area.
 (c) Medium toned (banded) with parallel ridges and trellis drainage patterns.
 (d) Light-toned sharp parallel ridges with dendritic drainage patterns and boxlike gullies.
 (e) Dark toned, flat to hilly land with parallel drainage patterns.
6. What is meant by the term mass wasting and what two factors contribute to mass wasting?
7. Describe the cuesta landform and state where a road should be located on the cuesta to minimize mass wasting.
8. What is the primary difference between a mature and an old geologic formation?
9. List six of the nine factors that should be considered when evaluating the potential erosion hazard of a particular soil.

Sixteen

Land Use Planning

Even though the actual development of a land-use plan is beyond the scope of this book, aerial photography and other remotely sensed data are essential to the production of a land-use plan. A land-use plan is concerned primarily with resource allocation and achieving a long-term balance between human activity and the capacity of the resource base to sustain that activity. The plan should be developed by a multidisciplinary team of experts. This team must be familiar with all phases of natural resource management, including the ecological and long-range economic effects of various resource allocation decisions and land-use restrictions. They must also understand the sociological and political aspects of resource allocation and land-use planning as well as the legislative requirements for the incentives and controls that should insure effective implementation. Effective land-use planning requires a comprehensive understanding of all natural resources and of human activities that modify land cover and resource potential.

Thus the use of aerial photographs and other remote-sensor imagery are valuable tools in all phases of the planning process, particularly the mapping and inventory phases. Therefore this chapter emphasizes legend systems for land-use mapping that have been developed for use with aerial photography and other remote-sensor imagery, including very small-scale satellite imagery. The inventory phase of determining other than the number of acres in particular classification is covered in Chapters Nineteen through Twenty-one using timber inventory as an example.

Objectives

After a thorough understanding of this chapter and the completion of the laboratory exercise, you will be able to:

1. Define land-use planning and a land-use plan.
2. List five phases of land use planning and give examples of how remote-

sensor imagery can be used in each phase to make the task easier.

3. Describe the essential features of the two land-use legend systems presented including the multilevel or hierarchical concept.

4. Explain what is meant by a computer compatible legend system and state the advantage of such a system.

5. Make a land-use and land-cover type-map emphasizing features of interest to your particular discipline using either of the two legend systems presented.

LAND-USE PLANNING DEFINED

Camp (1974) defined land-use planning as "The process of organizing the development and use of lands and their resources in a manner that wil best meet the needs of the people over time, while maintaining flexibility for a dynamic combination of resource output for the future." A land-use plan is "The concrete expression in map and text form of objectives which are considered desirable by a governing body with the power to approve and implement the plan" (Hills, Love, and Lacate, 1970).

PHASES OF LAND-USE PLANNING

The use of aerial photography and other remote sensing imagery is an essential tool in all five phases of the land-use planning process: (1) mapping, (2) inventory and analysis, (3) analysis and planning, (4) communication of ideas, and (5) monitoring and fine tuning the effectiveness of the implementation of the land-use plan.

Mapping

The actual process of mapping includes the delineation of land condition or cover type classes and the production of maps. Different aspects of this process are scattered throughout this book. Timber type-mapping is covered in Chapter Seventeen, soils mapping in Chapter Fifteen, and two different land-use legend systems are presented in this chapter. In addition, the principles of photo interpretation (Chapter Thirteen), photogrammetry (Chapters Eight through Eleven), stereoscopy (Chapter Six), and the delineation of effective areas (Chapter Ten) are all related to the mapping process.

Inventory and Analysis

The use of remote sensing imagery is an indispensable tool in the inventory and analysis process. This phase consists of the preparation of maps of existing resources and their current uses along with an analytical narrative and tabular summary. The summary tables should always show the amount of each resource type and the

number of acres devoted to each use. Tabular data alone are of little use in the planning process, however. Maps of a variety of themes are necessary to show the spatial relationship among the various uses, such as the distance from existing or potential recreation areas to population centers or the relationship between prime forest, range, or farmland and expanding commercial industrial and residential areas. A complete land-use map will also show all existing and proposed transportation and utility routes that enable the flow of goods and services that tie the whole system together.

It is impossible to clearly separate the analysis function of inventory from the analysis function of planning. The analysis function is an integral part of each phase. The resource and land-use inventory specialist, whom we call a *resource analyst,* must analyze and present some of the interpretations of the basic resource data as overlays or maps and tabulations that show interrelations, limitations, and potentials of the resource. In addition, it is not always possible to anticipate all of these kinds of needs in the inventory stage. They become evident only as the planning process unfolds. Thus it is necessary to treat these additional needs by more adequately addressing the basic maps and data to requirements for the statement of alternatives and the making of individual decisions throughout the planning process. This latter application of the analysis function is best done through a close working relationship between *planners* and *resource analysts.* This relationship must be maintained throughout the entire planning process.

Analysis and Planning

The planning process is basically one of identifying alternatives and analyzing their impacts in relation to the sustained capability of the resources to support or tolerate human activities. Human activities generally tend to upset or change the ecosystems in which they operate or live. Thus, it becomes necessary to synthesize large amounts of collateral information within the framework of the resource inventory and assess existing and potential land use before final land use decisions are made.

This additional information may or may not be obtainable by remote sensing. In addition to land cover and current land use, additional data may include information on soils; slope and aspect; climate; risk factors such as erosion, geology, ownership of land, existing restrictions (zoning), distance from population centers and other economic factors; and population shifts resulting from social and political factors as well as expansion or reduction of industrial capacity.

Communication of Ideas

In the process of developing land-use plans, information must be communicated among different specialists involved in the plan preparation. Public hearings are also held to get additional input from citizens. The land-use planner must explain the plan to the general public. Once again, aerial photography can be used

to a good advantage. Many people understand and relate to photographs better than maps. In many cases, a quickly prepared photo mosaic will be an excellent aid to communication in public meetings, hearings, and citizen-group planning sessions. Thus, being able to relate to the real world helps keep considerations factual and nonemotional. Both vertical and oblique photographs are frequently used —not necessarily of the entire area but of specific points of interest. These photos can be annotated with names, proposed structures, transportation routes, and suggested zoning lines. This may have a substantial impact on the understanding and appreciation of the land use plan that is frequently constructive.

Monitoring of Land-Use Change

In addition aerial photos are an important source of information concerning changes in land use over time. These changes indicate trends that can be extrapolated to predict future land use with and without various planning and zoning restraints. For example, Table 16.1 shows the changes in land use between 1956 and 1971 for 26 square miles of land consisting primarily of agriculture, forestry, and a small college town in the state of Oregon. The information was obtained from maps made from 1:63,360-scale photography. Over the 15-year period approximately 18 percent of the forest land and 10 percent of the agricultural land has been lost to other uses. This rate of change will probably not be the same in the future, however, because land use zoning laws have now been established.

TABLE 16.1 Illustration of Land-Use Change Over a 15-year Period

	Agricultural	Forest	Residential	Campus	Commercial	Water	Total
Acres 1956	8335	6684	1115	213	169	124	16,640
Acres 1971	6804	5987	3155	213	356	124	16,640
Acres of change	−1531	−697	+2040		+188		
Percent change[a]	−18.4	10.4	+182.9		+111.2		
Percent use 1956[b]	50.1	40.2	6.7	1.3	1.0	0.7	100%
Percent use 1971[b]	40.9	36.0	19.0	1.3	2.1	0.7	100%

From Paine (1979).
[a]Expressed as a percentage of the 1956 use.
[b]Expressed as a percentage of the total number of acres in the study.

Another example of the use of remote-sensor imagery to obtain information on change over time is shown in Table 16.2. These are the results of a study that used 1:1,000,000-scale Landsat imagery (see Chapter Twenty-five) and covered approximately 7,000,000 acres of forest land in southwestern Oregon. A portion of this area is shown on a color infrared photo in Plate VIII, bottom. It clearly shows distinct differences in the percent of forest land that has been clear-cut as a result of different management policies of different ownerships.

TABLE 16.2 Forest Land-Use Classes by Ownership

Land-use Class	Private		U.S. Forest Service		State of Oregon		Bureau of Land Management	
	Acres	Percent	Acres	Percent	Acres	Percent	Acres	Percent
Clear-cut	836,863	22.0	319,039	12.0	1,963	6.0	337,036	20.6
Forested	1,978,040	52.0	2,286,444	86.0	30,759	94.0	1,297,588	79.4
Other	989,020	26.0	53,173	2.0	0	0.0	0	0.0
Totals	3,803,923	100.0	2,658,656	100.0	32,722	100.0	1,634,624	100.0

Adapted from "The Comparative Evaluation of ERTS — I Imagery for Resource Inventory in Land Use Planning," final report to NASA Goddard Space Flight Center, Greenbelt Maryland by G. H. Simonson, Paine, Lawrence, Pyatt, Herzog, Murray, Norgren, Cornwell, and Rogers (1974).

MAP LEGEND SYSTEMS

Many different legend systems have been developed by land-use planners and natural resource managers. Most have been single-use maps such as timber type, range type and condition, water resources, soils, transportation, and urban or industrial development maps.

With the development of satellite and other sophisticated sensor systems capable of imaging large geographic areas and with the application of multiple-use concepts in resource allocation and management, there has become an increasing need for standardized land-use mapping systems that can be used at different levels of planning. Because of the large amount of information involved, it is advantageous if these mapping systems are compatible with computerized information management. This facilitates direct data storage and helps the land manager make multiple as well as single-use decisions based on properly integrated information derived from huge and complex sets of data.

Mapping Levels

Land-use maps may be quite general when produced from satellite or small-scale aircraft imagery, or they can be very detailed when produced from large-scale photography with intensive field verification.

Land-use planners and natural resource managers at the regional and state levels need the overall picture and less detail than a person managing a specific area of a small ownership. Thus, the mapping scale becomes increasingly larger and the amount of required detail increases as we go from regional planning to the actual management of specific areas of land. For example, the manager of a small forest ownership needs information about specific timber types such as density or volume by species and age class so that he or she can prepare harvesting schedules, prescribe silvicultural treatments, and predict future growth. The manager also needs information on topography, soils, wildlife habitat, moisture conditions, fire hazards, transportation networks, and areas in need of reforestation. On the other hand, the

land-use planner at the regional or state level may only be interested in where forest lands are, and whether they are commercial or noncommercial.

Up to now regional planners and local land managers have used different mapping legend systems and will probably be slow to standardize. However, with the development of computer compatible map legend systems, it is possible to combine regional and local land-use mapping to serve the needs of all levels of management with enough flexibility to accommodate many different aspects of land management. These considerations become particularly important as agencies develop comprehensive data information systems and move into computerized information management.

A computer compatible system means that the classification symbols are stored and manipulated so that corresponding acreages and other characteristics can be quickly compiled, and aggregated by logical classes to produce summary statistics for any specific use or combination of land uses at any level of detail desired. The two legend systems to be described here are hierarchical, starting with very general classifications that can be progressively subdivided and refined in a logical manner as information need increases.

A Land-use and Land-Cover Classification System

The Land-Use and Land-Cover Classification System for Use With Remote Sensor Data (Anderson, Hardy, Roach, and Whitmer, 1976) was designed to meet the needs of federal and state agencies for an up-to-date overview of current land-use and land-cover mapping throughout the United States. It is a four-level system that the authors hope will be uniformly applied at the first and second levels. It is intentionally left open ended so that more detailed land-use and land-cover classifications (the third and fourth levels) can be added by users who require more detail and at the same time remain compatible with each other at the national or regional levels of generalization.

The following levels and associated scales are suggested (Anderson et al. 1976).

Classification Level	Data Characteristics
I	Landsat type data (1:1,000,000 scale)
II	High-altitude data (1:80,000 and smaller scale)
III	Medium-altitude data (1:80,000 to 1:20,000 scale)
IV	Low-altitude data (1:20,000 and larger scale)

This relationship between level and data source is not intended to restrict users to particular scales. For example, level I information is most economically gathered by Landsat type platforms, but it could also be generalized from large-scale photo-

graphy or even compiled by ground surveys. The final mapping scale can also be changed. For example, Stevens, Ogden, Wright, and Craven (1974) referenced levels I and II land-use data to 1:24,000 topographic maps. Table 16.3 presents the standard level I and II categories.

Level II may be considered as the fulcrum of the classification system. It is probably the most appropriate level for regional or statewide use. Level II categories can be created by aggregating level III categories. In this sytem, levels III and IV are to be created by the user. For example, a level III breakdown of residential land might be as follows:

Level I	Level II	Level III
1. Urban or built up	11. Residential	111. Single-family units
		112. Multifamily units
		113. Group quarters
		114. Residential hotels
		115. Mobile-home parks
		116. Transient lodging
		117. Other

In a similar manner the system can be extended to level IV.

Plate V (right) illustrates the use of the legend system for levels I and II on 1:48,000-scale aerial photography for a portion of Osage County, Oklahoma.

A Comprehensive Ecological Legend System

A conceptually similar legend system for application in a logical and ecologically sound manner was developed by Poulton and his associates (1972) during the Apollo, Landsat, and Skylab experiments. The system has been used with space, high flight, and conventional photography at various scales and mapping intensities. It evolved through many deliberate iterations and has subsequently been used operationally in the United States, Canada, and in several of the developing nations (Charles E. Poulton, personal communication, 1979).

The system meaningfully portrays the ecology of natural and man induced vegetative complexes as well as land uses that have drastically altered the natural land cover. In addition it provides for the characterization of selected features of the physical environment at several levels of refinement, with a computer-compatible, numerical symbolization in a numerator/denominator format (Figure 16.1). It has been found highly practical to use the full numerator plus the macrorelief and landform classes from the denominator in a single map. This combination gives the resource manager and planner a wealth of useful information for decisionmaking, especially when considered along with other themes of surficial geology and soils (Charles E. Poulton, personal communications, 1979).

TABLE 16.3. Land Use and Cover Classification system for Levels I and II

Level I	Level II
1. Urban or built-up land	11. Residential
	12. Commercial and services
	13. Industrial
	14. Transportation, communications, and utilities
	15. Industrial and commercial complexes
	16. Mixed urban or built-up land
	17. Other urban or built-up land
2. Agricultural land	21. Cropland and pasture
	22. Orchards, groves, vineyards, nurseries, and ornamental horticultural areas
	23. Confined feeding operations
	24. Other agricultural land
3. Rangeland	31. Herbaceous rangeland
	32. Shrub and brush rangeland
	33. Mixed rangeland
4. Forest land	41. Deciduous forest land
	42. Evergreen forest land

5. Water

43. Mixed forest land
51. Streams and canals
52. Lakes
53. Reservoirs
54. Bays and estuaries

6. Wetland

61. Forested wetland
62. Nonforested wetland

7. Barren land

71. Dry salt flats
72. Beaches
73. Sandy areas other than beaches
74. Bare exposed rock
75. Strip mines, quarries, and gravel pits
76. Transitional areas
77. Mixed barren land

8. Tundra

81. Shrub and brush tundra
82. Herbaceous tundra
83. Bare ground tundra
84. Wet tundra
85. Mixed tundra

9. Perennial snow or ice

91. Perennial snowfields
92. Glaciers

From Anderson et al. (1976).

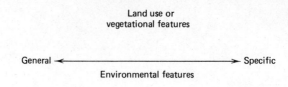

A Comprehensive Ecological Legend format

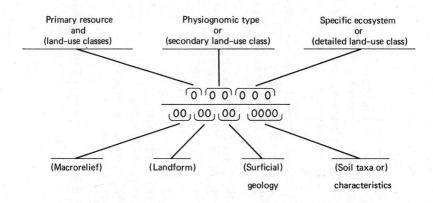

Figure 16.1. Generalized format for the Comprehensive Ecological Legend (upper) and detailed format (lower). The legend is computer compatible and includes multiple natural features as well as certain kinds of land-use information. Different elements or combinations may be expressed in separate thematic maps or overlays. (Courtesy Dr. Charles E. Poulton.)

Land-Use or Vegetational Features

As digits are added from left to right, the connotation proceeds from general to more specific characteristics of the landscape. The numerator can denote those developmental land uses that have permanently changed or strongly altered the natural vegetational features of the land cover. This has the advantage of displaying the ecological characteristics of the land more accurately. For example, it handles situations better where land and resources are amenable to multiple use where land uses would be forestry, grazing, and/or recreation. In addition, this system provides information for the interpretation of multiple land uses that are consistent with

resource characteristics instead of implying a single land use as is the case when a *range* or *forestry* primary classificaiton is used. The physical environmental features (information important in management) are meaningfully characterized in the denominator.

The legend system was purposefully left open-ended below the tertiary level to allow for flexibility in local or regional adaptation on a specific ecosystem basis. Following is an example of actual expansion of the system in a survey project of arid range lands in southeastern Oregon.

```
300— NATURAL VEGETATION
    320 — Shrub-scrub vegetation
        324 — Microphyllous salt tolerant vegetation
            324.1 — Saltage (Atriplex) prominent vegetation
                324.11 — Shadscale/Budsage communities
                    324.111 — Atco-(4-5)Arsp(3-4)/Sihy(3-5)-Brte(0-3)
                    324.112 — Atco(4-5)-Arsp(3-5)-Grsp(2-3)/Sihy(1-5)-Brte(0-5)
                    324.113 — Atco(4-5)-Arsp(3-4)-Save(2)/Sihy(3-5)-Pose(2-3)-Brte(0-5)
```

The symbolic descriptors at specific ecosystem level indicate the scientific name of the prominent species in the community and numbers code the range of prominence values for each of the indicator species. The differentiating species for each ecosystem is underlined. An example of an expanded forest cover type would be:

```
300 — NATURAL VEGETATION
    340 — Forest and woodland types
        341 — Needleleaf forest types
            341.3 — Ponderosa pine-dominant vegetation
                341.31 — Ponderosa pine/Bitterbrush/Grass communities
                341.32 — Ponderosa pine-Douglas-fir/Pinegrass community
                341.33 — Ponderosa pine-Douglas-fir/Ninebark community
```

With adequate ground knowledge and an awareness of what to expect, the first three levels in the numerator can frequently be interpreted from Landsat and high-flight photography. The fourth and lower levels of characterization usually require larger-scale photography (at least on a sample basis) and careful field verification. In some cases the combination of vegetation, landform, and soil associations will enable direct interpretation of classes at and below the tertiary level. Codes for symbolization or computer entry of the legend classes are shown in Table 16.4 as adapted from Legge, Jaques, Poulton, Kirby, and VanEck.

TABLE 16.4 Symbolic and Technical Legend Classes

Earth Surface and Land-use Features

Primary classes
 100 — BARREN LAND
 200 — WATER RESOURCES
 300 — NATURAL VEGETATION
 400 — CULTURAL VEGETATION
 500 — AGRICULTURAL PRODUCTION
 600 — URBAN, INDUSTRIAL, TRANSPORTATION
 700 — EXTRACTIVE INDUSTRY, NATURAL DISASTERS
 800 — RECREATION AND OPEN SPACE RELATED
 900 — OBSCURED LAND
Primary classes
 Secondary classes
 Tertiary classes
100 — BARREN LAND
 110 — Playas, dry, or intermittent lake basins
 120 — Aeolian barrens (other than beaches and beach sand)
 121 — Dunes
 122 — Sandplains
 123 — Blowouts
 130 — Rocklands
 131 — Bedrock outcrops (intrusive and erosion-bared strata)
 132 — Extrusive igneous (lava flows, pumice, cinder and ash)
 133 — Gravels, stones, cobbles, and boulders (usually transported)
 134 — Scarps, talus, and/or colluvium (system of outcropping strata)
 135 — Patterned rockland (nets or stripes)
 140 — Shorelines, beaches, tide flats, and river banks
 150 — Badlands (barren silts and clays, related metamorphic rocks, and erosional
 wastes)
 160 — Slicks (saline, alkali, soil structural nonplaya barrens)
 170 — Mass movement
 190 — Undifferentiated complexes of barren lands

200 — WATER RESOURCES
 210 — Ponds, lakes, and reservoirs
 211 — Natural lakes and ponds
 212 — Man-made reservoirs and ponds
 220 — Water courses
 221 — Natural water courses
 222 — Man-made water courses

Primary classes
 Secondary classes
 Tertiary classes
 230 — Seeps, springs, and wells
 231 — Seeps and springs
 232 — Wells
 240 — Lagoons and bayous
 250 — Estuaries
 260 — Bays and coves
 270 — Oceans, seas, and gulfs
 280 — Snow and ice
 281 — Seasonal snow cover
 282 — Permanent snow fields and glaciers
 290 — Undifferentiated water resources

300 — NATURAL VEGETATION
 310 — Herbaceous types
 311 — Lichen, cryptogam, and related communities
 312 — Prominently annuals
 313 — Forb types
 314 — Grassland, steppe, and prairie
 315 — Meadows
 316 — Marshes
 317 — Bogs and muskegs
 319 — Undifferentiated complexes of herbaceous types
 320 — Shrub/scrub types
 321 — Microphyllous, nonthorny scrub
 322 — Microphyllous thorn scrub
 323 — Succulent and cactus scrub
 324 — Halophytic shrub
 325 — Shrub steppe
 326 — Sclerophyllous shrub
 327 — Macrophyllous shrub
 328 — Microphyllous dwarf shrub
 329 — Undifferentiated complexes of shrub-scrub types
 330 — Savannalike types
 331 — Tall shrub/scrub over herb layer
 332 — Broad-leaved tree over herb layer
 333 — Coniferous tree over herb layer
 334 — Mixed tree over herb layer
 335 — Broad-leaved tree over low shrub layer
 336 — Coniferous tree over low shrub layer
 337 — Mixed tree over low shrub layer
 339 — Undifferentiated complexes of savannalike types

Earth Surface and Land-Use Features

340 — Forest and woodland types
 341 — Conifer forests
 342 — Broadleaf forests
 343 — Conifer-broadleaf mixed forest and woodlands
 344 — Broadleaf-conifer mixed forest and woodlands
 349 — Undifferentiated complexes of forest and woodland types
390 — Undifferentiated natural vegetation

400 — CULTURAL VEGETATION
 410 — Cultural herbaceous types
 411-419 — Tertiary levels duplicate those of natural vegetation (300)
 420 — Cultural shrub/scrub types
 421-429 — Tertiary levels duplicate those of natural vegetation (300)
 430 — Cultural savannalike types
 431-437, 439 — Tertiary levels duplicate those of natural vegetation
 440 — Cultural forest and woodland types
 441-443, 449 — Tertiary levels duplicate those of natural vegetation
 490 — Undifferentiated cultural vegetation types

500 — AGRICULTURAL PRODUCTION
 510 — Field crops
 520 — Vegetable and truck crops
 530 — Tree, shrub, and vine crops
 540 — Pasture
 550 — Horticultural specialties
 560 — Non-producing fallow, transitional, or idle land
 570 — Agricultural production facilities
 580 — Aquaculture
 590 — Undifferentiated agricultural production

600 — URBAN, INDUSTRIAL, AND TRANSPORTATION
 610 — Residential
 620 — Commercial and services
 630 — Institutional
 640 — Industrial
 650 — Transportation, communications, and utilities
 651 — Man and material transport
 652 — Utilities distribution
 653 — Power production
 654 — Communication
 655 — Sewer and solid waste
 659 — Undifferentiated
 670 — Vacant plots and lots
 690 — Undifferentiated urban

Earth Surface and Land-Use Features

700 — EXTRACTIVE INDUSTRY AND NATURAL DISASTERS
 710 — Nonrenewable resource extraction
 711 — Sand and gravel
 712 — Rock quarry
 713 — Petroleum extraction — gas and oil fields
 714 — Oil shale and sand extraction
 715 — Coal/peat
 716 — Nonmetallic, chemical, fertilizer, etc.
 717 — Metallic
 719 — Undifferentiated
 720 — Renewable resource extraction
 721 — Forest harvest
 722 — Fisheries
 729 — Undifferentiated
 730 — Natural disasters
 731 — Earth
 732 — Air
 733 — Fire
 734 — Water
 735 — Disease
 739 — Undifferentiated

800 — RECREATION AND OPEN SPACE RELATED
 810 — Natural greenways, open space, and buffer zones
 820 — Preservation areas and natural museums
 830 — Improved and developed open space
 840 — Historical and archeological sites
 850 — Scenic views
 860 — Rock hounding, paleontological sites
 870 — Recreation facilities
 880 — Designated destructive use areas
 890 — Undifferentiated

900 — OBSCURED LAND
 910 — Clouds and fog
 920 — Smoke and haze
 930 — Dust and sand storms
 940 — Smog
 990 — Undifferentiated obscured land

Adapted by permission from Legge, Jaques, Poulton, Kirby, and VanEck (1974).

TABLE 16.5 Macrorelief and Landform Classes[a]

Primary	Secondary/Tertiary/Quaternary	
1. Flat or slightly undulating flat lands	.1	Depressional, nonriparian basins
	.2	Depressional calderas
	.3	Bottomlands, riparian
2. Strongly undulating to rolling lands	.32	Bottomlands, riparian, stringer or narrow
3. Hilly lands	.33	Bottomlands, riparian, wide valley bottom
4. Mountainous lands	.4	Planar surfaces, lowland
	.402	Planar surfaces, lowland, strongly dissected
	.41	Planar surfaces, lowland, valley fill
	.412	Planar surfaces, lowland, valley fill, strongly dissected
	.42	Planar surfaces, pediment or toe slope
	.421	Planar surfaces, pediment or toe slope, moderately dissected
	.5	Planar surfaces, upland plateau (benches, mesas, broad ridgetops)
	.51	Flat to strongly undulating dip slopes
	.502	Planar surfaces, upland plateau, dissected
	.6	Strongly undulating to rolling landform
	.601	Strongly undulating to rolling landform, moderately dissected
	.7	Slope systems
	.71	Escarpments (no directly opposing slope)
	.72	Valley/canyon or gorge slope systems (base level with gentle relief change)
	.73	Butte or isolated hills and kopjes
	.74	Hill and mountain, smooth slope systems
	.75	Hill and mountain, angular slope systems
	.8	Gravity and mass movement landscapes (other than 0.7)

Dissected Classes for Use with Macrorelief Classes 1 and 2 and Landform Classes 0.4, 0.4 and 0.6	Exposure classes for use with macrorelief classes 3 and 4 and landform classes 0.6, 0.7, and 0.8
.xx1 Moderately dissected	.xx1 Protected
.xx2 Strongly dissected	.xx2 Exposed

[a]*Charles E. Poulton, (1978), personal communication, updating publication in progress.*

Environmental Features

The most recent adaptation of the macrorelief and landform features of the environmental portion of the legend is shown in Table 16.5 [Charles E. Poulton, (1975), personal communication, updating publication in preparation]. Note that these also follow the same numerical concept for primary, secondary, and tertiary levels. In practice it has rarely been found desirable to go beyond the tertiary level unless dissection or aspect is added. When one exceeds this level for designating physical environmental features it is much more meaningful to include a geological and/or soils survey in the resource analysis.

The surficial geology portion of the legend system is shown in Table 16.6. The secondary and lower levels indicate specific rock types and are left up to the ingenuity of the user as is the soils portion of the legend. There are numerous excellent examples of taxonomic classification of soils in the United States and other parts of the world. Most of these schemes are hierarchical and are thus compatible with both multiscale image interpretation and computer storage and retrievable systems (Poulton 1972).

A photographic example of the application of the legend concepts is shown in Plate VI.

TABLE 16.6 Primary Surficial Geological Features

10 —	Coarse-grained igneous
20 —	Fine-grained igneous
30 —	Sedimentary
40 —	Metamorphic
50 —	Unconsolidated material
90 —	Undifferentiated soil-forming material

Adapted by permission from Poulton, (1972).

Laboratory Exercise

There is no specific laboratory exercise for this chapter. Instead it is suggested that your instructor set up a land-use classification problem utilizing imagery of a local area that you can easily field check. The problem can be combined with other techniques presented in this book such as the transfer of detail from imagery to a map, the determination of areas, and the delineation of effective areas. Initial data for the project could range from satellite imagery to large-scale aircraft photography and either of the two legend systems presented could be used at any level. If you go beyond level II or III you could emphasize your discipline of expertise, forestry, range, geology, urban or suburban planning, etc.

Questions and Problems

1. What is the difference between land-use planning and a land-use plan? Write a specific definition for each term.

2. What are the five phases of land-use planning? How can remote sensor imagery be used in each phase?

3. Draw diagrams to illustrate (1) the generalized and (2) the specific features of the Comprehensive Ecological Legend System.

4. What is a computer-compatible legend system and what is the advantage of having a computer-compatible system?

5. What is meant by *levels* of land-use or land-cover classification? Give an example of two different levels.

Seventeen

Forestry

In this chapter we discuss specific uses of aerial photography by the practicing field forester. The forester, like many other land managers, can manage land areas in a more efficient manner if he or she possesses high-quality aerial photography and has a thorough understanding of how to make maximum use of this valuable tool. In addition to this chapter the forester should also study Chapters Nineteen, Twenty, and Twenty-one, which emphasize the measurement of timber volumes from aerial photography.

In this chapter we discuss timber type-mapping in detail and then briefly discuss the use of aerial photos in timber sales and forest fire protection work.

Objectives

After a thorough understanding of this chapter and completion of the laboratory exercise you will be able to:

1. Write a short paragraph to explain exactly what each symbol stands for in a given timber-type symbol from the U.S. Forest Service Pacific Northwest timber-type legend system.
2. Write the correct type symbol given a written description of different vegetative covers using the U.S. Forest Service Pacific Northwest Forest Type Mapping System.
3. List three phases of timber sales operations and write a short paragraph explaining how aerial photography can profitably be used in each phase.
4. List three phases of forest fire protection activities and write a short paragraph explaining how aerial photographs or thermal imagery can be profitably used in each phase.

TIMBER TYPE MAPPING

Timber-type mapping consists of the delineation and identification of homogeneous stands of timber or other plant cover on aerial photographs. A completely typed photo (Figure 17.1) also delineates the nonforested land within the forest boundary. Timber typing should always be accomplished with the aid of a stereoscope by an experienced photo interpreter who is also familiar with the area being mapped. Effective areas, as described in Chapter Ten, should be placed on the photos or on a clear overlay in india ink before the actual type mapping begins.

Preliminary Considerations

Before starting the actual mapping process there are several other decisions to be made such as (1) selecting the legend system to use, (2) deciding on the level or degree of refinement wanted, and (3) establishing minimum area and width standards.

The first two decisions are closely related and depend on your objectives. Do you want a single or multiuse map? Do you want generalized regional information or specific and detailed local information—or both? Should your system be computer compatible?

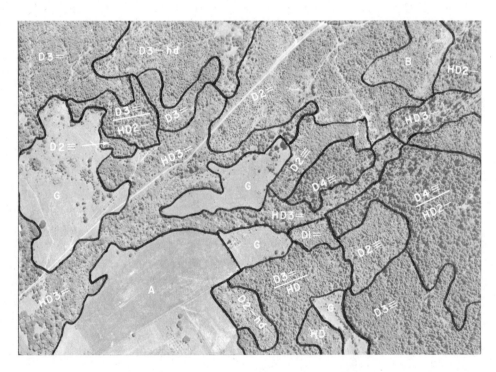

Figure 17.1. Portion of a type mapped aerial photo showing forest, agricultural and grassland.

Minimum areas and widths to be mapped are also related to your objectives as well as to photo scale and the scale of the final map. It would be impossible, for example, to map areas as small as one acre on a 1:60,000-scale photo. Usually the scale and minimum area is such that it is possible to write the legend symbol within the delineation. A reasonable minimum area standard for 1:12,000-scale photography is usually 5 to 10 acres.

We also need a minimum width standard. Suppose we have a minimum area standard of 5 acres on a 1:12,000-scale timber-type map. It would be possible to accumulate this minimum area by mapping all the connecting roads in a series of long strips. Is this desirable? If not, we can set a minimum width of, say, two chains, which is wider than the average country road. The roads could show on the map but they would not have a type-map boundary placed on both sides of them.

Finally, you must decide how you are going to transfer the type lines to the final map. Is it necessary to remove the effects of tilt and topographic displacement? If you want accurate acreage determination by mapping classifications, displacement must be removed using one of the stereoplotting instruments discussed in Chapter Ten.

Typing Methods

A type map can be produced entirely from aerial photos without any field checking. This is risky but may prove useful as a management tool if done by an interpreter who knows the area well. Normally, however, some field checking is done, to give continuing training to the interpreter, to pick up certain classes that cannot be recognized on the photos, and to correct errors.

There are two ways of combining field checking with photo interpretation. One is to *pretype*, or make obvious type lines on the photos before going into the field. Types identified on the photos alone are labeled and questionable areas are marked for field checking. At the start of a project, it is better to pretype only a few photos before field checking. Then, as experience is accumulated, larger areas can be type mapped before being field checked. Photo interpretation keys and sample stereograms of selected timber types are of great help to the beginner.

With a good job of pretyping, the field work can be done efficiently, since the areas in need of checking are identified. However, if too much guessing is done on the pretyping job, field time will be wasted by the frequent correcting of type lines and the field checker will lose confidence in the pretyping.

The other approach, *posttyping*, is to begin by traveling as many roads and trails as possible, identifying types and marking them on the photos. Then later, usually in the office, the blank areas are filled in by comparing them with those typed in the field. This method takes maximum advantage of the experience gained in the field checking. However, during the office typing job, it is not uncommon to come across questionable areas you wish you had checked in the field.

Regardless of which approach is used, there are several principles worth keeping in mind. Type mapping is essentially a subjective process, and the map's usefulness is largely dependent on the interpreter's ability and experience. It is not

an easy task to distinguish between real type differences and apparent differences caused by variations in the angle of view, date of photography, and printing methods. Doing the typing under the stereoscope helps, but there is no substitute for experience. It is easiest to begin by outlining the most definite types first, gradually working toward the difficult separations.

Systems Used in the Pacific Northwest by the U.S. Forest Service

There are two type mapping systems presently used in the Pacific Northwest. The older system is frequently called the PNW Forest Type-Mapping System (U.S.D.A. Forest Service, 1962), and the new method is called the PNW Ecoclass Identification system (Hall, 1974 and 1975).

The PNW Ecoclass Identification System

This is an open-ended computer-compatible, alphanumeric system. It differs from most systems in that it is not based on taxonomic similarities. Instead, general groupings are used, such as the coniferous forest formation, which is subdivided into tree species associations, which are further broken down by a vegetation series, and still further divided into community types by species of dominant ground vegetation. The system was designed for compatibility with the U.S. Forest Service *TRI System* (Total Resource Information System).

Ecoclass identification is based on the climax species types and not necessarily the species dominating the site at any one time. For example, a forest may be dominated by Douglas-fir with a western hemlock understory. If hemlock is considered to be the climax species, the symbolic code would be CH (C for conifer formation and H for western hemlock), because hemlock is more shade tolerant and will eventually replace Douglas-fir as the stable climax species.

The U.S. Forest Service PNW Forest Type Mapping System

This type of mapping system, or modification of it, has been used in the Pacific Northwest and British Columbia for many years by federal, state, and private agencies. It is presented in detail to illustrate only one of many systems in use today. Each geographic region or agency usually has its own system designed to meet its particular needs. The PNW Forest Type Mapping system was not originally computer compatible, but it was later converted to a computer-compatible system by assigning computer codes to each part of the complete timber-type symbol. It is based on present cover and not on climax associations.

Forest Versus Nonforest. One of the first decisions that must be made in timber-type mapping is the separation of forest from nonforest land. For the most part, this breakdown is easy to make. Water, urban areas, airfields, bare rock, glaciers, and cultivated fields can usually be positively identified. Forest areas with stands of visible trees also present no problem. However, there are a few situations where the forest-nonforest separation is almost impossible to make on aerial photos, for example, abandoned farm land that may or may not have seeded to trees, and

deforested land that may or may not be grazed. The latter situation is often difficult to distinguish even on the ground. The nonforest type symbols are:

A Agricultural
B Brush
G Grass
W Water
O Nonvegetative (barren, urban, etc.)

Commercial Versus Noncommercial. Much forest land is easily classified as either commercial or noncommercial. However, the borderline between them is often difficult to distinguish. Most definitions are subjective, involving decisions on accessibility, economic removal of timber, productive capacity, and maintenance of soil and watershed values. These decisions are often as difficult to make in the field as they are on the photos. Another problem is with constantly changing economic conditions—areas that were noncommercial a few years ago may be commercial today or in the future. It is possible that a better job can be done by an experienced person working only with photos than by an inexperienced person working in the field without photos. The noncommercial forest land type symbols are:

NR Noncommercial rocky
SA Subalpine
OM Oak-madrone (scrub stands)

Commercial Forest Land Classes and Symbols. Commercial type classifications are based on species composition, tree size, age class, the degree of stocking, understory conditions, and stand history.

The system uses a type symbol that permits the photo interpreter or timber cruiser to describe the forest type in any degree of detail that fills the need. The symbol in its most complete form includes six parts. These parts (starting on the left) indicate (1) the history of the stand as to its origin, (2) predominant species, (3) the size of the timber, (4) the degree of stocking, (5) species composition symbol (minor species in the stand), and (6) the date of origin of the stand. For example:

Forest Type: XD2 = h, c 1970

Where

X stands for restocked clear-cut area
D stands for Douglas-fir
2 stands for pole timber
= stands for medium stocking
h, c stands for minor species composition (hemlock and red cedar)
1970 stands for the approximate year of origin

When forest type data are to be processed by machine methods, the various species, stand diameter, stocking, age and other factors mentioned are given individual numbers rather than the conventional symbols. This numbering system varies from one agency to another.

Species Type. Types are determined on the basis of predominant species as indicated by stand volume for older stands or the number of trees for young stands. A common practice when type mapping on aerial photos is to use percent crown closure both as a measure of stocking and as an indicator of the predominant and minor species present. The predominant species symbols (listed as follows) are always capital letters.

Predominant Species Symbols	Species Common Name
D	Douglas-fir
P	Ponderosa pine
H	Western Hemlock
S	Sitka spruce
C	Cedars
FM	True fir-mountain hemlock
WL	Western larch
WF	White fir
W	White pines
LP	Lodgepole pine
HD	Hardwoods

The degree of success in identifying species type varies with the particular area, the photography used, and the interpreter's experience. Some types are quite distinctive and can usually be recognized wherever they occur. Others can be spotted part of the time, while some types are almost impossible to identify. Obviously photo scale has a big influence on whether or not individual trees or timber types can be correctly identified on the photo. See Figures 20.5, 20.6, and 20.7 (Chapter Twenty) for examples of coniferous species identification on large-scale photos taken in western Canada. Figures 17.2 and 17.3 are drawings of typical silhouettes and aerial views of selected hardwoods and conifers.

On smaller-scale photography, a knowledge of where the various types are, or are not likely to occur is important, because it enables one to narrow the field of possible choices. Knowing the geographic range of the various species is a starting point, and it can be further refined by learning their site preferences.

For example, Figure 17.4 illustrates the change of species with elevation. Alder (HD) is the predominant species at the lower elevation. As we go up this changes to a hemlock and alder (H,HD) mixture, then to a Douglas-fir, western redcedar and hemlock mixture (D,C,H). As we continue up the hill it changes to a cedar and hemlock mixture (C,H or H,C) and finally to a true fir (T) stand. Alder has also invaded the old logging roads and skid trails at the lower elevations producing a spokelike appearance at 2d and elsewhere. Clearcut logging is also visible at 1, 2, and 3 with the most recent cut at 3.

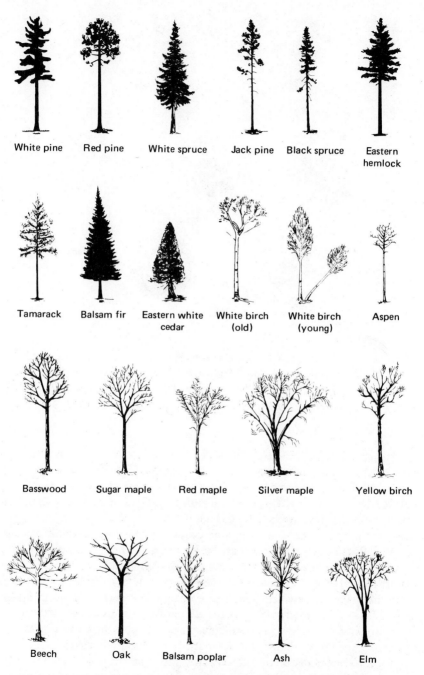

Figure 17.2. Typical silhouettes of forest trees as they might be seen from shadows or on the edges of large-scale aerial photos. (From L. Sayn-Wittgenstein, 1961, copyright 1961, *Photogrammetric Engineering,* Vol. 27, No. 5, published by the American Society of Photogrammetry.)

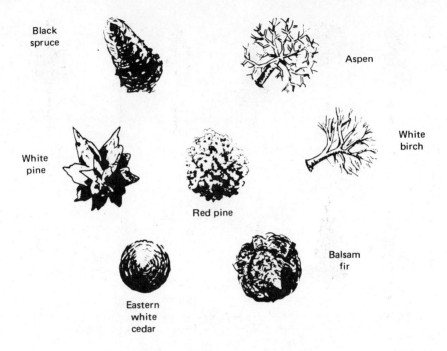

Figure 17.3. Drawings of aerial perspectives of forest trees as they would appear on large scale aerial photos. (From L. Sayn-Wittgenstein, 1961, copyright 1961, *Photogrammetric Engineering,* Vol. 27. No. 5, published by the American Society of Photogrammetry.)

The stereogram in Figure 17.5 is of a more arid climate and illustrates plant communities in relation to aspect. Treeless grassland is found on the dry southern aspects with Douglas-fir and lodgepole pine on the more moist north aspects. Aspen occupies the low areas of still higher soil moisture at 1a and 1b. The areas designated by x's in the diagram indicate logged areas.

Stand-size Class. The most common basis for stand-size classification is tree diameter. Broad diameter classes are easily recognized on aerial photos from the texture of the stand, height of the trees, and diameter and shape of the crowns. If data are available on the relation between stem diameter at breast height (dbh) and crown diameter, or between stem diameter and tree height, or both, tables like Table 17.1 can be used with occasional photo measurements. Otherwise, the interpreter makes use of past experience and assumes that the biggest trees—particularly the crown diameters—have the biggest stem diameter.

If there are two distinctly different size classes present, they can be recognized by a two-story type symbol with the overstory in the numerator and the understory in the denominator (see Figure 17.1).

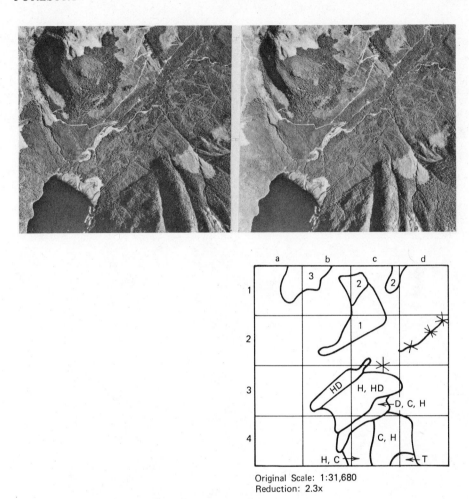

Original Scale: 1:31,680
Reduction: 2.3x

Figure 17.4. Tree species frequently change with elevation. Starting with alder (HD) in the valley bottom the species composition changes to a mixture of hemlock and alder (H, HD), to Douglas-fir, western red cedar, and hemlock (D, C, H), to mixtures of cedar and hemlock (H, C, or C, H) and finally to a true fir (T) stand. (Adapted from N. Keser, 1976, aerial photos from Surveys and Mapping Branch, Government of British Columbia.)

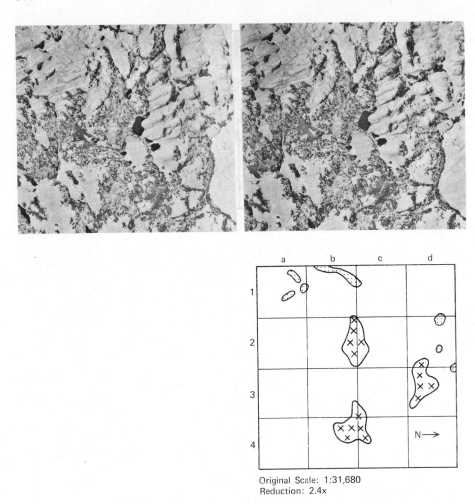

Original Scale: 1:31,680
Reduction: 2.4x

Figure 17.5. The relationship between aspect and plant communities. Grassland occupies the dry southern aspects while conifers are found on the more moist northern aspects with aspen on the lower and wetter sites. (From N. Keser, 1976, aerial photos from Surveys and Mapping Branch, Government of British Columbia.)

TABLE 17.1 Aerial Photo Diameter Breast Height Table for All-Aged Ponderosa Pine Stands in Oregon and Washington.

	Total Height in Feet																	
VCD[a]	24	30	36	42	48	54	60	66	72	78	84	90	96	102	108	114	120	126
	DBH in Inches																	
4	5	6	6	6	7	7	7	7	7	8	8	8						
6	6	6	7	7	8	8	9	9	9	10	10	11	11	11	12	12	13	
8	6	7	8	8	9	9	10	10	11	12	12	13	13	14	14	15	15	16
10	7	8	9	9	10	11	11	12	13	13	14	15	15	16	17	17	18	18
12	8	9	9	10	11	12	12	12	14	15	16	17	17	18	19	20	20	21
14					12	13	14	15	16	17	18	18	19	20	21	22	23	24
16					13	14	15	16	17	18	19	20	21	22	23	24	25	26
18					14	15	17	18	19	20	21	22	23	24	25	26	27	28
20									20	21	23	24	25	26	27	28	29	30
22									22	23	24	25	26	27	29	30	32	32

Adapted from Paine (1965).
[a]*Visible crown diameter (in feet).*

The stand-size symbols are:

Symbol	Stand-Size Class	Description
1	Seedlings and saplings	0 to 5 in. dbh (diameter breast height, or 4½ ft above ground level)
2	Pole timber	5 to 11 in. dbh
3	Small saw timber	11 to 21 in. dbh, mainly young growth
4	Large (mature) saw timber	21 in. and larger dbh
5	Large (over-mature) saw timber	21 in. and larger dbh (for Douglas-fir stands only)

Stocking Class. The most common photo measure of stocking is crown closure—the proportion of area covered by tree crowns. Crown closure is normally expressed as a percentage, and is ocularly estimated on the photos with occasional reference to a templet (Chapter Twenty, Figure 20.2) or a series of stereograms. For the purpose of type mapping it is usually sufficient to group stocking percents into broad classes.

Of course, crown closure can be used as a basis for stocking only when the trees are big enough to be seen on the photos. When the trees are too small, or hidden in the brush, a field check must be made to determine the degree of stocking. The percent stocking for seedling and sapling stands is based on the number of trees per acre, not as a percent of crown closure. The stocking classes are:

Symbol	Stocking	Description
—	Poor	10 through 39 percent
=	Medium	40 through 69 percent
≡	Well	70 through 100 percent

When stocking is less than 10 percent the area is classed as nonstocked. The symbol for stocking (one, two, or three bars) indicates the *total* of *all species* involved in the story.

Species Composition Symbols. Species composition is indicated by lower-case letters according to the following rules: (1) No secondary species will be recognized unless it comprises at least 20 percent of the *total existing stand* (or story in the case of multistoried stands). It is emphasized that 20 percent of the story means 20 percent of what is present, not 20 percent crown closure. (2) Species composition symbols follow the stocking symbol and are listed in decreasing order of abundance.

Ordinarily, not more than three species will be recognized in any one story of a type unit. (3) Whenever the main type symbol clearly indicates that one key species is involved, and no associated species is abundant enough for recognition, the species composition symbol is omitted. Normally the *predominant* species symbol *is not* repeated in the species composition symbol. Exceptions to this rule are: in all mixed types of ponderosa pine, or in any types of white pines, cedars, true fir or true fir-mountain hemlock mixtures the symbols of *all* recognized species (including the predominant species) will be listed in order of abundance. This exception no longer has any value. It is an artifact left over from an earlier version of the system and should no longer be considered. That is, we *will not* repeat the predominant species symbol in the *species* composition symbol. The species symbols are:

	Type			Type	
Symbol	**Common Name**		**Symbol**	**Common Name**	
	Conifers			**Pines**	
d	**Douglas-fir**		lp	(Lodgepole pine)	
	Spruces			(Shore pine)	
es	Engelmann spruce			(Knobcone pine)	
s	Sitka spruce		p	(Ponderosa pine)	
	Hemlocks		sp	Sugar Pine	
mh	Mountain hemlock		w	(Western white pine)	
h	Western hemlock			(Whitebark pine)	
	Cedars			**True Firs**	
yc	Alaska yellow-cedar		af	Alpine fir	
ic	California incense-cedar		nf	Noble fir	
pc	Port Orford white cedar		a	Pacific silver fir	
c	Western red cedar		srf	Shasta red fir	
	Larches		wf	(White fir)	
wl	(Western larch)			(Grand fir)	
	(Alpine larch)				
r	Redwood				
j	Sierra juniper				
	Deciduous trees				
hd	Hardwoods in general				

To this point we have discussed in some detail the four components of the main part of the type symbol: predominant species, size class, stocking class, and species composition symbols. Now, let us continue with age class and prefix symbols—which are not always used.

Date of Stand Origin. When available the date of origin of young stands will be shown to the closest decade, 1970. 1980, etc., with 5s rounded up. When used, the date of origin symbol is always the last part of the type symbol.

Forest Type Prefix Symbols

Prefix Symbol	**Description**
R	Indicates residual stand after partial cutting
X	Indicates restocked clearcut area
PL	Indicates planted area
FK	Indicates fire killed standing merchantable timber

Condition Class Symbols

Symbol	Condition Class
X	Recent clear-cut area, nonstocked (cut over during the last 5 years)
XO	Old clear-cut area, nonstocked (cut over prior to the last 5 years)
F	Area deforested by fire, nonstocked
I	Area deforested by insects, nonstocked
WT	Area deforested by wind, nonstocked

Notice the symbol X can be either a *prefix* symbol indicating a stand originating from a clearcut (and is stocked) or a *condition class* symbol—a recent clearcut, which is not yet stocked. In the latter case the X stands alone; in the former case it is followed by more symbols indicating that a new stand is present.

When type mapping multiple storied stands, each story is considered independently of the other stories. A stand is multiple storied when two or more distinct size classes are present with each size comprising at least 10 percent stocking. Type islands should theoretically be separated when any of the type symbols change. However, in actual practice we designate a different stand only when a major symbol (predominant species, size class, stocking class or species composition symbol) changes.

Selected Examples of Timber Type Symbolization

Symbols	Description
D4=	Large, mature Douglas-fir saw-timber, medium stocking.
P3=wf,lp	Small saw-timber, medium stocking, plurality of percent crown closure in ponderosa pine, but with at least 20 percent of the two bar stocking consisting of white fir and lodgepole pine (20 percent for each species).
H2-c,d 1960	Pole timber, poor stocking, plurality of percent crown closure in western hemlock, but with more than 20 percent each of western red cedar and Douglas-fir with the Douglas-fir least abundant. Stand originated between 1955 and 1964.

XD1≡h,c

Clearcut area restocked with a well-stocked seedling and sapling stand, predominantly Douglas-fir but with western hemlock and western red cedar as minor associates (each comprising 20 percent or more of the stand) with more hemlock than cedar.

PLD1=1980

Planted stand of seedling and sapling Douglas-fir, planted between 1975 and 1984, medium stocked.

D4-h
D1=1970

Two-storied stand having an overstory of poorly stocked, mature saw timber (averaging 21 inches or more in dbh) consisting primarily of Douglas-fir, but with at least 20% of the upper story in western hemlock. The understory is medium-stocked Douglas-fir seedlings which originated in about 1970.

AERIAL PHOTOS AND TIMBER SALES

Using aerial photos in timber sale work consists of putting skills and techniques covered in previous chapters to practical use. The ability to see stereo enables the forester to evaluate the terrain conditions and the distribution of timber on the proposed sale. With photos the forester can map out proposed road systems, make rough timber volume estimates (Chapters Twenty and Twenty-one), map the actual extent of the sale for the permanent records, and measure the acreage involved.

Presale

Aerial photography's role in timber sales planning starts during the off season when the photos are reviewed for possible locations of sale areas. This can be done when field reconnaissance is difficult or impossible because of snow or other adverse weather conditions. The photos, along with available timber-type maps, help locate areas of merchantable timber suitable for logging. An effective tool in choosing sale areas is a cutting-priority map. Such a map is made from a timber-type map, supplemented with additional photo interpretation. The forest area is divided into cutting-priority classes according to forest type and the nature of the terrain. For example, high-priority forest types would be old-growth stands, two-

story stands, and stands suitable for thinning. Cutting priorities are verified or may be altered because of terrain conditions as determined from aerial photos. Noncutting areas include noncommercial stands, immature stands, administravely restricted areas such as wilderness, recreation, and areas judged from photo or ground examination to have unstable soil conditions.

After the general area is selected, topographic features that influence cutting boundaries, logging methods, soil stability, and road layout can be studied more intensely on the photos.

Many of the steps in planning typical timber sales of several clearcut units can be carried out on photos. The first step is to roughly delineate several tentative cutting units on the photos. Consideration is given at this time to the future development of the area, that is, where subsequent cutting units will be. The development of the area as a whole can be visualized on the photos and the possibility of ending up with a group of illogically shaped units on the final harvest cut is minimized.

Although generalized cutting unit boundaries are drawn on the photos, the final determination of the boundary must be made in the field. Photos do not furnish enough detail to do this satisfactorily in the office. In areas where the timber is dense, it is difficult to precisely locate final boundaries on the photos, and ground traverses should be made to determine the area if the terrain is steep.

A rough volume estimate, helpful in determining the number of units to install in a proposed sale area, can also be obtained from aerial photos. One way is to make an ocular estimate by comparing the photo appearance of the stand with stands of known volume. Another way is to use aerial photo-volume tables (Chapters Twenty and Twenty-one).

After the units are located, the photos are helpful in deciding what kind of logging will be practiced. Landings, spar trees, spur roads, and swing locations can be first located on the photos and then checked in the field.

Photos are also useful in setting up timber sales in selectively cut operations. Gross sale-area boundaries are best determined from the photos. If unit-area control type of cutting is being practiced, generalized cutting unit boundaries can be delineated on the photos. However, the final decision on the location of the boundary must be made in the field just as with clearcut units.

In any timber sale program, salvage of the catastrophic losses that occur from time to time are of high priority. The location and amount of area affected by fire, disease, insects, and large-scale windthrow can be recorded on photos in two ways. First, existing photography can be utilized by flying over the problem area and having an experienced observer sketch in the location and boundaries of the affected areas on photos. If the problem is severe enough, new photography can be flown. This photography shows not only the limits of the damage but also its severity and helps in planning the salvage program.

Road Planning

The first step in road planning is to plan the entire system for an area at one time. This is done with topographic maps, timber-type maps, multiple-use plans, and geological and soil maps as well as aerial photographs. After the main road system is located, individual sale areas are selected from the cutting-priority map. Possible routes from the main road to the sale area are chosen, a grade line is located on the topographic map, and transferred from the map to the aerial photos. The photos furnish certain information used in road planning that cannot be obtained from topographic maps. Rock outcrops, slide areas, swamps, and sometimes areas of unstable soils can be recognized on photos and can be avoided in the road design. The final road route selection is made after a construction cost analysis and a ground reconnaissance.

During Sale

Photos continue to be helpful at the time of cutting. A poorly planned spur road and skid road system can be costly. It is here that photos can be used to a decided advantage. Tests have shown that photo-planned skid road systems in unit area control sales are acceptable and improve design efficiency (Bernstein, 1962).

Photos are a convenient medium on which to record the progress of logging operations (Figure 17.6). Road systems and cutting progress can be sketched in as the sale proceeds. Photos can also be shown to operators when explaining points in the sale contract. Enlargements are helpful in many cases. Enlarged photographs seem to be more easily understood by parties not familiar with the use of photos.

Postsale

Postsale use of aerial photography is usually confined to special small-scale coverage flown after the completion of the sale. This photography is used to map the cutting units and the road system developed by the sale.

Other uses for special photography have been applied. For instance, special oblique photography of cutting units for the planning of slash burning has been used in Canada. These photos show the general topography, concentration of fuels, and the location of skid roads. All of these factors are important in slash-burning plans. In addition, marked photos given to crews will help them understand their assignments better. The same photos can then be used to advantage prior to and during reforestation operations.

FOREST FIRE PROTECTION

Forest fire protection activities can be separated into three distinct phases: (1) presuppression, (2) suppression, and (3) postfire analysis. Fire specialists use aerial

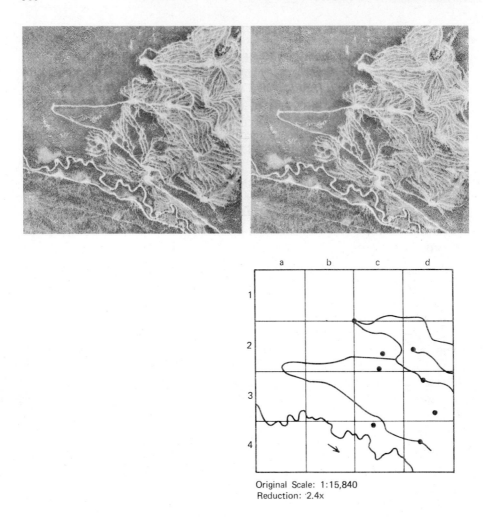

Original Scale: 1:15,840
Reduction: 2.4x

Figure 17.6. Road and skid trail pattern from tractor logging in mountainous terrain. Landings are designated by large dots on the diagram. More recent roads and cuts can be drawn on the photo or on an overlay. (From N. Keser, 1976, aerial photos from surveys and Mapping Branch, Government of British Columbia.)

photography and thermal scanner imagery (Chapter Twenty-three) in all three phases.

Presuppression

Presuppression includes all activities that take place before actual fire fighting begins and includes fire prevention, detection, and all the planning, preparation, and training activities that are so necessary for any efficient fire fighting

organization. Because thermal imagery penetrates smoke and detects heat, thermal scanning is an ideal method of forest fire detection (Figure 17.7). Research has shown that fires down to 1 ft or less in diameter can be detected under ideal conditions, but operational detection success depends on many things such as scan angle and the type of forest being scanned.

Because it would be too costly to continuously scan all forested areas of the county, flights are planned only during the fire season and during periods of high risk such as immediately after a lightning storm where little rain has fallen.

Panchromatic and regular color vertical and oblique photography is extensively used for planning purposes. The *Preattack Guide* (Dell, 1972) divides the forest areas into blocks of between 20,000 and 50,000 acres each. Oblique photographs are then obtained to adequately cover all topographic features within each block. All preattack information is transformed from the block map to the photos that become a part of the preattack plan. These photos are used primarily during the

Figure 17.7. Thermogram of the Perry Mountain forest fire taken at 2:00 A.M. near LaGrande, Oregon. This image was produced by a thermal scanner (not a camera) that can operate at night and penetrate dense smoke to locate the exact location of the fire and hot spots. See Chapter Twenty-three for more on scanners (Courtesy State of Oregon, Department of Forestry and the 1042nd Military Intelligence Company, Oregon Army National Guard.)

planning phase but can also be used for orientation and control strategies during the actual fire control operation.

The same information is also put on photo mosaics made from vertical photography at a 1:12,000-to-1:15,840 scale. Stereoscopic pairs of aerial photos are always helpful in any forest fire operation.

Another important presuppression use of aerial photography is in fuel mapping and in the planning of slash disposal operations after harvesting. Different cover types burn at different rates and intensities. Forest fuel maps are prepared from aerial photography, ground, and aerial reconnaissance for use during both the presuppression and suppression phases of fire control work. These and other types of maps are used to select the location of fuel breaks that can be built to break up areas of hazardous fuel types before a fire begins or after a fire has started. Aerial photos are also used in the planning phase of slash burning. Slash burning is the planned and controlled burn of debris after logging—usually in clearcuts. This removes unwanted brush, prepares the seedbed for reforestation, and removes the most hazardous type of fuel.

Suppression

Aerial reconnaissance including photography is essential to the fire boss. However, if the fire creates a great deal of smoke, conventional photography is practically worthless. Because thermal imagery penetrates smoke, it is particularly useful to locate the actual fire perimeter, hot spots within the perimeter, and spot fires outside the perimeter (Figure 17.7). To be useful, thermal imagery must also include enough topographic and other detail so that the thermal image can be oriented with existing maps and photos. There is enough detail in the thermal image in Figure 17.7 so that it can be matched with an existing aerial photo of the same area.

Postfire Analysis

Postfire analysis is for damage assessment. Not only is the total acreage of the burn easily determined but so is the severity. Forest fires frequently leave pockets of live timber. Color infrared film is best for showing this. Even timber volume losses can be estimated. The fire boundary is transferred from photography taken after the fire to photography taken before the fire and the timber volumes are estimated using techniques explained in Chapters Twenty and Twenty-one. Postfire photography is also valuable in assessing the amount of timber that can be salvaged after a burn and in picking the best place to build roads for salvage and reforestation efforts.

Finally, aerial photography is often used in the debriefing and final report writing. It may provide some evidence as to correct or incorrect action taken during the suppression phase that can be used to further future training programs.

Laboratory Exercise

Establish the effective areas on one or more aerial photos of forested land and prepare a timber type map using the legend system described in this chapter or use a

legend system developed specifically for your geographic area. You or your instructor must first establish minimum area and minimum width standards. Preferably you should select an area that you are familiar with or have access to for field checking. For forestry students this exercise can be combined with an exercise on the transfer of detail (Chapter Ten), a photo timber cruise (Chapters Twenty and Twenty-one), double sampling with regression (Chapter Nineteen), or all of these topics to produce an integrated laboratory exercise that could take several laboratory periods.

Questions and Problems

1. List three phases of timber sales operatons and write a short paragraph explaining how aerial photographs can profitably be used in each phase.
2. List three phases of forest fire protection activities and write a short paragraph explaining how aerial photographs or thermal imagery can profitably be used in each phase.
3. List in their proper sequence the six components of the Northwest Type Mapping System.
4. Write the correct timber-type symbol for each of the following using the Pacific Northwest Type Mapping System. All percents are in terms of a percent of the ground covered by tree crowns or the number of trees per acre for seedling and sapling stands.
 (a) A two-storied stand composed of 15 percent Douglas-fir, 8 percent western hemlock, and 2 percent Sitka spruce mature sawtimber in the overstory. The understory consists of 40 percent western hemlock, 20 percent Douglas-fir, and 8 percent Sitka spruce poles.
 (b) A stand composed of 15 percent ponderosa pine and 5 percent sugar pine small saw timber that has been recently selectively cut.
 (c) An area clearcut in 1974 and planted with Douglas-fir in 1975. The planting was not very successful, however, because only 8 percent of the area was stocked with seedlings in 1978.
5. Write a complete stand description for each of the following type symbols:
 (a) PLD1 ≡ 1970
 (b) HD2 ≡
 (c) FM2 − mh, af
 (d) $\dfrac{\text{D5}-}{\text{D3}=\text{h,c}}$
 (e) XO

Eighteen

Outdoor Recreation, Range, Fish and Wildlife Management, Agriculture and Water Pollution

It would be impossible to cover in detail all aspects of photo interpretation for all natural resource disciplines in a single book. However, the basic principles remain the same regardless of the discipline involved. In this chapter we present an overview of the use of aerial photos in disciplines not specifically covered in other chapter titles. Even considering these, several disciplines have been left out. New uses of aerial photography are continuously being discovered and put to use as new technology is developed.

Objectives

After a thorough understanding of this chapter you will be able to:

1. List seven photo interpretable features that can be used to evaluate potential outdoor recreation sites.
2. Define rangeland and list three examples of the use of remote sensor imagery in range management.
3. List four situations that aid the photo interpreter in assessing wild animal populations.
4. List four agricultural uses of aerial photography.

5. Give at least one reason why the identification of agricultural crops by species is easier than the identification of timber stands by species on aerial photographs. Give another reason why the reverse is true.
6. Give two theories that explain why diseased plants reflect less near infrared radiation than healthy plants.
7. List five types of water pollution that can be detected on remote sensing imagery.
8. State what type of water pollutants cause water to appear lighter or darker on aerial photography.

OUTDOOR RECREATION

Aerial photographs are used by the outdoor recreation planner in a way similar to that of the land-use planner (mapping, inventory, analysis, planning, and communication). He or she does not inventory the entire area of interest, however. Instead, he or she uses photographs to help find suitable locations for the establishment of recreational sites in relation to other uses. He or she looks for roads, trails, exceptional views, and the distribution of natural vegetation of interest. The three-dimensional capability of aerial photography is particularly useful in this respect.

The recreation planner searches for natural attractions such as water bodies, vistas, interesting landforms, and potential ski runs. He or she can examine stream and river beds for potential swimming and fishing holes as well as access to them. He or she can look at the river banks. Are they steep or gentle, covered with brush or open; are there riffles for fishing, or rocks for people to climb on?

Recreation planners use photos to locate danger spots such as potential slides or snow avalanches for hazard reduction efforts. If the hazard cannot be eliminated, its location can be annotated on the photograph or marked on a map. Search and rescue organizations also use photographs to locate possible ascent and descent routes.

Lindsay (1969) developed the following seven photo interpretative factors for the evaluation of potential outdoor recreation areas:

1. *Population centers*—to establish the need for outdoor recreation sites.
2. *Present land use*—frequently eliminates certain areas for consideration (intensive urban development, marshland, impenetrable brush, valuable cropland, too steep, etc.).
3. *Water value*—outdoor recreation activities depend on size, shape, surface, and shoreline characteristics.
4. *Roads*—existing and potential.
5. *Aesthetic value.*
6. *Unique features*—waterfalls, interesting rock formations, ski slopes, etc.
7. *Forest vegetation*—resistance to recreation impact and timber value was considered.

Lindsay used these seven factors and 1:6,000-scale vertical aerial photographs to select six areas near Amherst, Massachusetts, for potential outdoor recreational development. The selected sites were field checked, rated, and compared with the photo selections. Five of the six areas were found to have good to excellent qualities for outdoor recreation. The sixth area had been damaged by fire after the photographs were taken and the vegetative cover destroyed. These results indicated that aerial photos can be effectively used to locate potential outdoor recreation sites.

MacConnell and Stoll (1969) used vertical photography to evaluate recreational resources of the Connecticut River in four states. The purpose of their study was to (1) develop and test the use of aerial photogrammetric techniques as a tool for identifying river-based recreation sites, (2) examine a large river system using aerial photographs, prepare maps, and catalogue sites suitable for recreational use, and (3) determine the changes in land use over the previous 10 to 14 years.

They used existing 1:20,000-scale photography taken between 1951 and 1955 when the hardwoods were in leaf and obtained 1:12,000-scale photography taken in 1965 when the hardwoods were without leaf. They classified all the land within 1000 ft of the river's edge on aerial photographs and then transferred this information to existing USGS topographic maps. Minimum type sizes varied between ½ and 1 acre.

MacConnell and Stoll devised an elaborate classification system based on features that could be consistently and accurately interpreted on the aerial photos. The system described the nature of the land itself, the vegetation on the land, and the land use or other features of value to those interested in the river and land near it.

Their classification system included 9 agricultural types, 40 forest types, 9 wetland types, 12 urban types, 14 outdoor recreational types, and 26 river bed and edge types. Ground detail was easier to evaluate on the 1:12,000-scale photography because of the larger scale and the absence of leaves on the hardwoods. However, the hardwood vegetation without leaves was harder to identify for species and measure for height on this photography as compared to the summertime 1:20,000-scale photography.

The classification system was rigorously tested by four photo interpreters on both sets of photography. The river bank classification system could be applied only on the larger-scale photos taken when the hardwoods were without leaves in areas where the land was open and the trees were mostly of hardwood species. The 1:20,000 summer photography proved to be best for vegetation mapping and for the classification of forest, farm, and wetlands.

The time lapse showed that not much change had taken place. The river was still severely polluted in 1965 and continued to prevent recreational development and use. The photo study permitted accurate past land use and use changes.

The final maps included nearly everything of interest to recreational planners in this area. Aerial photographs proved useful for purposes other than application of the classification system such as present or potential access routes, parking, picnic and camping areas, and scenic overlooks. Evaluation of river conditions that

affect boating, fishing, and swimming were sometimes possible. The study clearly demonstrated the feasibility of analyzing the recreational potential of a large river from aerial photographs.

Annotated photo mosaics, vertical, and oblique photography are valuable for clarification of essential elements of a recreational plan. The support of administrators, legislators, and local residents is often required for the implementation of a plan. Overlays can be used to convey various alternative land uses in a multiple-use context. Aerial photographs can show the farmer, logger, or rancher that his or her interests have been considered. A plan that is presented with the support of aerial photographs is more likely to be understood and accepted than an equally good plan presented with only a map.

Occasionally, recreationists themselves may make use of aerial photographs. Hunters use them to locate hunting areas, plan their hunt, and locate camp sites. Fishermen and backpackers locate promising riffles and pools and even locate small unmapped lakes, access roads, and trails.

RANGE MANAGEMENT

Rangeland includes all land covered with herbaceous or shrubby vegetation with or without a tree overstory that is used by grazing animals, either tame or wild. Examples of rangelands include steppe, desert, woodland, tundra, and wetlands. In many situations a given piece of land may be classified as both range and forest land. Under this broad definition, rangeland comprises over 50 percent of the land in the continuous United States. During the past several years much of what was originally classified as rangeland has been converted to agriculture or urban, suburban, and industrial development. About all that is required for this conversion is the location of adequate water, frequently from deep wells.

Range managers use remote sensing imagery in much the same way as do foresters. The primary use is for inventory and the assessment of land use and vegetational changes over time. Even though Poulton's (1972) Comprehensive Ecological Legend System (Chapter Sixteen) was designed to accommodate all cover types and land uses, it is particularly adapted to rangeland inventory and mapping.

Most inventories of rangeland consist of area data, that is, the number of acres in various condition classes and their location. However, the range manager can also inventory forage yield and therefore animal-carrying capacity, from aerial photographs just like the forester obtains timber-volume estimates. Range inventories using recent photography can also include animal population levels by species, age, and sex ratios. This obviously requires large-scale photography and a sophisticated sampling design.

Large-scale photography is also required for the inventory of forage production by type and species. Of more importance is the trend in range condition. Repeated inventories over time can answer the following important questions. (1) What are the changes in species composition, relative vigor, and successional

manager may have a separate set of legend symbols and pay more attention to grazing, brushlands, and wetland. Sometimes he or she can make use of cover type maps already produced by the forester, range manager, or other natural resource status? (2) What are the seasonal or annual utilization levels? (3) What is the impact of fire, insects, and disease? (4) What is the human impact through land-use change or range improvement? Comparisons of old and more recent photos do not always provide conclusive explanations for change, but they do show areas where change has occurred so that field crews can determine more precisely the nature or causes for the change. It is not always necessary to procure new photography in order to detect changes. You can evaluate change by comparing present conditions in the field with those seen on old photographs.

FISH AND WILDLIFE MANAGEMENT

There are three uses of aerial photography in fish and wildlife management: (1) habitat assessment (Figure 18.1) and mapping, (2) censusing, and (3) administration and law enforcement.

Habitat Assessment and Mapping

Habitat assessment and mapping is similar to that of cover type mapping for other disciplines, but with perhaps a slightly different emphasis. The wildlife

Figure 18.1. Experimental wildlife habitat area. The bulldozed circular openings are only 35 ft wide and were designed for wildlife. They are not campground sites. The ground cover is mostly aspen and oak, but with some pine and spruce, Tuscola County, Michigan, PSR = 20,000. (Courtesy of Illinois Photographic Service.)

specialist. More frequently, however, the wildlife manager requires specialized photography in order to make detailed habitat assessments. To illustrate, reference is made to a study by Greentree and Aldrich (1970) who used large-scale photography to evaluate stream habitat for trout.

Normal color and color infrared photographs were obtained at 1:600, 1:1584, and 1:6000 scales of a 3½ mile portion of Hat Creek in northern California. The stream is crystal clear and meanders through meadows and pine- and oak-covered hills, which make it ideal for aerial photo analysis. They used a 70-mm format because it is relatively inexpensive and only a narrow strip covering the stream and surrounding vegetation was required. The photography was taken in 1968, just before efforts were made to rehabilitate the stream, and again in 1969 to access the rehabilitation efforts.

In consultation with fisheries biologists, the authors developed trout-stream habitat criteria that could be interpreted from large-scale aerial photographs. These criteria included (1) in-stream conditions such as aquatic vegetation, bottom types (sand, silt, gravel), water depth, stream cover (debris, structures, and shade) and (2) stream bank conditions such as vegetation type (trees, grass, gravel, bare soil, etc.) and bank types (high, low, undercut, not undercut, and eroded).

A dot grid was placed over the center photo of selected stereo triplicates and the photos were stereoscopically interpreted at each point. Of 95 points that were field examined, 68 points (72 percent) were correctly identified on the photos (Table 18.1).

TABLE 18.1 Accuracy of Classification for Four Trout-Stream Condition Classes Using Conventional Photo Interpretation Techniques; Color Photographs, 1:1548 scale, taken 1968 and 1969, Hat Creek, California

Stream Condition	Points Correct	Points Incorrect	Total
Aquatic vegetation			
Submergent	6	0	6
Bottom types			
Sand	2	0	2
Subtotal	8	0	8
Bank cover types			
Bare soil	2	1	3
Gravel, rocks, boulders	3	0	3
Grasses, green	37	6	43
Grasses, brown	4	0	4
Subtotal	46	7	53
Bank types			
Low bank, no undercut	13	17	30
High bank, undercut	1	3	4
Subtotal	14	20	34
Total	68	27	95

From Greentree and Aldrich (1970).

The best overall scale and film for evaluating streambank conditions were found to be normal color at 1:1584 scale. Exceptions were low grassy areas and where healthy aquatic vegetation was found—here color infrared film was best. The 1:600-scale photographs were better for a detailed description of stream conditions and the measurement of gravel sizes (Greentree and Aldrich, 1970).

The degree of shade on the stream, which is directly related to stream temperature, was successfully evaluated using a technique that includes measurement of vegetation shadow lengths and vegetation positions in relation to the stream and the use of solar position diagrams and formulas.

Overall, the authors and fisheries biologists concluded that large-scale aerial photography can be a valuable tool for evaluating trout-stream habitat. Most of the characteristics of trout streams are visible and can be described directly from the aerial photographs provided the stream is the type studied, that is, a *clear* meandering stream in meadows or under a very light forest canopy.

Wildlife Censusing

Censusing wildlife populations consists of the determination of the total number of animals or birds present in a given area. In addition the censusing technique attempts to determine mortality rates and the sex and age structure of the population.

The value of the census is described in terms of wildlife management, an activity that attempts to obtain the optimum balance between wildlife, habitat, and humans. With census information, factors such as carrying capacity of the habitat, population pressure, and hunting pressure can be determined.

Inventory of wildlife populations is accomplished by ground surveys, aerial observation, or aerial photography. One type of ground survey consists of one or more observers who get as close as possible to different groups of the population being studied and make actual counts. An alternative to this is the "animal drive" where a group of beaters drive the animals in front of them as observers count as they pass by. Another form of ground survey includes several types of statistical methods. These methods involve the counting of tracks, pellets, or other population indicators and relating this information to the number of individuals present.

For example, in situations, where it is known that photo inventories are not accurate but strongly correlated with actual or field counts, double sampling with regression techniques can be used to a good advantage (Chapter Nineteen). Gopher populations can be estimated from large-scale aerial photographs even if the gophers themselves cannot be seen. The gopher mounds are counted on the photographs and population estimates are made based on known relationships between the number of mounds and the number of gophers.

There are also several types of catch, tag, and recatch methods. This technique is usually limited to the census of fish and small mammals.

Most ground survey methods are costly, frequently inaccurate, and many wildlife areas are inaccessible. The aerial observation method consists of aerial

observers who attempt to count or estimate the number of individuals while flying over the area, usually at low altitudes. This requires highly skilled observers and quick judgments must be made. There is little time to determine the age or sex of the species being counted. Fatigue also becomes a problem after a short period of time and the accuracy is always in question. Low-flying aircraft frequently scare the wildlife and cause it to scatter before it is counted. Large aggregations of animals or birds may be too large for accurate counting in the short period of time available.

Because of these problems, vertical aerial photography is frequently the best method of making accurate wildlife counts (Heyland, 1972). The photo interpreter can take as much time as required to make accurate counts and study individuals to determine their age and sex when possible. For example, young whistling swans—those with gray heads and necks—can be distinguished from the white adults on normal color photography. Total counts and the ratio of young to adult swans is now accomplished by the Bureau of Sport Fisheries and Wildlife using normal color photography instead of previously used aerial observation techniques (Leedy, 1968).

Because wildlife is mobile it is sometimes difficult to keep from counting the same individual more than once or not count it at all. Using aerial photography allows the census taker to capture their images on film in a very short period of time, which eliminates or at least greatly reduces the movement problem. The use of aerial photographs also provides a valuable permanent record.

Certain types of animals are easier to census on aerial photos than others. They must be relatively large, out in the open, and preferably bunched together like bands of antelope, Stones caribou (Figure 18.2), musk ox (Figure 18.3), or flocks of waterfowl (Figures 18.4 and 18.5). Dark-colored species show up better in the winter against a snow background than in the summer with a soil or vegetative background. This is also the same time of year that many species tend to band together and the deciduous leaves have fallen from the trees making censusing possible even in certain kinds of forests.

Once images are captured on film, the counting may become a problem because of the large number of individuals present. For example, Spinner (1949) counted 13,494 Atlantic snow geese on a single enlarged print. This flock constituted most of the Atlantic snow geese then in existence. Transparent grid overlays are frequently used when making large counts such as this (Figure 18.6). Each square is marked as it is counted or sampling techniques can be used to cut down on the tedious counting. Pinpricking images over a light table during the counting process is another technique frequently used for large populations. Photos can also be used to stratify population densities for use in stratified sampling techniques.

Ultraviolet (UV) photography (0.3 to 0.4 μm) is being used to inventory fur-bearing animals in the arctic regions. White harp seal pups can be identified on UV photography (Figure 1.7) even though they are on a white snow or ice background. On conventional photography only the dark colored adults can be identified. The coats of white seal pups are strong absorbers of UV energy and thus photograph black. The same technique has proven useful in improving the contrast for the inventory of other wildlife species such as the polar bear and arctic fox.

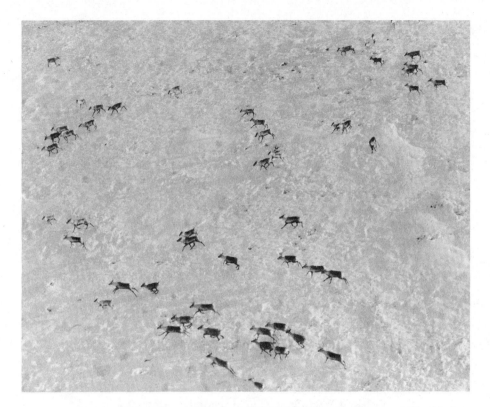

Figure 18.2. Stone's caribou photographed in the Lake Clark area on the Alaska Peninsula. (Courtesy of the U.S. Fish and Wildlife Service, Washington, D.C.)

However, there are problems with UV photography. First, even though most films are sensitive to the ultraviolet range, the atmosphere absorbs or scatters wavelengths below about 0.4 μm. Second, glass camera lenses absorb this energy. The solution to the last problem is to use a quartz camera lens. The first problem can be minimized by flying at low altitudes and during favorable atmospheric conditions.

In certain situations even fish can be counted on aerial photographs. Salmon and whales have been photographed and inventoried in their spawning grounds. The distribution and abundance of pelagic fish have also been studied on aerial photos. Pelagic fish are those that inhabit the upper portion of the ocean. They constitute a sizable portion of the U.S. fish production. Instead of counting individual fish these methods concentrate on the number and size of schools of fish.

Wildlife censusing using aerial photography has been successfully accomplished for elk, deer, moose, caribou, sheep, seals, sealions, penguins, and many species of waterfowl. Censusing requires relatively large-scale photography. Scales no smaller than 1:8,000 are generally recommended for large game animals such as

Figure 18.3. Large-scale photo of a small band of musk ox. (Courtesy of the U.S.
Fish and Wildlife Service, Anchorage, Alaska.)

elk and moose and scales between 1:3,000 and 1:5,000 are recommended for smaller
animals such as sheep, deer, and antelope.

Some species of wildlife, however, cannot be counted either by aerial observa-
tion or on aerial photographs if they are always under vegetative cover during the
hours of daylight. In this situation ground surveys are the only solution.

Administration and Law Enforcement

For certain types of hunting and fishing, wildlife administrators use aerial
photos to assess hunting and fishing pressures at a given time. Popular parking
areas can be photographed and the number of cars are counted. Then, using double
sampling with regression techniques, the number of hunters or fishermen can be
estimated. The same technique can be used to inventory fishing boats on rivers and
lakes. Law enforcement agencies sometimes use aerial photography to locate law-
breakers and the photos are sometimes used as evidence (Leedy, 1948).

Aerial photographs and topographic maps made from them have been used as
evidence in court cases involving the subdivision of property lines and the design of
roads and drainage systems. However, trial judges and lawyers are aware of "trick"

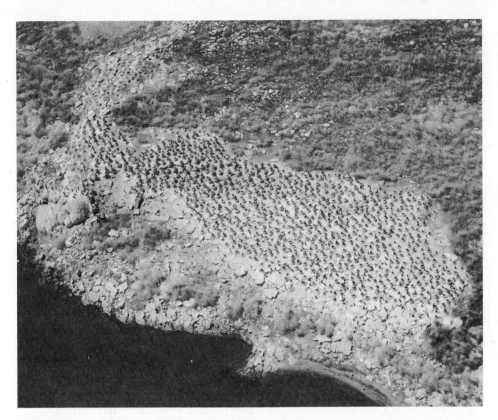

Figure 18.4. A colony of nesting cormorant on the Stillwater Refuge in Nevada.
(Courtesy of the U.S. Fish and Wildlife Service, Portland, Oregon.)

photographs, that is, altering the perspective by introducing false tilts during processing or by obscuring or adding imagery to the original photograph (Quinn, 1979).

Aerial photographs have been used as admissible legal evidence where a licensed professional engineer or registered surveyor identified the photograph and had personal knowledge of the location of the area shown in the photo as to the correct location of permanent objects in their true location to each other. Government-held aerial photographs have been admitted as evidence after proper authentication as to the taking time, camera used, and location of the area included in the photographs (Quinn, 1979).

AGRICULTURE

Agricultural uses of aerial photography include (1) the identification of crop species, (2) assessing the condition of crops as to maturity and potential yields, (3)

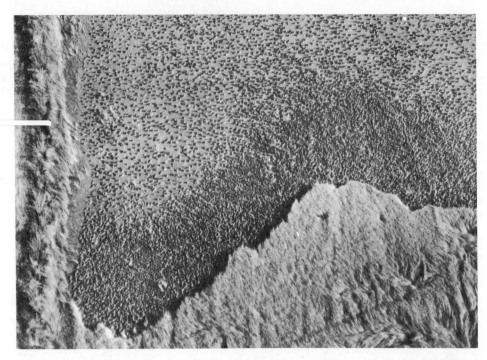

Figure 18.5. A portion of 18,000 pintails feeding on rice. Notice the extreme
density of birds close to the rice. Sacramento Refuge, California.
(Courtesy of the U.S. Fish and Wildlife Service, Portland, Oregon.)

the detection and inventory of insect and disease problems and other factors that
influence vigor such as fertilizer and moisture needs, and (4) the determination of
acreages of various crops.

 In some ways the interpretation of aerial photographs for agricultural pur-
poses is easier than for forestry or range management purposes because most
agricultural crops are grown in relatively pure stands of about the same age. Most
forests and range lands are composed of a wide variety of species and age classes.

 There are also factors that make agricultural photo interpretation difficult.
Agricultural crops make drastic changes in appearance over short periods of time.
Starting with bare ground they go through rapid changes of growth, vigor, and
maturity and are harvested frequently within a single growing season. The crop
appearance changes rapidly as it grows and covers more and more of the soil
surface. Soil moisture and soil color also have a great influence on the appearance of
the single crop species. Sometimes multidate photography (within the growing
season) is required to identify certain crop species. Table 18.2 is an example of a
dichotomous interpretation key developed for agricultural land in California for
panchromatic, single-date, 1:15,000-scale photography. Each geographic area

Figure 18.6. Grid superimposed over waterfowl on the Sacramento Refuge, California. The grid aids in counting and in designing a proper statistical sample.

should have its own set of interpretation keys—a separate key for each different type of film and scale used.

Except for the determination of acreages, color and color infrared photography is best for general agricultural interpretation. For the determination of insect and disease damage or the evaluation of plant vigor, infrared photography is far superior—especially color infrared. For example, Manzer and Cooper (1967) found color infrared photography to be far superior to regular color and panchromatic photography in the detection of late blight in potatoes (Figure 18.7 and Plate III). On panchromatic photography only areas of severe defoliation from the late potato blight disease were visible, whereas infrared photography revealed small infection in the early stages of infection—even before the plants developed discernible visual evidence in the field. Compare Figure 18.7 with the normal color and color infrared photos of the same area in Plate III. The diseased potato foliage is very dark on both the black-and-white and color infrared photos because of high

Figure 18.7. The difference between healthy and diseased potato plants is much easier to determine on infrared (top) than on panchromatic photography (bottom) because of a greater infrared reflectance of the diseased plants. The same is true when normal color and color infrared is compared (see Plate III, bottom right). In both comparisons the diseased plants are much darker on infrared film than the healthy plants.

TABLE 18.2 Dichotomous Airphoto Interpretation Key for the Identification of Major Crop and Land Cover Types in Agricultural Areas of California for Use with Summertime Panchromatic Aerial Photographs at a Scale of 1:15,000

1. Vegetation or soil clearly discernible on photographs	See 2
1. Vegetation and soil either absent or largely obscured by man-made structures, bare rock, or water	**Nonproductive Lands**
2. Cultivation pattern absent; field boundaries irregularly shaped	See 3
2. Cultivation pattern present; field boundaries regularly shaped	See 5
3. Trees present, covering most of ground surface	**Timberland**
3. Trees absent or widely scattered; ground surface covered by low-lying vegetation	See 4
4. Crowns of individual plants discernible; texture coarse and mottled	**Brushland**
4. Crown of individual plants not discernible; texture fine	**Grassland**
5. Crop vegetation absent	**Fallow**
5. Crop vegetation present	See 6
6. Crowns of individual plants clearly discernible	See 7
6. Crowns of individual plants not clearly discernible	See 8
7. Alignment and spacing of individual trees at intervals of 20 ft or more	**Orchards**
7. Alignment and spacing of individual plants at intervals of 10 ft or less	**Vine and Bush Crops**
8. Rows of vegetation clearly discernible usually at intervals of 2-5 ft	**Row Crops**
8. Rows of vegetation not clearly discernible; crops forming a continuous cover before reaching maturity	See 9
9. Evidence of use by livestock present; evidence of irrigation from sprinklers or ditches usually conspicuous	**Irrigated Pasture Crops**
9. Evidence of use by livestock absent; evidence of irrigation from sprinklers or ditches usually inconspicuous or absent; bundles of straw or hay and harvesting marks frequently discernible	**Continuous Cover Crops** (small grains, hay, etc.)

From National Research Council (1970).

infrared reflectance. The appearance of the diseased foliage will go through magenta, purple and finally dark green to black on color infrared photography because of the loss of photographic infrared reflectance. This loss of infrared reflectance can be related to the extent of the damage due to the blight.

Much has been written as to why this change in infrared reflectance takes place in diseased leaves and researchers are not in complete agreement as to exactly why. Evidently there are many factors. One of the chief factors is the change in the internal structure of diseased leaves—particularly the plugging or collapse of the

spongy mesophyll cells, which changes infrared reflectance. Gauseman (1974) stated that the change in infrared reflectance is caused by changes in the internal air space to cell wall-air space interface of hydrated leaves and internal discoloration of the leaf.

Regardless of why, the fact remains that infrared photography is far superior to noninfrared photography for the early detection of certain kinds of diseased plants.

Early detection of insect and disease problems in agricultural crops is not always possible. However, at least limited success has been attained for the following: corn leaf blight, potato blight, sugar beet leaf spot, stem rust of wheat and oats, pecan root rot, and others.

The role of aerial photography in determining crop yields is frequently limited to the determination of acreages. Yields per acre are obtained from sample field plots and the total yield is calculated by multiplying the acreage by the average yield per acre. Photographs can also be used to stratify acreages by vigor classes based on their photo appearance so that stratified sampling techniques can be used. The ultimate use of aerial photography for determining crop yield is to employ double sampling with regression techniques similar to techniques used in forest inventory. Correlations between leaf reflectance and crop yields have been moderately successful using color transparencies and densitometers.

There are other uses of aerial photography in agriculture. Individual farmers could make greater use of aerial photography, but usually don't because they are not trained to do so. In recent years agricultural consultants have begun to use aerial photography to render important services to farmers and government agencies. The *Manual of Photographic Interpretation* (1960) summarizes these services as follows:

1. To study soil and drainage conditions in relation to crops.
2. To detect gaps in seeding, or fertilization and areas where weed control is needed.
3. To detect disease and insect infestations at an early stage.
4. To brief farmers on areas to be treated and provide them with annotated photographs showing the location of areas to be treated.
5. To select soil-sampling locations.
6. To show governmental agencies that farmers have complied with requirements for receiving agricultural benefit payments.
7. To make long-term studies to assess trends in the improvement or deterioration of agricultural land.

WATER POLLUTION DETECTION

Because of increasing emphasis on environmental quality, aerial photography is being used more and more to detect, inventory, and assess the severity of water pollution sources. When discussing water pollution sources it is customary to consider two types of sources—point and nonpoint. *Point sources* are localized, such as the discharge of industrial wastes into bodies of water. *Nonpoint* sources are

not as localized and cover relatively large areas such as fertilizer runoff from agricultural fields, sediment runoff following heavy rainfall, or the leaching of sewage over large areas.

Point sources are generally easier to locate on aerial photographs than non-point sources. Some types of pollution can be detected directly on the photographs, some indirectly, and some cannot be detected at all on aerial photographs.

Direct detection is the result of a visible change in tone, color, or texture of the water as imaged. Indirect detection includes detectable changes in the environment caused by water pollution such as the killing of vegetation or aquatic life like oysters, fish, or waterfowl.

Some of the more easily photo-detectable water pollutants include sewage and other oxygen demanding wastes, soluble inorganic substances, nonsoluble inorganic sediments, oil slicks, and heat pollution, which is detectable by thermal scanners. Some of the more difficult (if not impossible) aerial photo detection problems include pollutants from infectious organisms that cause disease in humans or animals and radioactive pollutants (Strandberg, 1967).

Materials *suspended* in bodies of water cause the photographic tones to be lighter because more energy is reflected and less energy absorbed by the water. *Dissolved* fertilizers in bodies of water can frequently be indirectly detected through the stimulation of algae growth. Mine wastes frequently coat streambeds and create chemical changes that are easily detected on aerial photographs. Leached sulphuric acid from coal mines creates one of the most serious water pollution problems in the United States, and is easily detected on color aerial photography.

Heat pollution, frequently caused by industrial wastes and atomic power plants, changes the density and viscosity of the water. Sometimes this creates lighter tones on aerial photography. However, heat pollution is easier to detect through the use of thermal imagery.

Questions and Problems

1. List seven photo interpretable features for evaluating potential outdoor recreation sites.
2. Define rangeland and list three examples of the use of remote sensor imagery in range management.
3. List four situations that aid the photo interpreter in assessing wild animal populations.
4. List four types of agricultural uses of aerial photography.
5. Why is the specific identification of agricultural crops **(a)** easier and **(b)** more difficult than the specific identification of different stands of timber?
6. Why do diseased plants reflect less near infrared radiation than healthy plants?
7. List five types of water pollution that can be detected on remote sensing data.
8. Why does sediment suspended in bodies of water appear lighter in tone than does clear water on most film types?

References for Part Three

American Society of Photogrammetry. 1960. *Manual of Photographic Interpretation*, Falls Church, Va.

American Society of Photogrammetry. 1968. *Manual of Color Aerial Photography*, Falls Church, Va.

American Society of Photogrammetry. 1975. *Manual of Remote Sensing*, Falls Church, Va.

Anderson, J. R., E. H. Hardy, J. T. Roach, and R. E. Whitmer. 1976. "A Land Use Sensor and Land Cover Classification System for Use with Remote Sensor Data," *Geological Survey Professional Paper* 964, U.S. Government Printing Office, Washington, D.C.

Avery, T. E. 1977. *Interpretation of Aerial Photographs*, Third Edition, Burgess Publishing Co., Minneapolis, Minn.

Backhouse, D. G. 1977. *Fundamentals of Aerial Photography*, Second Edition, International Institute for Aerial Survey and Earth Sciences, Enschede, The Netherlands.

Bernstein, D. A. 1962. "Use of Aerial Photography in Unit Area Control Management," *Journal of Forestry*, Vol. 60, No. 3. pp. 191-195.

Bloom, A. L. 1969. *The Surface of the Earth*, Prentice-Hall, Inc., Englewood Cliffs, N.J.

Camp, H. W. 1974. "Land-Use Planning: What It Is and What It Is Not," *Foresters in Land-Use Planning Proceedings*, National Convention, Society of American Foresters, Portland, Ore. pp. 22-27.

Dell, J. D. 1972. *R-6 Preattack Guide—Area Planning and Development for Forest Fire Protection in the Pacific Northwest Region*, U.S.D.A. Forest Service, Portland, Ore.

Dilworth, J. R. 1979. *Log Scaling and Timber Cruising*, Oregon State University Bookstores, Inc., Corvallis, Ore.

Eastman Kodak Company. 1972. *Color As Seen and Photographed*, Second Edition, Eastman Kodak Co., Rochester, N.Y.

Eastman Kodak Company. 1972. *Kodak Aerial Films and Photographic Plates*, Eastman Kodak Co., Rochester, N.Y.

Eastman Kodak Company. 1977. *Applied Infrared Photography*, Eastman Kodak Co., Rochester, N.Y.

Eastman Kodak Company. 1978. *Filters and Lens Attachments for Black and White and Color Pictures*, Eastman Kodak Co., Rochester, N.Y.

Eastman Kodak Company. 1978. *Kodak Filters for Scientific and Technical Uses*, Eastman Kodak Co., Rochester, N.Y.

Gauseman, H. W. 1974. "Leaf Reflectance of Near-Infrared," *Photogrammetric Engineering*, Vol. 40, No. 2. pp. 183-191.

Greentree, W. J. and R. C. Aldrich. 1970. "Evaluating Stream Trout Habitat on Large-Scale Aerial Photographs," U.S.D.A. *Forest Service* Research Paper, PSW 123.

Hall, F. C. 1974. *Pacific Northwest Ecoclass Identification*, U.S.D.A. Forest Service, R6 Regional Guide 1-1, Portland, Ore.

Hall, F. C. 1975. *Codes for Pacific Northwest Ecoclass Identification*, U.S.D.A. Forest Service, R6 Regional Guide 1-2, Portland, Ore.

Herrington, R. B. and *S. R. Tocher.* 1967. *Aerial Photo Techniques for a Recreation Inventory of Mountain Lakes and Streams*, Intermountain Forest and Range Experiment Station, Research Paper, Int. 37, Ogden, Utah.

Heyland, J. D. 1972. "Vertical Aerial Photography as an Aid in Wildlife Population Studies," *First Canadian Symposium on Remote Sensing*, Ottawa, Canada. pp. 121-136.

Hills, G. A., D. V. Love, and *D. S. Lacate.* 1970. "Developing a Better Environment," *Ecological Land-Use Planning in Ontario—A Study of Methodology in the Development of Regional Plans.* Ontario Economic Council, Toronto, Canada.

Hirsch, S. N., R. L. Bjornsen, F. H. Madden, and *R. A. Wilson.* 1966. *Project Fire Scan Fire Mapping Final Report*, Intermountain Forest and Range Experiment Station. U.S.D.A. Forest Service, Research Paper INT 49, Missoula, Mont.

Jensen, N. 1968. *Optical and Photographic Reconnaissance Systems*, John Wiley and Sons, New York.

Keser, N. 1976. *Interpretation of Landforms from Aerial Photographs*, Research Division, British Columbia Forest Service, Victoria, British Columbia, Canada.

Lattman, L. H. and *R. G. Ray.* 1965. *Aerial Photographs in Field Geology*, Holt, Rinehart and Winston, New York.

Lauer, D. 1968. "Forest Species Identification and Timber Type Delineation on Multispectral Photography," *Annual Progress Report*, Forest Remote Sensing Laboratory, Berkeley, Ca.

Lavigne, D. M. and *N. A. Oristland.* 1974. "Ultraviolet Photography: A New Application for Remote Sensing of Mammals," *Canadian Journal of Zoology*, Vol. 52, No. 7. pp. 939-941.

Lawrence, R. D. and *J. H. Herzog.* 1975. "Geology and Forestry Classification from ERTS-1 Digital Data." *Photogrammetric Engineering and Remote Sensing*, Vol. 41, No. 10. pp. 1241-1251.

Leedy, D. L. 1948. "Aerial Photographs, Their Interpretation and Suggested Uses in Wildlife Management," *Journal of Wildlife Management*, Vol. 12, No. 2. pp. 191-210.

Leedy, D. L. 1968. "The Inventorying of Wildlife." *Manual of Color Aerial Photography*, American Society of Photogrammetry, Falls Church, Va.

Legge, A. H., D. R. Jaques, C. E. Poulton, C. L. Kirby, and P. VanEck. 1974. *Development and Application of an Ecologically Based Remote Sensing Legend System for the Kananaskis Alberta Remote Sensing Test Corridor (Sub-Alpine Region)*, Environmental Sciences Centre Kananaskis, University of Calgary, Alberta, Canada.

Lillesand, T. M. and *R. W. Kiefer.* 1979. *Remote Sensing and Image Interpretation*, John Wiley and Sons, New York.

Lindsay, J. J. 1969. "Locating Potential Outdoor Recreation Areas from Aerial Photographs," *Journal of Forestry*, Vol. 67, No. 1. pp. 33-35.

MacConnell, W. P. and *P. Stoll.* 1969. "Evaluating Recreational Resources of the Connecticut River," *Photogrammetric Engineering*, Vol. 35, No. 7. pp. 686-692.

Manzer, F. E. and *G. R. Cooper.* 1967. *Aerial Photographic Methods of Potato Disease Detection*, Maine Agricultural Experiment Station Bulletin 646, University of Maine.

Miller, V. C. 1961. *Photogeology*, McGraw-Hill Book Co., New York.

Mossner, K. E. 1960. *Training Handbook Basic Techniques in Forest Photo Interpretation*, Intermountain Forest and Range Experiment Station, U.S.D.A. Forest Service, Ogden, Utah.

Murtha, P. A. 1972. *A Guide to Photo Interpretation of Forest Damage in Canada*, Canadian Forestry Service, Ottawa, Canada.

National Research Council. 1970. *Remote Sensing with Special Reference to Agriculture and Forestry*, National Academy of Science, Washington, D.C.

Paine, D. P. 1965. *Photographic Mensurational Techniques for Obtaining Timber Management Data from Aerial Photographs of Ponderosa Pine Stands—Including the Application of Variable Plot Theory*, Ph.D. thesis, University of Washington, Seattle, Wash.

Paine, D. P. 1979. *An Introduction to Aerial Photography for Natural Resource Managers*, Oregon State University Bookstores, Inc., Corvallis, Ore.

Pfister, R. E. and *R. E. Frenkel.* 1974. *Field Investigations of River Use Within the Wild River Area of the Rogue River, Oregon*, Department of Geography, Oregon State University, Corvallis, Ore.

Pope, R. B., C. D. MacLean, and D. A. Bernstein. 1961. *Forestry Uses of Aerial Photographs*, Pacific Northwest Forest and Range Experiment Station, U.S.D.A. Forest Service, Portland, Ore.

Poulton, C. E. 1972. *A Comprehensive Remote Sensing Legend System for the Ecological Characterization and Annotation of Natural and Altered Landscapes*, Proceedings of the Eighth International Symposium on Remote Sensing of Environment, Environmental Research Institute of Michigan, Ann Arbor, Mich. pp. 393-408.

Quinn, P. E. 1979. "Admissibility in Court of Photogrammetric Products," *Photogrammetric Engineering and Remote Sensing*, Vol. 45, No. 2. pp. 167-170.

Ray, R. G. 1960. "Aerial Photographs in Geologic Interpretation and Mapping," *Geological Survey Professional Paper #373*, U.S. Government Printing Office, Washington, D.C.

Ray, R. G. and *W. A. Fisher.* 1960. "Quantitative Photography—A Geologic Research Tool," *Photogrammetric Engineering*, Vol. 26, No. 1. pp. 143-150.

Remeijn, J. M. 1972. *Photo Interpretation in Forestry*, International Institute for Aerial Survey and Earth Sciences, Enschede, The Netherlands.

Sabins, F. F. 1978. *Remote Sensing Principles and Interpretation*, W. H. Freeman and Co., San Francisco, Ca.

Sayn-Wittgenstein, L. 1961. "Recognition of Tree Species on Air Photographs by Crown Characteristics," *Photogrammetric Engineering*, Vol. 27, No. 5. pp. 792-809.

Sherman, C. L. 1962. *The Science of Photography*, Nelson Doubleday, Inc., Garden City, N.Y.

Simonson, G. H., D. P. Paine, R. D. Lawrence, W. T. Pyott, J. H. Herzog, R. J. Murray, J. A. Norgren, J. A. Cornwell, and *R. A. Rogers.* 1974. *The Comparative Evaluation of ERTS—I Imagery for Resource Inventory in Land Use Planning.* A multidiscipline research investigation final report to NASA Goddard Space Flight Center, Greenbelt, Maryland, Oregon State University, Corvallis, Ore.

Smith, J. T. 1968. "Filters for Aerial Photography," *Manual of Color Aerial Photography*, American Society of Photogrammetry, Falls Church, Va. pp. 189-195.

Spinner, G. P. 1949. "Observations on Greater Snow Geese in the Delaware Bay Area," *The Auk*, Vol. 66, No. 3. pp. 197-198.

Spurr, S. H. 1960. *Photogrammetry and Photo-Interpretation*, The Ronald Press Co., New York, N.Y.

Stevens, A. R., W. H. Ogden, H. B. Wright, and *C. W. Craven.* 1974. "Alternatives for Land Use/Cover Mapping in the Tennessee River Watershed." American Congress on Surveying and Mapping, American Society of Photogrammetry, annual meeting, St. Louis, Mo. pp. 533-542.

Strahler, A. N. 1975. *Physical Geography*, Fourth Edition, John Wiley and Sons, New York.

Strandberg, C. H. 1967. *The Aerial Discovery Manual*, John Wiley and Sons, New York.

Sussman, A. 1973. *The Amateur Photographer's Handbook*, Eighth Edition, Thomas Y. Crowell Co. pp. 475-477.

Tarnocai, C. and *J. Thie.* 1974. "Permafrost and Remote Sensing." *Second Canadian Symposium on Remote Sensing*, Vol. 2. pp. 437-447.

U.S.D.A. Forest Service. 1962. *Instructions for Type Mapping Forest Types in the Pacific Northwest Region*, Division of Timber Management, Pacific Northwest Region, Portland, Ore.

U.S. Departments of the Army, the Navy, and the Air Force. 1967. *Image Interpretation Handbook*, T. M. 30-245. U.S. Government Printing Office, Washington, D.C.

Van Zuidam, R. A. 1972. *Guide to Geomorphological Photointerpretation*. International Institute for Aerial Survey and Earth Sciences, Enschede, The Netherlands.

Way, D. 1968. *Air Photo Interpretation for Land Planning*, Dept. of Landscape Architecture, Cambridge, Mass.

Way, D. 1973. *Terrain Analysis, A Guide to Site Selection Using Aerial Photographic Interpretation*, Dowden, Hutchinson and Ross, Stroudsburg, Pa.

Wear, J. F., R. B. Pope and *P. W. Orr.* 1966. *Aerial Photographic Techniques for Estimating Damage by Insects in Western Forests*, Pacific Northwest Range and Experiment Station, U.S.D.A. Forest Service, Portland, Ore.

Weaver, K. F. 1969. "Remote Sensing—New Eyes to See the World," *National Geographic*, Vol. 135, No. 1. pp. 46-73.

Wilson, R. A., S. N. Hirsch, F. H. Madden, and *B. J. Losensky.* 1971. Airborne Infrared Forest Fire Detection System: Final Report. U.S.D.A. Forest Service, Research Paper INT 93, Missoula, Mont.

Worsfold, R. D. 1972. "A Qualitative Study of Kodak Aerochrome Infrared Film, Type 2443, and the Effect Produced by Kodak Colour Compensating Filters, at High Altitudes," *First Canadian Symposium on Remote Sensing*, Vol. 2. pp. 417-427.

Worsfold, R. D. 1976. "Color Compensating Filters with Infrared Film," *Photogrammetric Engineering and Remote Sensing*, Vol. 42, No. 11. pp. 1385-1398.

Yost, E. and *S. Wenderoth.* 1967. "Multispectral Color Aerial Photography," *Photogrammetric Engineering*, Vol. 33, No. 9. pp. 1020-1031.

Yost, E. and *S. Wenderoth.* 1968. "Additive Color Photography," *Manual of Color Aerial Photography*, American Society of Photogrammetry, Falls Church, Va. pp. 451-471.

Zander, A. D., R. M. Pomeroy and *J. R. Fisher.* 1966. *Typical Landscape Characteristics and Associated Soil and Water Management Problems on the Mt. Baker National Forest*, U.S.D.A. Forest Service, Bellingham, Wash.

Part Four

Forest Inventory

Nineteen

Elementary Sampling Techniques

One of the primary uses of aerial photography and other imagery produced by remote sensors is to inventory features of interest on the earth's surface. For example, the inventory may consist of a complete census or enumeration of acres in various condition classes, the use of a simple sampling procedure to estimate the number of waterfowl in a game preserve, or a more complicated double sampling technique to estimate the number of tons of forage or the board-foot volume of timber growing on a given area.

The first example, being a complete census where the entire population is measured or counted, does not require sampling. The second example might utilize a simple random or systematic sampling system with or without stratification and requires only an elementary understanding of sampling and statistics. The last example is a little more complicated because we cannot directly count or measure tons of forage or board-foot volume directly from a photograph. Instead, we must measure or estimate something related to tons or board-feet and convert this to units of measure that we are after.

In this chapter, we discuss only the basic elements of equal probability sampling. More advanced sampling designs such as unequal probability and/or multistage sampling are left for the specialist in sampling techniques.

Objectives

After a thorough understanding of this chapter, you will be able to:

1. List five reasons for sampling (in general) in contrast to measuring the entire population.
2. Define fully statistic, parameter, bias, accuracy, precision, mean, standard deviation, coefficient of variation, standard error of the mean, sampling

error, desired sampling, error, observation, sample, sample size, population, double sampling with regression, dependent and independent variables, slope, and intercept.

3. Given a set of necessary equations and the required data, select the proper equation and correctly calculate the mean, standard deviation, coefficient of variation, standard error of the mean, sampling error, and the required sample size for both finite and infinite populations.

DEFINITIONS OF BASIC SAMPLING TERMS

Before going further, it is imperative that we learn to speak the language of the statistician. You are probably familiar with some of the terms that follow, but you must become familiar with the precise statistical meanings.

Population

The *population* is the entire set of elements that we are seeking information about and it must be well defined in advance. For example, the population could be defined as the cubic-foot volume of all the timber in the United States, in a single state, in a particular country, or on just one specified acre, but the physical boundaries must be defined. The characteristic being sampled must also be well defined. In the above example, it was cubic-foot volume, but cubic-foot volume of what—stem, stump, roots, branches, leaves, or what? Instead, perhaps we are interested in the number of tree seeds or just the viable seeds. In any case, the population can be almost anything, but it must be well defined.

Sample

A *sample* is a portion of the population that we hope is representative of the population. A sample is made up of observations and there are n observations in one sample (sample size = n).

Observation

An *observation* is the basic element of our sample, usually one number. It could be the number of cubic-feet per tree or the number of cubic-feet per acre depending on how we define the observation.

Statistic

A *statistic* is a characteristic of a sample such as the sample mean (arithmetic average) or sample standard deviation (defined later). A statistic is an estimate of a parameter.

Parameter

A *parameter* is a characteristic of a population, such as the *population* mean or *population* standard deviation.

Accuracy

Accuracy is how close a measurement or observation is to the true value. Or in statistics, it usually refers to how close the sample mean (a statistic) is to the true mean (a parameter).

Bias

Bias refers to systematic errors, for example, errors all in the same direction— high or low. Bias is caused by faulty measurement techniques, measuring instruments being out of adjustment, or faulty sampling techniques. It is possible to have precise measurements that are not accurate if the measurements are different from the true values due to bias.

Precision

Precision has two connotations. One is how many decimals of precision are there. Thus, a measurement of 38.4079 ft is more precise than 38.4 ft. The other connotation (one used in statistics) is how repeatable are the measurements. For example, suppose we measured something 100 times and our measurements ranged from 38.3412 to 38.9726 as compared to a different 100 measurements that ranged from 38.4072 to 38.4074. Our second set of 100 measurements is more precise. Precision is usually expressed in terms of the standard deviation or standard error.

REASONS FOR SAMPLING

There are at least five different reasons for sampling as compared to making a complete census:

1. Total enumeration may not be feasible.
2. Sampling saves money.
3. Sampling saves time.
4. *Some* types of measurements are destructive.
5. Under *some* circumstances, sampling *may be* more accurate.

Total Enumeration Not Feasible

In many situations, a total enumeration is not feasible just because of the magnitude of the job. Counting all the waterfowl on a large game preserve or

determining the timber volume on a million acres, for example, is just too big a job for a complete enumeration.

Saves Time and Money

Even with aerial photographs to help, a complete enumeration is frequently just too expensive, too time consuming, or both. Therefore, most natural resource managers rely on some type of sampling process to estimate what their total resource might be. A saving of money is the most common reason for sampling, but a saving of time is sometimes more important. If an inventory must be completed by a certain date, sampling may be the only solution regardless of the money available.

Some Measurements Are Destructive

Suppose a chain-saw manufacturer wanted to know the average life of a particular chain-saw engine in hours of moderate to heavy sawing or a light-bulb manufacturer may wish to know the average length of time a particular brand and size of light bulbs would burn. In these situations, a 100 percent testing (inventory) would result in no chain saws or light bulbs left for sale. Sampling is the only solution.

Sampling May Be More Accurate

A pure statistician would not list boredom and fatigue as factors since he or she would assume that all measurements were made without error. But, in actual practice these factors are real. A timber cruiser probably makes more errors at the end of a week or when working in the cold rain than during the first day of a cruise or on a nice sunny spring day. Thus, it is *possible* that a small well-chosen sample, measured with great care, can yield results that are more accurate and accomplished at less cost in a shorter period of time.

ELEMENTARY SAMPLING DESIGNS

We will use the term sampling design to describe the way in which the individual observations that make up the sample are selected. There are dozens of sampling designs, but only three will be discussed here: simple random, systematic, and stratified.

Simple Random Sampling

A simple random sample is one in which every possible combination of *n* observations has an equal chance of being selected. This may be accomplished in several ways. Each unit or observation within the population can be assigned a

number and then *n* of these numbers are selected from a table of random numbers. The numbers could also be placed in a hat or other container, mixed, and selected one at a time until we have reached our desired sample size.

Another method more suitable for use with aerial photographs is to place a square grid (Figure 19.1) over the photos on which the vertical columns and horizontal rows have been consecutively numbered. The sample units are then selected using pairs of random numbers from a random number table.

Sampling can be either with or without replacement. When sampling with replacement, any observation can be selected more than once. When sampling without replacement, once an observation has been selected, it cannot be selected again.

Systematic Sampling

Systematic sampling is frequently used for natural resource inventory, particularly for intensive sampling. The units are laid out in a systematic pattern, usually square or rectangular (Figure 19.2). Theoretically, sampling theory and sampling

Figure 19.1. Square grid with 10 randomly selected plots. Ten pairs of random numbers were selected from a random number table. One number of the pair represented a row and the other represented a column.

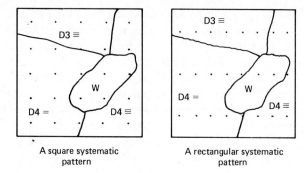

| A square systematic pattern | A rectangular systematic pattern |

Figure 19.2. Two of many possible systematic patterns. Strata boundaries are ignored when nonstratified sampling is used.

equations are based on random sampling. In actual practice, however, random sampling equations are used for both random and systematic sampling.

Stratified Sampling

In stratified sampling, the units of the population are grouped together into categories that are similar with regard to the characteristic being sampled. In sampling a forest for timber volume, all the tall and well-stocked stands are put in one stratum, the short and well-stocked stands in another stratum, and the medium and poorly stocked stands of various heights in still other strata, etc. Then, we select a separate sample from each stratum, make the desired calculations for each stratum, and statistically combine all strata to give an estimate for the entire population.

Where definite strata exist, this is a much more efficient method of sampling. The easiest and most economic method of determining and locating individual strata for natural resource inventories is through the use of aerial photography (Figure 19.3) with the stratum boundaries outlined. Sampling equations for stratified sampling are in Appendix B. This and the location of field plots may be the primary use of the photos, or the entire inventory can be accompplished on the photos with or without field verification. A third use of photos involves both photo and field plots in a double sampling with regression design (described later). Within each individual stratum, the plot or sampling unit can be selected either at random or systematically.

The advantages of stratified sampling are that it provides separate estimates of the mean and variance (defined later) of each stratum and it usually gives a more precise estimate of these parameters for the entire population than a random sample of the same size.

Some of the disadvantages are that each unit in the population must be assigned to one and only one stratum, the size of each stratum must be known, and a

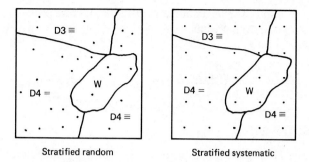

Stratified random Stratified systematic

Figure 19.3. Examples of stratified random (left) and stratified systematic (right) plot location. Strata boundaries are utilized when stratified sampling is employed. (From D. P. Paine, 1979, *An Introduction to Aerial Photography for Natural Resource Management,* O.S.U. Bookstores, Inc., copyright 1973, reproduced with permission.)

sample must be selected from each. The use of aerial photography can be used to eliminate one of these disadvantages—the lack of knowledge about the strata size.

BASIC STATISTICAL CALCULATIONS

The Sample Mean and Sample Total

Suppose a wildlife manager wanted to know the total number of adult migrating waterfowl of a given species that are nesting on an island off the Alaskan coast. Suppose that the island is 10 sq miles in size and all adult birds are visible on a series of aerial photographs. Let us further suppose that counting all these birds on the photo is just too big a job, so we decide to sample. First, we define our sampling unit. An obvious sample unit in this case would be an area of land—say ¼ acre. Next, we divide the land into ¼-acre plots and establish the boundaries of these plots on our photos or use a transparent overlay. Then, we select a sample—say 400 of these ¼acre plots and count the number of birds per plot. The mean number of birds per plot is calculated by:

$$\bar{y} = \frac{\Sigma y}{n}$$

Where

 \bar{y} = sample mean (arithmetic average)
 y = an observation (the number of birds per plot in this case)
 n = the number of observations (or sample size)
 Σ = sigma or "the sum of"

Suppose the sum of the bird counts for the 400, ¼-acre plots was 10,688. The sample mean would be 10,688/400 or 26.72 birds per ¼ acre. Thus, our estimate of the total number of birds is:

$$\left(\frac{26.72 \text{ birds}}{\text{¼ acre}}\right) \left(\frac{640 \text{ acres}}{\text{sq mile}}\right) (10 \text{ sq miles}) = 684,032 \text{ birds}$$

The Standard Deviation

Only by rare chance is the sample mean and sample total equal to the population mean and total. Repeated samples using different plots would give slightly different answers, so what we want to know next is how close our sample estimate is to the true estimate. The standard error of the mean gives us this answer but first let us define and calculate the standard deviation. The standard deviation (SD) is defined as *a measure of dispersion (or differences) of individual observations (measurements)* about their mean. It can be calculated by:

$$SD = \sqrt{\frac{\Sigma (y - \bar{y})^2}{n - 1}} \quad \text{or} \quad SD = \sqrt{\frac{\Sigma y^2 - \frac{(\Sigma y)^2}{n}}{n - 1}}$$

The first equation better shows what we are measuring—differences of individual observations about their mean or $(y - \bar{y})$. The second equation is the one more commonly used because calculation is easier in this form, particularly when using desk calculators. As an example, let's calculate the standard deviation of the numbers 4, 2, 4, 3, 6, and 6, using both equations.

y	y^2	$y - \bar{y}$	$(y - \bar{y})^2$
4	16	−0.167	0.028
2	4	−2.167	4.696
4	16	−0.167	0.028
3	9	−1.167	1.362
6	36	+1.833	3.360
6	36	+1.833	3.360
$\Sigma = 25$	$\Sigma = 117$		$\Sigma = 12.834$

$\bar{y} = 4.167$

$n = 6$

Using the first equation we get:

$$SD = \sqrt{\frac{12.834}{6 - 1}} = \sqrt{2.567} = 1.602$$

Using the second equation we also get:

$$SD = \sqrt{\frac{117 - \frac{(25)^2}{6}}{6 - 1}} = \sqrt{\frac{117 - 104.167}{5}} = 1.602$$

Even in this simple example, it is evident that the second equation is easier to use. The last two columns of numbers are not needed and, using a desk calculator, it is possible to accumulate the Σy^2 and the Σy at the same time without writing down the intermediate numbers making the entire calculation a very simple matter.

The Standard Error of the Mean

The standard error of the mean ($SE_{\bar{y}}$) is defined as *a measure of dispersion (or differences) of sample means about the mean of all possible means.* At first this definition sounds similar to that for standard deviation, but there is a distinct difference. It must be emphasized that the SD deals with individual observations and their mean while the $SE_{\bar{y}}$ deals with sample means and the mean of all possible sample means.

Actually, the $SE_{\bar{y}}$ is a standard deviation of means—*not observations, but means.* For small samples it can be calculated by:[1]

$$SE_{\bar{y}} = \sqrt{\frac{\Sigma (\bar{y} - \bar{\bar{y}})^2}{n - 1}} ,$$

Where $\bar{\bar{y}}$ is the mean of n sample means. We don't calculate the $SE_{\bar{y}}$ in this manner because we usually take only one sample. If we took all possible samples we would have inventoried the whole population and would have lost all the economic and other benefits of sampling. The equation used to calculate the $SE_{\bar{y}}$ based on only one sample is:

$$SE_{\bar{y}} = \frac{SD}{\sqrt{n}} = \sqrt{\frac{\Sigma y^2 - \frac{(\Sigma y)^2}{n}}{n (n - 1)}}$$

Using the same data as before for an example, the standard error of the mean is:

$$SE_{\bar{y}} = \frac{1.602}{\sqrt{6}} = 0.6540$$

[1] *For large samples (5 percent or more), the $SE_{\bar{y}}$ should be multiplied by the finite population correction factor $\sqrt{1 - n/N}$, where N = total number of possible observations in the population.*

Using the other equation we also get:

$$SE_{\bar{y}} = \sqrt{\frac{117 - \dfrac{(25)^2}{6}}{6(6 - 1)}} = \sqrt{\frac{12.833}{30}} = 0.6540$$

Coefficient of Variation

The coefficient of variation (CV) is nothing more than the standard deviation expressed as a percent of the mean and is easily calculated by:

$$CV = \frac{SD}{\bar{y}}(100) = \frac{\sqrt{\dfrac{\Sigma y^2 - \dfrac{(\Sigma y)^2}{n}}{n - 1}}}{\bar{y}}(100)$$

In our example the CV becomes:[2]

$$CV = \frac{1.602}{4.167}(100) = 38.4\%$$

Standard Error of the Mean in Percent

The standard error of the mean in percent ($SE_{\bar{y}}\%$) is known as the sampling error and is also expressed as a percent of the mean. It can be calculated by:

$$SE_{\bar{y}}\% = \frac{SE_{\bar{y}}}{\bar{y}}(100) = \frac{CV}{\sqrt{n}}$$

In our example the $SE_{\bar{y}}\%$ becomes:

$$SE_{\bar{y}}\% = \frac{0.6540}{4.167}(100) = 15.69\%$$

or

$$SE_{\bar{y}}\% = \frac{38.4\%}{\sqrt{6}} = 15.68\%$$

Interpreting the Standard Deviation and Standard Error

At this point the novice statistician may ask: "What does this mean? What is it good for? Why calculate it?" Well, the standard deviation tells us how uniform the population is. In our example the mean 4.167 and the SD is 1.602 or 38.4

[2] *It is understood that CV is expressed as a % of the mean.*

percent. This tells us that on the average about 68 percent (this probability is explained in the next section) of the *individual observations* fall somewhere between 4.167 ± 1.602 (between 2.565 and 5.769). Compare this with a more uniform population with the same mean of 4.167 but with an SD of 0.150. In this population we can expect about 68 percent of the observations to fall somewhere between 4.017 and 4.317. Thus even though the means of these two populations are the same, the population makeup is entirely different.

Of equal or perhaps more importance is the standard error of the mean. Once more using our example we have a mean of 4.167 with a standard error of 0.654 usually written as 4.167 ± 0.654. This tells us that 68 percent of all possible sample means will be between 3.513 and 4.821. After all, the true population mean is really what we are after and the best estimate of it is the sample mean. In our other example where the SD was 0.150, the $SE_{\bar{y}}$ (still assuming a sample size of 6) would be 0.061. This tells us that 68 percent of the *sample means* are somewhere between 4.106 and 4.228.

Both the standard deviation and standard error of the mean are frequently expressed as a percent of the mean (CV and $SE_{\bar{y}}$%) so that they can be combined or compared with similar terms but in different units. Suppose we have a stand of timber with a sample mean height of 120 ft and a standard deviation of 12 ft. The mean stem diameter is 30 in. with a standard deviation of 12 in. Which dimension is more variable? The diameter is more variable with a CV of 40 percent as compared to a CV of only 10 percent for height.

Confidence Intervals and *t* Values

The mean, plus and minus the SE, is known as the confidence interval. A more complete equation for the confidence interval (CI) is:

$$CI = \bar{y} \pm t \ (SE_{\bar{y}})$$

where *t* is the number of standard deviations. You may have wondered where the 68 percent probability came from. If we draw a normal curve (Figures 19.4 and 19.5) where the vertical axis is the frequency of our observations and the horizontal axis shows the values of the observations, it turns out that approximately 68.3 percent of the area under the curve is between the mean and plus and minus *one* standard deviation (*t* = 1). Similarly, approximately 95.4 percent of the area is between the mean and plus and minus two standard deviations (*t* = 2), and approximately 99.7 percent is between the mean and plus and minus three standard deviations (*t* =3). If we had a *t* table[1] we could come up with any percent of the area we wish, but these probabilities and corresponding *t* values are enough for this elementary discussion.

[1] *Technically, t tables are used with samples and z tables are used with populations. When the sample size approaches 30 or more the t and z tables show values approximately the same. For more information see any standard statistical text.*

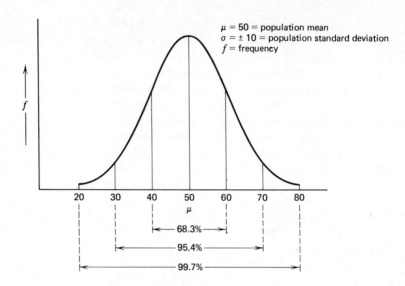

Figure 19.4. The normal frequency distribution showing the mean (μ) and the area under the normal curve for \pm one, two, and three standard deviations.

Please observe that Figures 19.4 and 19.5 are in terms of the *population* mean (μ) and the population standard deviation (σ) while our discussion at this point is in terms of the *sample* mean and sample standard deviation. This is perfectly legitimate because the normal frequency distribution theory applies to both populations and samples and their standard deviations. It also applies to sample standard errors.

A further fact of great importance is that many populations are not normal. It is important to realize that this does not invalidate the normal probability theory because of the central limit theorem, which states: "As the size of the sample increases, the distribution of the means of all possible samples of the same size drawn from the same population becomes more and more like a normal distribution" (Li, 1957). A sample size of about 30 is generally sufficient. The importance of this theorem is that we can use normal frequency distribution theory on nonnormal populations, provided the sample size is adequate.

Getting back to a previous example where the mean and standard error of the mean was 4.167 ± 0.654 we could further state that we are 95.4 percent confident that the true mean is somewhere between $4.167 \pm (2)(0.654)$ or between 2.859 and 5.475. Similarly, we could state that we are 99.7 percent confident that the true mean is somewhere between $4.167 \pm (3)(0.654)$ or between 2.205 and 6.129. It should be noted that the greater our sample size (more observations) the narrower our

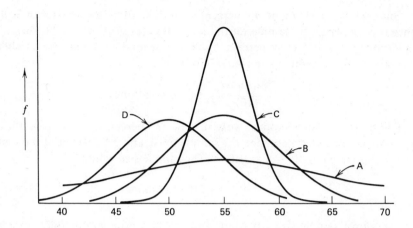

Figure 19.5. Four different normal frequency distributions. Distributions A, B, and C have the same mean (55), while D has a mean of 50. Distribution C has the smallest SD, while distribution A has the largest with distributions B and D with intermediate but equal SDs.

confidence interval. This statement is true and can be verified by the standard error equations:

$$SE_{\bar{y}} = \frac{SD}{\sqrt{n}} \quad \text{or} \quad SE_{\bar{y}}\% = \frac{CV}{\sqrt{n}}$$

SAMPLE SIZE EQUATIONS

We can calculate the sample size necessary to obtain a given sampling error by solving either of the standard error equations for n. We get:

$$n = \frac{(SD)^2}{(SE_{\bar{y}})^2} \quad \text{or} \quad n = \frac{(CV)^2}{(SE\bar{y}\%)^2}$$

To make this sample size equation complete, let's add a t^2 so that we can have other than 68 percent confidence. Let's also change the symbology of SE_y % to DSE% (the desired sampling error). It is no longer a value for which we wish to solve. Instead, it is the sampling error we wish to achieve. If we wish a low sampling error we must pay for it by increasing the sampling size (n). The sample size equation for infinite populations becomes:

$$n = \frac{(SD)^2 t^2}{(DSE)^2} \quad \text{or} \quad n = \frac{(CV)^2 t^2}{(DSE_{\%})^2}$$

Suppose we wish to be 95 percent confident that the true mean will be somewhere between the sample mean and ± 10 percent of the sample mean in a population with a CV of 40 percent. Using the second equation, the number of observations in our sample size would have to be:

$$n = \frac{(40)^2(2)^2}{(10)^2} = 64 \text{ observations}$$

One more example. Suppose we wish to be 99.7 percent confident that the true mean will be somewhere between the sample mean and ± 5 percent of the sample mean in the same population as before. The sample size would be:

$$n = \frac{(40)^2(3)^2}{(5)^2} = 576 \text{ observations}$$

The above sample size equation is for infinite populations only. In actual practice we use this equation where the sample size is small compared to the population size. One "rule of thumb" is to use the infinite population equation when we are sampling less than 5 percent of the population. Of course all populations become infinite when sampling with replacement, that is, we can select the same observation more than once.

The sample size equation for finite populations is:

$$n = \frac{N(CV)^2t^2}{N(DSE_\%)^2 + (CV)^2t^2} \quad \text{or} \quad n = \frac{N(SD)^2t^2}{N(DSE)^2 + (SD)^2t^2}$$

where $N =$ the total possible number of observations (population size). Suppose in our last example that the entire population was composed of only 1000 elements. Using the finite population sample size equation we would need to take only:

$$n = \frac{1000 \ (40)^2(3)^2}{1000 \ (5)^2 + (40)^2(3)^2} = 365 \text{ observations}$$

as compared to 576 observations using the infinite sample size equation. Thus, it pays to use the finite population sample size equation where applicable.

Taking the required number of observations assures us with a known degree of confidence, that the true mean is somewhere within the limits of the sample mean \pm the standard error of the sample mean *only if all observations are made without error. In no way can we compensate for systematic measurement errors by increasing the sample size.*

The desired sampling error and confidence level (t value) is set by the sampler. It depends on how important it is that the sample mean is close to the true mean and how much the sampler is willing to spend to get a reliable estimate. The true mean is never known unless all observations are measured. The coefficient of variation or standard deviation must be estimated in advance (based on past experience) or

estimated from a small presample prior to calculating n.

Equations for the mean, standard error of the mean, and desired sample size for stratified sampling designs can be found in Appendix B.

DOUBLE SAMPLING WITH REGRESSION

The term double sampling comes from the fact that *some* of the elements selected for the sample are measured twice. The larger sample is usually obtained at less cost per unit — as from an aerial photograph — but it is not as accurate as the smaller, or subsample, which is more costly — like ground or field measurements. Thus, we combine the accuracy of the field measurements with the economy of the photo measurements. Using a regression relationship we can remove the bias from all the photo measurements. The actual calculation of a regression equation, standard deviation, and standard errors about the regression line, and sample size equations can be found in Appendix B. In this chapter we will discuss the use of the regression relationship once it has been established.

Let's continue with an example. Suppose a recreation specialist wished to know the number of people visiting a particular ski resort at various specified times and that it is cheaper to take aerial photos of the area then it is to hire a crew to keep track of the number of people entering and departing the resort area. A guest register might be one way of doing this, but some people do not voluntarily sign in —let alone sign out — and frequently one individual may sign once for an entire family.

Our recreation specialist decided that one approach would be to establish a relationship between the number of vehicles (cars, buses, motorcycles, etc.) in all the parking lots about the resort and the number of people using the resort area at any given point in time. For several days the recreation specialist hired a crew to actually count the vehicles and their occupants as they entered and departed the parking lots. These entries and departures were also recorded as to time of day. With this information the recreation specialist computed a simple linear regression equation (see Appendix B), which is plotted in Figure 19.6 along with the original data points. The data points are matched pairs of the total number of vehicles in the parking lots and the total number of people in the area for different points in time.

The equation for any straight line is $\bar{y}_x = a + bx$,

Where

\bar{y}_x = the mean of y for a given value of x; y is the dependent variable (always on the vertical axis) or the one we want to predict (people in our example)

x = the independent variable (vehicles in our example)

a = the intercept or the value of y where x is zero

b = the slope of the line or rise over run

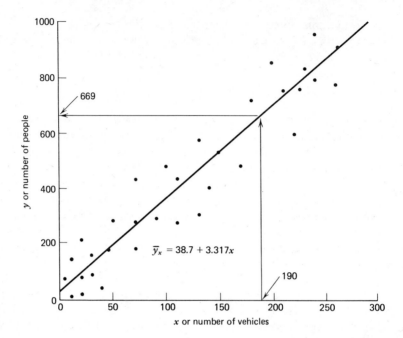

Figure 19.6. Simple linear relationship (regression) of the number of people in the ski resort area and the number of vehicles in the parking lots. The number of people present at any given time can be estimated by counting the vehicles and using the graph or the equation. (From D. P. Paine, 1979, *An Introduction to Aerial Photography for Natural Resource Management,* O.S.U. Bookstores, Inc., copyright 1973, reproduced with permission.)

Once this regression relationship is established one can count all the vehicles in the parking lot on an aerial photograph of the area and use either the regression equation or the graph to predict the number of people in the area at the time the photo was taken. Automatic car counters might be another way to determine the number of cars in the lots, provided the entrances and exits were one way. However, most automatic counters probably would not work too well under the usual snow and ice conditions present. Even where automatic car counts are possible, we would still need the regression relationship.

In our example, suppose we have just completed a vehicle count for a single point in time (an aerial photo is excellent for this). Suppose the vehicle count is 190 and the regression equation is $y = 38.7 + 3.317x$. The estimated number of people in the resort area at the time is:

$$y = 38.7 + 3.317 (190) = 669 \text{ people}$$

Similarly, from our graph (Figure 19.6) we find 190 on the horizontal (x) axis, go vertically until we intersect the regression line and then horizontally until we intersect the vertical (y) axis and read 665 to 670 people.

This basic relationship could be used at other ski resort areas if we are willing to assume the same relationship of people to vehicles. This assumption should be checked, because the relationship between people and vehicles may change with the distance of the resort area from the major population centers. There may be more people per vehicle where distances are greater in an effort to save on transportation costs.

As mentioned in other chapters, double sampling with regression techniques has many applications when using aerial photography to inventory natural resources. A complete discussion with an example of the use of this technique is presented in Chapters Twenty and Twenty-one in conjunction with an aerial photo timber cruise.

Questions and Problems

1. List five possible reasons for sampling as compared to a complete census.
2. Under what circumstances might a sample yield more accurate information than a complete census?
3. For each of the statistical terms listed under objective 3 at the beginning of this chapter, write a sentence or short paragraph to completely define each term.
4. What does the standard error of the mean measure?
5. The following numbers were obtained from a random sample of 100 acres of timber. They represent hundreds of cubic feet per one-fifth acre plot.

12	15	11
9	7	18
14	13	10

 (a) Calculate the sample mean volume in cubic feet per acre and in cubic meters per hectare.
 (b) Calculate the standard deviation in cubic feet and cubic meters among one-fifth acre plots, the coefficient of variation, and the standard error of the mean in cubic feet and cubic meters among plots and as a percent of the mean.
 (c) How many observations (plots) would it take so that you are 95.4 percent confident that the true mean is somewhere between the sample mean and ± 10 percent of the sample mean if you use (1) the infinite population sample size equation and (2) the finite population sample size equation?

Twenty

Aerial Photo Mensuration

Webster's dictionary defines mensuration *as the "act, process, or art of measuring. . . the branch of applied geometry concerned with finding the lengths, areas, and volumes from certain simple date." Bruce and Schumacher (1950) defined forest mensuration as "the determination of diameters, heights, or volumes either of standing timber or products cut therefrom. . . and the determination or prediction of rates of growth." Aerial photo mensuration is the use of aerial photography to measure tree and stand heights, diameters, volumes, site indices and growth rates.*

Aerial photo mensuration requires a highly skilled photo interpreter who is also trained in conventional on-the-ground mensurational techniques including sampling theory with emphasis on double sampling with regression. Because many tree or stand characteristics cannot be directly measured on photographs they must be measured indirectly, which makes it necessary to combine photo measurements with a small subsample of field measurements. The same general techniques described in this chapter and in Chapter Twenty-one can be adapted to inventory or measure other natural resources.

Objectives

After a thorough understanding of this chapter and completion of the laboratory exercise you will be able to:

1. State the difference between direct and indirect measurements on aerial photographs and give three examples of each.
2. List the three types of aerial photo volume tables discussed and give the usual dependent and independent variables associated with each type.
3. List four reasons why aerial photo timber cruising is not used more often by practicing field foresters in the United States and state how each of these deterrents can be overcome.
4. Define fixed (versus nonfixed) air-base photography and list three reasons

why it is possible to make very accurate height measurements from fixed air-base photography.

5. State how the Forest Management Institute of the Canadian Forestry Service was able to obtain accurate scale and flying height measurements on nonfixed air-base photography.

Aerial photo mensurational data may be conveniently organized into two categories: data obtained through (1) direct and (2) indirect measurements on aerial photographs. Direct measurements are taken directly from the photograph and the only errors to be considered are sampling errors and errors associated with precision and accuracy of the measurements. Indirect measurements are obtained through regression and correlation procedures and include additional variation resulting from imperfect correlations in addition to those errors stated above.

DIRECT MEASUREMENTS

Some of the data obtainable through direct measurement includes:

1. Total tree or stand height (TH).
2. Visible crown diameter (VCD).
3. Degree of stocking.
 (a) Individual crown count.
 (b) Percent crown cover.
4. Length and diameter of logs floating on ponds.

Total Height

The determination of total height of an individual tree, or the mean height of a stand of trees, is one of the most important operations in the measurement of standing timber. It is also one of the most difficult measurements for the average photo interpreter.

Three basic methods of obtaining height measurements from aerial photographs are (1) measurement of displacement on single photographs, (2) measurement of shadow length, and (3) measurement of parallax differences on stereoscopic pairs of photographs. Because neither of the first two methods are practical when applied to forest stands and because the latter method is difficult to master, foresters in the United States make less use of aerial photography in timber cruising than they should. To help eliminate this problem Paine and Rogers (1974) developed a set of aerial photo volume tables that requires only a reasonable stereoscopic estimate of stand heights into two or three broad height classes. These tables will be more fully explained later.

Hints for Estimating Height

Whether measuring stand or tree heights or just categorizing them into broad height classes based on measurement or ocular estimation, one of the chief difficul-

ties is that of finding the ground in a dense forest. First, the photo interpreter must find a hole in the canopy and then decide whether the surface seen at the bottom is really the ground or a brush patch with a significant height.

Height measurements should be made as close as possible to the tree or plot of concern. However, there will be frequent occasions when you can not see the ground at or near the plot. Thus, you must resort to trade-offs and do the best you can. Following are a few techniques that have been found to be useful. They all involve risk, but there is no alternative.

One approach is to make height measurements or estimates elsewhere in the same stand or in stands that appear to be similar. Sometimes it is possible to see the ground on opposite sides of the plot and, by interpolation, estimate where the ground level at the plot would be. Another technique is to trace the contour around from the plot to an opening where you can see the ground.

If the only usable canopy openings appear to be occupied with lower vegetation, you may have to estimate stand height above this surface, then add a measured or estimated height for the vegetation. Perhaps you can measure similar appearing vegetation nearby.

Photo measurements of individual trees or stands usually average less than the actual heights. One reason is that the ground is often covered with brush or other vegetation, which results in a loss of several feet of tree height, but the main reason is that you seldom see the actual treetop because of the lack of resolution. What appears to be the top may be as much as 5 to 15 ft below the actual top, depending on the shape of the tree crown and the type and scale of photography. There is little or no height loss on broad-crowned hardwoods or flat-topped mature conifers, but there is considerable loss on narrow-crowned young conifers. The larger the scale and the better the quality of photography, the smaller will be this loss.

Accuracy of Height Measurements

Because several types of height measurement errors are systematic (consistently high or low) corrections can be made. Studies have shown that the pattern of height measurement errors tend to vary with individual interpreters. Thus, as you begin to make stand height measurements in your own area on the kind of photos normally used, you should do some field checking. Height measurement errors usually fall into some kind of pattern. If you keep a record of this, adjustment factors can be developed for future use in those situations where you want the stand-height estimates to be as close as possible to the true height. One method of making corrections to tree height measurements is through the use of regression analysis to establish an equation for field measured height as a function of photo measured height.

MacLean and Pope (1961) found that errors in photo height measurements were not consistent for different tree heights. Based on five experienced interpreters each measuring 366 different stand heights, it was found that in each case the shorter stands were underestimated and the taller stands were overestimated. All interpreters had highly significant correlations between ground and photo measured height,

but some interpreters had linear and other interpreters had nonlinear relationships. Therefore, it is necessary for each interpreter to establish his or her own regression correction equation for each type and scale of photography used.

Tilt can cause height estimates to be either high or low but over a large number of photo pairs these errors will tend to compensate. However, on a given pair of photos the errors tend to be all positive or all negative. Such errors can be substantial, up to 10 or 20 percent.

Under ideal conditions an experienced interpreter with good depth perception can measure tree heights to within 5 to 10 ft of the true height on 1:10,000- to 1:20,000-scale photographs.

Visible Crown Diameter

Visible crown diameter (VCD) is the only individual tree characteristic, other than total height (TH), that can be directly measured on aerial photos. Visible crown diameter includes that portion of the tree crown that is visible on the aerial photo, which eliminates occasional long branches that extend past the general area occupied by the crown and not resolved on the aerial photo. For many species, crown diameter is related to stem diameter at breast height (dbh), especially when used in conjunction with total height. It is therefore a useful photo variable when attempting to estimate tree dbh, individual tree volume, or stand-size class.

Although VCD is usually included as a variable in individual tree volume tables, it is only occasionally used for stand photo-volume tables.[1] Most studies have shown that stand height and crown closure are the best variables for estimating stand volume, and the addition of average VCD does not improve the estimates significantly. The evidence indicates that VCD is more likely to be useful for hardwoods than for conifers and is more closely related to board-foot volume than it is to cubic-foot volume.

Measuring Visible Crown Diameter

Basically, measuring crown diameter on aerial photos is the same as making other distance measurements. You simply measure the diameter of the crown image and convert it to actual crown diameter using the photo scale. However, the small size of the image, and some problems caused by shadows and relief displacement, necessitate some departures from standard distance-measurement procedures.

Several types of measuring devices have been developed to help measure crown diameters (Figure 20.1). One type consists of a series of parallel lines with each line just a little longer to form a wedgelike appearance. Another type of wedge consists of a pair of lines meeting at an acute angle. The distance between these lines can be read from a scale alongside one of the lines. In use, the transparent wedge is placed on the photo and moved so that the crown image just fits between the two lines and the crown diameter at the photo scale read from the wedge.

[1] *Tree photo volume tables give volume per tree and stand photo volume tables give volume per acre.*

BAR TYPE MICROMETER WEDGE
INTERMOUNTAIN FOREST & RANGE EXPERIMENT STATION

NUMBERS INDICATE LENGTH OF LINES IN 0.0001 FEET

MICROMETER WEDGE

Number indicate distance between lines in 0.0001 feet

CROWN DIAMETER SCALE
CENTRAL STATES FOREST EXPERIMENT STATION

NUMBERS INDICATE DOT SIZE IN THOUSANDTHS OF AN INCH

Figure 20.1. Three types of micrometer wedges for measuring small distances or tree crown diameters on aerial photos. (Courtesy U.S. Forest Service.)

Another measuring device consists of a series of dots of graduated size. These dots are laid over the crown to be measured, the dot is selected that most nearly matches the crown diameter.

Crown diameters should be measured while using the stereoscope. Following are some hints on how to make VCD measurements. Whenever possible, measure on the photo where the crown image falls closest to the photo center. There is less displacement here. If the crown is approximately round, you can measure in any direction where you can see opposite sides. Normally you will have to avoid measuring parallel to the shadow because you can not see the crown edge on the shadow side.

If the crown to be measured is not near the photo center, it will be elongated due to relief displacement. In these situations, the crown diameter must be measured perpendicular to a radial line from the photo center to the tree top. If the tree crown is irregular, measure both the long and short axis and average the readings.

Accuracy of Crown Diameter Measurements

Unlike total height, field measurements do not constitute a satisfactory check against photo estimates of crown diameter. By using plumb bobs or vertical sighting devices, you can project the crown edge to the ground and measure across it. The trouble is that on the ground you do not know what part of the crown the interpreter sees. From beneath a tree the crown is extremely difficult to define. Branch tips project to various distances and often interlace with those of other trees. This is why we call it visible crown diameter.

Thus, we can not determine the accuracy of crown diameter measurements by comparing them with ground measured values. We can only determine the consistency with which given crowns are measured by different interpreters, or by the same interpreter on different occasions. Studies indicate that such differences in crown diameter measurements run no more than 3 to 4 ft, two times out of three, on 1:12,000-scale photos (Moessner and Jensen, 1951; Nyyssonen, 1957). Hence, most volume tables making use of crown diameter use 3- to 5-ft diameter classes.

Degree of Stocking

The degree or percent stocking of a stand is vital in determining stand volumes. It also has an influence on dbh and therefore volume of individual trees. It is not always used in conjunction with individual tree photo volume tables where VCD and dbh are strongly correlated. The degree of stocking can be measured on aerial photographs by estimating the percent crown cover or by counting the number of trees per acre.

Percent Crown Cover

Percent crown cover is defined as the percent of the ground area covered by a vertical projection of the tree crowns. This definition is incomplete, however, since it does not tell which crowns are to be included in the estimate. This has been a common fault in the application of crown closure estimates in photo mensurational work. The definition should be based on the use which is to be made of the information. If the objective is to determine stocking, then probably all visible tree crowns should be included. However, when the purpose is volume estimation, a better approach is to include only those trees that contribute substantially to the stand volume. One solution is to limit the crown closure estimate to the major canopy. This is a subjective definition that leaves it up to the interpreter to decide what constitutes the major canopy and reject trees not in the major canopy.

The determination of crown closure is considerably more subjective than the measurement of stand height or crown diameter. It is not really subject to measurement, and depends strongly on the interpreter's judgment. For this reason, it is not unusual to find occasional wide differences between interpreters, or even between repeat observations made by the same interpreter at different times.

The size or spread of the crown closure classes recognized on photos generally varies with the purpose for which the information is desired. For the evaluation of

stocking conditions, broad classes having a spread of about 30 percent are often used. However, when the objective is volume determination, crown closure is usually estimated in 5- to 10-percent classes.

There are two common methods for estimating crown closure: visual guides and ocular estimation. A third method, dot counting, has occasionally been used. When making crown closure estimates on plots, the beginning interpreter will probably rely to some extent on visual guides (templets and stereograms).

A variety of visual density guides has been developed in an effort to remove some of the subjectivity from density estimates. These guides are usually diagrammatic drawings of circular or square plots with various percentages of crown density represented by black dots for trees. Some guides come in several sizes so the interpreter can select the one closest to the size of the tree crowns on the photo (Figure 20.2).

Because the concept of crown density is relatively simple, it is possible to make satisfactory estimates by ocular methods without referring to any guides or measurement aids. However, in order to minimize the variation in these estimates, it is desirable to follow some sort of orderly mental process.

One of the simplest ways to systematize the ocular estimates is by successive division. The interpreter asks a series of questions. For example, is it more or less than 50 percent? If more, is it more or less than 75 percent? If less than 75, is it closer to 55 percent or 65 percent? By successive division, he thus narrows the choice down to the final figure.

Another technique called tree cramming (Pope, MacLean, and Bernstein, 1961) involves the mental gymnastics of moving trees around on the plot. It works best when the trees are clumped or irregularly distributed. First, the plot is mentally divided into sections, usually quarters, oriented according to the way the trees are grouped. Then trees are ocularly moved from scattered portions to fill gaps in the denser sections. When all trees are visually crammed together, the crown density is estimated. This is now easier to do than when the trees were scattered over the plot. The procedure can probably be best understood by following the examples in Figure 20.3.

As with crown diameter, it is virtually impossible to field check crown closure estimates. The person in the field can not really tell what portions of the crowns or what openings are visible to the interpreter. When comparing crown closure estimates between experienced interpreters, two out of three estimates should be within 10 percent of each other.

Tree Counts

Individual crown counts, along with average visible crown diameters, are used as a measure of density when using or developing individual tree photo volume tables. The number of trees alone, without regard to size, may have little or no correlation with true stand density. However, just as stand-density index (Reineke, 1933) takes into account both number of stems and average dbh, similar density

Figure 20.2. A variety of percent tree crown density scales for use on different scales of photography or for different size tree crowns. (Courtesy U.S. Forest Service, Intermountain Forest and Range Experiment Station.)

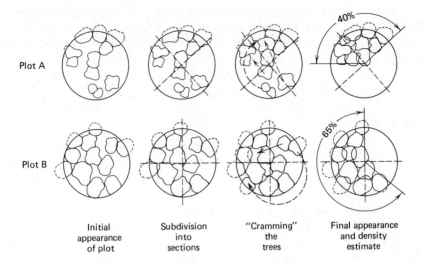

Plot A

Plot B

| Initial appearance of plot | Subdivision into sections | "Cramming" the trees | Final appearance and density estimate |

Figure 20.3. Procedure for the *tree cramming* method of estimating percent crown closure. (Courtesy U.S. Forest Service, Pacific Northwest Forest and Range Experiment Station.)

indexes could be developed using crown size and the number of stems, but so far this has not been done.

Tree counts can be made with considerable accuracy in open stands of intolerant species. On the other hand, in dense stands many trees are not visible because they are overtopped by other trees. Two factors contributing most to the accuracy of crown counts are photo scale and stand density. Young (1953) studied this relationship using one-quarter-acre plots of mixed pine and hemlock stands in Maine using black-and-white infrared photography. A total of five photo scales was studied ranging from 1:3,500 to 1:15,840. An analysis indicated that, even with a relatively large scale of 1:4,000 and a low density of 20 trees per acre, only 80 percent of the trees down to a minimum of a 4-in. dbh could be counted. Only 38 percent were visible on the smaller-scale photographs with a density of 400 trees per acre.

One explanation for these poor results is that infrared film was used, which is very poor for interpreting detail in shadows. It also is quite possible that several of the tolerant hemlock were cloaked by larger trees, especially when the ground count included 4-in. dbh trees.

Because most of the trees not counted are in the lower diameter classes, they contribute only a small portion of the total volume. Paine (1958) counted crowns on 1:9,600 panchromatic photographs of mature ponderosa pine. His count was 19.3 percent low, but because uncounted trees were much smaller than the average tree, only 2.3 percent of the total board-foot volume was unaccounted for.

Under optimum conditions, reasonably accurate counts can be made. Crown

counts were made of second-growth Douglas-fir on 1:12,000-scale photographs by Dilworth (1956) in the Pacific Northwest. The average difference between the visible count from the photos and dominant and codominant trees on field plots was +1.0, with a standard deviation of 2.02 trees. The photo count was higher because some trees too small to be classified on the ground as dominant or codominant were visible on the photos and therefore counted.

Scaling Log Rafts on Water

Individual log lengths and diameters can be measured directly on high-quality, large-scale aerial photographs like those shown in Figure 20.4. At a 1:3800 scale, log lengths can be accurately measured, but accurate measurement of diameters becomes more difficult. However, satisfactory results can be obtained when using positive transparencies and a magnifying stereoscope on a light table. Correction factors must be developed for diameter measurements because the full log diameter is below the surface of the water.

Individual log and log raft volumes (both gross and net) can be *indirectly* estimated using double sampling with regression, a technique more fully explained in the next section. Table 20.1 shows individual log dimensions and volumes for raft A (Figure 20.4) and the total volumes for rafts A, B, and C as measured on the pond. With this information and double sampling an estimate of the total volume on the pond can be obtained.

INDIRECT MEASUREMENTS

Many of the most important tree or stand characteristics cannot be measured directly on aerial photographs, thus, they must be estimated through statistical techniques using tree or stand characteristics that can be measured directly. Some of the indirect measurements that have been attempted from aerial photographs include:

1. Stem diameter at breast height.
2. Form class.
3. Site index.
4. Growth.
5. Age.
6. Stand structure.
7. Volume.
 (a) Of individual trees.
 (b) Of stands (volume per acre).
8. Basal area per acre.

Only stem diameter, volume, basal area, and site index are discussed here. The actual process of making tables to estimate these values from photo measurements is beyond the scope of this book.

TABLE 20.1 Individual Log Dimensions and Volumes for Log Raft A and Total Volumes for Log Rafts A, B, and C for Figure 20.4.

Length (ft)	Diameter (in.)	Volume in Board Feet	
		Gross	Net
42	35	2490	2250
42	42	3700	2010
42	25	1310	1310
42	22	960	960
28	45	2660	Cull
42	37	2820	1820
42	47	4540	4340
42	38	2970	2820
42	47	4540	2960
36	44	3320	2090
42	30	1820	1090
42	33	2170	1730
42	45	4160	3700
42	28	1620	710
42	32	2010	2010
18	40	1350	650
18	35	980	880
40	33	1960	1960
	Totals for Raft A =	44,640	33,290
	Raft B =	53,320	40,570
	Raft C =	36,990	33,180

Estimating DBH

One of the timber characteristics the forest manager often desires to know is tree diameter. This gives the manager an idea of the quality and type of product he or she can expect and indirectly is a clue to stand age.

Crown diameter is the photo measurement most closely associated with tree dbh. It can be used alone to predict tree diameter. For instance, data collected in the Pacific Northwest indicate that a rough rule of thumb for mature Douglas-fir is that tree diameter in inches equals 1½ times crown diameter in feet. For example, a 24-ft crown diameter would indicate a 36-in. dbh tree. The addition of total height as a second independent variable generally improves the estimate. Crown diameter and height measurements on individual trees can be used to predict *tree dbh*. Average height and average crown diameter for a stand can be used to predict average *stand dbh*. These relationships are also useful to the forester when preparing timber-type maps (Chapter Seventeen). The stand-size portion of the timber

Figure 20.4. Large-scale photo of logs on a log pond. Logs can be scaled (gross volumes only) on photography at this (PSR = 3800) or larger scales. Double sampling with regression could be used to improve the accuracy and to estimate net as well as gross volumes.

type symbol is based on dbh, a characteristic that can not be measured directly on aerial photos. Table 20.2 illustrates this relationship for ponderosa pine in the Pacific Northwest.

Estimating Timber Volumes

There are two general approaches to the development and use of aerial photo volume tables, the individual *tree* approach and the stand *approach*. The tree photo volume tables give volume per tree, whereas the stand photo volume tables give volume per acre or per hectare.

TABLE 20.2 Aerial Photo Diameter Breast Height Table For Even-Aged Ponderosa Pine

Total Height in Feet

VCD	18	24	30	36	42	48	54	60	66	72	78	84	90	96	102	108	114	120	126	132
4	4	5	5	6	6	6	7	7	7	8	8	8	9	9	9	10				
6	5	5	6	6	7	7	8	8	8	9	9	9	10	10	11	11				
8	5	6	6	7	8	8	9	9	10	10	11	11	12	12	13	13	14	14		
10	6	6	7	8	9	9	10	11	11	12	12	13	14	14	15	16	16	17	17	18
12	6	7	8	9	9	10	11	12	13	13	14	15	15	16	17	17	18	18	19	19
14	7	8	9	9	10	11	12	13	14	15	15	16	17	18	18	19	20	20	21	21
16			9	10	11	12	13	14	15	16	17	18	18	19	20	20	21	22	22	23
18				11	12	13	14	15	16	17	18	19	20	20	21	22	23	23	24	25
20							15	16	17	18	19	20	21	22	23	23	24	25	25	26
22									18	19	20	21	22	23	24	25	25	26	27	28
24									19	20	21	22	23	24	25	26	27	27	28	29
26									20	21	22	23	24	25	26	27	28	29	29	30
28									21	22	23	24	25	26	27	28	29	30	31	32
30															28	29	30	31	32	33
32																		32	33	34

From Paine (1965).

Based on 510 sample trees on sites III, IV and V.

Basic equation: $DBH = 3.76 + 0.01348\,(TH \bullet VCD) - 2.4459 + 10^{-6}\,(TH \bullet VCD)^2$

$$+ 2.4382 \times 10^{-10}\,(TH \bullet VCD)^3$$

$R = 0.973$ $SD = 1.44$ in. $= 11.3\%$

Tree Photo Volume Tables

A common method of developing *tree* photo volume tables is to indirectly estimate dbh by regression techniques and then use dbh and height to make photo volume tables from standard volume tables. This procedure is not statistically sound because dbh is first used as a dependent and then as an independent variable to predict volume. A better method is to estimate volume directly using photo-measurable variables.

The chief drawback to the tree volume approach is the difficulty of obtaining accurate crown counts. This method is practical on large-scale photographs and/or in the assessment of volume of scattered or open-grown trees of moderate to large size. However, Dilworth (1956) used the tree approach with success on 1:10,000-scale photographs of second-growth, even-aged stands of Douglas-fir that are anything but open grown.

Approximate photo volume estimates may be based on a single variable. Tree photo volume tables have been based on total height (TH) alone (Spurr, 1960) or VCD alone (Avery, 1958). However, the majority of the authors have used a minimum of two independent variables.

Zieger (1928) in Germany is credited with producing the first tree photo volume table. It was based on VCD and total height. Spurr (1952) published the first tree photo volume table in the United States. He developed it for white pine in 1946 using total height and VCD as independent variables.

The tree volume approach was used by Dilworth (1956) working with second-growth Douglas-fir in Oregon. His significant variables were TH, VCD, and their interaction. He also found that geographical location has only a limited effect on the VCD-height relationship; but VCD increased for a given dbh as site index decreased. Paine (1958, 1965) produced tree photo volume tables for even-aged and all-aged ponderosa pine stands in Eastern Oregon and Washington. Examples can be found in Appendix E.

Stand Aerial Photo Volume Tables

The *stand* photo volume approach has been the most popular method of photo cruising. This is primarily because percent crown cover can be substituted for crown counts that are sometimes quite inaccurate and difficult to obtain.

The first aerial photo volume tables were of this type. They were developed by students of Professor Hugershoff in Germany between 1925 and 1933 and were based on only one variable, either total stand height or stand density.

Most stand photo volume tables use both \overline{TH} and percent crown cover (%CC). A few authors have added mean visible crown diameter (\overline{VCD}) as a third independent variable. The addition of this variable does not, however, always produce more accurate tables. Nyyssonen (1957) concluded that the addition of \overline{VCD} was of little importance if percent crown closure is used. Gingrich and Meyer (1955) found that for upland oak, none of the regression coefficients that contained VCD was significant.

Pope (1950, 1962) was the first to produce stand photo volume tables for Douglas-fir in the Pacific Northwest. His 1950 tables used \overline{TH}, %CC, and \overline{VCD}, but his 1962 tables used only \overline{TH} and %CC. His 1962 tables used various combinations of these two variables, their squares and interactions.

A few years later Paine and Rogers (1974) once again utilized the same data Pope used. They found \overline{VCD} to be significant when used as a triple interaction term along with \overline{TH} and %CC. They produced a whole set of these tables for board- and cubic-foot volumes and called them "Three Variable Stand Photo Volume Tables" (Tables 21.1, 21.2, and 21.3).

Estimating Site Index

Site index is a measure of the ability of a piece of land to produce forest trees. It is the result of the effects of the biotic, climatic, and edaphic (soils) conditions of a particular site and is measured by foresters as the average height of a stand at a stated age. Total average height of a stand can be measured directly on aerial photographs, but age cannot. Therefore, site index must be measured indirectly on aerial photographs. The problem has not been completely solved but a limited

amount of research indicates moderate success in the prediction of site index from aerial photographs.

Most research has been limited to classifying site by topography, soils, geologic formations, drainage conditions, and vegetation. However, when statistically analyzed, only about 30 percent of the variation in site index could be accounted for by these variables when interpreted or measured on aerial photographs.

Spurr (1960) stated that the ratio of tree height to crown diameter may provide a measure of site index. He developed a site-index table based on this relationship using data for Scotch pine in Germany. Spurr also hypothesized that a measure of stocking should be added to this relationship. Johnson (1962) tested Spurr's theory on unmanaged stands of longleaf pine and finally concluded that the theory did not hold for this particular species.

Paine (1965) had better luck with even-aged stands of ponderosa pine in the Pacific Northwest. He produced Table 20.3 based on 21 plots. His regression equation accounted for 78.5 percent of variation in site index and had a standard deviation of under 10 ft (at 100 years) on a plot (not individual tree) basis. He fully realized that insufficient data went into this analysis and it is included here only to indicate that further research along this line may be justified.

TABLE 20.3 Aerial Photo Site Index Table for Even-Aged Ponderosa Pine Stands[a]

%CC	2	3	4	5	6	7	8	9
				Site Index				
10	74	78	85	93	103	115		
20	68	72	79	87	97	109		
30	62	66	73	81	91	103	117	
40		60	67	75	85	97	111	
50		54	61	69	79	91	105	120
60		48	55	63	73	85	99	114
70				57	67	79	93	108
80				51	61	73	87	102

Column header span: **Ratio of TH/VCD**

[a] *From Paine (1965). Values outside solid lines are extrapolated.*

USING AERIAL PHOTO MENSURATIONAL TABLES

Despite the availability of aerial photo volume tables to foresters in the United States for over 30 years, only limited use has been made of them. Occasionally they are used by research personnel, but only rarely are they used by the practicing field forester. With rapidly rising labor costs, an analysis of the reasons for not taking

full advantage of proven aerial photo cruising techniques is long overdue. There are several reasons but the most obvious appear to be as follows:

1. Photo volume tables have relatively large standard deviations (30 to 70 percent or higher).
2. Most photo cruises (without double sampling) are biased.
3. Photo cruising with double sampling is not economically feasible for small areas such as timber sales.
4. Most practicing foresters find it difficult to measure stand or tree height on aerial photographs.
5. Most foresters have not been trained in this technique.

An understanding and application of a few statistical concepts (Chapter Nineteen) should largely eliminate the first two problems. The standard error of the mean (sampling error) not the standard deviation is a primary concern of a forester. The sampling error can be made as small as desired by increasing the sample size. This principle applies to both field and photo cruises but can become quite expensive where small sampling errors are required and only field plots are used. Additional photo plots, however, are relatively inexpensive. The U.S. Forest Service Survey estimates that the cost of a photo plot is only about 1 percent of the cost of a field plot, not counting the cost of photography, which is also required for field sampling.

The proper use of double sampling with regression can greatly reduce, or eliminate, the problem of bias. This technique requires field measurements of only 20 to 30 field-measured plots. These *matched* pairs of plot volumes are used to establish regression equations (for both gross and net volumes if desired), which are then used to remove the average bias of all the photomeasured plots.

Although photo cruising of small areas is technically feasible it is economically impractical. The 20 to 30 field-measured plots required to establish the regression equation are expensive because they must be exactly the same plots measured on the photos. Locating the exact plot centers in the field is so time consuming that it is usually less expensive to conduct a standard line-plot field cruise of 50 to 100 plots. With the present state-of-the-art there appears to be no economic solution to this problem. For a large inventory-type cruise, however, we still only need 20 to 30 field plots to establish the regression equation with perhaps several hundred additional photo-measured plots. Thus, photo cruising becomes economically feasible for cruising large areas.

Perhaps the greatest deterrent to widespread acceptance of photo cruising is the inability of the average practicing forester to photogrammetrically measure tree or stand height. Accurate height measurements based on parallax differences require considerable training, skill, and high-quality vertical aerial photographs with little tilt. Even when these requirements are met, photo height measurements are quite time consuming compared to photo measurements of crown diameter and percent crown closure.

With this in mind Paine and Rogers (1974) studied the effects of ocularly *estimating* stand heights into broad height classes while viewing stereoscopic models on 1:10,000-scale photography. They used the three variable stand photo volume tables for Douglas-fir as previously mentioned. When these photo volumes were corrected using ground-measured volumes and simple linear regression techniques, it was found that little or no precision was lost when using height classes as broad as 60 ft. The results of comparisons between different height class intervals, their midpoints and the number of height classes are shown in Table 20.4.

The correlations shown in Table 20.4 are high because actual and not photo-estimated heights were used to test the effect of using height classes. However, the data shown include the errors made by grouping stand heights into broad height class intervals as well as errors in estimating percent crown closure and measuring average visible crown diameter. These results were encouraging because of the high correlations and low standard deviations between photo- and field-measured plot volumes. Using this approach practically eliminates the problem of measuring heights, but it still requires reasonable judgment, skill, and experience on the part of the interpreter.

For this particular study, it was concluded that three height classes (tall, medium, and short) were sufficient. In other areas, however, a different number of

TABLE 20.4 Effect of Changing the Height Class Interval, Number of Height Classes, and their Midpoints[a]

Interval (ft)	Midpoints (ft)	Correlation Squared[b]	SD_R MBF	SD_R %
Effect of Height Class Interval				
40	100-140-180	.922	7.62	19.54
50	90-140-190	.929	7.29	18.69
60	80-140-200	.922	7.64	19.54
Effect of Height Class Midpoint				
60	60-120-180	.836	11.06	28.36
60	80-140-200	.922	7.64	19.54
60	100-160-220	.920	7.74	19.85
60	120-180-240	.920	7.73	19.82
Effect of Number of Classes				
40	90-130-170-210	.900	8.64	22.15
40	80-120-160-200	.840	8.77	22.54
40	100-140-180	.922	7.64	19.59
40	120-160	.779	12.87	33.00
60	100-160	.817	11.72	30.05

[a]*From Paine and Rogers (1974).*
[b]*Correlation squared between photo- and field-measured board-foot volumes.*

height classes might be optimum. This decision must be made by the individual interpreter after a reconnaissance either in the field or from the aerial photos.

Types of Aerial Photo Volume Tables—A Summary

The following outline is presented to summarize the important features of three types of aerial photo volume tables.

I. Tree aerial photo volume tables
 A. Variables used
 1. Dependent — volume per tree
 2. Independent (a) visible crown diameter (VCD)
 (b) total height (TH)
 B. Advantages
 1. Information on individual trees (bd ft, cu ft, dbh)
 2. More adaptable to all-aged stands, especially open-grown stands
 C. Disadvantages
 1. Very time consuming in use—difficult (each tree must be measured or tree counts must be made)
 2. Tree height difficult to measure on photos
II. Stand aerial photo volume tables
 A. Variables used
 1. Dependent—volume per acre
 2. Independent (a) percent crown closure (%CC)
 (b) average stand height (\overline{TH})
 B. Advantages
 1. Easier to use than tree photo volume tables
 2. Gives volume per acre directly
 C. Disadvantages
 1. No information on individual trees
 2. Tree (stand) height difficult to measure
III. Three variable stand photo volume tables
 A. Variables used
 1. Dependent—volume per acre
 2. Independent (a) percent crown closure (%CC)
 (b) average visible crown diameter (\overline{VCD})
 (c) stand height class—tall, medium, short
 B. Advantages
 1. Gives volume per acre directly
 2. Precise tree or stand height measurements are not necessary (stereoscopic estimates as to tall, medium, or short are satisfactory)
 3. Results are just as precise as the other types of tables

 C. Disadvantages
 1. No information about individual trees
 2. Requires more interpretation time than stand photo volume tables but faster than tree photo volume tables

Additional Considerations

While the principle of using photo volume tables is simple, there are a few points that need to be emphasized.

Before you use an aerial photo volume table, be sure you understand the definitions used in making the tables. Most tables are in terms of gross volume, although it could be net volume.[2] If the minimum tree diameters and merchantable limits of the table differ considerably from what you want, adjustments must be made. You will also want to try to include the same trees in your estimates of stand height, crown closure, or average crown diameter as was used in the construction of the table.

When using a tree photo volume table for trees of about the same size, estimate the average height and crown diameter, look up the volume of this average tree, and multiply by the number of trees to obtain stand volume. If the trees are of different sizes, sort them into homogeneous classes and determine the volumes separately for each class.

Another consideration is plot size and shape. Field plots are frequently small, one-fifth to one-quarter of an acre. Photo plots of this size may be too small unless you have large-scale photography. One-acre photo plots are more common, which makes field measurement of these plots expensive. Some photo mensurationists have used different-sized plots on the photos than in the field, converting them both to volumes per acre. You can get by with this only in uniform stands of timber. It is better to use the same-sized plot on both the photo and in the field for double sampling with regression.

When estimating the volume on an even-aged plot, you will have no problems with stand volume tables. Just base your estimates of stand characteristics on the same definitions as stated for the volume tables in use. However, you will come across a good many stands that are not strictly even aged, and you will sometimes have to use a little ingenuity in applying the tables. One technique might be to treat the stand as two or three stories, cruise each story separately and add to get the total volume of the plot.

Another decision to be made is whether you are going to use photo estimates without correcting them by use of a small number of field measurements or whether you are going to use double sampling with regression. If time is limited or you want only approximate volumes or if the timber is in an inaccessible area, you might be satisfied with uncorrected photo volumes. However, if you want a volume estimate

[2]*Gross volume = sound usable wood. Net volume = gross volume minus unusable wood.*

in which you can place confidence and defend against critics, you will have to combine some field-measured volumes with your photo-estimated volumes. This allows you to (1) remove the bias in your photo estimates, (2) obtain net as well as gross volumes, and (3) calculate a meaningful sampling error.

PHOTO MENSURATION WITH LARGE-SCALE 70 MM PHOTOGRAPHY

Our discussion of aerial photo mensuration to this point has assumed the use of multiuse resource photography at scales between 1:10,000 and 1:20,000. In this section we discuss the use of specialized large-scale photography (1:2000 and larger) for forest mensurational purposes.

Fixed Air-Base Photography

Fixed air-base photography utilizes two cameras mounted on a boom a fixed and known distance apart (the air base). Avery (1958, 1959) was one of the first to use helicopters and fixed air-base 70 mm photography. He used two 70 mm cameras mounted 4 ft apart on a hand-held boom from a helicopter. His purpose was to eliminate differential tilt and parallax problems created by wind sway. Both photographs of the stereo pair may be tilted but they will be tilted the same amount and in the same direction, which greatly improves the accuracy of height measurements.

In conventional photography, differential wind sway can also affect height measurements by introducing a false parallax difference if the tree tops are at different lateral positions at two different exposure times. Avery eliminated this problem by firing the two cameras simultaneously.

Since this beginning, Lyons (1961, 1964, 1966, 1967) and Rhody (1976) have further improved this method. If both cameras are fired exactly at the same time and if their lines of sight are exactly parallel, the ground distance between principal and conjugate principal points of the resulting stereo pairs of photos is exactly the same as the fixed air base. This makes it possible to accurately determine the scale between the principal and conjugate principal points without ground measurements. Lyons used a 15-ft air base (a 15-foot boom and a helicopter) in his early research.

Scale Determination

The accurate determination of scale for large-scale, fixed air-base photography sounds good in theory but is difficult to achieve in practice. It is difficult to maintain parallel lines of sight between the two cameras, especially if the boom is mounted at right angles to the line of flight. If the boom is mounted parallel to the line of flight, for rigidity, the air base is unknown if the two cameras do not fire at exactly the same instant. Synchronization within microseconds μs is necessary. Lyons (1967) of the British Columbia Forest Service reduced synchronization

errors from $\pm 10\mu s$ to $\pm 0.5\mu s$ by shifting to Linhof 70 mm Aero-Electric cameras with between-the-lens synchrocompar shutters.

He further reduced scale-determination errors by calculating flying heights above the ground by calibrating the system and using a regression equation. The form of the regression equation is:

$$\frac{1}{H} = b_0 + b_1 \, (P)$$

Where

$\frac{1}{H}$ = reciprocal of the flying height above the ground in feet

P = photo measurement of the 15-ft air base in inches

b_0 and b_1 = regression coefficients

Using this method flying height was determined within 1 percent at 300 ft. This accuracy is sufficient for accurate photo measurements of photo scale, tree height, and crown diameter.

Tree Height Measurements

Lyons used the following parallax height equation:

$$h = \frac{H^2 \, (dP)}{H \, (dP) + f \, (B)}$$

Where

h = height of tree in feet

H = flying height above the ground in feet

dP = difference in absolute parallax in inches

f = focal length of the camera lens in inches

B = air base in feet (distance between cameras)

This is really the mountainous terrain height equation presented in a different form. If we divide both the numerator and denominator by H, we get:

$$h = \frac{H \, (dP)}{dP + \dfrac{f \, (B)}{H}}$$

The term $\dfrac{f \, (B)}{H}$ is really P in our mountainous terrain height equation. The advantage of Lyon's equation is that it eliminates the photo measurement of P.

Based on 394 trees of various species found in British Columbia and ranging in height from 50 to 150 ft, photo measurements of height averaged 0.10 ft high with a

standard deviation of only 2.87 ft as compared to felled tree measurements. The same trees measured standing with a chain and abney averaged 0.56 ft high with a standard deviation of 4.34 ft. Thus photo measurements of tree height were more accurate and more precise on 1:1500 and larger-scale photos than conventional ground measurements of standing trees (see figures 20.5, 20.6, and 20.7).

Crown Diameter Measurements

Crown diameter measurements were measured on the photos at a point halfway between the base and top of the tree and converted to ground measurements using the following equation:

$$CD = \frac{(H - 1/2h)\ PD}{f}$$

Where

CD = crown diameter at one-half the tree height, in feet

H = flying height above the base of the tree, in feet

h = height of the tree, in feet

PD = photo measured crown diameter, in inches

f = camera lens focal length, in *inches*

Figure 20.5. Large-scale (PSR = 1364) 70 mm stereogram used for individual tree measurement and species identification in British Columbia. Maximum heights are 150 ft for western hemlock at *H* and 190 ft for amabilis fir at *A*. (From E. H. Lyons, 1966, copyright 1966, by the Canadian Institute of Forestry, Quebec, Canada, reproduced with permission, photos courtesy E. H. Lyons.)

This is not a new equation. If we substitute PSR for $\dfrac{(H - \frac{1}{2}h)}{f}$ we have a standard distance equation.

Tree Species Identification

Lyons (1967) correctly identified 1200 out of 1211 coniferous trees as to the correct species in interior British Columbia. He did even better when working with coastal British Columbia stands where he correctly identified 1086 out of 1091 coniferous trees. He concluded that, from a practical standpoint, species identification using large-scale (1:1500 and larger), fixed air-base photography is just as good as ground identification. The stereograms in figures 20.5, 20.6 and 20.7 are from these studies.

Measurement of Logging Residue

Using even larger scales (1:373) of fixed air-base 70 mm photography, Lyons (1966, 1967) showed that the size and volume of logging residue can be measured on the photos nearly as well as on the ground (Figure 20.8).

Figure 20.6. Large-scale (PSR = 1261) 70 mm stereogram used for individual tree measurement and species identification in British Columbia. Maximum tree heights are 160 ft. Douglas-fir is at D, western hemlock is at H, and western red cedar is at C. (From E. H. Lyons, 1966, copyright 1966, by the Canadian Institute of Forestery, Quebec, Canada, reproduced with permission, photos courtesy E. H. Lyons.)

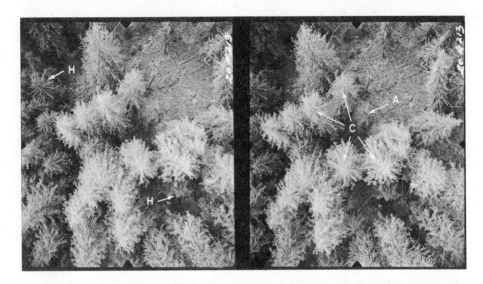

Figure 20.7. Large-scale (PSR = 1276) 70 mm stereogram used for individual tree
measurement and species identification in British Columbia. Maxi-
mum tree heights are 160 ft. Western red cedar is shown at C, western
hemlock is shown at H, and amabilis fir is shown at A. Cedar foliage
becomes sparce with age (250 years) and spike tops are common.
(From E. H. Lyons, 1966, copyright 1966, by the Canadian Institute
of Forestry, Quebec, Canada, reproduced with permission, photos
courtesy E. H. Lyons).

**TABLE 20.5 Measurements of 32 Logs Measured on Fixed Air-Base Aerial Photos
Compared with Ground Measurements.**

	Mean Diameter (in.)	Mean Length (ft)	Mean Volume (cu ft)
Ground	8.50 ± 3.07	26.11 ± 12.80	10.47 ± 10.08
Interpreter 1	8.93 ± 2.93	25.12 ± 12.26	10.50 ± 9.41
Interpreter 2	8.49 ± 2.90	25.30 ± 12.94	9.71 ± 9.35
Interpreter 3	8.42 ± 2.98	25.66 ± 12.14	9.68 ± 8.88

Reprinted by permission from the Forestry Chronicle, *December 1966, Vol. 42, No. 4.*

Figure 20.8. Very large-scale (PSR = 373) 70 mm stereogram used to measure logging residue. See Table 20.5 for a comparison of photo and field measured residue. (Photos courtesy E. H. Lyons, B. C. Forest Service, Victoria, B. C.)

Using line transects through 0.1 acre plots, 155 pieces of material were counted crossing the transect line. On the photos three interpreters each counted 151 pieces. The four missing pieces were all completely covered. Table 20.5 shows the results of 32 logs measured by the three interpreters compared with the ground measurements.

The mean ground and photo volumes of eight 0.1 acre plots were 3663 ± 819 (ground) and 3306 ±997 (photo) cubic feet per acre. Equally satisfactory results were obtained at a photo scale of 1:571. Thus it was concluded that by correcting for a small negative bias due to hidden material, photo estimates are as good as ground methods for the prediction of mean gross volume of logging residue.

Nonfixed Air-Base Photography

For many years the Forest Management Institute (FMI) of the Canadian Forestry Service at Ottawa, Ontario, has been developing a large-scale, 70-mm photography system for forest inventory. Their objective is to *replace* most, but not all of the groundwork required to make sample plot estimates of species composition, measurements of tree variables such as height, diameter, and volume and stand variables such as stocking, basal area, volume, and the distribution of trees by diameter and volume classes (Aldred and Hall, 1975).

The FMI has continued to use large-scale photography (between 1:500 and 1:5000) of sample plots using 70 mm cameras. However they use both fixed wing and helicopters and have abandoned the fixed air-base concept. To obtain accurate photo scales without ground measurements they first determine accurate flying heights with a radar altimeter that is unaffected by intervening vegetation between the aircraft and the ground (Nielsen, 1974). Flying height readings are recorded directly on all photos by simultaneously photographing a numerical display in one of two secondary optical systems in the camera as shown in the lower left corner of the photos in Figure 20.9, (257 and 261 m, respectively).

They mathematically correct for measurement errors created by differential tilt through the use of a tilt indicator that is simultaneously photographed through the other optical system in the camera. This information is recorded as a binary code and is shown in the lower right corner of the photos in Figure 20.9 (Nelson, 1974b).

Measuring the Photo Plots

The desired plot size and shape is delineated on the photos between the principal and conjugate principal points. A 0.081-hectare (1/5 acre) rectangular plot is illustrated in Figure 20.10. Next, all trees larger than a specified size are numbered, identified as to species, and photogrammetrically measured. A small subsample of these photo plots is field measured to develop photo volume tables and to correct for systematic errors using double sampling with regression techniques.

Recent Trials

In 1973, the FMI in conjunction with the Canadian International Paper Company conducted a full-scale trial of their complete system on a 3200-acre forest in western Quebec (Aldred and Hall, 1975). An analysis of their results, based on a field check of 8 of the 63 plots indicated the following:

1. Species identification was 90 percent accurate.
2. Photo scale was within 1 percent of the true scale 66 percent of the time.
3. Tree heights averaged 0.7 m low with a standard deviation of 0.8 m.
4. The standard error of the volume estimate was 15 percent. This could be reduced by increasing the sample size with an increase in cost.

It was estimated that a ground cruise of the same precision would have cost very close to what was spent on the photo cruise. However, the efficiency of the large-scale photo cruise would gain in relative efficiency as either the size of the inventory or the intensity of the sampling increases.

Another full-scale trial was conducted by the FMI in cooperation with the Alberta Forest Service (Aldred and Lowe, 1978). They used 163 photo plots to inventory a 3000-km^2 management unit. Twelve of these plots were field measured

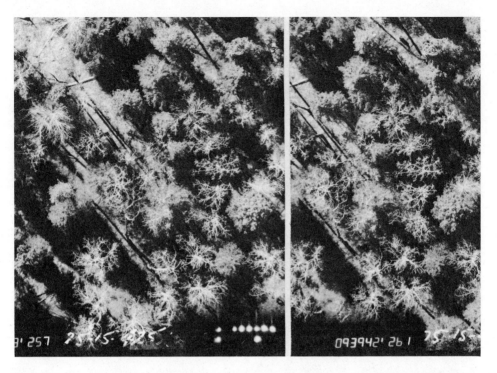

Figure 20.9. Large-scale (contact PSR = 840) 70 mm stereogram of mixed hard-
wood and conifer species in Alberta, Canada, showing the exact
flying heights above ground (lower left) at the instant of exposure
printed directly on the photographs as measured by a radar altime-
ter. The flying heights were 257 m (left photo) and 261 m (right
photo). At the lower right of the left photo is a binary code showing
the amount and direction of tilt at the instant of exposure used to
make adjustments to the photo measured tree heights. (From A. H.
Aldred and Low, 1978, photos courtesy of Forest Management
Institute, Ontario, Canada, reproduced with permission.)

to check the accuracy of the photo measured plots and to provide data for the
construction of tree volume and diameter equations. An analysis of the results
indicated that:

1. The photo method would have a cost advantage over the ground method if
 more than 100 to 500 plots are required. The exact number of plots for the
 break-even point depends on the size, accuracy, and intensity of the
 inventory; the nature of the forest; and the accessibility.

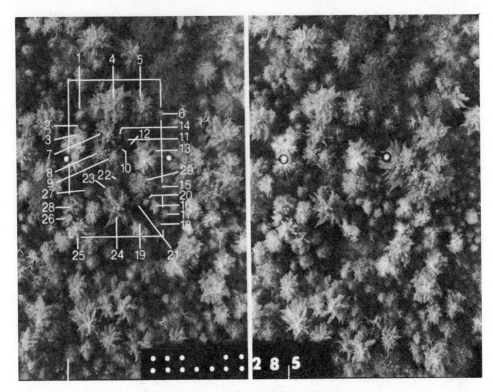

Figure 20.10. Large scale 70 mm stereogram of a 0.081 hectare (one-fifth acre) rectangular plot. (From A. H. Aldred and Hall, 1975, copyright 1975, by the Canadian Institute of Forestry, Quebec, Canada, reproduced with permission, photos courtesy A. H. Aldred, Forest Management Institute, Ontario, Canada.)

2. On the plots checked, 95 percent of the 387 trees were correctly identified for species with no species errors between conifers and hardwoods.
3. Plot-size error was less than 0.1 percent with a standard deviation within 2 percent.
4. There was no detectable systematic error in height measurements and the standard deviation for tree heights was 0.8 m. Tree height measurement errors of up to 4.4 m were attributed to tilt. When mathematical corrections for tilt were made, errors attributed to tilt were reduced to 0.1 m. With adequate tilt and scale control tree heights were measured more accurately on the photos than with conventional ground mesaurements using a hypsometer and tape.

5. The addition of crown *area* to the tree height prediction equation increased the precision of volume and dbh measurements, but the extra time required to measure crown area on the photos nullified the advantage from an economic standpoint.

6. Flying heights contained a systematic error of 3.1 m which, after calibration, was removed, leaving a standard deviation of 2.2 m at a flying height of 300 m. The effect of flying-height error was found to be somewhat compensating because of the partial compensating effects on plot size and tree volumes from which plot volume is derived.

7. Because office-oriented union agreements with field cruisers have seriously reduced the length of the field workday, the number of field plots measured per day is falling while the cost per crew day is rising. This trend strengthens the advantages of the photo method.

8. Application of the photo method requires well-developed skills in forest photo interpretation and mensuration as well as good understanding of statistics, photogrammetry and photography.

Laboratory Exercise

The laboratory exercise for aerial photo mensuration is a timber cruise and is at the end of Chapter Twenty-one following an example timber cruise.

Questions and Problems

1. What is the difference between direct and indirect measurements made on aerial photographs?
2. For each of the following types of information that can be obtained from aerial photographs, indicate whether they are obtained by direct or indirect measurements.

 (a) Tree stem diameter.
 (b) Total tree height.
 (c) Visible crown diameter.
 (d) Site index.
 (e) Percent crown closure.
 (f) Cubic-foot volume per acre.
 (g) Basal area per acre.

3. List the independent variables usually associated with the three different types of aerial photo volume tables.
4. List the primary advantages of each of the three different types of aerial photo volume tables.
5. List four deterrents to aerial photo timber cruising and state how each of

these deterrents can be overcome.

6. What is fixed air-base photography?

7. Give three reasons, in addition to the large photo scale used, why it is possible to measure tree heights using fixed air-base photography more accurately than using a tape and hypsometer on the ground.

8. The Forest Management Institute of the Canadian Forestry Department abandoned the idea of fixed air-base photography. How did they **(a)** obtain accurate scale and flying height measurements without field measurements and **(b)** overcome the problem of differential tilt between the two photos of the stereo pair?

Twenty-One

An Example Photo Timber Cruise

This chapter is a continuation of Chapters Nineteen and Twenty. It adds to the statistics presented in Chapter Nineteen and includes a complete numerical example of an aerial photo timber cruise. Timber cruising is that part of forest mensuration that includes the measurement of gross and net tree and stand volumes. The chapter concludes with a laboratory exercise which is an aerial photo timber cruise with a complete statistical analysis.

Objectives

After a thorough understanding of this chapter and completion of the laboratory exercise, you will be able to:

1. Perform the required photo measurements that are required for an aerial photo timber cruise.
2. Use the measurements obtained in objective 1 and the appropriate aerial photo volume tables to determine the average uncorrected photo plot volume per acre.
3. Calculate the corrected gross and net average plot volumes per acre using the uncorrected photo plot volumes and a subsample of field volume measurements using the double sampling with regression technique.
4. Calculate the total volume of a stand of timber, the standard error of the total volume in board-feet and as a percent of the corrected mean volume per acre.
5. Calculate the number of photo-measured and field-measured sample plots that would be required to obtain a specified sampling error at a specified confidence level.

DESCRIPTION OF CRUISE AND CRUISE AREA

The example photo timber cruise uses plots numbered A through J on the stereograms in Figures 21.1 and 21.2. The laboratory exercise uses plots numbered 1 through 32 on the same stereograms. The area cruised is a 320-acre tract of primarily Douglas-fir sawtimber, but with small amounts of grand fir, oak, maple, and alder as secondary species. The oak, maple, and alder, being mostly noncommercial in this part of the country, are not included in the cruise. Thus, that portion of the crown closure occupied by these species will be ignored. The grand fir volume consists of less than 5 percent of the conifer volume and will not be separated from the Douglas-fir volume. It is very difficult to separate these two species on the scale of photography used.

You should realize that this is only an example cruise and therefore (1) does not include enough pairs of photo and field plots to be statistically sound, (2) does not include a large enough area to be economically feasible, and (3) you will be looking at halftone reproductions and you will not be able to see as much detail as on the original photos. On the other hand, this is an actual example including the field-measured volumes.

The Data Sheet

Figure 21.3 shows the completed data sheet of the example cruise. The average visible crown diameter for each plot is first recorded in thousandths of an inch as measured on the photo and then converted to actual crown diameters using the appropriate scale equation. We really can not measure this accurately, but that's the way the crown diameter scale is calibrated. When converting to actual diameters, round to the nearest *even* two feet to make interpolation in the volume tables easier. We estimated percent crown closure to the nearest five percent using the tree cramming method (Chapter Twenty) and estimated tree height as to tall, medium, and short. Field volumes were measured using standard field procedures. Field plot locations were accurately located to correspond to the plots located on the photos.

The photo volume tables shown in Tables 21.1, 21.2, and 21.3 were used to obtain the estimated or uncorrected photo plot volumes. These photo volume tables were selected from a whole series of tables for different stand height classes to include the range of stand heights found in the cruise area. Tables for other stand heights can be produced from the volume equation shown below the tables. Notice the plots, C, G, and T were treated as two-storied stands. The photo estimated volume for these plots is the sum of the volumes for the over and under story. Plot C was really a one-storied stand but treated as two stories because of drastically different crown diameters. We would have obtained about the same end result by using an average VCD of 24 ft and a total crown closure of 35 percent.

Description of Plots A-J

You should view the stereograms in Figures 21.1 and 21.2 with a stereoscope as you study the following descriptions of each plot.

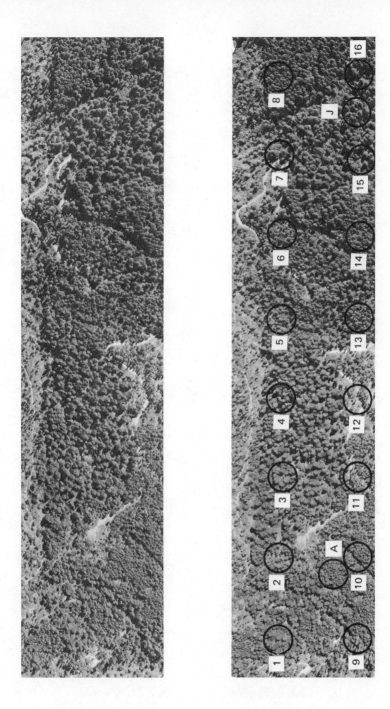

Figure 21.1. Stereogram for timber cruise. Plots A and J are part of the example cruise and plots 1 through 16 are part of the laboratory exercise. See Figure 21.2 for the remaining plots and the text for instructions. Photo plots K through T are not shown.

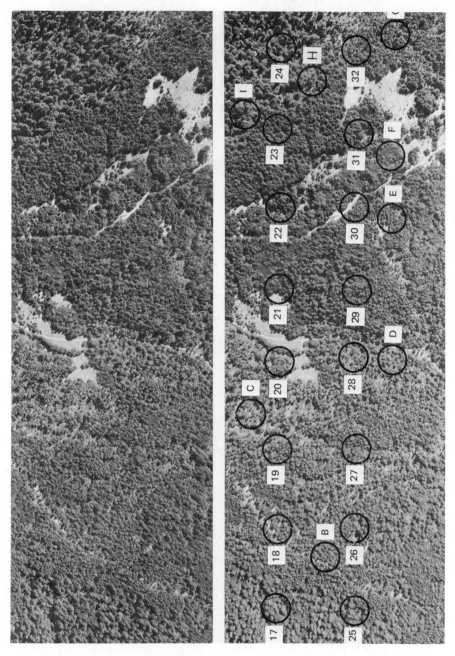

Figure 21.2. Stereogram for timber cruise. Plots B through I are part of the example cruise and plots 17 through 32 are part of the laboratory exercise. See Figure 21.1 for the remaining plots and the text for instructions. Photo plots K through T are now shown.

Aerial Photo Timber Cruise
(Data Sheet)

No. Acres Cruised = <u>320</u>

Photo Scale = <u>1:12,000</u>

These volumes are in:

MBF — Scribner 100s C.F

Please circle correct volume.

Photo VCD (in .001 of an inch) x <u>1000</u> = Ground VCD (in feet)

Plot No.	VCD[a] Photo Inches	VCD[a] Ground Feet	Percent Crown Closure	Height[b] Class	Estimated Photo Volume	Field Volumes Gross	Field Volumes Net
A	0.0175	18	85	M	62	46	44
B	0.0225	22	65	M	59	40	40
C	0.0325/0.0175	32/18	15/20	M/M	39	40	25
D	0.0225	22	5	M	7	8	5
E	0.0175	18	55	S	19	23	20
F	0.025	26	5	S	5	1	1
G	0.030/0.015	30/16	25/35	M/S	44	24	12
H	0.035	34	25	T	65	44	36
I	0.035	34	35	T	89	85	64
J	0.038	38	35	T	99	58	40
K	0.025	24	45	M	45		
L	0.020	20	80	M	65		
M	0.025	26	45	M	48		
N	0.030	30	45	T	100		
O	0.030	30	60	T	130		
P	0.030	30	40	M	50		
Q	0.030	30	35	S	20		
R	0.025	26	30	T	59		
S	0.030	30	30	M	38		
T	0.0275/0.020	28/20	15/20	T/M	52		

[a] *Visible crown diameter.*

[b] *Tall = T = 190 ± 25 ft.*
Medium = M = 140 ± 25 ft.
Short = S = 90 ± 25 ft.

Sum = 1095 MBF
Mean = 54.75 MBF

Figure 21.3. Completed data sheet for example timber cruise. (Adapted from D. P. Paine, 1979, *An Introduction to Aerial Photography for Natural Resource Management,* O.S.U. Bookstores, Inc., copyright 1973, reproduced with permission.)

TABLE 21.1 Three-Variable Stand Aerial Photo Volume Table for Douglas-Fir[a]. In Thousands of Board Feet per Acre for 90-Ft-Tall Stands[b] (short)

	Visible Crown Diameter (VCD)[d]											
%CC[c]	8	12	16	20	24	28	32	36	40	44	48	52
5	4	4	4	5	5	5	6	6	6	7	7	7
10	4	5	6	6	7	8	8	9	10	10	11	11
15	5	6	7	8	9	10	11	12	13	14	15	16
20	6	7	8	10	11	12	13	15	16	17	19	20
25	6	8	10	11	13	14	16	18	19	21	22	24
30	7	9	11	13	15	17	19	20	22	24	26	28
35	8	10	12	14	17	19	21	23	26	28	30	32
40	8	11	13	15	19	21	24	26	29	31	34	37
45	9	12	15	18	20	23	26	29	32	35	38	41
50	10	13	16	19	22	26	29	32	35	39	42	45
55	10	14	17	21	24	28	31	35	39	42	46	49
60	11	15	19	22	26	30	34	38	42	46	49	53
65	11	16	20	24	28	32	37	41	45	49	53	58
70	12	17	21	26	30	35	39	44	48	53	57	62
75	13	18	22	27	32	37	42	47	51	56	61	66
80	13	19	24	29	34	39	44	49	55	60	65	70
85	14	19	25	30	36	41	47	52	58	63	69	74
90	15	20	26	32	38	44	49	55	61	67	73	79
95	15	21	28	34	40	46	52	58	64	70	77	83
100	16	22	29	35	42	48	55	61	68	74	80	87

Table developed by Dr. David P. Paine, Associate Professor, Forest Management, School of Forestry, Oregon State University and Mr. Roger A. Rogers, Research Assistant, School of Forestry, Oregon State University.

[a]*Gross volume, Scribner Log Rule, in trees 11.0 in. dbh and larger. Trees 11.0 to 20.9 in. scaled in 16-ft logs to top dib of 50 percent of the scaling diameter of butt log. Trees 21.0 in. and larger scaled in 32-ft logs to top dib of 60 percent of the scaling diameter of the butt log. Volume tables used: D. Mason, D. Bruce, and J. W. Girard. 1969. Board Foot Volume Tables Based on Total Height. Published and copyrighted by D. Mason, D. Bruce, and J. W. Girard, Consulting Foresters, Portland Oregon. Information is based on total height and form-class.* Equation for Table:

$$Vol. = 3.05565 + 1.9903 \times 10^{-6} (Ht^2 \bullet \%CC \bullet VCD).$$

[b]*Average height of dominants and codominants.*
[c]*Includes all coniferous trees in the major canopy.*
[d]*Average visible crown diameter of dominants and codominants.*

TABLE 21.2 Three-Variable Stand Aerial Photo Volume Table for Douglas-Fir[a] In Thousands of Board Feet per Acre for 140-ft-Tall Stands[b] (medium)

| %CC[c] | \multicolumn{12}{c}{Visible Crown Diameter (VCD)[d]} |
|---|---|---|---|---|---|---|---|---|---|---|---|---|

%CC[c]	8	12	16	20	24	28	32	36	40	44	48	52
5	5	5	6	7	8	9	9	10	11	12	12	13
10	6	8	9	11	12	14	16	17	19	20	22	23
15	8	10	12	15	17	19	22	24	26	29	31	33
20	9	12	16	19	22	25	28	31	34	37	41	44
25	11	15	19	23	26	30	34	38	42	46	50	54
30	12	17	22	26	31	36	41	45	50	55	59	64
35	14	19	25	30	36	41	47	52	58	63	69	74
40	16	22	28	34	41	47	53	59	65	72	78	84
45	17	24	31	38	45	52	59	66	73	80	87	94
50	19	26	34	42	53	58	65	73	81	89	97	104
55	20	29	37	46	55	63	72	80	89	97	106	115
60	22	31	41	50	59	69	78	87	97	106	115	125
65	23	33	44	54	64	74	84	94	104	115	125	135
70	25	36	47	58	69	80	90	101	112	123	134	145
75	26	38	50	62	73	85	97	108	120	132	143	155
80	28	41	53	65	78	90	103	115	128	140	153	165
85	30	43	56	69	83	96	109	122	136	149	162	175
90	31	45	59	73	87	101	115	129	143	158	172	186
95	33	46	62	77	92	107	122	136	151	166	181	195
100	34	50	65	81	97	112	128	143	159	175	190	206

Table developed by Dr. David P. Paine, Associate Professor, Forest Management, School of Forestry, Oregon State University and Mr. Roger A. Rogers, Research Assistant, School of Forestry, Oregon State University.

[a] Gross volume, Scribner Log Rule, in trees 11.0 in. dbh and larger. Trees 11.0 to 20.9 in. scaled in 16-ft logs to top dib of 50 percent of the scaling diameter of butt log. Trees 21.0 in. and larger scaled in 32-ft logs to top dib of 60 percent of the scaling diameter of the butt log. Volume tables used: Mason, Bruce, and Girard, based on total height and form class. Equation for table:

$$Vol. = 3.05566 + 1.9903 \times 10^{-6} \ (Ht^2 \bullet \%CC \bullet VCD)$$

[b] Average height of dominants and codominants.
[c] Includes all coniferous trees in the major canopy.
[d] Average visible crown diameter of dominants and codominants.

TABLE 21.3 Three-Variable Stand Aerial Photo Volume Table for Douglas-Fir[a]. In Thousands of Board Feet per Acre for 190-Ft-Tall Stands [b] (tall)

	Visible Crown Diameter (VCD)[d]											
%CC[c]	8	12	16	20	24	28	32	36	40	44	48	52
5	6	7	9	10	12	13	15	16	17	19	20	22
10	9	12	15	17	20	23	26	29	32	35	38	40
15	12	16	20	25	29	33	38	42	46	50	55	59
20	15	20	26	32	38	43	49	55	61	66	72	78
25	17	25	32	39	46	53	61	68	75	82	89	96
30	20	29	38	46	55	63	72	81	89	98	107	115
35	23	33	43	53	63	73	84	94	104	114	124	134
40	26	38	49	61	72	84	95	107	118	130	141	153
45	29	42	55	68	81	94	107	119	132	145	158	171
50	32	46	61	75	89	104	118	132	147	161	175	190
55	35	50	66	82	98	114	136	145	161	177	193	209
60	38	55	72	89	107	124	141	158	175	193	210	227
65	40	59	78	96	115	134	153	171	190	209	227	246
70	43	63	84	104	124	144	164	184	204	224	244	265
75	46	68	89	111	132	154	175	197	219	240	262	283
80	49	72	95	118	141	164	187	210	233	256	279	302
85	52	76	101	125	150	174	198	223	247	272	296	321
90	55	81	107	132	158	184	210	236	262	288	313	339
95	58	85	112	140	167	194	221	249	276	303	331	358
100	61	89	118	147	175	204	235	262	290	319	348	377

Table developed by Dr. David P. Paine, Associate Professor, Forest Management, School of Forestry, Oregon State University and Mr. Roger A. Rogers, Research Assistant, School of Forestry, Oregon State University.

[a]*Gross volume, Scribner Log rule, in trees 11.0 in. dbh and larger. Trees 11.0 to 20.9 in. scaled in 16-ft logs to top dib of 50 percent of the scaling diameter of butt log. Trees 21.0 in. and larger scaled in 32-ft logs to top dib of 60 percent of the scaling diameter of the butt log. Volume tables used: Mason, Bruce, and Girard, based on total height and form class.* Equation for the table:

$$\text{Vol.} = 3.05566 + 1.9903 \times 10^{-6} \, (Ht^2 \bullet \%CC \bullet VCD)$$

[b]*Average height of dominants and codominants.*
[c]*Includes all coniferous trees in the major canopy.*
[d]*Average visible crown diameter of dominants and codominants.*

Plots A, B, and C.

These are all pure conifer plots with trees of medium height (about 120 ft) and with relatively small VCDs for their height. The average VCD for plot B is slightly larger than for plot A—probably a direct result of poorer stocking for B (the crowns had more room to grow). Plot C is really a one-storied stand but with two distinct VCD classes. This area has been thinned leaving several small-crowned trees and three to four trees with large crown diameters. We simply treated this one-storied stand like a two-storied stand. The volumes for all two-storied stands are the sums of the volumes in the two stories.

Plot D.

This is in the middle of an alder type with *very* few conifers present so do not give it too much crown closure. This predominantly hardwood stand is difficult to separate from predominantly coniferous stands, but it can be separated on the original photos by experienced photo interpreters.

Plot E.

These are short conifers (about 70 ft) with VCDs about the same as for plot A, but the trees in plot A are much taller.

Plot F.

These trees are mostly oak (dark tone) and maple (light tone) with only a few conifers visible in the photos. In general, you can count individual conifers on these photos but you cannot count the hardwoods because their crowns "run" together. Thus, hardwoods have a *fine* texture and conifers a *coarse* texture. The conifer texture becomes even more coarse as the tree crowns become larger.

Plot G.

This is a two-storied stand of conifers, Some of the overstory is grand fir but the plot is mostly Douglas-fir.

Plots H, I, and J.

These are all large-crowned tall conifers (about 200 ft) but not as well stocked as you might think. Stereoscopic examination reveals that much of the apparent crown closure is made up of shadows and an understory of hardwoods— particularly in plot H. These *average* crown diameters are not over 35 to 40 ft and the crown closure for the conifers is generally below 40 percent. Remember, we are not cruising the hardwoods.

You may wish to photo cruise plots A through J for practice and compare your answers with the "school solution." Do not be alarmed if your unadjusted photo volumes differ by as much as 50 to 100 percent from the "school solution." This is perfectly all right if your answers are *consistently* different—always high or low or

even high for the low-volume plots and low for the high-volume plots or vice versa. Your degree of consistency is measured by the correlation coefficient. A correlation coefficient of .70 or greater is economically acceptable when photo-field cruising large acreages of timber in the Pacific Northwest. The double sampling with regression technique greatly reduces photo bias.

Adjusting the Photo Volumes

Next, establish a regression correction equation using the matched pairs of field- and photo-measured plot volumes. Notice that in the field we measured both gross and net volumes. With this information we can develop both gross and net regression equations. These equations can be calculated by computers, programmable calculators, or by nonprogrammable calculators (see Appendix B).

Figure 21.4 shows the results of a printing programmable calculator solution to our example. Notice that all the numbers are in scientific notation. The last two digits to the right (after some spaces) tell you how many places to the right or left you should move the decimal point. Data at the top part of the figure represent the input variables, that is, the photo- and field-measured volumes in our example. The lower part of the figure shows the output data which, among other things, gives us our regression equation. The last number is a (the intercept) and the second to last number is the b value (slope). The output data also include the correlation coefficient (r), the standard deviation about the regression line (SD), and the variance about the regression line $(SD)^2$.

With the above information we can now calculate our corrected (bias removed) gross and net mean volumes as follows:

Regression model: $y = a + bx$

Corrected mean *gross* volume = $a + b$ (mean estimated photo volume)

= 3.0475 + 0.6937 (54.75)[1]

= *41.03 MBF per acre*

Corrected mean *net* volume = 2.5953 + 0.5349 (54.75)[1]

= *31.88 MBF per acre*

In our example we sample cruised 320 acres so the total volumes are

Total gross = (41.03 MBF/acre) (320 acres) = 13.13 million BF

Total net = (31.88 MBF/acre) (320 acres) = 10.20 million BF

[1]Regression coefficients from Figure 21.4 and the unadjusted mean from Figure 21.3.

	Gross Input			Net Input	
	6.200000000[a]	01[b]		6.200000000	01
	−4.600000000	01		−4.400000000	01
	5.900000000	01		5.900000000	01
	−4.000000000	01		−4.000000000	01
	3.900000000	01		3.900000000	01
	−4.000000000	01		−2.500000000	01
	7.000000000	00		7.000000000	00
	−8.000000000	00		−5.000000000	00
	1.900000000	01		1.900000000	01
	−2.300000000	01		−2.000000000	01
	5.000000000	00		5.000000000	00
	−1.000000000	00		−1.000000000	00
	4.400000000	01		4.400000000	01
	−2.400000000	01		−1.200000000	01
	6.500000000	01		6.500000000	01
	−4.400000000	01		−3.600000000	01
	8.900000000	01		8.900000000	01
	−8.500000000	01		−6.400000000	01
	9.900000000	01		9.900000000	01
	−5.800000000	01		−4.000000000	01

	Gross Output			Net Output	
	0.000000000	00		0.000000000	00
	0.000000000	00		0.000000000	00
$(SD)^2 =$	1.119640866	02	$(SD)^2 =$	1.013364020	02
$SD =$	1.058130836	01	$SD =$	1.006659833	01
$r =$	9.132198384	−01	$r =$	8.760424555	−01
$b =$	6.936981261	−01	$b =$	5.349319756	−01
$a =$	3.047531445	00	$a =$	2.595319585	00

[a] *The numbers without a dash are photo estimated volumes and the numbers with dashes in front are field measured volumes.*
[b] *Scientific notation: denotes how far to shift the decimal to the right or left.*

Figure 21.4. Calculator printout of regression solutions for gross and net volumes of the example cruise. (Adapted from D. P. Paine, 1979, *An Introduction to Aerial Photography for Natural Resource Management,* O.S.U. Bookstores, Inc., copyright 1973, reproduced with permission.)

The 54.75 or x value in our equation is the average unadjusted photo volumes based on *all* photo-measured plots (Figure 21.3). These equations removed the photo interpretation bias as well as any bias present in the photo volume tables and provided estimates of net in addition to gross volumes.

Photo volume tables for 190-, 140-, and 90-ft height classes for tall, medium, and short categories were used. However, we could have used a different set —tables for 220-, 170-, and 120-ft heights for example. The average *unadjusted* photo volumes would have been considerably greater, but we would have had different *a* and *b* coefficients in our regression equations and very close to the same corrected average volumes per acre. In fact, it has been found that Douglas-fir stand photo volume tables can be substituted for ponderosa pine photo volume tables and vice versa with very little loss in accuracy, provided the photo estimates are adjusted by double sampling with regression using the appropriate field volumes.[2] It is strongly suspected that this could be carried further. Perhaps all that is needed is one photo volume table for conifers and another for hardwoods. Representative aerial photo volume tables for several species and different geographical regions of the United States can be found in Appendix E. Still more photo volume tables can be located using the references at the end of Chapter Twenty-one.

Correlation

The correlation coefficient, *r* (third figure from bottom, Figure 21.4) tells us about our degree of consistency. Correlation coefficients range from 0 to ±1.0 with 0 indicating no correlation (no relationship between photo and field estimates) at all, and ± 1.0 indicating a perfect relationship. A perfect relationship, which will never happen in photo timber cruising, would result in a perfect straight line when field volumes are plotted over photo volumes. A positive correlation indicates that as photo volume estimates go up, so do the field volume estimates. We should never have a negative correlation (or negative slope) when photo timber cruising using double sampling with regression. In our example the net correlation coefficient is almost .88, which is very good. With correlations of less than about .7 there is little or no economic gain in the use of aerial photos for timber measurements.

Graphic Illustration

Figure 21.5 illustrates graphically what has been done. It shows both gross (the *x*'s) and net (the ⊙ 's) volumes plotted over the photo estimated volumes with their respective regression lines. Despite the apparently wide scatter of points about the regression lines, we obtained very respectable correlation coefficients. Instead of using the regression equation to correct the photo volumes we could have read the corrected values from the graph. For example, locate the mean uncorrected photo volume (54.75) on the horizontal axis and go straight up until we intersect the regression lines. Then go left until we hit the vertical axis and read the corrected mean volumes of about 41 and 32 MBF per acre for gross and net volumes, respectively (Figure 21.5). The regression equation was used to plot the line on the

[2] *Unpublished research by D. P. Paine and independent unpublished research by Charlene A. Metz, Department of Forest Management, Oregon State University, Corvallis, Ore.*

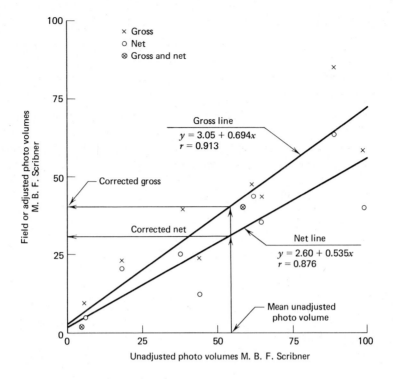

Figure 21.5. Graphic illustration showing the plotted gross and net volumes, their regression lines, and how to obtain the average gross and net volumes per acre from the graph for the example cruise. (From D. P. Paine, 1979, *An Introduction to Aerial Photography for Natural Resource Management,* O.S.U. Bookstores, Inc., copyright 1973, reproduced with permission.)

graph in the first place. However, "in a pinch" the regression lines could have been drawn "by eye." When doing this the regression line must pass through the mean of x (photo volume) and the mean of y (field volume).

Establishing the Regression Line on the Graph

The regression equation is plotted by choosing *two* values of x (one high and one low) and solving the equation for two values of y. The easiest x values to pick in this example are 0 and 100. Thus, where x is 0, y is the intercept (2.59) and where x is 100, y is 100 times the slope plus the intercept or 55.09 board-feet per acre when using the net regression equation. Next, plot these two points and draw a straight line between them. Do the same for the gross line.

STATISTICAL ANALYSIS

In this section we cover specialized techniques for calculating the number of photo-measured and field-measured plots to achieve a specified sampling error at a desired confidence level. The procedure for calculating the sampling error for a combined photo-field timber cruise is also shown.

Combined Sampling Error for Double Sampling

In double sampling with regression there are two components of variance. These components are the variance about the regression line and the variance among field-measured plots that must be combined to obtain a valid sampling error when using double sampling with regression. The method that follows was adapted from Freese (1962). The equation is:

$$SE_{\bar{y}_{R,D}} = \sqrt{S^2_{y \cdot x} \left(\frac{1}{n_2} + \frac{(\bar{x}_1 - \bar{x}_2)^2}{SS_x} \right) \left(1 - \frac{n_2}{n_1}\right) + \frac{S^2_y}{n_1}\left(1 - \frac{n_1}{N}\right)}$$

Where[3]

$SE_{\bar{y}_{R,D}}$ = standard error of the mean for double sampling with regression

$S^2_{y \cdot x}$ = variance about the regression line

$$= \frac{SS_y - \left\{ \dfrac{(SP_{xy})^2}{SS_x} \right\}}{n_2 - 2}$$

S^2_y = variance of the *field* volumes = $\dfrac{SS_y}{n_2 - 1}$

SS_x = net SS of photo plots *that were also selected for field measurement*

SS_y = Net SS of the field measured plots

SP_{xy} = Net sum of products of matched field and photo plots

\bar{x}_1 = mean of *all* unadjusted photo volumes

\bar{x}_2 = mean of the unadjusted photo volumes *that were also measured in the field*

n_1 = number of photo measured plots

n_2 = number of field measured plots

N = total possible number of plots in the population if sampling without replacement.

Let's take a look at an example. Suppose a combined photo-field timber cruise of 3200 acres of timber using 32 one-acre photo plots of which 13 were also measured in the field has been completed. The regression analysis gave us the following additional information:

[3]*See Appendix B for the calculation of* SS_x, SS_y, *and* SP_{xy}.

$$S_{\bar{y}\cdot x}^2 = 119.22$$
$$S_{\bar{y}}^2 = 686$$
$$SS_x = 9287$$
$$\bar{x}_1 = 48.09 \text{ MBF (based on 32 unadjusted photo plots)}$$
$$\bar{x}_2 = 40.53 \text{ MBF (based on 13 unadjusted photo plots)}$$
$$\bar{x} = 45.52 \text{ MBF (based on 32 } adjusted \text{ plots)}$$
$$n_1 = 32 \text{ plots}$$
$$n_2 = 13 \text{ plots}$$

The combined sampling error is:

$$SE_{\bar{y}R,D} = \sqrt{119.22(\frac{1}{13} + \frac{(48.09 - 40.53)^2}{9287}) (1 - \frac{13}{32}) + (\frac{686}{32}) (1 - \frac{32}{3200})}$$

$$= \sqrt{119.22(0.0831) (0.5937) + (21.437) (0.99)}$$

$$= 5.21 \text{ MBF}$$

Calculated as a percent of the adjusted mean we get:

$$SE_{\bar{y}\%R,D} = \frac{5.21 \text{ MBF}}{45.52 \text{ MBF}} (100) = 11.45\%$$

The total volume on the 3200 acres is:

$$\frac{45.52 \text{ MBF}}{\text{acre}} (3200 \text{ acres}) = 145.664 \text{ million board-feet}$$

and the standard error of the *total* is:

$$0.1145 (145.664 \text{ MMBF}) = 16.67 \text{ million board-feet}$$

The standard error of the *total* can also be calculated by:

$$\frac{5.21 \text{ MBF}}{\text{acre}} (3200 \text{ acres}) = 16.67 \text{ million board-feet}$$

The Number of Field and Photo Plots Required

In Chapter Nineteen two sample-size equations were given. However neither of these equations calculate how many of the photo-measured plots must also be measured in the field when using double sampling with regression. The following equations give this information for infinite populations. Two of the many factors that influence the ratio of photo to field plots are (1) the cost of a photo plot as compared to the cost of a field plot and (2) the correlation coefficient (r) between the photo and the field estimated volumes.

$$n_f = \frac{(CV)^2 \, (t)^2}{(DSE_\%)^2} \left\{ \frac{C_f}{E[C_f + (R) \, (C_p)]} \right\}$$

$$n_p = n_f(R)$$

Where

n_f = number of field-measured plots
n_p = number of photo-measured plots
CV = coefficient of variation of the field plot volumes
$DSE_\%$ = desired sampling error as a % of the mean
C_f = cost of a field plot
C_p = cost of a photo plot

and

$$E = \frac{C_f/C_p}{[\sqrt{(1 - r^2) \, (C_f/C_p)} + r]^2}$$

$$R = \frac{1}{\sqrt{(\frac{1 - r^2}{r^2}) \, (\frac{C_p}{C_f})}}$$

Where

E = efficiency
R = optimum ratio of photo to field plots
r = correlation coefficient between matched pairs of photo- and field-measured plots

Let's work out a numerical example using the following data: This example assumes a 3200-acre tract of timber and that we can use the infinite sample-size equation.

Photo cost per plot	$0.75
Interpretation cost per plot	$0.75
Total photo cost per plot	$1.50
Total cost of a field plot	$150.00
Correlation coefficient	.89
Desired sampling error	± 10%
Desired confidence (68%)	$t = 1$
Coefficient of variation between field plots	= 70%

To some readers the field plot cost may seem high, but it is not. These are randomly selected plots scattered out over 3200 acres. More time is spent accurately locating the plot in the field than on its actual measurement. In actuality, all the assumed costs are low. However, they are proportionatley low and therefore have no effect on the required sample size. Let's see what we get.

$$R = \frac{1}{\sqrt{\frac{[1 - (.89^2)]}{(.89)^2}} \left(\frac{1.50}{150.00}\right)} = 19.518$$

$$E = \frac{100}{[\sqrt{(1 - (.89)^2)}\,(100) + 0.89)]^2} = 3.367$$

$$n_f = \frac{(70)^2(1)^2}{(10)^2} \left\{ \frac{150}{(3.367)[(150) + (19\ 518)\,(1.50)]} \right\} = 12 \text{ field plots}$$

$$n_p = 12\,(19.518) = 234 \text{ photo plots}$$

Cost of the field plots = 12 ($150) = $1800
Cost of the photo plots = 234 ($1.50) 351
 Total costs $2151

In order to obtain the same precision using field plots alone without double sampling it would take:

$$n = \frac{(CV)^2(t)^2}{(DSE_\%)^2} = \frac{(70)^2(1)^2}{(10)^2} = 49 \text{ plots}$$

at a cost of ($150) (49) = $7350. Thus, using the photos and double sampling with regression resulted in a theoretical *savings of $5199* in this particular example.

The savings are even more dramatic when the sampling intensity increases. For example, suppose the desired confidence is raised from 68 to 95 percent ($t = 2$). The required number of field- and photo-measured plots increases to 48 and 936, respectively. In this example the double sampling technique results in a savings of over $13,000 as compared to a field inventory.

The efficiency of double sampling decreases (1) as the ratio of field to photo plot costs is reduced and (2) as the correlation between field and photo plots goes down. This relationship is illustrated in Figure 21.6 (Wear, Pope, and Orr, 1966). In our first example the efficiency of double sampling as compared to field sampling was 3.42 or $4900 divided by $1434. We could also obtain this efficiency rating from the graph in Figure 21.6. The cost ratio of 100 is found on the x axis. We can estimate an efficiency of about 3.4 as read on the y axis using a correlation of .89.

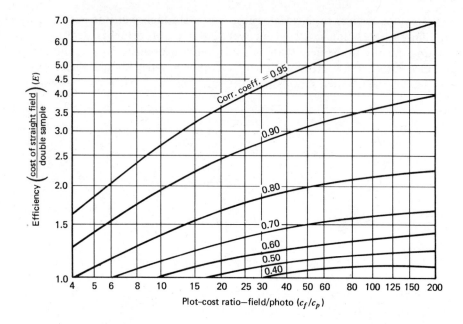

Figure 21.6. Efficiency of double sampling with regression. (From J. F. Wear, R. B. Pope, and P. W. Orr, 1966, Pacific Northwest Forest and Range Experiment Station.)

Laboratory Exercise

Conduct a combined aerial photo and field timber cruise of 320 acres using the 32 *numbered* plots in Figures 21.1 and 21.2. Conduct the cruise exactly as was done in the example to include the calculation of the adjusted total volume on the 320 acres. Your instructor may also have you calculate the combined sampling error when using double sampling with regression and the required number of photo and field measured plots for a specified sampling error. Listed below are the gross and net field volumes for 13 of the 32 plots. Both field and photo plots are 1 acre in size and volumes are in thousands of board-feet, Scribner Log Rule. Do not look at the field volumes until after you have completed your cruise. If you do, your cruise will be biased. If you want to practice first, practice on plots A through J.

As an alternate laboratory exercise it would be better to photo cruise an area in one of your local forests using aerial photo volume tables developed specifically for that area. You will need the assistance of your instructor to do this.

Plot	Field Measured Volumes (MBF/acre)	
Number	Gross	Net
2	15	10
6	56	55
7	59	47
8	95	75
10	61	50
11	37	34
12	24	24
16	56	28
20	24	22
22	28	23
28	2	1
30	6	5
31	34	25

Questions and Problems

1. Given:

 Mean *unadjusted* photo volume per acre = 44.7 thousand board feet
 Regression equations for: (It is permissiable to use photo estimated board feet in the cubic-foot regression equation)

 Corrected gross board-foot volume, $\bar{y}_x = 1.012 + 1.3471x$
 Corrected net board-foot volume, $\bar{y}_x = -2.148 + 1.1874x$
 Corrected gross cubic-foot volume, $\bar{y}_x = 0.741 + 0.2245x$
 Corrected net cubic-foot volume, $y = 0.341 + 0.2148x$

 Calculate the corrected mean board- and cubic-foot volumes per acre.

2. Given:

 $S_{y.x}^2 = 188.75$
 $S_y^2 = 686$
 $SS_x = 7168$
 $\bar{x}_1 = 37.66$ (mean of 36 *unadjusted* photo plots)
 $\bar{x}_2 = 32.69$ (mean of 12 *unadjusted* photo plots)
 $\bar{x} = 35.19$ (mean of 36 adjusted photo plots)
 $n_1 = 36$ (number of photo plots)
 $n_2 = 12$ (number of field plots)

 (a.) Calculate the combined sampling error in thousands of board-feet per acre and for the total if the total area was 10,000 acres.

 (b.) Calculate the combined sampling error expressed as a percent of the adjusted mean if the adjusted mean is 32.7 MBF per acre.

3. Calculate the required number of field- and photo-measured plots given the following data.

Photo cost per plot	$1.00
Interpretation cost per plot	$0.75
Total photo cost per plot	$1.75
Total cost of a field plot	$150.00
Correlation coefficient	.84
Desired sampling error	15%
Desired confidence (95%)	$t = 2$
Coefficient of variation between field plots	60%

References for Part Four

Aldred, A. H. and *J. K. Hall,* 1975. "Application of Large-Scale Photography to a Forest Inventory," *The Forestry Chronicle,* Vol. 51, No. 1. pp. 9-15.

Aldred, A. H. and *J. J. Lowe.* 1978. *Application of Large-Scale Photos to a Forest Inventory in Alberta,* Department of Environment, Canadian Forest Service, Forest Management Institute Information Report FMR-X-107.

Allison, G. W. 1955. The "Accuracy of Tree Height Measurements on Various Qualities of Aerial Photographs." *Forest Chronicle,* Vol. 32. pp. 444-450.

Allison, G. W. and *R. E. Breadon.* 1960. *Timber Volume Estimates from Aerial Photographs,* Forest Survey Note No. 5, British Columbia Forest Service, Victoria B.C., Canada.

Avery, T. E. 1957. *Forester's Guide to Aerial Photo Interpretation,* Southern Forest Experiment Station Occasional Paper 156, U.S.D.A., Forest Service.

Avery, T. E. 1958a. "Composite Aerial Volume Tables for Southern Pine and Hardwoods," *Journal of Forestry,* Vol. 56, No. 10. pp. 741-745.

Avery, T. E. 1958b. "Helicopter Stereo-Photography of Forest Plots," *Photogrammetric Engineering,* Vol. 24. pp. 617-625.

Avery, T. E. 1959. "Photographing Forests from Helicopters," *Journal of Forestry,* Vol. 57. pp. 339-342.

Avery, T. E. and *D. Myhre.* 1959. *Composite Aerial Volume Tables* for Southern Arkansas, Southern Forest Experiment Station, U.S.D.A. Forest Service, Asheville, N. C.

Avery, T. E. and *M. P. Meyer.* 1959. *Volume Tables for Timber Estimating in Northern Minnesota,* Lake States Forest Experiment Station, U.S.D.A. Forest Service, St. Paul, Minn.

Bonnor, G. M. 1966. *Provisional Aerial Stand Volume Tables for Selected Forest Types in Canada,* Department of Forestry and Rural Development, Departmental Publication No. 1175, Ottawa, Canada.

Bruce, D. and *F. X. Schumacher.* 1950. *Forest Mensuration.* Third Edition, McGraw-Hill Book Company, New York.

Chapman, R. C. 1965. *Preliminary Aerial Photo Stand-Volume Tables for Some California Timber Types,* Southwest Forest and Range Experiment Station, U.S.D.A. Forest Service, Berkeley, Calif.

Dilworth, J. R. 1956. *The Use of Aerial Photographs in Cruising Second-Growth Douglas-fir Stands,* Ph.D. dissertation, University of Washington, Seattle, Wash.

Dilworth, J. R. 1977. *Log Scaling and Timber Cruising.* Oregon State University Bookstores, Inc., Corvallis, Ore.

Ferree, M. J. 1953. *A Method of Estimating Timber Volumes from Aerial Photographs,* Technical Publication 75 of the State University of New York College of Forestry at Syracuse.

Freese, F. 1962. *Elementary Forest Sampling,* U.S.D.A. Forest Service. Agricultural Handbook No. 232, Washington, D.C.

Freese, F. 1967. *Elementary Statistical Methods for Foresters,* U.S.D.A. Forest Service. Agricultural Handbook No. 317, Washington, D.C.

Gingrich, S. F. and A. H. Meyer. 1955. "Construction of an Aerial Stand Volume Table for Upland Oak," *Forest Science,* Vol. 1. pp. 140-147.

Johnson, E. W. 1962. *Aerial Photographic Site Evaluation for Longleaf Pine,* Alabama Agricultural Experiment Station, Bulletin No. 339.

Li, J. C. R. 1957. *Introduction to Statistical Inference,* Distributed by Edwards Brothers, Inc., Ann Arbor, Mich.

Lyons, E. H. 1961. "Preliminary Studies of Two Camera, Low Elevation Stereo Photography from Helicopters," *Photogrammetric Engineering,* Vol. 27, No. 1. pp. 72-76.

Lyons, E. H. 1964. "Recent Developments in 70 mm Stereo Photography from Helicopters," *Photogrammetric Engineering,* Vol. 30, No. 5. pp. 750-756.

Lyons, E. H. 1966. "Fixed Air Base 70 mm Photography, a New Tool for Forest Sampling," *The Forestry Chronicle,* Vol. 42, No. 4. pp. 420-431.

Lyons, E. H. 1967. "Forest Sampling with 70 mm Fixed Air Base Photography from Helicopters," *Photogrammetria,* Vol. 22, No. 6. pp. 213-231.

MacLean, C. D. and R. B. Pope. 1961. "Bias in the Estimation of Stand Height from Aerial Photographs," *The Forestry Chronicle,* Vol. 37, No. 2. pp. 160-161.

Moessner, K. E. and C. E. Jensen. 1951. *Timber Cruising on Aerial Photographs,* Central States Forest Experiment Station Technical Paper No. 126, U.S.D.A. Forest Service.

Moessner, K. E. 1957. *Preliminary Aerial Volume Tables for Conifer Stands in the Rocky Mountains,* Intermountain Forest and Range Experiment Station, U.S.D.A. Forest Service, Ogden, Utah.

Moessner, K. E. 1960. *Training Handbook — Basic Techniques in Forest Photo Interpretation,* Intermountain Forest and Range Experiment Station, U.S.D.A. Forest Service, Ogden, Utah.

Moessner, K. E. 1962. *Preliminary Aerial Volume Tables for Pinyon-Juniper Stands,* Intermountain Forest and Range Experiment Station, Research Paper No. 69, U.S.D.A. Forest Service, Ogden, Utah.

Moessner, K. E. 1964. *Two Aerial Photo Basal Area Tables,* Intermountain Forest and Range Experiment Station, Research Note INT-23, U.S.D.A. Forest Service, Ogden, Utah.

Nielsen, U. 1974a. *Description and Performance of the Forestry Radar Altimeter,* Department of Environment, Canadian Forest Service, Forest Management Institute Information Report FMR-X-59.

Nielson, U. 1974b. "Tests of an Airborn Tilt Indicator," *Photogrammetric Engineering,* Vol. 40, No. 8. pp. 953-956.

Nyyssonen, A. 1957. "On the Estimation of Growing Stock from Aerial Photographs," *Metsantytkimuslaitoksen Julkaisuja,* 46. pp. 7-54.

Paine, D. P. 1958. *Preparation of Aerial Photo Tree Volume Tables for Old-Growth Ponderosa Pine,* Master's Thesis, Oregon State College, Corvallis, Ore.

Paine, D. P. 1965. *Photogrammetric Mensurational Techniques for Obtaining Timber Management Data from Aerial Photographs of Ponderosa Pine Stands — Including the Application of Variable Plot Theory,* Ph.D. Dissertation, University of Washington, Seattle, Wash.

Paine, D. P. and R. A. Rogers. 1974. *A Set of Local Aerial Photo Stand Volume Tables for Douglas-fir.* Unpublished research. Department of Forest Management, Oregon State University, Corvallis, Ore.

Paine, D. P. 1979. *An Introduction to Aerial Photography for Natural Resource Management,* Oregon State University Bookstores, Inc., Corvallis, Ore.

Pope, R. B. 1950. "Aerial Photo Volume Tables," *Photogrammetric Engineering,* Vol. 6, No. 3. pp. 325-327.

Pope, R. B. 1957. "The Effect of Photo Scale on the Accuracy of Forestry Measurements," *Photogrammetric Engineering,* Vol. 23. pp. 869-73.

Pope, R. B., C. D. MacLean and D. A. Bernstein. 1961. *Forestry Uses of Aerial Photos,* Pacific Northwest Forest and Range Experiment Station, U.S.D.A. Forest Service, Portland, Ore.

Pope, R. B. 1962. *Constructing Aerial Photo Volume Tables,* Research Paper 49, Pacific Northwest Forest and Range Experiment Station, U.S.D.A. Forest Service, Portland, Ore.

Reineke, L. H. 1933. "Perfecting a Stand-Density Index for Even-Aged Forests," *Journal of Agricultural Research,* Vol. 46. pp. 627-637.

Rhody, B. 1976. "A New Versatile Stereo Camera System for Large-Scale Helicopter Photography of Forest Resources in Central Europe," *Photogrammetric,* Vol. 32. pp. 183-197.

Spurr, S. H. 1954. "History of Forest Photogrammetry and Aerial Mapping," *Photogrammetric Engineering,* Vol. 20. pp. 551-560.

Spurr, S. H. 1960. *Photogrammetry and Photointerpretation,* Second Edition, The Ronald Press Company, New York.

Young, H. E. 1953. "Tree Counts on Air Photographs in Maine," *Photogrammetric Engineering,* Vol. 19. pp. 111-116.

Wear, J. R., R. B. Pope, and *P. W. Orr.* 1966. *Aerial Photographic Techniques for Estimating Damage by Insects in Western Forests,* Pacific Northwest Forest and Range Experiment Station, U.S.D.A. Forest Service, Portland, Ore.

Zieger, E. 1928. "Ermittlung von Bestandesmassen aus Flugbidern mit Hielfe des Hugershoff-Heydeschen Autokartographen (Determination of Stand Volume from Aerial Photographs with the Help of Hugershoff-Heyde Autocartograph)," *Mitteilungen aus der Sachsischen Forstlichen Versuchsanstalt zu Tharendt,* Vol. 3. pp. 97-127.

Part Five

An Introduction to
Nonphotographic
Remote Sensing

Twenty-Two

Additional Characteristics of Electromagnetic Energy

In the broadest sense, the term remote sensing *involves techniques used to detect and study objects at a remote distance without physical contact. In this context, animal or human sight, smell, and hearing as well as the bat's radar system are all examples of remote sensing. To this list of living remote sensors we can add man-made systems that include cameras, scanners, television, radar, lasers, radio receivers, sonars, seismographs, gravimeters, magnetometers, scintillation counters, and perhaps others. In this text, however, we limit our study to three sensor systems that produce a picturelike image: cameras, line scanners, and radar. Within this limitation a more precise definition of remote sensing is the detection recording and evaluation of reflected or emitted electromagnetic energy from a remote distance. Images produced by these sensors have different names: a camera produces a photograph, a thermal scanner produces a thermogram, and a radar system produces a radargram. The term "image" refers to any one or all three of these picturelike representations. Most remote sensing is accomplished from an aerial or space platform (tower, airplane, or satellite). The remaining chapters of this book briefly discuss some of the more important nonphotographic remote-sensing systems.*

In this chapter we first compare the data acquisition characteristics of photographic and nonphotographic sensor systems and then discuss physical characteristics of the electromagnetic energy spectrum utilized by optical-mechanical scanner and radar systems.

Objectives

After a thorough understanding of this chapter you will be able to:

1. State the difference between photographic and electrical remote sensors as to their detection and storage systems and the relative ease of sending the acquired data through space.
2. Use the wave and quantum equations, to derive the relationship between energy and wavelength and state why this relationship helps explain the loss in resolution as we go from short to long wavelength sensors.
3. Define active as compared to passive remote sensors and give one example of each type.
4. With words and a graph, define and illustrate the theoretical spectral signatures of two objects with different reflectance or emittance properties.
5. Using the theory of a *blackbody*, explain the term emissivity, give the equation for emissivity and state the effect of emissivity on a thermal image.
6. Define the terms *thermal conductivity, thermal capacity,* and thermal inertia, and state what controls the magnitude of thermal inertia.
7. Define the term *crossover* and explain how this is related to thermal inertia.
8. State the advantages and disadvantages of computer-assisted analysis as compared to visual interpretation of multispectral scanner data.
9. Define *computer-assisted* analysis of multispectral data and briefly explain how it works.

DATA ACQUISITION

Remote sensors can obtain data either by photographic or electronic means. Photographic sensors utilize chemical reactions in the emulsion layers of the film to *detect, store, and display energy variations* within a scene. Electronic sensors *generate electric signals* that correspond to energy variations within a scene. These electronic signals are usually stored on magnetic computer tape from which they can be converted to an image by the use of a televisionlike screen. The image can then be photographed. Even though final images produced by electronic sensors may eventually end up on photographic film, the film is only for visual display and is not a part of the detecting system. This is in contrast to photographic systems where the film acts as a detector, visual display device, and storage medium.

The remote sensing capabilities of the camera are limited to the photographic region of the electromagnetic spectrum between 0.4 and 0.9 μm. [1] Other limitations

[1] *Special film can be made to extend the range to 0.3 μm to 1.2 μm.*

of the camera are that (1) the output is a photograph that is awkward to telemeter or to process for discrimination analysis, and (2) its use is limited by clouds, fog, smoke, and darkness. The primary advantages of camera systems are that they produce images with the best resolution and are inexpensive relative to other remote sensing systems.

Nonphotographic sensors operate in portions of the electromagnetic spectrum from the ultraviolet to the microwave regions including the photographic region. Thermal infrared, passive microwave, and radar sensors can operate in darkness as well as daylight and radar is not seriously hindered by clouds, fog, or smoke. In addition, because data collected by these sensors are obtained in electrical form, they can easily be telemetered to and from remote locations, like from orbiting spacecraft to the earth, and discrimination analysis can be electronically processed. Nonphotographic imaging systems are also heavier, more complicated, and more expensive.

CHARACTERISTICS OF ELECTROMAGNETIC ENERGY FLOW

The sun is the original source of most electromagnetic radiation used in remote sensing. However, all matter at temperatures above absolute zero ($0°$ K or $-273°$ C) emits electromagnetic radiation. Therefore, all objects on the earth are sources of radiation. Terrestrial objects emit a different distribution of wavelengths of a considerably different magnitude than the sun, but these wavelengths can be remotely sensed by various sensors even though we cnnot "see" them. The aerial camera and the human eye can sense certain portions of *reflected* sunlight but it takes different instruments to sense other portions of the spectrum.

Although we generally assign names to various regions of the electromagnetic spectrum there is no clear-cut division between one region and the next. Division of the spectrum is more or less arbitrary and has grown out of the various methods of sensing each type of radiation. Thus, we generally describe the spectrum and the type of detector in terms of the frequencies and/or wavelengths being detected (Table 22.1).

The Wave and Quantum Theories

Electromagnetic waves can be characterized either by their wavelength (λ) or by their frequency (f'). The wavelength is the shortest distance between similar portions of the waves, like from trough to trough or peak to peak. Frequency is the number of waves (traveling at the speed of light) that pass a fixed point in one second. These two quantities are related inversely as can be observed from the basic wave equation

$$C = f' \lambda \quad \text{or} \quad \lambda = \frac{C}{f'}$$

TABLE 22.1 Electomagnetic Spectral Bands

Band	Wavelength	Remarks
Gamma ray	<0.03 nm	Absorbed by the atmosphere but radioactive materials can be detected from low-flying aircraft.
X ray	0.03 to 3nm	Absorbed by atmosphere but artificially created for use in medicine
Ultraviolet, UV	3nm to 0.4 μm	<0.3 μm absorbed by atmosphere
Photographic UV	0.3 to 0.4 μm	Atmospheric scattering is severe, quartz lenses required on cameras
Visible	0.4 to 0.7 μm	
Blue	0.4 to 0.5 μm	
Green	0.5 to 0.6 μm	
Red	0.6 to 0.7 μm	
Infrared, IR	0.7 to 300 μm	Atmospheric windows separated by absorption bands
Reflected IR	0.7 to 3 μm	
Photographic IR	0.7 to 0.9 μm	Special film can record out to almost 1.2 μm
Thermal IR	3 to 5 μm 8 to 14 μm	These are the windows within the "heat" range of the spectrum
Microwave	0.3 to 300 cm	Long wavelengths penetrate clouds and for imagery acquired in active and passive mode
Radar	0.3 to 300 cm	Active remote sensing
K$_a$ band	1.1 to 1.7 cm	These are the most commonly used bands. There are several others, however.
X band	2.4 to 3.8 cm	
L band	15.0 to 30 cm	
Radio broadcast		Not used in remote sensing

From Sabins (1978).

Where[2]

C = speed of light (about 3×10^8 m/s or 186,000 miles per second)
f' = wave frequency (number per second)
λ = wavelength in meters

Even though the wave theory describes characteristics of the electromagnetic spectrum, the particle or quantum theory yields insight into how electromagnetic energy interacts with matter. The energy of a quantum is:

$$E = h'f'$$

Where[2]

E = energy of a quantum
h' = Planck's constant

Now, solving the wave equation for f' and substituting $\dfrac{C}{\lambda}$ for f' in the quantum equation, we get:

$$E = \frac{h'C}{\lambda}$$

The magnitude of the numbers in this equation is not important but the relationship is important. It shows that the energy of a quantum is *inversely* proportional to its wavelength, that is, the *longer* the wavelength, the *lower* its energy. Therefore in remote sensing, the longer wavelengths are more difficult to sense than the shorter wavelengths. This means that systems operating in longer wavelengths of the energy spectrum must sense larger areas in order to obtain a detectable energy signal. This theory partially explains the loss in resolution as we go from the photographic mode to the thermal scanner that operates in the intermediate wavelengths to radar that operates in even longer wavelengths.

Active and Passive Remote Sensors

All remote sensing systems are either *active* or *passive*. An active system, such as radar, produces its own source of energy, whereas a passive system, such as the camera, uses an external source of energy, usually the sun. We generally think of the camera system as passive, but terrestrial camera systems become active with the use of flashbulbs and even aerial camera systems become active with the use of flares to light up the terrain. Thermal sensors are also passive. They sense emitted radiation that we know better as heat.

The Energy-Flow Profile

In Chapter One, a generalized energy-flow profile was presented for passive remote-sensing systems (Figure 1.8). Energy interactions with particles in the

[2]*f' and h' are used here because the symbols f and h have been used elsewhere in the book.*

atmosphere, the earth, and features on the earth were discussed in terms of *reflectance, absorptance,* and *transmittance.* Even though the total amount of energy striking the earth can be separated into the above components, the proportions of the components change when interacting with different earth features depending on the nature of the material. These differences allow us to distinguish between different objects on an image. The proportion of reflected, absorbed, and transmitted energy changes with different wavelengths. Thus, two or more different objects may look the same in one wavelength and look very different in another wavelength.

In the visible band these differences produce what we call color. For example, an object that appears red, reflects red, and absorbs blue and green. This same principle works for all reflected energy (0.3 to 3 μm), even though we can not always "see" it. Thus, the difference between conifers and hardwoods (Figure 12.6) is much more pronounced on infrared photography than on panchromatic photography or to the human eye because of the different reflectance characteristics in different regions of the spectrum. Similarly, other types of remote sensors can distinguish between different features using wavelengths both within and outside the photographic range of the spectrum.

Spectral Reflectance and Emittance Curves

Figure 22.1 is an example of *spectral reflectance curves,* also known as *spectral signatures.* These curves represent the percent of incident radiation reflected by different materials as a function of wavelength. Similarly, *spectral emittance curves* for wavelengths greater than 3.0 μm are also frequently referred to as *spectral signatures.* These signatures serve two valuable functions: (1) they provide a comparison standard for identifying unknown objects and (2) they are used to identify spectral regions for the differentiation of different objects. Thus, if we wish to separate conifers from hardwoods more easily we should "look" in the photographic infrared region (0.7 to 0.9 μm) (see Figure 22.1) and not in the panchromatic or visible region (0.4 to 0.7 μm).

Notice that the signatures from both hardwoods and conifers in Figure 22.1 have a considerable amount of variation, that is, a considerable amount of variation within each wavelength. Thus it might be better to call these *response patterns* rather than *signatures* because the term signature implies something more definite and unique. This variation is caused by many things such as soil moisture tension, season of the year (which may or may not be associated with soil moisture tension), genetic variation within a species (Figure 22.2), the presence or absence of adequate soil nutrients, and plant maturity (Figure 22.3). Still another cause of variation is the amount and condition of the soil or vegetative background that is not the primary material of concern. For example, many agricultural crops start with nearly 100 percent bare soil. The percentage of bare soil in the background gradually decreases as the vegetative cover increases, frequently to cover 100 percent of the area. In addition many spectral signatures are developed in the laboratory using small samples of homogeneous material whereas remotely sensed images are usu-

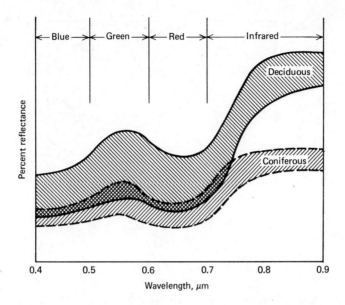

Figure 22.1. Spectral signatures or *response patterns* of coniferous and hard-
woods (deciduous trees). (From Paul R. Wolf, 1974, *Elements of
Photogrammetry,* copyright 1974, by McGraw-Hill Book Com-
pany. Used by permission of McGraw-Hill Book Company.)

ally obtained at great altitudes of less homogeneous material. The student of remote
sensing must keep in mind the variability of spectral signatures.

Properties of Thermal Energy

Heat, or *kinetic energy* is the random motion of particles of matter. This
motion ceases at absolute zero (0 K or −273° C). Using the Kelvin scale, ice melts at
273° and water boils at 373°. *Kinetic* energy is measured with a thermometer placed
in direct contact with the material we are measuring and therefore can *not* be
measured at remote distances. On the other hand, *radiant* energy can be measured
at remote distances by devices that can measure the wavelengths of electromagnetic
radiation in the thermal infrared region of the spectrum.

Emissivity

Heat transfer by *radiation* in contrast to heat transfer by conduction and
convection is in the form of electromagnetic waves that can travel through a
vacuum, as from the sun to the earth. *Radiant* temperatures of materials are *less
than kinetic* temperatures because of a property called *emissivity.* To explain
emissivity we must first introduce the concept of a blackbody.

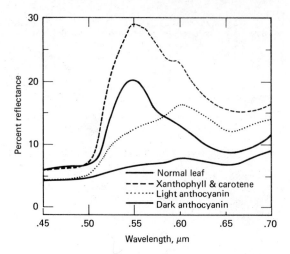

Figure 22.2. Diffuse reflectance of the leaves of four genetic strains of cotton. Each spectrum is the average of five leaves and is shown here as a spectral signature and not as a response pattern. (Copyright 1975, *Manual of Remote Sensing,* published by the American Society of Photogrammetry.)

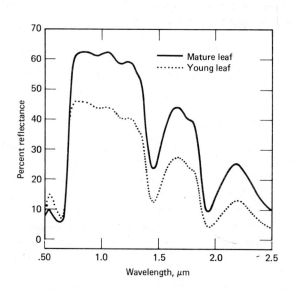

Figure 22.3. Diffuse reflectance of the upper surfaces of young (bottom dotted line) and mature (top solid line) of orange leaves. (Copyright 1975, *Manual of Remote Sensing,* published by the American Society of Photogrammetry.)

A *blackbody* is a *theoretical* material that *absorbs all* radiant energy that strikes it. The blackbody concept is a theoretical abstraction because no such body actually exists. A blackbody is also a perfect radiator. For *real* materials emissivity, *e* is defined as:

$$e = \frac{F_r}{F_b}$$

where F_r is the electromagnetic energy radiated from a source and F_b is the electromagnetic energy radiated from a blackbody. Thus *emissivity is the radiating efficiency of the surface of an object.* Because different materials have different emissivities, the distribution of radiant energy emission among different objects is not a linear function of the surface kinetic temperature. Thus the difference in emissivity between materials can greatly affect apparent surface temperatures and therefore, the resultant tone of an image produced by a thermal scanner. It is possible to have two objects at two different surface temperatures, but due to emissivity, the apparent temperatures are the same and can not be separated on a thermal image. On the other hand, two objects of the same surface temperature can be separated if their emissivities are different. A lower emissivity gives the appearance of a lower temperature and therefore a darker tone on a thermogram.

Thermal Conductivity, Thermal Capacity, and Thermal Inertia

Thermal conductivity is a measure of the *rate* at which heat will pass through a material. The thermal conductivity of rock, soil, and water is low compared to that of metals. *Thermal capacity* is the ability of a material to store heat and *thermal inertia* is a measure of thermal response of a material to temperature change. The thermal inertia of materials is a function of its thermal conductivity, thermal capacity, and density with density being the most important. In general, thermal inertia increases with an increase in density. Thermal inertia helps create a phenomenon called *crossover*, which creates a situation where a substance with a *low* thermal inertia is warmer than its surroundings during the day, but cooler at night.

Even though the thermal inertia of water is similar to that of soils and rocks, the day surface temperature of water is cooler and the night temperature is warmer. This is because convection currents operate in bodies of water but not in soils and rocks.

DATA INTERPRETATION

Because data collected by electronic sensors are in digital form on magnetic tape they can be analyzed directly by computers. Multispectral data can be computer analyzed by individual bands and/or jointly using all bands. This has certain advantages and disadvantages over human interpretation of data in image form.

The advantages are that computer interpretation is rapid and where *spectral* differences are of primary concern, digital data are more precise because of the limited ability of the eye to discern the tonal value of an image. In addition, when

several distinct bands are involved, there are too many variables for the human mind to simultaneously comprehend and subtle differences may go undetected. Finally, summary tables such as the number of acres in a particular classification can be rapidly and economically produced by a computer.

On the other hand, computer analysis is no better than the computer programs used to make the analysis and we should not sell the human mind short. Visual interpretation makes use of the human mind to *qualitatively* evaluate *spatial* patterns and make subjective judgments. Because humans are limited in their ability to evaluate *spectral* patterns and computers are limited in their capacity to evaluate *spatial* patterns, the best approach is the combination of visual and computer techniques called "computer assisted analysis or supervised classification." This combines the speed and economy of the computer with the judgment and wisdom of the human mind.

Computer-assisted analysis provides the computer with sample *ground-truth* data by grid coordinates. *Ground truth* is the correct identification of objects or ground cover obtained by actual ground visitation by field crews or by conventional large scale aerial photography. Ground-truth data must include samples of all ground conditions of interest. The areas in which these data are collected are called *training sites*. The computer then analyzes the spectral bands of the training sites and matches similar spectral conditions within the entire scene with the known conditions of the training sites. The results are then printed in two-dimensional space by the computer using different symbols to represent different ground condition classes.

Ideally there should be an alternate set of test sites, not originally used by the computer, to check the accuracy of the computer interpretation of these areas. In practice, computer-assisted interpretation is not as simple as just described. Several computer runs are usually required, with changes in the grouping of similar data sets made until the desired results are attained. The actual process of discriminating between different data sets and the combining of similar data sets is beyond the scope of this book.

Plate VIII (top right) is an example of computer assisted interpretation of Landsat 1 multispectral data. Table 22.2 presents a computer-produced summary of the scene that gives the number of acres in each ground condition class. This particular scene was originally printed by the computer using different symbols for different condition classes and then color coded by hand.

Questions and Problems

1. Photographic film acts as a detector, visual display, and storage system for data when used in a camera. How does this differ for optical-mechanical scanner remote sensors for which the final product may or may not be recorded on photographic film?

2. Use the wave equation ($C = f'\lambda$) and the quantum equation ($E = h'f'$) to partially explain why remote sensing in the longer wavelengths generally

TABLE 22.2 Computer-Assisted Analysis of Landsat Data[a]

Class	Color Code	Acres	%	Band Means 4	5	6	7	Threshold
Younger basalt	Black	16,551	12.4	8.89	6.23	5.55	4.54	10.00
Older basalt	Red	14,417	10.8	8.84	6.41	8.77	9.19	12.00
Water	Dk. blue	418	0.3	7.66	3.21	2.17	1.22	7.00
Forest 1 — mixed	Dk. green	47,688	35.7	8.24	4.99	10.06	12.21	10.00
Forest 2 — Douglas-fir or ponderosa pine	Yellow	17,283	12.9	8.12	4.63	13.19	16.50	6.00
Forest 3 — lodge-pole pine	Lt. green	13,164	9.9	7.65	4.59	8.47	9.90	12.00
Clearcut 1 — little revegetation	Brown	5,982	4.5	10.87	9.94	14.43	16.74	18.00
Clearcut 2 — bushy revegetation	Pink	3,872	2.9	10.30	7.72	17.32	21.41	21.00
Snow	Lt. blue	332	0.2	41.76	43.05	37.76	28.10	70.00
Burn	Orange	7,257	5.4	11.52	10.26	11.94	12.18	13.00
Unclassified	White	6,678	5.0					
Total		133,632	100.00					

[a]*From Lawrence and Herzog (1975). Copyright, 1975, by American Society of Photogrammetry. Reproduced with permission. This is a computer-generated summary table of Mount Washington and surrounding area in the state of Oregon. The computer-generated map of the area is shown in Plate VIII (top right). See Chapter Twenty-five for further description of the Landsat multispectral imaging system.*

results in poorer resolution than remote sensing in the shorter wavelengths.

3. What is the difference between an active and a passive remote sensor? Give an example of each type.

4. Draw a graph with properly labeled axes to illustrate the spectral signatures of two different objects and indicate the wavelength region that would best separate the two objects on an image.

5. Define fully the following terms as they relate to remote sensing in the thermal region of the spectrum: kinetic and radiant energy, blackbody, emissivity, thermal inertia, and crossover effect.

6. Fully discuss the significance of emissivity, thermal inertia, and crossover in terms of the effect on the interpretation of thermal imagery.

7. Define computer-assisted analysis of multispectral data and explain briefly how it works.

8. State the advantages and disadvantages of computer-assisted analysis as compared to visual interpretation of multispectral scanner data.

Twenty-Three

Optical-Mechanical Scanning Systems

Optical-mechanical scanning systems are capable of producing imagery over a wide range of the electromagnetic energy spectrum that includes ultraviolet, visible, photographic infrared, and thermal infrared wavelengths. Notice that this range includes some of the same wavelengths detected by aerial cameras but the detection process is entirely different. In this chapter we first discuss thermal scanners that operate in the thermal bands and then discuss multispectral scanners that simultaneously operate in several bands within the photographic and/or thermal regions of the spectrum.

Objectives

After a thorough understanding of this chapter you will be able to:

1. Name the three primary components of a thermal scanner and describe briefly the function of each.
2. With a diagram and words show how an optical-mechanical scanning system scans the terrain to produce a two-dimensional image.
3. List and explain the cause and/or characteristics of the following types of irregularities associated with thermal imagery: topographic displacement, compression of imagery at the far edges, pitch, roll, yaw, scattered clouds and scattered rain, surface wind, and transmission from aircraft radios.
4. Define and explain the significance of the term *crossover* as it pertains to the interpretation of thermal imagery.
5. Draw a diagram to show the primary difference between thermal scanners and multispectral scanners.

6. List five advantages and two disadvantages of multispectral scanning systems as compared to photographic systems.

THERMAL SCANNERS

Figure 23.1 diagrams the essential features of a typical airborne thermal infrared scanner system. This system is composed of three basic components: (1) an

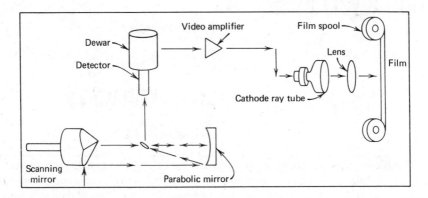

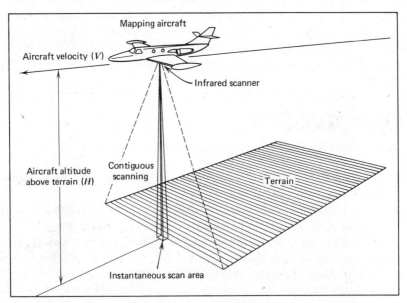

Figure 23.1. Schematic diagram of a typical thermal scanner (top) and scanner coverage (bottom). (From U.S. Forest Service, 1968.)

optical-mechanical scanning component, (2) a thermal detector, and (3) an image-recording component. The scanning component consists of a first-surface mirror mounted on a rotating or oscilating shaft that is oriented parallel to the line of flight. The mirror, mounted at 45° angle from the vertical sweeps the terrain at right angles to the flight path with an angular field of view usually between 90° and 120°. This mirror collects energy radiated from the earth and focuses it onto a thermal infrared detector that converts the radiant energy into an electrical signal that varies in proportion to the intensity of the incoming radiation.

Different detector elements are used to sense within different thermal regions of the spectrum. Figure 1.6 in Chapter One indicates atmospheric windows between the 3.5 to 5 μm and between the 8- to 14-μm ranges of the spectrum. When sensing the 3.5- to 5-μm band, a common detector is *indium antimonide* (see Figure 23.2 bottom), and a frequently used detector for the 8- to 14-μm range is *mercury cadmium telluride* (see Figure 23.2 top). Depending on its composition, mercury cadmium telluride can also be used to detect in the 3.5- to 5-μm range. Another detector in common use is *mercury-doped germanium*, which is a wide band detector from 3 to 14 μm.

As shown in Figure 23.1 the recording component consists of a magnetic tape recorder and/or direct film recorder. The forward motion of the aircraft carries the scanner forward so that successive scans cover different and adjacent strips on the ground. The recording film advances at a rate proportional to the aircraft ground speed so that each ground scan line is represented by a scan line on the film. Situations where there is a gap between scan lines are called *underlap* and the reverse is called *overlap*. These situations occur when the aircraft speed is not properly synchronized with the ground speed and the rotating speed of the mirror.

The heart of any scanning system is the detector that converts the incident radiation into an electric signal. The selected wavelengths for scanner detection can be altered by the use of filters as well as changing the detector element. In the case of thermal scanners the detector must be cooled to approximately 77° K or lower. The coolant in Figure 23.1 is liquid nitrogen enclosed in a vacuum bottle called a dewar.

Characteristics of Thermal Scanner Images

In our discussion of thermal scanners, only the qualitative or interpretative nature of the imagery is discussed. However, in some cases thermal imagery is calibrated to give actual ground (or water) temperatures. An example would be the use of thermal imagery to monitor surface water temperatures of effluent from a nuclear power plant. Thermal scanner imagery (Figures 23.2 and 23.3) looks very much like a conventional photographic image when recorded on standard black-and-white film in various shades of gray, but there are significant differences. The lighter tones represent the warmest radiant *temperatures* and the darker tones represent the coolest *temperatures*.

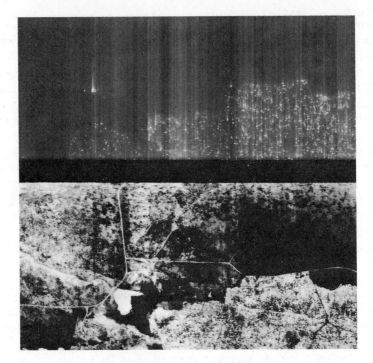

Figure 23.2.　Thermal scanner imagery of a forest fire taken at about 11:00 P.M. with two different detectors. The image at the bottom was made with an *indium antimonide* detector and shows the fire boundary as well as nearby roads to help locate the fire position. The top image was detected with a *mercury cadmium telluride* detector, which picks up only the hotter areas. (Courtesy State of Oregon, Department of Forestry and the 1042nd Military Intelligence Company, Oregon Army National Guard.)

Effects of Emissivity

Emissivity as defined in Chapter Twenty-two is the ratio of the amount of energy radiated from a source to the amount of energy radiated from a blackbody at the same temperature. Because different materials have different emissivities, they appear different on thermal images than their true *kinetic* temperatures would indicate. For example, suppose we have an early morning thermal image of a bright and shiny unpainted metal building surrounded by sand and that the kinetic temperatures of the metal and the sand are the same. The metal building would show up darker than the sand because of a much lower emissivity. Therefore, interpreters of thermal imagery should be aware of the emissivity of common materials as shown in Table 23.1.

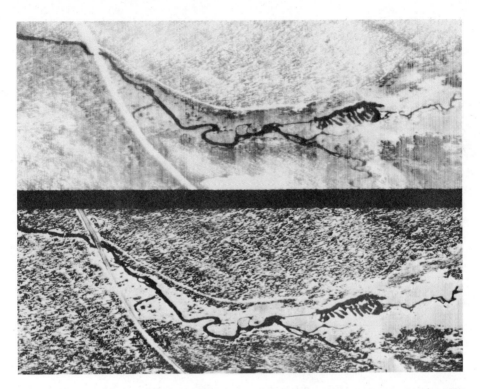

Figure 23.3. Thermal scanner imagery of a portion of a river and surrounding
countryside in western Oregon. The two images were recorded
simultaneously by two different detectors operating in different
regions of the thermal infrared spectrum. This is a daytime scan (2:50
P.M.) as indicated by the dark (cold) river and the light (warm)
highway. (Courtesy of the 1042nd Military Intelligence Company,
Oregon Army National Guard.)

Figure 23.4 is a thermal scan of part of the Oregon State University campus
taken at 10:30 P.M. in the winter to find heat loss from poorly insulated buildings.
As expected the heat loss from green houses at A is high. Heat loss through the roof
of the building at B is low but heat vents in the roof are clearly evident. The same
building however shows considerable heat loss through the windows. Warm side-
walks surrounded by cool moist grass can be seen at C along with the insulating
effects of trees. The fieldhouse at D shows up as quite cool because it is generally
unheated. Another interesting observation is the clear separation of recently parked
cars with engines still warm as contrasted to cars with cold engines in parking lots at
E and elsewhere. The light linear features at F and elsewhere are underground heat
tunnels from the central heating plant to various campus buildings. Some of these

TABLE 23.1 Emissivity of Selected Materials as Determined in the 8- to 12-μm Wavelength Region

Material	Emissivity
Granite	0.815
Dunite	0.856
Obsidian	0.862
Feldspar	0.870
Granite, rough	0.898
Silica sandstone, polished	0.909
Quartz sand, large grains	0.914
Dolomite, polished	0.929
Basalt, rough	0.934
Dolomite, rough	0.958
Asphalt paving	0.959
Concrete walkway	0.966
Water, with thin film of petroleum	0.972
Water, pure	0.993

Adapted from Buettner and Kern (1965).

tunnels are under streets or sidewalks, while others are under several feet of soil. Unnecessary heat losses (leaks) were detected as a result of this imagery.

Distortion

There are several types of distortion associated with scanner imagery. First, topographic distortion is at right angles to the *nadir line* (a line directly below the flight path) in contrast to being radial from the *nadir point* on a photograph.

Second, because of the greater distance from the scanner to the ground, at both ends of the scan line, than directly beneath the aircraft, the *ground* resolution cell of the detector is smaller at the ends of the scan line. The scanning mirror rotates at a constant *angular* rate while the imagery is recorded at a constant *linear* rate causing compression at the edges of the image. This type of distortion can be corrected when data on magnetic tapes are recorded onto film using an electronic correcting device.

Third, scanner imagery, like photographic imagery, is subject to distortion caused by *x* and *y* tilt, but it is called *pitch* and *roll*. Pitch corresponds to *y* tilt (nose up or down) while roll corresponds to *x* tilt (wing up or down). Roll is usually the most serious. Most scanners incorporate a gyroscopic system to compensate for aircraft roll up to about 10°.

Still another form of distortion is caused by the aircraft not flying in a perfect straight line. This causes the scan lines to be compressed on one side of the nadir line

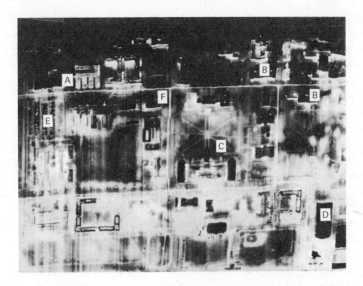

Figure 23.4. Thermal scanner image of a portion of the Oregon State University
campus taken in the winter at night. The light-toned detail is warmer
than the darker tones. See text for more detail. (Courtesy of the
1042nd Military Intelligence Company, Oregon Army National
Guard.)

and spread apart on the other side. Crosswinds causing *yaw* (crab) also cause
distortion throughout the image.

Effects of Weather, Electronic Noise, and Processing

These effects cannot be called distortion but they can become bothersome and
must be considered. Patchy clouds create patchy warm and cool patterns. In
addition, scattered showers produce a pattern of streaks parallel with the scan lines.
Even surface winds can produce smears and streaks. Wind streaks are usually
downwind from an obstruction and appear as warm plumes.

Transmissions from aircraft radios also cause strong interference patterns and
processing effects create noticeable differences. For example, the processing opera-
tor may have to abruptly shift the recording base level to stay within the optimum
range.

Time of Day

One difference between day and night thermal imagery is that there is more
reflected radiation during the day than at night.

Geologists prefer nighttime thermal scanner imagery because the thermal
effects of different solar heating and shadowing are reduced and geologic features

are better defined. Topography is the dominant feature of daytime thermal images of rough terrain because of differential solar effects.

Just before dawn, images of different ground objects tend to be closer to thermal equilibrium than at any other time. After sunrise, this equilibrium is changed as different objects warm up at different rates and reach a maximum radiant temperature in the afternoon. Maximum scene contrast also occurs at about this time.

Different materials not only heat and cool at different rates, but they also have different ranges between minimum and maximum temperatures. Water is a substance with a relative narrow diurnal temperature difference as compared to soil and vegetation. Water is usually cooler than its surroundings during the day and therefore shows up dark on daytime thermal imagery. However at night it is frequently warmer and shows up on thermal imagery in lighter tones. This means that at least twice during a 24-hour day water would be the same temperature as its surroundings and would be undetectable. This is known as the *crossover* phenomenon and occurs with substances other than water.

The thermal signatures of water bodies in relation to their surroundings are a reliable indication as to the time of day of image acquisition. On the other hand, damp ground is cooler than dry ground, both during the day and at night because of the cooling effect of evaporation. The *transpiration* of water from green vegetation also creates a cooling effect. This creates relatively cooler daytime signatures for deciduous vegetation when transpiration is high as compared to nighttime signatures when transpiration is low. Dry vegetation has a warm nighttime signature as compared to bare soil because of its insulating effect.

MULTISPECTRAL SCANNERS

A multispectral scanner (MSS) is very similar in design and operation to the thermal scanner just discussed. It has a rotating or oscillating mirror that scans perpendicular to the line of flight and the forward movement of the aircraft advances the scanline to form a two-dimensional image. The difference is that the MSS system separates the incoming radiation into several discrete spectral bands that are independently sensed and recorded. The thermal scanner has only one detector element that usually operates in either the 3.5- to 5-m or 8- to 14-m range of the spectrum, or both, although there are other detectors available for sensing in other wavelengths.

In the MSS system (Figure 23.5) reflected and emitted wavelengths are separated by a *dichroic grating* and either a prism or a *diffraction grating*. The *reflected* wavelengths are separated into a series of discrete bands within the ultraviolet, visible, and reflected infrared wavelengths by means of a prism or diffraction grating. The dichroic grating separates the *emitted* infrared wavelengths into discrete bands. A separate detector element is then used to independently measure each discrete band. The signals from each detector are amplified and stored on magnetic tape using a multichannel tape recorder. The data can also be recorded on a CRT

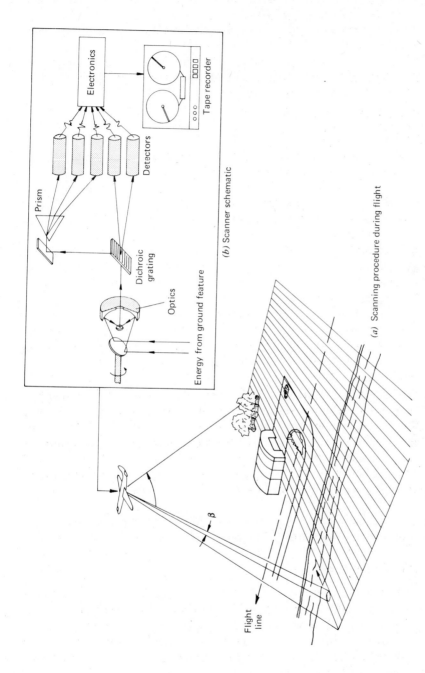

Electronics

Tape recorder

Detectors

Prism

Dichroic grating

Optics

Energy from ground feature

(b) Scanner schematic

β

Flight line

(a) Scanning procedure during flight

Figure 23.5. Schematic diagram of a typical scanner coverage (bottom). (From T. M. Lillesand and R. W. Kiefer, 1979, *Remote Sensing and Image Interpretation*, copyright 1979, John Wiley and Sons, Inc., reprinted with permission.)

tube or on photographic film, but the preferred mode of storage is on tape for later geometric rectification and digital analysis. Storage of digital data on computer tape preserves the maximum resolution as compared to photographic storage where some resolution is lost.

Multispectral scanners range from two-channel systems such as the spaceborne scanner on one of the meteorological satellites weighing only 18 lb to Bendix Corporations airborne 24 channel system weighing 2800 lb.

Advantages of MSS systems as compared to photographic systems are summarized as follows:

1. The simultaneous collection of data in all bands avoids the problem of registration among bands, a common problem with multiband camera systems. Exactly the same scene is simultaneously recorded in each band.
2. The entire range of the spectrum from the ultraviolet to the thermal infrared regions can be sensed with the same optical system to collect data in all bands.
3. Because multispectral data are generated electronically, they are easier to calibrate and telemeter through space. Thus, a supply of film is not required. This feature is essential for the use of unmanned spacecraft as data platforms (prior to the Space Shuttle).
4. Individual bands of the MSS systems can be color coded and one or more bands can be combined to produce a true color or an almost unlimited number of false color renditions. A similar product can be produced using multiband photography, but exact registration of the selected bands is easier with the MSS system.
5. The data collected and displayed can be either visually interpreted and/or computer interpreted including computer assisted interpretation. Thus, vast amounts of data can be economically interpreted and summarized in a short period of time. Again this function can be achieved using photographic film but the film must be first be scanned with a microdensitometer, at a loss in resolution. The advantage of the MSS system is that the image is originally in computer form.

The primary advantages of photographic systems as compared to MSS systems are reduced costs and better resolution.

Questions and Problems

1. Name the three primary components of an optical-mechanical scanning system and draw a diagram illustrating how an optical-mechanical scanner collects data from which an image can be made.
2. Topographic displacement on an aerial photograph radiates from the nadir point. How does topographic displacement differ for an optical-mechanical scanner image?

3. Because the scanning mirror rotates at a constant *angular* rate while the resulting imagery is recorded at a constant linear rate, the resulting imagery is distorted. What would be the general shape on an uncorrected scanner image of a linear feature on the ground that goes diagonally across the image?

4. Define the phenomenon of *crossover* and state how it affects the interpretation of thermal imagery taken at different times during a 24-hour day.

5. Other than the fact that thermal scanners operate only in the thermal band of the spectrum, explain the primary difference between thermal and multispectral scanners.

6. List five advantages and two disadvantages of multispectral scanning systems as compared to photographic systems.

Twenty-Four
Imaging Radar

Radar *is classified as an active remote-sensing system because it provides its own source of energy to "view" the terrain. The word* radar *is an acronym for* Radio Detection And Ranging, *which implies that it operates in the radio and microwave regions of the electromagnetic spectrum.*

Some types of radar produce picturelike images, but others do not. A common nonimaging radar is the one used by law enforcement and other agencies to determine the velocity of moving objects. These systems use Doppler *frequency shifts, which are functions of the relative velocities of the transmitter and reflector to measure velocity. A radar altimeter is another example of a nonimaging radar system.*

Still another form of radar is the plan position indicator *or* PPI. *This system produces an image, but the resulting resolution is so poor that it is not used for remote sensing except for weather prediction and navigational purposes. PPI systems produce a circular display that indicates image positions using circular sweeps, requiring a moving circular antenna.*

In this chapter we limit our discussion to an overview of side-looking airborne radar, a system that uses a fixed antenna that looks to the side of a moving aircraft to produce high-quality imagery.

Objectives

After a thorough understanding of this chapter you will be able to:

1. State what the acronyms RADAR and SLAR stand for.
2. State the range of wavelengths for the Ka, X, and L radar bands and explain why random letters were assigned to designate the different radar bands.
3. Draw a diagram to illustrate the following directions or distances associated with a SLAR unit: azimuth direction, range direction, slant range distance, and ground range distance.

4. Name and describe the primary function of the six basic components of a SLAR system.
5. Explain what controls the resolution of SLAR imagery in the azimuth and range directions and state what can be done to improve this resolution.
6. State the difference between real and synthetic aperture SLAR and state the primary advantage and disadvantage of each.
7. State what controls the scale of a radar image in the azimuth and range directions.
8. Briefly describe the purpose and function of the *inertial navigator* that is used when obtaining radar imagery.
9. Briefly explain *cross-polarized* and *parallel-polarized* radar imaging systems.
10. Explain the similarities and differences in topographic displacement on a radar image as compared to (1) scanner, and (2) photographic imagery.
11. List four types of displacement, distortion, or other type of SLAR image irregularity.
12. List three different ways in which stereoscopic SLAR imagery may be flown.
13. List and briefly discuss six advantages and two disadvantages of SLAR imagery as compared to photographic imagery.
14. List four recent or possible future advancements in the technology of SLAR that are of major significance.

SIDE-LOOKING AIRBORNE RADAR

The acronym, SLAR, stands for *Side-Looking Airborne Radar*. This active imaging system creates a two-dimensional image by transmitting and receiving short bursts of energy to the side of a moving aircraft. This forward movement of the aircraft produces the second dimension of the image similar to that of an airborne scanner.

Different SLAR systems operate at different wavelengths ranging from about 0.8 to 100 cm with random letters assigned to the different wavelength bands. Random letter designations were originally assigned by the military because of the classified nature of early radar development. SLAR was developed in the 1950s to obtain imagery over unfriendly terrain without having to fly directly over the area being imaged. These letter designations and wavelengths are shown in Table 24.1. The shorter wavelengths produce the best resolution but the longer wavelengths are better for the penetration of clouds and rain. Most of the imagery obtained today is in the Ka, X, and L bands.

TABLE 24.1 Radar Wavelengths and Designated Random Letters

Band Designation	Wavelength (cm)
Ka	0.8 to 1.1
K	1.1 to 1.7
Ku	1.7 to 2.4
X	2.4 to 3.8
C	3.8 to 7.5
S	7.5 to 15.0
L	15.0 to 30.0
P	30.0 to 100.0

From Sabins (1978).

Terminology

Before describing how a radar system works we must become familiar with new terminology with reference to Figure 24.1. The direction of the line of flight is the *azimuth* direction and the *range* or look direction is at right angles to the azimuth direction. The *ground range* is the *ground* distance at right angles to the azimuth direction from the nadir line to a given point being imaged and the *slant range* is the *air* distance from the sensor to the ground point, also in the range direction. The slant range distance always exceeds the ground range distance but the difference between these distances becomes less and less as the range increases.

Like optical-mechanical scanner imagery, radar images have a *nadir line* instead of a *nadir point*. However, because SLAR looks to the side the nadir line is not down the center of the image unless the unit is imaging both to the right and left.

Figure 24.1. Schematic diagram of SLAR direction terminology.

RADAR systems can look to either or both sides of the aircraft, if two antennas are used. Distances up to as much as 100 km can be imaged with a single flight line. Because of this feature and its nearly all-weather capability, SLAR is an ideal military imaging system.

Components and Operation of a Typical SLAR System

The basic components of a typical SLAR system (Figure 24.2) include (1) a pulse generator, (2) a transmitter, (3) a switch or duplexer, (4) an antenna, (5) a receiver, and (6) a data-storage device such as a CRT (cathode ray tube or television screen) and camera.

The pulse *generator* produces very short (1 to 2 μs) bursts or pulses of microwave energy that are transmitted to the earth in the range direction. Because the same antenna both transmits and receives the radar pulse, an electric switch (duplexer) prevents interference between the transmitted and received pulses. The switch blocks the receiver during transmission and blocks the transmitter during reception.

The *antenna* focuses the pulses for transmission and collects the energy return as it is reflected from the terrain. The *receiver* is similar to an ordinary radio receiver that amplifies the weak energy waves collected by the antenna. This amplified energy is displayed on a CRT and recorded on film.

The printed scan line illustrated in Figure 24.3 is a single scan line. Additional and adjacent scan lines are made possible by the movement of the aircraft to produce a two-dimensional image. Also shown is a graph of a single pulse plotted as a function of the return intensity over a two-way pulse *travel time* scale. By electronically measuring the return time of the pulses (echos), the range distance between the transmitter and terrain objects can be determined using the known

Figure 24.2. Basic components of a typical SLAR system. (From Floyd F. Sabins, Jr., *Remote Sensing: Principles and Interpretation*, W. H. Freeman and Company. Copyright 1978, reproduced with permission.)

velocity of energy propagation. This *radar-ranging* principle of electronic distance measurement is common to all imaging radar systems.

The intensity of the returned pulse is a complex function of the interaction between the terrain and the transmitted pulse. Although this interaction is not completely understood, the following observations are well known. The front of a mountain (Figure 24.3) has a strong return (light image) because of its more perpendicular orientation relative to the antenna, while the back of the mountain has no return at all causing a dark image or *radar shadow*. Vegetation produces a speckled image of intermediate intensity and metallic objects like bridges produce very strong returns. Calm water produces dark tones because the radar impulses are

Figure 24.3. Ground coverage and signal processing of a pulse of SLAR energy. (From Floyd F. Sabins Jr., 1973, copyright 1973, by the Association of Engineering Geologists Special publication, reproduced with permission.)

reflected away from the antenna. For the same reason, other smooth surfaces such as airport runways, highways, beaches, dry lake beds, etc. also produce dark images.

Resolution

The SLAR resolution cell has two dimensions (azimuth and range) that are controlled by different features of the system. The combination of range and azimuth resolution determines the minimum size of the ground resolution cell. Resolution in the range direction is controlled by the *duration* of the transmission of an individual pulse called *pulse length*. For two objects to be resolved separately in the range direction, the returned signals must be received separately by the antenna. Resolution in the azimuth direction is determined by the *width* of the radar beam. To be resolved on the ground, two objects must be separated in the azimuth direction by a distance greater than the width of the transmitted beam.

Range Resolution

Slant range resolution is equal to one-half the pulse length. For example, a 0.1-μs pulse length is 30 m long, yielding a slant range resolution of 15 m. Thus *slant* range resolution, but not *ground* range resolution, is independent of the distance from the aircraft. Ground range resolution depends on the depression angle (see Figure 24.1) and can be calculated by dividing the slant range distance by the cosine of the depression angle. For example, the cosine of 35° is 0.819, which results in a ground range resolution of 18.3 m in our example. In Figure 24.4, objects at A and

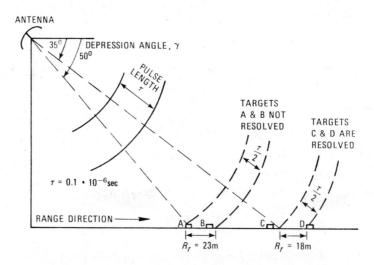

Figure 24.4. Radar resolution in the range direction. (From D. J. Barr, 1969, U.S. Army Engineer Topographic Laboratories, Tech. Report 46-TR.)

B are not resolved in the near range because they *are* both within the slant range distance of one-half the pulse length and are not received separately by the antenna. On the other hand, objects C and D in the far range, which are the same *ground* distance apart as A and B, are resolved because both objects are *not* within one-half the slant range distance. Objects C and D are therefore received separately by the antenna. Thus a peculiarity of SLAR is that *ground range resolution improves* as the distance from the aircraft increases.

An obvious way to improve range resolution would be to shorten the pulse length. But this reduces the total amount of energy transmitted by each pulse and a strong pulse return is required for good imagery. However, recent advances in technology have been developed to shorten the *apparent* pulse length while maintaining a sufficiently strong pulse return.

Azimuth Resolution

Azimuth resolution is determined by the beam width which, for real apertures, fans out as the range increases (Figure 24.5). Thus objects at A and B are resolved in the near range because the beam width is less than the distance between the objects. On the other hand, targets at C and D are not resolved in the far range even though they are the same distance apart as objects A and B because the beam width is wider

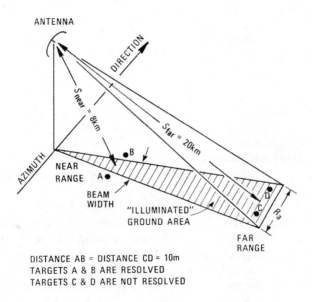

Figure 24.5. Radar resolution in the azimuth direction for real aperture SLAR. (From D. J. Barr, 1969, U.S. Army Engineer Topographic, Laboratories Tech. Report 46-TR.)

in the far range. Thus, *azimuth resolution decreases* with an increase in range, whereas, resolution in the *range direction increases* with an increase in range.

Real and Synthetic Aperture SLAR

The two basic types of SLAR systems are *real aperture* (brute force) and *synthetic aperture.* They differ in the method of achieving resolution in the azimuth direction. The actual mechanics of how they operate is beyond the scope of this book. However. in general we can state that azimuth resolution is proportional to the antenna length. Therefore, real aperture or "brute force" systems use antennas of maximum practical length to produce a narrow beam for better resolution. The maximum length is limited by the size of the aircraft (or spacecraft).

To help overcome this problem, synthetic apertures have been developed in recent years. These systems use relatively short antennas that produce a moderately wide beam. The Doppler principle and sophisticated data processing techniques are used to *synthetically* produce the *effect* of a long antenna and a narrow beam width resulting in improved resolution. This is a very powerful technique. For example, a synthetic aperture system with a physical antenna of only 2m can synthetically produce the effect of a 600-m brute force antenna (Figure 24.6).

Brute force systems are relatively simple in design, are less expensive, and require less maintenance than synthetic aperture systems. On the other hand, coverage in the range direction is limited and only the shorter wavelengths can be used if high resolution is required. Synthetic aperture systems overcome these problems, but at a much greater cost and complexity of design, operation, and image production.

Scale

The scale and appearance in the range direction are a function of the speed of electromagnetic energy propagation. The scale and appearance in the azimuth direction is a function of the speed of the aircraft and the rate of advancement of the image recording film. Reconciling and equalizing these two independent scales on the final image is a difficult and demanding problem in making accurate maplike radar images.

This and many other complex problems involved in the production of high-quality SLAR images have been solved by the use of an *inertial navigator* installed in the aircraft. The *inertial navigator* uses a computer that is programmed to provide a wide variety of information and control requirements. It guides the aircraft above or through clouds during the day or at night and at the right elevation. It also assures that each flight line is almost exactly parallel to the previous one so that a mosaic can be made. It keeps the aircraft on course in a disciplined mode that avoids erratic maneuvers that would distort the image. The inertial navigator's angular sensors control the attitude of the radar antenna in the three angular coordinates so that the antenna is always pointed at the terrain at the same angle with respect to the aircraft's line of flight. The output of the inertial navigator also meters the rate at which the radar pulses are emitted and the velocity

Figure 24.6. *Synthetic aperture* SLAR (bottom) produces much better resolution than *real aperture* (brute force) SLAR (top). (Courtesy of Goodyear Aerospace Corporation and Aero Service Division of Western Geophysical Corporation of America.)

at which the imaging film is advanced. Thus, the speed at which the moving spot travels across the CRT display controls the image scale in the range direction and the speed of the image-recording film controls the scale in the azimuth direction.

Polarization

The transmitted energy pulse may be polarized in either the horizontal or vertical plane. After striking the earth and returning, most of the energy is still in the same plane but a portion of the energy has been depolarized by the interaction with the earth. Some systems have a second antenna that receives the returned wavelengths that are at right angles to the transmitted pulse. This is known as *cross-polarized* imagery and may be either HV (horizontal transmit, vertical return) or VH (vertical transmit, horizontal return). Without the second antenna the resultant imagery is *parallel polarized* (HH or VV). Most imagery is obtained in the HH mode because this produces the strongest return. However it is difficult to say that one mode is any better than another because it varies with different situations. Sometimes HH and HV polarizations are used simultaneously.

Distortion, Displacement, and Other Irregularities

Another difference between photographic and radar imagery is that topographic displacement of high elevations relative to the nadir *point* or *line* on a radar image is *toward* the nadir *line* rather than away from the nadir *point* on a photograph. This is because SLAR is a *distance-* and not an angle-measuring system. Because SLAR operates to the side, the distance and therefore the time required for the transmitted pulse to travel to and return from the top of a mountain is less than the time required for a return from the base of the mountain. This is called the *layover* effect where tall features appear as though they are leaning toward the nadir line. This effect is more severe in the near than in the far range.

Because topographic displacement is perpendicular to the nadir line on a radar image there is no topographic displacement in the azimuth direction. In general there is less topographic displacement in a SLAR imagery than in conventional photography making SLAR an excellent base for mapping and the construction of mosaics.

SLAR imagery can be presented either as a ground range or slant range display, depending on the design of the image recording system. *Slant range* displays are distorted by a compression of scale in the near range of the image because the time interval between transmission and reception of the return signal is proportional to the slant range and not the ground range distance. *Ground range* displays are not distorted because the CRT sweep incorporates a timing correction to compensate for these travel time differences between the near and far ranges.

Other irregularities of SLAR imagery include *side-lobe banding, back scatter* from precipitation, and the effects of aircraft motion such as pitch (*y* tilt), *roll* (*x* tilt), and *yaw* (crab). *Side-lobe banding* (caused by secondary pulses of transmitted energy) often creates bright bands in the image parallel to the line of flight. This

irregularity is more pronounced in the near range and on cross-polarized images than in the far range and parallel-polarized images. Heavy rain, snow, and sleet will cause short wavelength radar (Ka band) to backscatter, that is, the transmitted pulse is returned by weather and not the terrain, causing shadowed streaks on the image in the range direction. In fact this is the principle used by weather radar. Generally weather has little or no effect when wavelengths of 3 cm or longer are employed.

Just as x tilt and y tilt creates a displacement on a photographic image, aircraft pitch and roll creates a similar displacement on a radar image. Most antennas have stabilization systems to accommodate normal aircraft pitch and roll but severe image displacement is created when the normal limits are exceeded.

Stereoscopic SLAR

Stereoscopic SLAR imagery (Figure 24.7) can be viewed with an ordinary stereoscope using adjacent overlapping flight strips. Stereoscopic SLAR models can also be produced by imaging the same terrain from two different look directions or from two different flying heights to produce different viewing angles of the same terrain. Object heights can be calculated using parallax differences measured on SLAR imagery, but the actual method is beyond the scope of this book.

SLAR Mosaics

High-quality SLAR mosaics (Figure 24.8) are now possible using synthetic aperture systems, the same look direction for different strips, and only the far range of each strip. Using the same look direction causes the radar shadows to fall in the same direction and using only the far range results in more consistent shadow lengths, less layover and better resolution. However, SLAR imagery acquired for mapping rather than for interpretation purposes requires a very complex array of navigation and control systems within the aircraft, the inertial navigator.

Advantages of SLAR

The advantages of SLAR can be summarized as follows:

All-Weather Capability

There are portions of the earth that have never been photographed or mapped because of their remote locations and/or they are hidden by an almost continuous cloud cover. A good example is Darian Province, Panama. This province had never been completely mapped until 1967 when it was mapped using SLAR imagery. Besides mapping new portions of the province, SLAR imagery was used to correct any errors on existing maps—some of them major errors.

Long-wavelength SLAR can operate through nearly all atmospheric conditions (Figure 24.9). The general rule is if the weather will permit the plane to fly, SLAR imagery can be obtained. Very heavy rain will have some effect on the 3-cm wavelength energy of X-band SLAR, but no effect on the 25-cm L-band SLAR.

Figure 24.7. Stereoscopic SLAR. This Stereogram was produced by imaging the same terrain from two adjacent overlapping flight strips at the same altitude. (Courtesy of Goodyear Aerospace Corporation and Aero Service Division of Western Geophysical Corporation of America.)

Figure 24.8. Portion of a high quality mosaic of the San Diego bay area in California, PSR M 1:250,000. This is the radar image that was combined with a Landsat image of the same area to produce Plate VII (bottom). (Courtesy of Goodyear Aerospace Corporation and Aero Service Division of Western Geophysical Corporation of America.)

Between 1971 and 1976, the rain forests of Venezuela and Brazil were imaged by radar. Today, this type of imagery and maps made from it provide the primary source of inventory information about potential mineral, forest, range, and water resources for much of the world's remote and/or cloud covered areas.

Nighttime Capability

SLAR imagery can be obtained both during the hours of daylight and darkness. This allows its use at high latitudes during periods of winter darkness to monitor the surface of the ocean and to determine wind, wave, and ice conditions. This nighttime, as well as all-weather capability makes SLAR an ideal military reconnaissance system.

Long Lateral Coverage

Because SLAR has a range of up to 50 or more km to one side, the aircraft can fly over friendly territory while imaging the enemy—another military advantage. As a civilian use this long lateral coverage allows the imaging of vast amounts of terrain with few flight lines, especially if imaging both sides of the aircraft.

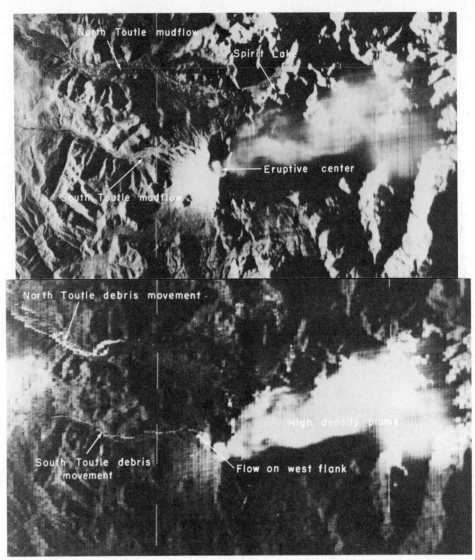

Figure 24.9. Satisfactory SLAR imagery can be obtained through almost any atmospheric condition as evidenced by the image of Mt. St. Helens shown at the top of the page. The SLAR image at the bottom was taken in the "moving target indicator" mode. Note that the ash plume and the Toutle River mud flows (debris movement) are more evident in this mode while the stationary features are less evident. Both images of Mount Saint Helens were obtained on May 18, 1980 during one of the heavy eruptive phases. (Courtesy of Dr. Charles L. Rosenfeld, Oregon State University, Department of Geography, the 1042nd Military Intelligence Company, Oregon Army National Guard and the *American Scientist*, copyright 1980, Vol. 68, No. 5.)

Enhancement of Geologic Features

The oblique illumination of terrain features by the radar pulse creates a shadow effect that enhances topographic features of geologic significance such as faults, fractures, and lineaments.

Suppression of Detail

For many uses the suppression of minor detail and the poor resolution of SLAR as compared to the photographic mode is a distinct advantage. The suppression of vegetative cover and minor cultural detail sometimes helps the interpreter identify larger terrain features of interest—particularly the geologist.

Limited Geometric Distortion

Because SLAR produces long, continuous, and wide strips of imagery with a minimum of geometric distortion, maps and radar mosaics are easily made for regional analysis of geologic and other features.

Disadvantages of SLAR

SLAR has many more advantages than disadvantages. However, the major disadvantage—the relatively poor resolution of SLAR as compared to photographic imagery—is a major one for many applications. Because of this, radar imagery is seldom produced at scales greater than 1:125,000. However, these two systems are not in competition. Instead the systems are complementary—each with advantages for specific applications. Frequently the maximum information obtained by remote sensing is obtained by the combined use of photographic, SLAR, and scanner imagery.

The Future of SLAR

Even though recent advances in SLAR technology have been major accomplishments, it is felt that future advances will be just as significant. Because the early development of SLAR was accomplished by the military it was classified for security reasons. It was not until the middle and late 1960s that radar technology was partially declassified. It has taken the civilian sector a few years to catch up and develop new technology and new applications. Many feel that the most recent technological developments made by the military are still classified—particularly in the area of resolution improvement.

Recent advancements in technology include the display of SLAR imagery on color film (Plate VIII top left) and the adaptation of SLAR for use on satellites. The latter accomplishment was achieved by the development of synthetic aperture systems for improved resolution and the development of new power systems that do not excessively drain the satellites' limited power supply. It must be remembered that radar is an active system that provides its own power. The Seasat satellite had L-band SLAR capability during its short period of operation, and the space shuttle missions scheduled for the 1980s will have SLAR capabilities.

Research is just beginning with the very long wavelengths of SLAR to study subterranean features. Other possibilities for future radar development include more research on combining radar imagery with other kinds of imagery, the development of multispectral radar, and further research with a variety of polarization modes. In fact, the Environmental Research Institute of Michigan has already developed a multifrequency, multipolarized synthetic SLAR system.

Goodyear Aerospace and the Aero Service Division of Western Geophysical Corporation of America have worked together to combine images made by SLAR with images made by the *Landsat* multispectral scanner. This combination of imagery preserves the distinctive capabilities of both systems. These combinations of color Landsat imagery become more significant with the added enhancement of land forms and rich detail of radar imagery (Plate VII). The future of SLAR is bright!

Questions and Problems

1. What do the acronyms RADAR and SLAR stand for?
2. What are the ranges in wavelengths within which Ka, X, and L band radar operate? Why were they designated as the Ka, X, and L bands?
3. Draw a diagram to illustrate the following: azimuth and range directions, and slant range and ground distances.
4. Name and describe the primary functions of the six basic components of a SLAR system.
5. What controls the resolution of SLAR imagery and what can be done to improve the resolution? Be sure to include resolution in both the azimuth and range direction.
6. What is the primary advantage of a synthetic aperture as compared to a real aperture SLAR system?
7. Fully define the following terms as they relate to SLAR: duplexer, inertial navigator, and layover.
8. What is the difference between parallel polarized and cross polarized SLAR systems?
9. List three different ways in which stereoscopic SLAR imagery is flown.
10. List and briefly discuss six advantages and two disadvantages of SLAR imagery as compared to photographic imagery.
11. List four recent or possible future advancements in SLAR technology of major significance.
12. See the questions at the end of Chapter Twenty-five for further questions relating to both scanner and SLAR imagery.

Twenty-Five

Landsat

Even a brief introduction to nonphotographic remote sensing would be incomplete without mention of the Landsat series of unmanned satellites. These satellites were developed specifically to collect earth resource data. The program, initiated in 1967, was originally designated ERTS (Earth Resources Technology Satellites). The prelaunch designations were ERTS-A, B, C, and so forth and the successful postlaunch designations were to be ERTS-1, 2, 3 and so forth. However, just prior to the launch of ERTS-B in 1975, the program name was changed from ERTS to LANDSAT to distinguish it from Seasat[1], the oceanographic satellite program.

At the time of this writing, three Landsat space vehicles have been successfully launched: Landsat-1 on July 23, 1972, Landsat-2 on January 22, 1975, and Landsat-3 on March 5, 1978. Additional launches are scheduled for the future.

Objectives

After a thorough understanding of this chapter you will be able to:

1. Draw a diagram and with words describe how Landsat orbits the earth to obtain coverage of almost the entire earth at 18-day intervals.
2. List and describe briefly the two sensor systems utilized by Landsat. State the ground resolution in meters for both systems and for all three Landsat missions.
3. Explain how multispectral data is transferred from Landsat to the earth and then converted to an image.
4. Describe the two major changes in the imaging systems of Landsat-3 as compared to Landsats-1 and -2.
5. Explain why pitch, roll and topographic displacements are negligible on Landsat imagery.

[1] *The first Seasat vehicle lasted only a very short time before disintegrating and only a small amount of imagery (Radar) was obtained.*

6. Explain why vertical exaggeration of Landsat imagery is generally limited and why it is more at the equator than at the poles.
7. Briefly describe the operation of solid-state linear array remote sensors using pushbroom scanning.
8. Name and describe the three components of the Space Shuttle and describe the two modes of operation.
9. Briefly describe the main features of the large format camera being designed for the Shuttle.

LANDSATS-1 AND -2

Landsats-1 and -2 carry the same sensor systems, are essentially in the same orbits, and can therefore be described together. A drawing of the vehicle is shown in Figure 25.1. It is about 1.5 m by 3 m (5 ft by 10 ft) in size and weighs about 959 kg (2100 lb). When fully extended, the solar panels increase the width to 4 m (13 ft).

Orbital Characteristics

The Landsat series is in a nearly polar orbit (Figure 25.2) at a nominal altitude of 917 km (570 miles). Thus, as the earth turns on its axis, nearly complete coverage of the earth is obtained. The orbit is sun synchronous, which means that the orbit plane proceeds about the earth at the same angular rate that the earth moves about the sun. This feature enables the spacecraft to cross the equator at the same *local sun* time (between 9:30 and 10:00 A.M.) on the sunlit side of the earth. Thus, the sun-synchronous orbit produces constant and repeatable sun angle conditions, which are essential for (1) the monitoring of changes that take place on the earth over time and (2) the production of high-quality mosaics. The early morning sun angle was selected to take advantage of shadows to enhance relief.

Each orbit takes about 103 min, which results in 14 orbits per day. Each successive orbit shifts westward about 2875 km (1786 miles) at the equator creating large gaps in coverage. However, on the following day, the 14 orbits are parallel to those of the previous day with a westward shift of only 159 km (99 miles) from the previous day's orbit (Figure 25.3). Thus, it takes 18 days to fill in the 2875-km gaps and therefore the entire earth, except for clouds and a small area near the poles.

Because each pass images a swath 185 km (115 miles) wide and the westward shift is 159 km, there is a 14 percent sidelap at the equator, which increases to approximately 85 percent at 80 degrees of latitude.

Sensor Systems

There are two imaging systems on board Landsats-1 and -2. One is a three-channel television system called RBV (return beam vidicon), but on Landsat-1 it was turned off early because of a switching malfunction and has been used very little in Landsat-2.

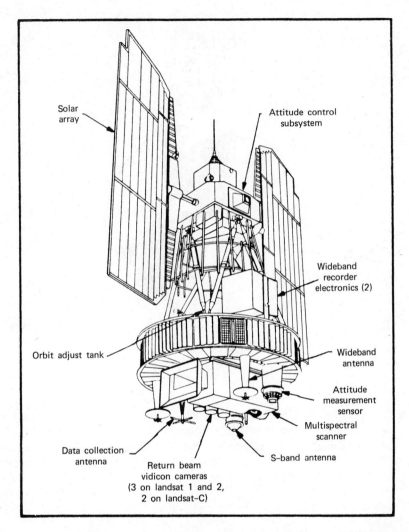

Solar
array

Attitude control
subsystem

Wideband
recorder
electronics (2)

Orbit adjust tank

Wideband
antenna

Attitude
measurement
sensor

Multispectral
scanner

Data collection
antenna

S-band antenna

Return beam
vidicon cameras
(3 on landsat 1 and 2,
2 on landsat-C)

Figure 25.1. LANDSAT space vehicle configuration. It is about 5 ft wide (with-
out the solar panels), 10 ft high and weighs approximately 2100 lb.
(From National Aeronautics and Space Administration's *LAND-
-SAT Data Users Handbook*, 1976.)

The three channels of the RBV system are designated as channels 1 to 3
respectively and have a resolution of about 80 m (262 ft). The RBV cameras do not
contain film; instead the images are temporarily stored on a photosensitive surface
and telemetered to receiving stations on the earth.

The second imaging system is a four-channel multispectral scanner (MSS),

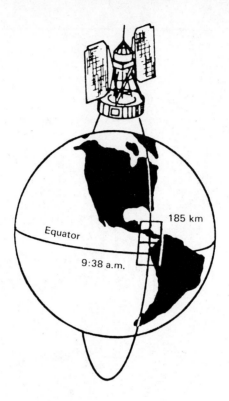

Figure 25.2. The LANDSAT space vehicle is sunsynchronous (constant sun angle) and is in a nearly polar orbit. (From N. M. Short, P. D. Lowman, Jr., J. C. Freden, and W. A. Finch, Jr., *Mission To Earth: LANDSAT Views The World,* 1976, courtesy of National Aeronautics and Space Administration.)

which produces a continuous image strip of scan lines covering a width of 185 km (Figure 25.4). These bands are designated as channels 4 to 7, respectively. The spectral regions of these bands are:

MSS Band Number	Wavelength, μm	Spectral Region
4	0.5 to 0.6	Green
5	0.6 to 0.7	Red
6	0.7 to 0.8	Photographic infrared
7	0.8 to 1.1	Photographic infrared

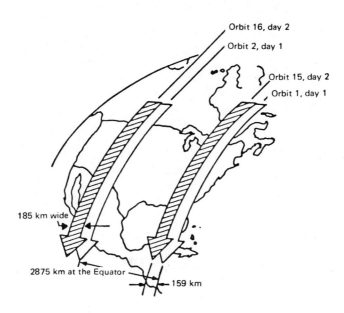

Figure 25.3. LANDSAT ground coverage pattern. There are 14 revolutions per day and global coverage requires 18 days. (From N. M. Short, P. D. Lowman, Jr., S. C. Freden, and W. A. Finch, Jr., *Mission to Earth: LANDSAT Views The World, 1976, courtesy of National Aeronautics Space Administration.)*

The reflectance data obtained by these four bands are first converted to electronic signals that vary in proportion to the intensity measured. The signals are then converted to digital form and telemetered to one of three receiving stations within the United States or to stations of participating foreign countries. Data can be collected by these receiving stations for a 2800-km (1700 mile) radius. Data obtained when the satellite is beyond this range are stored on magnetic tape for later transmission to earth when the satellite comes within range of one of the receiving stations.

This digital data is reformatted onto computer compatible tapes for analysis by researchers and users using a variety of computer programs. In addition to black-and-white renditions of single bands, color images are made from combinations of individual black-and-white images by projecting one or more bands through a particular filter. The usual combination consists of band 4 (green) projected through a blue filter, band 5 (red) projected through a green filter, and band 7 (infrared) projected through a red filter to produce an image that is equivalent to the standard color infrared photographic film. However, many other combinations can be produced to enhance various features of the earth's surface.

Because the satellite is extremely stable, tilt distortion is small and because the flying altitude of the spacecraft is great, topographic displacement is also small.

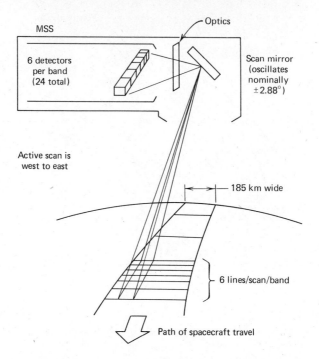

Figure 25.4. Multispectral scanner orientation. (From N. M. Short, P. D. Lowman, Jr., S. C. Freden, and W. A. Finch, Jr., *Mission to Earth: LANDSAT Views the World,* 1976, courtesy of National Aeronautics and Space Administration.)

Therefore, Landsat imagery is nearly orthographic and meets current national map standards at scales as large as 1:250,000. This feature along with the constant sun angle allows the production of large mosaics covering broad regions and even entire continents with relative ease and good accuracy.

Data Collection Platforms

The Landsat series is also employed to relay radio signals sent from data collection platforms (DCPs) located on the ground to the regular receiving stations. Data relayed by the DCPs consists of physical measurements such as water or soil temperatures, wind velocity, rainfall, or seismic activity recorded by ground sensors. This information helps to interpret the image or helps in other aspects of the experiment. DCPs are usually located in remote areas that are difficult to reach for data collection by ground personnel.

Stereoscopic Viewing

The MSS Landsat imaging system was not designed for stereoscopic viewing of the resulting imagery. However, it is possible to do so on a limited basis. Because MSS imagery is produced by a scanning system there is no parallax parallel to the line of flight, which makes stereoscopic viewing in the endlap portion impossible. However, a limited amount of parallax, and therefore an impression of relief is present when viewing images from two overlapping orbits.

The amount of parallax difference is small however because of the great flying height of the spacecraft. The impression of depth is maximum at the equator where the overlap is least but gets progressively less toward the poles where the overlap increases. There is a greater airbase to flying height ratio at the equator to produce more vertical exaggeration. Obviously there is no stereoscopic viewing possible where there is no overlap.

Despite the minimal vertical exaggeration, stereoscopic viewing of MSS imagery is a valuable aid for geologic interpretation. Future Landsat missions could be redesigned to improve stereoscopic viewing.

Because sterescopic viewing is a particularly valuable technique in the analysis of landform, a technique similar to the one used to produce stereomates for orthophotos (Chapter Eleven) has been developed for Landsat imagery. In this process each picture element of the Landsat image is offset in accordance to its relative position to create an artificial parallax to produce a three-dimensional effect when viewed stereoscopically. The relative elevation of each picture element must be obtained from some other source such as a topographic map.

LANDSAT-3

Two major changes were incorporated into the imaging systems of Landsat-3. First, a thermal band was added to operate in the 10.4 to 12.6-μm range. Thus the MSS became a five-band system with the thermal band designated as band 8. The thermal detector is cooled to about 100° K by a passive radiation cooler and has a nominal resolution of about 240 m (787 ft). Unfortunately, band 8 never became fully functional after launch and was turned off.

The second change was the halving of the resolution of the RBV system to about 40 m (131 ft). This was accomplished by doubling the focal length of the camera lens and halving the exposure time to reduce image motion. This in turn increases the scale, but reduces the coverage per frame. Therefore, two RBV cameras are mounted side by side to provide 183 km by 98 km coverage and, thus, a total of four scenes are required to cover the same area as the MSS system. The RBV system in Landsat-3 is a single-channel system with a spectral sensitivity range of from 0.505 to 0.750 μm.

INTERPRETATION OF LANDSAT IMAGERY

It was never intended that Landsat imagery would replace conventional aircraft photography. People who have thought that it would have been disappointed. The scale and area covered per scene is entirely different. Landsat imagery is designed for broad area coverage for the overall view. The existence or significance of certain large geologic features may be clearly evident on Landsat imagery but easily overlooked on conventional photography because of the large number of aerial photographs required to cover the same area. For example, it would take almost 7000 aerial photographs at a scale of 1:12,000 without overlap to cover the same area as covered by a single Landsat scene.

On the other hand, the scale and resolution of aerial photography is much better. The choice of imagery depends on the objectives of the interpreter. Frequently the most economic use of imagery is a combination of Landsat and conventional photography at several different scales as in a multistage sampling design. The Landsat image is used at the first stage and provides 100 percent coverage. Conventional photography is then used in subsequent stages in a sub-sampling process to obtain any degree of detail required. The last stage is either large scale photography or on-the-ground measurements.

In the past, regional land-use planning has been severely hampered by the lack of up-to-date maps and by inadequate means to handle and analyze the tremendous quantity of data involved. The Landsat system not only gathers the data, but it also puts them into digital form for analysis and summarization by computers.

The high frequency of repetitive coverage provided by Landsat is more than enough to allow for the annual update of maps and to follow changes over time. This is also possible with conventional photography but not on such a large scale and is generally not done even for small areas.

Landsat imagery is becoming extensively used in the fields of agriculture, forestry, range, geology, land-use planning, water resources, and environmental monitoring. These uses will continue to increase as technology continues to advance and as the user gains experience with this relatively new tool.

LANDSAT-D AND ITS THEMATIC MAPPER

At the time of this writing, Landsat-D is being built for launch in 1982. At present the plan is for it to carry a newly designed remote sensor called a *thematic mapper* (TM). It is not completely compatible with the sensors onboard the first three satellites of the series but has a higher designed resolution.

The TM is planned as a seven-band scanner with the bands chosen to maximize vegetation analysis, particularly agricultural applications. The following bands have been proposed.

Band 1 (0.45 to 0.52 μm)	For better penetration into water bodies and better analysis of soil and water characteristics
Band 2 (0.52 to 0.60 μm)	For a better look at the green reflectance peak of vegetation between two chlorophyll-absorption bands.
Band 3 (0.63 to 0.69 μm)	For better discrimination among vegetation types and between nonvegetated areas. This band is within one of the chlorophyll-absorption bands.
Band 4 (0.76 to 0.90 μm)	For emphasis of soil-crop and land-water differences and as in aid in crop identification.
Band 5 (1.55 to 1.75 μm)	For better identification of crop type, crop water content, and soil moisture.
Band 6 (2.08 to 2.35 μm)	For better identification of rock formations.
Band 7 (10.40 to 12.50 μm)	For better classification of vegetation types, vegetation stress, soil moisture, and other thermal conditions.

The first six bands will have a resolution of about 30 m (98 ft) and band 7 will have a resolution of about 79 m (259 ft), which is significantly better than the previous MSS systems.

The TM is a very complex system that requires extremely small manufacturing tolerances and exact mechanical control of the scanning mirror. The tolerances are so small that it is impossible to make further improvements in the future to lower the resolution below 30 m. The TM does not represent a major breakthrough in new technology. It is the result of evolutionary growth of the present Landsat MSS systems.

For further applications that may require resolution as high as 10 m or narrower spectral bands, a completely new type of sensor system is necessary. Such a system is now being developed using solid-state linear array technology. In fact it is thought by some (Colvocoresses, 1979) that this technology is far enough advanced so that it could replace the presently planned TM on Landsat-D.

SOLID-STATE LINEAR ARRAY REMOTE SENSORS

Pushbroom scanning is a term used to describe a new technique used to sweep a linear array of detectors across a scene using the forward motion of a satellite. There are no moving parts in this linear array of thousands of individual detectors

oriented perpendicular to the ground track across the scene being imaged as illustrated in Figure 25.5. A different array is used for each spectral band. The satellite motion provides the along-track dimension and the linear array of individual detectors provides the cross-track dimension.

A 30-m resolution sensor system requires 6300 individual detectors per spectral band and 800,000 parts per instrument to achieve the same coverage as obtained by the present Landsat MSS system. This is made possible with the use of solid-state integrated circuit technology in which a single monolithic chip of silicon can provide hundreds to over a thousand individual detectors (Thompson, 1979).

Pushbroom scanning has now matured to the point of application for the visible and photographic regions of the spectrum and arrays designed to operate within 1 to 5 and 8 to 14 μm thermal regions are planned for development over the next few years. These may be ready as early as 1984, and the first launch of a pushbroom scan sensor with all the spectral bands of the TM is anticipated by 1988 (Thompson, 1979).

Pushbroom scanning is possible from small spacecraft at much less cost than the present Landsat series (Figure 25.6) and can be designed for repeated stereoscopic coverage using front to back offset pointing (Figure 25.7).

Alden Colvocoresses (1979) and others suggested that a multi-spectral linear array (MLA) system be installed in Landsat-D. This suggestion is based on Tables 25.1 and 25.2. Table 25.1 compares various parameters of the proposed Landsats TM and the MLA system. Notice that the MLA system is compatible with Landsats-1, -2, and -3, and that the TM is not. The 25:1 cost ratio per scene in favor of MLA system is also an important factor (Table 25.2).

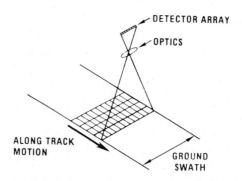

Figure 25.5. Geometry of pushbroom scan technique using a linear array of detectors. (From L. L. Thompson, 1979, *Photogrammetric Engineering and Remote Sensing,* copyright 1979, Vol, 45, No. 1, published by the American Society of Photogrammetry, reproduced with permission.)

THE SPACE SHUTTLE

The largest of NASA's current programs is the Space Shuttle, which is designed to operate in two modes. In the sortie mode it will orbit the earth for periods of from 3 to 30 days while the crew conducts remote sensing and other experiments before reentering the atmosphere for an airplane-like landing on the earth.

Operating in the other mode the Shuttle can carry individual spacecraft into orbit and build large space stations. It can also rendezvous with a free-flying satellite, place it into the cargo bay for servicing or return it to earth for a major overhaul.

The Shuttle consists of three components: (1) a pair of *solid fuel booster rockets,* (2) one large *liquid propellant tank,* and (3) *Orbiter* (Figure 25.8). Orbiter is about the size of a DC 9 aircraft with a cargo bay of 4.6 m (15 ft) in diameter by 18.3 m (60 ft) long, and a maximum payload of 30,000 kg (33 tons). The payload will

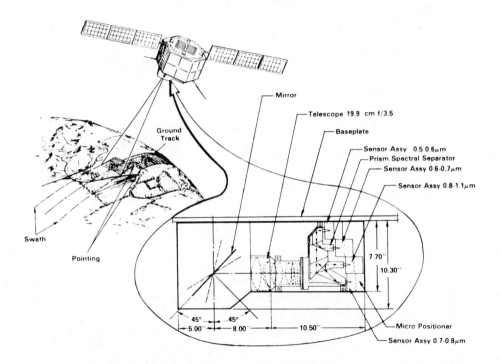

Figure 25.6. Proposed linear array sensor on a small spacecraft. (From R. A. Tracy and R. E. Noll, 1979, copyright 1979, *Photogrammetric Engineering and Remote Sensing,* Vol. 45, No. 1, published by the American Society of Photogrammetry, reproduced with permission.)

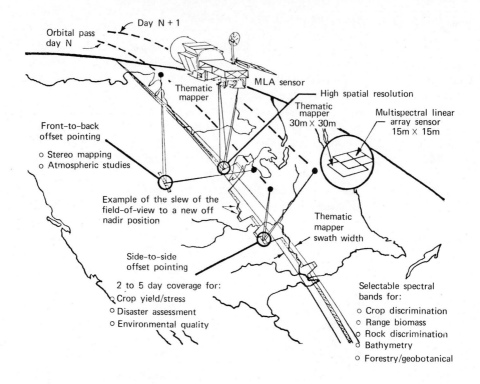

Figure 25.7.　Concept of a multispectral linear array sensor which provides repeated and stereoscopic coverage. (From L. L. Thompson, 1979, copyright 1979, *Photogrammetric Engineering and Remote Sensing,* Vol, 45, No. 1, published by the American Society of Photogrammetry, reproduced with permission.)

consist of a combination of pressurized modules in which crew members can work in a shirtsleeve atmosphere.

One of the major advantages of the Shuttle system is its economy. Both the Orbiter vehicle and the solid-state rockets are recoverable and reusable — only the liquid propellant tank is abandoned. The Orbiter vehicle is reusable for up to 500 missions with 100 missions between overhauls.

The shuttle will be launched by the solid-state booster rockets and liquid propellant tanks. When expended, the solid-state rockets are jettisoned and recovered via parachute. After reaching the proper orbit the liquid tank is jettisoned and abandoned. Present plans call for five vehicles and between 30 and 50 missions per year.

Initial launches will be from Cape Canaveral space center from which Orbiter can cover the earth between latitudes 57° N and 57° S. By 1983 it is anticipated that

TABLE 25.1 Parameters of Landsat Follow-On

	LANDSAT-D (TM)	Alternative (MLA)
Sensor	TM	MLA
No. bands	6 or 7	3
Resolution (IFOV)	30-50 m (5 or 6 bands)	30-40 m (1 band)
	120-180 m (1 band)	60-90 m (2 bands)
Data transmission rate	84-100 Mb/s	15 Mb/s
Data bits per unit area (normalized)	6	1
Expected life	2-4 yr	6-12 yr
Orbit altitude	716 km	919 km
Compatible with Landsats-1, -2, & -3	no	yes
Scenes per day	100	400
Processing complexity (normalized)	10x	x
Risk factor (based on complexity)	10x	x

From Colvocoresses (1979).

TABLE 25.2 Estimated Costs of Landsat Follow-On

	Landsat-D (TM)	Alternative (MLA)
Expected lifetime	1,000 days	3,000 days
Scenes per day	100	400
Total scenes	100,000	1,200,000
Processing per scene	1,000	$100
Satellite, launch, and operation	$ 300 M	$100 M
Upgrading foreign stations[a]	50 M	0 M
Data processing costs	100 M	120 M
Total	$ 450 M	$220 M
Cost per scene	$4,500	$180
Cost factor per scene[b]	25	1

From Colvocoresses (1979).
[a] *Assumes that 10 foreign reception stations will be built before launch of the TM or MLA; thus, basic station costs are not included.*
[b] *Scene value for TM and MLA is related as equal. TM has more spectral bands (six or seven to three), but with 30 m resolution (one band) MLA will have higher effective spatial resolution, higher geometric accuracy, and adequate radiometric fidelity. Moreoever, MLA imagery will be acquired in a daily pattern of adjacent paths whereas TM imagery will be obtained from a generally undesirable skip orbit, with at least 48 hours between adjacent paths.*

Figure 25.8. Orbiter component of the Space Shuttle showing the location of the large format camera (LFC). (From F. J. Doyle, 1979, copyright 1979, *Photogrammetric Engineering and Remote Sensing,* Vol. 45, No. 1, published by the American Society of Photogrammetry, reproduced with permission.)

launches can be made from Vandenburg Air Force Base and will allow polar orbits. Orbits are planned for altitudes between 200 and 1200 km. (124 and 746 miles). When fully operational, the Shuttle is expected to replace all expendable launch vehicles.

The Shuttle system has the potential for a wide variety of remote sensing applications from space. Orbiter can carry a variety of payloads and retrieve them for servicing or return to the earth. A primary payload is Spacelab, which is being built by the European Space Administration (ESA). Initially Spacelab will remain attached to Orbiter but later it is designed for independent operation.

NASA's plans are to develop Spacelab into an Earth Viewing Applications Laboratory (EVAL). There have been several proposals to ESA for earth observation satellites. France has proposed the SPOT Spacecraft, Germany the ARGUS Spacecraft, and the Japanese have proposed JEOS 1 through 5.

NASA is building a large-format camera (LFC) for the Shuttle. It has a 30.5-cm (12 in.) focal length and a 23 cm by 46 cm (9 in. by 18 in.) format. From an altitude of 300 km (186 miles) each frame will cover 225 km by 450 km (140 miles by 280 miles) and will have a ground resolution of 14 m to 25 m (46 ft to 82 ft) depending on the type of film used. With the long dimension of the frame in the direction of flight, there will be sufficient vertical exaggeration to permit

compilation of topographic maps with contours of 20 to 30 m (66 to 98 ft) intervals.

Initially the LFC will be carried in the cargo bay, but if photography from the sortie missions proves to be as useful as expected, the camera may be mounted in a free-flying spacecraft and positioned in a near-polar orbit. Here it would remain operational for many months, with film being recovered and returned to the earth by the Shuttle (Figure 25.9). Thus, for the first time, photogrammetrists will be able to compile 1:50,000 scale topographic maps from space photographs anywhere in the world.

OBTAINING LANDSAT AND OTHER NASA IMAGERY THROUGH EROS

The EROS Program

The Earth Resources Observation Systems (EROS) Program provides access to the National Aeronautics and Space Administrations (NASA'S) Landsat imagery, aerial photography acquired by the U.S. Department of the Interior, and photography and other imagery acquired by NASA from research aircraft and from Skylab, Apollo, and Gemini spacecraft. The primary functions of the center are data storage, reproduction, and user assistance.

Figure 25.9. Small satellite with large format camera being retrieved by the orbiter. (From F. J. Doyle, 1979, copyright 1979, *Photogrammetric Engineering and Remote Sensing,* Vol. 45, No. 1, published by the American Society of Photogrammetry, reproduced with permission.)

The EROS Program of the U.S. Department of Interior was established in 1966 and is administered by the U.S. Geological Survey. Its purpose is to apply remote sensing techniques to the inventory, monitoring, and management of natural resources. In addition to providing remotely sensed data at a nominal cost to scientists, resource planners, resource managers, and the general public, the EROS program includes research and training in the interpretation and application of remotely sensed data.

At the heart of the data center is a central computer complex that controls a data base of over six million images (as of January, 1975) and photographs of the Earth's surface features, performs searches of data on geographic areas of interest, and serves as a management tool for the entire data-production process. The computerized data storage and retrieval system is based on a geographic system of latitude and longitude, supplemented by information about image quality, cloud cover, and type of data. A customer's inquiry about availability of remotely sensed data may be about a geographic point location or a rectangular area specified by latitude and longitude corner coordinates. In conducting a geographic search based on a customer's request, the computer will print out a listing of available imagery and photography from which the requester can make a final selection. Receipt of a prepaid order initiates processing. To place an order, to inquire about the availability of data, or to establish a standing account order, you should contact:

> User Services
> EROS Data Center
> Sioux Falls, S.D. 57198
> Phone: (605) 594-6511, ext. 151
> FTS[2]: 784-7151

Questions and Problems

1. Draw a diagram and explain how Landsat orbits the earth to obtain almost complete coverage of the earth every 18 days.
2. What two imaging systems are onboard the Landsat series? Briefly describe the sensing bands of both systems and state the difference between these bands on Landsats-1 and -2 as compared to Landsat-3.
3. Why is displacement caused by pitch, roll, and topography almost negligible on Landsat imagery?
4. Why is the vertical exaggeration of Landsat imagery greater at the equator than near the poles? Why is vertical exaggeration of Landsat imagery quite small?
5. Briefly describe the operation of solid-state linear array remote sensors using pushbroom scanning.

[2] *Federal Telecommunications System.*

6. Name and describe the three components of the Space Shuttle and describe the two modes of operation.
7. Briefly describe the main features of the large format camera being developed for the Shuttle.

The last two questions are based on Chapters Twenty-three, Twenty-four, and Twenty-five.

8. Matching: after each item in the first column, place the letter corresponding to the appropriate sensing system in the second column. Sometimes there are one or more correct matches for each item.

Poorest resolution	____	C = camera
Best resolution	____	R = SLAR
All weather capability	____	TS = thermal scanner
Simplest in design	____	MSS = multispectral scanner
Passive system	____	(without a thermal band)
Day and night capability	____	
Nadir point	____	
Nadir line	____	
Stereoscopic viewing	____	
On Landsats-1 and -2	____	
On Landsat-3	____	

9. Place an x in each appropriate space in the following chart concerning the characteristics of topographic displacement on imagery produced by different sensor systems.

High Elevations Displaced	Camera	Scanner	SLAR
From nadir point			
From nadir line			
Toward line or point			
Away from line or point			

References for Part Five

American Society of Photogrammetry. 1975. *Manual of Remote Sensing,* Falls Church, Va.

Barr, D. J. 1969. *Use of Side-Looking Airborne Radar (SLAR) Imagery for Engineering Studies,* U.S. Army Engineer Topographic Laboratories, Tech. Report 46-TR, Fort Belvoir, Va.

Barr, D. J. and R. D. Mills. 1970. "SLAR Imagery and Site Selection," *Photogrammetric Engineering,* Vol. 36, No. 11. pp. 1155-1170.

Baston, R. M., K. Edwards, and *E. M. Eliason.* 1976. "Synthetic Stereo and Landsat Pictures," *Photogrammetric Engineering and Remote Sensing,* Vol. 42, No. 10. pp. 1279-1280.

Brandli, H. W. 1978. "The Night Eye in the Sky," *Photogrammetric Engineering and Remote Sensing,* Vol. 44 No. 4. pp. 503-505.

Buettner, K. J., and *C. D. Kern.* 1965. "Determination of Infrared Emissivities of Terrestrial Surfaces," *Journal of Geophysical Research,* Vol. 70. pp. 1329-1337.

Coggershall, M. E. and *R. M. Hoffer.* 1973. Basic Forest Cover Mapping Using Digitized Remote Sensor Date and ADP Techniques, LARS *Information Note* 030573, Laboratory of Applications of Remote Sensing, Purdue University.

Colvocoresses, A. P. 1979. "Multispectral Linear Arrays as an Alternative to LANDSAT-D," *Photogrammetric Engineering and Remote Sensing,* Vol. 45, No. 1. pp. 67-69.

Doyle, F. J. 1978. "The Next Decade of Satellite Remote Sensing," *Photogrammetric Engineering and Remote Sensing,* Vol. 44, No. 2. pp. 155-164.

Doyle, F. J. 1979. "A large Format Camera for Shuttle," *Photogrammetric Engineering and Remote Sensing,* Vol. 45, No. 1. pp. 73-78.

Hirsch, S. N., R. F. Kruokeberg, and *F. H. Madden.* 1971. "The Bispectral Forest Detection System," *Proceedings, 7th International Symposium on Remote Sensing of Environment,* University of Michigan, Ann Arbor. pp. 2253-2259.

Holz, R. K. (ed.). 1973. *The Surveillant Science: Remote Sensing of Environment,* Houghton Mifflin, Boston, Mass.

Jensen, H., L. C. Graham, L. J. Porcello, and E. H. Leith, "Side Looking Airborne Radar," *Scientific American,* Vol. 237, No. 4. pp. 84-95.

Kroech, D. 1976. *Everyones Space Handbook,* Piolet Rock, Arcata, Ca.

Lewis, A. J. (ed.). 1976. "Geoscience Applications of Imaging Radar Systems," *Remote Sensing of the Electromagnetic Spectrum,* Vol. 3.

Lillesand, T. M. 1976. *Fundamentals of Electromagnetic Remote Sensing.* State University of New York, College of Environmental Science and Forestry, Syracuse, N.Y.

Lillesand, T. M. and R. W. Kiefer. 1979. *Remote Sensing and Image Interpretation,* John Wiley and Sons, New York.

Lintz, J. and D. S. Simonett (eds.) 1976. *Remote Sensing of Environment,* Addison-Wesley, Reading, Mass.

Loeman, P. D., Jr., 1965. "Space Photography — A Review," *Photogrammetric Engineering,* Vol. 31, No. 1. pp. 76-86.

MacDonald, H. C. 1969. Geologic Evaluation of Radar Imagery from Darien Province, Panama, *Modern Geology,* Vol. 1, No. 1. pp. 1-63.

National Academy of Science. 1970. *Remote Sensing With Special Reference to Agriculture and Forestry,* Washington, D. C.

National Aeronautics and Space Administration. 1974. *Skylab Earth Resources Catalog,* No. 3300-00586, U.S. Government Printing Office, Washington, D. C.

National Aeronautics and Space Administration. 1976. *LANDSAT Date Users Handbook.* Goddard Space Flight Center, Greenbelt, Md.

Office of Naval Research, Department of the Navy. 1965. *Handbook of Military Infrared Technology,* Washington, D.C.

Paine, D. P. 1979. *An Introduction to Aerial Photography for Natural Resource Management,* Oregon State University Bookstores, Inc., Corvallis, Ore.

Rosenfeld, C. L. 1980. "Observations on Mount St. Helens Eruption," *American Scientist,* Vol. 68, No. 5. pp. 494-509.

Sabins, F. F. 1978. *Remote Sensing — Principles and Interpretation,* W. H. Freeman and Co., San Francisco, Ca.

Short, N. M., P. D. Lowman, Jr., S. C. Freden, and W. A. Finch, Jr. 1976. *Mission to Earth: LANDSAT Views the World,* National Aeronautics and Space Administration, Washington, D. C.

Thompson, L. L. 1979. "Remote Sensing Using Solid-State Array Technology," *Photogrammetric Engineering and Remote Sensing,* Vol. 45, No. 1. pp. 47-55.

Tracy, R. A. and R. E. Noll. 1979. "User Oriented Data Processing Considerations in Linear Array Applications," *Photogrammetric Engineering and Remote Sensing,* Vol. 45, No. 1. pp. 57-61.

Weaver, K. F. 1969. "Remote Sensing — New Eyes to See the Work," *National Geographic,* Vol. 135, No. 1. pp. 46-73.

Appendix A

Summary of Photogrammetric Formulas

SCALE AND DISTANCE

$$\text{PSR} = \frac{H}{f} = \frac{A - E}{f} = \frac{\text{GD}}{\text{PD}}$$

$$\text{RF} = \frac{f}{H} = \frac{f}{A - E} = \frac{\text{PD}}{\text{GD}}$$

$$\text{PSR}_B = \text{PSR}_A + \frac{E_A - E_B}{f}$$

$$\text{PSR} = \frac{(\text{MD})\,(\text{MSR})}{\text{PD}}$$

$$\text{GD} = (\text{PD})\,(\text{PSR}) = (\text{MD})\,(\text{MSR})$$

$$H = f\,(\text{PSR})$$

$$A = f\,(\text{PSR}) + E$$

Where

RF	=	Representative fraction
PSR	=	Photo scale reciprocal; that is the reciprocal of representative fraction.
A	=	Altitude of aircraft above sea level.
E	=	Elevation of ground above sea level.
$H = A - E$	=	flying height above the ground
f	=	Camera focal length (in feet)
GD	=	Ground distance
PD	=	Photo distance
MD	=	Map distance
MSR	=	Map scale reciprocal

Useful Equivalents

66 ft = 1 chain
792 in. = 1 chain
80 chains = 1 mile
5,280 ft = 1 mile
640 acres = 1 sq mile
43,560 sq ft = 1 acre
208.7 ft × 208.7 ft = 1 acre
10 chains × 1 chain = 1 acre
25.4 mm = 1 in.
2.471 acres = 1 hectare

HEIGHT AND ELEVATION DIFFERENCE ON STEREOSCOPIC PAIRS

$$h = \frac{(H)\ dP}{P + dP} = \frac{(H)\ dP}{P_t}$$

$$h = \frac{(H)\ dP}{P_b + dP} = \frac{(H)\ dP}{P + \dfrac{P(\pm \triangle E)}{H} + dP}$$

$$h = (DPF)\ (PSR)\ (dP)$$

$$dP = \frac{h(P_t)}{H} = \frac{h(P_t)}{f(PSR)}$$

Where

h	=	Height of object or difference in elevation between two ground points
dP	=	Difference in absolute parallax between two elevations
P	=	Average absolute parallax of the baseline (PP to CPP) or average photo distance between PP and CPP
P_b	=	Absolute parallax at the base of the object
P_t	=	Absolute parallax at the top of the object = $P_b + dP$
$H = A - E$	=	Flying height above the base of the object
DPF	=	Differential parallax factor

$\pm\triangle E$ = Difference in elevation between average baseline and base of the object (+ if base of object is higher and − if lower)

TOPOGRAPHIC DISPLACEMENT OR HEIGHT ON SINGLE PHOTO

$$d = \frac{r(h)}{H} = \frac{r(h)}{A - E}$$

$$h = \frac{d(H)}{r} = \frac{d(A - E)}{r}$$

Where

d = Radial displacement (with respect to the nadir) on the photo at the same scale as the nadir

r = Radial photo distance from nadir (use PP) to the point of displacement (usually top of object)

h = Height of the object or difference in elevation ($\pm\triangle E$) between nadir and displaced point

H = Flying height above the base of the object (or above the nadir in some situations

AREA MEASUREMENT

$$A = \frac{(\text{PSR})^2}{6{,}272{,}640} \left(\frac{\text{DC}}{\text{DI}}\right)$$

$$A = \frac{\left(\frac{\text{PSR}}{12}\right)^2}{43{,}560} \left(\frac{\text{DC}}{\text{DI}}\right)$$

$$\text{Ha} = \frac{(\text{PSR})^2}{100{,}000{,}000 \text{ sq cm/ha}} \left(\frac{\text{DC}}{\text{DI}}\right)$$

Where

A = Number of acres on the ground

Ha = Number of hectares on the ground

PSR = Photo scale reciprocal

6,272,640 = Number of square inches per acre

43,560 = Number of square feet per acre

$\dfrac{\text{DC}}{\text{DI}} =$ Number of square inches or square cm in photo if dot-count method is not used

DC = Photo dot count

DI = Dot intensity = number of dots per square inch or per square cm on the templet

VERTICAL EXAGGERATION AND PERCENT SLOPE

$$VE = \frac{(1 - \%E)\ (Fmt)\ (PSR)}{1.8(H)} = \frac{(1 - \%E)\ (Fmt)}{1.8f}$$

Where

VE = Vertical exaggeration $= \left(\dfrac{\text{vertical RF}}{\text{horizontal RF}} = \dfrac{\text{horizontal PSR}}{\text{vertical PSR}} \right)$

$\%E$ = Percent endlap expressed as a decimal (60% = 0.6)

$1 - \%E$ = Net gain per photo expressed as a decimal

Fmt = Photo format in the direction of flight (inches)

1.8 = A constant

PSR = Photo scale reciprocal

H = Flying height above the average ground elevation

$$\% \text{ Slope} = \frac{\text{rise}}{\text{run}}\ (100) = \left(\sqrt{\frac{4c^2}{b^2} - 1} \right) \left(\frac{100}{VE} \right)$$

Where

c = Length of a side of an isosceles triangle (see Figure 3.15)

b = Length of the base of an isosceles triangle

VE = Vertical exaggeration

Appendix B

Summary of Statistical Formulas

STANDARD DEVIATION, STANDARD ERROR, AND SAMPLE SIZE

$$SD = \sqrt{\frac{\Sigma(y - \bar{y})^2}{n - 1}} = \sqrt{\frac{\Sigma y^2 - \frac{(\Sigma y)^2}{n}}{n - 1}}$$

$$SE_{\bar{y}} = \sqrt{\frac{\Sigma y^2 - \frac{(\Sigma y)^2}{n}}{n(n - 1)}} = \frac{SD}{\sqrt{n}}$$

$$SE_{\bar{y}\%} = \frac{SE_{\bar{y}}}{\bar{y}}(100) = \frac{CV}{\sqrt{n}} \qquad CV = \frac{SD}{\bar{y}}(100)$$

Standard error of the sum:

$$SE_{\bar{x}_1} + SE_{\bar{x}_2} \ldots + SE_{x_n} = \sqrt{(SE_{\bar{x}_1})^2 + (SE_{\bar{x}_2})^2 + (SE_{\bar{x}_3})^2 \ldots + (SE_{\bar{x}_n})^2}$$

Standard error of the product:

$$SE_{\bar{x} \cdot \bar{y}} = \sqrt{(\bar{x})^2 (SE_{\bar{y}})^2 + (\bar{y})^2 (SE_{\bar{x}})^2}$$

Sample size (random and systematic):

$$n = \frac{(SD)^2\ (t)^2}{(DSE_{\bar{y}})^2} = \frac{(CV)^2\ (t)^2}{(DSE_{\%})^2} \qquad \text{for infinite populations}$$

$$n = \frac{N(t)^2\ (CV)^2}{N(DSE_{\%})^2 + (t)^2\ (CV)^2} \qquad \text{for finite populations}$$

Where

y = An observation
\bar{y} = Mean of y
SD = Standard deviation
$SE_{\bar{y}}$ = Standard error of the mean
CV = Coefficient of variation
$SE_{\bar{y}\%}$ = Standard error expressed as a percent of the mean
$DSE_{\bar{y}}$ = Desired sampling error of the mean
$DSE_{\%}$ = Desired sampling error in percent
n = Sample size
N = Population size

DOUBLE SAMPLING WITH REGRESSION AND SAMPLE PLOT ALLOCATION

Linear regression: $y = a + bx$

Where

y = dependent variable
x = independent variable
a = intercept
b = slope coefficient

And

$$b = \frac{SP_{xy}}{SS_x} \qquad\qquad SS_x = \Sigma x^2 - \frac{(\Sigma x)^2}{n}$$

$$a = \bar{y} - b\bar{x} \qquad\qquad SS_y = \Sigma y^2 - \frac{(\Sigma y)^2}{n}$$

Correlation coefficient (r):

$$r = \sqrt{\frac{(SP_{xy})^2}{(SS_x)\,(SS_y)}}$$

Where

$$SP_{xy} = \Sigma xy - \frac{(\Sigma x)\,(\Sigma y)}{n}$$

Standard deviation from regression:

$$s = \sqrt{\frac{\text{Residual SS}}{n - 2}}$$

Where

Residual SS = SS_y − regression SS

Regression SS = $\dfrac{(SP_{xy})^2}{SS_x}$

Example

Using the data from the sample timber cruise in Chapter Twenty-one, we get:

$$SS_x = 33{,}164 - \frac{(488)^2}{10} = 9350$$

$$SS_y = 19{,}011 - \frac{(369)^2}{10} = 5395$$

$$SP_{xy} = 24{,}493 - \frac{(488)\,(369)}{10} = 6486$$

$$b = \frac{6486}{9350} = 0.6937$$

$$a = \frac{369}{10} - 0.6937\left(\frac{488}{10}\right) = 3.047$$

Regression equation is:

$$y = 3.047 + 0.6937x$$

The correlation coefficient is:

$$r = \sqrt{\frac{6486}{(9350)\,(5395)}} = 0.91$$

The standard deviation about the regression line is:

$$\text{Regression SS} = \frac{(6486)^2}{9350} = 4499$$

$$\text{Residual SS} = 5395 - 4499 = 896$$

$$S = \sqrt{\frac{896}{10 - 2}} = 10.58$$

Allocation of photo and field sample plots for double sampling:

$$n_f = \left[\frac{(CV)^2\,t^2}{(DSE_{\bar{y}\%})^2}\right]\left[\frac{C_f}{E\,(C_f + R\cdot C_p)}\right]$$

$$N_p = n_f\,(R)$$

$$R = \frac{1}{\sqrt{\left[\frac{(1 - r^2)}{r^2}\right]\left[\frac{C_p}{C_f}\right]}}$$

$$E = \frac{\dfrac{C_f}{C_p}}{\left[\sqrt{\left(1 - r^2\right)\left(\dfrac{C_f}{C_p}\right)} + r\right]^2}$$

Where

n_f = number of field plots	$DSE_{\bar{y}\%}$ = desired sampling error in percent
n_p = number of photo plots	t = confidence level
R = ratio of photo plots to field plots	$t = 1$ for 68.3%
	$t = 2$ for 95.4%
E = efficiency	$t = 3$ for 99.7%
CV = coefficient of variation	r = correlation coefficient between matched pairs of photo and field plots
C_f = cost of a field plot	
C_p = cost of a photo plot	

Standard error for double sampling with regression:

$$SE_{\bar{y}_{R,D}} = \sqrt{S_{y\cdot x}^2 \left(\frac{1}{n_2} + \frac{(\bar{x}_1 - \bar{x}_2)^2}{SS_x}\right) \left(1 - \frac{n_2}{n_1}\right) + \frac{S_y^2}{n_1}\left(1 - \frac{n_1}{N}\right)}$$

Where

$SE_{\bar{y}_{R,D}}$ = standard error of the mean for double sampling with regression

$S_{y\cdot x}^2$ = variance about the regression line

$$= \frac{SS_y - \left[\dfrac{(SP_{xy})^2}{SS_x}\right]}{n_2 - 2}$$

S_y^2 = variance of the *field* columes = $\dfrac{SS_y}{n - 2}$

SS_x = net SS of photo plots *that were also selected for field measurement*

\bar{x}_1 = mean of *all* unadjusted photo volumes

\bar{x}_2 = mean of the unadjusted photo volumes *that were also measured in the field*

n_1 = number of photo-measured plots

n_2 = number of field-measured plots

N = total possible number of plots in the population if sampling without replacement

STRATIFIED SAMPLING

The mean of the stratified sample is:

$$\bar{y}_{st} = \frac{\Sigma N_h \bar{y}_h}{N}$$

Where

\bar{y}_{st} = the mean of the stratified sample

N_h = the total number of observations in each stratum ($h = 1, 2, 3 \ldots$ to the total number of strata)

N = the *total* number of observations in *all* strata

The standard error of the mean for the stratified sample is:

$$SE_{\bar{y}_{st}} = \sqrt{\frac{1}{N} \Sigma \left[\frac{N_h^2 \, (SD_h)^2}{n_h} \left(1 - \frac{n_h}{N_h}\right)\right]}$$

Where

$SE_{\bar{y}st}$ = the standard error of the mean for a stratified sample
h = the strata designation
n_h = the number of observations in strata h
SD_h = the standard deviation of strata h

Appendix C

Print Varnish and Gum Arabic

PRINT VARNISH (FOR WEATHERPROOFING PHOTOS)

4 oz crushed rosin
Turpentine to cover
64 oz white gasoline (six parts)
43 oz Benzol (four parts)
16 oz commercial ether (one part)

Use a 1-gal jug, put in rosin, and cover with turpentine. Allow rosin to dissolve completely. In another jug make diluting solution of white gas, benzol, and ether. Add diluting solution slowly, shaking constantly, to rosin solution. If rosin precipitates, allow solution to dissolve it. Allow to set one or two days. Decant clear solution into clean bottle. Makes 1 gal.

ADDITIONAL USES

1. To prepare photo surfaces for taking ink or colored pencil.
2. To clean off colored pencil from photo surface.

TO USE

1. Wipe on photo with Kleenex.
2. Wipe off immediately.
3. Photo may be used immediately, but it is preferable to let photo dry for several hours.

GUM ARABIC

Salicylic acid	3½ oz
Gum arabic tears	5 lb
Glycerine	10 oz

Dissolve tears in 1 gal water (120° F) and add salicylic acid and glycerine. Gum arabic allows for easy adjustment of the prints and permanently seals all joints. However, because it uses water as a solvent, it creates problems with controlled mosaics if the paper expands more across the grain of the paper than with the grain.

Appendix D

Specimen Contract for Aerial Photography[1]

This sample contract is designed to point out various specifications of an aerial photo contract. It it not intended to provide a form that will fit all situations.

The contract itself is usually preceded by an "invitation to bid" or a "request for quotations," which furnishes the contractor with such information as to the work to be accomplished, area to be photographed, beginning and completion date, season of photography, qualifications of bidders, ownership of negatives, performance bonds, penalty clauses, subcontracting allowed, and other pertinent information.

The successful bidder enters into a written contract with the agency or company concerned. Most organizations have their own forms and contract procedures.

Items included within parentheses are explanatory only and are not part of the contract.

AGREEMENT

THIS AGREEMENT made on ————————————————————— , at Corvallis, Oregon, by and between the J. D. Lumber Company of Corvallis, Oregon and Oregon Aerial Surveys, Inc., a corporation, of Portland Oregon, hereinafter called "OREGON."

[1] *Courtesy of J. R. Dilworth, Oregon State University School of Forestry, Corvallis, Ore.*

WITNESSETH

WHEREAS, the J-D Lumber Co. desires to have aerial photographs taken of certain terrain for purposes of forest type and planimetric mapping, and

WHEREAS, Oregon is a corporation qualified to perform such aerial photography.

NOW, THEREFORE, in consideration of the promises and mutual covenants and conditions hereinafter set forth, it is agreed by and between the parties hereto as follows:

1. Oregon agrees that as a corporation it shall furnish at its own expense all materials, supervision, labor, equipment and transportation necessary to take, and it promises that it will take aerial photographs for forest type and planimetric mapping purposes, at approximately 12,000 feet above the average mean terrain, according to the plans and specifications hereinafter stated, of an area totalling approximately 158,720 acres, and for the purposes of this agreement, this area is not subject to change, situated in the State of Oregon by the J-D Lumber Co., which map as reference is incorporated herein as "Exhibit No. 1," the boundaries of said area to be photographed being generally described as follows:

Part or all of: T. 11 S., Rs 6 and 7 W.; T. 12 S., Rs 6 and 7 W.; T. 13 S., Rs 6 and 7 W.; T. 14 S., Rs, 7 and 8 W., Willamette Meridian, in Benton County.

At the request of Oregon the J-D Lumber Co. agrees to furnish Oregon not to exceed three (3) copies of said map.

2. Oregon agrees to begin the work as soon after the signing of this agreement as flying weather is suitable for photography but not prior to April 15. (No photography will be accomplished after September 15 without prior written approval by the J-D Lumber Co.) If flying weather permits, delivery of the completed photos will be made on the following schedule:

Photos for 50% of area	On or before July 1, _____
Balance of photos	On or before August 1, _____

It is understood that the completed photos submitted on or before July 1, _____ will represent complete coverage of a solid block of sections in the north half of the area included within Township 11 and 12 S., and Ranges 6 and 7 W.

A line index indicating the location of the flight strips and the number of the first and last exposure of each flight strip shall be furnished by Oregon at the time of delivery of each group of photographs.

3. A progress report of work accomplished will be furnished by Oregon upon request of the J-D Lumber Co.

4. Oregon agrees to do such aerial photography in an expeditious, safe and workmanlike manner, in accordance with the most advanced methods of aerial photography and according to the following specifications:

A. WORK TO BE DONE—The work to be done under these specifications consists of taking aerial photographs of the area described in Paragraph 1 hereof according to the map—Exhibit No. 1—furnished by the J-D Lumber Co. is the best available map and on it Oregon is to lay out the proper flight lines to accomplish the following:

(1) SCALE: The scale of the aerial photography will be approximately 1 to 12,000 or one inch (1″) on the negative is equivalent to 1000 feet on the ground. Contact prints showing a departure of more than 5 percent from the specified negative scale, exclusive of relief displacement, may be rejected.

(2) MATERIAL TO BE FURNISHED: Two sets of contact prints on semi-matte finish low-shrink waterproof paper, one set of contact prints on glossy finish single weight paper, and one photo index having a scale of approximately 1:62,500 and printed on glossy double weight paper are to be furnished to the J-D Lumber Co. by Oregon. The prints will be free of chemicals, stains, streaks, dirt, fingerprints, scratches, smoke, static marks, snow, staple holes or other blemishes. Prints will be of uniform color and density and shall be of such a degree of contrast that all details of the negative will show clearly, both in the shadows and highlights, as well as in the halftones between shadows and highlights. Prints from excessively thin or thick (dense) negatives will not be acceptable. Additional copies of the contact prints or copies of enlargements will be furnished the J-D Lumber Co. at standard commercial rates as requested, but in no event to exceed the sum of $2.25 per contact print or $14.00 per 20 in. × 20 in. enlargement, with prices to be in proportion for enlargements of other sizes.

B. CAMERA EQUIPMENT TO BE USED: The photographs will be made with a single lens standard vertical aerial precision mapping camera with a 12 in. lens and using a 9 in. by 9 in. negative. The camera must be equipped with a between the lens shutter. The camera shall be so equipped as to hold the negative flat by means of an adequate vacuum behind the film. No glass will be permitted between the lens and the film. The camera shall also have fiducial marks which shall appear clear and sharp on each negative to facilitate the locating of the exact geometric center (principal point) of the 9 in. by 9 in. photograph. The camera shall function properly at the altitude specified.

If the precision of the lens, camera body, and cone combination is questioned for any reason, a copy of a certificate from the National Bureau of Standards showing the results of a test of the equipment concerned shall be supplied the J-D Lumber Co. by Oregon upon request. Failure by Oregon to provide this certificate showing the equipment to be capable of producing photography that meets specifications included within this agreement will be considered sufficient cause to reject all photography accomplished with the camera in question.

C. FILM AND FILTER TO BE USED: Kodak Super XX or Aerographic, or equivalent film of fine grain, high speed, low-shrink panchromatic emulsion on a topographic safety acetate base. The film must be fresh and otherwise of good quality. Oregon shall furnish the J-D Lumber Co. with the film date and other film specifications upon request.

A Wratten No. 12 minus blue filter shall be used. The filter shall be made from stained optical "A" glass the two planes of which are within 10 seconds of being parallel. The filter shall have a metallic coating, designed so as to compensate for the falling off in illumination of the field as the half angular field is approached.

D. PROCESSING FILM: Laboratory handling of the film shall be such as to ensure proper development, thorough fixation, and adequate washing of all film and

to avoid rolling the film tightly on drums in such a manner that the film becomes distorted. Processing shall be completed, for any film used, within two weeks of the exposure date.

E. NUMBERING OF NEGATIVES AND PRINTS: Each negative and subsequent print shall be marked to show the date, project, flight line and print number. In addition, on the first and last photo of a flight strip, at each break in the flight line and on the first and last negative of each roll the calibrated focal length of the camera-magazine combination, the time of exposure to the nearest minute and the approximate scale shall be shown. These identifying marks shall be placed along the north edge of the print for north-south flight lines, (and along the west edge of the print for east-west flight lines.)

F. TIME SUITABLE FOR AERIAL PHOTOGRAPHY: Photographs shall be taken between the hours of 1000 and 1400 (Pacific Standard Time) on days when weather conditions are such that clear photographic negatives can be made, except that the time will be reduced to 1100 to 1300 (PST) during the months of April and September. Cloud and cloud shadows will not be permitted. Oregon will be responsible for making its own estimates on weather conditions.

G. RECONNAISSANCE AND ESTIMATE OF TERRAIN AND TOPO-GRAPHIC CONDITIONS: Oregon will make this reconnaissance and estimate. The J-D Lumber Co. shall make available to Oregon any company-owned maps that would be helpful in flight planning.

H. FLIGHT LINES: Direction of flight lines shall be north and south (in some cases direction may be left up to Survey Co.). The flight altitude of each flight shall be adjusted to yield an average negative scale of 1:12,000 based on the mean terrain elevation. Each flight strip shall be flown within five degrees of parallel. Particular care shall be taken to keep all flight strips as straight as possible. Failure of any flight strip or portion thereof to meet the above requirements, or subsequent requirements on forward lap and side lap in paragraph H3, may be cause for rejection for all or any part of the flight strip. No photographs shall be taken on "banks" between successive strips. Each flight shall be so photographed that the principal points on the first and last negatives of that flight strip shall fall on or outside the boundary as shown on the map. The side boundaries of the area photographed shall not fall more than one-fourth photo width away from the principal points of the photos along area boundaries. All photographs in a flight strip shall be consecutive exposures, the time interval between exposures being no longer than that required to provide the forward lap.

(2) REFLIGHTS: Reflights under this agreement shall be made at the expense of Oregon and shall cover that portion of the original flight designated by the J-D Lumber Co. Each reflight line will have 100 percent or more forwardlap with the original flight line at the point of juncture between the reflight and original flight lines. No reflight line shall consist of less than 8 exposures, and shall be centered over the area where the reflight is required.

(3) FORWARDLAP AND SIDELAP: Forwardlap shall average 60 percent and shall not be more than 65 percent or less than 55 percent. Sidelap shall average 30 percent and shall not be more than 45 percent or less than 15 percent.

(4) CRAB: Any series of two or more consecutive photographs crabbed in excess of 10 degrees as measured from the line of flight (as indicated by the principal

points of the consecutive photographs) may be considered unsatisfactory and cause for rejection of that particular flight line or any portion thereof.

(5) TILT: Tilt shall not exceed 3 degrees in any picture. Any series of three or more photos evidencing tilt of more than 2 degrees will be considered cause for rejection.

5. PERFORMANCE BOND: At the time Oregon and the J-D Lumber Co. enter into this written agreement, Oregon will furnish the J-D Lumber Co. a performance or service bond for the total amount of the bid. The bond will be returned to Oregon upon the successful performance of the contract.

6. If Oregon has reason to believe that it will be unable to complete the work in accordance with the specifications within the time specified, Oregon shall give immediate notice in writing to the J-D Lumber Co. If the J-D Lumber Co. finds that the inability of Oregon to meet the time limit is due to unforeseeable causes beyond the control of and without the fault or negligence of Oregon, including, but not restricted to acts of God, fire, flood, weather, embargoes, strikes, and so forth; the J-D Lumber Co., at its discretion, may grant an extension of the time limit. If Oregon refuses or fails to prosecute the work with such diligence as will assure its completion within the time specified, or any extension thereof, or fails to complete said work within such time, the J-D Lumber Co. may by written notice sent by registered mail to Oregon, terminate, five days after receipt of such notice, Oregon's right to proceed with the work or such part of the work as to which there has been delay. In cause of default by Oregon, the J-D Lumber Co. reserves the right to procure personnel and equipment from other sources and to hold Oregon responsible for any excess cost occasioned thereby.

In the case of delay wherein the J-D Lumber Co. has not extended the time limit or where delay continues beyond an extension, or when the right of Oregon to proceed has not be terminated; Oregon shall continue to work and shall be liable to a penalty of $20.00 per calendar day of delay beyond the time limit or extension until the specified work is completed and accepted.

7. It is further understood and agreed by the parties hereto that the J-D Lumber Co. is to have title to and exclusive use of these negatives, photographs and mosaics and that Oregon is to retain the negatives in trust for that purpose. The negatives shall be carefully cleaned, properly packed and stored in a fireproof file. The metal reels and containers shall become the property of J-D Lumber Co. Negatives, photographs and mosaics shall not be used by Oregon for making reproductions for any other person or company without the written approval of the J-D Lumber Co. The J-D Lumber Co. reserves the right to obtain possession of the negatives at any time without prior notice.

8. Oregon shall not, without prior written approval of the J-D Lumber Co., assign this contract in whole or in part, or enter into any subcontracts covering any part of the work contemplated by this contract.

9. Oregon, as a corporation, shall assume all risk in connection with the performance of this contract, and shall be solely liable for and save the J-D Lumber Co. harmless from any and all claims, demands, suits and actions made or brought on account or any death or injury to any person or loss of or damage to any property whatsoever sustained in the performance of this contract, including without limiting the generality of the foregoing, employees of and property owned by the J-D Lumber Co.

(Prior to commencing work hereunder, and until the same shall be fully completed, Oregon will maintain public liability and property damage insurance which shall cover the J-D Lumber Co. as well as Oregon in respect to work to be performed hereunder.)

10. In the event this contract shall not be fully performed by August 1, ____, the J-D Lumber Co. shall have the right to terminate Oregon's right to continue with the work. Paragraph 6 stipulates the action that the J-D Lumber Co. may take in case of default by Oregon.

11. The J-D Lumber Co. agrees to pay Oregon for the aerial photography so performed a total contract price of _____

in cash, payable as follows:

35% when photos of 50% of the area have been delivered and accepted in accordance with the provisions of paragraph 2.

Balance due when photos of the entire area have been delivered and accepted and the terms of this contract satisfied.

IN WITNESS WHEREOF the parties hereto affixed their signature the day and year above written.

J-D Lumber Co.

By _____
 President
Attest:

 Secretary

Oregon Aerial Surveys, Inc.

By _____
 President
Attest:

 Secretary

Appendix E

Selected Aerial Photo Volume Tables

See the list of references at the end of Chapter Twenty-one for the source of additional tables and references for the tables in this appendix.

Aerial Photo *Stand* Volume Table for Ponderosa Pine in the Pacific Northwest[a]

(in tens of board feet per acre)[b]

Stand Height (ft)[c]	Crown Closure (percent)[d]									
	5	15	25	35	45	55	65	75	85	95
20	—	2	28	53	79	104	130	155	180	206
30	—	50	107	165	222	278	335	391	447	503
40	15	117	218	319	419	518	617	714	811	907
50	44	203	360	515	668	820	970	1117	1263	1407
60	79	307	531	751	967	1179	1387	1591	1791	1987
70	120	428	729	1023	1309	1588	1860	2124	2381	2631
80	168	567	955	1329	1692	2041	2378	2703	3015	3315
90	222	723	1205	1666	2108	2530	2931	3313	3674	4016
100	281	895	1478	2030	2552	3044	3505	3935	4335	4705
110	347	1082	1772	2417	3018	3574	4085	4552	4974	5351
120	419	1283	2084	2822	3496	4107	4655	5140	5561	5919
130	497	1498	2412	3239	3979	4632	5197	5676	6067	6372
140	580	1725	2753	3663	4457	5133	5693	6135	6460	6667
150	668	1963	3103	4089	4920	5597	6120	6488	6702	6761
160	763	2211	3460	4509	5358	6008	6457	6706	6756	—
170	862	2468	3820	4917	5759	6347	6679	6757	—	—

[a] *From Paine and Payandeh (1965).*

Equation for table: $V_b = -367.2 + 0.064406\,(H^2C) - 1.52504 \times 10^{-8}\,(H^2C)^2$.

Where V_b = *board-foot volume per acre*

H = *stand height in feet[c]*

C = *Crown closure in percent (upper story only)*

Multiple correlation coefficient (R) = 0.932.

Standard deviation from regression or standard error of estimate = ±5,200 board-feet per acre or ±33.3 percent of the mean plot volume.

Based on 156 one-acre plots on the east side of the Cascade mountains in Oregon.

[b] *Gross volume per acre of all trees 11.0 in. and larger with the top scaling limit set at 50 percent of the scaling diameter of the butt 16-ft log (or 60 percent in the case of the 32-ft butt log), or 8 in., whichever is greater. Volume to basal area ratio table derived from Mason, Bruce, and Girard's form class tables based on total height.*

[c] *Average height of the five tallest trees per acre as measured in the field.*

[d] *Includes the upper story only in the case of all aged stands and dominants and codominants in the case of even-aged stands.*

Aerial Photo *Stand* Volume Table for Ponderosa Pine in the Pacific Northwest[a]

(in tens of cubic feet per acre)[b]

Stand Height (ft)[c]	Crown Closure (percent)[d]									
	5	15	25	35	45	55	65	75	85	95
20	27	32	36	40	45	49	53	58	62	66
30	30	40	50	59	69	79	88	98	107	116
40	34	51	68	85	102	119	136	152	168	184
50	39	66	92	118	144	170	195	220	244	268
60	45	83	121	158	194	230	265	299	332	365
70	52	104	155	204	252	299	344	388	430	471
80	60	127	192	255	316	374	430	483	535	583
90	69	154	234	312	385	455	521	583	642	696
100	79	182	280	372	459	539	614	683	747	805
110	90	214	329	436	535	625	707	781	846	903
120	102	248	381	503	613	711	797	872	934	985
130	115	283	435	571	690	794	880	951	1006	1044
140	129	321	491	640	766	871	954	1014	1053	1071
150	144	361	549	708	838	940	1012	1056	1072	—
160	160	402	607	774	905	998	1053	1072	—	—
170	180	445	665	838	963	1041	1071	—	—	—

[a] *From Paine and Payandeh (1965).*

Equation for table: $V_c = 252.2 + 0.010909 \ (H^2 C) - 2.84338 \times 10^{-9} \ (H^2 C)^2.$

Where V_c = *cubic-foot volume per acre*

H = *stand height in feet*[c]

C = *crown closure in percent (upper story only)*

Multiple correlation coefficient (R) = 0.943.

Standard deviation from regression or standard error of estimate = ±781 cu ft per acre, or ±26.8 percent of the mean plot volume.

Based on 156 one-acre plots on the east side of the Cascade mountains in Oregon.

[b] *Gross volume per acre of all trees 5.0 in. and larger from stump height (equivalent to D.B.H. with a maximum of 24 in.) to a top limit of 4.0 in. d.i.b. volume to basal area ratio tables from Table 8A, p. 340,* Log Scaling and Timber Cruising, *by Dilworth 1965.*

[c] *Average height of the five tallest trees per acre as measured in the field.*

[d] *Includes the upper story only in the case of all-aged stands and dominants and codominants in the case of even-aged stands.*

Aerial Photo *Stand* Volume Table for Douglas-fir in the Pacific Northwest

(in thousand board feet per acre)[a]

Stand Height[b] (ft)	Crown Closure (percent)[c]								
	15	25	35	45	55	65	75	85	95
50	1	3	4	5	5	4	3	1	—
60	2	5	7	8	8	8	6	4	—
70	4	8	10	12	13	12	11	8	4
80	6	11	14	17	18	18	16	14	10
90	8	14	19	22	23	24	23	20	16
100	10	18	23	28	30	31	30	28	24
110	13	22	29	34	37	39	39	37	34
120	16	26	34	41	46	48	49	48	44
130	19	31	41	49	54	58	60	59	56
140	22	36	48	57	64	69	72	72	70
150	25	41	55	66	75	81	85	86	85
160	29	47	63	76	86	94	99	101	101
170	33	53	71	86	98	107	114	118	118
180	37	60	80	97	111	122	130	135	137
190	41	67	89	108	125	138	148	154	158
200	46	74	99	121	139	154	166	174	179
210	50	82	109	134	154	172	185	196	202
220	55	90	120	147	170	190	206	218	226
230	60	98	132	161	187	209	228	242	252
240	66	106	143	176	205	230	250	267	279
250	71	116	156	192	223	251	274	293	308
260	77	125	168	208	242	273	299	320	337

From Pope (1962).
Equation for table: $V_b = 0.9533C^2 + 3.2313HC + 0.0716H^2C - 0.0883HC^2 - 3285$
Where V_b = *volume, board-feet per acre*
H = *stand height in feet*
C = *crown closure in percent*
Multiple correlation coefficient (R) = 0.918.
Standard deviation around regression or standard error or estimate = 26,312 board-feet per acre, or 34.8 percent of the mean plot volume.
Based on 282 1/5-acre plots, largely in western Oregon.

[a] *Gross volume, Scribner Decimal C, in trees 11.0 in. and larger. Trees 11.0 to 20.9 in. scaled in 16-ft logs to top d.i.b. of 50 percent of the scaling diameter of butt log. Trees 21.0 in. and larger scaled in 32-ft logs to top d.i.b. of 60 percent of the scaling diameter of the butt log. Volume tables used: Mason, Bruce, and Girard, based on total height and form class.*
[b] *Average height of dominants and codominants, as measured in the field.*
[c] *Includes all trees in the major canopy (occasionally excluding small trees definitely below the general canopy); average photo estimate of several experienced interpreters.*

Aerial Photo *Stand* Volume Tables for Douglas-fir in the Pacific Northwest

(in hundred cubic feet per acre)[a]

Stand Height[b] (ft)	Crown Closure (percent)[c]								
	15	**25**	**35**	**45**	**55**	**65**	**75**	**85**	**95**
40	5	8	11	13	14	15	15	14	13
50	7	11	15	18	20	21	22	21	20
60	9	15	20	24	27	29	30	29	28
70	12	19	25	31	34	37	39	39	38
80	14	24	31	38	43	46	48	49	49
90	17	28	38	45	52	56	59	61	61
100	21	33	45	54	61	67	72	74	75
110	24	39	52	63	72	79	85	88	90
120	28	45	60	73	83	92	99	103	106
130	31	51	68	83	95	106	114	120	124
140	35	57	77	94	108	121	130	138	143
150	40	64	86	105	122	136	148	157	163
160	44	71	96	118	136	153	166	177	185
170	49	79	106	130	152	170	185	198	208
180	54	87	117	144	168	188	206	220	232
190	59	95	128	158	184	208	227	244	257
200	64	104	140	173	202	228	250	269	284
210	70	113	152	188	220	249	274	295	313
220	75	122	165	204	239	271	298	322	342
230	81	132	178	220	259	293	324	351	373
240	87	142	192	238	280	317	351	380	406
250	94	152	206	256	301	342	379	411	439
260	100	163	221	274	323	367	408	443	474

From Pope (1962).
Equation for table: $V_c = 0.9233HC + 0.0070H^2C - 0.0086HC^2 - 179$.
Where V_c = volume, cubic feet per acre
 H = stand height in feet
 C = crown closure in percent
Multiple correlation coefficient $(R) = 0.904$.
Standard deviation around regression or standard error of estimate = 3,777 cu ft per acre, or 29.2 percent of the mean plot volume.
Based on 282 1/5-acre plots, largely in western Oregon.

[a]*Gross volume, in trees 5.0 in. and larger, from stump to top limit of 4.0 in. d.i.b. Volume tables from U.S. Dept. Agr. Handb. 92.*
[b]*Average height of dominants and codominants, as measured in the field.*
[c]*Includes all trees in the major canopy (occasionally excluding small trees definitely below the general canopy); average photo estimate of several experienced interpreters.*

Aerial Photo *Tree* Volume Tables for Northern Hardwoods on Sites I and II Land

Site I				Site II			
Actual Visible Crown Diameter (ft)	D.B.H.	Gross Volume per Tree		Actual Visible Crown Diameter (ft)	D.B.H.	Gross Volume per Tree	
		Board-Feet (Int. ¼)	Cubic Feet (I.B.)			Board-Feet (Int. ¼)	Cubic Feet (I.B.)
5	5.0		2.1	7	5.8		1.9
6	5.8		2.8	8	6.5		2.8
7	6.6		3.6	9	7.3		3.8
8	7.3		4.8	10	8.0		4.8
9	8.0		5.8	11	8.9		6.6
10	8.8		7.4	12	9.7		8.4
11	9.8		10.0	13	10.5		10.2
12	10.3		11.6	14	11.3		12.8
13	11.2		14.6	15	12.0	83	14.8
14	11.9	99	18.2	16	12.9	100	18.0
15	12.7	118	20.5	17	13.6	116	20.6
16	13.4	136	23.8	18	14.4	136	24.0
17	14.2	160	27.6	19	15.2	163	27.6
18	15.0	184	32.0	20	16.0	181	31.0
19	15.7	210	36.0	21	16.8	206	35.2
20	16.5	243	41.0	22	17.6	233	39.6
21	17.2	272	45.8	23	18.4	262	44.0
22	18.0	307	51.2	24	19.2	293	49.2
23	18.8	347	56.8	25	20.0	327	54.2
24	19.5	385	62.0	26	20.8	361	59.6
25	20.3	427	67.8	27	21.6	398	65.5
26	21.0	466	74.2	28	22.4	436	71.0
27	21.8	512	79.8	29	23.2	478	77.6
28	22.6	563	86.5	30	24.0	520	84.0
29	23.4	616	94.0	31	24.7	561	90.0
30	24.1	664	100.6	32	25.5	610	97.2
31	25.0	728	109.4	33	26.3	662	105.0
32	25.7	776	116.2	34	27.1	714	113.2
33	26.5	838	124.8	35	27.9	768	121.6
34	27.2	892	132.0	36	28.7	824	130.8
35	28.0	960	141.0	37	29.4	876	138.8
36	28.8	1035	150.0	38	30.3	945	149.2
37	29.5	1107	159.0	39	31.3	1025	161.6
38	30.3	1202	170.0	40	31.9	1074	169.4
39	31.0	1296	180.0				
40	31.8	1410	193.0				

From Ferree (1953).

Composite Aerial Volume Table for Northern Minnesota[a]

(in gross cubic feet per acre[b] [c])

Average Total Height (ft)	Crown Closure (percent)									
	5	15	25	35	45	55	65	75	85	95
30	40	120	200	280	360	440	520	600	680	760
35	80	190	300	410	520	630	740	850	960	1070
40	180	310	440	570	700	830	960	1090	1220	1350
45	460	590	720	850	980	1110	1240	1370	1500	1630
50	740	870	1000	1130	1260	1390	1520	1650	1780	1910
55	1020	1150	1280	1410	1540	1670	1800	1930	2060	2190
60	1300	1430	1560	1690	1820	1950	2080	2210	2340	2470
65	1580	1710	1840	1970	2100	2230	2360	2490	2620	2750
70	1860	1990	2120	2250	2380	2510	2640	2770	2900	3030
75	2140	2270	2400	2530	2660	2790	2920	3050	3180	3310
80	2420	2550	2680	2810	2940	3070	3200	3330	3460	3590
85	2700	2830	2960	3090	3220	3350	3480	3610	3740	3870
90	2980	3110	3240	3370	3500	3630	3760	3890	4020	4150
95	3260	3390	3520	3650	3780	3910	4040	4170	4300	4430
100	3540	3670	3800	3930	4060	4190	4320	4450	4580	4710

From Avery and Meyer (1959).

[a]*Subtract 10 to 15 percent for* pure *hardwood stands and add 10 to 15 percent for* pure *coniferous stands. Based on 50 one-acre plots.*

[b]*Gross volumes are inside bark and include all trees 5.0 in. d.b.h. and larger from stump to a variable top diameter not less than 4.0 in. i.b.*

[c]*Volumes may be converted to rough cords per acre by dividing by 80.*

Composite Aerial Photo *Stand* Volume Table[a] in Scribner Board Feet per acre for Ponderosa and Jeffrey Pine, Douglas-fir, and White and Red fir in California

Stand Height[b] (ft)	Crown Cover (percent)[c]									
	5	15	25	35	45	55	65	75	85	95
	M Board-Feet per Acre									
40		1	2	2	3	3	4	4	5	5
50		2	3	4	5	6	7	8	8	9
60.	1	4	6	7	9	10	11	12	13	14
70	2	5	9	11	13	15	17	18	19	20
80	3	8	12	16	19	21	23	25	26	27
90	4	10	16	21	25	28	30	32	34	34
100	5	14	21	27	32	36	39	41	42	43
110	6	17	26	34	40	44	48	50	52	52
120	7	21	32	41	48	53	57	60	61	62
130	9	25	38	48	56	63	67	70	72	72
140	10	29	44	56	65	72	77	80	82	83
150	12	33	50	64	74	82	88	91	94	94
160	13	36	56	71	83	92	98	102	105	106
170	14	40	61	78	91	101	109	114	117	118
180	15	43	66	85	100	111	119	125	129	130
190	16	46	71	91	107	120	129	136	141	143
200	17	48	75	97	114	128	139	147	153	157
210	17	50	78	102	121	137	149	158	166	170
220	18	51	81	106	127	144	158	170	178	185

From Chapman (1965).

[a]*Gross volume in trees 11.0 in. d.b.h. and larger to average utilized top.*
[b]*Average height of dominant stand measured in the field.*
[c]*Includes all trees in major crown canopy.*

Composite *Stand* Aerial Photo Volume Table for Southern Pines and Hardwoods in Arkansas

Average Total Height (ft)	Crown Closure (percent)									
	5	15	25	35	45	55	65	75	85	95
	Gross Cubic Feet per Acre[a]									
40	175	215	250	290	325	365	400	440	475	515
45	240	295	345	400	450	505	555	610	660	715
50	330	395	460	525	590	655	720	790	855	920
55	395	490	580	675	765	860	950	1045	1140	1230
60	480	600	715	830	950	1065	1180	1300	1415	1530
65	585	725	860	1000	1135	1275	1410	1545	1685	1820
70	715	865	1020	1175	1330	1480	1635	1790	1945	2100
75	860	1025	1195	1360	1530	1695	1865	2030	2200	2365
80	1020	1200	1380	1555	1735	1910	2090	2270	2445	2625
85	1205	1390	1575	1760	1945	2130	2315	2500	2685	2870
90	1410	1600	1785	1975	2165	2350	2540	2730	2915	3105
95	1635	1820	2010	2200	2385	2575	2765	2950	3140	3330
100	1875	2060	2245	2430	2615	2800	2985	3170	3355	3540
105	2140	2315	2495	2675	2850	3030	3210	3385	3565	3745
110	2420	2590	2755	2925	3095	3260	3430	3600	3765	3935
115	2725	2880	3030	3185	3340	3495	3650	3805	3960	4115
120	3045	3180	3320	3455	3595	3730	3870	4005	4145	4280

From Avery and Myhre (1959).

[a]*Gross volumes are inside bark and include the merchantable stems of all live trees 5 in. d.b.h. and larger from stump to a variable top diameter not smaller than 4 in. i.b.*

Appendix F

Partial Answers to Questions and Problems

Answers to questions that do not require calculations can be found within the chapter.

Chapter 1

7. 2204.16 m²/ha

Chapter 2

3. 500 ft (152 m)
4. 10,000 ft (3048 m)
5. The listed height is 1454 ft (443 m).

Chapter 3

7. VE = 2.91

Chapter 4

3. 1 in. = 1 mile, 1.578 cm = 1 km
4. RF = 1:63,360, PSR = 63,360
7. RF = 1:15,840, 4 in. = 1 mile
8. PSR = 15,331, PSR = 15,329
9. PSR = 12,250
10. PSR = 11,050
11. PSR = 1:63,356
13. A = 11,000 ft (3353 m)

Chapter 5

3. Rotate clockwise
4. Correct as is
6. 1.54 hours
7. 3.56 in (9.05 cm) plus safety factor
8. 30.47 acres (12.33 ha)
10. 24.44 acres (9.89 ha)

Chapter 6

1. 50 photos
4. No, would have to fly at 35,680 ft (10,875 m)
5. 11.05 s (round down to 11 s)
6. 113 mph
7. 24,200 ft (7376 m)
11. (a) 0.34 in. (0.86 cm), (b) 1.28 in. (3.25 cm), (c) 0.6 in. (1.52 cm)

Chapter 7

1. y is higher than z, both y and z are lower than the baseline (higher elevations have larger *absolute* parallaxes)
2. Elev. B = 2,000 ft (610 m) because h = 1,000 ft (305 m)
3. B at the same elevation as baseline (they have the same absolute parallexes)
4. A = 8040 ft (2451 m), PSR = 15,879
5. h = 119 ft (36 m)
6. Tree B
7. The first photo
8. Point z higher than point y
10. The flying cows walked right. If they would have walked left, they would appear under ground. Those on the ground remained stationary between exposures.

Chapter 8

6. (a) 320 acres, (b) 80 acres, (c) 360 acres, (d) 23,040 acres
7. 193.62 miles, bearing = S (tangent of 3.342)° E. or S 73° 21′ E. (55 miles south and 185.5 miles east)

Chapter 9

3. (a) decreases toward PP, (b) no effect, (c) no effect (topographic displacement is 0 in both cases), (d) decrease, can't tell direction.

Chapter 10

7. $H = 2400$ ft
9. $C = 945$

Chapter 12

5. Adjusted AEI = 100
9. 10 line pairs per millimeter

Chapter 15

5. (a) eolian deposits (loess), (b) sedimentary (shale), (c) sedimentary (tilted), (d) metamorphic (gneiss), (e) igneous (extrusive basalt)

Chapter 17

4. (a) $\dfrac{D4 - h}{H2 = d}$, (b) RP3-s, (c) X (as of 1978)
5. (a) a well-stocked stand of Douglas-fir seedlings and saplings planted sometime between 1965 and 1974, (b) a well-stocked stand of hardwood pole timber, (c) a poorly stocked stand of pole timber consisting primarily of true fir—mountain hemlock with more mountain hemlock than alpine fir, (d) a two-storied stand with poorly stocked overmature Douglas-fir in the overstory and a medium-stocked stand of small saw timber in the understory. The understory consists mostly of Douglas-fir but with at least 20 percent of the story made up of western hemlock and western red cedar with more hemlock than cedar, (e) an area clearcut over 5 years ago and not restocked

Chapter 19

5. (a) mean = 6056 cu ft per acre (424 cu m per hectare), (b) SD = 333 cu ft (9.4 cu m), CV = 27.50%, $SE_{\bar{y}}$ = 111 cu ft (3.14 cu m), $SE_{\bar{y}}$ = 9.16%, (c) infinite equation = 30.25 or 31 plots, finite equation = 28.52 or 29 plots

Chapter 21

1. (a) 61.2 MBF, 50.9 MBF 10.8 M cu ft. 9.94 M cu ft
 (b) 3,916,800 MBF, 3,257,600 MBF, 691,200 M cu ft, 659,200 M cu ft
2. (a) $SE_{\bar{y}}$ = 5.93 MBF per acre or 59,300 MBF on 10,000 acres, (b) $SE_{\bar{y}}$ = 16.85%
3. n_f = 22 plots, n_p = 315.22 = 316 plots

Appendix G

Partial Answers to Laboratory Exercises

Chapter 3

Stereoscopic Perception Test

Block A: A-5, B-7, C-2, D-4, E-1, E-6
Block B: A-1, B-8, C-3, D-1, D-5, E-6
Block C: A-2, A-5, B-7, C-3, D-1, E-8
Block D: A-1, B-4, B-7, C-2, C-5, D-3, E-6

Chapter 13

Photo Interpretation Test

1c—orchard
2a—bridge
3c—irrigation canal
4b—farm pond
5a—farm buildings
6d—road
7d—ranch buildings
8b—cottonwood
9a—irrigated field
10c—baled hay piles
11b—grass-sagebrush
12a—irrigation ditch
13b—lava rock ledge
14b—conifers
15a—hard rock cliff
16d—rapids
17a—fence line

18c—tillage pattern
19b—grass-sagebrush
20c—drainage canal
21a—marsh pattern
22a—clay piles
23b—narrow-gage RR grade
24c—mine buildings
25a—abandoned mine
26b—improved road
27a—water ditch
28a—pine trees
29b—pine saplings
30d—exploration pit
31b—fireline road
32a—aspen poles
33d—mountain meadow
34d—hardwood brush

35b—rock dike
36a—main haul road
37a—clearcutting
38d—old beaver meadows
39a—cutting line
40b—lodgepole pine
41c—beaver pond
42a—main haul road
43d—jammer roads
44d—road junction
45c—cirque wall
46a—toe slope with boulders
47d—talus slope
48c—spruce, alpine fir
49a—timberline fir
50d—snow

Index